ART:
THE WAY IT IS

ART:
THE WAY IT IS

FOURTH EDITION

JOHN ADKINS RICHARDSON

PROFESSOR OF ART AND DESIGN

SOUTHERN ILLINOIS UNIVERSITY AT EDWARDSVILLE

PRENTICE HALL, INC., ENGLEWOOD CLIFFS, NEW JERSEY

HARRY N. ABRAMS, INC., NEW YORK

I am grateful to the University of Illinois Press and to Prentice Hall for permission to use brief passages from my books *Modern Art and Scientific Thought* and *Basic Design,* respectively.

Fourth Edition 1992

Library of Congress Cataloging-in-Publication Data
Richardson, John Adkins.
 Art, the way it is / John Adkins Richardson. —4th ed.
p. cm.
Includes bibliographical references and index.
ISBN 0–13–040437–3 (pbk.)
1. Art. I. Title.
N7425.R48 1992
701'.1—dc20 91–19855

Published in 1992 by Harry N. Abrams, Incorporated, New York
A Times Mirror Company

Printed and bound in Japan

CONTENTS

PREFACE AND ACKNOWLEDGMENTS

This is a different kind of book, and not just because it contains cartoons, comic strips, popular illustrations, and other things rarely encountered in an art appreciation book in addition to the customary masterpieces and diagrams. When the first edition appeared in 1974 these things made it unique. Since then, others have followed our lead. Still, it is more typical to find only masterworks included in books of this type. And usually the writer is at pains to demonstrate that "high art" is more serious, complex, and genuine, more sincere and more profound than the kinds of things most people like when they are not pretending to be "cultured." What is truly different about *Art: The Way It Is* is that the author does not take a reverential attitude toward fine art. For while it is surely true that serious fine art is generally the more complex, genuine, sincere, and profound, it does not necessarily follow that one should for that reason prefer it over what is simpler, less thoughtful, or more frivolous.

Those of us who spend our lives concerned with the arts usually do not like what is commonplace or simple, and that is natural. True sports fans are bored by routine performance; they are fascinated by the exceptional. The professional mathematician would go mad had he nothing to do but routine applications of the calculus. The more we know of a thing the less concerned we are with its ordinary manifestations.

Similarly, when one knows very little about a subject one is apt to like what is most familiar and to be impressed with what seems difficult. As it happens, what is most familiar is quite often mediocre, and what a layman considers remarkable a professional would look upon as routine. College and high school art teachers wage eternal war against the hackneyed nature of most cartooning and illustration and dutifully oppose the shallowness of "dime-store" reproductions.

This book, however, accepts common taste as valid. But it is motivated by a genuinely serious concern for civilized values. The professional art historian or critic who reads it will realize that it takes its lead from the work of men like E. H. Gombrich, who recognize that a good deal of what appeals to people in popular art is not what is simple-minded so much as what is fundamental, and that what appears in Michelangelo in elevated form may be present in another

fashion in the work of a popular artist. And, since people unfamiliar with art are more likely, as a rule, to grasp the significance of Norman Rockwell than they are to appreciate the subtleties of either Rembrandt or Picasso, it seems a good idea to begin with Rockwell rather than Rembrandt. This is not to argue that a Rockwell painting is equal to a Rembrandt painting; I contend only that one can learn a great deal about the latter by way of the former. In other words, this volume is based on the assumptions that it is possible to talk sensibly about art without demeaning it, to convey its values without preaching, and to do this in a book of rather modest cost.

We should not presume that one art book can do *everything*. Lectures, discussions, supplementary reading, and exposure to actual works in museums, galleries, and studios are also necessary. Yet, learning is not dependent on any of that. To help in moving beyond this volume, a bibliography and a glossary are provided. The index contains the names of all the artists mentioned. And, because many of the names are foreign, a pronunciation guide has been supplied.

Several of the reproductions are repeated over and over again. The purpose of doing this is threefold: (1) It enables the reader to grow familiar with a number of great works and to appreciate the fullness and richness of some exemplary ones; (2) it assists the reader's understanding by limiting the sheer mass of factual material to be digested; and (3) it makes it easy to refer to a picture without turning back fifty pages to where it first appeared.

PREFACE TO THE FOURTH EDITION

Surely this book has the faults inseparable from any human production and those, of course, are the fault of the author's carelessness or ineptitude. Some of its virtues are owed him too, but many must be credited to others. Without the assistance of artists, museums, galleries, publishers, and photographic services, a book of this kind could never be produced. Although they are recognized elsewhere in the captions and the photographic credits, I offer them here my special thanks. Users of the book in colleges and universities have continued to offer recommendations and insights in response to the second edition of *Art · The Way It Is*, and the fourth edition shows the effect of their opinions.

It is more or less routine to amplify some subjects that were slighted in earlier editions of a book, to increase the number of colorplates and add black-and-white illustrations. I am always concerned with keeping the cost of these volumes as low as possible and, since one of the costliest production items is the four-color reproduction, we have kept that expansion to a minimum while materially augmenting the black-and-white imagery.

The most significant change in the fourth edition is the addition of a brief survey of the history of Western art from prehistory to the present. Materials previously included elsewhere as separate chapters and under special subheadings have been incorporated into this description of the evolution of art and architecture. It should be obvious that any such overview will err on the side of the superficial and omit more than can be included. However, I do believe that it is no more imperfect than similar general surveys done by others. The treatment of prehistoric art contains a description of the radiocarbon dating process and one way of ameliorating the conflict between Fundamentalist beliefs and scientific evidence. At the opposite extreme from such lofty considerations of faith and reason are the materialistic aims of those whose principal interest in art is speculative investment in precious objects. Recently, the astronomical prices paid for paintings by late-nineteenth-century artists have given normal folk new reason to look upon the art world with renewed skepticism and mounting bafflement. Our new chapter three, therefore, attempts to deal with the sometimes mystifying relationship between art and money.

While undertaking to make these changes, I have attempted to retain the conversational directness that has made this book popular with many readers. This sort of thing is not quite so easy to do as it might seem, and I owe a good deal of thanks to my friend and publisher at Prentice-Hall, Norwell Therien, Jr., and his assistant, Barbara Barysh. At Harry N. Abrams, I am pleased to acknowledge the help of the entire staff. Once again, Barbara Lyons produced photographs when no museum, gallery, or individual artist could. Joanne Greenspun, who edited this edition, contributed invaluable assistance and a truly remarkable efficiency to the production. The completely new design is the work of Dirk Luykx and Gilda Hannah and provides a felicitous context for the ideas. Locally, the book owes, as always, a great deal to the faculty of the Department of Art and Design at Southern Illinois University at Edwardsville. My deepest gratitude, however, goes to my wife, Glenda M. Lawhorn.

J.A.R.
March 1991

PART ONE

INTRODUCTION

WHO'S PUTTING ON WHOM?

Y ou and I, reader, might as well level with each other straight off. For it is important that we understand each other's position.

What you have in your hands is a book on what is commonly called art appreciation, that is, on the understanding and enjoyment of pictures, statues, and the like. To many it seems odd that anyone wishes to be instructed in such activity. An acquaintance with art has no direct bearing on earning a livelihood. Nor is it necessary to a happy and fruitful life; one can get along quite nicely without knowing a Picasso from a put-on.

Still, there is a peculiar universality about books on art appreciation; they are to be encountered everywhere. And such prevalence suggests a need.

Frequently, the need is connected with one's social life. Some readers may hope to gain a bit of confidence regarding home decor. Too, there is real utility in knowing a little about the arts if one wishes to advance in a corporate structure from the lower to the executive levels. Yet, art is a puzzle to many people, even when they know what they like, and you may be hoping to find its key within these pages.

Such self-interested views are not altogether foreign to the writer who wishes to overcome the idea that aesthetic progress consists of paving over all that is natural or happens to be old. What most laymen are apt to want is just a bit of polish. And that is the most an author dares hope to achieve. True, the attempt to apply a bit of polish often leads to something that is not so superficial. But I cannot promise to do more than gloss surfaces, for there are basic difficulties in dealing with a thing so all-encompassing as art.

A famous art historian, Erwin Panofsky, once raised against the idea of art appreciation the objection that it is doomed to mislead the very people it is supposed to serve. He wrote that "he who teaches innocent people to understand art without bothering about classical languages, boresome historical

methods and dusty old documents, deprives naiveté of its charm without correcting its errors."[1] There is much to be said for this way of looking at the matter, but it fails to recognize that many other forces operate to deprive naiveté of any charm whatever. At least this is true in contemporary industrial society. It may not be true in other societies. A peasant rustic's enthusiasm for the folk crafts of his people is charming, and frequently the objects themselves are very appealing. But what passes for good taste in suburbia, the garish distractions that surround the urban dweller, and the billboards afflicting the rural landscape are all invitations to depravity. Perhaps art appreciation books can do little against these influences, but they can scarcely do more harm. The visual clutter that assails us all is, if you wish, a form of pollution as damaging to the sensibilities of the unwary as fertilizers are to a stream. As a matter of fact, the situation is quite similar. For, just as excessive nitrogen fed into a pond produces overgrowth that chokes out animal life, so the plethora of images in our culture tends to stifle the quality of perception.

But there is also something to be said on behalf of our excess. The dullest living laymen are much better educated about pictures than were any of the generations that preceded them. They are exposed to more imagery by far than were their counterparts during the Italian Renaissance or the Golden Age of Greece. In Leonardo da Vinci's day his *Mona Lisa* was seen by but a few hundred of the elite. Today color reproductions reveal her smile to everyone. René Huyghe has said that all modern men are "importuned, and obsessed, by the visual."[2] When one considers the degree to which our lives are dominated by motion pictures and television, by diagrams and news photos, by maps, advertising illustrations, and comic strips, one sees how aptly the description *visual* fits our everyday existence. Throughout most of history a picture of any but the rudest kind has been a thing of magic and delight, but today everyone takes "living color" pretty much for granted.

We are, all of us, experts at looking. What few of us can do is *see*. If all of us knew how to see, then all of us could draw. I know that sounds outrageous, absurd on the face of it, but I assure you it is true.

Figure 1-1 is a drawing of a man's head that I have done with a felt pen held in my teeth. Figure 1-2 is a similarly shaky rendering of my right hand done by my left, the one that rarely holds a pen. No claim of quality is made for either case. I do insist, however, that neither rendering looks amateurish. Manual

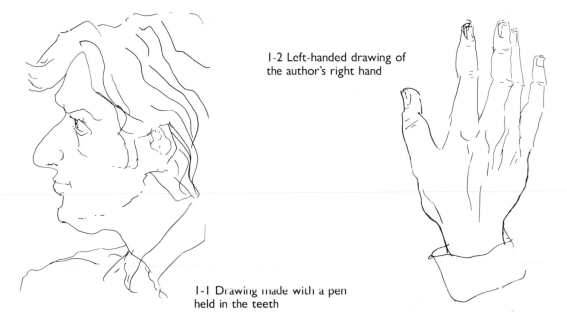

1-2 Left-handed drawing of the author's right hand

1-1 Drawing made with a pen held in the teeth

dexterity has very little to do with art, even in drawing; what drawing has to do with is understanding the visual. I am not particularly dexterous, but I have learned to see in terms of two-dimensional representation. Knowing how to draw is, for the most part, a question of knowing what to look for. Some will say that it is, in any case, a matter of something called "talent." Well, of course, some people have greater talent for grasping the visual facts than do others—just as some have a superior ability in mathematical reasoning, and others a gift for sleight of hand.[3] But art appreciation requires no special aptitude. On the contrary, it is my conviction that the inadvertent education all of us received from magazines, motion pictures, children's books, television, and newspapers can be the basis of real insight.

What Is Art? It is customary in art appreciation books to define the term *art* early on. In doing so authors hope to distinguish between what is worthy of attention and what is not. Curiously, it almost invariably occurs that— regardless of the definition—what is *really* art comprises a group of works such as those in figure 1-3 and excludes from consideration the kinds of things we find in figure 1-4. The reaction of the reader to this description is all too frequently "I guess I just don't like art." I hope to avoid this consequence by a special stratagem. But before I reveal my ploy I wish to turn some of yours aside.

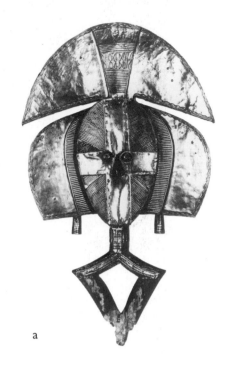

a

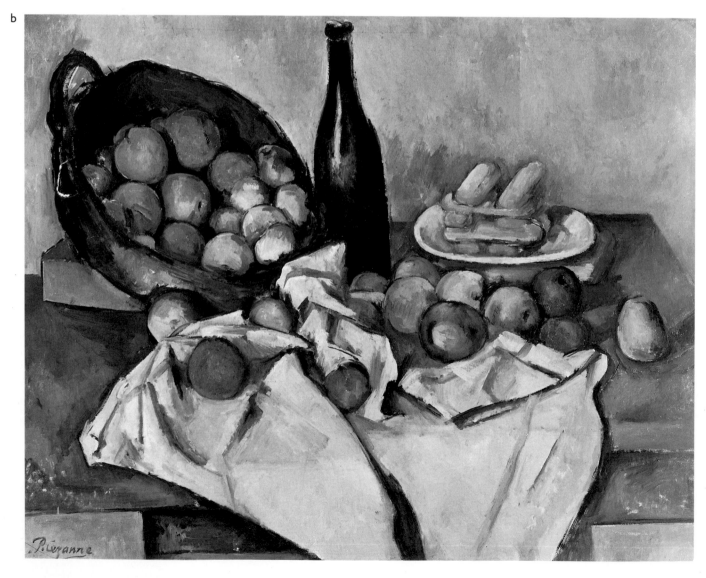

b

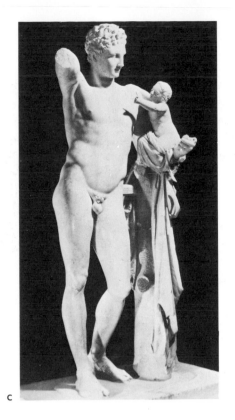

c

d

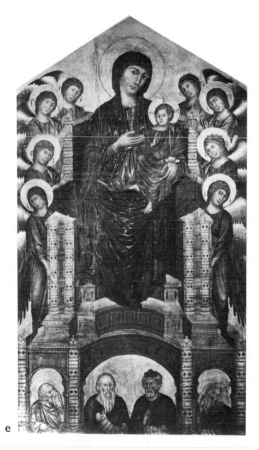

e

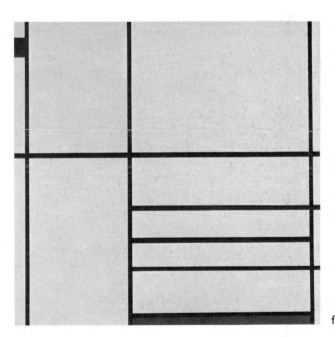

f

1-3 Types of images that are unquestionably "art" in the opinion of most authorities: Guardian figure, from the Bakota area, Gabon. 19th–20th century. Wood, covered with brass and copper, height 30″. Ethnographical Museum of the University of Zurich (a); PAUL CÉZANNE. *The Basket of Apples.* 1890–94. Oil on canvas, 25¾ × 32″. The Art Institute of Chicago. Helen Birch Bartlett Memorial Collection (b); PRAXITELES. *Hermes and Dionysus.* c. 330–320 B.C. Marble, height 85″. Museum, Olympia (c); MICHAEL SMITH. *Yellow Arc.* 1968. Synthetic polymer paint on canvas, 30 × 28″. Collection Robert Kutak, Omaha, Nebraska (d); CIMABUE. *Madonna Enthroned.* c. 1280–90. Tempera on panel, 12′6″ × 7′4″. Uffizi Gallery, Florence (e); PIET MONDRIAN. *Composition in White, Black, and Red.* 1936. Oil on canvas, 40¼ × 41″. Collection, The Museum of Modern Art, New York. Gift of the Advisory Committee (f)

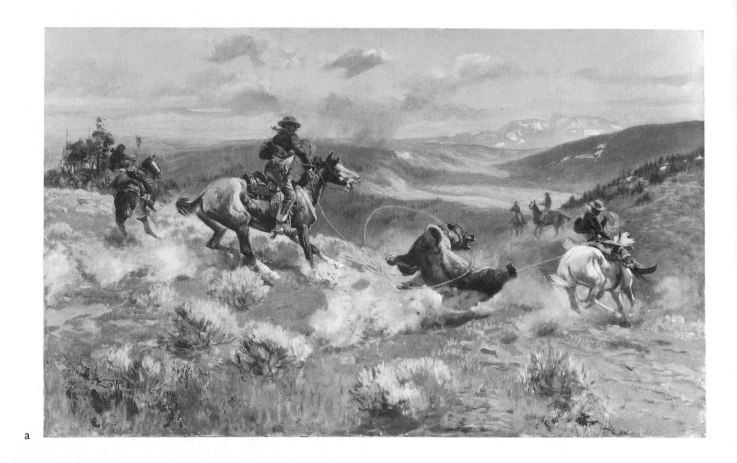

a

b

c

1-4 Types of images that are not considered "art" by most authorities: CHARLES RUSSELL. *Loops and Swift Horses Are Surer than Lead.* 1916. Oil on canvas, 29½ × 47½". Amon Carter Museum of Western Art, Forth Worth, Texas (a); JOHN ADKINS RICHARDSON. *Maxor.* © 1992, John Adkins Richardson (b); Science-fantasy and graphic story illustrations by the author (c); HOWARD PYLE. Illustration from *The Story of the Champions of the Round Table.* © 1905, Charles Scribner's Sons (d)

d

It may be helpful to look at what many readers consider art. One of the most common presumptions is that art is an imitation of reality. And few of us would dispute that the amazing still lifes (fig. 1-5) of William Harnett (1814–1892) are art. *After the Hunt* seems so like the things it mimics that one might believe the rabbit could be taken up and cooked. Only an uncommon fool would deny that such illusion has artistic merit merely because the thrill it produces appeals to common tastes. But consider figure 1-6, a photograph of a tableau by Edward Kienholz (born 1927) entitled *Back Seat, Dodge—38.* The Kienholz is as realistic as you can get; it *is* real. This actually is a 1938 Dodge sedan, although it is so truncated that the rear seat is up against the fire

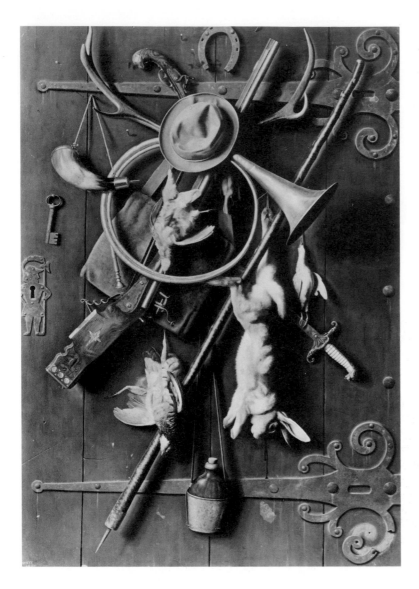

wall. Probably most people would respond that it isn't realistic, it's just real; it's junk, trash.[4]

Very well, the obvious response to Kienholz is, "I don't mean a duplication of reality when I say 'imitation of reality'; I mean something that involves more apparent skill, more artifice . . . like the Harnett." Fine. Is figure 1-7 a work of art? It is exact and to scale, a perfect physical model of an old schooner. I carved and built it and I don't consider it art. It's a trivial exercise in painstaking small-scale construction. It's worthwhile, you understand. And I got a kick out of doing it. But the fact is that I created it only for my wife to use as a decor item in a room she is redecorating. The room does contain one of my paintings that I do consider art.

And how about this painting (fig. 1-8)? Roy Lichtenstein (born 1923) gives one the impression of imitating a comic-strip panel right down to the Benday dots that printers use to give color to the pictures (see page 59). I imagine that most readers would concede the possibility that the cartoonist on whose work this is based is some sort of artist but would think less of the man who copied the original.

Of course, you might respond to these examples by using another presumption, saying that art has to be beautiful and that this stuff "isn't even pretty." Possibly it is true that art has to be beautiful in some fashion or other. A good

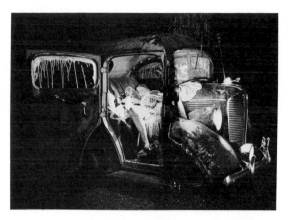

1-6 EDWARD KIENHOLZ. *Back Seat, Dodge—38.* 1964. Mixed media, height 66″. Collection Lyn Kienholz, Los Angeles

1-7 Model of a fishing schooner

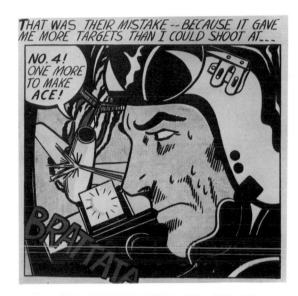

1-8 ROY LICHTENSTEIN. *Brattata.* 1962. Oil on canvas, 42 × 42″. Courtesy of Greenberg Gallery of Contemporary Art, St. Louis

deal of it is, clearly. For example, *Le Moulin de la Galette* (fig. 1-9) by Auguste Renoir (1841–1919) is actually pretty. There is no better way of describing it. But then gardenias, butterflies, charlotte russes, and Easter eggs are also pretty. Usually we don't consider those things artistic in and of themselves. And a lot of what might be called art by many is not attractive in any sense normally connoted by the term.

If beauty is the measure of artistry, what is one to make of such a work as the *Crucifixion* from the famous *Isenheim Altarpiece* (fig. 1-10) by Matthias Grünewald (active c. 1503–1528)? It is an image of absolute ghastliness. This Christ does not suffer a purely spiritual pain; he suffers for all mankind in a horrible, perfectly physical way. The crown of thorns bites into his forehead and draws blood; his flesh, of a greenish pallor, is marked by the putrescent sores and scars of brutal treatment. His lips are blue, spotted by the foam-flecked vomit of approaching death. The picture inspires disgust, even revulsion. And yet it is a powerfully moving image of sacrifice, a conception that brings home the meaning of Christ's passion through an extremely naturalistic treatment. It is perhaps the outstanding example of ugliness put in service of devotion. Is it not art?

I could continue in this fashion, challenging commonplace conceptions of art with obvious exceptions, but I think the point is clear. No simple definition

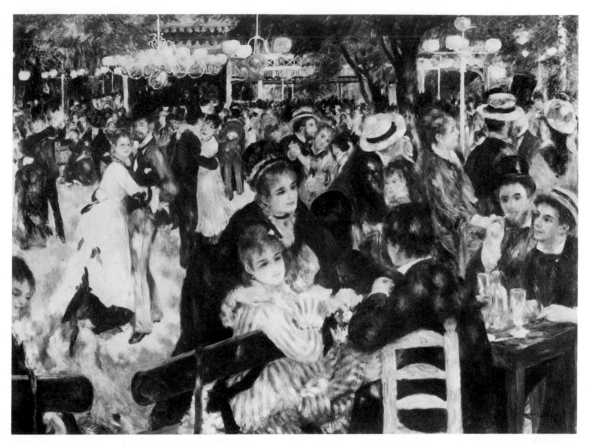

1-9 PIERRE-AUGUSTE RENOIR. *Le Moulin de la Galette.* 1876. Oil on canvas, 51½ × 69″. Musée d'Orsay, Paris

is sufficient to describe everything that comes under the heading of art. For that matter, I do not believe that any definition, whether commonplace or esoteric, could be true and also useful. My belief is certainly debatable. But that doesn't really matter. Fortunately, we don't need to define art in order to talk about it.

It may seem preposterous to assert that we can discuss a thing without knowing precisely what we are talking about, but we all do it constantly without troubling ourselves at all. The everyday speech of the most fastidious and lucid speakers is filled with inexactitude. A very important thinker, philosopher Ludwig Wittgenstein, once used the example of the term *game* to make this clear. He says that we can look at all sorts of games—board games, card games, ball games, Olympic games, and so on. We call each a "game," and yet they have very little in common. For example, compare a board game such as chess with contract bridge. There are many correspondences, but the element of chance is completely absent in chess. In most respects of actual play, the game of baseball is quite unlike either the board or card games. Moreover, some card games—solitaire for instance—are not competitive in the normal sense. Similarly, crapshooters are really playing against the odds, not against the other shooters. Likewise, a child playing a game of ball alone, throwing the ball against a wall and catching it, is competing only with himself and gravity. Finally, think of ring-around-a-rosie, where almost all the features we associate with a game have disappeared; only the constant of amusement remains. Still, not everything amusing is called a game.

As Wittgenstein points out, what we see summed up by the word *game* is a series of *family resemblances,* like those of a real family. One can say that

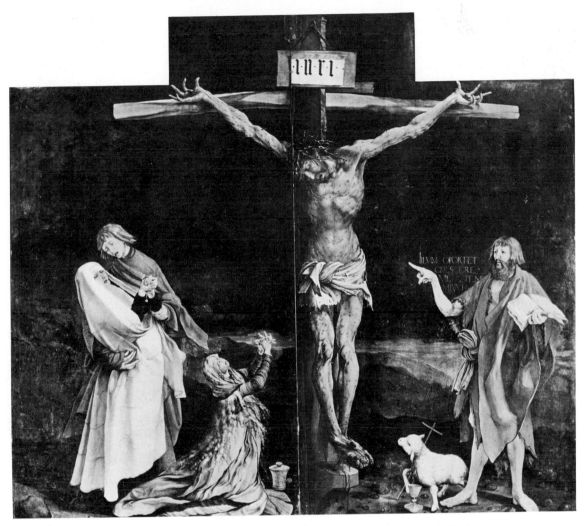

1-10 MATTHIAS GRÜNEWALD. *Crucifixion,* center panel of *Isenheim Altarpiece* (closed). c. 1510–15. Oil on panel, 8'10" × 10'1". Unterlinden Museum, Colmar, France

games form a family of activities. We are not stopped from using the word *game* because the network of similarities is so complicated.

Dealing with things in this way is to use what logicians call an *ostensive definition.* That is, the term is defined by citing a number of examples. This is precisely the way one might distinguish between a "board" and a "stick" for a child. There are arenas in which we may not, amongst ourselves, agree. Thus, I may call boxing a game and you may not. Or your notion of "stick" might include mine of "log." But for the most part we will concur. In the same way we can deal with art while not defining it precisely.

I look upon art as another family of relationships. Some members are black sheep, some are elite. A Rembrandt such as *Christ at Emmaus* (fig. 1-11) is surely art, and toenail clippings or metronomes are not. Of course, given so broad a description, it will be necessary for me to assume that art can be bad or indifferent as well as fine in quality. (This view is anathema to many art critics, but that is not my fault.)

Even my liberality does not allow me to evade every problem. Thus, figure 1-12 shows us a purported work of art. *Indestructible Object* by Man Ray (1890–1976). It is nothing but a metronome with a photograph of an eye paper-clipped to the arm. Has the metronome become an art object because of its new acquisition? I should say yes, it is an art object of a very minor sort, although, as it happens, this object is of historical moment—largely because it

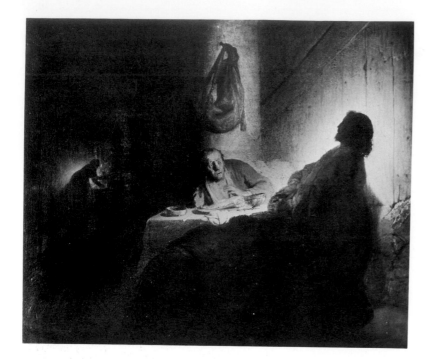

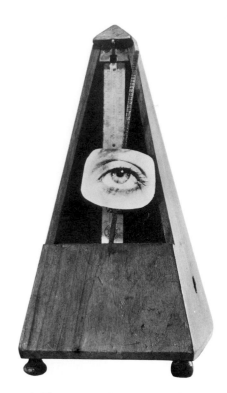

1-12 MAN RAY. *Indestructible Object (or Object to be destroyed).* 1964. Replica of 1923 original. Metronome with cutout photograph of eye on pendulum, 8⅞ × 4⅜ × 4⅝". Collection, The Museum of Modern Art, New York. James Thrall Soby Fund

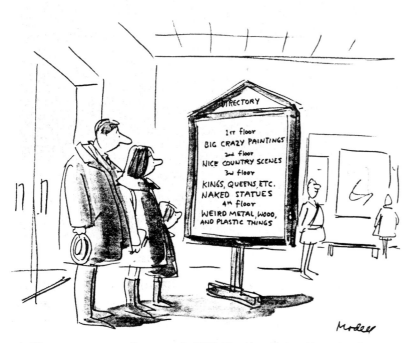

1-13 FRANK MODELL. Cartoon. © 1983 *The New Yorker Magazine,* Inc.

represents an art movement which poked fun at the silliness of people concerning themselves with just such troublesome but inconsequential questions as "What is art?"

Artists themselves rarely worry about the matter; for them, art is simply what they do. If pressed, they may come up with elaborate verbal statements to justify their works. But if it could be shown that their art was inconsistent with their creeds, they'd revise the statements rather than the work. The art generates rules and definitions; the rules don't create art.

All this may seem to leave us quite at sea. Many people feel very unconfident and frustrated without some sort of guideline whereby they can evaluate specific works of art. That kind of insecurity is the source from which Frank Modell's cartoon (fig. 1-13) draws its humor.

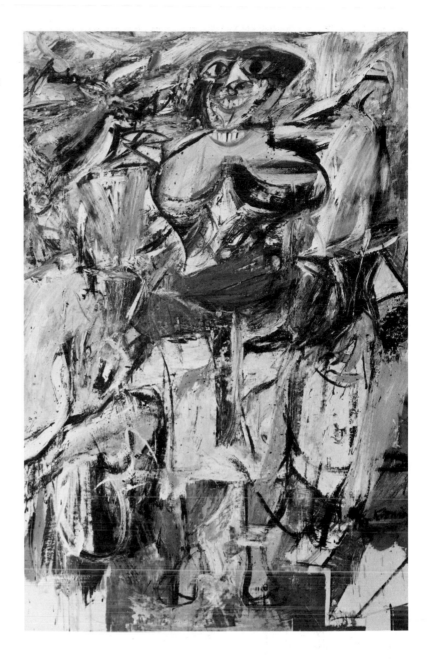

1-14 WILLEM DE KOONING.
Woman and Bicycle. 1952–53.
Oil on canvas, 76½ × 49".
Whitney Museum of American
Art, New York

Why Do They Exhibit That Crazy, Weird Stuff? Most of us would be as startled as the family in the cartoon were we to encounter a museum catalogue that described the collection on view in commonplace terms everyone could understand. That is not likely to happen, because museums affect an air of grave stateliness that far exceeds ordinary human dignity. For a good reason, actually. We use casual language when we wish to put people at their ease, and the very last thing any gallery or museum wishes visitors to feel is "at home." A relaxed atmosphere would put precious objects in the way of hazard, whereas formality conveys an almost ineluctable impression of the lofty and enduring worth of whatever is enshrined. Solemnity keeps ordinary people at a respectful distance from masterpieces and compels them to treat with deference even things in which they have very little interest. Indeed, most people who deal with the fine arts strive to implant in all others an almost religious sense of the seriousness with which artworks are to be taken, imposing upon viewers a presumption that the objects on display occupy a far higher level than that of mere human existence.

Rationally considered, it is absurd to attribute such extravagant status to material objects. On the other hand, it is necessary to inculcate such attitudes if we wish to preserve the finest things that humanity has produced. Of course,

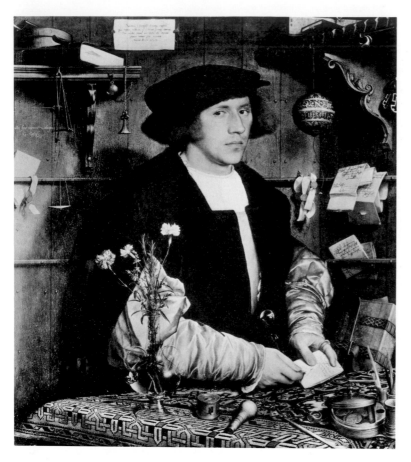

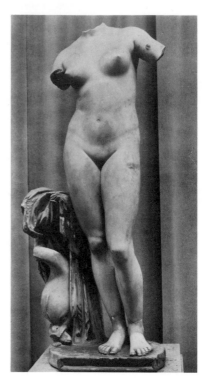

1-16 *Aphrodite of Cyrene.* 1st century B.C.? Marble, height 60″. Terme Museum, Rome

1-15 HANS HOLBEIN THE YOUNGER. *Georg Gisze.* 1532. Oil and tempera on panel, 38 × 33″. Staatliche Museen, Berlin-Dahlem

1-17 JOHN CONSTABLE. *The Hay Wain.* 1821. Oil on canvas, 51¼ × 73″. The National Gallery, London

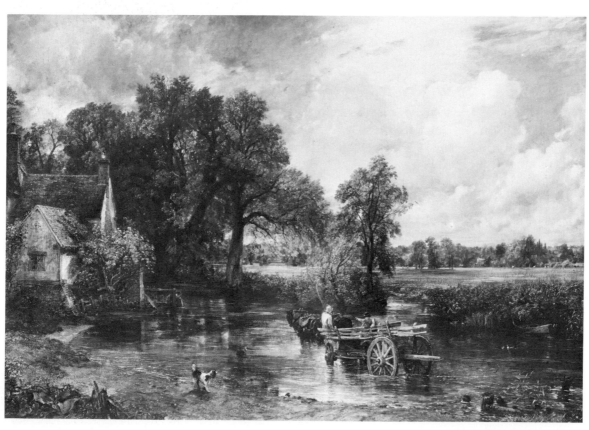

museums are not the only institutions dedicated to conserving the past. Neither are they absolute umpires of artistic merit to whose standards the rest of us are obliged to defer. Still, most people tend to think of museums as being responsible arbiters of taste. That being the case, it often confuses museum visitors when artworks housed within stately marble halls appear, themselves, to defy any and all attempts to take them seriously. Willem De Kooning's (born 1904) painting (fig. 1-14), for example, looks a simple mess of meaningless scrawls to many passersby. What does have recognizable relationship to the title seems grotesquely inept in its drawing. Is it a joke of some kind? The work of a charlatan—a fake? Can it really make any sense to those who stop and examine it with what appears to be real thoughtfulness, or are they just pretentious fools, putting on airs?

Anyone can see that Renaissance portraiture (fig. 1-15) and Classical statuary (fig. 1-16) are done with great skill; there's no question of that. Some of the landscapes (fig. 1-17) are breathtaking. The French Impressionists seem, perhaps, not to be so careful about their drawing, but their dabs of bright color do at least add up to scenic phantoms of the real world (fig. 1-18). But where's the sense in De Kooning's *Woman and Bicycle?* And what is one supposed to make of a pile of firebricks stacked on a gallery floor (fig. 1-19)? Any untrained nitwit could set such bricks down upon the floor in this way; even the arrangement is unimaginative. Common sense would seem to dictate that we are wasting our time to bother with anything except the second and third floors of Modell's art museum, that is, "Nice Country Scenes, Kings,

1-18 CLAUDE MONET. *Haystack at Sunset Near Giverny.* 1891. Oil on canvas, 29½ × 37". Museum of Fine Arts, Boston. Juliana Cheney Edwards Collection

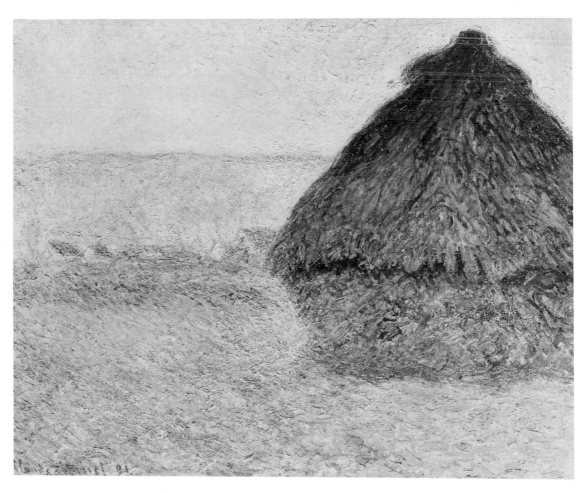

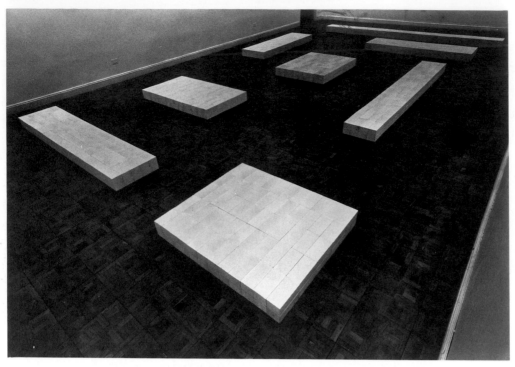

1-19 CARL ANDRE. *Equivalents.* 1966. Bricks in units of 120, 3×20′, 4×15′, 5×12′, 6×10′. Installation by Tibor de Nagy. The Tate Gallery, London

Queens, etc., and Naked Statues." All of us can like and understand at least some of those. As for the rest, it may seem as though a normal person has no basis for judging what is or isn't any good. And, when it turns out that the Tate Gallery has paid several thousand pounds for a stack of 120 bricks that retailed for between £40 and £80 a thousand, a sensible person can be excused for throwing up his or her hands and screaming: "Aren't there *any* rules?"

Some people do believe that objective standards can be adduced for the assessment of artworks. Rarely today are these people to be found among the serious philosophers of art. More typically, they are artists, teachers of artists, or laypeople who may or may not know something about art; whatever the case, the person who thinks that art can be distinguished from nonart by a set of adjudicating guidelines is someone who has come to treat her or his personal preferences as universal, absolute criteria. Such a person will not be shaken by the appearance in museums and art magazines of things that do not match his or her own opinions of what ought to be there. Carl Andre's (born 1935) firebricks did not fulfill the concept of art held by the editors of London's *Daily Mirror,* so they charged the fine-arts experts at the Tate Gallery with wasting part of the public money that subsidizes the institution by purchasing nonart. Professors of painting who maintain that real art is defined by certain formal properties of balance, control, and finesse may feel quite justified in despising the intentionally scruffy lyricism of De Kooning. But others, who reject the very idea of restraint as something that is funda-mentally anticreative and repressive will laud De Kooning while denigrating Harnett (fig. 1-5). Andre himself is more theoretician than artist, perhaps. His creations are, he says, atheistic, materialistic, and communistic. They are atheistic because they lack any "transcendent form" and are without "spir-itual or intellectual qualities." The work is "materialistic because it is made out of its own materials without pretension to other materials. And commu-nistic because the form is equally accessible to all men." If one is prepared to grant the artist the integrity of purpose his seriousness implies, then one must

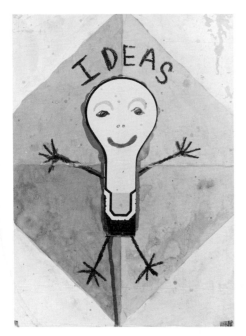

1-20 ROBIN WINTERS. *Ideas.* 1977.
Mixed media on paper, 11½ × 8″.
From the series Travel Notes,
1975–80. Collection the artist.
Courtesy of Michael Klein Gallery,
New York

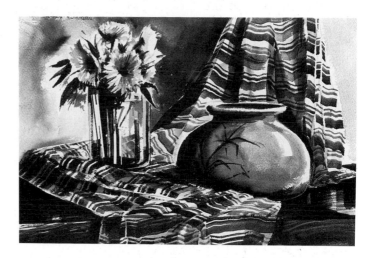

1-21 *Still Life with Striped Cloth.* Watercolor

admit that his works are of value, not for their objective quality, generally, but as commentaries upon art criticism in particular. If that small truth leads you to suppose that a stack of firebricks six across, ten deep, and two tall is a meritorious work of art, I would like you to get in touch with me about a piece of waterfront property I have for sale. Yet, it is true that the bricks do make a critical comment. And the fact that many writers have given the work quite a bit of attention indicates that it is a somewhat more significant comment than I like to credit it as being.

In dealing with Carl Andre's works we are forced to deal also with very elitist concerns that are far, *far* removed from the realm of practical affairs. But we are also made to ponder the roles that fad and fashion play in any artistic selection made in any time or place. The fact is that during the 1970s, when the Tate purchased the Andre bricks, artwork of this sort was being given a very marked celebrity. So-called minimal art had been given intensive publicity in exhibitions and art magazines for a decade, and it is very difficult for a publicly supported art institution to dismiss as irrelevant the importance of such notice. To do what common sense suggests—simply recreate the work from £15 worth of ordinary firebricks—would be equivalent to plagiarism or parody, neither of which an institution like the Tate wishes to be accused.

This is not by any means a simple matter. There is absolutely no question at all that at least some of the museum purchases and public commissions of artworks made today will be found wanting on the morrow. But it is never easy to predict what will turn out to look dated, pretentious, or inane to the generations of the future. One might suppose, offhand, that once the matter-of-fact simplicity of *Equivalent VIII* and the deliberately naive coarseness of Robin Winters's (born 1950) *Ideas* (fig. 1-20) have been admitted into the noble halls of the fine-arts museums, there are, indeed, no standards remaining and that anything goes. But this isn't so. For instance, no museum would be apt today to accept the still life (fig. 1-21) as part of its permanent collection. It's too commonplace in its appeal—too easy to like. It presents no challenge of any kind at all. It is neither majestic nor profoundly crude; it's merely slick and somewhat pretty. The same things may be said of the landscapes (figs. 1-22, 1-23) and the portrait (fig. 1-24). The author is in a good position to so characterize these particular works because he created

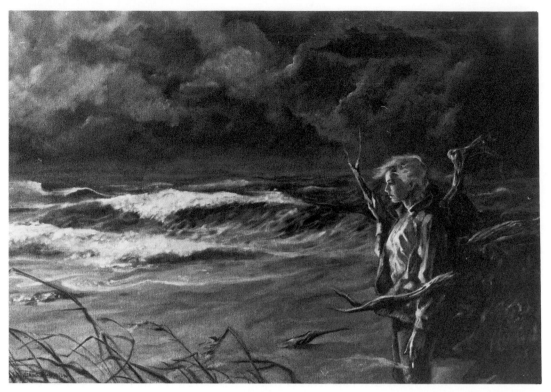

1-22 *Approaching Storm at Halfmoon Bay.* Oil on canvas

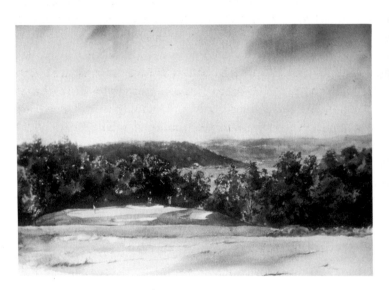

1-23 *Golf Course at Lake of the Ozarks, Missouri.* Watercolor

1-24 Detail of *Portrait of Glenda in an Eighteenth-Century Mode.* Oil on panel

them. Each resulted from the application of skills that are no longer in fashion partly because they are, after two centuries of experimentation, easily taught through well-known routines and readily mastered by any conscientious student whose imagination doesn't get in the way. *Naturally* they appeal to the average viewer. That's to be expected and there's nothing wrong with it. But there are literally thousands of still lifes, landscapes, and portraits of these general types, done by artists of far greater skill, already sequestered in the great art collections of the world. And one of the unwritten rules of serious art collecting is that you don't collect just one kind of thing done in a single manner.[5] Another such rule of thumb is the famous dictum of Alexander Pope in his *Essay on Criticism* (1711): "Be not the first by whom the new are try'd, /

Nor yet the last to lay the old aside." And so it is that, usually, a great museum will await some notice of an artist's work before it mounts a special one-person show. Frequently, from that exhibition—but sometimes much later—a piece by this same artist, now "certified," will be bought for the permanent collection, to be displayed as long as it holds a certain glamour. Should the artist fall from grace in critical circles, the work will be relegated to the storage rooms and, if the neglect is prolonged, it will eventually be placed on the auction block. But that will probably be postponed for a good long while; a revival of interest in the artist or the movement or its period would cause the creation to be dusted off and shown again. In this way museums are able to keep new artistic blood flowing into the reliquaries of the past and, at the same time, to guard against too heavy an investment in transient modes that have no staying power.

Are there rules, then? Yes. But they are the kinds of guides to judgment that gamblers and speculators employ and not the solemn law one might expect to hold sway over the custodians of the world's great artifacts. Not that expedience is the end all/be all of the art world. Knowledge and fundamental attitudes support the experts' judgments and, although it would be a mistake to suppose that the interests of the collector and the connoisseur constitute "art appreciation," there is a certain affinity and overlap of attitudes. Ultimately, appreciation of a work of art is a matter of personal preference. But in gaining knowledge of a subject people also acquire discernment. That is why people with some experience and information about painting are less apt than the uninformed to take for granted that people like De Kooning or Robin Winters paint as they do because they cannot do otherwise.

The Incompetent Artist Theory of Style in Art Laymen are apt to think that Pablo Picasso (1881–1973), for example, began painting things like "Ma Jolie" (fig. 1-25) because he could not draw. And when an art professor like myself says that such work is very profound, really, the skeptic is ready to assume that the professor's defense is also a revelation of incompetence, that the professor is in the position of the pretentious fools in Hans Christian Andersen's famous story "The Emperor's New Clothes."[6] Fortunately, it is easy to prove that Picasso was not a fraud and that I am not gullible, at least when it comes to artistic skill or the absence thereof.

First, my own work tends to be rather conservative, as you can see from figures 1-21 through 1-24. I do not believe that these pieces are outstanding works of art; they are not. But they are at least routinely competent. And I do know how to draw. So did Picasso.

Pablo Picasso, even as a child, drew with incredible facility. At the age of twelve he was already expert in drawing from Classical statuary (fig. 1-26). And his so-called Blue Period pictures, done between the ages of twenty and twenty-three, are very popular evocations of wistfulness and poverty (fig. 1-27). Most of the really important modern masters were gifted representationalists. The work of Wassily Kandinsky (1866–1944) may look sloppy and chaotic to the average layman (see fig. 1-28). It is easy to assume that he's just smearing paint on canvas. "My three-year-old can paint better than that!" is a common reaction, the imputation being that the artist cannot draw. But look at another picture by Kandinsky (fig. 1-29). From a conventional point of view it is really quite impressive. It is representational, charming, and very intricate. Well, then, is it the case that he finally learned how to paint after doing *Improvisation Number 30?* No, the picture of Russia was done in 1904 and *Improvisation Number 30* in 1913. Ah! Did he, then, degenerate? Not at

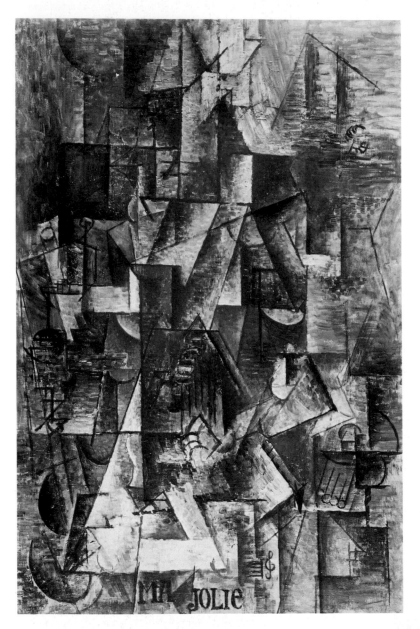

1-25 PABLO PICASSO. *"Ma Jolie."* Paris (winter 1911–12). Oil on canvas, 39⅜ × 25¾". Collection, The Museum of Modern Art, New York. Acquired through the Lillie P. Bliss Bequest

1-27 PABLO PICASSO. *The Frugal Repast.* 1904. Etching on zinc, printed in black, plate: 18³⁄₁₆ × 14¹³⁄₁₆". Collection, The Museum of Modern Art, New York. Gift of Abby Aldrich Rockefeller

1-26 PABLO PICASSO. Drawing from a cast. 1893–94. Conté crayon, 18¼ × 25¼". Whereabouts unknown. Reproduced from *Cahiers d'Art,* courtesy of the publishers

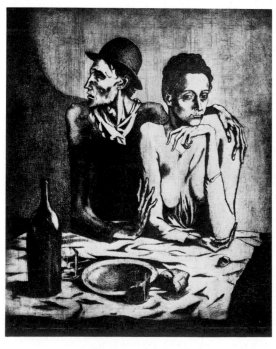

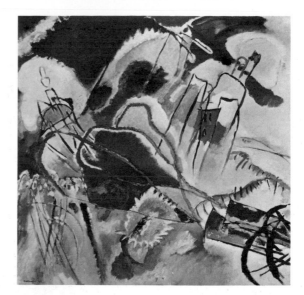

1-28 WASSILY KANDINSKY. *Improvisation Number 30.* 1913. Oil on canvas, 43¼ × 43¾". The Art Institute of Chicago. Arthur Jerome Eddy Memorial Collection

1-29 WASSILY KANDINSKY. *Sunday (Old Russia).* 1904. Oil on canvas, 17¾ × 37⅜". Museum Boymans-van Beuningen, Rotterdam

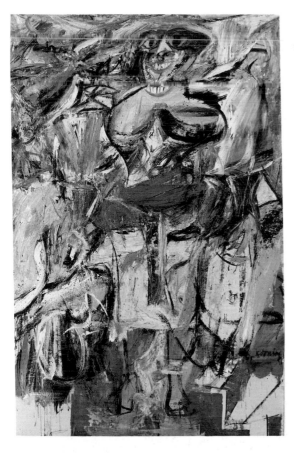

1-30 WILLEM DE KOONING. *Woman and Bicycle.* 1952–53. Oil on canvas, 76½ × 49". Whitney Museum of American Art, New York

1-31 WILLEM DE KOONING. *Portrait of a Woman.* c. 1940. Pencil on paper, 16½ × 11". Collection the artist

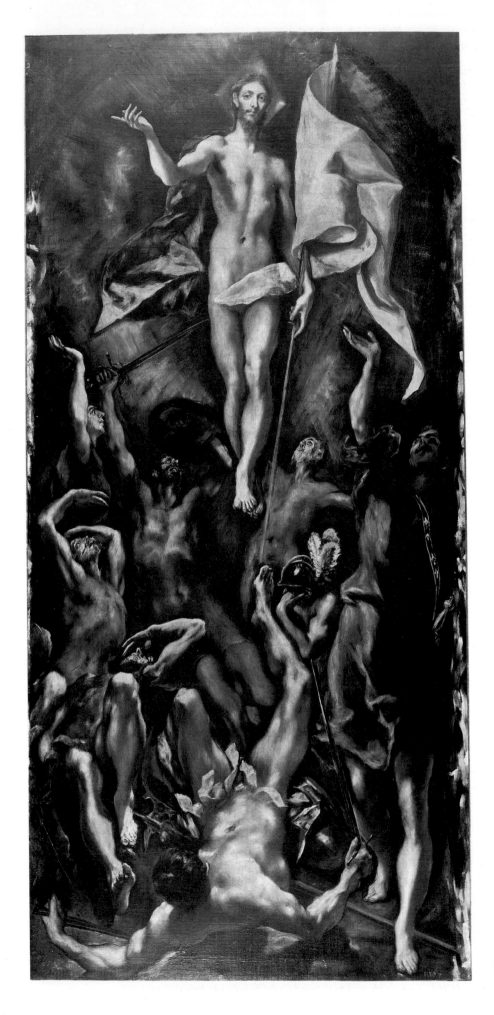

1-32 EL GRECO. *Resurrection.*
c. 1597–1604. Oil on canvas,
9′1¼″ × 4′2″. The Prado, Madrid

1-33 Astigmatic image

1-34 Normal image of the same subject

all. It's just that he was trying to do something different in the later work, something that does not have to do with the representation of objects. Just what he *was* getting at we'll leave until later. My only point is that it is misleading to assume that people become abstractionists because of incompetence. Willem De Kooning, famous for his grotesque, expressionistic women (fig. 1-30), also has a mastery of conventional drawing (fig. 1-31). No doubt there are some modernists who do not; that, however, does not necessarily mean that the unorthodox works by them are without value, any more than it would follow from a folk musician's inability to play Mozart that his "blue grass" fiddle playing is inferior.

The Incompetent Artist Theory of Style has another, slightly more sophisticated, version. This one frequently crops up among physicians who have some interest in art but no very firm grasp of what painting is all about. In this version it is assumed that radical distortions in pictures can be traced to some defect of vision in the artist. For instance, it is sometimes argued that the Spanish artist El Greco (1541–1614) drew men and women as he did (fig. 1-32) because he was afflicted with astigmatism. Astigmatism arises from an irregularity of the cornea in which light rays from a single point of an object fail to meet in a single focal point (as they do in normal vision), thus causing the image of a point to be drawn out into a line. Astigmatic lenses produce images such as the one in figure 1-33. When contrasted with the normal image (fig. 1-34), it is easy to see that El Greco's elongated figures are somewhat similar to the astigmatic distortion. It might follow then that the artist's style was the result of astigmatism. At least it sounds plausible. But a little thought will reveal just how muddle-headed the notion really is.

The cartoon (fig. 1-35) shows us what is supposed to happen. El Greco's models are fat, but because of his astigmatism he sees them as thin. Rendering them passively, just as he sees them, the plump Spanish girls appear wraithlike on his canvas. But this view of El Greco does not take into account the full experience of the astigmatic. For to an astigmatic eye the canvas, too, would appear elongated, and the image on it would look elongated. Besides, the astigmatic distortion is of such a nature that the reclining girl would not appear lean but would appear even fatter, as in figure 1-36. El Greco may or may not have had astigmatism, but his style does not depend upon it.

Explaining El Greco's work by referring to imperfectly formed eyes, scorning unrealistic-looking art as fraudulent, and putting down popular musicians as tone-deaf drug freaks are all alike. They are examples of prejudice. Usually prejudices are based on *some* sort of common-sense experience. After all, no one likes to think of himself as a pig-headed bigot. Yet prejudice can lead one far astray, even in things where the emotions do not play a role. Study the following columns of figures.

A	B	C	D
0	0	5	8
1	2	5	5
2	4	7	4
3	6	3	9
4	8	6	1
5	1	4	7
6	3	9	6
7	5	1	3
8	7	0	2
9	9	10	0

Column *A* is obvious in its order; the numerals are arranged in their conventional sequence. How about *B*? Yes, they are divided among even and odd. And *C*? A few moments of reflection should suggest the answer; they are so arranged that each successive pair of numbers adds up to ten. What about *D*? Can you divine the order of that arrangement? It is no more complicated than any of the other patterns. No unusual mathematical ability is required to solve it. But if you can solve the puzzle of its order, you are in a real minority. Work on it a few minutes. If you get it, you'll understand the point I'm making. If you do not, you can find the solution on page 399.[7] There you can also find the solution to a related puzzle: On what basis have the letters OTTFFSSENT been ordered?

Our experience with numbers leads us to suppose, quite reasonably, that the order of column *D* will be arithmetical. And I reinforced this bias by giving three instances in which the prejudgment was borne out. The fourth instance did not play to your prejudice—that is, your prejudgment—and so you failed to solve the puzzle. (Yes, I know. Most of you didn't even try to figure it out. But if you had, you'd have blown it anyhow. Right? Right.) Your expectations played you false. And column *D* doesn't make any sense arithmetically. But if we wanted to index these numbers in an arithmetic book, it would make perfect sense to employ the arrangement that occurs in *D*. In the same way, you were probably misled into imagining that the arrangement of the letters OTTFFSSENT was numerologically determined.

The history of art since the end of the Middle Ages and the emergence of photography has led most of us to expect pictures to be more or less realistic.

1-35 Cartoon of El Greco in his studio with models

1-36 Cartoon of El Greco revealing his work

And Kandinsky's *Improvisation Number 30* just doesn't make sense in those terms. The best you could say for it is that it's an incredibly clumsy portrayal of cannon firing at a city. But that is not what the artist was after. He once said of this particular work, which he had nicknamed *Cannons,* that the designation was not to be conceived as an indication of the "contents" of the picture. Rather, the "observer must learn to look at the picture as a graphic representation of a mood and not as a representation of objects." What Kandinsky was trying to do was make of painting an art like that of music, in which feelings are evoked by the art itself. That is, you do not expect music to sound like something else—birdsong, babbling brooks, or wind through trees—you respond to it in terms of melody, rhythm, harmony, and so on. We all know, however, that music, although not at all representational, can convey moods. Kandinsky, who had studied music as seriously as he had art, envied the composer. He wrote:

> A painter who finds no satisfaction in mere representation, however artistic, in his longing to express his internal life, cannot but envy the ease with which music, the least material of the arts today, achieves this end. He naturally seeks to apply the means of music to his own art. And from this results that modern desire for rhythm in painting, for mathematical, abstract construction, for repeated notes of color, for setting color in motion, and so on.[8]

Whether Kandinsky accomplished his objectives is, of course, another matter. That is a problem we shall take up elsewhere in this book. I'm not sure he did achieve his goals. I do think that he painted a very good picture. You may not agree. That's all right. But at least we'll be arguing about something that is relevant to the artist's interests and not attacking him for not doing something he never intended to do.

TWO

IMAGE CREATION AND CONVENTION

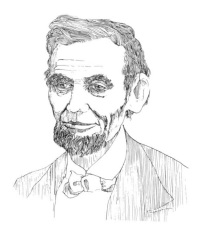

2-1 Outline drawing

When people say that they like only pictures or statues that look "real," we know pretty much what they mean. At any rate, it is not hard to predict what they probably *won't* like. But the term *reality* is one that has worried philosophers since very ancient times. It may mean very different things to different people, and may even mean many different things to a given individual. For instance, which of my drawings of President Abraham Lincoln is the most realistic? Is it the precise outline (fig. 2-1), the one reducing all light and shade to either black or white (fig. 2-2), or the one made up of little dots of ink (fig. 2-3)? Obviously, none of these pictures shows Lincoln the way he actually looked to someone encountering him in the flesh.

This shows that the creation of images does not have as much to do with the direct copying of details of reality as one might think. It has to do with highly selective choices about what to include and what to leave out. Moreover, this is two-way communication; the viewer is as much involved in creating the image as the artist is. The artist knows what marks to put into the picture and where to put them; the onlooker must understand what those marks mean. To people brought up surrounded by photographs this may seem to be a relatively simple matter. It is not.

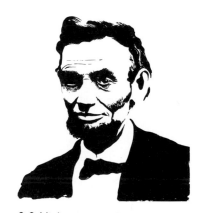

2-2 High contrast drawing

Even the most familiar and convincing of all realistic images, the reflection in the mirror, is not quite what it seems. You are almost surely mistaken about how you appear in your looking glass. I am not talking about the fact that the image is reversed or that most of us see ourselves as being far more attractive than we appear to other people. In the mirror, your face isn't even the same size you think it is. Try this: take a piece of soap and trace the silhouette of your head as it is reflected in your bathroom mirror. You will be astonished by the small size of the traced shape.[1] The psychological reality of the reflection is not at all like the reality of measurement. And if this most perfect of all realistic images does not correspond to our conceptions of visual reality, it is easy to see that a picture made of ink and paper or paint and canvas or emulsion on film will not match visual reality.

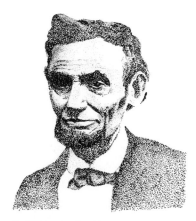

2-3 Stipple drawing

2-4 BILL BRANDT. *Nude.* 1953. Photograph

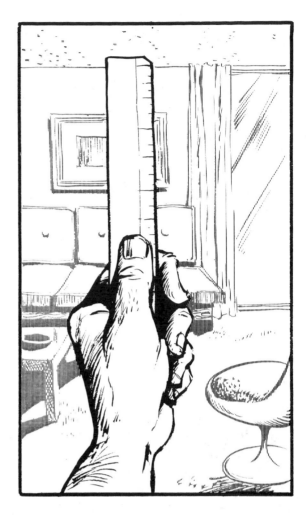

2-5 Measuring visual scale of things with a ruler

2-6 Some lines and marks

2-7 Cartoon image

So-called photographic distortion, such as the effect in figure 2-4, is not a visual distortion at all; it is a psychological one. Possibly you have noticed in snapshots of your home that the rooms tend to look more spacious than they really are. This is because an object ten feet away doesn't really seem smaller; it just looks farther away. But if you hold a ruler out at arm's length and measure off heights of objects (as in figure 2-5), you will see that *in terms of measurements and magnitudes* the photograph is relatively accurate. You see in these terms only when you make a deliberate effort to do so, whereas the camera "sees" in terms of geometric relationships at all times. Thus, with regard to your living room, you are struck by the reduction of moderately distant objects in much the same way that the reduction of the girl's head strikes you in figure 2-4. Normally we sense such scale relationships only when things are very, very far off, when we speak of people looking like ants or toy soldiers.

If the relation between images and reality is so opaque, how then do artists accomplish their ends? It is a matter of organizing elements. Figure 2-6 does not resemble anything very much, but when the elements are rearranged (fig. 2-7) we are confronted by "good ol' Charlie Brown," familiar to us from Charles Schulz's (born 1922) comic strip *Peanuts*. Charlie doesn't look human, of course. Yet cartoonists are able to convey all sorts of subtleties of human feeling through simple modifications of a few basic elements (fig. 2-8). We accept such marks as representative of living creatures in much the same way we accept letters on paper as representative of sounds. That is true even when the figures are stylized to the point of serious deformity—as in *Cathy* (fig. 2-9), which features quadratic mouths and hands like ruffles.

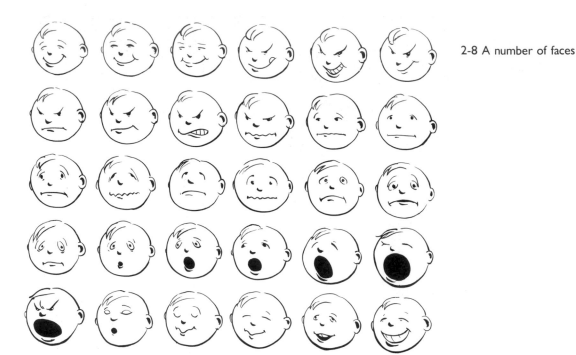

2-8 A number of faces

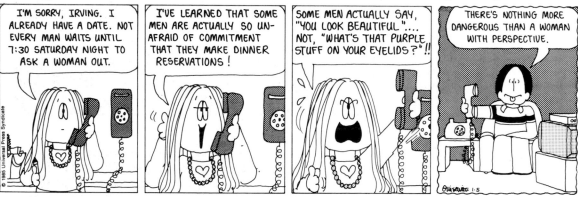

cathy® **by Cathy Guisewite**

Panel 1: I'M SORRY, IRVING. I ALREADY HAVE A DATE. NOT EVERY MAN WAITS UNTIL 7:30 SATURDAY NIGHT TO ASK A WOMAN OUT.

Panel 2: I'VE LEARNED THAT SOME MEN ARE ACTUALLY SO UN-AFRAID OF COMMITMENT THAT THEY MAKE DINNER RESERVATIONS!

Panel 3: SOME MEN ACTUALLY SAY, "YOU LOOK BEAUTIFUL"…. NOT, "WHAT'S THAT PURPLE STUFF ON YOUR EYELIDS?"!!

Panel 4: THERE'S NOTHING MORE DANGEROUS THAN A WOMAN WITH PERSPECTIVE.

2-9 CATHY GUISEWITE. *Cathy.* © 1985, Universal Press Syndicate

What about strips done in what is often called the "illustrators' style"? For instance, Mike Kaluta's young women (fig. 2-10) look pretty realistic, don't they? Or do they? When did you last see someone whose face was dead white and whose clean cheek contained thin black marks? That is shading, you say? True, that is what the marks represent. Still, you must admit that shadows look nothing at all like that. Moreover, all pen-and-ink renderings, all etchings, and all engravings are subject to the same analysis. The *Self-Portrait* (fig. 2-11) by Edgar Degas (1834–1917) is much more refined than any comic-strip image, but it is nonetheless made up of little black marks. Similarly, the sketch of an angel (fig. 2-12) by Michelangelo (1475–1564) is bounded by dark lines and shaded with inky blots that stand for edges and shadows but do not appear in any real figure. This is obvious, surely. But the obviousness is wrapped in complexity. Let us consider the matter from a different angle—the appearance of movement.

Michelangelo is one of the finest artists of all time, and his angel seems to be moving through space because of the way the torso twists on its axis and the foot shrinks into the distance. What if we wished to really emphasize the notion of movement; what if we wanted to give it tremendous stress? A

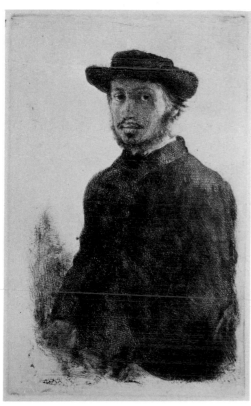

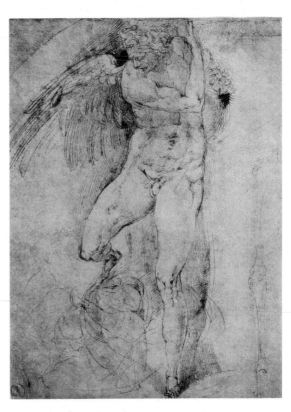

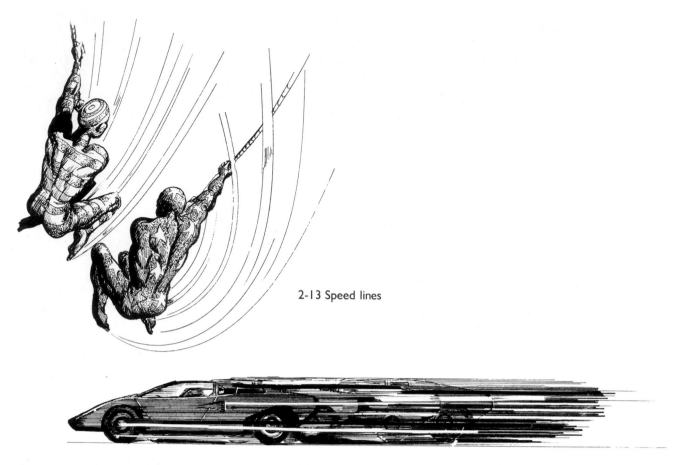

2-13 Speed lines

2-14 Rapidly moving sports car

cartoonist might do just what I have done in figure 2-13. You know exactly what is happening because the lines indicating motion are always *following* the subjects and, so, describe their paths, even when the effect is perverse. This is not at all like the blurriness of rapidly moving objects as the eye perceives them. But we know how to read the symbol. Likewise, the use of lines to convey shadows is a symbol, a *convention;* that is, an agreed-upon method of indicating darkness. It is very systematic: the more dense the lines in the Degas etching, the more shadowy the region.

It is important to understand that I am not saying that only drawings are conventional in this way. The reference to speeding objects is worth exploring a bit. In figure 2-14 we have what is one of the world's fastest road cars, the Lamborghini Countach, doing 180 mph. We can see this because we are shown how terribly great its momentum is. Again a mass of lines is used to suggest speed. This is a conventional cartoonists' symbol and we all understand what it means. What would a photograph of something moving at high speed look like? Figure 2-15 gives us an example. We gather that the car is moving because the image is blurred. But this is *also* a conventional reaction. We know this kind of blur means movement because of our experience with photography. Without such experience one might imagine that we are seeing the dissolution of some vaporous object. Foreknowledge tells us that blur equals motion. But all we can be really sure of is that movement occurred when the picture was snapped. In this case it could have been the camera that moved rather than the car. In figure 2-16 it *was* the camera. The camera was also moving in figure 2-17, but, because the automobile is clear and the background fuzzy, it is understood by the viewer that the car is the moving object. In figure 2-18 we see the result of higher-speed film and a faster shutter; it is not possible to be sure whether the vehicle is moving or stationary.

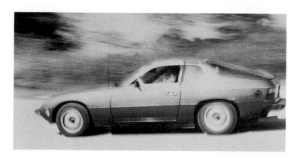

2-15 Photograph of a moving car with both car and background blurred

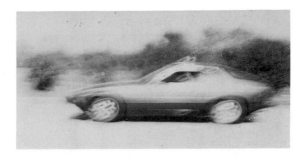

2-16 Parked car photographed as camera moved

2-17 Photograph of moving car with car clear and background blurred

2-18 Photograph of moving car taken with fast shutter speed

Long before the invention of photography, a Spanish painter named Diego Velázquez (1599–1660) captured the same effects in his large oil painting *The Spinners* (fig. 2-19). In this picture he may be said to have devised a technique for representing motion. The spinning wheel, its spokes lost in motion, has a supporting strut whose vibration Velázquez suggested by means of an afterimage (fig. 2-20). This is the sort of thing the eye sees. You have only to riffle the pages of this book to observe that your eye retains briefly the image of a thing you have just seen if movement is sufficiently rapid. This characteristic of the eye is the ultimate source of the blurriness of fast-moving objects. But seeing the afterimage in the blur is one thing, and devising a way of representing it in a picture is quite another. *The Spinners* and the photographs symbolize actual visual phenomena in a way approximating ordinary vision. The cartoonists give us a schematic representation that is less like what one sees.

Sometimes the artist wishes to convey by visual means something that has never been seen and is not even presumed to exist as a visual phenomenon. Then the employment of convention is much more evident. As an example, let us take the Christian art of an age gone by.

Religion, Economics, and Artistic Convention During the Middle Ages—from, say, 400 to 1300—the civilization of the Western world was dominated by an ascetic ideal. We associate the term *ascetic* with monks, nuns, priests, and other people who have given up worldly pleasures for the joys of the spirit. Medieval men and women saw life as merely a passing moment in an eternity, most of which would be taken up by an afterlife. Worldly pleasures were seen as snares of Satan, and those who abstained from them were more highly regarded than those who did not. These people dwelt in a world where the trees growing in paradise, the angels in heaven, and the demons of hell were more real to them than anything or anyone a man beheld during his lifetime. From a contemporary point of view they spent their lives in a jungle of the imagination where the abnormal was routine and the

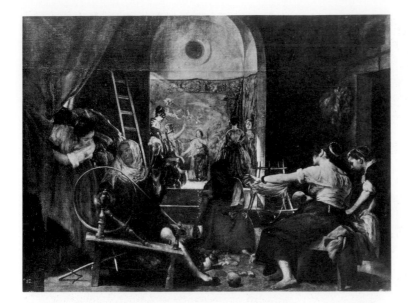

2-19 DIEGO VELÁZQUEZ. *The Spinners.* 1656. Oil on canvas, 7'3⅜" × 9'5¾". The Prado, Madrid

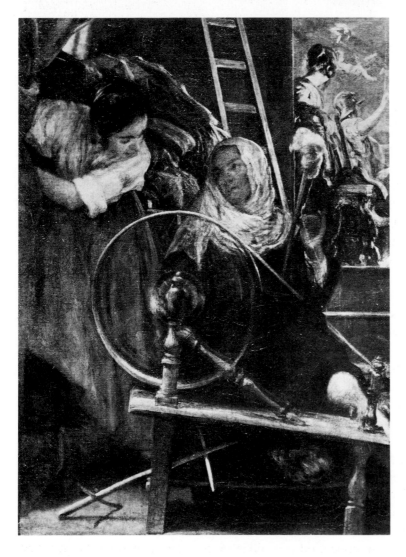

2-20 DIEGO VELÁZQUEZ. Detail of *The Spinners*

fabulous commonplace. They believed. And, since what they believed in most fervently of all was supernatural, the art they created looks *un*natural. To them the meaning of a work of art was more important than its appearance. This is quite consistent with the Bible itself. In the Greek epics by Homer, in Vergil's *Aeneid,* and in the *Satyricon* of Petronius there are many descriptive

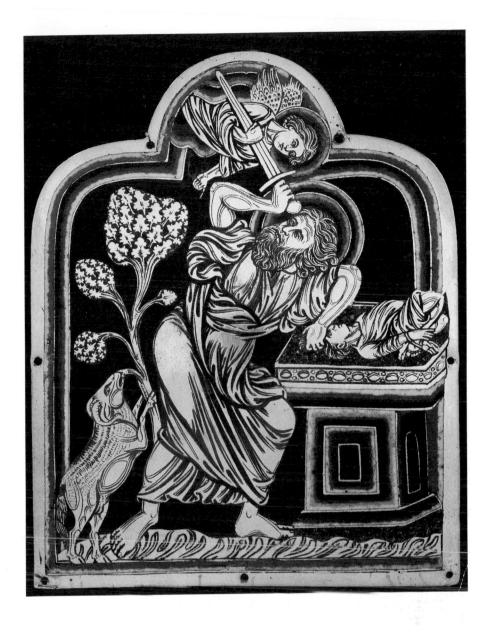

2-21 NICHOLAS OF VERDUN
Sacrifice of Isaac. 1181.
Gold and enamel plaque,
height 5½". Abbey of
Klosterneuburg, Austria

passages; the world is observed in some detail even when the land concerned is only mythological. But the Bible contains hardly any description; we do not know what kind of landscape the characters inhabit, or what clothing they wear, or whether they have long noses or short ones. Moreover, every meaning seems to have another one behind it. Everything is, as it were, fraught with significance. Thus, in the book of Genesis, where God demands of Abraham that he sacrifice his only son, Isaac, we are told that Abraham and his followers rose "early in the morning and went unto the place of which God had told him." As Erich Auerbach points out in his *Mimesis,* the true significance of "early in the morning" is not that it specifies the time of day but that it makes an ethical observation. It is intended primarily to express the quality of Abraham's resolution to do God's will. The author of the story is lauding the punctuality of the sorely tried father in obeying the divine command to kill his only son. These concealed meanings of the stories in the Old and New Testaments have inspired much great art and literature. (They have also provided texts for innumerable tedious and boring sermons, but that is neither here nor there.) Like the Bible, a great deal of this art is similarly indifferent to description and full of meanings that lie beneath the surface.

Consider a representation of Abraham and Isaac done in enamel on gold near the end of the twelfth century (fig. 2-21). As the father raises his sword to

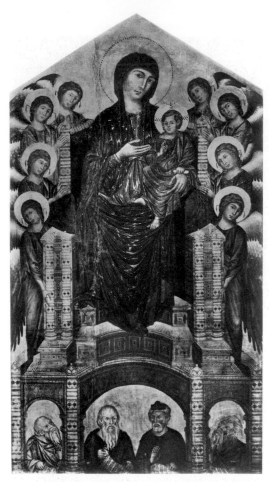

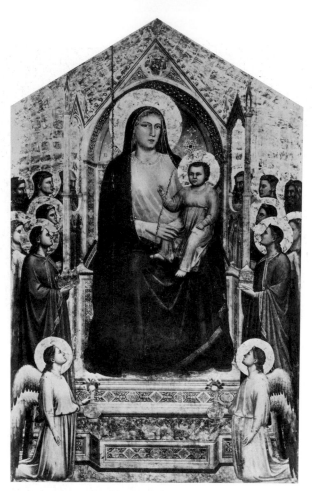

2-22 CIMABUE. *Madonna Enthroned.* c. 1280–90. Tempera on panel, 12′6″ × 7′4″. Uffizi Gallery, Florence

2-23 GIOTTO. *Madonna Enthroned.* c. 1310. Tempera on panel, 10′8″ × 6′8″. Uffizi Gallery, Florence

strike the small, bound figure of Isaac, the angel of the Lord interrupts the sacrifice by seizing the blade. The artist has presented only the essentials of the story in a highly formal, stylized manner: the principals, an altar out of doors, and also the ram that Abraham beheld behind him, "caught in a thicket by his horns." This sheep has been provided by God. Thus, "Abraham went and took the ram and offered him up for a burnt offering instead of his son."

Notice the circle ringing the head of Abraham. The angel, too, has one. It is a halo. This symbol was originally Persian and signified the descent of the Persian religious figure Zoroaster from the sun, so indicating his holiness. The motif was absorbed into Eastern Orthodoxy and became a convention of all Christian imagery. Throughout the Middle Ages the halo appears over and over again, designating spiritual radiance. It is used to indicate the sacredness of certain individuals—Jesus, His family, the disciples and apostles, various sainted prophets, martyrs, and so forth. It is interesting to observe what became of this symbol as it was subjected to the aesthetic conventions of various periods. For, while the halo remains even today a meaningful convention, the character of the halo has undergone radical transformations.

Although art underwent many changes during the medieval era, the really profound modifications of treatment and convention occurred as the Renaissance began to emerge during the 1300s. In the work of the Italian artist Cimabue (c. 1240–1302?) one already sees marginal changes that are tokens of a new direction. In his *Madonna Enthroned* (fig. 2-22) the prophets in the lower region are treated much more realistically than the principals above.

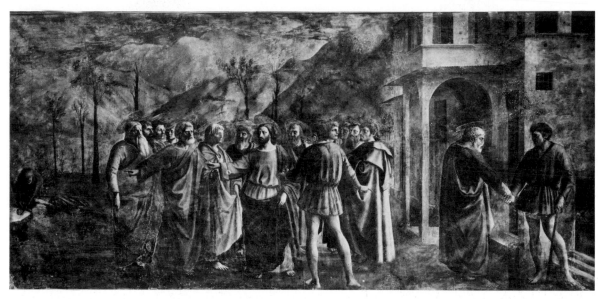

2-24 MASACCIO. *The Tribute Money.* c. 1427. Fresco. Brancacci Chapel, Santa Maria del Carmine, Florence

Still, the picture is very much like those of centuries past, with many of the medieval conventions. Mary and the infant Jesus are very large relative to the other figures, an indication of their importance; the work is quite flat in effect, and there is little feeling for these people as anything but emblems of worship. The halos are simply signs of holiness. They don't look like anything in particular; we know that they are not meant to have an objective referent in the real world.

Cimabue's pupil Giotto (c. 1266/7–1337) carried the realism hinted at in the lower part of the Cimabue much further in his own *Madonna Enthroned* (fig. 2-23). The advances are much more radical than the casual observer is likely to recognize, and we are going to deal with their importance later on. For now, it is enough to say that here, too, the halos are merely emblematic — flat golden circles behind the heads.

It is in the work of the short-lived Masaccio (1401–c. 1428) that the seeds sown by Cimabue and Giotto come to flower in a style that can safely be called Renaissance. In his *Tribute Money* (fig. 2-24) the halo is no longer a mere emblem. Now it resembles an element of the visible world, like nothing so much as a golden plate hovering over the head of the holy being. The appearance of the halos is subsidiary to the effect of the whole painting, which, compared with the other works, is more substantial and real-looking.

The sudden emergence of Masaccio's realism is connected with a more general modification of convention — the whole set of changes that are known, collectively, as the Renaissance. The emergence of this set of attitudes, social forms, and artistic conventions has never been completely accounted for. Certainly, it was the product of many things. One of the most profound influences was undoubtedly the creation of a middle class.

In the United States we tend to associate the term *middle class* with middle-income groups. But this is a peculiar usage. Historically speaking, the middle class is the one which stands between the lower classes and the aristocracy; it is made up of those who have either wealth or education but are untitled, that is, are not princes, duchesses, earls, baronesses, etc. For the most part its members are merchants, and their principal goal in life is the making of a profit.[2] During the Middle Ages this group was too small and insignificant to

constitute a social class. Indeed the whole idea of profit-making was in eclipse from the fall of Rome until the beginning of the fourteenth century.

The idea of gain as a positive social good is a relatively modern one. Throughout most of recorded history it has been conspicuous by its absence. Even our Pilgrim forefathers considered the notion of "buying cheap and selling dear" nothing short of satanic doctrine. Nonetheless, a genuine middle class appeared as a social force in the Mediterranean region during the course of the fourteenth century. Its development coincided with an increase of trade occasioned by two related discoveries. The first was the invention of the technique of tacking against the wind, a procedure that made sailing much less subject to the whims of nature than it had been before. The other was the compass. Marco Polo had brought one of these magical instruments back from Cathay in 1295 (although it does seem to have been known in Europe a century earlier), and general use of the device by mariners made navigation a good deal more certain than it would otherwise have been. Soon new trade routes opened up all over the world. Surplus capital came into existence and, with it, new ambitions. By the beginning of the fifteenth century a number of merchants had become wealthier than any king. The fortune established by one of these, Giovanni de' Medici (1360–1429), created what we know as the Florentine Renaissance. The history of the city of Florence was for centuries the history of the banking house of the Medici. For the Medici became the discreet dictators of the city—ostensibly a republic—without ever holding public office. The Medici were bankers to all of Europe. Their home base, Florence, became a cultural center to rank with the Athens of ancient Greece.

Although the Medici held social views that you and I might, loosely, call "aristocratic" and although they eventually became a line of dukes by marriage and through papal action, their fundamental attitude toward life was very different from that of the medieval nobility. In many respects their world view was distinctly middle class. The middle class is dynamic and businesslike; it distrusts class privilege when that privilege is based on nothing more than a birthright, and it at least gives lip service to the idea of an aristocracy of proven ability. This is the class which supported the republican revolutions in England, France, and America. As a class it tends to be highly opportunistic, hard-headed, and pragmatic.

It is hardly surprising that whenever the middle class makes its tastes felt in art the resulting art is apt to be rather down-to-earth. But the effect is not unmixed. The art sponsored by the Medici was not *just* realistic. Not only did the weight of tradition influence everyone's taste in art; there was also the influence of the preferences of the genuine nobility, who maintained greater or lesser power into the nineteenth century. And there was the mitigating factor of abstract thought. Bankers and merchants, after all, do deal constantly with ephemeral abstractions such as market values, profit and loss, relative quality, interest rates, and so on. Even for their practical minds reality is not just what shows on the surface; beneath everything there is a sort of hidden substructure. Throughout its history the art of the Italian Renaissance exhibits a marriage of mimesis and formality; that is, realistic effects are packaged in unnatural form.

This excursus seems, perhaps, to have taken us far from anything to do with halos. Nothing could be further from the truth. Masaccio, whom we are discussing, is singular in the whole span of history. Within the short space of six years he moved from the late medieval style into a full-blown Renaissance manner. This genius, who died at twenty-seven, was the creative descendent of Giotto, and he revolutionized painting by incorporating into it a whole

repertory of pictorial devices that constitute what, for most people, is "real art." Not only do his halos look like solid objects, the figures themselves are profoundly three-dimensional in appearance. And his picture contains cast shadows, scientific perspective, plausible drapery, and a high degree of anatomical exactitude. *The Tribute Money* looks a good deal more like a segment of real space than does Giotto's *Madonna Enthroned*. Even the halos, purely symbolic things, look substantial. They express a middle-class preference for

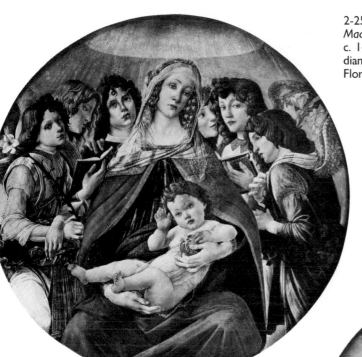

2-25 SANDRO BOTTICELLI. *Madonna of the Pomegranate.* c. 1487. Tempera on panel, diameter 56¼". Uffizi Gallery, Florence

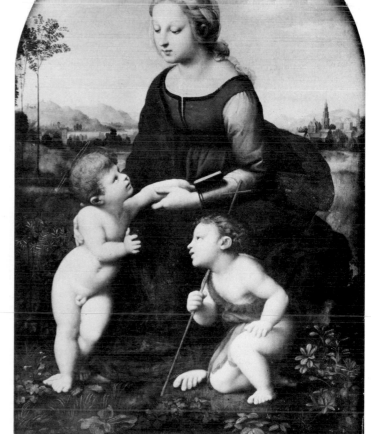

2-26 RAPHAEL. *Madonna of the Beautiful Garden.* 1507. Oil on panel, 48 × 31½". The Louvre, Paris

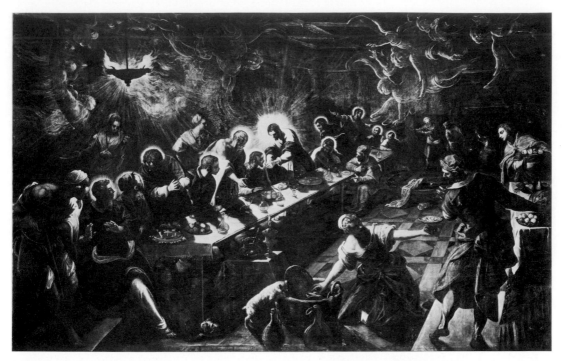

2-27 TINTORETTO. *The Last Supper.* 1592–94. Oil on canvas, 12′ × 18′8″. San Giorgio Maggiore, Venice

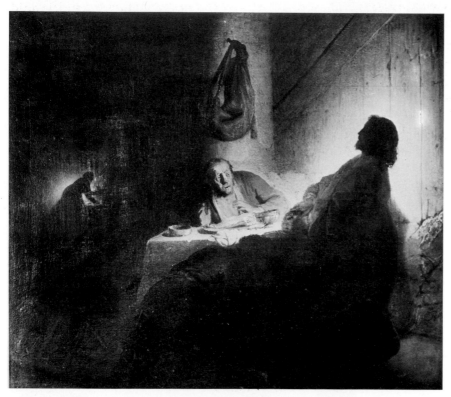

2-28 REMBRANDT VAN RIJN. *Christ at Emmaus.* 1628–30. Oil on paper, mounted on panel, 15⅜ × 16½″. Musée Jacquemart-André, Paris

the straightforward and true to life over and above aristocratic acceptance of the purely emblematic.

Sandro Botticelli's (1444?–1510) *Madonna of the Pomegranate* (fig. 2-25), painted by a man born almost twenty years after Masaccio's *The Tribute*

Money was completed, takes advantage of all that the earlier painters had accomplished and contains halos that are far more illusionistic. Now they seem to be made of glass. They are not so obtrusive as the golden plates, but they seem even more like things that might be seen on earth.

Still later, Raphael (1483–1520), in his *Madonna of the Beautiful Garden* (fig. 2-26), uses the kind of halo that is the commonest symbol of holiness even today; above the Christ Child's head hovers a slender golden ring. Hardly noticeable, the ring halo is more of a concession to the demands of the middle class for what is palpable and easily accommodated into its matter-of-fact image of what is true.

By the sixteenth century, when the middle classes were burgeoning, buying titles, and otherwise moving toward suzerainty, Tintoretto (1518–1594) substituted for a disk or ring a nimbus of flame that blazes in the dark behind his figures' heads (fig. 2-27). But it remains for Rembrandt van Rijn (1606–1669) in that most middle-class of all nations, the Dutch Republic, to reduce the halo to ambiguity. In his *Christ at Emmaus* (fig. 2-28), is the halo radiated by Jesus, or is it a coincidental flash of light from a firelight to his right? All that one can be certain of is that mundane reality has been invested with significance. And to do that is common to the middle classes. A belief in Christian doctrine prevails, the faith that gives believers hope remains; but the symbol of divinity is cast in a form that presents the miraculous as a direct experience. How different the Rembrandt is from the Cimabue, where everything unworldly is simply accepted and the solicitations of the material world play an incidental role. The halo is a traditional symbol, and both Cimabue and Rembrandt use it. But the artistic conventions of their respective periods are as different as the economic and social bases of their times, and the way the halos are rendered shows it.

Social Convention and Artistic Convention Whether the paintings of Rembrandt would look as conventionalized to Cimabue as the Cimabues look to us is impossible to say. Probably they would not. Most likely Cimabue would consider the Rembrandt "profane." His concept of religious truth probably would not have room for the Dutchman's conventions of realistic rendering. All we can do is guess at such things. There is no way to verify our suppositions.

We do know that certain kinds of cultures are so removed from any notion of direct depiction that photographs mean nothing to them. There is a famous story of some anthropologists who showed a photograph of Queen Victoria to a group of African tribesmen on the Gold Coast. The nearest guess the tribesmen could make as to the identity was that the picture might be of a British man-of-war. Well, the old girl was pretty formidable-looking at that. But the tribesmen would have had similar reactions to a snapshot of a lovely maiden from their own circle. Those men were not stupid or uncultured. They had a highly developed social structure, a complete metaphysics, even an epistemology. But they were unfamiliar with the conventions of realistic portrayals. All the photographic print showed them was blotches of variegated gray. Theirs was quite a common reaction for so-called primitives. Usually, however, they can be taught to comprehend the meaning of photographs very swiftly if they are permitted to trace outlines with their fingertips. The tactile sense of an outline indicates the nature of the three-dimensional thing the flat picture represents in a way that vision unaided cannot.

The disparate ways in which men see other men and nature in terms of artistic conventions is made clear in a comparison of figures 2-29 and 2-30.

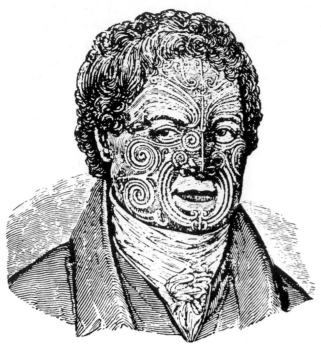

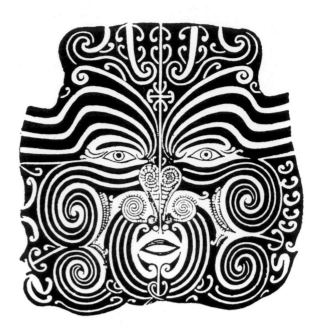

2-29 JOHN SYLVESTER. *Tupai Kupa*. c. 1800. From *The Childhood of Man* by Leo Frobenius. Lippincott, 1909. Reprinted by permission of Lippincott, New York, and Seeley, Service & Co. Ltd., London

2-30 TUPAI KUPA. *Self-Portrait*. c. 1800. From *The Childhood of Man* by Leo Frobenius. Lippincott, 1909. Reprinted by permission of Lippincott, New York, and Seeley, Service & Co. Ltd., London

Figure 2-29 is a drawing of the Maori chieftain Tupai Kupa made by Englishman John Sylvester about 1800. Figure 2-30 is a self-portrait by Tupai Kupa. The self-portrait is a flat, bisymmetrical pattern. It is, however, the way the chief saw himself. He identified his entire appearance with the ornamental pattern of his facial tattoo. But it is a true likeness, an authentic self-portrait. Among the Maoris of New Zealand each tattoo is peculiar to its owner. No two are alike; the convention is such that by his scarified design every tribesman is set off from the others. In one sense the tattoos are more individual than bone structure, as distinctive as fingerprints.

A likeness of a person means something very different to a Maori from what it does to a European. Conceiving of an accurate likeness in terms of relative values of light and shade, in terms of specific kinds of proportions, in terms of detached, mechanical optometrics, is a peculiarly Western convention. Our technology has given it a certain universality, but the conception itself is no more correct or civilized than its alternatives. Still, it is *your* way of looking at things. And it scarcely matters whether your ancestors were Europeans, Africans, Asiatics, Native Americans,[3] or Oceanics.

All of us have learned to look at pictures through the eyes of the West. Yet the world of art is not a provincial place to live. White artists have been influenced by the power of black insight (figs. 2-31 and 2-32) and, in Nigeria, there is sculpture from the 1100s (fig. 2-33) rivaling the harmonious realism of the far later Renaissance. The human adventure is a single adventure upon which all races and cultures have embarked together. If this primer helps the reader to a greater awareness of what art has to do with his own role in that adventure, it will have served its purpose well.

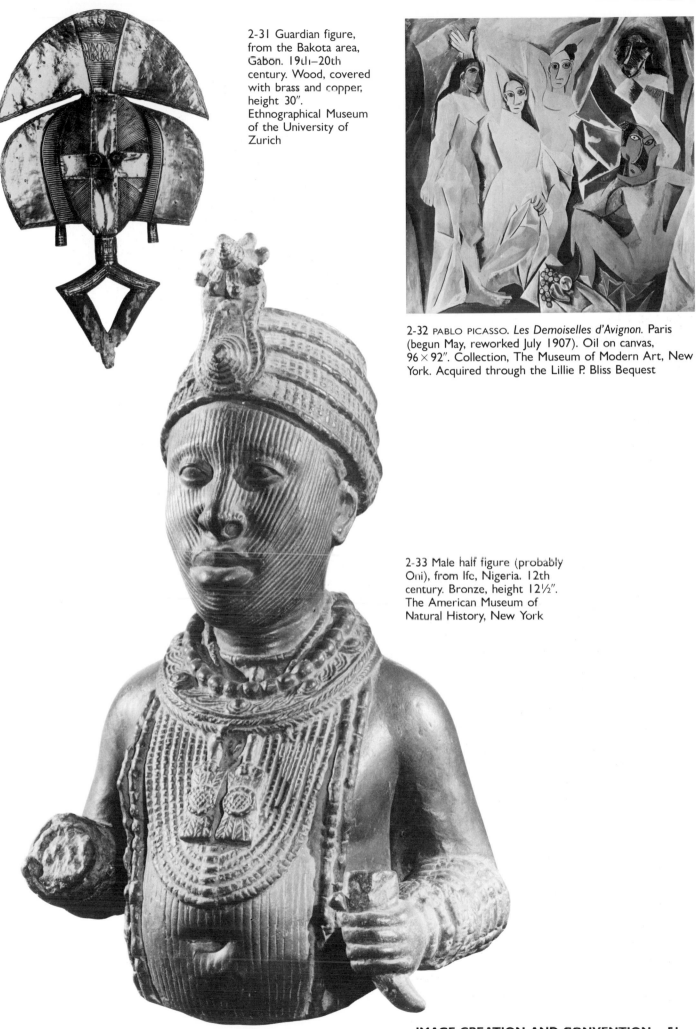

2-31 Guardian figure, from the Bakota area, Gabon. 19th–20th century. Wood, covered with brass and copper, height 30". Ethnographical Museum of the University of Zurich

2-32 PABLO PICASSO. *Les Demoiselles d'Avignon.* Paris (begun May, reworked July 1907). Oil on canvas, 96 × 92". Collection, The Museum of Modern Art, New York. Acquired through the Lillie P. Bliss Bequest

2-33 Male half figure (probably Oni), from Ifc, Nigeria. 12th century. Bronze, height 12½". The American Museum of Natural History, New York

ART AND MONEY

The book in hand is about art but it deals, in the main, with only a certain category of artistry. Whatever concern it expresses with such things as music, literature, dance, and drama is incidental. The kinds of artworks we have dealt with so far, and with which this book is for the most part concerned, are of a special sort. They are primarily visual in nature and are in the form of material objects, such as paintings, sculptures, drawings, prints, and so forth. Everyone realizes that poetry is made up of words, music of otherwise meaningless sounds, and paintings of visual sensations that may or may not have an illusory effect. It should be obvious, too, that visual art is peculiar in consisting of physical entities and that that alone gives it a special nature. The implications of this fact are not, however, well understood or appreciated by most of us.

What if some strangely evil lunatic of vast wealth—we shall call him Basil Slinksnard—wished to destroy a masterpiece? Were he to choose a famous painting, the undertaking would be relatively simple, even though its execution might pose all sorts of practical problems so far as overcoming security measures are concerned. But, however difficult the task, it is clear that all Slinksnard and his minions would have to accomplish is destruction of a specific work of art.

But what if it were a symphony Basil wished to erase? Then the task would be insuperable. For it would require not only the elimination of every manuscript and score but also all of the recordings and every musician who could, from recollection and after trial and error, reconstruct it. On the other hand— and this is what's really important—no human being could own the piece itself, because musical works exist as works only when they are being performed. One may possess an original score, from the composer's own hand, but that is not the work. Legally, of course, certain people are said to "own" pieces of music they have copyrighted, but copyright holders don't really own

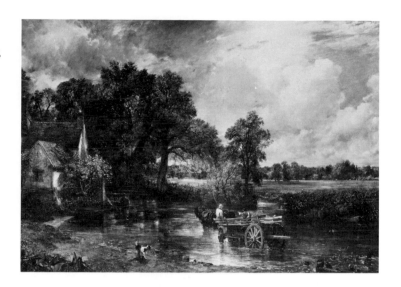

3-1 JOHN CONSTABLE. *The Hay Wain*. 1821. Oil on canvas, 51¼ × 73". The National Gallery, London

the material itself; what they truly possess is legal justification for demanding payment of a fee whenever the music or lyrics are used to make money. Conceivably, one might own every record, tape, or other transcription of some concerto in every instance it has been presented, but all the owner of these would hold, in fact, would be electronic ghosts of occasions of the performances. Similarly, a dramatic work exists only as it has been performed upon the stage or, strictly, when it is actually being undertaken by actors on the boards.

In general, literary works have an immortal existence; they need not necessarily be in printed form since perfect recall of the words is sufficient for a narrative to remain intact. I grant that, were every printed copy of *War and Peace* to evaporate, it is unlikely that the whole of Tolstoy's novel would remain, even in the collective consciousness of readers of Russian who have memorized its greater portions. Still, it should be obvious that the novel is not a manuscript or printed volume in the same way that Constable's *Hay Wain* (fig. 3-1) is oil paints applied to a piece of linen canvas on a wooden stretcher, framed and hanging against a particular wall in the National Gallery in London, England. The Constable is, in simplest fact, a physical object as well as a work of art.

No other art is like visual art in the above regard. That works of fine art are first and foremost physical objects has given them a special place in the hearts of those whose cultural and intellectual interests scarcely exist otherwise. It's easy to appreciate something that exists as a precious object and can be purchased, shown off, and eventually sold for a profit. If there's something enjoyable or ostensibly uplifting about it, so much the better. It is hardly surprising to find operating in art auctions the same speculative judgments that dominate the stock exchange and the market for precious minerals. Within the last decades, auction prices for art have risen enormously—even when adjusted for inflation.

In 1931 American millionaire Andrew Mellon paid just under $1 million for Raphael's *Alba Madonna*. Today, if that Raphael came on the market it would surely attract bids of more than $50 million. Prices have risen markedly. Among recent auction prices well calculated to stagger the imaginations of those of us for whom a million dollars is still a lot of money are a few paid for works by other artists included in this book: Jackson Pollock—$2 million; Piet Mondrian—$2.4 million; Pablo Picasso—$2.97 million; Giorgio de Chirico—$5.28 million; Diego Velázquez—$5.5 million; Claude Monet—

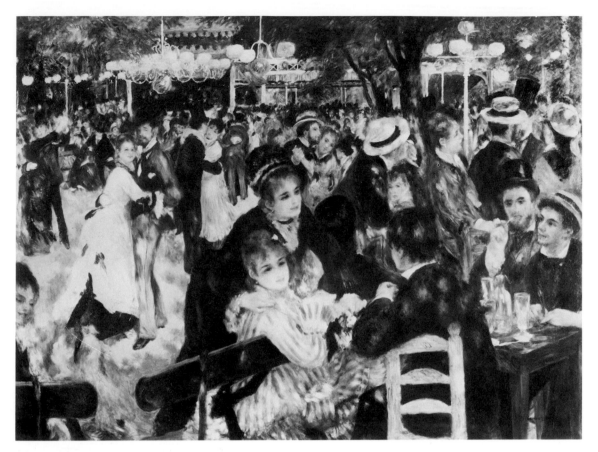

3-2 PIERRE-AUGUSTE RENOIR. *Le Moulin de la Galette.* 1876. Oil on canvas, 51½ × 69″. Musée d'Orsay, Paris

$6.6 million; J.W.M. Turner—$17 million; Wassily Kandinsky—$20.9 million. Then the staggering sum of $53 million for Vincent van Gogh's Postimpressionist masterpiece, *Irises.*

As I write, the French Impressionists and so-called Postimpressionists are among the bluest of blue chips on the big board. A smaller version of Renoir's *Le Moulin de la Galette* (see fig. 3-2) has been sold for what might seem the utterly astonishing sum of $78.1 million were it not for the fact that a week before a work by Vincent van Gogh was bid up to $82.5 million. Even Renoir, who came from a poor family and always longed for celebrity and riches, might have felt this kind of return on his work a bit excessive. Van Gogh, whose whole career resulted in the sale of a single one of his paintings[1] would, probably, have felt vindicated by history, but it is also possible that he would be chagrined to learn his portrait of his last physician, Dr. Paul Gachet, was more renowned for its phenomenal price than for anything it has to do with art or humanity. For Van Gogh tended to exaggerate the spiritual, humanistic qualities that are supposed to reside in serious art, believing that true art exalts humanity even more than religion does. He may, perhaps, have been correct. But before we get into that—an issue that has many more ramifications than most artists and collectors care to consider—let's address the question that most of you must surely have in the forefront of your minds.

Cost vs. Value What makes a picture—any picture—worth tens of millions of dollars? It seems ridiculous, even outrageous, in view of the human and environmental tragedies that the investment of so vast a sum might alleviate. Common sense tells us that it's utterly mad to suppose a picture is actually worth so much money. Right?

My own immediate, instinctive reaction is like your own. That a fragile thing of canvas, wood, and paint can command a price equivalent to the lifetime earnings of a thousand fairly well-paid Americans seems patently absurd. But consider this: Would we find it so ridiculous were we told that a treasure chest of golden coins and precious gems had a value of $100 million? Probably not. At any rate, most of us can stretch our limited imaginations just far enough to conceive that *some* amount of gold is worth that much. And yet, the gold doesn't do anything but weigh heavily and gleam. It is more durable than a painting; that's true. But it is in every other respect less interesting. The only reason we value it is just because we value it. That is, civilizations have agreed that this immutable, noncorroding metal will be a standard of exchange; that it will serve as a surrogate for the things of genuine value that more backward but pragmatic cultures use as measures of wealth, such as livestock, arable land, or water.

Today's art prices are like the prices governing costs of precious metals in that they reflect what investors are willing to pay. There are, of course, numerous differences, too. The artwork is unique. That is, only one owner—Mr. Ryoei Saito—can possess Renoir's *Moulin de la Galette* and Van Gogh's *Dr. Gachet*. It's true that his purchases may drive up the value of other works by these artists when they come to the block at the two principal auction houses for serious art, Sotheby's and Christie's, but it's not as if some other billionaire could call up his broker and order her to buy up "ten more units of Renoir's *Moulin de la Galette*." Indeed, it is the uniqueness of the artworks that gives them their preciosity, whereas it is the constancy of gold, silver, platinum, and jewels that sustains theirs. One would, therefore, never speak of a bar of precious metal being "priceless." Its very value resides in its pricefulness, as it were. It is, however, commonplace to characterize uniquely irreplaceable objects (such as singularly large or precious gemstones, finely wrought antique vessels, and painted masterpieces) as being priceless. All that that means, really, is that those who possess the object cannot conceive of a circumstance in which a given amount of money would warrant its sale.

It may seem as if little more is involved here, when all other considerations have been stripped away, than the difference between what are called the intrinsic and extrinsic values of a thing. *Intrinsic values* are those qualities within the nature of a thing rather than external to it. The *extrinsic values* are the qualities external, that is, values attributed to or imposed upon the object. Like all philosophic distinctions, this one is less easy to apply than common sense may suggest, but a typical way of describing the distinction is to apply it to something like a fine wine. The intrinsic values of a particular burgundy will be resident in its taste, bouquet, color, and relative dryness. Since these qualities depend in turn upon the character of particular grapes picked during a given year's harvest, they will be identified with a specific vineyard and vintage. The extrinsic value, on the other hand, is what a bottle of Château Mouton 1853 will bring at auction. After a century or so, the intrinsic properties of the wine are likely to have evaporated and the taste gone bad, so the value of the bottle is then to be found more in its antiquity than anything else.

What is true of fine wines is nearly the same with art. Paintings, too, become decrepit with age, although their intrinsic values are not as fleeting as those of vintage wine. It is also true that mere age does not increase the value of a mediocre work of fine art any more than it does that of *vin ordinaire*.

Americans, probably because of the youthfulness of our nation, are apt to ascribe momentous effects to modest degrees of antiquity. Too, art dealers

like to put it about that most of what they sell will appreciate in value. And, of course, there is the widespread myth that upon the death of an artist the works that he or she produced will escalate just because no more can be produced. Perhaps it's a betrayal of my colleagues to point out that everyone in the business knows full well that most artwork—even very accomplished artwork—does not appreciate but depreciates from year to year and the demise of the creator rarely has any effect whatever upon the decline. Collecting art as investment property is a very risky business, even for wealthy people who buy "big names." For most of us it will be a losing proposition so far as capital risks are concerned. Exceptions to the rule are incredibly rare, despite the legends that are told and the occasional killing to be made. Presently, in the United States and Britain, there are more people with professional training as artists, art historians, and museologists than there have ever been before. If it were as easy for knowledgeable people to make money by investing in art as it is for similarly sophisticated financial experts to make it in the "futures" market, there'd be a lot more Ph.D.s enjoying self-made fortunes than you can find today.

The best reason for collecting art in this inflated period is the same as ever: Buy it for your private enjoyment and for the delectation of your friends, which is not to say that you might not be lucky in your tastes or happen to have a phenomenal sense of the market. I know of one such collector. But, like most who've been successful, he began with a considerable advantage. He owned four or five banks.

Prints and Reproductions There is every reason to be suspicious of things offered at a bargain, particularly in the field of art. Practically every "print" by a well-known artist that you see available for what seems to the layperson a reasonable price is not what art professionals call by the term. Almost invariably they are reproductions, an entirely different thing. Handmade artworks are labor-intensive undertakings created by highly skilled people. Reproductions are mechanical imitations and knowing a little about the differences is essential to your well-being and pocketbook.

No matter how well-to-do you happen to be, an original Rembrandt oil painting is probably beyond your means. Today such a work would cost millions of dollars, most likely. But if you wish to save up for a while, you might be able to pick up a good etching from the hand of the same master for only a few thousand. The etching is just as much an "original Rembrandt" as an oil painting but not nearly so precious because it is but one of a number of copies. It has the qualities of great art but isn't as rare a thing as a one-of-a-kind painting. That is the main purpose of printmaking—to produce multiple originals of genuine quality.

In order to make what I'm talking about perfectly clear, it is wise to distinguish between *prints* and *reproductions*. Artistically speaking, a print has the following characteristics: the printing surface was made by the artist himself; it is printed by him or under his direct supervision; the processes involved are done by hand. In modern times a specified, limited number of individual pictures are made from a given plate or block, which is then defaced or destroyed so that more cannot be printed.

A reproduction is produced by photomechanical methods, not by hand, and the relations between the artist and the printer are incidental or nonexistent. A so-called print of *Christina's World* (fig. 3-3) by Andrew Wyeth (born 1914) is not a genuine artist's print; it is a color reproduction. Wyeth had nothing to do with it. Some reproductions are of very high quality; some are

3-3 ANDREW WYETH. *Christina's World.* 1948. Tempera on gessoed panel, 32¼ × 47¾".
Collection, The Museum of Modern Art, New York. Purchase

poor. Some reproductions of artists' prints are *so* fine that they can be palmed off on the inexpert as original etchings, woodcuts, and lithographs; in that case the reproduction is a mechanically produced facsimile—a counterfeit. Sometimes one sees ads for a "limited edition of color prints of" what is clearly a reproduction of a painting. The limits of such an edition will, as likely as not, be a thousand or more. Legally it is "limited," and narrowly defined it is a print (after all, a press prints it); but from a printmaker's point of view anything over a hundred is a very large edition. A reproduction of a painting is really just a fancy poster worth no more than any other gift shop item. Of course, it may be worth every penny to you as a decor item; a good reproduction of the Wyeth is higher on the scale of aesthetic value than the tenth-rate original oil paintings turned out by hacks for department stores and traveling bazaars featuring the work of ostensibly struggling artists.[2] All I wish to make clear here is that reproductions and prints are not in the same category, even when the posters are signed by the artist individually and numbered in the order they were spit out by an offset press.

Degas's *Self-Portrait* (fig. 3-4) is an etching. What we are looking at here is a black-and-white reproduction of the print. The reproduction was made from a photograph of an impression of the print owned by the National Gallery of Art in Washington, D.C. There are other impressions of the same print in other collections here and abroad. The *print* is the picture Degas's etched copperplate produced. An *impression* is any individual picture made from the etched plate. An *edition* is the total number of impressions Degas printed from the plate. If you buy a print from a contemporary artist, it should have the following information in pencil on the lower margin: title, edition number, artist's signature, and year.

The edition number is important. It will read "16–100" or "24–50" or "34–34" or something. This means that you are examining the sixteenth of

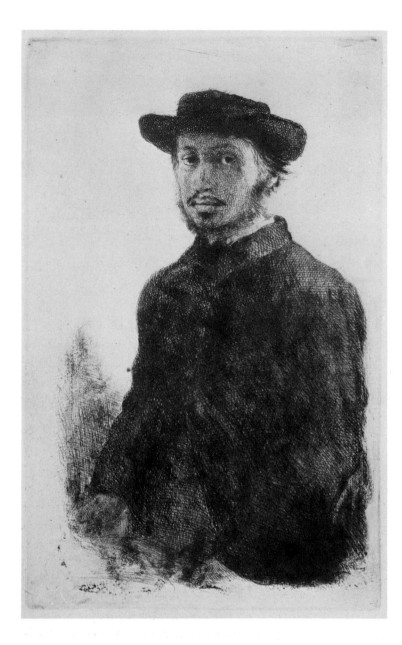

3-4 EDGAR DEGAS. *Self-Portrait.*
Probably 1857. Etching,
9 × 5⅝″. National Gallery of
Art, Washington, D.C.
Rosenwald Collection

one hundred impressions or the twenty-fourth of fifty impressions or the last of thirty-four. The artist will also have "pulled" (that is, printed) a few impressions for himself which are not in the numbered edition. Normally these will be labeled "artist's proof" and will be marked with a Roman numeral to identify the order in which they fall. Early impressions and artist's proofs are supposed to be worth more than later impressions, but in an edition of less than one hundred there are not apt to be any real qualitative differences.

All the pictures in this book were reproduced by photomechanical printing processes. That is, the works of art were photographed onto photosensitive plates which were then chemically prepared for printing by machinery. The processes correspond to those in the fine arts and, indeed, derive from the hand processes of the artist.

Relief (letterpress) Letterpress is the kind of printing with which most people are familiar. Raised type, having been inked, imparts the image to a sheet of paper. Many newspapers are printed by this process. Pictures reproduced for letterpress are of two types: linecut and halftone.

PRINTED IMAGE BLANK PAPER

IMPRESSION CYLINDER

INKING ROLLERS

PLATE

MOVING BED

3-5 Letterpress method of printing reproductions

Linecuts are made from drawings that are of one value only—like the diagrams I have drawn to illustrate the printing processes. Sometimes my diagrams contain what appear to be grays, but if you look closely at the reproductions, you will see that the grays are really made up of tiny black dots very close together. Such a dot pattern is called a *Benday tint* and is available in many patterns and forms. In linecut the drawing is photographed to produce a negative. Normally, the negative will be smaller than the original drawing; most comic strips, for instance, are drawn three or four times the size you see them. The negative is placed on a sheet of zinc that has been coated with a photosensitive solution and is exposed to a very strong arc light. The black of the negative (white in the drawing) blocks out the light; the clear area on the negative (black in the drawing) permits light to pass through. The light hardens the coating on the zinc so that it is insoluble in water. Careful washing removes the unexposed areas. The plate is then inked and dusted with a fine ground called *dragon's blood* which is very similar to etching ground. It clings only to the hardened areas and not to the remainder of the plate. The piece of zinc is immersed in an acid bath, and the parts not covered with ground are etched away. The plate is then mounted on a wooden block to bring it up to the same height as type and is printed exactly like type. What it prints, of course, is a small duplicate of the original drawing (see fig. 3-5).

The same procedure is used for the reproduction of continuous-tone photographs, that is, for things like the pictures of paintings and prints in this book. All photographs are reproduced by this process, called *halftone*. The difference between halftone and linecut is that in halftone two sheets of plate glass covered with lines are involved. The lines are engraved diagonally and are filled in with black pigment. When the two plates are placed face to face with the lines at right angles, a grid or *screen* is formed. The negative is photographed onto the zinc plate through the screen. Because the plate is able to "see" only in terms of the highest possible contrast, it reads light areas as made of large dots and dark ones as small dots. (Remember, all this is in negative.) The ultimate consequence is that when the zinc has been prepared as it is for a linecut a lot of little dots stand up in relief; there are many dots close together where the image is to be black and very few where it is to be light. If you look at a newspaper, you will see that reproductions of the photographs answer to this description. Newspapers use very coarse halftone screens for their halftones. Magazines use finer ones. The dots can become so fine that you cannot see them with the naked eye.

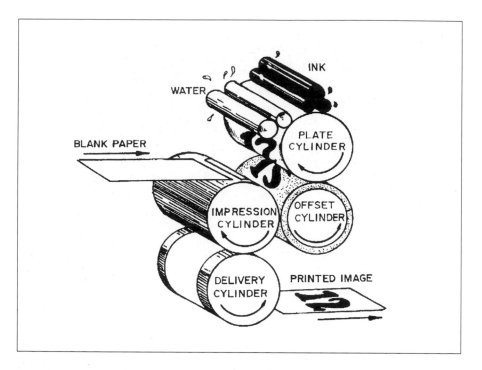

3-6 Photo-offset method of printing reproductions

Offset Lithography The preparation of negatives and plates for the mechanical version of lithography is about the same as for letterpress; it is the printing process that differs (see fig. 3-6). The plate is a thin sheet of zinc or aluminum treated so that certain areas are receptive to ink and others to water, exactly as in stone lithography. Once the line or halftone image has been fixed in the plate, the plate is wrapped around a drum on an offset press. When the press is turned on, the plate on the drum turns. As it turns, it is contacted first by a set of rollers that wet it with water and then by a set of rollers that apply the ink. The plate next contacts another drum, this one wrapped in a rubber blanket. The inky image on the plate is "offset" onto the blanket, and the roller prints it onto the paper.

Offset lithography permits finer printing on rougher paper than letterpress and has such other advantages as speed and longer-lasting plates. Practically all magazines, brochures, and illustrated books are printed by this method. The images are not, however, quite as clean and sharp as in good letterpress work. But this is the means used to manufacture all of those "limited edition lithographs of an original painting" one sees advertised. They are expensive posters, which is not to say they are invariably worthless. Some posters by Pop artist Roy Lichtenstein have been auctioned for thousands of dollars. That sort of occurrence is exceptional, however—kind of like the collectibility of some old comic books, baseball cards, paper dolls, or varieties of barbed wire. (Barbed wire? It's true. Some people collected samples of it!)

Sometimes superficial knowledge of the possible is not sufficient to deal with concrete problems. For example, you may be offered a lithograph that looks like a real artist's print on high-grade paper, signed, perhaps even numbered. Perhaps something makes you suspicious; for instance, the number is "210" but there's no indication that this means anything, really, so far as the size of the edition is concerned. (Sometimes when a gallery describes something as being in an edition of 300, it means only that the gallery has ordered that many for sale.) How can you tell whether the thing is a poster or a print? Inspect it through a magnifying glass such as a jeweler's loupe or a photographer's "inspection lens." If tiny black dots in regular alignment show

3-7 GILBERT STUART. *"Athenaeum"*
Portrait of George Washington.
1796. Oil on canvas, 39⅝ × 34¼".
Boston Athenaeum, on deposit at
the Museum of Fine Arts, Boston

up, you are looking at a halftone reproduction of an impression of a genuine lithograph. In a sense what you are dealing with is a mechanical counterfeit. It is hard to be certain that the seller is actually dishonest, though, because the language of the art marketplace is so undefined and inexact. Still, most people who are really interested in art will avoid items of this kind. To be sure of detecting the halftones, you need a lens more powerful than the common reading glass. Something between 5X and 10X power should do nicely.

It is true that some kinds of very high-quality counterfeits are difficult to expose through ordinary magnification. There are ways of getting around the halftone dots, and it is also possible to print nearly perfect reproductions of etchings and engravings by their photomechanical cousin, gravure. Modern, abstract color lithographs and serigraphs made up of ungraduated flat areas can be practically indistinguishable from the real thing. Of course, if they're *that* good their authenticity probably won't make any difference to anyone but the connoisseur or speculator.

Replicas, Copies, and Forgeries Figure 3-7 reproduces, in black and white, a famous work by one of the greatest of the American painters of the early nineteenth century. It is Gilbert Stuart's (1755–1828) *"Athenaeum"*

3-8 HENRICUS VAN MEEGEREN. *Woman Taken in Adultery.* 1942. Oil on canvas, 39⅜ × 35⅜". Rijksdienst Beeldende Kunst, The Hague

Portrait of George Washington, so called because it is the property of the Boston Athenaeum. Stuart painted it in 1796 and referred to it as his "hundred dollar portrait" because he could always sell a replica for that amount when he was short of cash. Only the head is finished but that was sufficient to serve as the model for the seventy-odd imitations he made of it. Such copies, undertaken by the original artist are, technically, *replicas.* When done by another they are known as *copies.* It is not always possible to determine with any finality which are which when, as happened often enough, the copy was done under the direct supervision of the original master. Needless to say, replicas that can be attributed to the master himself are more valuable to collectors than those that cannot. Inevitably, there are the unscrupulous dealers and over-enthusiastic owners of copies who do not hesitate to palm off questionable pieces as authentic replicas.

Forgeries, of course, are attempts by skilled criminals to counterfeit the style of the master so that their imitations can be sold for the sums only originals will bring. Creating these fakes entails a good deal more than merely being able to mimic the overt appearance of a master's style. The successful forger must take into account the physical nature of the originals, too. In other words, the painting or other work must take on the evident age of its prototypes. Since contemporary specialists in the forensics of documentation are able to employ a great battery of tools in determining the genuineness of objects, anyone hoping to fool them into believing a recent creation is an antique has to be clever and careful beyond all expectation.

One of the most notorious forgers of modern times was a Dutchman named Henricus van Meegeren, who was so accomplished at creating what he represented as previously unknown works by Jan Vermeer (1632–1675) that

3-9 JAN VERMEER VAN DELFT. *Young Woman with a Water Jug.* c. 1665. Oil on canvas, 18 × 17″. The Metropolitan Museum of Art, New York. Gift of Henry G. Marquand, 1889

finally he was compelled to reveal his technique in order to avoid being convicted of betraying his country to the Nazis when he was charged with being a collaborator after Germany's defeat in World War II. He was able to demonstrate that he had not sold a Vermeer version of *Woman Taken in Adultery* to Field Marshal Hermann Goering but had, in fact, duped the Nazi leader with a painting (fig. 3-8) he had himself created.

In order to fool the experts, even back in the 1940s, Van Meegeren had to anticipate and overcome tests they would apply to any supposed Vermeer. It goes without saying that the general appearance of the drawing and application of pigments had to be similar. Van Meegeren was a trained academician who, as it happened, worked in a sort of slicked-up, Vermeerlike style to begin with. When he did his imitations, he stole a face from this painting, clothing from another, a piece of furniture from here, a hand from there, and so on, mixing it up into an original composition. Not too awfully difficult. The really tough part was making the painting seem old.

The first step in his deceptions involved securing a canvas of approximately the same age as a Vermeer. There are available, even today in The Netherlands, many seventeenth-century oil paintings of no particular value. The old painting was essential to the forger's ends for a number of obvious reasons, but especially because it would show the characteristic crackle of age. Those tiny cracks go all the way from the surface to the canvas and they are inimitable. Once in possession of a work containing them, Van Meegeren could use paint removers to strip the original painting away from the ground—a sort of primer coating—that also contains the crackle. On this surface, he painted his imitation Vermeer. The pigment powders he used had to be those available to the master. For instance, the beautiful blue in Vermeer's *Young Woman with a Water Jug* (fig. 3-9) was done with ultramarine blue, a paint produced by grinding into dust the semiprecious gemstone lapis lazuli. From the middle of the nineteenth century, ultramarine has been synthetically produced by com-

bining cobalt with other minerals, all of which produce identifiable patterns in spectroscopic analysis. Obviously, one of the things the experts do routinely in the course of their investigations is spectroscopic analysis of minute flecks of pigment from suspect paintings. In fact, two of Van Meegeren's forgeries were found out when the chemist from whom he purchased his pigments cheated him by adulterating the very expensive lapis lazuli with a bit of inexpensive cobalt. That did not, however, bring the forger to the dock; it simply made it appear that he too had been fooled by a forger and tended to confirm the experts in their confidence that the four other "Vermeers" that he had supposedly discovered were real.

The resins with which pigments are mixed to make oil paint are not so identifiable or particular to a time as are the mineral components of the paint. Their age can be more or less determined, though, because of their tendency to stay soft and susceptible to dissolution for many years. Oil paint is usually dry to the touch in a week or so, but takes a year to dry thoroughly. To harden, however, requires fifty years or more. Obviously, one of the first tests a forensic chemist will apply to any oil painting in question is the resistance of the surface of the painting to solvents. Van Meegeren got around the problem by mixing his pigments in phenol-formaldehyde and baking the painting until the surface was as hard as if it were two hundred years old. Once it had cooled, he reinduced the old crackle by rolling the canvas around a metal cylinder, causing the brittle skin to crack along the points of least resistance. He obtained two kinds of crackle this way: (1) the cracks of the original ground and (2) some new, intervening lines that also resembled aging except they did not penetrate all the way down. Dirtying the cracks with sooty ink made them obvious and also imitated the dirt that always accumulates with time. Obviously, Van Meegeren was a conscientious and cunning criminal. Ironically, once cleared of the collaboration charge, he was tried and sentenced to a year in prison for fraud. He died before he could begin serving the sentence. In 1945 it was his very success that brought about his downfall; the only way he could avoid a long sentence and dishonor as traitor to his country was by revealing his career as forger. Today his fakes would probably be unveiled straightaway. As it was, the times helped him in his career by providing the ultimate distraction—a world war of unprecedented scale and horror.

Art Criticism, Preciosity, and Mystification Even a casual reader of books and articles on art must be struck by the type of language that is used and by the kinds of claims made for objects of paint and canvas or pieces of rock or other substances. When someone writes that a picture of a woman who has been dead for two hundred years is done with a vigor that "breathes life into the likeness in a way that is miraculous" we take it as the license of an inept poet. Obviously, this is an exaggeration. But what about the critic who claims for some very polished photographs of homoerotic subjects that they "redeem what is not wrong from the sinful sink to which it has been consigned"? Or that some set of posters pushes art "to the brink of apocalypse"? Well, these claims are still within the bounds of warranted exaggeration, given the convictions of their authors. Readers *know* the statements are not to be taken literally. But some art criticism makes claims for art that are of a different kind. It describes the artworks themselves as having qualities they cannot have or characterizes existing qualities as having an importance they do not possess.

Statements of the latter sort are typically marked by sonorous phrases and impressively recondite terminology asserting what cannot bear analysis. A

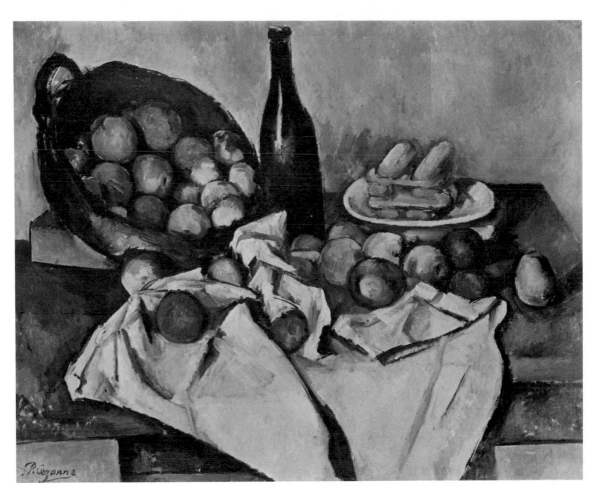

3-10 PAUL CÉZANNE. *The Basket of Apples.* 1890–94. Oil on canvas, 25¾ × 32″. The Art Institute of Chicago. Helen Birch Bartlett Memorial Collection

favorite example of mine uses Paul Cézanne's (1839–1906) *Self-Portrait with Palette* to extoll the inventiveness of the painter. It was written by Maurice Raynal: "The structure of the face embodies geometric elements whose purpose is both to segregate forms (*i.e.* to 'abstract' them), and to give a heightened sensation of volume. The monumental, plastic quality of this work—so apt to baffle the devotees of perspective and chiaroscuro—derives from the presence of elements of cones and cylinders, of dihedral and even tetrahedral angles."[3] What does this *mean?* Read it again. Segregation of forms being equivalent to abstraction does not sound outrageous to me. It also doesn't connote much of anything. What is a dihedral? Nothing more than two planes joined at an angle—like the corner of a room. A tetrahedral is something having the shape of a tetrahedron and that is a geometric solid constituted of four triangular sides, a sort of three-sided "pyramid." Actually, there aren't any in the portrait cited. But if there were, would that be so odd?

Raynal has made it seem that the artist is unusual in his use of fundamental shapes. But even Holbein, whose verisimilitude gives an impression of reality equal to or even surpassing that of photography, could be said to have derived his realism through the meticulous description of small lumps, crevices, slopes, and bulges of flesh and bone that can be thought of as geometrical. Those of us who teach drawing nearly always make some reference to the geometry of the skull that dominates every human appearance. The skull can be thought of as an imperfect sphere, the face and jaw as a tapered rhomboid, the features conceptualized as planar, conical, semispherical. It may surprise

laypeople that artists think of faces in this way, but I can assure them, it is a customary approach.

Why did Maurice Raynal write what he did? Because he himself believed that it explained something about modern art and Cézanne's influences upon it. It is a common error among writers on modern art to assume that this master based his designs on the reduction of things to an ideal geometry of cones, cubes, spheres, and cylinders. Despite the tireless efforts of a few of us to correct this error, it persists.

People who should know better believe it because of something Cézanne wrote to the younger artist Emile Bernard in April 1904. However, he did not say what he is purported to have said. This is the *actual* statement: "May I repeat what I told you here; treat nature by the cylinder, the sphere, the cone, everything in proper perspective so that each side of an object or a plane is directed towards a central point."[4] You will notice that he failed to mention cubes—the form most commonly associated with his style—and that he *does* definitely say that everything should be "in proper perspective," a condition to which his own paintings are immune (see fig. 7-47). One has only to look at his work to see that the shapes in them are not especially geometric. That is, in *The Basket of Apples* (fig. 3-10) the real apples were probably at least as spherical as the painted ones. The most obvious thing about the objects in this still life is that they are not in perspective. Typically, Cézanne "blunts" convergences and flattens out ellipses. Why, then, his instruction to Bernard? A second letter, this one to his son Paul in 1906, gives us a good clue. The master mentions "the unfortunate Emile Bernard . . . an intellectual crushed by the memory of the museums, but who does not look at nature enough."[5] In the earlier epistle, Cézanne was not telling Bernard the "secret" of how to paint a Cézanne; he was instructing him on how to look at nature—in terms of basic geometric forms. This was standard academic advice to students at the time and, indeed, is still standard advice to beginners today.

The penchant early apologists of modernism have for associating its anti-traditional features with some sort of historically progressive movement akin to the advances in science is not merely a propaganda technique. It is part of a much older tendency to give high art a superior, nearly mystic, status that has little to do with what it is or is actually about and has everything to do with its sheer preciosity.

Treating fine artworks as sacrosanct is, of course, precisely what museums do when they keep their patrons at a distance from the works. These objects are held to be of such lofty purpose and cultural significance that they must be worshipped with deference—even when they are no more than stacks of firebrick. This approach to things is what the Marxists call "mystification." What they say is worth paying at least a little attention to because, although history seems to have consigned their economics to its dustbin, they do seem rather good at sociology. They've pointed out that societies often protect conservative, discriminatory practices from challenge by obscuring their injustices with idealistic camouflage. For instance, we are all familiar with the argument, used in different ways by both conservatives and radical feminists, that women are inherently more noble, caring, and sensitive than men. They are the nurturers of society. They excel at things men are too impatient and crude to manage. They are morally superior. It would, therefore, be wrong for them to fight in wars, to hold positions of leadership in a mean, cruel world, to carry the burden of financial planning, to take responsibility for life-and-death decisions in a surgical theater, and so on. In other words, women are too fine to do anything really exciting or challenging, so they are left to do things

3-11 TITIAN. *Venus of Urbino*. 1538. Oil on canvas, 47 × 65". Uffizi Gallery, Florence

like change diapers and cook meals. It falls, alas, to men to undertake adventure and tolerate the stress of command. This particular mystification is known as the *feminine mystique*. Like most fictions based in stereotypes it has a kernel of truth at its heart; the extension is the fault. And not only on the right, by the way. From the other side the contention is made that were women in charge there'd be no wars, violent crime, or acid rain. Uh huh. A somewhat mystifying exaggeration, in view of historic figures like Mrs. Thatcher, Elizabeth I, Cleopatra VII, Lucrezia Borgia, Queen Zenobia of Palmyra, and other iron-willed women who've been aggressive, even bellicose, leaders of their people.

In the world of art we encounter the same sort of mystification and it, too, is institutionalized in the ways we talk about objects of art. Art historians can be heard to say that a figure like that of the young lady in Titian's (c. 1487/90– 1576) *Venus of Urbino* (fig. 3-11) is not *naked* but is, instead, *nude*. What's the difference? None, really. But the notion is that nudes are of a loftier spiritual character. They are admirable expressions of the humanist spirit, abstract formulations of pure beauty and proportion. There's *something* to this idea, particularly when changing fashion has made the model's proportions less appealing than they would have been to her contemporaries. Make no mistake; the Duke of Urbino for whom Titian did this work was not a man to overlook the sexually provocative elements of the portrayal. Surely, he saw this through the typically informal eyes of a normal male. This Venus wasn't nude for the Duke; she was the equivalent of a pinup, albeit a very high-class, costly version of the always naked pinup. British poet and art critic John Berger put it rather well: "In the art-form of the European nude the painters and spectator-owners were usually men and the persons treated as objects,

usually women. This unequal relationship is so deeply embedded in our culture that it still structures the consciousness of many women. They do to themselves what men do to them. They survey, like men, their own femininity."[6]

In quoting Mr. Berger with approval, I do not wish to ally myself with those who think that representations of unclad women or men are somehow offensive. I think you'd have to go a long way indeed (and probably walk among the incompetent) to find an artist or art historian who felt that way. That the images are unquestionably meant to be sexually exciting doesn't *necessarily* mean they are denigrating to women. To believe that whatever is sexual is therefore sexist seems to me a very unrealistic view of human life. It's another mode of mystification. I want only to point out that there is a rather strong tendency to ascribe spiritual properties to painted images almost the way worshipers of idols in a savage environment might. It should, therefore, not surprise you when you encounter learned people writing things about art that are in defiance of common sense. Really, there's no more difference between nakedness and nudity than the one we like to pretend exists. Yet, as art historian David Freedberg has said of the Titian Venus: "The sensuality of the representation would have been plain to many and may well continue to be so. But not many will admit to this—at least not if they are well schooled."[7] And why the bookish evasions? A Marxian critic would probably say that they are to conceal what the painting truly means in social terms. It is a demonstration of what money can buy: oil paintings, beautiful lovers, or (in genres other than the nude) land, animals, food and flowers, leisure-time spectacles and the moods that accompany them. The paintings have economic status denied to commonplace things like posters, and they are appreciated by people of property and education, so a whole mythology grows up around them in support of the preferences of the elite.

One must, of course, be a little cautious here. Sometimes it really isn't possible to discuss artistic qualities in language that is utterly factual and straightforward. More often than not we must rely on metaphor and even a little affectation to convey what lies beyond the most obvious aspects of painting or sculpture. Thus, if I were to say that one of the things we find useful in distinguishing between what critics refer to as "nakedness" and what they call "nudity" is self-consciousness exhibited by a painted figure, I am taking into account that the distinction *is* one commonly drawn but I am also speaking as if the painted image could *itself* be self-conscious of its bareness. Of course, it cannot. It is simply paint, an illusion without thought or feeling. Even when I am affecting an iconoclastic, hardheaded, no-nonsense posture, I can't get around the fact that art does not easily concede to language and, so, I must bow to the need for phrasing that's not just matter-of-fact. A person cannot be too literal-minded when discussing fine art. Nonetheless it's a good idea to be just a little hesitant about accepting what writers of books, articles, and reviews say about the intrinsic qualities of a work of art. Does this apply to the volume you are now perusing? Hmmmmm . . . What do you suppose?

PART TWO

ELEMENTS
OF ART

FOUR

LINE AND FORM

All I have done so far is emphasize that art has many faces and make an issue of the fact that the relationship between art and reality is relatively obscure. We have given incidental attention to ways in which artists of various ages and places have translated reality into pictures and some effects the status of art objects as possessions has upon our perception of them. But we have not paid much attention to the things common to all visual art, to what are called its "elements." The visual elements are fundamental, basic. Without them no imagery could exist. Usually, they are identified as *line, form, space, texture, light,* and *color.* But to label them in this way is merely a convenience; in fact, the attributes described by these words merge into one another so that it is impossible to draw hard and fast distinctions among them. They are quite a lot like the interrelated components of music: melody, harmony, rhythm, meter, and timbre. Artists and composers don't very often think of such elements as separate entities. They use the words, however, to make it easier to talk about certain aspects of their works. To a layman they and their critics sometimes seem to be playing fast and loose with the English tongue, as when artists discuss the "line" in work like that of Mark Rothko (fig. 4-1). Here again, however, a common-sense approach can help us understand precisely what is meant.

There are ten different black marks in figure 4-2. They are all the same height; the widths vary. Which of them would you refer to as "lines" in casual conversation and which would you call "forms"? The most common reaction is to call "lines" those marks which are so thin that you don't really pay attention to their ends. They have a noticeable length—they terminate—but the look of the ends themselves is not an important feature of their appearance. With respect to the "forms," though, the character of the end is of sufficient thickness that we are apt to call it the "top" or "bottom" of the shape. Now in fact *all* the marks are forms; some are long and thin, some are not. We are aware that C is wider than A, but nonetheless it is true that what predominates in C is its length; our eye seems to run up and down A, B, and C whereas it seems to run around H, I, and J. We might go so far as to say—as some readers undoubtedly already have—that H, I, and J have lines *around*

4-1 MARK ROTHKO. *Orange and Yellow*. 1956. Oil on canvas, 91 × 71″. Albright-Knox Art Gallery, Buffalo, New York. Gift of Seymour H. Knox

a b c d e f g h i j

4-2 Lines and forms

4-3 Square

4-4 Geometric forms indicated by isolated dots

4-5 A line of dots

4-6 Automobile

4-7 Automobile

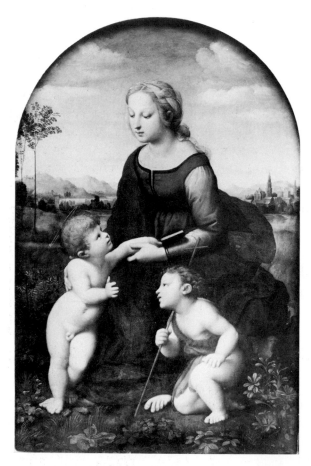

4-8 RAPHAEL. *Madonna of the Beautiful Garden.* 1507. Oil on panel, 48 × 31½″. The Louvre, Paris

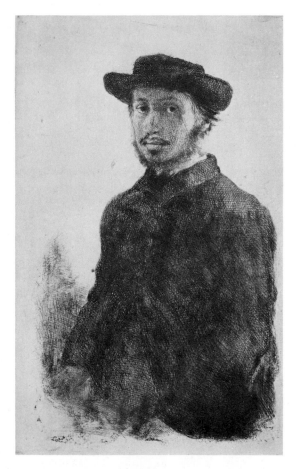

4-9 EDGAR DEGAS. *Self-Portrait.* Probably 1857. Etching, 9 × 5⅝″. National Gallery of Art, Washington, D.C. Rosenwald Collection

them, that their edges are the same as lines. And this is perfectly correct. A line can describe the edge of a form, or it can be a long thin mark enclosing an area (fig. 4-3). In both cases we could call them "boundaries" or out*lines*.

That is not the close of the matter. For we also have invisible lines. Thus, in figure 4-4 our tendency will be to link up the isolated dots into a square, a parallelogram, and a triangle. And with a few more units (fig. 4-5) we provide the viewer with a *line* of dots.

What is important to the concept of line is the impression of movement. When someone says, "Lines do not exist in nature," he simply means that your arm, say, is not bounded by long thin marks. But we commonly refer to such things as the *line* of the horizon, the tree*line,* and the receding hair*lines* of older men. And, in a sense rather close to that of the artist, we speak of the *lines* of a car. The line of an automobile design is not just the outline of the machine. It is also the general flow of the forms. Figure 4-6 is identical in silhouette to figure 4-7; but the "lines" are not the same, only the outlines are. Such language is very inexact, of course, but the meaning is quite clear.

When the artist or critic speaks of the lines in such work as Raphael's *Madonna of the Beautiful Garden* (fig. 4-8) or *Orange and Yellow* (fig. 4-1) by Mark Rothko (1903–1970), he is talking about movements. Most often such movements are along the edges of forms, that is, they are lines of boundary as in the Raphael. Sometimes, though, they are as diffuse and generalized as the movement around the hazy rectangles in the Rothko. My meaning is fairly obvious when I speak of lines existing in something like the Degas *Self-Portrait* (fig. 4-9). In this work there are actual drawn lines[1]—that is, thin forms—and there are also the outlines of the larger forms or shapes which result from the accumulation of the thin black marks.

In a very real sense all drawn lines can be thought of as forms that serve to emphasize movement. For example, the lines in figure 4-10 indicate the directions the edges would take if Maxor were treated in terms of bold masses (fig. 4-11) instead of in terms of thin black forms. All lines are pathways that connect up shapes and forms in a work of art. If we put Maxor back into the original composition (fig. 4-12) by the author, we can see that he is at the crest of a general sweep of lines and forms beginning at the bottom of the picture and curving up and back to the center of action. This is a very impor-

4-10 After *Maxor* by John Adkins
Richardson

4-11 After *Maxor* by John Adkins
Richardson

4-12 JOHN ADKINS
RICHARDSON. *Maxor.*
© 1992, John Adkins
Richardson

4-13 JOHN ADKINS RICHARDSON. *Ted, Red, and Willie & "The Spinster Who Liked Cats."* Comic book "splash" page. © 1985, John Adkins Richardson

4-14 Preparatory sketch for figure 4-13

tant use of line in pictorial composition. It is the result of an alignment of forms, in this case a lining up of shapes so insistent that one's eye is drawn through the illustration almost as if by a powerful magnetic force. Even the streaked sky contributes to our little drama.

Experience tells me that the foregoing discussion will raise eyebrows and questions. After all, lines do run both ways. How can I say that these point to Maxor and the Cyborg instead of away from them? Because the majority of the curves converge upon them, and convergence tends to draw our eye to a point of closure. Did I do this deliberately, though? Yes, it was deliberate, unequivocally. That such a pattern could occur by accident is far beyond the realm of chance; besides, it is fairly common pictorial practice. The reason it seems implausible, if not incredible, to laypeople is because they have no understanding of the way in which a professional artist undertakes the drawing of a picture.

Figure 4-13 is also from another of my own graphic stories. Again, I do not submit it as exemplary. It is routine illustration, although fairly complicated. But, as it happens, I have the initial pencil sketch over which the final ink rendering was done. As you can observe in figure 4-14, the broad sweeping movements of the pencil established the basic relationships that were maintained in the successive stages that refined detailed elements of the illustration. All trained artists work in this general fashion; they first establish a general scheme of relationships and only then begin to specify silhouettes and shadows. The amateur tries, instead, to "trace" the precise outlines of each component element. Only the greatest geniuses of drawing could manage to produce anything of value in this way—and they would do so by following a mental sketch that held proportions in the imagination the way they ordinarily appear on paper or canvas. And even the few we know of who, at one time or

4-15 RAPHAEL. Preparatory sketch for the *Madonna of the Beautiful Garden*. 1507. The Louvre, Paris

4-16 Diagram of movements in Raphael's *Madonna of the Beautiful Garden*

4-17 Three-legged arch

another, are said to have fabricated images in this fashion as a sort of trick—Michelangelo, Picasso, Raphael—chose, usually, to pursue the figments of their imaginations in the more conventional way. Consider, for instance, the early preparatory study for the *Madonna of the Beautiful Garden* (fig. 4-15). Despite the fluent curvilinearity that is retained in the finished painting (fig. 4-8) the sketch reveals far more natural attitudes of posture among the three principals; the baby Jesus is much more a typical toddler who draws away from his mother so he can go play. The tentativeness of a plan is shown, too, in the multiple lines and various corrections.

Notice how in the finished painting the forms of Christ's body establish a curved movement that is carried on through the arm of the Virgin. There are a number of such linear developments throughout the work. I have diagrammed some of them in figure 4-16. Of course, a diagram is not the work itself; there are other alignments and pathways that I have overlooked or deliberately ignored. Indeed, one is wise to be suspicious of critics who engage in very much of this kind of analysis; truth is apt to exist in inverse proportion to the number of schematic diagrams. But it is sometimes necessary to sacrifice a bit of truth to understanding. Which brings me to another caution.

I have had frequent recourse to such phrases as "the eye runs up and down," "the eye runs around," "our eye is drawn," and "pathways through the picture." While these phrases are commonly used among artists and critics, there is no real evidence that we comprehend pictures in this way. Certainly it is not true that the focus of our vision is actually along the lines in a picture. If it were so, the bizarre image in figure 4-17 would not disturb us in the least; we would accept it as a matter-of-fact array of long thin marks. But we see it in its totality, and the top half doesn't go with the bottom part. The notion of movement of line in art has more to do with a generalized sensation than it has to do with the actual mechanics of vision. Yet the *feeling* that one's eye moves along pathways is so pronounced in something like the elaborate cartoon of Maxor or the Raphael Madonna that it is both convenient and convincing to talk as if it were true that vision finds its way through pictures by using stepping-stones and pathways.

A painter of the American West, Charles Russell (1864–1926), made very obvious use of such pathways in his oil painting *Loops and Swift Horses Are Surer than Lead* (fig. 4-18), which shows a couple of wranglers roping a bear. The lariats establish a bold, looping curve through the middle of the work. This same curve, albeit without the loop, is repeated in the shapes of the valley beyond, carried through the slant of the horses' legs, and echoes in the posture and movement of the cowboys. Notice, too, that the sagebrush is not so random in disposition as one might at first suppose. The clumps are lined up in curves; some correspond to the line of the lariat, others lead up from the foreground into the center of the action. At first glance the painting looks perfectly natural. But a little analysis reveals the artist at work, arranging things in terms of movements.

It would be difficult to find a more contrasting painting than *Composition in White, Black, and Red* (fig. 4-19) by Piet Mondrian (1872–1944). Here there is no action, not even a portrayal of any kind—nothing but black lines on a white panel with a thin rectangle of red at the base. What Mondrian was interested in, obviously, was outlining different size zones on his canvas. This looks simple, but it is a difficult sort of problem and Mondrian has handled it very sensitively. Because his style was associated with a certain development in architectural design, reflected in such structures as Mies van der Rohe's buildings (fig. 4-20), it is common to teach people to "appreciate" it by

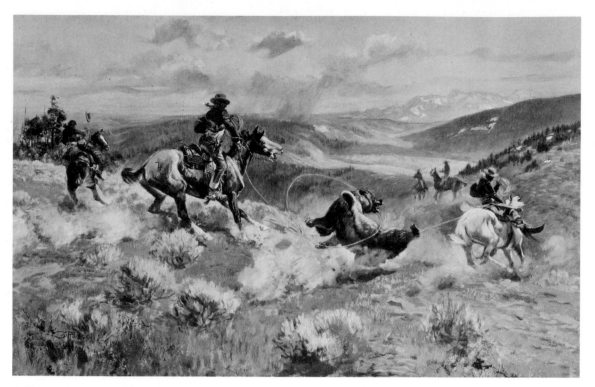

4-18 CHARLES RUSSELL. *Loops and Swift Horses Are Surer than Lead.* 1916. Oil on canvas, 29½ × 47½". Amon Carter Museum of Western Art, Fort Worth, Texas

suggesting that they think of the black stripes in the work as steel members, the white spaces as glass, and the red strip as brick. Yes, it resembles a storefront of the sort one might see on a fashionable street. This approach demonstrates, perhaps, the relevance of Mondrian's ideas to our daily lives, but it misses what is most intriguing about the painting itself, namely, the relationships of the forms.

May I suggest that you try looking at the work not as if it were produced by placing black stripes on a white background but, instead, as if Mondrian had placed large white units on a black background? The exquisite proportioning of the various elements may be more apparent when seen in this light than when looked at in the expected fashion. However, it might not; some people find this kind of thing dull no matter how expertly it's done. In any case, you may get some idea of Mondrian's seriousness of purpose. He was deeply in earnest about his art, feeling that it was a purified representation of the kind of harmony and equilibrium toward which all nature strives but never experiences in fact.

Charles Russell, "the cowboy artist," was a popular illustrator who appealed directly to a mass audience. His audience was interested first and foremost in the anecdote, that is, in the story the picture told. They were somewhat less concerned with imagery, although the authenticity of details had a decisive bearing upon reception of the anecdote. As to the composition, the fans of Russell were indifferent. Russell organized his forms in order to present the anecdote effectively, not out of some noble, artistic motive. Mondrian was far more serious-minded and self-sufficient about his picture; he was devoted to an ideal and he wished to express it. He organized his composition for the sake of the composition itself. For him it had a value in and of itself. Russell was not indifferent to artistic form by any means, but he looked upon the forms as means to another end.

It would be misleading to say that the painters of the Italian Renaissance wanted to achieve the same ends as Mondrian. They did not. Yet they were

4-19 PIET MONDRIAN. *Composition in White, Black, and Red.* 1936. Oil on canvas, 40¼ × 41". Collection, The Museum of Modern Art, New York. Gift of the Advisory Committee

4-20 MIES VAN DER ROHE. Crown Hall, Illinois Institute of Technology, Chicago. 1952–56

somewhat more like Mondrian than like Russell. They sought far above themselves for inspiration and turned their backs on the details of everyday existence. In its way the famous *Last Supper* (fig. 4-21) by Leonardo da Vinci (1452–1519) is as good an example of the Renaissance search for harmony as Mondrian's painting is of twentieth-century seriousness. Let us examine it in terms of line and form.

The work is remarkably symmetrical. Leonardo assembled the twelve apostles in four groups of three with two groups to the left of Christ and two groups to His right. Christ Himself is posed and drawn so as to form a pyramid (fig. 4-22). He is the most stable shape in the entire work, and the most isolated and self-sufficient figure. The moment is immediately after He has spoken the words, "One of you shall betray me." The party is alive with speculation. Judas, whose head is fourth from the left, draws back in fear and hatred. His outline is as triangular as the Master's but is lopsided, scalene, and far less stable. Of the disciples only he has a face caught by darkness. His left arm is parallel to the left arm of the disciple seated between him and Jesus, and the two disciples' arms are at an angle to the table which is precisely opposite to the angle struck by Jesus's right arm. This establishes between Christ and His neighbor a wide V that echoes His own silhouette inverted. At the point of the V He is in contact with the adjacent disciple. But the width of the V and the repetition of its left side in Judas's arm bars Him from the traitor. By means of this geometry Leonardo conveys both the historical closeness and the moral distance between the Messiah and Judas. Their shared triangularity accents the fact that they are the principal actors in this historic event. Of course, Christ is the focus of the tale. And He is, quite literally, the focus of the picture. Not only is He on center stage, He is the spot on which the lines of the ceiling converge. Similarly, the tops of the tapestries on either wall are in line with His forehead. So are the edges of the table. He is seated before a rectangular window accented by a curved molding that resembles a halo. Too, there are linear developments through the disciple groups, leading us to the central figure. It is a very austere, harmonious, and thoughtful work.

4-21 LEONARDO DA VINCI. *The Last Supper.* 1495–98. Mural. Santa Maria delle Grazie, Milan

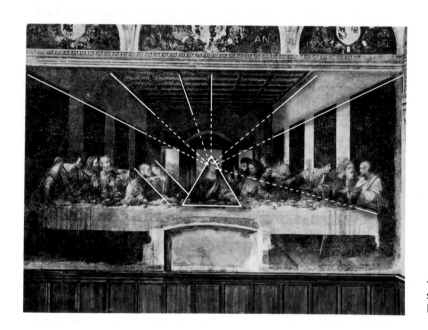

4-22 Diagram of principal structural properties of Leonardo's *The Last Supper*

Leonardo's *Last Supper* is the most famous of them all, but the subject has been treated by many other painters. Nearly a century later, the Venetian painter Tintoretto undertook the same theme on a similar scale (fig. 4-23). But how different from Leonardo's is his conception of the event! The main point of convergence is no longer Christ's face but is over on the far right. The whole thrust of the room is opposed to that of the viewer's eye, which is yanked across the picture toward Jesus. This effect is achieved partly by means of Christ's bright halo; all the halos are like shouts in the night in this dark and smoky inn, but His is largest. It is also the most radiant, and it casts a light so powerful that sharp shadows fall from it across the figures in the forefront of the picture. A very distinct pathway is created by the coincidence of the

4-23 TINTORETTO. *The Last Supper.* 1592–94. Oil on canvas, 12′ × 18′8″. San Giorgio Maggiore, Venice

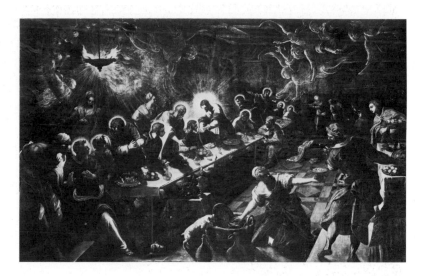

shadow beneath the foot of the nearest person in the right foreground, the folds in the garments of the kneeling maid, the shadow of the maid's head, Christ's plate, and the edge of His robe. The cherubim and seraphim boiling down from the oil lamps in the ceiling are coordinated with the figure of Christ. There are numerous other chains of this general type, such as the one leading from the basket up through the serving table and on to Christ.

The Tintoretto is far, far more dramatic than the Leonardo. It is theatrical. This has a good deal to do with the history of the Church. The Leonardo was painted before the beginnings of the Protestant Reformation. Leonardo was, personally, a skeptic in matters of the faith. But he was not self-conscious about the depictions of gospel stories. He took them for granted. In fact, the stability of Rome, the permanence of the Church, and the patronage of the devout could all be taken very much for granted. After 1517, however, this was no longer true. Once Martin Luther had successfully challenged the authority of Rome, the Church was on the defensive. Tintoretto was a painter of the Counter Reformation, Rome's answer to the threat of Protestantism, an increasingly powerful influence in northern Europe.[2] Tintoretto did not take the Last Supper for granted; he wished to thrill viewers with his portrayal, wished to move them to accept the continuity of the Roman Church from Christ through Peter all the way up to their own day. Notice that Leonardo keeps us down in the orchestra pit, as it were, while Tintoretto sets us upon the stage. Leonardo shows us a tableau; Tintoretto invites our participation. Tintoretto was a propagandist for the Catholic position, and his work is devoted to propagation of the true faith. He marshals every resource available to him to dramatize events from Christ's life, to invest mere paint with hints of the truly miraculous. Thus his use of line and form is charged with dynamic energy, full of grand sweeps, thrusts, and counterthrusts. He enlists the capacities of line and form to touch the viewer emotionally so as to simulate the effect of a mystical experience. Leonardo's pacific symmetry is an emblem of a time when the permanence and order of the Church were exempt from challenge. Tintoretto's style is a shout for attention.

The Shapes of Venus and Adonis Line and form are characteristics of all images, not just those produced by artists with pencils, pens, and brushes. The photograph of a nude woman (fig. 4-24) is subject to the same kind of analysis as a painting or a drawing. The photographer cannot control the line as decisively as a painter; but he can, by means of pose and lighting, articulate his images. The woman portrayed in figure 4-24 is composed. The photogra-

4-25 Three exemplary women:
a statistically "average"
twenty-one-year-old, a
"pinup," and a fashion figure

pher has studied her in terms of massings of anatomical forms and their outlines to produce a very cohesive work. And she is treated as a female human being, an animal having certain physical properties distinct from other beings. The commercial photographer who makes pictures for the enjoyment of readers of men's magazines such as *Playboy* approaches women with a quite different objective in mind. He does everything possible to make the figures resemble those depicted by pinup artists. Such renderings have proved highly provocative to most males in Western culture. They don't look like real women, though, despite the tremendous stress on female secondary sexual characteristics. You've only got to study them dispassionately to see this.

As an aid to such reflection I present, in figure 4-25, three archetypal forms of a mature young woman, beginning on the left with a quite attractive version of the statistically average twenty-one-year-old who is 5'4" tall, and has bust, waist, and hip dimensions of 35½", 29", and 38". (For purposes of comparison she is shod in high heels, like her companions, despite the well-recognized perils such footwear poses for the feet, spine, and pelvis.) The lady on the right is, of course, a fashion figure. She is terribly thin and incredibly attenuated, being about 10 heads tall in contrast to the human average of 6¼. In this particular rendering she is about six feet tall. That is too tall even for *haute couture* models, but had she been drawn in a more appropriate scale she would look like a boy or a victim of anorexia in comparison with the other women. In fact, fashion figures are little more than ectoplasmic clothes racks and no one expects any human being — not even fashion models — to resemble them.

Our central figure is the stereotypical pinup girl. Naive and coquettish, lithe and voluptuous, all at once, she is quite impossible, physically, for the internal organs of anyone who looked like this would be in utter disarray. One can't use that fact alone to ridicule her, however. Many figures by Michelangelo, Botticelli, Delacroix, and other great masters are equally unsound from a physiologist's point of view. One of the most striking things about the pinup is the treatment of the bosom, which makes the whole area look as if it were made of tensed erectile tissue, altogether lacking in the softness more typical of the female body in repose. A human breast is a gland surrounded by fatty tissue, a form on which gravity exercises marked effect. Here, it resembles a pneumatic pillow; in other renderings you will have seen shapes reminiscent of missile nose cones, halved grapefruit, and other unlikely prototypes. Too, pinup breasts are almost always enormous. In this instance, the bust is 42" while the waist is only 25" and the hips 32". She has broad shoulders, abnormally high nipples, a very flat abdomen, narrow hips, full thighs, and slender calves. Were she turned sideways, we could observe that her buttocks are unexpectedly prominent, given the leanness of her hips.

Think about those proportions for a moment. They are inhuman and bizarre, but there is something more besides, something very odd. The only reason this pinup's body looks at all feminine is because it has breasts and the waist is so terribly pinched in that the swelling curves of the hips, by contrast, resemble those of a normal female. But, if we were to delete the breast forms and fill the waistline to match that of the woman on the left, what would we have? A broad-shouldered male youth with long hair and a suggestively coy manner. The aggressive "femininity" of the pinup is barely skin-deep; a young man is hiding under there.

The popularity of such treatments insinuates something unsettling about our civilization. But the point I wish to make here is that the pinup photogra-

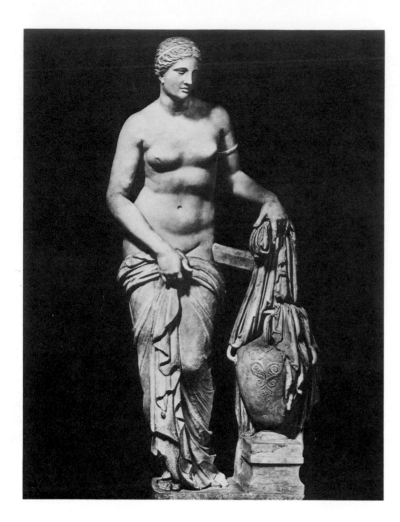

4-26 PRAXITELES. *Aphrodite of Knidos.* Roman copy after an original of c. 330 B.C. Marble, height 80". Vatican Museums, Rome

pher does everything he can to duplicate them. The *Playboy* model tends to be posed with her arms raised, her thorax inflated, her stomach held in, her legs tensed. The photographer cannot overcome the effect of gravity in fact; but he can choose a model with an unusually high bosom, tilt the set so that the forces of nature are canceled out, and then tilt the camera so that the picture looks straight. And he can retouch the negatives and prints to erase certain blemishes, unwanted lumps, and other evidences of humanity—particularly female humanity.

During the last two decades photographs of living women and the prominence of nudity in the cinema softened the stereotypical ideal of sexual beauty projected by the mass media, and pinups today look a bit more organic than they used to. But the same general criteria remain in place. And they are peculiarly discriminatory. I remarked earlier, in connection with Titian's Venus, that I do not believe every portrayal of a human being as an object of sexual interest is dehumanizing. On the contrary, celebration of sexuality is humanistic and, therefore, in my view, commendable. And, yet, it would be wrong to suppose that all sex objects are of equal merit. You needn't be a puritan to sense that some kinds of artwork do more harm than good.

What, then, is so terrible about our pinup? In a sense, *all* notions of consummate perfection applied to living beings are arbitrary and unjust, but idealizing the popular image of the modern glamour girl is especially pernicious because, unlike historic ideals, this ideal is not a perfected image of living women of marriageable age. Glance at figure 4-26, a Roman copy of what was reputed to be the most beautiful female nude of the ancient world, and notice that this statue closely approximates the proportions of the normal

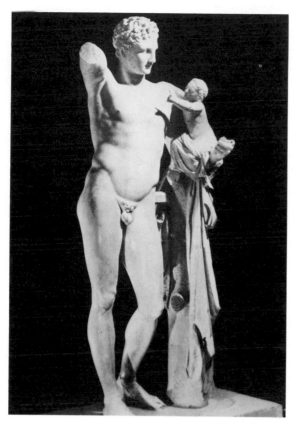

4-27 PRAXITELES. *Hermes and Dionysus*. c. 330–320 B.C. Marble, height 85". Museum, Olympia

4-28 *Aphrodite of Cyrene*. 1st century B.C.? Marble, height 60". Terme Museum, Rome

young woman on the left in figure 4 25. I promise you that when I drew the latter figure the comparison with Praxiteles' *Aphrodite* had not occurred to me. Yet, the statue is very nearly like a refined and perfected version of the average twenty-one-year-old—more graceful by far and possessed of remarkably high, conical breasts, but harmoniously consistent nonetheless. How different from this ancient paragon is the pinup, living approximations of whom are astonishingly scarce. That is, large-bosomed women often have full thighs and protuberant buttocks, but it is rare to find such ripeness of these forms in the same body that possesses an extremely flat stomach, a wasp waist, and thin calves. The genetic likelihood of these things occurring together along with reasonably attractive features is so incredibly slight as to ensure that only a handful of women out of any million will begin even to approximate the ideal. So it is not surprising that cosmetic body surgery and silicone implants have become commonplace among those who earn their livings by means of self-display, or that advice columns in newspapers and magazines are full of letters from people who are anxious about their failure to measure up to such an implausible standard of beauty. Thoughtless men are conditioned to seek unattainable ideals and naive women to judge themselves against a male-generated model that nature does not very often provide. I should, however, emphasize that we are speaking here of a kind of fantasy imagery that is explicitly erotic and note that a man who daydreams about sharing intimacies with some provocatively formed pinup may be surprisingly apathetic toward her living approximation.

In ages past, men were less nervous about the female form. This is particularly evidenced in the many statues and paintings of the goddess of love and beauty, Aphrodite (or, as the Romans called her, Venus). In the fourth century

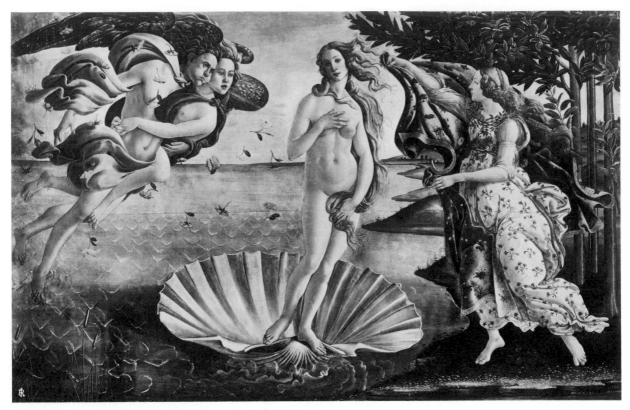

4-29 SANDRO BOTTICELLI. *The Birth of Venus.* c. 1480. Tempera on canvas, 5'8⅞" × 9'1⅞". Uffizi Gallery, Florence

before Christ a great Greek sculptor named Praxiteles (active 375–330 B.C.) carved a statue of her—the one we have already compared with an average American—for the city of Kos. As it happened, that city was nervous about uncovering the beauties of Aphrodite and rejected Praxiteles' nude in favor of a draped figure. The people of another city, Knidos, were to profit by this piety, for they became the owners of the nude version of the goddess, possibly the most famous statue in all antiquity. The original work is lost, and only imperfect Roman copies remain. Still, it is easy enough to see the general approach chosen by the artist.

The Knidian Aphrodite is a bit heavy for modern tastes (as for the Flemish of the seventeenth century, she'd have been too slim), but she is nonetheless of an extraordinary perfection of form. She is relaxed, unselfconscious, and posed with her hip swung out in the way the French call *déhanchement*. The arc of her right hip, sweeping up to the sphere of the breast, is balanced by the long graceful undulation of the left side. No one of the time questioned that the statue was intended as an embodiment of physical desire; for a Greek, that would be connected with religious veneration of the goddess of love. Indeed, a Greek author of late antiquity tells how a companion was overcome by erotic frenzy at the sight of the sculpture. Granted, it is hard to believe in his story on the basis of the Roman copy before us. Just how imperfect an imitation it must be can be estimated by a glance at the sole remaining work that is pretty surely from the hand of Praxiteles, the *Hermes and Dionysus* (fig. 4-27).[3] The translucent delicacy so astonishing in this work is altogether absent from Roman copies. The only surviving marble from the ancient world that today imparts some hint of the sensual thrill the Knidian Aphrodite must have provoked is the far later *Aphrodite of Cyrene* (fig. 4-28), where stone seems nearly turned to flesh.

Female nudes occur throughout art history. Even in medieval times there were isolated examples, usually of Eve. But between the fall of Rome and the emergence of the Renaissance, the representation of the sensuous was proscribed. When Venus reappeared, she exhibited the same mixture of sensual realism and abstract harmony observable in all other art of the fifteenth and sixteenth centuries. The earliest of these masterpieces is Botticelli's *Birth of Venus* (fig. 4-29), but the most influential of all Renaissance nudes was the *Sleeping Venus* (fig. 4-30) by the Venetian artist Giorgione (c. 1476/8–1510).

Giorgione's *Venus* established a pose so satisfying to painters' eyes that she has served as a model for the greatest painters of female nudes—for Titian, Rubens, Manet, Renoir, and even Picasso. Sir Kenneth Clark has said of the painting:

> Her pose seems so calm and inevitable that we do not at once recognize its originality. Giorgione's *Venus* is not antique. The reclining figure of a nude woman does not seem to have been the subject of any famous work of art in antiquity . . . She lacks the weighty sagging rhythm, as of a laden branch, in which the antique world paid equal tribute to growth and to gravity.[4]

The treatment of the figure is such that she is, as Clark remarks, like a bud enfolded. Giorgione has given to the female form a compression of shape that brings about perfectly smooth transition from shape to shape. The lines flow insensibly from one place to another. The forms of the beautiful cloth on which Venus lies express the same kind of coherence and are a sort of reflection of the graceful outline of her body. She sleeps a gentle sleep, removed from immediate reality, in a landscape that is suffused with mellow golden light.

Titian's *Venus of Urbino* (fig. 4-31) is very like the Giorgione in pose, yet the mood is different. The *Venus of Urbino* is awake; she invites us to her side with her eyes. And Titian has turned the torso a bit more toward us. By intensifying certain darks he has produced stronger contrasts of form within an outline that is almost as cohesive as the silhouette of the Giorgione *Venus*. But, because Titian is less insistent on imposing a rule of form, such as that each line defining a body part must resemble all of the others, his nude more nearly corresponds to reality. Compare the arches of the feet. Giorgione's is exaggerated so that it will echo the curves of the breasts, the back of the knee, the delicate fold of the thigh against the body, and so on. He has even drawn the armpit so it contains an unlikely yet harmonious arc. Titian sacrificed some of this artifice to naturalness, then used adjunct elements—such as the tresses trailing over the shoulder, the bracelet, and the shadow curving beneath the upper leg—to sustain similarly melodious harmonies.

The appeal of these Renaissance nudes is sensuous and direct, largely achieved through the manipulation of line and form. While it would be going too far to say that the artists have revealed the carnal nature of Venus, it is well within the bounds of truth to note that their treatment of female anatomy in terms of enclosed forms which have the solidity of spheres and cylinders points up woman's physical being. Only those who accept the human body in an open, straightforward manner have such a command of line and form.

By the middle of the nineteenth century the naturalness of Titian had been supplanted by a stuffy, high-minded attitude toward the female nude. The nineteenth century worshiped women in the sense that Victorian men put their ladies on pedestals and idealized them. But the nineteenth-century view

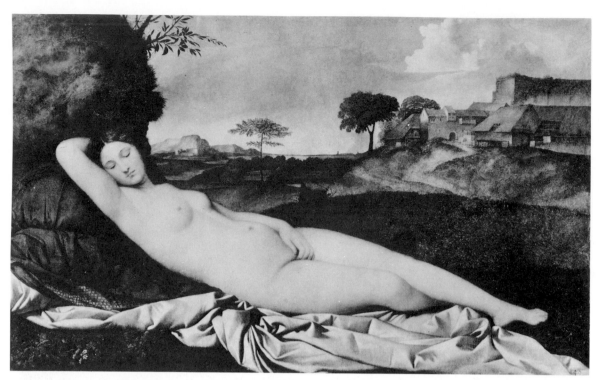

4-30 GIORGIONE. *Sleeping Venus*. c. 1508–10. Oil on canvas, 42¾ × 69″. State Picture Gallery, Dresden

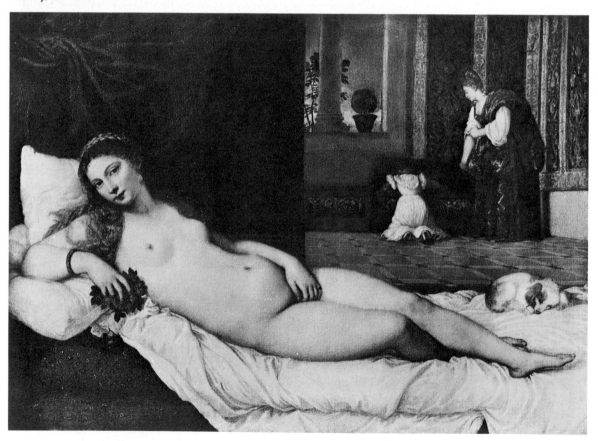

4-31 TITIAN. *Venus of Urbino*. 1538. Oil on canvas, 47 × 65″. Uffizi Gallery, Florence

depended upon a rejection of women as human beings. The successful painters of the day—whose names are now known mostly by professionals only—had one thing in common: when it came to depicting naked women, they glossed over the facts.[5] Of course, Renaissance nudes were not given anatomically explicit detail either, but their artists sought a harmony of parts that measured reality even as it departed from naturalism.

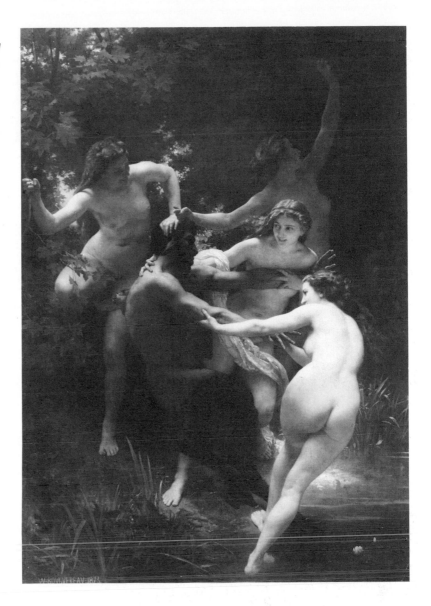

4-32 ADOLPHE WILLIAM BOUGUEREAU. *Nymphs and Satyr.* 1873. Oil on canvas, 8′6⅜″ × 5′10⅞″. Sterling and Francine Clark Art Institute, Williamstown, Massachusetts

An artist like Adolphe William Bouguereau (1825–1905) imitated the mannerisms of the Renaissance but had no feeling or interest in the substance of the women he depicted. He substituted for the articulate volumes and coherent lines of Giorgione and Titian a slick, waxy-looking surface and placed his women in a mythological fantasy (fig. 4-32). Their geometry corresponds to a genuine ideal but it is explicitly sexual in a way intended to appeal to men by turning rather realistic young girls into identically unblemished objects of desire. In 1863 Edouard Manet (1832–1883) challenged this popular image with the exhibition of his *Olympia* (fig. 4-33).

The *Olympia* is based on Titian's *Venus of Urbino.* Manet was perfectly open as to that. But while the poses are similar, the women are quite different. This is not Titian's loving creature; this is a hard and cold professional—a high-class prostitute, a courtesan. Her stare is not inviting; it measures one. Moreover, the girl is very much an individual; her face and figure are rendered with an eye to their specific characteristics. We could probably recognize Manet's model on the street. And we encounter her here in probable surroundings. The picture is a fine example of the style art historians know as French Realism, a movement opposing the high-flown fancies of men like Bouguereau with the realities of the everyday world. Titian had been concerned with reality too, but it was a reality that went beyond the one that Manet represents. The Renaissance artist strove to reveal the substance that

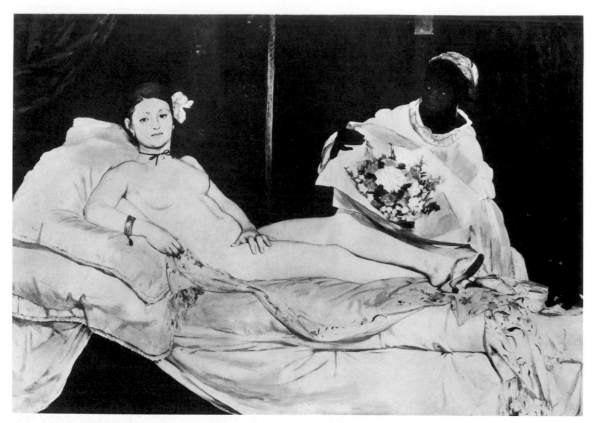

4-33 EDOUARD MANET. *Olympia*. 1863. Oil on canvas, 51¼ × 74¾". Musée d'Orsay, Paris

4-34 Titian's *Venus of Urbino* out of focus 4-35 Manet's *Olympia* out of focus

lay beneath superficial appearances. The Realists were obsessed with appearances only. That they were so concerned drew upon them the charge that their works were both shallow and ugly.

Still, Manet's *Olympia* is as significant for the painting to follow as its prototype, the *Venus of Urbino*, was for the art that succeeded it. Generally, the *Olympia* is considered the first example of truly "modern" art. This may sound odd. The term *modern art* connotes to most of us a kind of art that doesn't resemble anything—the sort of thing Picasso, Kandinsky, Mondrian, and Rothko do—and the *Olympia* is very true to life. What makes Manet modern is the way he employs the elements of art.

Certainly, the *Olympia* doesn't look much like the *Venus of Urbino;* she is flat, pale, and the lines are crisp and rather cold. Compare figures 4-34 and 4-35, out-of-focus photographs of the Titian and Manet, respectively. The two photographs are blurry to the same degree, but the lines and forms in the

4-36 RICHARD LINDNER. *119th Division*. 1965. Oil on canvas, 80½ × 50½". Walker Art Center, Minneapolis

Titian remain relatively clear while those in Manet's nude are nearly lost. The one line in the Manet that does remain clearer than any in the Titian is the outline of the pale silhouette containing the girl, the bed, and the maid's clothing. This large light area has some of the impact of a gigantic poster. Within it there are no deep shadows to produce an impression of deeply rounded forms. The outline of the nude Olympia is a faintly shaded edge as narrow as a drawn line. Thus, the form of *Olympia* produces an entirely different effect from that of the *Venus of Urbino*.

The image of woman in the work of Richard Lindner (1901–1978), an American artist, evokes still other thoughts. His work (see fig. 4-36) constitutes a statement on the kind of society in which men get their "kicks" from looking at women presented in the way the pinup artists show them—as nonwomen. Lindner's figures are armored, corseted, and otherwise constrained. They are grotesque caricatures of the painted, pampered American Woman, a woman who (Lindner seems to say) is about as yielding as a chunk of sidewalk. The lines of his figures are of an inhuman regularity; their forms are geometric to the extent that nothing animal is left. They are robots in the form of sex machines. They represent the pinup view of woman carried to its logical conclusion.

Contemporary realist Philip Pearlstein (born 1924), on the other hand, paints nudes that are scrupulously exacting so far as anatomical detail is concerned, but which are treated in so detached and clinical a manner as to be de-sexed objects. Consider *Female Model on Platform Rocker* (fig. 4-37). The principal motif of this painting is the vibration of the multiple shadows of the

4-37 PHILIP PEARLSTEIN. *Female Model on Platform Rocker.* 1977–78. Oil on canvas, 72¼ × 96⅛". The Brooklyn Museum, New York

4-38 Three exemplary men: a statistically "average" twenty-one-year-old, a "beefcake" pinup, and a fashion figure

chair against the wall; the nude woman is merely another set of patterns played off against that flamboyant shadow. Pearlstein's nudes are not women or men so much as female and male surfaces. They are equivalent to old-fashioned still lifes or to nonobjective studies like those by Mondrian.

Clearly, the image of Venus changes with the role of women in society, and artists convey their feelings about that role by the way they describe women through the medium of art. But, when one examines what are taken to be sex objects, it is always necessary to bear in mind that lust, vulgarity, and condescension are not embodied in the objects themselves but in the reactions of diverse viewers to these objects. After all, there are some people whose unbridled passion is raised by shoes, some who lust after lacy lingerie, and others, probably, whose base desires are in thrall to fire hydrants. People from different races, nations, cultures, and even from different social classes within a given society display radically contrasting preferences. American men and women, for instance, seem not to share the same opinion as to what is most attractive in their own sex.

Figure 4-38 is the masculine counterpart of figure 4-25. The fellow with the kayak paddle is about 5′10″ tall and, as a 168-pound size 38 Regular, is a

perfectly average guy. The 6'2" pinup with his 52" chest and alarmingly well-defined musculature is the conventional model for physically powerful athletes and warriors in popular illustration although, in point of fact, no world champion in any sport has ever resembled Mr. Universalbeefcake—not even the weightlifters, who are more massively compact. This figure really represents an aesthetic ideal rather than an athletic paragon. Also purely aesthetic is the fashion world's idea of a handsome man, seen here on the far right. This chap is always about six feet tall and is wonderfully lithe. When he is fifty years old he will look exactly the same in ads for bathing togs except that he'll have a neatly trimmed gray mustache and hair to match. It is, I think, rather interesting that the fashion-plate male is a fairly close approximation of what most women in opinion surveys describe as their idea of a physically attractive man. Svelte rather than brawny and more boyish than macho. Also, neither this graceful young fellow nor the pinup are as grossly implausible-looking as their female equivalents in figure 4-25.

One problem in dealing with the male figure in art—as many women have written asking me to do—is that the fine arts, like most fields, have been dominated for centuries by men and, therefore, the male sexual ideal expressed in painting and sculpture is, like the artistic standard for distaff beauty, a masculine rather than a feminine conception. Too, if not more rational or pragmatic than men about sex, most women do seem to be more attracted by personal traits rather than by mere appearances. Still, what is visible plays its role and neither sex is immune to stereotypes of beauty incessantly promoted by arts both commercial and fine. As it happens, the masculine physical ideal projected by the fine arts merges all three of the "types" illustrated in figure 4-38, although the emphasis throughout Western history has been upon the muscleman who is the centerpiece. The musculature, however, derives from an arrangement of lines and forms that had its basis in art rather than in anatomy.

The torso of Praxiteles' *Hermes* (fig. 4-39) looks real enough on first inspection, but it is actually a softened version of something invented by an earlier master called Polyclitus (c. 450–c. 420 B.C.), whose *Doryphorus* or "Spearbearer" (fig. 4-40) we know only through Roman copies and through literary references to it as an embodiment of the ideal proportions of the perfect male figure. Attempts to rediscover the ratios that make up Polyclitus' famous *canon* (or rule) by measuring copies of the *Doryphorus* have come to naught, probably because they are geometric rather than arithmetic. Certainly, the sculptor's fondness for pristine geometry in place of imperfect anatomy can be easily discerned when one contrasts his athlete's torso (fig. 4-41) with the physique of a highly developed devotee of bodybuilding (fig. 4-42).

The Roman copy in marble of a statue originally cast in bronze produces an unpleasantly lifeless, facade-like body, but it does have the advantage for us of providing diagrammatic clarity (fig. 4-41). Notice the way in which the pectoral muscles forming the chest echo the thorax below and how the principal elements of the latter faintly mirror the abdominal masses that support it. Humanity does not come so well-packaged (fig. 4-42). Human parts do possess the unity of an organic whole, it is true, but they are not harmonized in the way Polyclitus' sculptural forms are. In literary art we think of such relationships as rhyme, alliteration, assonance; in a way one might even say that the line and form relationships of Classical art are to visible reality as verse is to common speech. Unfortunately, the Roman copy of Polyclitus' sculpture must be a very coarse imitation of the original. Perhaps we can secure a

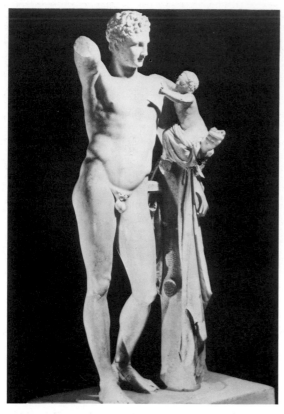

4-39 PRAXITELES. *Hermes and Dionysus.* c. 330–320 B.C. Marble, height 85″. Museum, Olympia

4-40 POLYCLITUS. *Doryphorus.* Roman copy after an original of c. 450–440 B.C. Marble, height 78″. Museo Nazionale, Naples

4-41 The Greek Classical torso

4-42 An extremely well-developed human torso

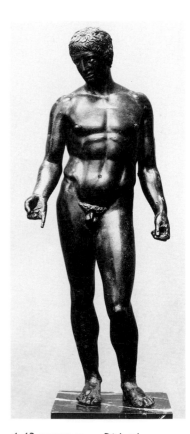

slightly better idea of the impression produced by the original by studying the Louvre's *Diskophoros* (fig. 4-43), another copy of a Polyclitus but this time done in the artist's own era by a follower working in the original medium.

Although Greek knowledge of human anatomy was hampered by religious proscriptions against dissection of the human cadaver, and artists' understanding of man's form was restricted to what was visible on the surface, the Greeks had one singular advantage. Their athletes competed wholly naked in contests that were dedicated to a peculiarly humanistic religion which lent to the cult of human perfection an ecstatic solemnity. As Lord Clark wrote: "Greek athletes competed in somewhat the same poetical and chivalrous spirit as knights, before the eyes of their love, jousted in the lists; but all that pride and devotion which medieval contestants expressed through the flashing symbolism of heraldry was . . . concentrated in one object, the human body."[6]

4-43 POLYCLITUS. *Diskophorus.* Bronze copy. The Louvre, Paris

4-44 MICHELANGELO. *David.* 1501–4.
Marble, height of figure, 13′5″.
Academy, Florence

4-45 MICHELANGELO. *The Creation of Adam.* 1508–12. Fresco. Sistine Chapel, Vatican, Rome

One peculiarity of all these Greek and Roman idealizations is the prominence of the ridge separating the pelvis from the abdomen. It is one of the few conventions of male beauty most of us no longer accommodate in our image of someone "built like a Greek god," but even Michelangelo retained in moderated form this characteristic in what is arguably the most beautiful male in the history of marble statuary, the *David* (fig. 4-44).

Michelangelo's representation of David certainly surpasses all existing antique sculpture both in scale and in the marriage of formal perfection with physiological veracity. Despite the strictness with which the sculptor accepted the symmetrical architecture of the torso invented by Polyclitus and infused with pliant liveliness by Praxiteles, there is a new kind of vitality in the rippling muscles that seem to pulse beneath a tissue of skin stretched taut. Michelangelo had, however, certain advantages over the ancients when it came to the attainment of verisimilitude and control. In the first place, he owned steel chisels—tools made of a substance unknown to Praxiteles—and in the second, he had an intimate knowledge of anatomy, secured in an age when dissection of human cadavers was practiced with some regularity.

Unless you are unusually attentive to picture captions, you have probably overlooked the enormous scale of the work. It stands over fourteen feet tall and is not really meant to be seen from the point of view our reproduction suggests. As a matter of fact, originally it was intended for a station some forty feet aloft, as part of one of the buttresses of Florence Cathedral (see fig. 12-2), and that is one of the reasons for the exaggerated prominence of the muscles, features, and heavy locks of hair. Seen today from the floor of the Academy's rotunda, where it is displayed, the lower limbs look larger in proportion to the body and the head not quite so big. Such distortions of standing figures are standard in monumental sculpture because, if carved in measurably correct proportions, a human form as tall as a two-story house will appear to viewers looking up at it the same way the girl in figure 2-4 does in Brandt's photograph.

Distortions of another sort, employed by Michelangelo in his painting *The Creation of Adam* (fig. 4-45) on the Sistine Chapel ceiling, are done for

4-46 PETER PAUL RUBENS. *The Rape of the Daughters of Leucippus.* c. 1616–17. Oil on canvas, 7′3½″ × 6′10¼″. Alte Pinakothek, Munich

compositional and expressive reasons more than for illusionistic ones. To take but one example, Adam's rib cage is as implausible as it is enormous. Yet, if you study the way this deformity produces a long, pointed, curving form that begins with the shoulders and sweeps through the torso and pelvis down the right leg to taper away at the foot, you can, perhaps, also appreciate the way in which this bold shape echoes the movement of God the Father, His cloak, and the entourage He brings toward Him with a left arm that has an extra elbow hidden behind the head of yet-to-be-incarnated Eve.

Whereas the ideal female form fluctuates, burgeoning and withering throughout history, the male stays pretty much the same. Peter Paul Rubens (1577–1640), painter of such lusty works as *The Rape of the Daughters of Leucippus* (fig. 4-46), in which we observe the Gemini, Castor and Pollux, abducting Phoebe and Hilaira for marital purposes, is famous for his fleshy female nudes. But, as you can see, his male twins are massive and muscular, constructed along the lines of defense men in professional football.

When an ideal of physical masculinity is still represented in the arts—and that is largely restricted to heroic figures of the comics and on the covers of paperback adventure novels—the standard remains pretty much the same as it was for the Greeks, Michelangelo, and Rubens. Other than in such commercial illustration the heroic ideal does not exist in twentieth-century art. Picasso's famous couple (fig. 4-47), locked together in an embrace that helps them resist adversity, do possess a certain dignity, through desperate self-affirmation. But they are rendered with a line that seems virtually to imprison them, it is so stiff, so inorganic. Leonard Baskin's (born 1922) *Anatomist* (fig.

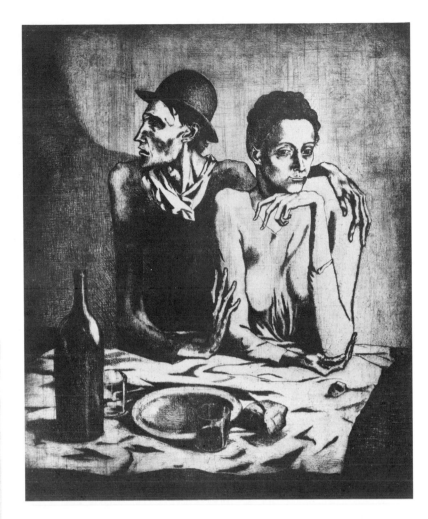

4-47 PABLO PICASSO. *The Frugal Repast.* 1904. Etching on zinc, printed in black, plate: 18³/₁₆ × 14¹³/₁₆″. Collection, The Museum of Modern Art, New York. Gift of Abby Aldrich Rockefeller

4-48 LEONARD BASKIN. *The Anatomist.* 1952. Woodcut, printed in color, block: 18³/₄ × 11″. Collection, The Museum of Modern Art, New York. Gift of the Junior Council

4-48) possesses wrinkles, a chart, and a small skeleton; all of them share a common, dry thorniness in the slashed lines and crabbed forms. His is a study of physical and intellectual desiccation in which the old scholar has become as lifeless as the description of life he offers. Nearly always, modern artists delineate humanity in ways that are reductive and somehow diminishing. Often, they seem to be saying that art itself is noble and the individuals it portrays sometimes courageous and worthy, but the world itself is absurd and without real meaning. And this is revealed more in the sheer rendering than it is by the character of the subject matter. The moods peculiar to the individual pictures are produced in large part by the varying character of the lines and forms.

Line, Form, and Feeling There is a kind of folk-art knowledge embodied in the name of the weeping willow tree. Everyone knows that drooping lines are supposed to convey sorrow or fatigue. A calm sea is placid, and placidity is marked by horizontal lines. When you're "up" you are happy, and upcurving lines are often used to indicate joy. These associations of line direction with mood probably derive from somatic identifications; that is, with their occurrence in our own bodies. Figure 4-49 illustrates the presumed relationships. Actually, the inference that downturned lines are sad and upturned ones joyous is simple-minded. For instance, the face made up of only upturned lines is not as gleeful-looking as the top-left face in figure 2-8 because the latter corresponds more closely to actual configurations in a smiling face. But simplistic or not, it is obvious that there is *something* to the idea that line movement and mood are connected.

Leonardo's *Last Supper* (fig. 4-21) conveys a pacific feeling. It is a calm picture. The Tintoretto version (fig. 4-23) boils with energy; its line movements are highly charged. In viewing it one feels less at rest because it is not at rest. Its mood is intense and aims at provoking a feeling akin to ecstasy, religious fervor. In an analogous fashion, two famous works from the late

4-49 The supposed physiognomy of linear moods

4-50 VINCENT VAN GOGH. *The Starry Night.* 1889. Oil on canvas, 29 × 36¼".
Collection, The Museum of Modern Art, New York. Acquired through the Lillie P. Bliss Bequest

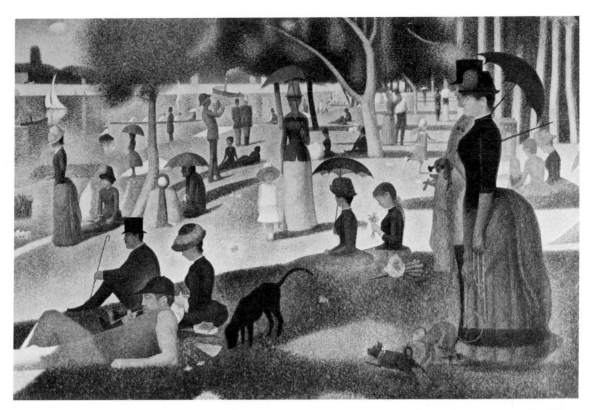

4-51 GEORGES SEURAT. *A Sunday Afternoon on the Island of La Grande Jatte.* 1884–86. Oil on canvas, 6'9½" × 10'1¼". The Art Institute of Chicago. Helen Birch Bartlett Memorial Collection

nineteenth century, *The Starry Night* by Vincent van Gogh (1853–1890) and *A Sunday Afternoon on the Island of La Grande Jatte* by Georges Seurat (1859–1891), evoke different moods because of the different ways the artists have used line and form.

The brushstrokes in the Van Gogh (fig. 4-50) are exceptionally linear, and their movement is torrential. *Starry Night* is emotional to the point of being vehement. The nebulae raging across the heavens of the night are not things seen but something felt. In *A Sunday Afternoon on the Island of La Grande Jatte* (fig. 4-51) the painter has employed little dots of color. His lines are regulated, predictable, serene. Everything is thought out. Even the forms between the figures are calculated; they resemble jigsaw cutouts. And the repetitions of line are very clear. Compare the back of the lady in the bustle on the far right with the line movement from the seated girl ahead of her up through her companion's parasol to the hip of the oncoming mother. Such similarities can be discerned throughout the painting. The mood? It is one of calm, appropriate to a quiet Sunday afternoon in Paris.

Line and form are but two of the elements of art. They are, as you have seen, so closely related as to be almost interchangeable. The other elements are similarly dependent upon each other. Without contrast between dark and light we could not perceive form, and without form we would not have line. Darkness or lightness is an aspect of color. In fact, the aspect of color summed up by the terms *dark* and *light* is perhaps the most important aspect of all. One can be colorblind and still see very well indeed. But without the contrast between lights and darks one would be unable to see at all.

FIVE

LIGHT, SHADE, AND TEXTURE

In discussions of light and shade it must be ever borne in mind that painters work with pigment and not with real light. They cannot make us squint into painted sunsets, cannot actually blind us with the radiance of desert skies. We need not shield our eyes from the glare on Turner's water (fig. 5-1). Artists create illusions within a very limited range. But they always have our help, our willingness to go along with the tricks.

A good example of just how tolerant we are when it comes to accepting deviations from reality in pictures can be had by studying a slide of Jan van Eyck's (c. 1390–1441) *Giovanni Arnolfini and His Bride* (fig. 5-2) projected onto a screen in an appropriately darkened room. Pick out something in the picture that looks very dark, even black. It will not be as dark as any number of things in the room around it. The slide is, in other words, a very pale image

5-2 JAN VAN EYCK. *Giovanni Arnolfini and His Bride.* 1434. Oil on panel, 32¼ × 23½". The National Gallery, London

of reality. Yet, until you make an effort to notice this effect, it is not apparent. Even when you are aware of it, the image on the screen continues to look "right." This is because the relationships among contrasts in the original painting and its slide reproduction remain pretty constant. It's like playing an instrument at higher or lower pitch; the difference is obvious, but the relationship between tones doesn't change much.

5-3 Gray strip in graduated background

5-4 Natural light

5-5 Artificial light

5-6 Diagram of light sources and effects. Slanting lines indicate parallel sunbeams and radiating artificial light rays

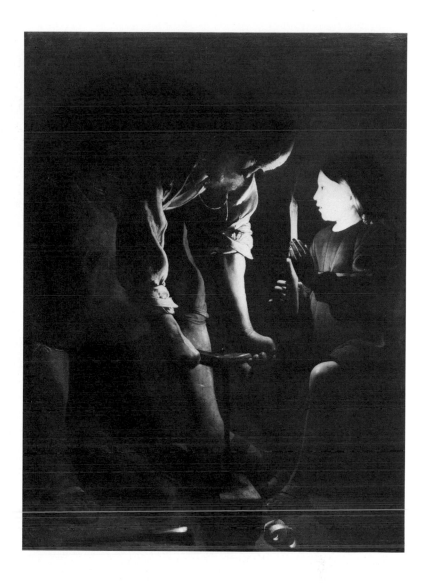

5-7 GEORGES DE LA TOUR. *Joseph the Carpenter.* c. 1645. Oil on canvas, 53⅞ × 40⅛". The Louvre, Paris

One can see the importance of such relationships by glancing at figure 5-3. The background is gradated from black to faint gray, the central strip remains a constant gray; the strip only *seems* to change because its relationship to the background is inconstant.

Convincingly realistic pictures, such as photographs, preserve the principal relationships that obtain for vision. Thus, in figure 5-4 sunlight, falling in parallel rays, lights the sides of things in a consistent fashion. Everything to our left is light, and what is to the right is in shadow. Of course, the shadows are not utterly black, because air itself is reflective and holds light even in the shade. Artificial light, emanated by candles, lanterns, electric bulbs, and the like, radiates so that the things in figure 5-5 are lighted on the side toward the torch. The effect is obvious to everyone. Figure 5-6 diagrams it. What is toward a light is lighted; what is away from it is darker. *Giovanni Arnolfini and His Bride* is based on the assumption that light is entering the bedchamber from our left, and Giovanni Arnolfini's face is light on the left and dark on the right. Similarly, all the things in the room—the oranges on the sill, the folds in the bride's gown, even the individual hairs on the little dog—are light on the left and cast shade to the right.

Georges de La Tour (1593–1652) was fascinated by the effects of artificial light, and in his painting *Joseph the Carpenter* (fig. 5-7) he has used a flame to illuminate the figures. They are consistently light on the side of the light source and lost in deep, deep shadow elsewhere. The face of the boy Jesus is so

5-8 PIERRE PAUL PRUD'HON. *Study for La Source.*
c. 1801. Black and white chalk, 21¼ × 15¼". Sterling
and Francine Clark Art Institute, Williamstown,
Massachusetts

5-9 ALBRECHT DÜRER. *Head of a Disciple.* 1508. Brush,
ink, and wash, 12½ × 9". Graphische Sammlung
Albertina, Vienna

5-10 HEINRICH GOLTZIUS.
Sea Goddess. c. 1588–89.
Chiaroscuro woodcut,
12¾ × 10½". Museum of
Fine Arts, Boston

5-15 MA YUAN. *Landscape with Bridge and Willows.* Sung Dynasty, early 13th century. Ink and colors on silk, 9⅜ × 9⅝". Museum of Fine Arts, Boston

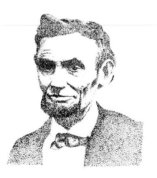

5-11 Shadow lettering

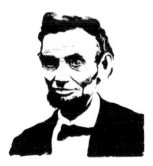

5-12 Metallic strips forming letters

5-13 High contrast drawing

5-14 Stipple drawing

brightly lit as to suggest the spiritual radiance of a halo. It is not magic that makes it look so like a firelit scene; it is the artist's consistency.

Chiaroscuro and Modeling The Italians have a word for the effect of light and shade in art. They call it *chiaroscuro*. This is the term artists apply to the general effect; the specific applications of it to noses, lips, eyes, drapery folds, and so forth are called *modeling*. Chiaroscuro always refers to light and dark, but there are some specialized uses of the term that you should know about. It is often applied to a kind of drawing (figs. 5-8, 5-9) emphasizing light-and-shade effects. In such drawings the artists work on tinted paper, usually gray, indicating shadows with a dark crayon or ink and noting the lightest places with a white crayon or paint. There is a woodcut technique called chiaroscuro (fig. 5-10) in which light in the print is indicated by white paper, semishade by some medium tone, and dark shade by black or extremely dark gray. But these usages are just special applications of the term. Chiaroscuro is literally *chiaro*, meaning light, plus *scuro*, meaning dark.

We can best understand how artists use light and shade to create an illusion of solidity if we ignore the subtleties of modeling. A very good example for our purposes is the kind of lettering in which the letter forms are indicated by what would be the shaded side if they were made of metal strips (fig. 5-11). Viewers perceive the letters as if they were as I have rendered them in figure 5-12. But of course there is no thin band along their thickness in figure 5-11: the viewer merely "fills in" with such a band; he pretends it is there.

You do the same thing when you look at an ink drawing such as the picture of Lincoln (fig. 5-13); you imagine the intermediate grays that are actually defined by tiny dots in figure 5-14. In both figure 5-11 and figure 5-12 you are projecting your expectations onto emptiness. The empty surface is as much a part of the image as the black forms are. A number of art styles are based on precisely this effect. The Chinese created an entire aesthetic tradition based on the power of expressing things through the absence of ink. The whiteness of the silk in figure 5-15 is not just a void; it is as palpable a part of the depicted scene as are the brushstrokes that evoke hillocks, trees, and mounds of earth.

5-16 ROCKWELL KENT. *Northern Light.* c. 1928. Wood engraving, 5½ × 8⅛″. Philadelphia Museum of Art

5-17 CARAVAGGIO. *Christ at Emmaus.* c. 1598. Oil on canvas, 55 × 77½″. The National Gallery, London

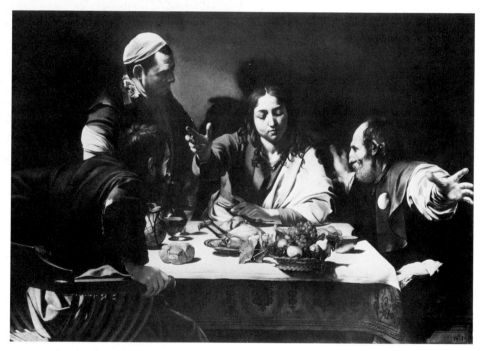

5-18 FOLLOWER OF CARAVAGGIO. *A Feast.* 17th century. Pen, brown ink, and wash, 6½ × 7¾″. The Fine Arts Museums of San Francisco. Achenbach Foundation for Graphic Arts

5-19 HENRI ROUSSEAU. *The Dream.* 1910. Oil on canvas, 6'8½" × 9'9½". Collection, The Museum of Modern Art, New York. Gift of Nelson A. Rockefeller

It is also true that a number of media, such as wood engraving (fig. 5-16), rely on the willingness of viewers to fill in absent information. In the case of the Kent print, however, it's the *black* that holds the unseen yet imagined.

That the contrast between the large masses of shade and the blankness of light is fundamental to the painter's illusions is borne out by the practice of the great masters of representational art. When Caravaggio (1573–1610) painted *Christ at Emmaus* (fig. 5-17), he detailed every surface, and we luxuriate in the satiny perfection of his tones. In his preparatory studies, however, Caravaggio, like his followers (fig. 5-18), was brusque, searching not after subtleties of light and shade but studying their larger disposition. Since it is known that Caravaggio worked directly on his paintings, without recourse to careful preparatory drawings, it is likely that the initial sketching onto the canvas was similarly bold, perhaps something quite like figure 5-18.

In learning to draw, it is important for art students to come to the understanding that the big relationships are primary. If the general effect is plain, precise detail is relatively easy to attain, but no amount of fussy detail will convey an impression of reality. Such itemizing may be charming (fig. 5-19), may even possess its own distinctive kind of genius; but it does not provide a convincing illusion. Many amateur works of art look naive because the painter has approached his subject "backwards."

The reduction of the complex world of light and shadow into simpler contrasts also has the effect of packaging the volumes more coherently than they come to us in ordinary life. For example, look at Vermeer's *Head of a*

5-20 JAN VERMEER. *Head of a Young Girl.* c. 1665. Oil on canvas, 18¼ × 15¾". Mauritshuis, The Hague

5-21 Y in a hexagon

5-22 A cube

Young Girl (fig. 5-20). Jan Vermeer van Delft may be the very greatest master of light and shade. He modeled his forms with such certainty that this girl seems extant in space as no real person could ever be. The volumes are so explicit that one knows almost exactly how this head would look if the girl were in profile or if she were looking up or looking down.

Whenever in painting a light meets a dark, an accent is obtained, just as a contrast in tone creates an accent in a musical sequence. When this accent is formed by the junction of two areas, one uniformly light relative to another that is uniformly dark, an apparent change of plane occurs. In other words, if nothing else opposes the illusion, such a contrast is read as though it were a corner carved from space. Thus, in figure 5-21 we have a Y in a hexagon, but with one segment darkened we have a cube (fig. 5-22). Whether such a corner seems carved into space or seems to project outward depends on its relation to the other contrasts. Thus, had Vermeer darkened the top of the young lady's nose instead of its side, the nose would appear to be a hideously deep scar. As this suggests, darkening the nose on its side—the side corresponding to the dark side of the face—made it stand away from the head. Likewise, placing a continuous series of accents over the turban, down the forehead, by the eye, down the neck, and across the shoulder creates the impression that the planes to either side are moving back into a dark void. The girl's head and body constitute one large volume containing smaller volumes (like noses and ears) and are not merely aggregations of little details.

Of course, it is not really possible to describe the Vermeer in terms of light versus dark. There are all sorts of in-between tones; some parts of the shadow

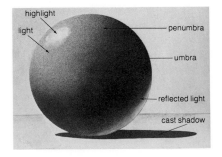

5-23 The nomenclature of chiaroscuro

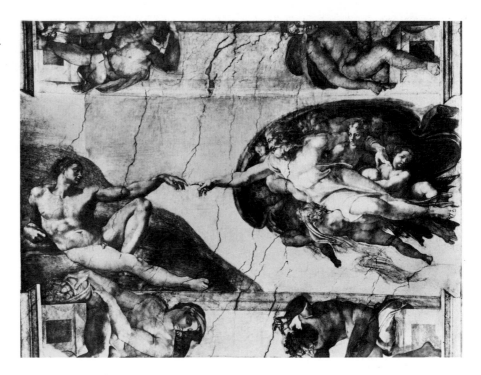

5-24 MICHELANGELO. *The Creation of Adam.* 1508–12. Fresco. Sistine Chapel, Vatican, Rome

are darker than others, some lighted surfaces are much lighter than others, and everywhere there are transitions. The technical term in physics for a space of partial illumination between perfect shadow and full light is *penumbra*. This is the term applied to the "twilight" area of the moon, to the hazy edge of an eclipse, and also to gradations from dark to light in pictures.

Figure 5-23 illustrates the traditional way of describing form as it is revealed by light and shade. The *highlight* represents a reflection of the light source; it is nearly pure white. On a dull surface the highlight will not be reflected in so clear a fashion, it is then merely part of the *light* area. The *penumbra* provides the transition to what is known as the *umbra* (or core of shadow). The *cast shadow* is, of course, the shade of the object on another surface and is usually the darkest of all these components. The final element is *reflected light*.

Reflected light is perhaps less well understood by laymen than are the other components of chiaroscuro. So far as that is concerned, the paintings by Jan van Eyck and Vermeer at which we've been looking contain hardly any reflected lights. The Caravaggio (fig. 5-17) has some, but they are not treated in a very obvious fashion. The most familiar demonstration of reflected light is the child's game where a buttercup is held beneath the chin to see whether the subject "likes butter." Invariably, a yellow glow appears. It is sunlight reflected from the blossom. In sunlit atmosphere such reflections are all around. Most people aren't aware of their presence, but without them things on earth would look a good deal more stark than they do. In fact, the absence of an atmosphere on the moon decreases the chance for reflection with predictable consequences—the shade is black. The photographer, in his studio, often uses both a primary and a secondary light source in order to enhance his illusions, with the secondary source doing duty for reflected light. But the value to artists of representing reflected light goes beyond the duplication of sunlit reality.

Michelangelo's *Creation of Adam* (fig. 5-24) makes good use of reflected light on the upper arm of God the Father. Without the glossy light touching the curve of His triceps, the thrust of the entire arm would be less powerful.

5-25 IVAN LE LORRAINE ALBRIGHT. *Into the World Came a Soul Called Ida.* 1929–30. Oil on canvas, 56¼ × 47″. The Art Institute of Chicago

5-26 SALVADOR DALI. *Apparition of a Face and Fruit Dish on a Beach.* 1938. Oil on canvas, 43½ × 57″. Wadsworth Atheneum, Hartford, Connecticut. The Ella Gallup Sumner and Mary Catlin Sumner Collection

And a similar treatment of God's right leg brings the leg out from the mass of nudes supporting Him. In the same way, the glisten of a light under God's left wrist helps distinguish His arm from the background. These reflected lights also help continue certain linear patterns which compose the picture into a unified whole.

Ivan le Lorraine Albright of Chicago (1897–1983) painted "uglies" (fig. 5-25). Even his paint surfaces look corrupt. And his shadows have the phosphorescent glow of utter putrefaction, a unique use of reflected light.

The Spaniard whose name is synonymous with the bizarre in art, Salvador Dali (1904–1989), has turned chiaroscuro into a game in his *Apparition of a Face and Fruit Dish on a Beach* (fig. 5-26). What seems one thing is quickly transmuted into another. Take the bridge over the river at the upper right. It is also a dog's collar! A little attention will reveal the entire animal. The hole through the hillside is the dog's eye. His hindquarters seem to be of a holocaust at sea. Dali accomplishes these shifts of meaning through a clever use of the principles of chiaroscuro, turning one set of lights into relative darks (in the sea scene, for instance), making the reflected light serve double duty, and so on. It is very ingenious, if rather tricky and superficial.

The mechanical procedures for producing chiaroscuro modeling are more easily observed in drawings than in paintings, simply because the procedures are more direct. Anyone can see how fantasy–science-fiction illustrator Virgil Finlay (1914–1971) did his ink drawing (fig. 5-27): very *care*fully.

Finlay's technique involves both cross-hatching, in which lines are drawn over one another, and stippling, in which dots are made with the pen. His work is particularly useful in discussions of light and shade because he is a painstaking craftsman in love with simple artifice. With a kind of puritanical insistence his lines follow every curve of flesh; they are incredibly controlled as pen lines go, almost as precise as the engraved lines he imitates (see fig. 5-28). The stippled dots are used to intensify a few darks and to moderate the lighter areas of the sea god's face. Notice that the illustration contains every facet of chiaroscuro. By bringing the umbra—the darkest part of a shadow— right up against the light on the girl's back, Finlay even obtains a highlight.

5-28 HEINRICH GOLTZIUS. *The Farnese
Hercules.* c. 1592–93. Engraving. Museum
of Fine Arts, Boston

LIGHT, SHADE, AND TEXTURE 109

5-29 Pen scratches

5-30 Cross-hatching

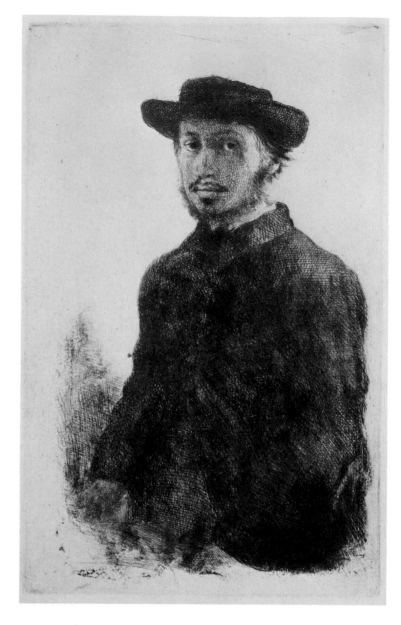

5-31 EDGAR DEGAS. *Self-Portrait.* Probably 1857. Etching, 9 × 5⅝″. National Gallery of Art, Washington, D.C. Rosenwald Collection

5-32 GEORGES SEURAT. *Seated Boy with Straw Hat.* 1882. Conté crayon, 9½ × 12¼″. Yale University Art Gallery, New Haven. Everett V. Meeks, B.A. 1901, Fund

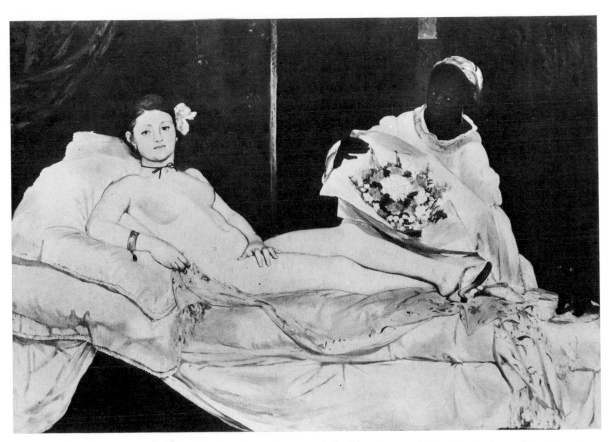

5-33 EDOUARD MANET. *Olympia.* 1863. Oil on canvas, 51¼ × 74¾″. Musée d'Orsay, Paris

This produces the illusion of increased whiteness nearest the dark. It is a well-known effect — Finlay is not at all imaginative in terms of artistic approaches — which can be observed in El Greco's *Resurrection* (fig. 1-32). It derives from the illusion we noted in figure 5-3.

The means of operation in the Finlay is the same as that in any pen-and-ink drawing, line etching, engraving, or similar image. The darkness or lightness of an area is the result of the relative density of units. Where there are more lines or dots per square inch, there is the deepest shade. Obvious? Of course. But it has some consequences. It is, for example, a good deal easier to control the relative concentration of lines or dots if a rather systematic procedure, like Finlay's, is used. In the work of professional artists you rarely see scratchy effects like those in figure 5-29. Normally, the artist will crosshatch by going from light to dark, building up the darks by adding new lines at different angles from the ones he puts down first (fig. 5-30).

In his *Self-Portrait* (fig. 5-31) Edgar Degas presents himself lighted from behind, his face and body in shadow faint enough to reveal his features and details of his clothing. The shading entails several levels of cross-hatching, each one growing progressively darker. First, there is the general half-light of the silhouette. It is rendered as a haze of very, very thin marks. Over this, Degas applied a layer of slightly heavier lines, following the contours of his flesh and his clothing. Finally, another set designates the darkest shadows, the eyes, mustache, beard, and so on.

A slightly later painter, Georges Seurat, did many drawings with black crayon on a very distinctively textured paper (fig. 5-32). One can see that he was very conscious of the crayon as a granular substance. Again, the relative density of units (in this case particles of crayon) determines relative darkness,

5-34 Shading techniques

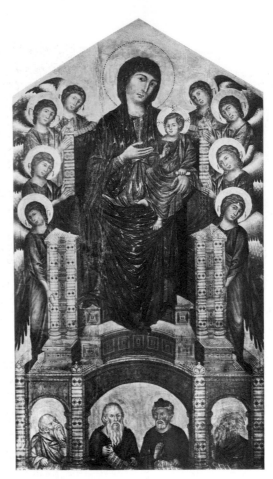

5-35 CIMABUE. *Madonna Enthroned.* c. 1280–90. Tempera on panel, 12′6″ × 7′4″. Uffizi Gallery, Florence

5-36 FERNAND LÉGER. *The Card Players.* 1917. Oil on canvas, 50⅜ × 76″.
Kröller-Müller Museum, Otterlo, The Netherlands

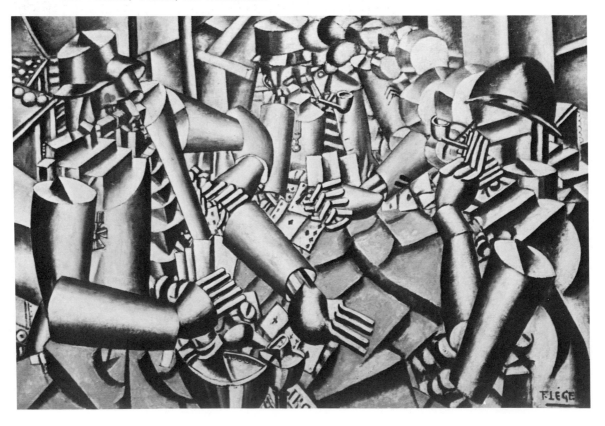

5-37 Treatments of a cube

5-38 After Chardin's *Still Life: The Kitchen Table*

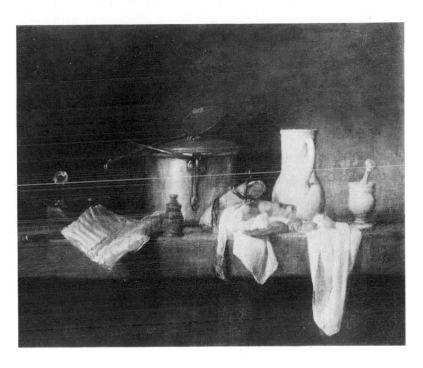

5-39 JEAN-BAPTISTE-SIMÉON CHARDIN. *Still Life: The Kitchen Table.* 1733. Oil on canvas, 15½ × 18⅝". Museum of Fine Arts. Boston. Gift of Peter Chardin Brooks

and light and shade in Seurat's drawings take on a curiously crepuscular quality.

You may have noticed that most of the artists discussed in this chapter contrive to work with a light source that is above and to the left or right (usually to the left) of the subject. There are various advantages to proceeding in this fashion, but it is not essential to do so. Manet's *Olympia* (fig. 5-33) seems to be lighted from directly in front, as if by a flashgun; and the faint shadows curve around the edges of the model's torso, head, arms, and legs. This relationship of lights and darks can be turned to advantage by artists who wish to give an impression of the third dimension without making use of the full range of light and shade effects. Figure 5-34 contains some geometric solids treated in terms of a light source in panel *a* and, in *b*, on the assumption that light areas stand for advancing or protruding forms and dark ones for receding edges. *B* is not consistent with any real light source, not even one out

front, but it is an effective way of representing the objects. Cimabue (fig. 5-35) and other late medieval painters attempted to convey solidity in this way, generally, but a certain timidity stood in the way of the kind of exaggeration I have employed in my drawing. That is not true of the modern painter Fernand Léger (1881–1955). In his *Card Players* (fig. 5-36) and in other works he turns everything into a series of mechanical forms by means of the same technique.

Léger also uses a related device whose basis is demonstrated in figure 5-37, where *a* is treated as if sunlit and *b* as the result of a simple alternation of dark-light contrasts.

What is important in every one of these images is that they depend upon contrast between light and dark. The impression can be of greater or lesser verisimilitude, depending on the degree to which the drawings or paintings approximate actual light effects; but the presence of dark-light contrast is essential. In figure 5-38 I have taken an exquisitely subtle still life (fig. 5-39) by the eighteenth-century Frenchman Jean-Baptiste-Siméon Chardin (1699–1779) and ruthlessly reduced it to gross relationships which derive from a theoretical light source and mechanical alternation of darks and lights. Despite some passages that would be inexplicable in nature—such as the darks on the wall behind the objects—the result is an image of solid objects occupying space.

The Meaning of Light and Dark Darkness means more to us than just the absence of light. It conjures up within our minds notions associated with the night—concealment, mystery, danger, evil. In nearly every culture blackness has some identification with evil. It is not true that white racism is the sponsor of such associations;[1] they grow out of the long ages of mankind when night was filled with terrors, before artificial lighting had mitigated the hazards of darkness in the forest, on the prairie, and in the jungles. Even today the lightest streets are the safest ones.

Rembrandt's etching *The Descent from the Cross: By Torchlight* (fig. 5-40) uses light to dramatize the scene and also to heighten the symbolic meaning of the event. Whiteness is associated with Christ, the Light of the World, and darkness with the great sin of humanity. The hand raised to receive Christ's head is as eloquent as the ancient symbol of the drowning man; it reaches out of the gloom as if in hope of salvation.

The Spanish painter Francisco Goya (1746–1828) makes use of dramatic lighting in a rather similar fashion. In *The Third of May, 1808* (fig. 5-41), representing French troops crushing a rebellion by the people of Madrid, the principal victim is in the center of a veritable explosion of light. The effect is all the more striking because his flesh is dark. He throws his arms out in a gesture of defiance and signifies that he, like Christ, is being "crucified." In the distance a tiny cross on a church building drives home the point. The firing squad is shadowy and featureless: the soldiers have no individual personalities; they are merely instruments of French imperialism, the tools of the oppressor.

Works of art that are highly dramatic, such as the Goya, the Rembrandt etching, Tintoretto's *Last Supper* (fig. 4-23), or El Greco's *Resurrection* (fig. 1-32), frequently contain areas of extremely high contrast. Usually the drama is produced by bright light in dark surroundings. But once in a while the artist will do the opposite and show us a dark shape against the light, as Richard Corben does in his comic strip (fig. 5-42), as Théodore Géricault (1791–1824) did in his famous *Raft of the "Medusa"* (fig. 5-43), and as Honoré

5-40 REMBRANDT VAN RIJN. *The Descent from the Cross: By Torchlight.* 1654. Etching, 8 × 6¼". Rijksmuseum, Amsterdam

5-41 FRANCISCO GOYA. *The Third of May, 1808.* 1814–15. Oil on canvas, 8'8¾" × 11'3⅞". The Prado, Madrid

LIGHT, SHADE, AND TEXTURE 115

5-42 RICHARD CORBEN. *Den.* © 1973, Richard Corben

5-43 THÉODORE GÉRICAULT. *The Raft of the "Medusa."* 1818–19.
Oil on canvas, 16′1″ × 23′6″. The Louvre, Paris

5-44 HONORÉ DAUMIER. *The Laundress.* c. 1861. Oil on panel, 19¼ × 13″. The Louvre, Paris

5-45 JOSEPH MALLORD WILLIAM TURNER. *The Dogana and Santa Maria della Salute, Venice.* 1843. Oil on canvas, 24⅜ × 36⅝″. National Gallery of Art, Washington, D.C. Given in memory of Governor Alvan T. Fuller by the Fuller Foundation

Daumier (1808–1879) did in *The Laundress* (fig. 5-44). In any case, the extreme contrast between dark and light areas makes for a highly charged impact.

Not all painters wish to be so dramatic as Goya or Tintoretto, and not every subject lends itself to collisions between dark and light. The later works of the Englishman J.M.W. Turner (1775–1851) are so light as to approximate luminous phantoms on the canvas (see fig. 5-45). The typical Rembrandt tends toward gloominess. An American painter, the late Ad Reinhardt (1913–1967), did abstractions so dark that when you walk into a gallery full of them your first impression is that the place has been hung with dark brown and black rectangles (see fig. 5-46). His pictures contain very, very somber rectangles, and there is a kind of magic in their emergence out of sunless depths.

Paintings and photographs in which the majority of tones are, like Turner's, lighter than a middle gray (fig. 5-47a) are called high key. Those in which most of the tones fall below middle gray (fig. 5-47b) are referred to as low-key pictures. (These terms have nothing to do with tension and relaxation; they refer only to the comparative lightness or darkness of things.)

In his *Olympia,* Manet combines low-key background relationships with high-key values that predominate in the foreground (see fig. 5-55). Titian's *Venus of Urbino,* like many Classical works, employs the entire range of values, except for the most extreme lights and darks (see fig. 5-54).

The key of a painting has an important bearing on its general character. It is not altogether true that dark paintings are sad and light ones joyous, although there is a kind of affinity between the mood and the key. It is true, though, that the representation of minuscule detail can be achieved only in the lower register. Notice that the two most detailed works we've so far examined, the Harnett (fig. 5-48) and the Van Eyck (fig. 5-49), are dark.

The impression of complete and absolute fidelity to nature achieved in a work like *After the Hunt* derives from the artist's handling of the sparkle of reflections on the various surfaces. For it is in the treatment of the reflection of the light source that the variety of textures is revealed. The same thing is true of *Giovanni Arnolfini and His Bride.* But, since the highest possible highlight is nothing but white pigment, it is necessary that lightness not be approached too rapidly. The reason for this has to do with something we barely touched on earlier. I mentioned above that there would not be distinct highlights on a dull surface, that the highlight there would be merely a part of the lighted area. The art historian E. H. Gombrich once made use of an old-fashioned textbook example similar to figure 5-50 to make a point about the difference between light and luster. The way light falls on an object reveals its form. The way the object's surface reflects the light reveals its texture. The matt-surfaced top hat exemplifies light's operation; the shiny silk top hat is filled with highlights that are reflections of the light source distorted by the curvature of the tissue of fabric.

It is a commonplace of art criticism that works like the Harnett and the Van Eyck are less secure in rendering forms in space than are works in which surfaces have not been treated with such miraculous precision. Thus, a Masaccio (fig. 5-51) is far more solid-looking than a Van Eyck, although not nearly so detailed. When Caravaggio, in his *Christ at Emmaus* (fig. 5-52), placed his objects on a table, moving back into space, he sacrificed some of the illusion Harnett retained. The Harnett is convincing partly because it is shallow, because the need to use dark and light to handle spatial relationships has been suppressed.

5-46 AD REINHARDT. *Abstract Painting, Blue.* 1952. Oil on canvas, 75 × 28″. Museum of Art, Carnegie Institute, Pittsburgh

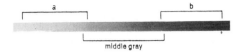

5-47 Value scale

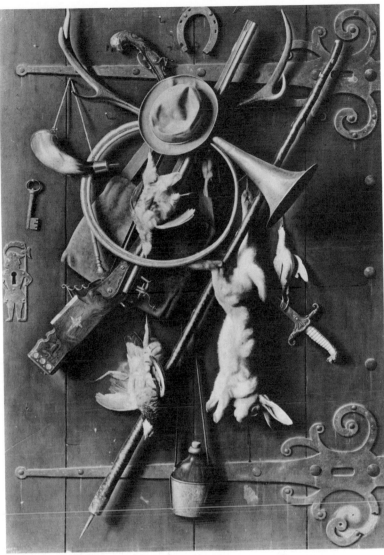

5-48 WILLIAM HARNETT. *After the Hunt.* 1885. Oil on canvas, 71 × 48½". The Fine Arts Museums of San Francisco. Mildred Anna Williams Collection, 1940.93

5-49 JAN VAN EYCK. *Giovanni Arnolfini and His Bride.* 1434. Oil on panel, 32¼ × 23½". The National Gallery, London

5-50 Light and luster

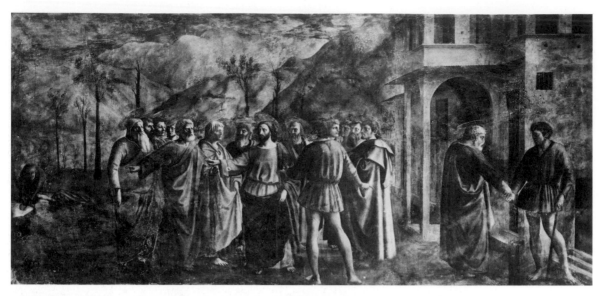

5-51 MASACCIO. *The Tribute Money.* c. 1427. Fresco. Brancacci Chapel, Santa Maria del Carmine, Florence

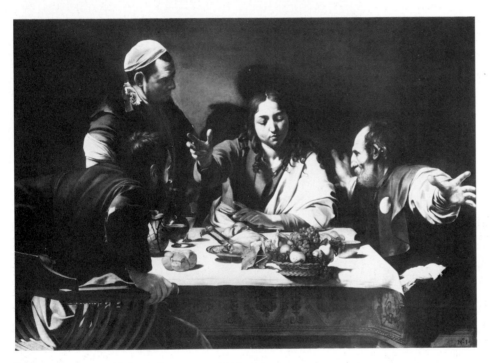

5-52 CARAVAGGIO. *Christ at Emmaus.* c. 1598. Oil on canvas, 55 × 77½″. The National Gallery, London

You will notice that in figure 5-50 the highlight of the matt-surfaced hat is no less white than the highlight on the shiny one. Consider then my treatment of a jewel (fig. 5-53). In both *a* and *b* I have begun by painting the jewel so as to reveal its form, without indicating anything of the texture. Below, in each case, I have tried to render the texture of the jewel on the basis established above. But the highlights in *a* don't sparkle as they should, and the gold setting has none of the sheen of real metal. The finished rendering in *b* is much more convincing in its detailing, if not its luminosity, simply because I began with a lower-key representation of the form and could, therefore, vary the lightness of the highlights, achieve different contrasts, and simulate the flashing variability of vision. This condition prevails for all renderings of meticulous

a b

5-53 Pale and dark underpainting

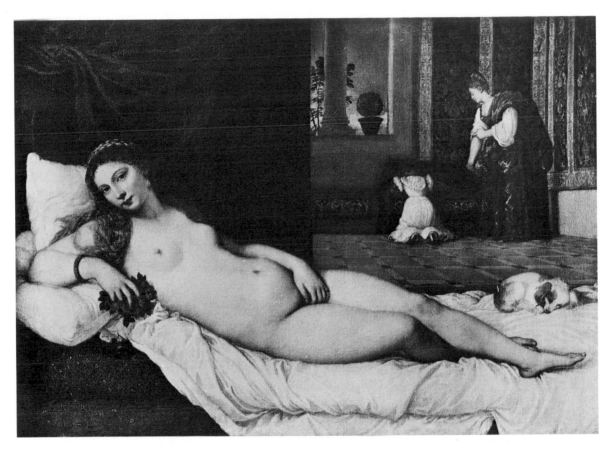

5-54 TITIAN. *Venus of Urbino.* 1538. Oil on canvas, 47 × 65″. Uffizi Gallery, Florence

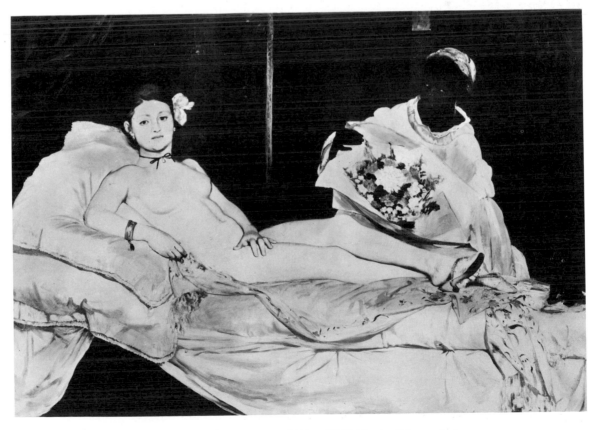

5-55 EDOUARD MANET. *Olympia.* 1863. Oil on canvas, 51¼ × 74¼″. Musée d'Orsay, Paris

detail. You can't have high-key pictures that are impressively detailed in the way that the Harnett and Van Eyck are.

The condition of relatively far-ranging contrast between the highest light and the darkest dark holds for all powerful illusions of three-dimensionality too. This is the reason that the Masaccio looks more solid than the Van Eyck. Masaccio didn't expend his highest lights on detailing; he used them to model bold forms in space. It is also the reason that Titian's *Venus of Urbino* (fig. 5-54) gives an impression of roundness and fullness that the more photographic *Olympia* (fig. 5-55) does not.

Manet, however, was onto something else. But it is something that cannot be understood without an understanding of color theory, the subject of the next chapter.

Texture The term *texture,* like many common words, has a simple meaning which has been complicated by an entanglement of connotations. Ordinarily, we think of texture as what appeals to the sense of touch, that is, the surface qualities of things, and in the strict sense there is nothing without texture. A coarse and nubby burlap has one sort of texture, a smooth sheet of window glass another, and the faint toothiness of kid leather still another. Yet, it is common to speak of some surfaces as being *more* textured than others. By that is meant, of course, that the character of a given texture is more prominent than that of another. For example, the roughness of the burlap is more attention-getting than the uninterrupted slickness of the glass. This usage is consistent with the original meaning of the word *texture,* which has the same root as the word "textile" and originally meant "to be woven." It has since come to refer to the physical structure of any material and, by extension, to the surface properties of objects (fig. 5-56).

Usually we use the adjectives associated with the sense of touch to describe such visible properties as smoothness, roughness, grittiness, graininess, or velvetiness, but that is not always the case. One might also describe the appearance of a surface in terms of pure visibility, as being unbroken, irregular, dimpled, in sharp relief, and so forth. Still, it is simpler to convey precise meanings by taking recourse to the vocabulary of tactile sensation, for our eyes afford us the experience of touch even when we cannot reach the surface. Indeed, even artworks that emphasize texture as an important feature of design rely upon the vicarious perception of feeling through sight, since handling paintings and sculptures is harmful to them. In the fine arts, visibility is all.

Collage, of course, was one of the first serious arts to maximize the concreteness of art works by the use of surface texture. Picasso's *La Suze* (fig. 5-57) is made up of various kinds of papers cut into shapes which have been glued down on top of one another and enhanced by drawing. This not only gives the individual scraps a special, almost precious uniqueness but also emphasizes the way in which ordinary vernacular material is made artistic by becoming part of a design. Paul Klee (1879–1940) portrayed a German singer of serious music by exercising the synesthetic appeal of his art. *Vocal Fabric of the Singer Rosa Silber* (fig. 5-58) combines exposed linen canvas, fabric-textured *gesso,* and stains of watercolor *gouache* to suggest a lyrical sensibility. The lettering (which marries the singer's initials and the standard vowel sounds) is posed against all of this as if it were musical notation for a specific melody. Klee's textural experiment makes no attempt to copy the appearance of Rosa Silber; rather, it represents the auditory qualities of her singing style.

5-56 A sampling of textures

5-57 PABLO PICASSO. *La Suze.* 1912–13. Paper pasted with charcoal, 25¾ × 19⅝". Collection, Washington University, St. Louis

It is typical of extremely realistic renderings of texture that the actual texture of the picture is unbroken. The Harnett, the Van Eyck, and the Holbein (fig. 5-59) are all smooth, virtually without brushstrokes, although each of them details many different textures with astonishing meticulousness. The reason for this is obvious, we realize. Smooth textures are the least obtrusive. They don't get in the way of illusion whereas more prominent textures do. Thus, the texture in figure 5-60 comes through with a certain authenticity when it is printed on smooth white paper but is muddled when imposed upon a fabric having a conspicuous weave (fig. 5-61).

Visual texture is communicated to us by light reflections reaching the eye. The ability of someone like Harnett to capture the fundamental difference between the soft highlights gleaming on ebony tuning pegs and sharp ones glinting from tautly strung wire is nothing short of miraculous. Van Eyck and Holbein discriminate exact distinctions among fur, velvet, and hair. The woods, the brass, and the fabrics in their paintings are distinguished by the most exactingly minute chiaroscuro.

William Harnett's work is like camouflage insofar as it is deliberately deceptive. It would, however, be easy to detect the difference between the

5-58 PAUL KLEE. *Vocal Fabric
of the Singer Rosa Silber.*
1922. Watercolor and
plaster on muslin, mounted
on cardboard,
24½ × 20½″. Collection,
The Museum of Modern
Art, New York. Gift of Mr.
and Mrs. Stanley Resor

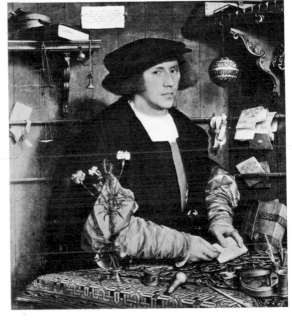

5-59 HANS HOLBEIN THE
YOUNGER. *Georg Gisze.*
1532. Oil and tempera on
panel, 38 × 33″. Staatliche
Museen, Berlin-Dahlem

5-60 A texture

5-61 The same texture seen in figure 5-60 printed onto another prominent texture

picture and an absolutely identical assemblage put together in a frame merely by changing your position slightly because the relationships among three-dimensional objects change when one's viewpoint changes whereas relationships among two-dimensional renderings do not. (That is, you cannot see the side of Harnett's matchbox by stepping to the left as you could if it were real.) That is one of the reasons that the most successful *trompe l'oeil* pictures depict things that are relatively flat.

For all of their precision, the Van Eyck and Holbein could never persuade a viewer that they are pieces of reality in the way the Harnett might for at least a few moments. Nonetheless, each of the paintings in figures 5-48, 5-49, and 5-59 does represent the appearances of various textures in a convincing way. As is typical of such works, these are all smooth and fairly dark-complected.

Finally, to close this discussion, we come to a work which outreaches all of

5-62 STEPHEN POSEN. *Variations on a Millstone.* 1976. Oil on canvas, 86⅝ × 68⅛″. The Pennsylvania Academy of the Fine Arts, Philadelphia. Funds provided by the National Endowment for the Arts, Charles E. Merrill Trust, and Craig Burn Fund

the others in its oblique approach to the representation of textures. *Variations on a Millstone* (fig. 5-62) by Stephen Posen (born 1939) is a deliberate exercise in balancing illusion against reality. Study the painting. Its complex play of textures and contradictory spaces is quite disconcerting. On the one hand, it is photographically realistic and, on the other, impossibly queer. Here's how it was done: Posen began with a black-and-white photograph of great resolution and then enlarged it enormously, until it was just over seven feet tall. He then created a collage by stapling an arrangement of colored fabric strips to the photograph. Using this collage as a model, he painted a picture of exactly the same size as the enlarged photograph, and it is this painting that is reproduced as figure 5-62. Beginning with photographically objective visual textures, Posen added physically tactile elements, and ultimately reproduced the whole by hand. This quirky illusionism takes on the complexities usually encountered only in philosophical discussions of things like epistemology.

SIX

COLOR

In our discussion of light and shade we were already dealing with color theory, for lightness and darkness are aspects of color. Everyone must be aware of that. Navy blue is dark and sky blue is light, and all that the two colors share is their common blueness. In every other respect they are different. Scarlet is different from crimson, but both are reds. If we want to be precise in our description of a color, we must refer to three specific attributes: (1) the *value*, (2) the *hue*, and (3) the *intensity*. I would describe a "passion pink" as having a high value (it is light) and being in the hue of red at full intensity.[1] Since we are going to be talking about some features of painting that depend upon hue and intensity as well as dark-light relationships, it will be necessary for you to understand exactly what the terms mean.

Before getting into a more elaborate discussion of the meaning of value, hue, and intensity, however, I wish to remind you once more that painters are not working with light; they are using pigments. Of course, they see only in terms of light rays, like everyone else, but they cannot imitate light effects in a direct way. What is true of the brightness of sunlight as compared with the brightness of white pigment is true of everything else in painting. For instance, in light theory the presence of all colors equals white light, but if I were to mix all the colors on my palette together, I'd end up with a dark brown muddle. White light, when broken down into its components by a glass prism (fig. 6-1), produces a full range of spectrum colors: violet, blue, green, yellow, orange, red, and all the intermediate gradations. White light striking white pigment reflects back almost entirely, while nearly all of it is absorbed by dull black paint. Red paint absorbs some of the white light but no red; the red is reflected back to our eyes and therefore we see the paint as a red area. Of course, this doesn't apply just to paint. It applies to everything. Lemons absorb some of everything but yellow, the green felt on a billiard table reflects back nothing but green.[2] (To ask what these substances "really" look like makes no sense. That is like wondering what a guitar sounds like apart from the sensations it produces in the ear, or asking what sugar tastes like apart from what it does to the taste buds in the mouth.)

We have already discussed *value* at some length because it is the basis of chiaroscuro. There will be more to say about it, but color is most easily approached by beginning with the notion of *hue*.

6-1 Components of white light broken down by prism

Hue Hue is what most people think of when they think of color. When you are arguing with a friend about whether a sports car you saw was blue or blue-green, you are arguing about the hue. A simple way of describing hue would be to say that it represents a segment of the spectrum. In discussing color, artists often make use of a color wheel (fig. 6-2). This is nothing more than the hues of the spectrum bent into a wheel. (There is, however, one color in the wheel that does not appear in the rainbow of hues the prism gives us. Red-violet is used to tie the ends of the spectrum together into a circle.) It would be possible to make the circle of hues continuously gradated into one another, but it is customary to divide color wheels into twelve units.

You will notice that three of the hues are labeled with the numeral *1*, three with a *2*, and six with a *3*. The colors labeled with a *1* are called *primary hues*. You cannot mix these from any other hues; you must begin with them. Given these three primary colors, red, yellow, and blue, you can mix any of the other hues.

If you mix two primaries together in equal amounts, you will get one of the hues labeled *2*, hence the name *secondary hues*. Red + yellow = orange. Yellow + blue = green. Blue + red = violet. And, of course, the hues labeled *3* are the tertiary hues, the mixtures standing between the primaries and secondaries. Red + orange = red-orange. Orange + yellow = yellow-orange, and so forth. By adding a little more red to the orange one gets a redder red-orange, a scarlet. By adding quite a lot of red to a red-violet you can produce a red red-violet, a crimson. All such intervening colors are referred to as *tertiary hues* even though the number of variations is infinite. All of them are the result of combining any two of the three primaries.

Hues that are very similar—adjacent to each other on the color wheel—are called *analogous hues*. Analogous relationships always involve a tertiary color, since these fall between primaries and secondaries. Analogous hues tend to be harmonious and restful when used together in a design. *Orange and Yellow* (fig. 6-3) by Mark Rothko has an analogous color scheme involving oranges, red-oranges, yellows, and yellow-oranges. Those luminous rectangles float effortlessly, tensionlessly, in a cottony atmosphere.

The Last Supper (fig. 6-4) by Emil Nolde (1867–1956) is different from the Rothko in many ways, but one of the most striking differences is in the color organization. Nolde's painting is the opposite of an analogous design; the hues are highly contrasting. Greens and reds, yellows and violets, contest for our attention in much the way that dark and light do in Tintoretto's *Last Supper*. Nolde's color scheme is a *complementary* one involving hues that are comple-

VALUE SCALE

high light

light

low light

middle

high dark

dark

low dark

INTENSITY SCALE

full intensity

¾

½

¼

neutral

6-2 Color wheel

ments, that is, directly opposite each other on the wheel. The effect is one of excitement and intensity.

Rarely do artists work exclusively with analogous hues or complementary ones. More often they use complex arrangements in which analogous areas contrast with each other or in which zones of highly contrasting hues are played off against harmonious ones. In Picasso's *Girl Before a Mirror* (fig. 6-5)

6-3 MARK ROTHKO. *Orange and Yellow.* 1956. Oil on canvas, 91 × 71″. Albright-Knox Art Gallery, Buffalo, New York. Gift of Seymour H. Knox

6-4 EMIL NOLDE. *The Last Supper.* 1909. Oil on canvas, 33⅞ × 42⅛″. Royal Museum of Fine Arts, Copenhagen

much of the upper portion is made up of analogous hues, and the background and the girl herself are constituted of complementary and primary contrasts. *Girl Before a Mirror* is a particularly bold and well-orchestrated example of such balance, but you will find some hint of this kind of equilibrium of hues in most paintings.

Another feature of color is the relative *warmth* or *coolness* of hues. The identification of reds, yellows, and oranges as warm colors, and blues, blue-greens, and violets as cool colors, derives no doubt from our experience of nature. Extremely hot things are usually red or orange, and the ocean, the sky, distant mountains, and ice cubes are bluish. Artists have come to term hues lying toward the red-orange side of the color wheel "warm" and those lying toward the blue-violet end "cool." Within the various hues, too, there are different temperatures; a red-violet is a cooler red than a red-orange and a yellow-green is warmer than a blue-green. But the connection between hues and actual temperature is extremely vague—as observe "white heat" and "blue flames." For the moment it is best to consider "warmth" and "coolness" as descriptive of the placement of hues on a spectrum or color wheel and ignore the other implications.

Value *Value* refers to the lightness or darkness of a color. The hue of a color depends on the kinds of white light rays the color absorbs and which one or ones it reflects back. The value of a color depends on how *much* of the light is absorbed. Pure violet absorbs far more light than pure yellow. If we wish, however, we can lighten the violet to the point where it is as light as pure yellow by introducing white into it. When this is done, the resultant color, orchid, is a *tint* of violet. A tint of a hue is a lightened version of the hue. There are various ways of darkening the yellow. We could add black to it, for instance. A yellow so darkened would be called, technically, a *shade* of yellow. (Yes, I know, paint salesmen and interior decorators, among others, use the terms *tint* and *shade* interchangeably. Color theorists don't.) Generally speaking, artists do not add black to hues to darken them, because it deadens them. All the same, the term for a color darkened by the addition of black is *shade*.

There is very little to be said about dark and light values in art that we have not already covered. In figure 6-2 a value scale gives an indication of possible comparisons and contrasts among hues. Needless to say, the lightest of all colors is white and the darkest is black. (These *are* considered colors even though they have no hues.)

Intensity Of all the attributes of color the most difficult to explain is intensity. *Intensity* is the term used to describe the brightness or dullness of a color, and there is a tendency for people to confuse intensity with value. But if you look at the intensity scale that is shown in figure 6-2 you will realize that intensity has to do with how much of the hue is present in a given color sample. Anything you do to a color that neither tints it nor changes its hue will vary its intensity. That is, if you mix white into a pure red, you tint it: it becomes a bright pink.[3] If you mix yellow into red, you modify the hue: the red turns into red-orange or orange. If, however, you add black to the red, you change its shade and also its intensity (it becomes less bright), but you do not change its hue. And, as odd as it may seem, the introduction of green into the red also will make the red duller without changing the hue.

Look at figure 6-2 again. Notice that the colors at the top of the intensity scale are quite bright and that they decrease in brightness as they go down. The value of all the squares is the same; only the brightness has changed. And

6-5 PABLO PICASSO. *Girl Before a Mirror.* Boisgeloup, March 1932. Oil on canvas, 64 × 51¼". Collection, The Museum of Modern Art, New York. Gift of Mrs. Simon Guggenheim

the bottom square in all three rows is a "neutral," a gray. The neutral in the left column is the dullest orange it is possible to have. Similarly, the last square in the second row is as dull a green as you can get. In the same way, the lower-right-hand square is the dullest of all violets. It is also the case that the gray squares are, respectively, the dullest blue, red, and yellow possible. In fact, the neutral in the left-hand column is the product of an equal mixture of orange and blue (tinted to maintain the value of the original orange). Likewise, the neutral in the next row is a mixture of green and red, and in the right-hand

6-6 Still life shaded with black

6-7 Still life shaded with complements

row it is a mixture of violet and yellow. Those particular hues "neutralize" each other when they are mixed. It is no accident that they do or that these six hues predominate in our two scales. They are complements.

Complements are not merely what are across from each other on a color wheel. They can be defined in other ways. If you are in doubt as to what the

6-8 JASPER JOHNS. *Flags*. 1965. Oil on canvas, 72 × 48″. Collection the artist

complement of, say, yellow is, you have only to think of what hue would be produced by the two primaries not present. In this case the two left out are blue and red, which mixed make violet. Violet is the complement of yellow, and yellow the complement of violet. Red's complement is blue plus yellow, that is, green. Orange is a mixture of red and yellow; its complement is blue.

Obviously, a neutral can also be produced in other ways than by mixing two complements: the three primaries can be combined, or black and white can be mixed. But one can obtain far richer grays—warm, cool, soft, or clear—by mixing complements in equal amounts and adding white. Black tends to deaden colors as well as dull them, and painters use it very sparingly indeed.

An artist's usual means of dulling a color is to mix into that color its complement. And, since shadows on objects are not only darker than lighted areas but also duller, it is typical for a realistic painter to paint them by dulling the color of the object with a bit of the complement. In other words, the shadow on a green vase will be green with a good deal of red mixed into it. What this produces in layman's terms is frequently a "brown." If you study the intensity scale in figure 6-2 you can observe that brown is nothing but a step on the way to the neutral. In figure 6-6 I have used black to indicate shadows. In figure 6-7 I have used complements except on the white cloth, where dull bluish tones predominate. The latter rendering surely looks more realistic to you than the other one. At any rate, it more nearly resembles a color photograph of the objects. But this doesn't necessarily mean that the objects would look this way to you in fact. Eyesight is far more sensitive than color film.

Fugitive Sensations The eye perceives things no camera could ever see. Jasper Johns (born 1930) has painted many pictures of the American flag. Here (fig. 6-8) he used peculiar colors. Stare at the dot on the flag for one minute. Then switch your gaze to the black dot below. Ah ha! There it is, Old Glory, rather shifty and pale but in its normal hues. Johns has made use of a so-called fugitive sensation, in this case an afterimage. If you look at the sun in the sky, you'll experience the same kind of thing, a black dot floating around in front of your eyes for a few moments afterward. The eye remembers strongly impressed images in terms of their opposites: for the brightness of the sun, darkness, for colors (as in the case of Johns's flag), their complements (blue for orange, red for green, white for black). The technical name for the experience of such a fugitive sensation is *successive contrast.*

A related phenomenon is *simultaneous contrast,* the tendency of a color to induce its opposite in hue, value, and intensity in an adjacent color. In figure 6-9 identical circles appear slightly different due to operation of this effect. The one set in violet surroundings seems slightly yellowish and lighter than it really is; the circle in the red field is identical to the one in violet but appears greenish and also darker. The dot on the yellow seems cooler and darker although it is the same. The last dot seems most brilliant of all because the background is its complement and, so, reinforces the brightness of that dot.

Pigments All artists' pigments are substances which have been ground up into powder and are then mixed with a vehicle such as linseed oil to make paint. It would even be possible to make pigments from plate glass, but as it happens, colored glass would not make very good paint. It is not nearly as intensely colored as commercial pigments and would not have much tinting strength. To have covering power, a pigment must have a higher refraction index than the vehicle in which it is suspended. *Refraction index* is the technical term for the relative change in velocity of light caused by its deflection when passing through a substance. (In other words, how much does it slow down?) The refraction index of boiled linseed oil is in the neighborhood of 1.5. If the particles mixed into it have a similar or lower refraction index, the light will pass through them with little change in velocity

6-9 Simultaneous contrast

and to the human eye it will be just as if the particles were absent, even though the viscosity and other properties of the oil have been altered. Plain window glass, finely ground, has a lower refraction index: it takes the form of a brilliant white powder, but when mixed with oil, this powder produces a paint with no more opacity than clear varnish. The refraction index of titanium dioxide, however, can be as high as 2.76. Titanium white oil pigment is one of the least transparent of all pigments and has extremely high covering power. Zinc white is a clearer white but has less covering power. Lead white is as opaque as titanium white but has the disadvantage of less permanence of color—over the years it yellows more than either titanium or zinc. But what is true of these white pigments also holds for pigments of other hues. Each substance has its own peculiar attributes.

The oldest artists' pigments came from earths and other natural materials. The most permanent of all colors are the so-called earth colors. Two of these get their names from the areas in Italy where they were first dug from the soil. Tan *raw sienna* and brown *raw umber* are from the soil of Siena and Umbria. When these earths are calcined (heated to a high temperature but below the melting point), they darken into a reddish brown and dark brown respectively; then they are called *burnt sienna* and *burnt umber*. *Terre verte* (literally, "green earth") is of all greens the least brilliant and the most stable. Ocher is an earthy, impure iron ore that may be yellow, red, or orange. The best known of the ochers is *yellow ocher*, a brownish yellow about the color of butterscotch pudding.

The earth colors are cheap, but some of the pigments of the old masters were extremely valuable. *Tyrian purple* was ground from the glands of a snail found off the coast of Lebanon (ancient Tyre). To make even a tiny amount of the pigment so many animals were required that the color gained the name "royal purple." The original *ultramarine blue* was powdered lapis lazuli, a semiprecious stone worth its weight in gold. It had to be imported from the Orient, from *ultra marine* (beyond the sea). Today ultramarine blue is synthesized from calcined kaolin, soda ash, sulphur, and charcoal, strengthened with a little cobalt blue. *Cobalt blue* is cobalt aluminate. *Cerulean blue* is cobalt stannate. *Alizarin crimson* was once ground from the root of the madder plant; it is now manufactured synthetically from anthraquinone. A few colors are not pigments in the usual sense at all; the *lake colors* are dyes. A dye is without body; it is really only a soluble stain. Lake colors are transparent bases that have been dyed so that they can be used as paints. They have little covering power despite their brilliance, and they are frequently impermanent.

Few pigments are really permanent. Some are highly unreliable. The billiard table in Van Gogh's *Night Café* (fig. 6-10) was once a bright kelly green. It eventually turned greenish tan, possibly the result of the artist's use of a color newly invented in the nineteenth century, malachite green, made of unstable copper salts. The billiard table is an extreme example of the effects of aging on paint, but every picture changes over the years; colors darken or fade, oil vehicles grow brown and crack, watercolor papers become yellowed. Sometimes, as in the case of Van Gogh's table, the original appearance can be restored by experts using new materials and specialized technology. Even pigments of proven permanence, such as the original ultramarine blue, will change in appearance. The degree of change will depend upon the vehicle the pigment is mixed with. Tempera paint changes less in appearance over the years than oil paint because the vehicle for the pigment is less subject to change. The only difference between ultramarine blue oil paint and ultra-

6-10 VINCENT VAN GOGH. *The Night Café.* 1888. Oil on canvas, 28½ × 36¼". Yale University Art Gallery, New Haven. Bequest of Stephen Carlton Clark, B.A. 1903

marine blue tempera paint is the substance with which the powdered lapis lazuli is mixed; the pigment remains the same, only the medium that binds the particles together differs. Over the centuries ultramarine ground in oil will *appear* to have changed color more than ultramarine ground in tempera.

Since the appearance of pigment color is dependent on so many variables other than the hue of the powder itself, it should not surprise you to learn that few paints actually correspond to theoretical color systems. It is easy enough to say that equal amounts of red and green will produce a neutral, but in fact an ounce of red paint and an ounce of green will not necessarily turn out to be an indeterminate neutral when mixed. Black introduced into yellow doesn't just darken it; it also turns it green. Contingent factors such as the refraction index of the pigment and its vehicle, the size of the pigment particles, and the chemical purity of the substances make the painter's art less dependent on theory than on craftsmanship. Painters don't speak of red paint or yellow, but of cadmium red, alizarin crimson, and of cadmium-, zinc-, or Naples yellow. To secure a "true" red, you must mix a little alizarin into the cadmium red. Cadmium yellow is a golden hue, zinc a lemon yellow. Naples yellow is a beautiful creamy tone made of lead and antimony.

Historic Combinations and Consequences Although the three main attributes of color—hue, value, intensity—are all important to any painting, throughout most of history the fundamental character of painting has been governed by value relationships. After all, a person blind to hue can see the world. But without contrast between darks and lights vision cannot exist. Were it otherwise, we should have had to use color reproductions throughout this book, which would have raised its cost enormously. As it is, black and white adequately defines the works and so serves our purposes.

Saying Grace (fig. 6-11) by Norman Rockwell (1894–1978) involves skillful juggling of darks and lights. It is primarily through the value relationships that we understand the picture. The glare of light along the top of the little boy's bentwood chair back draws our attention to the center of interest in the illustration. Actually, that highlight is no lighter than the highlight along the café curtain at the window, but it seems lighter because the adjacent area is so dark. Simultaneous contrast is being used here to intensify the impression of brightness. Thanksgiving Day beyond the window is overcast

6-11 NORMAN ROCKWELL. *Saying Grace.* 1951. Oil on canvas, 43 × 40". Courtesy of Ken Stuart, New York, and Norman Rockwell

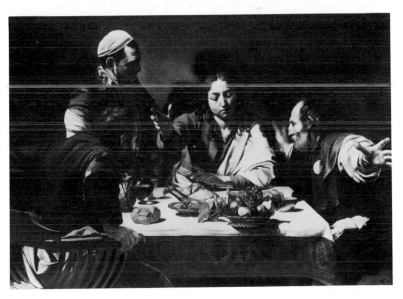

6-12 CARAVAGGIO. *Christ at Emmaus.* c. 1598. Oil on canvas, 55 × 77½". The National Gallery. London

but still fairly bright. The high key of that area of the picture tells us everything we need to know. And it is kept in harmony with the interior contrasts by means of the last part of the word *restaurant* lettered on the glass. That the hue of things is rather unimportant is evidenced by the low intensity of the reds and greens which predominate in the color scheme.

We have already used Caravaggio's *Christ at Emmaus* (fig. 6-12) to exemplify chiaroscuro. It is a far more complicated work than Rockwell's magazine illustration, and hue and intensity play a larger role in the Caravaggio—in the handling of the still-life objects on the table, the fabrics, and the flesh. But still, hue and intensity of color are ancillary to the values. In black-and-white reproduction more of the qualities of the Caravaggio than of the Rockwell are lost, but not so many that one feels the reproduction is utterly false. The small painting of the Vatican from across the Tiber River

6-13 JEAN-BAPTISTE-CAMILLE COROT. *View of Rome: Bridge and Castel Sant'Angelo with the Cupola of St. Peter's.* 1826–27. Oil on paper, mounted on canvas, 8⅝ × 15″. The Fine Arts Museums of San Francisco. Museum purchase, Archer M. Huntington Fund

6-14 JEAN-BAPTISTE-CAMILLE COROT. *View of Rome: Bridge and Castel Sant'Angelo with the Cupola of St. Peter's.* 1826–27. Oil on paper, mounted on canvas, 8⅝ × 15″. The Fine Arts Museums of San Francisco. Museum purchase, Archer M. Huntington Fund

(fig. 6-13) by Jean-Baptiste-Camille Corot (1796–1875) loses something without the dull blue-gray sky, golden scraps of cloud, and melodious umbers and siennas of the original (fig. 6-14) but not enough to completely falsify our impression of it. For it, too, is primarily a work of neutralities managed in terms of dark and light.

With Manet's *Olympia* of 1863 (fig. 6-15) a new thrust occurs. Good color reproductions of it are hard to come by and never adequate. This is because the hue of the colors is so important to the character of the painting. I remarked earlier on the absence of genuine chiaroscuro in the *Olympia*. The modeling of the nude is so delicate, the shading so lean and pale, that in contrast to Titian the forms are not at all solid-looking. But Manet turned what conservative critics of his day considered a weakness into what present-day critics consider a strength. He deliberately suppressed volumes by his method and virtually eliminated transitions from dark to light.

Chiaroscuro inevitably attenuates the brilliance and purity of colors—that is, it dulls them or otherwise weakens them. Surely, that is obvious. Just lowering the value of a flesh tone lowers its intensity. Adding white makes it less vibrant. And, in any case, what is most obvious about traditional painting techniques is their reliance on dark-light relationships. That is why black-and-white photographs do them some justice. In his *Olympia* Manet has virtually eliminated chiaroscuro. Its absence means that the color can be rich even when it is not particularly intense. The nude's body is not strongly modeled and gives little impression of three-dimensionality, but, despite this, the color of the figure is powerful because of its consistency and its contrast to the dark surroundings. The clarity of the zones of color is achieved through

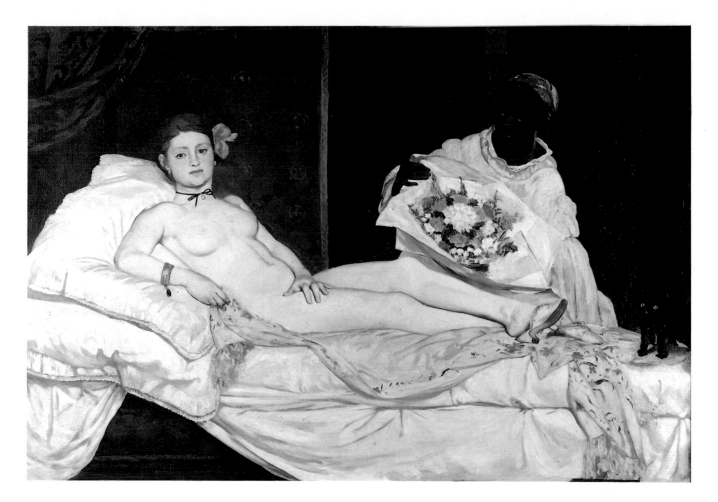

6-15 EDOUARD MANET. *Olympia.*
1863. Oil on canvas, 51¼ × 74¾".
Musée d'Orsay, Paris

lightness of values against dark contours. The final impression is of clear tints spread over the canvas, with a few very bright notes in the flowers and bedspread accenting the purity of the other tones in the composition. The importance of this general effect to the history of art would be difficult to exaggerate. Within thirteen years young radicals considered Manet the spearhead of a new movement in painting. It is no exaggeration to say, as Lionello Venturi did, that Manet is the foundation of modern painting.

If we understand that *something* in the real world of light must always be sacrificed to the nature of pigment when painting a picture, it should be easy to see that the sacrifice is not exclusively relative darkness or lightness. The hues of the rainbow, the intensity of reflected light, cannot be duplicated with paint any more than the radiance of the sun can be applied to canvas. It was absolutely necessary for the masters of chiaroscuro to give up all sorts of hues and many levels of intensity in order to paint their highly modeled surfaces. The same thing is true of color photography: it cannot capture the subtleties of the hues the eye takes in.[4] Manet, to some extent, abandoned the modeled surface. He opened the way to a different sort of sacrifice: the giving up of extreme contrasts of value in favor of a play of varied hues and increased intensity of color.

The painting of a haystack at sunset (fig. 6-16) by Claude Monet (1840–1926) may strike you as completely fantastic. The color may seem to you merely ornamental. It isn't; in fact, the picture is a kind of super color-realism. These hues actually do occur in one's visual field, but most of us are not accustomed to paying attention to their existence. Some of them are fugitive sensations; Monet rendered these as faithfully as older painters did

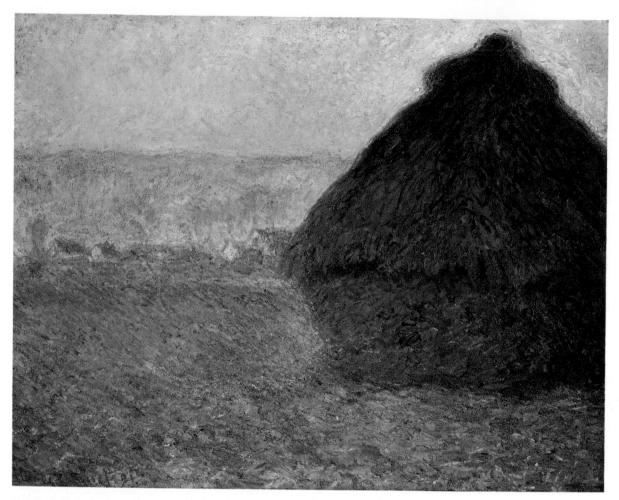

6-16 CLAUDE MONET. *Haystack at Sunset Near Giverny.* 1891. Oil on canvas, 29½ × 37″.
Museum of Fine Arts, Boston. Juliana Cheney Edwards Collection

solid objects. He once said in an interview: "Try to forget what objects you have before you. . . . Merely think, here is a little square of blue, here an oblong of pink, here a streak of yellow, and paint it just as it looks to you, the exact color and shape, until it gives your own naïve impression of the scene before you."

It would be difficult to exaggerate the revolutionary character of Monet's method. For, while it represented no more than a logical extension of traditional realism, it accepted things that every authority had said should not be countenanced by painters. The picture is full of optical effects that are usually considered illusory. For example, many of the color spots he indicates are the result of simultaneous contrast. Others are representations of *mouches volantes.* The latter are nothing more than particles floating in the vitreous humor (the fluid) of the eyeball. We normally don't notice them unless we are staring at a bright light field—a waste of snow, the sky, a sunset, something of that sort. A famous authority on optics contemporary with Monet, Dr. Hermann von Helmholtz, commented on the difficulty most people have in seeing these things:

Even the after-images of bright objects are not perceived by most persons at first except under particularly favourable external conditions. It takes much more practice to see the fainter kinds of after-images. A common experience, illustrative of this sort of thing, is for a person who has some ocular trouble that impairs his vision to become suddenly aware of the so-called mouches volantes in his visual field, although the causes of this

phenomenon have been there in the vitreous humor all his life. Yet now he will be firmly persuaded that these corpuscles have developed as the result of his ocular ailment, although the truth simply is that, owing to his ailment, the patient has been paying more attention to visual phenomena.[5]

Helmholtz also noted that "not every illumination is suitable for representing a landscape." His studies implied that painters should not light objects from behind, since that would cause them to appear flat. That this would be the consequence is quite right. In figure 6-17 there are two haystacks, one lighted from the side and the other from behind. The second seems less round because chiaroscuro does not indicate any relief, only silhouette; moreover, the stack appears continuous with its own shadow. Besides, Helmholtz pointed out, if the artist looks into the bright sun in this way, his vision will be impaired by *mouches volantes* and other fugitive sensations dancing within the field of vision. About this too the scientist was correct. Not only is Monet's haystack flat, but his picture is filled with all sorts of colors that existed only in his retina.

Monet did not discover such phenomena; they were well known. But when older painters had looked long and hard at a green vase and begun to see red or violet spots afloat on it, they took into account that this was the product of fatigue and simultaneous contrast. They left the spots out of the painting. They knew that the spots were not "real." That is, the vase was green, and the spots were only in the eye.

The traditional idea of the nature of that green vase derived from a fixed idea of color. The idea has a name, *local color*. Monet's approach utilized *optical color*. The following example will explain the difference. We may know that a mountain thirty miles away is covered with green trees. But because of additive mixing of colors and because of the intervening layer of atmosphere, which exercises a subtractive effect by scattering light rays in the air, the mountain looks blue (see fig. 6-18). Green is the local color of the mountain; the blue that reaches one's eyes is the optical color. Another example would be a burning cigarette in a room lit by a red bulb. The coal of the cigarette appears bright white in such circumstances, although we know that in white light it would be red-orange. If the smoker is wearing a green shirt, the shirt will look black in the red light. Again, red-orange is the local color of the cigarette tip, and white the optical color. Green is the local color of the shirt, black the optical color.

The example of the distant mountain shows that painters and laymen accept without qualm the substitution of optical color for local color when the effect is sufficiently obvious and universal. The example of the red-lighted smoking room should demonstrate just how arbitrary the idea of local color is. That is, in these special circumstances the cigarette tip *is* glowing white. And the green shirt *is* black. All that local color means is that an object seen under white light will have that particular hue.

But Monet wanted to show in his paintings that vision is not constant even in sunlight—to depict such phenomena as the simultaneous contrasts on the green vase. The major difference between Monet and a traditional painter is that he was willing to substitute optical color for local color at all times and without exception. So far as Monet was concerned, what he saw was what was. He painted the colors of the haystack just the way they looked to him, the exact color and shape, until he had, in his own words, a "naive impression of the scene." And by "naive" he meant to indicate a more honest and truthful

6-17 Haystacks lighted from the side and from behind

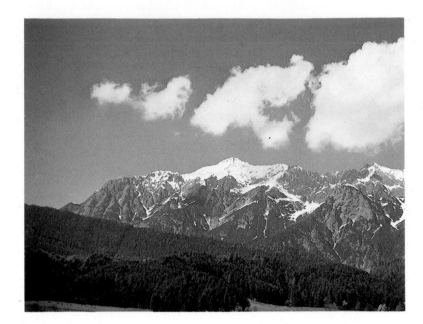

rendition. Now Monet couldn't really portray the thing precisely as it appeared; that is impossible. What he did do was rely on visual sensation to the exclusion of intellectual knowledge about local color. And he eliminated chiaroscuro to retain the purity of the hues he saw. This was the unavoidable alternative, since chiaroscuro presupposes shading and, as we observed earlier, shading with pigments inevitably darkens and dulls hues. Yet, in the shadows of a sunlit day, the eye may discern nuances of color whose dim radiance is to pigment as a sunburst is to a spot of white paint. To suggest these nuances in painting, Monet necessarily sacrificed deep shade. By de-emphasizing values he sacrificed the illusion of volume in order to record more fully delicate sensations accessible to the responsive eye.

Monet was the outstanding representative of *French Impressionism,* a movement about which I shall have more to say later. Its influence was not restricted to the acceptance of optical color in place of local color, but this was the most striking thing about it.

When the public was first exposed to Impressionist painting, it reacted with incredible hostility. The reaction was due partly to the kind of brushwork the Impressionists used and to some extent to the kinds of subject matter typical of the style, but it was due more than anything else to the use of optical color. After all, the average person perceives optical color as differing from local color only under very unusual circumstances, as in a room lit by a red light. To him the Monet would look fantastic. A fellow Impressionist, examining the Monet, would see it as a refreshingly accurate recording of visual reality. The Impressionists had trained themselves to see such things. The cliché about the beholder's eye was never more true than it is in this case.

Georges Seurat invented a later style typified by *A Sunday Afternoon on the Island of La Grande Jatte* (fig. 6-19). He retained in this work the Impressionist interest in purity of hue and intensity of color, but he did something very radical: he looked at the whole matter from a reverse point of view. Monet had copied optical color sensations with little dabs of oil paint. Seurat attempted to *create* optical color sensations with little dots of oil paint.

Paint also has its local color. There is no difference, so far as optical receptivity is concerned, between light reflected from a green leaf on a living tree and light reflected from dead pigment of the same hue if both are viewed under similar conditions. This is obvious, of course, but we don't often look at pictures from just this angle. Seurat did. He conceived of his paints not so

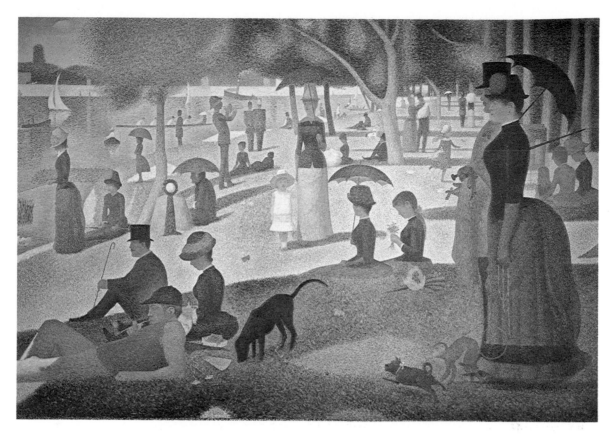

6-19 GEORGES SEURAT. *A Sunday Afternoon on the Island of La Grande Jatte.* 1884–86. Oil on canvas, 6′9½″ × 10′1¼″. The Art Institute of Chicago. Helen Birch Bartlett Memorial Collection

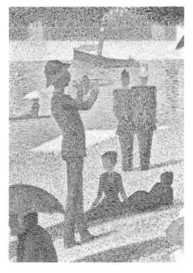

6-20 GEORGES SEURAT. Detail of *A Sunday Afternoon on the Island of La Grande Jatte*

much as colors that could imitate the hues of nature, but as colors that were themselves sensation-producing. He was thereby led to apply himself to the science of optics and devise a set of principles to guide his intuition. These principles were largely derived from the writings of the physicists Ogden Rood and Michel Chevreul and were later jotted down by another painter, Lucien Pissarro, for his own use. Among them is the following:

> Two complementaries mixed in unequal portions destroy each other partially and produce a broken color which is a variety of grey, a tertiary color. The law of complementaries permits a color to be toned down or intensified without becoming dirty; while not touching the color itself one can fortify or neutralize it by changing the adjacent colors.[6]

This is a description of simultaneous contrast. Monet copied the effect. Seurat used it. Not content with Impressionism's copies of the world of visual phenomena, Seurat aimed at constructing a phenomenal image at first hand, an image that would possess all the brilliance and variability of the world of light itself because it was constructed according to the laws governing the mechanics of vision.

In order to accomplish his ends, he had to control the color relationships very precisely. This is one of the reasons for his use of thousands of separate dots of color instead of the usual brushstrokes (fig. 6-20). The technique of application is known as *pointillism,* the style itself either as *Neoimpressionism* or, by Seurat's own preference, *Divisionism.* Most critics and authors of art appreciation books assert that the way to view a Seurat is to stand far enough away so that the dots fuse and only the effect is plain, as if Seurat's style were a kind of handmade halftone reproduction—so blue dots and green

6-21 RICHARD ANUSZKIEWICZ. *All Things Do Live in the Three*. 1963. Oil on Masonite, 21⅞ × 35⅞". Collection Mrs. Robert M. Benjamin, New York

dots together give you blue-green. Nonsense! The optical mixtures and contrast effects will not occur at such a distance. To appreciate the picture you must be standing just close enough to comprehend the dots as separate areas of color.

There is a somewhat related set of experiments with color in art which has come in recent years to be called *Op Art*. Among the outstanding practitioners of the mode is the American Richard Anuszkiewicz (born 1930). His *All Things Do Live in the Three* (fig. 6-21) is an example of Op Art and also a good illustration of what a small but distinct area of color can do to adjacent hues. The red background is continuous but appears to change according to the influence of the colored dots upon it. Notice, too, that the effect of the blue-green dots on the red is different from that of the blue dots going to the outer edges. If you have someone hold the book up far enough away for the dots to become invisible, the outer edge is indistinguishable from the internal form. This supports my point about not standing so far from the Seurat as to cause the dots to merge.

Emotional Effects of Color This chapter has been almost exclusively concerned with the visual attributes of color. But color also has another side, as noted in such common terms as "black mood," "the blues," "green with envy," "seeing red," "a yellow coward," "purple prose," and "brown funk."

For reasons not understood at all well, specific hues are associated with certain moods. Folk knowledge of this fact led the famous football coach Knute Rockne to have the team dressing rooms at Notre Dame painted red for the home team and blue for the visitors. The assumption was that red would maintain the emotional "heat" of his players during the half-time break while blue would cause the visitors to relax. Rockne won a lot of football games and was noted for his half-time pep talks that sometimes snatched victory from

defeat. Whether the wall colors had the effect he hoped for is impossible to say, but he did recognize that cool colors are more restful than warm ones. Motivational psychologists have made considerable use of such recognitions in packaging products, marketing automobiles, and selling political ideologies.

Painting a locker room red would have at least one disadvantage, because warm colors tend to advance and cool ones to recede. A claustrophobic quarterback would concentrate much better in a blue room. When interior decorators wish to make a room look larger, they use cool colors and minimal contrast. If, conversely, they want to make a large room seem more intimate and cozy, psychologically smaller, they will tend to use warm hues and plenty of contrast. Hotel rooms are apt to be cool in hue and to use analogous color schemes. The lobby of a large ski lodge is likely to be full of browns, yellows, and reds, with a few highly contrasting hues and values to make the setting seem less institutional. These colors will also make the lobby seem literally warmer than it otherwise would.

The terms *warm* and *cool* are well chosen to describe the effect of color on the inhabitants of a room. It has been discovered that personnel working in offices painted with warm tones, such as red-orange, are physically comfortable at lower temperatures than those working in offices painted blue, green, or violet.

Painters make use of the emotive content of color. In chapter five I discussed at some length the feelings evoked by darks and lights and their relationships. Van Gogh, speaking of *The Night Café* (fig. 6-10), said that his colors were not entirely true to life but were meant to "express the terrible passions of humanity by means of red and green." The café, he said, is a place where one might run mad, commit a crime. The violent contrasts of the complementaries are no longer so garish as they must have been when these words were written, but Van Gogh's understanding of the emotional function of color is made quite clear in a beautiful passage from a letter written to his brother Theo in September 1888. "I am always between two currents of thought," he said, "first, the material difficulties . . . and second, the study of colour. I am always in hope of making a discovery there, to express the love of two lovers by a marriage of two complementary colors, their mingling and their opposition, the mysterious vibrations of kindred tones. To express the thought of a brow by the radiance of a light tone against a somber background. To express hope by some star, the eagerness of a soul by a sunset radiance."

I have one last statement to make about the psychology of color. For years I have heard psychologists, art theorists, and others make reference to studies which have shown women to be slightly superior to men in color discrimination. Usually, the relevant experiment was supposed to have involved equal numbers of males and females sorting strands of differently hued yarn into piles; the women tended to discern more kinds of blue, of green, and so on, and consequently ended up with more piles of yarn than the men. I say that the experiment is "supposed" to have been like this because no such experiment seems to be on record. It's a myth. There are, however, experiments *refuting* such claims. Women may be more expert in using color names because of tradition and social influences (just as men are more apt to know about machinery) but there is no evidence that they are fundamentally better at judging color likenesses or differences.[7] The only difference between men and women so far as color is concerned would appear to be the well-known fact that color blindness is vastly more common in the male, the proportion being 8 percent for men and 0.5 percent for women.

SEVEN

SPACE

You cannot help but notice that we have been talking about two different kinds of forms in the previous chapters. There are the kind that make up the Mondrian (fig. 7-1)—flat, two-dimensional areas—and the kind that seem three-dimensional (fig. 7-2). In actuality the Titian is no more three-dimensional than the Mondrian, of course; it's just that chiaroscuro provides an illusion of roundness and relief. Physically, the works are much the same. Psychologically there is a world of difference. And the difference is mostly spatial.

There are two primary alternatives painters have when they create a picture. They can treat the canvas as if it were a window or *picture plane* through which the world is seen, or they can treat the canvas as a window on which forms are placed. Psychologically, it is the same with paintings as with real windows. If you focus on the world beyond the screen, you are not aware of the screen (fig. 7-3); and if you focus on the screen itself (fig. 7-4), the world beyond has little prominence. Thus, *The Marriage of Isaac and Rebekah* (fig. 7-5) by the French painter Claude Lorrain (1600–1682) really does somehow seem "in" the page, while Picasso's *Girl Before a Mirror* (fig. 7-6) is more easily accepted as being printed on the page.

Since pictures are flat, not deep, laymen are usually more intrigued by the illusion of depth than they are by an arrangement of zones on a surface. And well they might be. The creation of spatial illusions is a major achievement of Renaissance art. In some respects, the deep space of the Claude Lorrain depends even more upon conventions than do chiaroscuro or line drawing. But these particular conventions have proved their effectiveness over and over again through the medium of photography, which incorporates them. Indeed, the impression these conventions make is so powerful that, once you've learned them, the illusion is apt to remain even when you are doing your damnedest to destroy it. The humorous engraving (fig. 7-7) by William Hogarth (1697–1764) is an attempt to defy the conventions. Yet the space of the picture is not flat or nonexistent; it's just that some of the things contained in the space look bizarre.

The primary clue to spatial order is overlapping. What blocks out something else is ahead of it. Basic to all spatial *illusions* is the fact that things distant from the viewer appear smaller than things close to him. If an artist wants something to look far away in a picture, he draws it small relative to something he wants to look near. While it is necessary to use this device to convey depth, it is not, as the Hogarth engraving proves, in itself sufficient. What is absolutely essential to the spatial illusion—apart from overlapping

7-1 PIET MONDRIAN. *Composition in White, Black, and Red.* 1936. Oil on canvas, 40¼ × 41". Collection, The Museum of Modern Art, New York. Gift of the Advisory Committee

7-2 TITIAN. *Venus of Urbino.* 1538. Oil on canvas, 47 × 65". Uffizi Gallery, Florence

7-3 Focused beyond the screen 7-4 Focused on the screen

and relative size—is the one other thing Hogarth preserved (whether by design or inadvertence): a clear notion of the viewer's station relative to the scene. The artist and the viewer must both understand the vantage point from which a scene is viewed. That is, if the picture were reality, where would you have to be standing in order to see the objects as they appear in the picture? Hogarth's objects look implausible, but you do know, intuitively, that you are standing on the ground looking out between the two sides of the image, about on center. In the first panel of Neal Adams's *Green Lantern* (fig. 7-8) you, the viewer, are standing approximately on line with the older man. In panel two you are very, very close to him but lower and looking up. The third panel puts you above the superhero and his questioner. Adams adapted this kind of

7-5 CLAUDE LORRAIN. *The Marriage of Isaac and Rebekah (The Mill)*. 1640. Oil on canvas, 58¾ × 77½". The National Gallery, London

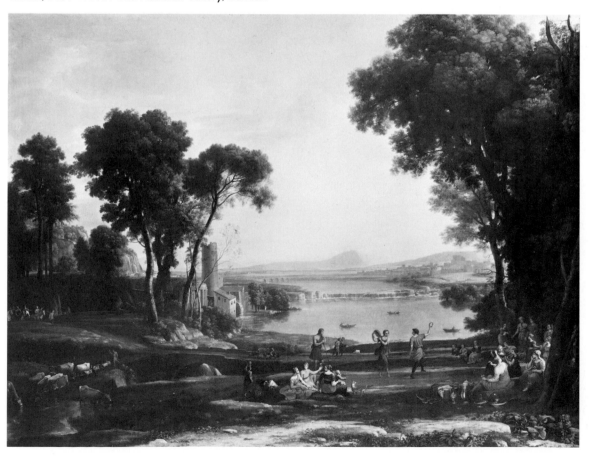

7-6 PABLO PICASSO. *Girl Before a Mirror.* Boisgeloup, March 1932. Oil on canvas, 64 × 51¼″. Collection, The Museum of Modern Art, New York. Gift of Mrs. Simon Guggenheim

7-7 WILLIAM HOGARTH. Frontispiece to "*Kirby's Perspective*" (Joshua Kirby's edition of Dr. Brook Taylor's *Method of Perspective*). 1753. Engraving, 8¼ × 6¾″. The British Museum, London

7-8 NEAL ADAMS. *Green Lantern.* © 1970, DC Comics Inc.

presentation from Milton Caniff, the first cartoonist to make effective use of shifting points of view. Caniff got it from the movies. So far as this book is concerned, there is no difference between a pictorial vantage point and a camera angle except that, historically, the former was necessary to the latter. What photographers and commercial artists take for granted was hard won by geniuses of the past.

Cimabue's *Madonna Enthroned* (fig. 7-9) reveals the artist fumbling after an illusionistic space in the lower part of the painting. The concave steps below Mary's feet are an indication of his attempt. He tried to carry the effect on down into the arch above the anonymous prophets' heads, but the marriage of arches and concavity gave birth to ambiguity. Is the arch an arch like the ones that flank it, or is it an indentation that happens to look like the flanking arches? No one can say.

About thirty years after Cimabue painted his *Madonna Enthroned,* Giotto, who was probably a student of Cimabue's, did a rather similar one (fig. 7-10). Both of them are displayed in the same room in the Uffizi Gallery in Florence, Italy, and thereby invite comparison. The Giotto is vastly more advanced in the direction of Renaissance realism, despite the retention of many medieval characteristics such as larger scale for the more important figures. Giotto didn't know scientific perspective—it wasn't invented until after his death— but he did establish a vantage point. The viewer is conceived of as standing slightly to the left of center and being approximately as tall as the two angels standing on either side of Mary's throne. Your position to center left is very certain; you can see slightly more of the left end of the step than the right end, and you see a little more of the inside of the throne on the side that is to your right. This explicitness is important. Cimabue gives you no good clues as to your position. You might say that you are meant to see the Cimabue as if from dead center but you'd be wrong. Yes, you *would*. Because you can see the inside of both sides of all three arches, and this would be impossible if you were viewing them from on center.

As for the relative height of the viewer, I must confess that this is somewhat uncertain in the Giotto. We can see the tops of the throne arms, which means that our eyes must be above them. And we can see the underside of the throne's canopy, which means our eyes must be below that. So we feel that we are somewhere on the level of the standing angels. But the viewer cannot be sure which rank of angels is at his level. Even so, the Giotto is a considerable advance over the Cimabue.

In the Cimabue there is no sense whatever for the vertical position of the observer. When looking at a reproduction in a book, our first impulse is to identify with Mary's eye level, as if we were looking straight across at her. (Confronted with the actual work, which is over twelve feet tall, one is less likely to suppose this.) But there is nothing to prevent us from supposing that we are on the level of *any* of these painted figures. The only consistent pattern is of looking down onto elements of the throne. And we always see the throne from the same angle no matter how high or low its elements, unlike Giotto's throne, parts of which are obviously above our gaze, parts of which are obviously beneath our gaze.

Giotto does numerous things to make his picture like a segment of real space. Cimabue drew Mary's halo in line with the collar of her blouse, a procedure that makes for flatness. Giotto gave the collar a different contour. He also drew the Virgin's cowl in such a way that you can see the outside of it on one side of her head and the inside on the other. This gives one a greater sense of looking at a three-dimensional object. The light in Cimabue seems to

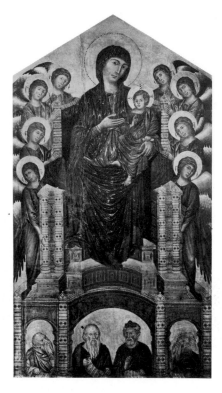

7-9 CIMABUE. *Madonna Enthroned.* c. 1280–90. Tempera on panel, 12'6" × 7'4". Uffizi Gallery, Florence

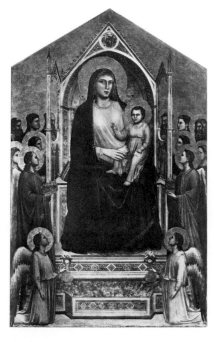

7-10 GIOTTO. *Madonna Enthroned.* c. 1310. Tempera on panel, 10'8" × 6'8". Uffizi Gallery, Florence

7-12 MASACCIO. *The Tribute Money.* c. 1427. Fresco. Brancacci Chapel, Santa Maria del Carmine, Florence

come from up front, if anywhere. It is somewhat realistic. But Giotto shifted the light source to the right so that it is obviously a light *source*. His angels are shaded on the left side and lighted on the right.

Finally, there is a sense of gravity in Giotto's work. This is due partly to the greater roundness of his figures; they look solid and heavy compared to Cimabue's. But what really enhances the effect is the distribution of the figures. In Cimabue they are all over the place, from top to bottom. Giotto masses his figures toward the bottom of his picture, and this makes them seem like things tied to earth. It helps convey to us the notion that we are related to them as fellow creatures sharing a common gravity. The total effect is a feeling of being presented with an extension of our own space. The illusion is incomplete and unconvincing to us because we are surrounded by images like that in figure 7-11. But without Giotto or someone like him, photography might not have come to be.

Masaccio's *Tribute Money* (fig. 7-12) is by the next artist of Giotto's stature. It is in his work that we first encounter scientific perspective. Perspective was not invented by Masaccio; it seems to have been the invention of the architect Filippo Brunelleschi (1377–1446).[1] But it is in Masaccio's work that it becomes part of the vocabulary of art.

7-13 ALBRECHT DÜRER.
*Demonstration of Perspective,
Draftsman Drawing a Lute.*
From the artist's treatise
on geometry. 1525.
Woodcut, 5¼ × 7⅛″.
Kupferstichkabinett, West
Berlin

Geometric Projections I am going to tell you enough about perspective to give you a pretty good notion of how it works. You should understand at the outset, however, that perspective drawings are not really realistic. Rather, they are mathematical approximations of the way you see with one eye closed and your head in a fixed position. Albrecht Dürer (1471–1528) once did a woodcut of an experiment to show, in one quick step, how the system works. His *Demonstration of Perspective* (fig. 7-13) depicts two men doing a drawing of a lute as it would look to us if we were standing so that our eye was at the spot on the wall marked by the hook, the center for a central projection. One man attaches the string (which represents a light ray) to the point on the lute to be noted. The other man drops a plumb down to where the string passes through the frame (representing a picture surface), then loosens the string and swings the drawing board around to mark the dot. Such a procedure will give you an accurate perspective drawing of the lute. Perspective theory accomplishes the same thing and doesn't require awkward apparatus. Photography does the same thing with a convenient mechanical device.

Perspective drawing is like photography because both are products of the same mathematics. Neither is really like human vision, though. In the first place, most of us see binocularly, that is, with two eyes, and perspective and photography are usually monocular. An entire photograph is in focus from top to bottom and edge to edge, at least within what is called its *depth of field*. Usually, in perspective drawings everything within the picture is in the same degree of clarity. Our eyes don't work that way. They pick out a tiny portion of the whole scene and focus on it. The eyes are constantly moving and we combine hundreds of different focused views into a mental image that seems similarly clear because of the rapidity of thought. A photograph is like a generalized statement of what one moving eye would see from a fixed position. Scientific perspective is an outline diagram of the objects as they would be seen that way, too. It is a specialized form of projective geometry, and it is but one of many ways to project objects in space onto a two-dimensional surface.

Consider figure 7-14, which combines a plan with orthographic projections or "elevations." People speak of the different elevations as "views," but they are not. If the front elevation were a view of this object, the cabinet

7-15 Front *view* of cabinet

7-14 Plan drawing with elevations

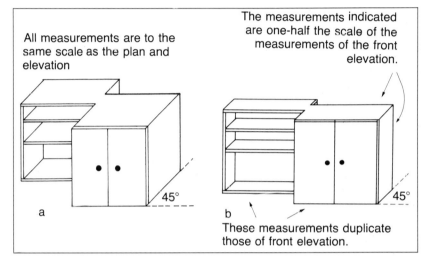

7-16 Oblique projections:
cavalier (a) and cabinet (b)

section would appear to be on a different plane from the bookcase section (see fig. 7-15). Moreover, you would be able to see the undersides or the tops of at least some of the shelves in the bookcase. All an elevation does is give you a drawing of measurements: if something on the side is to be one inch wide, it is drawn to the same scale as anything else that is to be one inch wide whether it is on the nearest face, six inches back, or two hundred feet back. A plan drawing is made to be worked from rather than looked at. But even carpenters, machinists, and masons find it helpful to have pictures of the things they are constructing. For their purposes a method of drawing pictures that offers a high degree of accuracy and clarity is required. There are three broad techniques of technical illustration that provide this kind of clarity. All are forms of engineering drawing and none requires the slightest talent for freehand drawing.

Oblique projections (fig. 7-16) simply combine the plan with the front and side elevations from the original diagram. They give a fairly good approximation of how the object will look when completed and also provide measurements in scale. There are two kinds: *cavalier projection* and *cabinet projection* They are not particularly popular, however, because the first looks "wrong" and the second requires that side and top measurements undergo at least one translation, into halves, even when the cabinet projection is the same size as the object itself.

Planometric projections (fig. 7-17) take the measurements of the elevations and the plan and rotate them at an angle. If the vertical scale is reduced, a planometric projection is then referred to as being in *military perspective.*

Axonometric projections (fig. 7-18) are the most widely used forms of

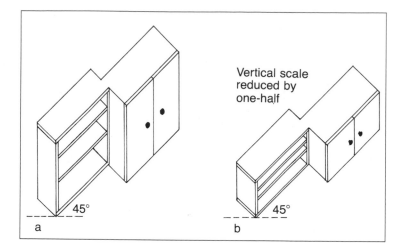

Vertical scale reduced by one-half

45°

a

45°

b

7-17 Planometric projections: planographic (a) and military perspective (b)

30° 30°

a

Depth ratio is one-half that of front

15° 15°

b

Height is three-fourths that of front and depth is two-thirds

60° 30°

c

7-18 Axonometric projections: isometric (a), dimetric (b), trimetric (c)

engineering drawings and are of three kinds: *isometric, dimetric,* and *trimetric.* Of these, isometric projection is by far the most commonly encountered and, of all the modes of axonometric, it is the most useful and easily learned. Its principal advantage is that all measurements in the projection are to the same scale, yet the shape of the object represented is not as distorted-looking as it is in cavalier or planographic projection. The word *isometric* means "of equal measure" and describes figure 7-18a perfectly. *Dimetric* (double measure) and *trimetric* (triple measure) describe figures 7-18b and 7-18c with equal precision. Dimetric projections look slightly more plausible than isometric simply because the viewer always seems to be staring down on top of objects in isometric whereas in dimetric the front or side faces of things can be emphasized. However, dimetric rendering is subject to the same objection as cabinet projection and military perspective. Working in two different scales is tedious. Trimetric, of course, requires three translations of scale, one for each dimensional plane, and most of us consider it far too much trouble for ordinary drafting purposes. As it happens, however, most "mechanical drawing" today is done entirely by computers using programs called CAD (Computer Aided Design) that can process the calculations with incredible swiftness. Figure 7-19 contains some drawings I did using software called DesignCAD 3-D from American Small Business Computers, Inc. As you can see, these are very convincing approximations of real perspective renderings although some experimentation has convinced me that they are actually more akin to trimetric projections than they are to anything else. It *is* possible to do genuine perspective on computers but that requires more powerful equipment and more expensive software than most individuals can afford. DesignCAD 3-D requires only a personal computer with a hard disk, graphics display, and a minimum of 640K RAM. (If this jargon means nothing to you, then don't run out this afternoon and buy a computer; find someone who knows

7-19 Drawings done on a personal computer with computer-aided design software (Design CAD 3D, version 3.0)

computers but does not have anything to sell.) I'd advise also that you possess a "mouse," math coprocessor, color VGA monitor, and a 24-pin or laser printer. It would be helpful, too, if the operator cultivates a "Type B" personality; patience is called for because doing graphics of any complexity takes *time*.

I have two reasons for including my CAD-built aircraft: (1) I wanted to emphasize the extent to which all such drawing is a form of applied geometry and mathematical calculations of point positions, and (2) I hope to reveal the kinds of advantages technology has provided for your generation. This latter point is not perhaps well demonstrated by the pictures themselves. And the fact is that using conventional means I could easily have done a more impressive drawing of the "Ramjet" I once made up for a French language comic book or a more authentic version of Grumman's experimental interceptor, the Skyrocket. What, then, is so notable about these particular images? It is that each plane, no matter from what angle it is presented to you—either side, behind or ahead, above or below—or how it is lighted, exists for the computer as one drawing. That is, I drew one picture of the Ramjet; that done I can direct the computer to print out any view I wish with whatever shading I specify. It's like doing a three-dimensional model that can then be photographed from any angle, except that this is done on a monitor screen and printed with a few strokes on the keyboard. Producing the original takes a good deal of time and effort—I include a brief description of the procedure in a footnote[2]—but once it's accomplished you can churn out an endless variety of individual images. What you actually draw, in four simultaneous "views," is a multicolor rendition of that complex, isometric interlacing of lines at the center of figure 7-19; the shading and exaggerated spatial effects are manifestations of the printing process.

Trimetric projections, whether generated by CAD or with pen and ink, are popular with one group of professionals, who customarily refer to them as

7-20 Trimetric architectural projection. *Arressicondo.* 1982. Courtesy of ARRESSICO

"axonometric drawings." Architects frequently represent large structures with trimetric projections (see fig. 7-20). It is easier, in fact, for architectural *delineators* to do trimetric projections than to undertake the usual alternative, central projections.

Scientific Perspective *Central projection* is the technical name for scientific perspective. The center of this projective technique is the center of one eye—or any point of focus. In Dürer's woodcut (fig. 7-13) the hook in the wall from which the string radiates out to the different points represents the eye. If we wished to do so, we could explain how the eye is where the hook is or where the camera lens would be were we to photograph the lute, and also how it corresponds to the point where the edges of the table would converge if drawn far enough beyond the lute. One does not have to understand the optical facts in order to appreciate the character of perspective drawing, however. For the purposes of this book a brief introduction is sufficient.

Just bear in mind that perspective drawing is not *the* correct way to represent things but is merely a more complicated form of engineering drawing associated with projective geometry. Perspective theory depends upon the idea of a functional infinity. Ordinary perspective drawing depends upon two fundamental notions: (1) the horizon line or *eye level* and (2) *vanishing points* toward which the edges of things converge.

Figure 7-21 contains three pictures of a telephone pole. In figure 7-21*a* we are above the pole, as if in a helicopter. In figure 7-21*b* we are standing looking at the pole. In figure 7-21*c* the pole is higher than we are—it's

a

b

c

7-21 Horizon line and viewer's eye level

floating. The drawing of the pole is the same in all three pictures; the only change is the position of the line of the horizon relative to the pole. When you are above the pole, the line is above it. When you are on the ground, the horizon line passes through the pole. When you are below the pole, the line is below it. All of us have seen telephone poles from these angles in essentially these ways. (You would see one like figure 7-21c if it had a steep hill running up from the bottom to support it.) The horizon line is *always* and invariably at the same level as your eyes. *Always!* Even when you are flying in an airplane, the horizon line is level with your eyes. If you are looking out over the wing, you will see that the edge of the Earth or a cloud is passing through your window, not lying beneath the fuselage.

You can check the truth of this statement by imitating the people in figure 7-22. Look through a sash-hung window, a casement window, or any window with open Venetian blinds. Stand looking at the horizon so that some other horizontal (sash, crossbar, blind slat) matches the line of the Earth against the sky. Squat. The horizon will descend. Stand on a chair. The horizon will ascend. Climb on a ladder and it will rise still higher. Lie on the floor and it will follow you down. In figure 7-22 you are given the eye level of one of the individuals in each of the cartoons. The artist lying on the floor sees the room from a perspective different from that of the robot who has mistaken Léger's *Three Women* for a pinup. The gallery worker on the ladder looks down on everything else. Notice that the horizon line passes through everything no matter how near or far. "Horizon line" used as I am using it refers to the edge of the globe. Trees and houses and mountains get in the way, so keep it in mind that the eye level is what we are really concerned with.

Imagine that you are standing in the desert in the middle of a railroad track (fig. 7-23a). Of course, the rails converge to a single point. What you might not realize is that every edge or alignment parallel to the rails is directed to the same point (fig. 7-23b). This is a perspective drawing. The horizon line establishes the viewer's eye level relative to the scene. The point at which all of those diagonals converge is called a *vanishing point*, and it is what establishes the viewer's position. In figure 7-23c the viewer has moved just left of the tracks. In figure 7-23d the viewer is up on a watertower. (By the way, so far as the artist is concerned, *he* is the viewer.) This kind of image involves one vanishing point.

What if the viewer is supposed to be standing way, way around to the side of the tracks—so they go off to the edge of the picture as in figure 7-24? Where do the ties go? How do you know how to draw the crossbars on the poles? In such a case the artist sets down a second vanishing point and directs anything that is at a right angle to the rails to the new point, as in figure 7-25. (Don't worry now about how I knew where to put the second one; the main thing is not to get them too close together.) Actually, as you can see, I have established a third vanishing point for the nearby crate and two more for the box that is over by the tracks. So we have, altogether, five vanishing points on our horizon line. The system, however, is called two-point perspective because it never involves more than two vanishing points for any single object. In somewhat the same fashion an image like those in figure 7-23 is called one-point perspective because most of the principal elements are directed to one point. There is also a three-point perspective system, used for drawing things like skyscrapers (fig. 7-26), but it is very uncommon in the fine arts. In drawing certain sorts of things—such as houses with pitch roofs—there are elevated vanishing points (fig. 7-27), but the system itself is included in two-point perspective.

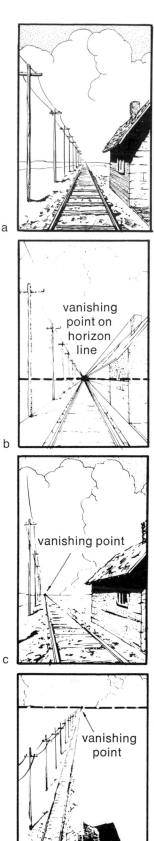

7-22 Horizon represented by the
dotted line for the eye-levels of the
gallery worker on ladder (a), the robot
looking at a Léger (b), and the artist
lying on the floor (c)

7-23 Railroad track (a),
railroad track with lines drawn
to vanishing point (b), viewer
standing at left of track (c),
and viewer on high elevation (d)

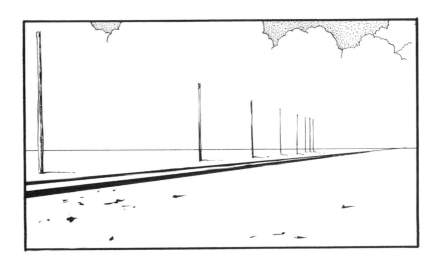

7-24 Viewer standing at far right of track

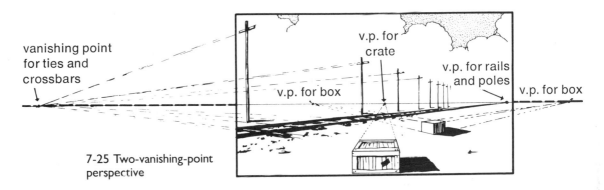

vanishing point for ties and crossbars

v.p. for crate

v.p. for box

v.p. for rails and poles

v.p. for box

7-25 Two-vanishing-point perspective

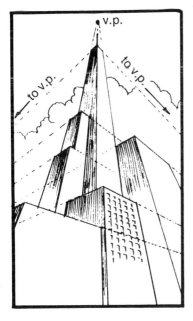

v.p.

to v.p.

to v.p.

7-26 Three-vanishing-point perspective

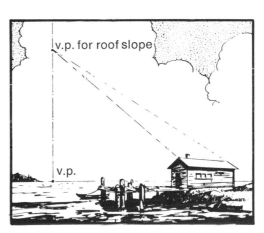

v.p. for roof slope

v.p.

7-27 Sloping roof in perspective

Regardless of the number of points, any circle drawn in correct perspective will appear as an ellipse (fig. 7-28)—unless, of course, it is parallel to the picture plane or exactly on eye level. There are many, many special rules and exact procedures for doing scientifically correct perspective renderings; they have to do with the optimum angle of vision, the procedure for establishing relative distances among objects as they recede into the distance, techniques for doing things like roller coasters, spiral staircases, and so on. None of these need concern us here. But I do want to confirm the utterly mathematical and theoretical nature of central projections. And one way to do this is to show you how an architectural draftsman would go about making a perspective drawing of some cubes stacked in a slightly unsystematic way.

People who do technical illustration and architectural studies are not often required to have ability in freehand drawing. I have done both, and I know. When architects show you a perspective drawing of a building to be put up, they are not showing you an artist's sketch. They are showing you a drawing

7-28 Circles in perspective

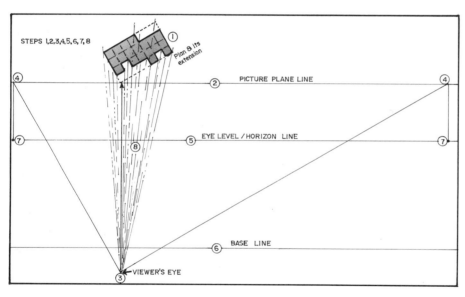

STEPS 1,2,3,4,5,6,7,8

① Plan & its extension

② PICTURE PLANE LINE

⑤ EYE LEVEL / HORIZON LINE

⑥ BASE LINE

③ ← VIEWER'S EYE

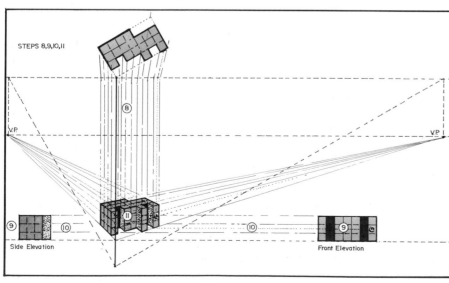

STEPS 8,9,10,11

V.P.

V.P.

Side Elevation

Front Elevation

7-29 Perspective drawings of an irregular stack of blocks derived mechanically from plan and elevations

7-30 Delineation of a
vintage airplane using a plan
and elevations

that was produced mechanically, by application of the techniques of projective geometry. The mechanical procedure for drawing the stack of blocks is described in figure 7-29: (1) The plan is put down at an angle to a line representing the picture plane, with one corner just touching it. Notice that the plan is contained within a box that describes its extensions. Figure 7-30 provides an illustration of the same procedure applied to the shapes of an antique airplane. (2) A point is fixed directly below that corner. This point represents the viewer's eye and will be nearer to or farther from the plan depending on how far from or near to the object the viewer is supposed to be. Since all the measurements are in exact scale, it is possible to calculate precisely the distance, height of eye level, and angle of vision. For instance, if the stack of blocks is two feet tall, we are six feet away and are seated so that our eye level is about twelve inches above the top of the stack. (3) From the point representing our eye, lines are run out parallel to the edges of the plan. (That is somewhat fortuitous, however. If the plan were trapezoidal in contour, we would still put the two lines at a 90° angle to each other with only one parallel to a plan edge.) (4) A second horizontal line is placed at some distance below the picture plane line. This is going to be the eye level and is necessarily related to the next step. (5) A third horizontal line, known as the "base line," is drawn beneath the eye level. If the drawing is to be in a specified scale and from a particular viewpoint, the distance between the lines can be calculated quite easily. (6) Directly beneath the spots where the diagonal lines intersect the picture plane line, we place two dots on the eye level. These will eventually be the vanishing points for our drawing. (7) Lines are drawn from important points on the plan to the viewpoint and marked off where they intersect the picture plane line. Then verticals are dropped from the points of intersection through the eye level. (8) An elevation is placed on the base line. (9) Measurements on the elevation are carried across to the line connecting the viewpoint to the plan. Using these coordinates, (10) the delineator can make a perspective drawing of any object from blueprints alone. Also the angle of the plan, the height of the eye level, and the distance of the viewer from the subject can be varied to produce whatever version of the object is desired. The versions can, in fact, be quite far removed from the original (fig. 7-31). Regardless of that degree of freedom, though, there remain severe limitations on just how

7-31 Variations on a theme

7-32 LENG MEI. *Lady Walking on a Garden Terrace*. 18th century. 42 × 22". Museum of Fine Arts, Boston

far you can deviate from specified viewpoints and proportions. Figure 7-30 preserves the construction lines never seen in conventional illustrations. I have also included a square zone in the center of the illustration; that is the absolute limit of undistorted imagery. In the plate the landscape may look as if it is correctly drawn all along the distant skyline but that's only because the terrain is irregular and the things shown are sort of "neutral," spatially. If you look to the lower regions of the illustration you should be able to see that such things as the shed don't look right relative to what is shown within the square. The shed, for instance, looks "bent down." But the vintage airplane is set within a very safe angle of vision—30°.

Of all forms of projection, perspective is the most nearly like human vision. Wherever it has been introduced, it has tended to drive out other ways of seeing the world for artists who wish to portray objects in a realistic way. Once you have been conditioned to the camera's eye, no other kind of drawing looks altogether right. All the same, perspective space is a very special and unnatural kind of imagery; it depends upon substituting calculation and

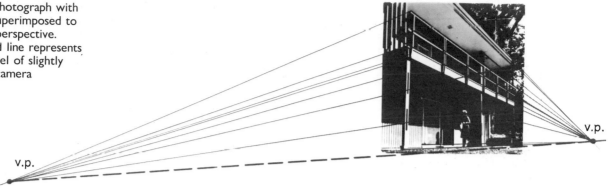

7-33 Photograph with lines superimposed to show perspective. Dotted line represents eye-level of slightly tilted camera

v.p.

v.p.

7-34 ARRESSICO. Architectural delineation of proposed building, 1984

magnitudes for the intuitive comprehension of space. Interestingly, the other kinds of projections, besides having their geometrically exact versions used in engineering drawing and technical illustration, have their intuitive corollaries in the drawings of children and in the history of the fine arts. Observe the terrace in Leng Mei's eighteenth-century painting (fig. 7-32). It very much resembles a dimetric projection. We can find many things of the same sort in the West as well. For example, Cimabue's throne looks quite a bit like two cabinet projections, one for the left half of the picture and one for the right, joined together behind the Virgin (see fig. 7-9).

That photography's images closely correspond to drawings produced by the application of strict perspective (fig. 7-33) is not surprising, since most camera lenses are ground in accordance with the geometry of central projection. Both perspective and photography do, of course, have *something* in common with the way a single human eye functions despite the differences noted earlier. But what struck perspective's first converts as being almost miraculous was its ability to generate from applied geometry pictures of imagined structures that would precisely match the appearance of the things when they were actually built. And indeed, even today, it strikes many people as nearly magical that a photograph of a building constructed according to the plans and elevations that produced figure 7-34 will match the drawing of the building line for line.

Renaissance painters, from the time of Masaccio on, made constant use of scientific perspective. It affected them powerfully because it seemed the ultimate example of an abstract, theoretical system that revealed a visual truth. Out of mathematical order illusion is produced. And the orderliness of perspective, with its completely unified space, appealed to them almost more than its realistic effects. In chapter four I remarked apropos of Leonardo's

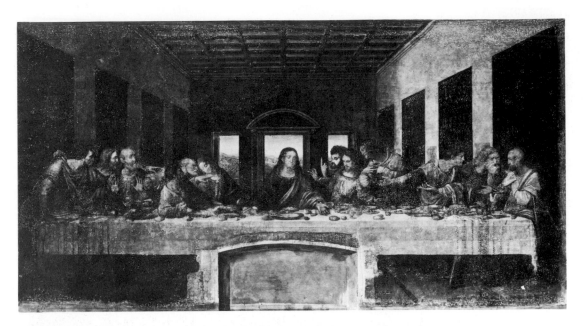

7-35 LEONARDO DA VINCI. *The Last Supper.* 1495–98. Mural. Santa Maria delle Grazie, Milan

7-36 TINTORETTO. *The Last Supper.* 1592–94. Oil on canvas, 12′ × 18′8″. San Giorgio Maggiore, Venice

Last Supper (fig. 7-35) that the convergent lines of the ceiling, the tops of the tapestries, and the table edges all pointed to the face of Christ. It will now be obvious that this is a consequence of one-point perspective. In Masaccio's *Tribute Money* (fig. 7-12) the vanishing point for the architecture is on Christ's face. Tintoretto, in his *Last Supper* (fig. 7-36), has used a distorted one-point perspective to accomplish his ends. The viewer is conceived of as standing way over on the right, more or less in line with the nearby male figure. If the table were drawn in two-point perspective (which, technically, this span of the room demands), the viewer might well imagine himself over to the left. Since the ends of the table are parallel to the eye level while its sides converge on the same vanishing point as other major elements of the room, we know the viewer is remote from the center of the room, in line with the vanishing point. For in one-point perspective the viewer is always directly ahead of the point of convergence. Tintoretto's aims are not scientific but emotional, and it is to his advantage to break the rules. His "error" is partially hidden by the glamorous chiaroscuro.

One of the most famous examples of deliberate deviation from the rules is a painting by an artist who was a contemporary of Leonardo, Andrea Man-

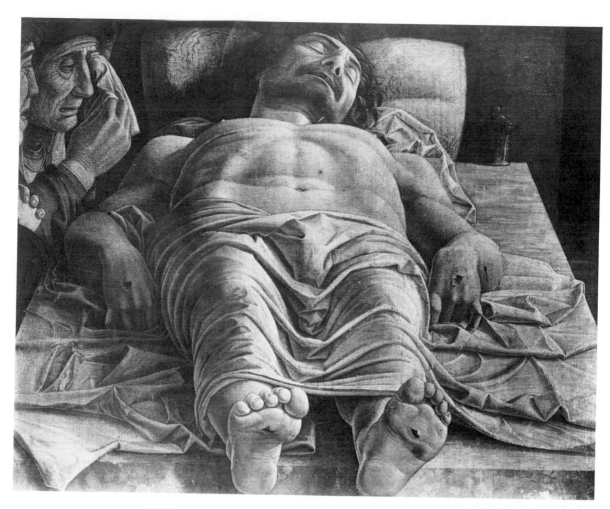

7-37 ANDREA MANTEGNA. *The Dead Christ.* c. 1501. Tempera on canvas, 26 × 30″.
Brera Gallery, Milan

tegna (1431–1506). Mantegna's *The Dead Christ* (fig. 7-37) is a perspective
study which is "wrong" from a technical point of view. Again, though, the
artist knew what he was doing when he made his mistakes. If he had projected
the body of Christ mechanically from this angle, the feet would have dwarfed
the rest of the figure. Given the nature of the subject matter, the result would
not be humorous, but it would demean the sacred spirit of the work. So
Mantegna has adjusted his projection in order to preserve the dignity and
solemnity of Jesus. When you realize this, it becomes very obvious that the
legs and feet are smaller than one would expect them to be. Until just now,
however, you probably didn't notice it.

Usually, in the fine arts, the absence of scientifically correct perspective is
neither deliberate nor the result of ineptitude. It is the consequence of an
antipathy for mechanical exactitude. Edgar Degas was actively interested in
perspective drawing, but his mature work (fig. 7-38) is full of inconsistencies.
He's always doing things that would drive a mechanical-drawing teacher up
the wall. He takes in too much of the floor; he paints things from slightly
different points of view. His receding parallels don't have a common vanish-
ing point. *Foyer of the Dance* proves him guilty on every count. Yet the
painting doesn't look unreal; on the contrary, it gives an impression of
considerable accuracy. Degas's perspective is not inaccurate so much as
empirical. He knew the rules and they assisted his intuition. But it was an
impression of the room he wished to project onto his canvas and not a

7-38 EDGAR DEGAS. *Foyer of the Dance*. 1872. Oil on canvas, 12½ × 18″.
Musée d'Orsay, Paris

geometric diagram. His perspective is sensed rather than constructed. Most
artists' drawings are done freehand in the way Degas drew in his picture.

Even an artist like Canaletto (1697–1768), famed for his perspective
vistas, did not do paintings with the precision theory would require. Still, it is
obvious that when he painted *Santa Maria della Salute, Venice,* showing the
Molo as seen from the Piazzetta (fig. 7-39), he began with a pretty systematic
central projection. The figures are distributed in such a way as to measure off
distance in the picture, and he used the lines in the pavement as well as the
architectural components of the buildings to mark off the square with excep-
tional clarity.

Francesco Guardi (1712–1793) was another painter of eighteenth-century
Venice, and he has given us a very similar view (fig. 7-40). But in his picture
the perspective is empirical, felt, much as it is in the Degas. Guardi sacrificed a
lot to atmospheric effect. His perspective is not exact. All the same, the space
of the picture is deep and dramatic. And in his work we are conscious of the
essentials of the perspective scheme. The eye level is firmly established, and the
ideal of the vanishing point remains even though the actual points at which
edges of things converge stray far from the ideal. Fortunately for painters like
Degas and Guardi, those of us who see their pictures are very tolerant of such
positionings and are not disturbed by shifts away from geometric perfection.
As a matter of fact, since buildings settle and human constructions are rarely
so regular as drawn diagrams, the "sloppiness" of Degas and Guardi may
actually make their scenes appear more true to life.

Atmospheric Perspective One reason for the effectiveness of both the
Canaletto and the Guardi is that neither relies entirely on central projection.
Guardi, especially, achieves depth through so-called *atmospheric perspective.*

7-39 ANTONIO CANALETTO. *Santa Maria della Salute, Venice.* 18th century. Oil on canvas, 17¾ × 28″. Galleria Giorgio Franchetti, Ca' d'Oro, Venice

7-40 FRANCESCO GUARDI. *Santa Maria della Salute, Venice.* 18th century. Oil on canvas, 17¾ × 28″. Galleria Giorgio Franchetti, Ca' d'Oro, Venice

Everyone must be aware of the influence atmosphere has on the appearance of things that are far away. The layer of air between us and distant mountains is one of the causes of their appearing blue. They are also less clear; even relatively nearby things are somewhat blurred by atmospheric haze. Artists copy this effect to represent the near and far in their works. But in paintings it is not blurriness that is the deciding factor in creating the impression of depth. The lucid, transparent light in which Canaletto's scene is bathed is one of the most appealing things about it. We feel that this is a clear day indeed, because

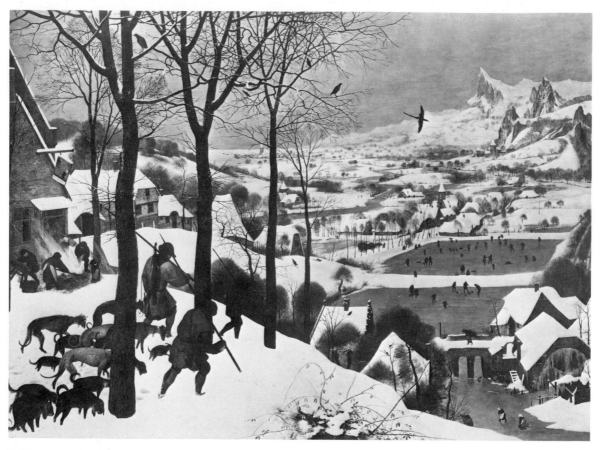

7-41 PIETER BRUEGEL THE ELDER. *The Return of the Hunters*. 1565. Oil on panel,
46 × 63¾". Kunsthistorisches Museum, Vienna

7-42 CLAUDE LORRAIN. *The Marriage of Isaac and Rebekah (The Mill)*. 1640. Oil on
canvas, 58¾ × 77½". The National Gallery, London

FOLLOWED BY THIS GROTESQUE HINDRANCE, MAXOR STEPS INTO THE BLINDING DAYLIGHT OF THE ARENA.
THE CROWD STILLS— IN ALL THE CITY NOTHING MOVES BUT FESTIVE BANNERS AND, TWO MASSIVE GATES ACROSS THE RING.

7-43 JOHN ADKINS RICHARDSON. *Maxor of Cirod.* © 1971, John Adkins Richardson

distant buildings are almost as sharp as things nearby. Despite the universal clarity, those domes do look far away. And the illusion is due to more than scientific perspective.

The Return of the Hunters (fig. 7-41) by Pieter Bruegel the Elder (1525/30–1569) does not depend for its spatial illusion on scientific perspective, because the landscape contains few elements that are geometrically regular. The same can be said of the Claude Lorrain (fig. 7-42). Both pictures rely for their impression of depth upon atmospheric perspective, a perspective whose character is only incidentally related to air. What this system really has to do with is value contrast. *Things high in contrast appear closer than things low in contrast.* That is, the difference between lights and darks is greater close up than far off. Thus, in the Bruegel, the trunks and branches of the nearby trees are far darker than distant ones, and those in the middle distance are darker than the ones that are far, far away. At the same time, the foreground snow is whiter than that of the valley, and the snow in the valley is not so dark as that on the mountainside. Everything gets grayer toward the horizon.

In Claude Lorrain, too, one is led back through passages of diminishing contrast. As you go back, the darks get lighter and the lights grow somewhat darker. What is important to the illusion, however, is the decrease of contrast *between* lights and darks. One could simply make all the lights grow darker,

leaving an impression of the distance shrouded in gloom. Conversely, a painter might lighten darks and preserve the same lightness throughout. Because Claude Lorrain lightened his darks a bit more than he darkened lights, his picture suggests far-off things lost in a luminous haze. The isolated panels of my comic strip *Maxor of Cirod* (fig. 7-43) make use of the principle of atmospheric perspective by eliminating large black spots from the distance, by reducing the amount of unbroken white space in the end of the arena and the mountains, and by treating the outline of the clouds with a faint, broken line.

From the close of the Renaissance to the middle of the nineteenth century, painting underwent many stylistic changes without forsaking the spatial conception that gave birth to both scientific and atmospheric perspective. John Constable (1776–1837) was one of the great masters of English landscape painting. His *Hay Wain* (fig. 7-44) was really quite radical in its treatment of nature. It was painted straight onto the canvas from studies done at the scene, and Constable employed spontaneous, sketchy brushwork designed to capture the transitory aspects of nature—the flicker of light on water, the leaves fluttering in the breeze, the clouds crawling lazily across the sky. This painting made so profound an impression on the French painter Eugène Delacroix that he revised the background of his *Massacre at Scio* in imitation of Constable. The *Hay Wain* is not a timid work. It is anything but conservative. But the space of the picture is no different from the space in the Pieter Bruegel or Claude Lorrain.

A contemporary of Constable, J.M.W. Turner, became so fascinated with the correlation between light and color that his work foreshadows Impressionism. In essence, however, his paintings (see fig. 7-45) share the spatial effects of Claude Lorrain. Corot's (fig. 6-14) solidity exists within the same general scheme as that of his predecessors. It is with the French Impressionists that the concept began to change.

Space in French Impressionism Actually, the modification of traditional space was just a by-product of the Impressionists' concern with sensation. Monet's procedure of painting scenes in terms of color notations without regard for much except his "naive impression of the scene" (fig. 6-16) would have itself denied the deep space typical of his predecessors. The scientist Hermann von Helmholtz pointed out that if you look at the world from an unusual position it looks flat.

> In the usual mode of observation all we try to do is judge correctly the objects as such. We know that at a certain distance green surfaces appear a little different in hue. We get in the habit of overlooking this difference, and learn to identify the altered green of distant meadows with the corresponding color of nearer objects. . . . But the instant we take an unusual position and look at the landscape with the head under one arm, let us say, or between the legs, it all appears like a flat picture. . . . This whole difference seems to me to be due to the fact that the colours have ceased to be distinctive signs of objects for us, and are considered merely as being different sensations.[3]

Monet's haystack picture makes no distinction between the spots of color used to indicate farm buildings in the distance and those which indicate light on stubble just behind the stack. Because of this the houses are hard to identify. (They are strung out in line with the division between the hump and sides of

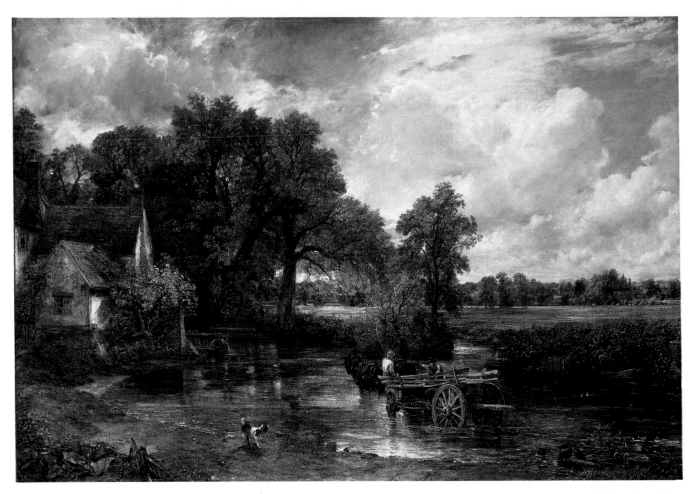

the haystack.) Does the horizontal line between the houses and the top of the picture represent the edge of a hillside or the crest of a cloud bank? You'd have to know the locality to make a good guess, and even then you'd not be sure. Colors have ceased to be distinctive signs of objects and are treated merely as different sensations. It is just as Helmholtz said.

The kind of spatial ambiguity exhibited by the Monet is called *frontality*.[4] The nude and bedclothing in Manet's *Olympia* have the same property. Most Impressionist paintings have it to some extent. It is not the result of a doctrinaire denial of the perspectives of the past; it is merely one consequence of the outlook of painters who wished to be true to their sensations. Our discussion of scientific perspective should have proved its abstract, impersonal character if nothing else. Monet would have considered the rules of central projection an imposition upon his sensations which was inconsistent with his purposes. And he would have been correct. The rules dictate certain proportions that are not in accord with sensational responses. They substitute measurement and magnitude for intuition. Atmospheric perspective is similar insofar as it presupposes an ideal range of value relationships.

Degas did not consider himself an Impressionist, although he exhibited with them. He did not concern himself with color sensation in and of itself until quite late in life. To cite him as an example of Impressionist divergence from abstract principle is to select the poorest example—for he was interested in perspective more than any other Impressionist. Yet, even in his work, the perspective is never scientifically correct; it is Impressionistic.

Two French Impressionists who were not particularly fascinated by perspective drawing were all the same disturbed by what seemed to them the

7-45 JOSEPH MALLORD WILLIAM
TURNER. *The Dogana and Santa
Maria della Salute, Venice.* 1843. Oil
on canvas, 24⅜ × 36⅝″. National
Gallery of Art, Washington, D.C.
Given in memory of Governor
Alvan T. Fuller by the Fuller
Foundation

superficial nature of the Impressionist method. Both Auguste Renoir and Paul
Cézanne became disenchanted with the relative looseness of Impressionism.
Renoir attempted to combine Renaissance form with Impressionist color. His
Bathers (fig. 7-46) was the first critical success among Impressionist works
and is noteworthy for having made Monet, Pissarro, Degas, and the others
collectible. In this work the blending of tradition and modernism is very easy
to detect; the background is Impressionist and the ladies rather stiffly conven-
tional. Cézanne is often said to have done the same sort of thing Renoir did,
but his accomplishment goes far beyond this rather obvious synthesis of
conservative figure drawing with Monet's color and fluffy landscapes. He
invented what the English critic Roger Fry called a *perspective of color.*

Cézanne's Perspective of Color Cézanne's art is very complicated. It
is rather like the music of Bach; solemn contemplation of each part and its
relationship to the whole is necessary if one is to come to an appreciation of it.
Perhaps the following remarks will not convey what I want them to. Roger Fry
thought that the method Cézanne employed was inexplicable. Fry was a
lyrical critic of art, and he didn't attempt to analyze the specific functions of
line, form, and color. What a poet would not try, I perhaps should not
attempt. But I am going to, anyhow. Maybe I can give you some notion of the
majesty of Cézanne's accomplishment.

Let us examine the panoramic landscape entitled *Mont Sainte-Victoire* (fig.
7-47). At the base of the lone central tree there is a dark clump of brush. It is
juxtaposed with the yellow-brown wall of a little house. The house is nearly
hidden by foliage. It has a lavender roof. Notice, now, that the ridgepole along
the middle of the roof and the eaves on its right-hand side form a single line,
interrupted only by the tiny chimney. The house is virtually a continuous

7-46 PIERRE-AUGUSTE RENOIR. *The Bathers (Les Baigneuses)*. 1887. Oil on canvas, 46⅜ × 67¼″. Philadelphia Museum of Art. Mr. and Mrs. Carroll S. Tyson Collection

7-47 PAUL CÉZANNE. *Mont Sainte-Victoire*. 1885–87. Oil on canvas, 25⅝ × 31⅞″. The Metropolitan Museum of Art, New York. The H. O. Havemeyer Collection. Bequest of Mrs. H. O. Havemeyer, 1929

plane because of this line. Almost as if unbroken, it leads the eye back into the picture from the accent of the brush. But it is not unbroken. It is divided by hue into two parts, the yellow-brown of the wall and the pale violet of the roof. From this simple division emerge the many relationships that, together, identify a Cézanne.

When you place a cool color (blue-green) against a warm color (yellow-brown) and the two hues are of different value, they tend to separate—as, for instance, is the case in figure 7-48*a*, where the ordinarily recessive cool color seems to hover over the darker warm color. In somewhat the same way, the brown wall in the Cézanne drops away from the green shrub. And space, thereby, comes to exist *within* a receding plane. But the effect has another side. Put together, colors dissimilar in hue temperature but of approximately the same value suggest a "folding" of space; that is, they create the illusion of an angle (fig. 7-48*b*). For this reason, the single segmented plane of the house can also be viewed as composed of a wall parallel to the viewer and a rooftop slanting away from him. Having such a duality of recession, the form is doubly cogent. Moreover, the plane of the little house is but a section of a still larger plane which penetrates the house, the trees on the left, and drifts into the ground plane of the valley. Such planes, of which the entire work is composed, are like great slabs of light superimposed over the volumes of the landscape. And what is most intriguing about it all is that Cézanne managed to make the picture deep and frontal at the same time.

Frontality in *Mont Sainte-Victoire* stems from the fact that elements of the foreground participate in the illusion of deep space. For example, the bit of foliage to the left of the lone pine tree belongs to the tree and also acts as an accent for a set of shifting planes that tip up and backward to become Mont

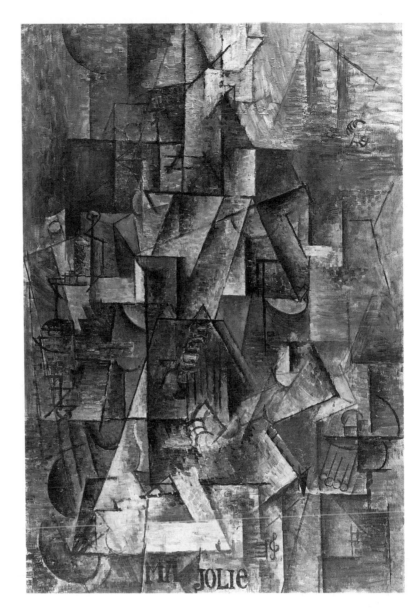

7-49 PABLO PICASSO. *"Ma Julie."* Paris (winter 1911–12). Oil on canvas, 39⅜ × 25¾". Collection, The Museum of Modern Art, New York. Acquired through the Lillie P. Bliss Bequest

7-50 Overlapping planes

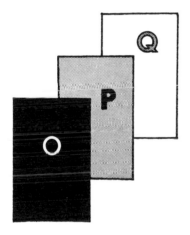

7-51 Cubistic treatment of space

Sainte-Victoire. We'd think the green was a clump of trees; except that they would have to be the largest trees in the world if they towered as they seem to over the ancient Roman aqueduct. A branch on the right of the pine projects a corresponding spot of green out over the landscape. This spot is the accent for a plane that passes along the branch to the aqueduct. Numerous elements of this kind predominate. The projecting branch aligns two green spots and also lies parallel to the roof of the little house and to the general direction of the distant river. The meanderings of that river are almost exactly repeated in the line of the mountain range against the sky. The entire shape between the river and the mountaintops can be relished as an independent chunk of the picture. When you look at that segment of the picture, you can see just *how* frontal it can seem. The picture is an exquisite marriage of Classical structure and harmony with Impressionist sensitivity and frontality. It contains both and resembles neither.

The Uncanny Space of Cubism Five years after Cézanne's death in 1906, two young artists invented a style that was to revolutionize painting in modern times. The artists were Pablo Picasso and Georges Braque (1882–1963), and the style came to be called *Cubism*, although it had nothing to do

with cubes. It is the first truly nonrepresentational or "abstract" movement in modern art, and we shall have more to say about it later on. For now, I am interested in its curious spatial quality.

The space of Cubism is so unusual that it has led to all kinds of speculations: that it is derived from multiple viewpoints of objects, that it is dependent on a mystical fourth dimension, and that it has something to do with Einstein's Theory of Relativity, which was enunciated about the same time. These speculations are almost always based on a misunderstanding of both the style itself and the scientific ideas.[5] What we are presently concerned with is the space of painting.

Picasso's "Ma Jolie" (fig. 7-49) looks, at first glance, like a jumble of forms which doesn't make much sense at all. Select one of those forms and try to figure out whether it is ahead or behind another one. Things *do* look as if they are ahead or behind; the picture doesn't look flat. Virtually any form you select can also be construed differently, however. If the one selected seemed to be on top of an adjacent one, imagine it beneath. You can shift assumptions this way with great ease. Picasso has taken to its ultimate conclusion Cézanne's method of rendering things so that they retain their volume as well as their frontality. The space doesn't depend on the color variations of Cézanne; it does derive from the ambiguities he used. It should be easy for anyone to see that in figure 7-50 plane P lies between O and Q. The illustration is typical of traditional overlappings. But what about the situation in figure 7-51? This schematic drawing takes a Cubist image as a point of departure, and, in fact, some later Cubist works actually resemble this diagram. Where is P? Possibly it lies both ahead of and behind the other forms and lines. This ambiguity is not due to a transparency of the forms. It is due to the arrangement of masses and edges. The same is true of "Ma Jolie."

The bizarre space of Cubism is of great interest because the whole character of a painting like "Ma Jolie" changes as you change assumptions about where in space the elements are. Take that one tiny form you took before. Look at the whole picture in terms of it. Then assume that the form is not where you at first supposed it was but is in the opposite relationship. The assumption makes the rest of the picture look different. Too, if you select another form and make alternative assumptions, similar changes will occur. This is the simplest version of what is most interesting about the painting: that it never "wears out." I have seen it many, many times, and it always shows me a somewhat different face. It is not a very decorative picture in terms of color (it is all browns and grays), but it is a work of art that one could live with forever.

Let me hasten to say that this is also true of Rembrandts, Caravaggios, and others. What is particularly intriguing about the Picasso is that its interest depends completely upon the way it was painted and not at all on what it represents.

PART THREE

THE ELEMENTS COMBINED

FORMAL COMPOSITION AND STYLES IN ART

have been using the word *form* interchangeably with *shape*. There is, however, another usage current in the fine arts. In writing about art, the terms *form* and *content* are frequently opposed. Like many terms in art, these have their counterparts in common speech. Suppose you are at a public forum dealing with the application of I.Q. tests to urban schools, a subject fraught with hazards. A speaker says: "White urban Jews do consistently better than white Protestants from rural Appalachia in I.Q. tests." You ask: "Are you saying that urban Jews are smarter than Appalachian whites?" The speaker responds: "No, not at all. They just get higher scores on intelligence tests. Let me put it in a different *form*. The whole social structure and life-style of the typical Jewish child gives him the skills a normal I.Q. test measures. This is not true of the mountain people." Now the speaker has said essentially the same thing in both cases. The amplification didn't really add anything that was not implicit in the previous remark. The form made all the difference. What was said was the content of the remarks. The way they were made was their form.

In discussing artworks critics often distinguish between *form* and *content*. The content of a picture is what it's about, its subject matter. The form, of course, is what it looks like—what kinds of colors, lines, and shapes the artist used. This distinction is not as easy to make as you might think. In fact, sometimes it is hard to see exactly what the content is.

Content Jan van Eyck's *Giovanni Arnolfini and His Bride* (fig. 8-1) seems to have a pretty obvious subject—a young man and woman standing behind a dog in a bedroom. That, along with all the subsidiary items in the room,

8-1 JAN VAN EYCK. *Giovanni Arnolfini and His Bride.* 1434. Oil on panel, 32¼ × 23½″. The National Gallery, London

might seem to be the content. As it happens, the content has further content. That is, the subject matter has a meaning, a theme, and the meaning is part of the total content of the work. There is a whole branch of art history concerned with content in this sense. It is called *iconography.* A closer, iconographic inspection of *Giovanni Arnolfini and His Bride* will quickly reveal what lies beyond the ostensible subject of the work.

Your first impression of Mrs. Arnolfini may be that hers was a "shotgun wedding," that the bride was pregnant. No, she was not, or at least most probably not.[1] She is holding the folds of her gown against her midsection. True, she does have a slightly protrudent abdomen, but that was the stylish figure of her day. This is easily observed in a rare nude from Van Eyck, a painting of Eve from the famous Ghent Altarpiece completed in 1434. In figure 8-2 I have superimposed upon a laser scan of that figure an outline drawing of the long train of heavy velvet Mrs. Arnolfini's left arm supports. It would certainly be mistaken, though, to suppose that the posture of the bride has no reference to childbearing at all. At the very least, the promise of fruition is here implied.

Giovanni's posture is of greater importance. Notice how he holds up his right hand. He is taking an oath, the oath of marriage. At the time of the painting the Church did not require the presence of the clergy for a valid marriage contract to be made between man and woman. The sacrament of

8-2 Laser scan of a Van Eyck nude with gown superimposed on it

holy matrimony was one that could be dispensed by the recipients. All that was required was a *fides manualis* (oath by joining of the hands) and a *fides levata* (oath by raising the forearm) on the part of the man. But this kind of private ceremony raised problems, since its proper performance could later be denied by a partner tired of his or her spouse. The husband might, for instance, say that he had had his fingers crossed or something. The unhappy consequences of such unions caused the Council of Trent, in the sixteenth century, to issue a decree requiring (whenever possible) the presence of a priest as God's witness to the event. The Medici banker Giovanni Arnolfini took his bride long before that. And this painting was commissioned as a proof of the event. It is, if you will, a kind of document. Indeed, there is an inscription on the wall which reads "Jan van Eyck was here." And the mirror just above reflects the room, showing the backs of the couple and, minutely pictured, the painter and a companion. Van Eyck was witness to the exchange of marital vows, and his painting notarized it.

Despite the almost magical realism of the picture, it is more than a painstaking wedding "snapshot." It was painted in 1434, when the thoughts of men were still dominated by the thoughts of the Roman Church. For centuries in northern Europe there had been no reason to do an elaborate painting except for some purpose associated with God or the Church. Hence, for hundreds of years commonplace objects depicted in art had had a special "transfigured" meaning as things that functioned in some sacred moment. Van Eyck felt that the marriage of the Arnolfinis was inferior as a subject to a picture of Christ or an apostle. Probably his patrons agreed. So the artist invested everything with religious significance. He turned a relatively insignificant moment into a sacred symbol. It became not just a picture of two middle-class patrons but also a glorification of the Christian institution of

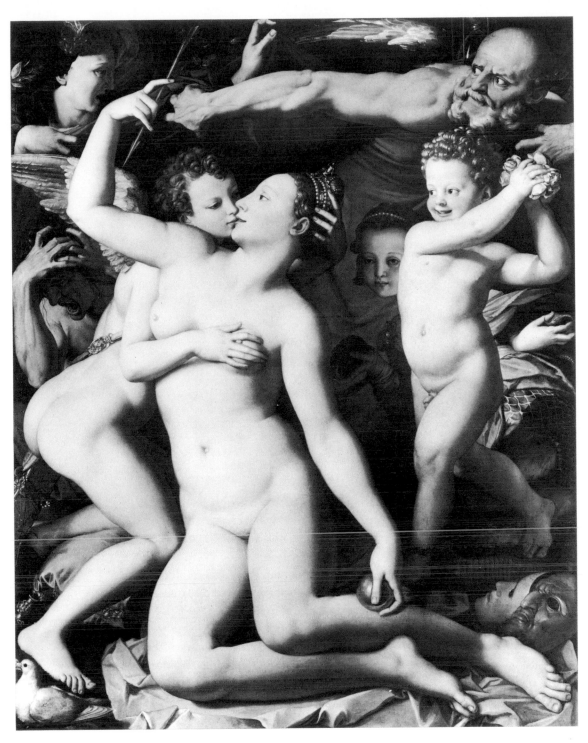

8-3 AGNOLO BRONZINO. *Exposure of Luxury*. c. 1546. Oil on panel, 57½ × 45¾".
The National Gallery, London

marriage. The Arnolfini portrait is replete with symbols relating to this theme. The bed in the background is reminiscent of those in Northern medieval Annunciations—when the Angel Gabriel informs Mary that she is to bear the Christ Child. The little dog is doubtless a symbol of fidelity. In the chandelier a lone candle burns; a candle burning in a lighted room signifies the presence of God. Sunlight itself alludes to the purity of the bride, particularly since it bathes the fruit resting on the windowsill. The fruit harkens back to the story of Adam and Eve. Finally, the mirror is convex and takes in more than a flat glass would. It has been compared to the eye of God beholding the witnesses as well as the bride and groom.

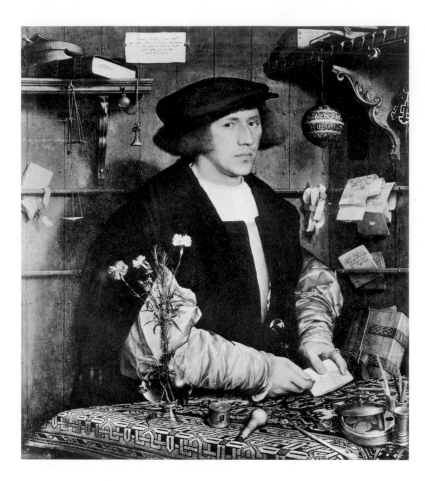

8-4 HANS HOLBEIN THE YOUNGER. *Georg Gisze*. 1532. Oil and tempera on panel, 38 × 33". Staatliche Museen, Berlin-Dahlem

A little over a century later the Italian artist Agnolo Bronzino (1502–1572) did a painting also having to do with sexual love, his *Exposure of Luxury*, formerly known as *Venus, Cupid, Folly, and Time* (fig. 8-3). It is characterized by a sort of cold lasciviousness. Venus was Cupid's mother, and here her adolescent son fondles her in a way that suggests anything but filial tenderness. She holds in her right hand an arrow taken from his quiver and in her left an apple. We take the word *sinister* from the Italian *sinistra* (left). Cupid can see the apple, but not the arrow. He is offered something that is delicious but dangerous. On the right a little figure (of a type called a *putto* in art) strews roses. He combines the ideas of pleasure and jest, something already hinted at in the apple and arrow. Venus's behavior also suggests deceit, and the picture is full of things relating to fraud. Beneath the putto there are masks, and behind him a curious creature sometimes referred to by critics of the painting as a Harpy. This being has the face of a precociously sensual little girl; the lower extremities are scaly, reptilian. In her right hand she is holding a honeycomb and in her left a poisonous lizard. But her right hand is formed like a left hand, and her left is like a right. Again, a sinister image, explicitly, the symbol of Deceit. Consider, too, the peculiar relationship of Cupid's head to his body; we have some question as to whether the head and body belong together. He kneels on a pillow, the standard symbol of idleness and luxury, just behind two billing doves signifying amorous caresses. Beneath his wing we observe an old woman tearing at her hair, a figure that has been identified as Jealousy. This highly suggestive group of weirdos is revealed to Truth by Father Time, who is shown drawing back a curtain. The subject is treacherous pleasure. It is a warning against luxury to the supersophisticated who would dismiss manifest evils as diverting pastimes.

Not all paintings are complicated in this way. *Giovanni Arnolfini and His Bride* was the result of a deliberate attempt to invest a dual portrait with

8-5 MASTER OF FLÉMALLE (ROBERT CAMPIN?). Mérode Altarpiece of the *Annunciation*. c. 1425–28. Oil on panel, center panel 25″ square, each wing 25 × 10″. The Cloisters, The Metropolitan Museum of Art, New York

religious significance. The Bronzino is an allegorical work; in fact, the title is sometimes given as *Allegory*. An allegory is a work (whether in the fine arts or in literature) in which symbolic figures and actions represent ideas about human conduct.

The majority of paintings and sculptures—the *vast* majority—are about just what they seem to be. The portrait of the German merchant Georg Gisze (fig. 8-4) by Hans Holbein the Younger (c. 1497–1543) is exactly that, a picture of a man surrounded by the materials of his trade. One might, of course, be interested in knowing who Gisze was, precisely how he earned a living, and what purpose each of the objects depicted served, but one can gain a pretty fair idea of all this just from the objective representation Holbein has given us.

What these pictures are of and about is their content; the way the artists painted them is their form. What is of more than passing interest is the way in which form can modify the meaning of the subject matter, that is, the way form influences content.

The Interdependence of Form and Content Many of you are familiar with at least the general outline of the story of Othello, the Moor of Venice. It is famous because of William Shakespeare's play. Othello, a black man who is a gallant general in the service of Venice, is married to Desdemona, daughter of a white Venetian senator. He has offended a cunning fellow named Iago by promoting a younger soldier, Cassio, over his head. Iago arranges it to seem that Desdemona and Cassio are having an affair, and stirs Othello to such a frenzy of jealousy that he murders his wife in her bed. When it turns out that Desdemona had been faithful and his fury unjustified, Othello kills himself in remorse.

Even if you've not read or seen the play, you can probably imagine how it was handled by Shakespeare. Fine. Imagine how it might appear in the work of Sir Walter Scott. Mark Twain? Ernest Hemingway? Ishmael Reed? Ann Beattie? Tom Robbins? Robert Ludlum? Obviously, the same plot would have entirely different implications in the hands of each of these authors. Indeed, the meaning of the events would take on different aspects because of the

8-6 FRA ANGELICO. *Annunciation.* 1438–45. Fresco. San Marco, Florence

varying forms the writers would give to them. Quite the same is true of painting and sculpture.

The Annunciation is a very common subject in Christian art. The essentials are the Angel Gabriel and Mary. In terms of both form and content one of the most elaborate Annunciations ever painted is the Mérode altarpiece (fig. 8-5), done by a painter whose identity was for years uncertain. You will, for this reason, see it credited to the Master of Flémalle. Most scholars now identify the Master of Flémalle as Robert Campin (c. 1378–1444), who was the leading painter of Tournai.

The altarpiece is a *triptych* (three-paneled painting). The left panel depicts the couple who donated the picture to the church. They look toward the central panel through a garden door. The spring flowers denote the season of the Annunciation. Moreover, forget-me-nots stand for Mary's eyes, and the violets and daisies symbolize her humility. The rosebush is thorny (a reference to Christ's martyrdom) and full of beautiful blossoms (standing for Mary's love). The brick wall alludes to the Song of Songs in the Bible, where a virgin is described as "a garden enclosed." The man in the background is the broker who arranged the donors' marriage. The door is a symbol of hope. The lock symbolizes charity, and the key stands for the desire of God.

The central panel depicts the Annunciation itself, taking place in a fifteenth-century Flemish room. The room contains all sorts of references to purity: a basin, a lily, a white towel, white cloths, and white walls. The Infant Jesus, carrying a tiny cross, speeds through the window on a sunbeam. And the candle on the table has just gone out; its smoke trails up in a wisp. This signifies that God has assumed human form in Mary's womb.

The right-hand panel shows Joseph in his shop. The workbench is laden with sharp gouges and other tools, all of which summon up thoughts of

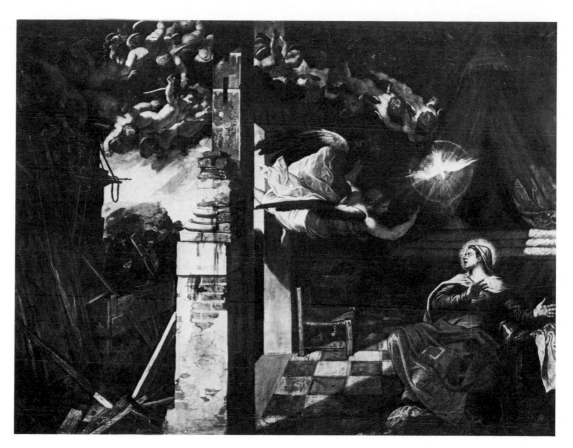

8-7 TINTORETTO. *Annunciation*. 1583–87. Oil on canvas, 13′10″ × 17′10½″. Scuola di San Rocco, Venice

torture and the Crucifixion. Joseph is boring holes in a board. There is uncertainty among scholars as to what he's supposed to be making. Erwin Panofsky, greatest of all iconographers, suggested a footwarmer. Another authority has said that it looks like a spike block. And Meyer Schapiro, another great scholar, thought it might be a fish trap. The latter suggestion is rather persuasive, because fish symbolize Christ[2] and because there is another kind of trap in Joseph's shop, a mousetrap. It is by his elbow on the table. St. Augustine had written that the crucifixion of Christ was the bait in a trap that caught the Devil just as a mousetrap catches a mouse. Marilyn Aronberg Lavin, however, would seem later to have come up with the best explanation. It is, she believes, from a winepress. Given the role of wine in the Eucharist and in Christian symbolism, it would be altogether fitting for Joseph to be drilling holes for a winemaker's sieve.

The Mérode altarpiece is heavy with content. But when one has seen what Campin's younger contemporary Van Eyck made of a simple marriage portrait, one can appreciate the care with which Campin inventoried all symbols connected with an event of universal significance. It is consistent with the style of fifteenth-century Flemish painting.

In the South during the same period, a little Dominican monk named Fra Angelico (1400–1455) decorated the monastery of San Marco in Florence with fresco paintings. One of these is an Annunciation (fig. 8-6). Again, the flower-carpeted garden symbolic of virginity is used. But nearly everything else is different. The event takes on a tender charm quite unlike the hard objectivity of the Flemish painting. Fra Angelico has used perspective and other Renaissance inventions for drawing the architecture, anatomy, and drapery, but has used them primarily with an eye to decorative effect. Even the secondary content is kept to a minimum so that attention is not distracted

from the shy Virgin and God's messenger. (The dark halos, incidentally, have no significance. Originally, the halos were painted in gold leaf. The gold has long since vanished, leaving in its place the adherent of dark gum.)

Tintoretto, whose *Last Supper* has received quite a lot of attention in these pages, also did an Annunciation (fig. 8-7). It is as flamboyant as Fra Angelico's is restrained. Gabriel swoops down through the door, startling Mary half out of her wits.

The essential subject matter of all these Annunciations is the same. But the form in which the scene was cast makes the content rather different from one to another. It is also the thing that gives the works their quality. It would be easy to imagine me telling *you,* for example, everything to put into a picture of the Annunciation, even giving you the precise positions of the figures. It might not be quite so easy for some of you to imagine undertaking a picture according to my description, but let's pretend that I'm going to pay several hundred dollars if you do—regardless of how poorly finished the picture is. Obviously, you are not going to be able to produce anything of the quality of the Campin, the Fra Angelico, or the Tintoretto, even when the content is exactly the same. As a matter of fact I could not do so myself, though I dare say mine would prove more accomplished than the trials of most—but not all—of my readers.

Since, in the final analysis, it is the form of the work that determines whether the work is good, bad, or indifferent, it is the form with which we shall concern ourselves in the rest of this chapter.

Formal "Rightness" and Families of Forms and Colors All of us have had the experience of being asked whether something—an arrangement of furniture in a room, or a combination of clothing—looks "right." Sometimes we say, "No, there's something a little bit wrong, I'm not sure what. . . . Hmmmm. . . . Maybe if you changed—" and so on. You sort of play around with possibilities until everyone is happy with the situation or until it becomes obvious that it "just won't do." Of course, one person may be satisfied with what another cannot abide. There's no way of proving yourself right or wrong in such circumstances because there are no rules. It all depends on how the thing "feels." This is true even when you agree to decide taste by majority vote of a group; one set of feelings is being weighed against another. But let's face it, some people have feelings you can rely on and some don't; some of us have good sense about these things and some of us are stupefying clods. Whose opinion would you take on selecting draperies—the collective judgment of your father's bowling team or the suggestion of an interior designer?

Since ancient times men have tried to devise prescriptions for attaining beauty in art. None of the formulas have been confirmed by history. What seemed unquestionable in one age was overturned in the next. Even an abstract, objective system like scientific perspective, which *does* have hard and fast rules, cannot be employed strictly, without exception. When it's technically wrong, as in Mantegna's *Dead Christ,* it's artistically right for the picture—because content affects form just as form affects content.

There is an old academic device used by many traditionalists to devise their compositions and, surprisingly, it retains a certain usefulness in teaching people to look at works of art. If we superimpose upon a picture a grid of evenly spaced horizontal and vertical lines further subdivided by diagonals connecting intersections, various relations that determine the composition often come into prominence. *This is not necessarily because the artist employed such grid patterns to compose the work.* Rather, formal regularity

8-8 Some masterpieces divided into thirds and "cornered" by diagonals: FRA ANGELICO. *Annunciation.* 1438–45. Fresco. San Marco, Florence (a); TINTORETTO. *Annunciation.* 1583–87. Oil on canvas, 13′10″ × 17′10½″. Scuola di San Rocco, Venice (b); HANS HOLBEIN THE YOUNGER. *Georg Gisze.* 1532. Oil and tempera on panel, 38 × 33″, Staatliche Museen, Berlin-Dahlem (c); FRANCISCO GOYA. *The Third of May, 1808.* 1814–15. Oil on canvas, 8′8¾″ × 11′3⅞″. The Prado, Madrid (d); PABLO PICASSO. *Girl Before a Mirror.* Boisgeloup, March 1932. Oil on canvas, 64 × 51¼″. Collection, The Museum of Modern Art, New York. Gift of Mrs. Simon Guggenheim (e); PIET MONDRIAN. *Composition in White, Black, and Red.* 1936. Oil on canvas, 40¼ × 41″. Collection, The Museum of Modern Art, New York. Gift of the Advisory Committee (f)

8-9 Some masterpieces divided into quarters and subdivided by diagonals: FRA ANGELICO. *Annunciation.* 1438–45. Fresco. San Marco, Florence (a); TINTORETTO. *Annunciation.* 1583–87. Oil on canvas, 13′10″ × 17′10½″. Scuola di San Rocco, Venice (b); HANS HOLBEIN THE YOUNGER. *Georg Gisze.* 1532. Oil and tempera on panel, 38 × 33″. Staatliche Museen, Berlin-Dahlem (c); FRANCISCO GOYA. *The Third of May, 1808.* 1814–15. Oil on canvas, 8′8¾″ × 11′3⅞″. The Prado, Madrid (d); PABLO PICASSO. *Girl Before a Mirror.* Boisgeloup, March 1932. Oil on canvas, 64 × 51¼″. Collection, The Museum of Modern Art, New York. Gift of Mrs. Simon Guggenheim (e); PIET MONDRIAN. *Composition in White, Black, and Red.* 1936. Oil on canvas, 40¼ × 41″. Collection, The Museum of Modern Art, New York. Gift of the Advisory Committee (f)

assists our intuition in evoking another kind of coherence in somewhat the same way that seeing notes on a scale can help even those of us who cannot actually read music to follow the melody of a song.

In figures 8-8 and 8-9 I have applied triadic (three-part) and quadratic (four-part) systems of formal subdivision to some Renaissance and modern masterpieces. One can scarcely help being impressed with how often major components of the works coincide with the divisions and crossings. Even the two Picassos fit the structures rather well. Most surprising, perhaps, is the Mondrian, since nothing *at all* corresponds to one of the grid lines in either mode. But this is a pretty definitive demonstration that Mondrian's arrangements of stripes are a great deal more creative than a cursory examination might suggest. Mondrian, in effect, devised new compositional possibilities. His asymmetries are of a higher and more original order than those of the other artists. On the other hand, many of his proportions do subscribe to the ancient formula for beauty, Euclid's *Golden Section.*

The geometric proportion called the *Golden Section* has, since its discovery by Euclid, sometime during the third century before Christ, been considered the key to formal beauty by any number of theorists in art. It is a ratio between the two dimensions of a plane figure or the two divisions of a line such that the small element is to the larger as the larger is to the whole (fig. 8-10). There is something peculiarly natural and appealing about the proportion. It occurs all through nature, even in seashells and microscopic cell structures. I have tested its appeal in art appreciation classes by giving students identical strips of paper and asking each to cut out one "perfect" rectangle. When I collect all the rectangles from a class of one hundred, there are always a few silly ones — uncut long strips, tiny little bits, and so on — but a slight majority are usually so much alike that you can shuffle them like a deck of cards. And the rectangle in the deck is a *Golden Rectangle;* the short end is to the long edge as the long edge is to the end plus itself. Incredible! But true. A typical picture shape is a Golden Rectangle: most architectural forms subscribe to the proportion, painters employ it, and trees and eggs sometimes come in that proportion (fig. 8-11). Here, the temple, the Mondrian, and the Bakota sculpture contain many Golden Rectangles interlocked with one another.

As you might expect, many artists have attempted to paint perfectly composed pictures by applying the Golden Section to their designs. Unfortunately, the fact that this ratio is a persistent feature of great works does not mean that its presence will assure greatness. It does not even imply that a work containing it will be good. And, of course, it certainly doesn't mean that works from which the ratio is absent will be poor. True, there are some zealots who insist that the Golden Section and similar ratios can *inevitably* be found in all great works of art. Their demonstrations of this contention are fre-

8-11 Golden Rectangles. The limits of interlocking ones are indicated by similar arrows at corners

quently ingenious and even fascinating. Sometimes, too, they are a rarefied form of mental torture. I am convinced that whenever the ratios are so well hidden as to require logarithmic functions to evoke them, they are not essential—that in effect they do not exist. In any case, it is possible to use the same techniques to concoct similar justifications for paintings that are hideous. All too often the measurements "come out" if you begin halfway over on a fingernail but won't work if you measure from either of the two sides of the nail. That's altogether too "iffy" for this writer. Good composition in art is less the result of ideal proportions than it is a matter of consistency of line, form, and color.

Consistency alone won't make for quality; in fact, complete consistency would be monotonous. The trick, or so it seems to me, is to attain unity without monotony. To pull off the trick won't guarantee that a work of art will be great, but it seems a basic attribute of most fine painting and sculpture that it treads a line between chaos on one side and tedium on the other.

Confronted with a blank canvas, the artist can, in principle, do anything at all. Compare his or her situation with this: I hand you a piece of white cardboard and a thousand scraps of paper in a variety of colors. You are to create a design using no more than one hundred of those pieces. So you begin gluing them onto the cardboard. At first just any shape or color will be okay. But before long you will discover that certain things don't seem to fit in with the others. For instance, if you've used rounded forms in primary hues, a pentagon of chartreuse may look completely out of place. By the time you've put in ninety-nine shapes, the character of the one-hundredth one is going to be pretty well determined.

The American artist Stuart Davis (1894–1964) did paintings that might have been created by a method like the one just described. His *Colonial*

8-12 STUART DAVIS. *Colonial Cubism.* 1954. Oil on canvas, 45 × 60″. Walker Art Center, Minneapolis

Cubism (fig. 8-12) contains choppy forms resembling paper cutouts. The white spots on the right might not look as if they went with the star in the lower left if it were not for the intervening shapes. The star is very like some of those shapes, the spots resemble parts of others, and when you have them all together they "fit." A perfect square of pale blue-green wouldn't belong. (Incidentally, this picture is quite Cubistic in its space. If these were cut paper shapes, which would be on top and which beneath?)

What Davis did in *Colonial Cubism* was create a *family of forms*. That's also what you would have done with your cardboard and scraps. We can presume that Davis, as a practiced professional painter, did a better job of it than you would have, but the principle involved in the attainment of unity would have been the same.

Families of forms exist outside art just as Golden Sections do. Trees constitute such a family of forms. So do leaves. So do people. And designers in professions *entirely* removed from art take formal consistencies into account. Among objects most people would not consider "artistic" are handguns, which is precisely why I am using them in this connection.[3]

Still, the family of forms making up my 9mm Parabellum "Luger" is entirely different from the family that constitutes the Colt .44 (fig. 8-13). The harsh, knobby look of the Parabellum has made its silhouette immediately identifiable to generations of small boys. Those prominences are functional. The one on top is a hinge for the mechanism that ejects spent cartridge cases, the one on the bottom of the handle is a grip to remove the cartridge clip, and

8-13 Parabellum "Luger" and Colt

8-14 Fantasy handgun

the one by the trigger is a button which releases the clip. The smooth contours of the Colt had some obvious advantages for a working cowboy in the 1880s. The weapon is easy to wipe clean, it comes out of a holster smoothly, and it isn't apt to get hung up on anything.

In figure 8-14 I have drawn a hybrid pistol made up of incompatible families of forms. You might like it because of its exotic, bizarre look. Science-fiction illustrators sometimes mix up things in this way to make an object look alien by making it look implausible. But only in special circumstances will one actually encounter such an odd amalgam of forms. It is not absolutely necessary that the Parabellum's grip be of that particular contour; nothing requires the butt to have a knob pull. It would work just as well if it were formed the way other semiautomatic pistols are. The knob is consistent with the general character of the weapon, that's all.

American Gothic (fig. 8-15) by Grant Wood (1892–1942) is unusually clear in the kinds of forms the painter has used as a basis for the composition. One of the most obvious forms is the pitchfork. Actually, it is somewhat unusual for a fork to have three tines; four or five are far more common. But three-tined ones are standard for handling bundles from self-tying reapers in Grant Wood's Iowa. Moreover, the trident shape is particularly well suited to Wood's artistic purposes. It is repeated in the stitching of the man's bib overalls, in the stripes on his shirt, in the symmetry of his face, in the first-floor windows behind him, and in the pseudo-Gothic window of the upper story. The curve of the fork recurs in the rickrack border on the woman's apron and in the trees behind the house.

Cézanne's *The Basket of Apples* (fig. 8-16) is far more complex in its structure, although it may seem at first to be ineptly drawn. It is full of rather queer distortions. The bottle is asymmetrical and tilted. The plate is not elliptical as it would be seen from this angle. And that table is really strange; the near edge loses its identity as it passes beneath the cloth. We might suppose that there were two tables placed together underneath the tablecloth if it weren't for two things. In the first place, Cézanne does this all the time. Secondly, the table edge doesn't match up on the backside either; a line drawn along the right side through the plate won't meet the side on the left of the plate. And there are other strange things. Why is the basket of apples propped up so that fruit spills out on the table? And how about those cookies? Now, I ask you, who would stack cookies that way?

You can probably guess that I wouldn't point out these things if I didn't

8-15 GRANT WOOD. *American Gothic.* 1930. Oil on beaverboard, 29⅜ × 24⅞". The Art Institute of Chicago. Friends of American Art Collection

8-16 PAUL CÉZANNE. *The Basket of Apples.* 1890–94. Oil on canvas, 25¾ × 32". The Art Institute of Chicago. Helen Birch Bartlett Memorial Collection

a b

8-17 Scheme of Cézanne still life contrasted with scheme of traditional still life

want to say something about them. And, after the analysis of Cézanne's *Mont Sainte-Victoire,* you most likely realize that the artist knew what he was up to.

The queer-looking bottle is a good place to begin. Notice how similar it is to the shape between itself and the basket; that space looks a little like the bottle inverted, flipped over, and painted a lighter color. The highlight on the bottle makes its left side resemble the dark shadow at the very bottom of the picture. And it is possible to draw a continuous line from the left edge of the bottle down under the basket through the cloth all the way to that dark spot. Also, notice how the lower half of the basket has its curve mirrored in the line from the apple on the far right along the edge of the folded cloth through the next apple and up to the apple adjacent to the basket. Not easily seen in the black-and-white reproduction is an echo of that movement in a depression beneath the lowest apple of the three directly below the basket. There are many such familial relationships. These are but a few.

A comparison of the two schematics in figure 8-17 should serve to illustrate the magnitude and meaning of Cézanne's departure from traditional drawing. One thing is apparent at a glance; of the two the "Cézanne" (*a*) is by far the more stable. It is more like the space it fills; its lines and forms are reminiscent of the outline of the rectangle containing them. *B,* a shabby composition, drawn in accordance with the rules of geometric perspective, has no comparable suitability to its particular space. It does, however, have a highly dramatic and effective space. By contrast *a* is "standoffish," like a wall. Its space is not dramatic at all. But the relationships within the space are dramatic. One must be aware that the table in Cézanne's drawing had no prior existence. This isn't true of the table in *b* because it is a projection, and projections have an existence in the rules according to which you draw them. Cézanne's table is unique. Yet it is not drawn in this odd way just to be perverse. It belongs, like everything else in his picture, to a whole series of relationships. Meyer Schapiro has said of this still life that "deviations make the final equilibrium of the picture seem more evidently an achievement of the artist rather than an imitation of an already existing stability in nature."[4]

Turn back for a moment to figure 6-5, Picasso's *Girl Before a Mirror.* Obviously, the forms are of a related family. Study for a while the way one shape fits into another and the way these join together to make still larger shapes. Look, for example, at all the shapes under the extended arm. Pick out the ones that contain black or touch a black zone of color. Do you see how they connect up into their own independent group and grow over into other areas

of the painting? Try the same thing with the white shapes, with cool ones, with those that curve, and so on. You will discover that new aspects of the work constantly emerge and that they awaken new attitudes toward the painting.

Some Comparisons and Contrasts In these pages such a point has been made of the fact that painters must depart from reality in order to portray it that you may suppose the same isn't true of sculptors. They are, after all, dealing with three-dimensional forms, and it is possible to model figures of wax that are so like living beings that they can be mistaken for humans at rest. Still, we do not consider Madame Tussaud's amazing craft an art of much importance. So close a copy of a human being or a piece of fruit is fascinating precisely because considerations of formal composition do not enter in. The moment you become aware of the artifice involved in creating them, the manikins in a wax museum look horribly stiff and dead.

Michelangelo's *David* (fig. 8-18) is clearly not a person—it is thirteen feet tall and made of solid rock—but it bursts with a vitality more potent than that of living creatures, although the *David* is not shaped the way real men are, not even the way highly developed men are.

Within recent decades there has been a movement toward waxworks-like realism among certain American sculptors. The works of Duane Hanson (born 1927) are made by taking plaster casts of people, making plastic molds from the casts, and finally adding real clothing and other paraphernalia (see fig. 8-19). The content is rather amusing as a comment on the vacuity of certain social values. The form is startling in its verisimilitude. But it hasn't

8-18 MICHELANGELO. *David.* 1501–4. Marble, height of figure, 13'5". Academy, Florence

8-19 DUANE HANSON. *Tourists.* 1970. Fiberglas and polychromed polyester, 64 × 65 × 47". National Galleries of Scotland, Edinburgh

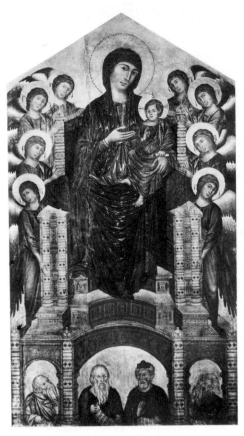

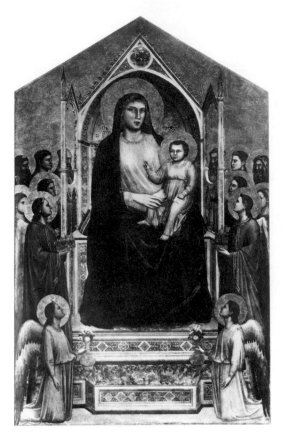

8-20 CIMABUE. *Madonna Enthroned.*
c. 1280–90. Tempera on panel,
12′6″ × 7′4″. Uffizi Gallery, Florence

8-21 GIOTTO. *Madonna Enthroned.* c. 1310.
Tempera on panel, 10′8″ × 6′8″. Uffizi Gallery,
Florence

the power of continuous interest of something like the *David*. Quite probably we in art would pay no attention to Fiberglas copies of people if it weren't for the fact that serious art had been dominated by nonrepresentationalism for so long. It was kind of refreshing to see people like Hanson flying in the face of all that art critics and professors have been saying is good for forty years. But we must not forget that even during the days when abstract art was "it" no one doubted that Michelangelo's *David* was a masterpiece. Even Hanson is defended by his dealer, Ivan Karp, on the grounds that his work is interesting "because the volumes are right."

It may be of interest, at this point, to reexamine some of the masterpieces we've touched on before.

That Cimabue was aware of the necessity to maintain a pattern of similar forms is made clear in his *Madonna Enthroned* (fig. 8-20). There is so much repetition that the work verges on the monotonous. Giotto's version (fig. 8-21) is as advanced in its composition as it is in its spatial effects. Note that the upper third of the picture is light in value. The central section containing the standing angels and the body of the Virgin has a lot of darks. The lowest part, including the two kneeling angels and what's between them, contains large light areas. There is an overall pattern of large-scale value masses. Within that pattern many others operate. The dark area of Mary's robe contrasts with the lightness of her face, blouse, and child. The impact of this large accent draws one's attention to the dominating personalities. The same kind of device was used by Holbein two and a half centuries later in the portrait of Georg Gisze (fig. 8-22). It would be easy to lose our way in the mass of detail surrounding Gisze were it not for the fact that the sitter's face and blouse constitute the largest and lightest area surrounded by the largest, darkest areas. In the Giotto the content also helps direct attention to the center of interest. In the

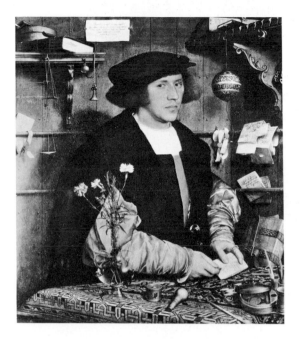

8-22 HANS HOLBEIN THE YOUNGER. *Georg Gisze.*
1532. Oil and tempera on panel, 38 × 33″.
Staatliche Museen, Berlin-Dahlem

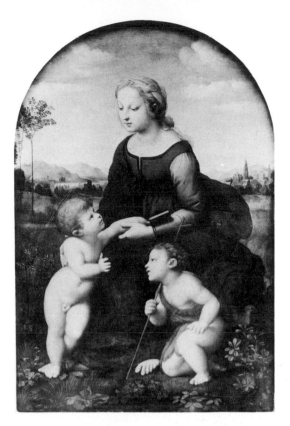

8-23 RAPHAEL. *Madonna of the Beautiful Garden.*
1507. Oil on panel, 48 × 31½″. The Louvre, Paris

Cimabue all the angels look out at us, Mary looks out, Christ looks out. Only the two prophets in the lower left and right direct their gaze toward anything within the work itself. In Giotto there is a psychological focus. The angels all look at Mary and her son. Mary looks at us. Christ is the most self-sufficient of all; He seems already to ponder the meaning of His life on earth.

Raphael's *Madonna of the Beautiful Garden* (fig. 8-23) is a later painting and is much more sophisticated. The artist has turned his figure group into an articulated whole by means of smooth, graceful curves. The line of Christ's hip continues up through His mother's arm and proceeds in an S turn back over her shoulders. Her shoulders are themselves abnormally smooth and circular. The top of her dress matches them. The hills, the clouds in the sky, and even the arc of the frame relate to the gentle swelling curves prevailing in the figures.

Monet's *Haystack at Sunset Near Giverny* (fig. 8-24) and Van Gogh's *The Starry Night* (fig. 8-25) were painted only two years apart (1891 and 1889) by modern artists of unquestioned genius. In some ways they are very much alike. Both are landscapes, both are frontal, both are concerned with private visions. The private vision of Monet was based on his attempt to render with complete objectivity the color sensations he perceived in a given time and place. That of Van Gogh was a blend of the objective condition of reality with his subjective feelings about it. Monet broke everything down into little spots of color, weaving a fabric of interlaced hues. His technique reduced the world to brushstrokes, and they produced a cohesive pattern because of their similarity in scale and weight. The relative massings of strokes of various hues coalesced into shapes from which the larger composition grew. The brushstrokes in *The Starry Night* are more like drawn lines than spots. They are filled with energy and drive that reveal the painter's feelings about the world. Nebulae rage across the heavens in the night, and cypresses spring up like dark flames against the sky.

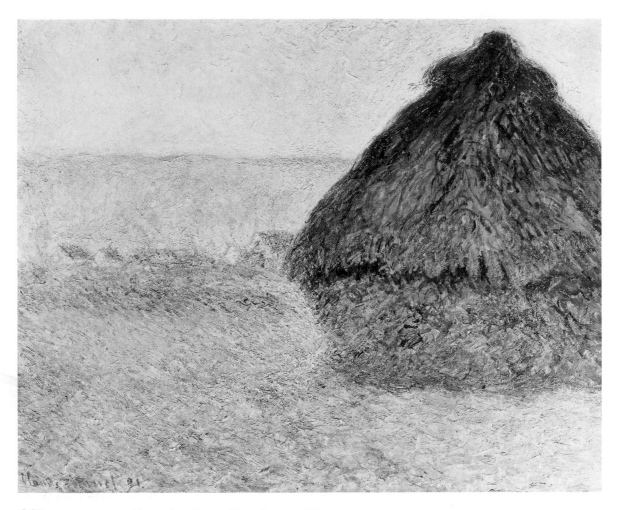

8-24 CLAUDE MONET. *Haystack at Sunset Near Giverny.* 1891. Oil on canvas, 29½ × 37″. Museum of Fine Arts, Boston. Juliana Cheney Edwards Collection

It is easy to see why Vincent van Gogh has come to represent in the popular mind the example of a genius who created in the throes of maddened frenzy. He *was* mentally ill: he had delusions, once during a seizure he cut off about half of his own ear, and he finally committed suicide.[5] But he was a great artist in spite of, not because of, his affliction. His study for *The Starry Night* (fig. 8-26) is excessive in its fervor; everything is sinuous, intertwined, over-wrought. In the final painting such violence has been curtailed. The painting has been ordered, resolved, and made richer by pitting stable lines against wavy ones. The sketch is typical of sophomoric "Expressionistic" works, the oil painting, an example of excellence.

One of the most famous paintings in the entire history of art is Leonardo's *Mona Lisa* (fig. 8-27). Her strange smile is so haunting that it has become a part of the folklore of our civilization. The subject was Lisa,[6] wife of Francesco del Giocondo, but she never got the portrait; Leonardo liked it so much that he kept it for himself. A great deal has been written about why she looks at us in this way, about the circumstances under which the picture was painted, and so on. Most of it is nonsense. When you hear someone explain the smile, you must take into account something that most speakers don't—this is an oil painting done in a technique that is time-consuming. Such an expression occurs in this kind of oil portrait because the painter chooses to put it there.

In his *Mona Lisa* Leonardo is playing games with us. The ambiguity of the famous "gioconda smile" is the result of two things. One is the artist's skill in

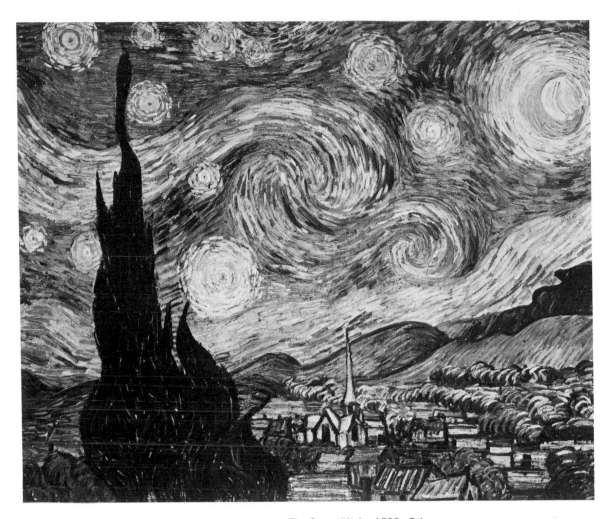

8-25 VINCENT VAN GOGH. *The Starry Night* 1889. Oil on canvas, 29 × 36¼". Collection, The Museum of Modern Art, New York. Acquired through the Lillie P. Bliss Bequest

8-26 VINCENT VAN GOGH. *Cypresses and Stars,* study for *The Starry Night.* 1889. Reed pen, pen, and ink, 18½ × 24⅝". Formerly Kunsthalle, Bremen (destroyed in World War II)

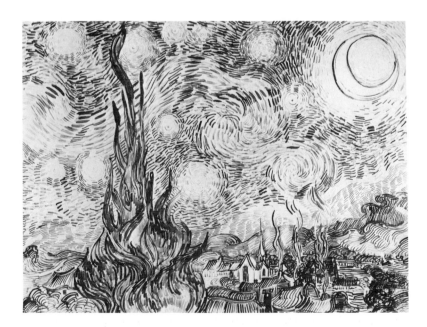

handling chiaroscuro so as to blur our perception of the second thing. The second thing is the radical asymmetry of the face. Cover up the left half and you will see that she is smirking rather superciliously. Cover up the right half and you will observe that she is cool and reserved. All faces are asymmetrical,

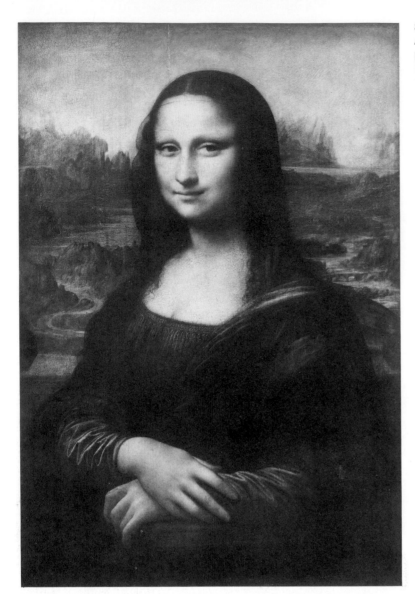

8-27 LEONARDO DA VINCI. *Mona Lisa.* 1503–5. Oil on panel, 30¼ × 21″. The Louvre, Paris

and all good portrait painters make use of this fact. But Leonardo has made La Gioconda's face do what a real face couldn't—maintain two expressions simultaneously without a hint of strain or unnaturalness. Also, the face has been harmonized by bringing the arc of the brows, the cheeks, the lips, and the chin into parallel. The same curve is repeated in the top of her dress, the slope of her shoulders, the shape of the top of her head, and in details of clothing. It is a masterful and ingenious work, in which form and content are so completely tied together as to be inseparable.

Leonardo was a homosexual. Willem De Kooning is not. But about 1950 De Kooning started painting gigantic pictures of women in a way that would make you think he avoids both women and sex. His *Woman and Bicycle* (fig. 8-28) evokes the female as a crazed, maniacal, vampirish sex symbol. The forms are born of violent, smeary brushwork played off against flat zones of color. Yet all kinds of artistry are working here, revolting though their consequences may seem. To take a simple example, the feet of the figure merge with the immediate background so as to produce a whole area of sienna. An adjacent yellow area above (a skirt?) has a similar configuration. Seek out such comparisons and you will be able to see why critics speak of De Kooning's talents as a painter. I myself cannot abide his work in this vein; in my opinion it is vastly overrated. I can see, however, that it is not empty of value. Some of you may be as enthusiastic as most critics. You don't have to agree with my judgment, obviously. Neither do you have to go along with

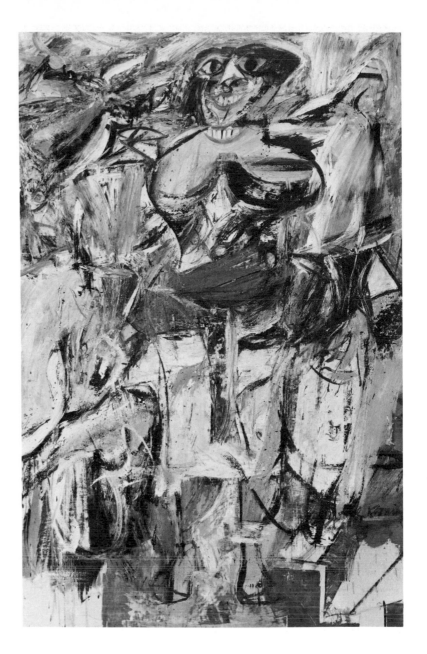

8-28 WILLEM DE KOONING. *Woman and Bicycle.* 1952–53. Oil on canvas, 76½ × 49″. Whitney Museum of American Art, New York

fashionable opinion. Who knows? I may change my mind about De Kooning. I have modified my opinion of Roy Lichtenstein.

Lichtenstein is what has come to be called a *Pop* artist. His early work was very delicate and sensitive. In the 1960s he developed a new manner. It involved turning comic-strip panels into huge paintings. Figure 8-29 is from a comic strip; figure 8-30 is a Lichtenstein painting. At first they look quite a lot alike, although perhaps the looseness of the cartoonist's rendering is more appealing than the tight, almost mechanical drawing in the oil painting. Art historian Albert Boime did a formal comparison of the panel with the painting, and it is worth quoting here:

> In the *Brattata* the balloon is modified from the original to correspond more closely to the shape of the pilot's visor. . . . the balloon stem is carefully brought into compositional play with regularly recurring features in the picture. Departing from the straight stem of the original panel Lichtenstein repeats his own crescent shape in the speed lines of the falling plane, in the highlights of the visor and around the knob on the control panel. Its arc parallels the curve of the helmet and recurs in the contours of the pilot's profile. An even more significant change is Lichtenstein's formal emphasis of the cartoonist's visual "sound effect" of

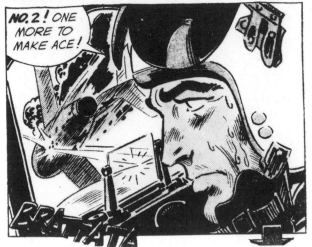

8-29 Anonymous comic-strip panel

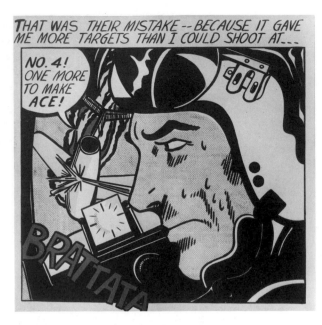

8-30 ROY LICHTENSTEIN. *Brattata*. 1962. Oil on canvas, 42 × 42". Courtesy of Greenberg Gallery of Contemporary Art, St. Louis

machine-gun fire (*Brattata*) not only in size and color but in the increased tilt which counterbalances the mass of the falling plane. A comparison with the original also reveals how Lichtenstein uses the balloon in his correction from two to four as the number of downed planes required "to make Ace."[7]

The paintings of Larry Rivers (born 1923), like those of De Kooning, marry Expressionistic brushstroking to representational drawing. And, like Lichtenstein, Rivers sometimes paints pictures of pictures. His *Dutch Masters and Cigars III* (fig. 8-31) proves just how complicated this can get. First off, the Dutch Masters trademark is an old master, Rembrandt's *The Syndics*, and so while Rivers is using popular art as a point of departure, he is also closely tied to fine art. Using *The Syndics* for a trademark is a case of honoring greatness with levity, especially when the painting is animated for TV. Rivers reversed this by memorializing the trivial and making a cigar box into a cultural monument. The coupling of his drawing style with Rembrandt's figure composition produced an extraordinary effect of renewed vitality. And there is a kind of fascinating interchange of forms occurring between the top and bottom versions in Rivers's painting. The rhythmic play of the angular blotches that move through the pictures, seeming to erase them at one point, helping to articulate them at another, is almost like counterpoint in music. The cigars are handled with similar delicacy. The two at the base suggest the traffic lanes and divider strips of the Long Island Expressway, where the billboard that inspired this painting stood.

Style in Art Each of the foregoing artists has an individual "style" that is unique and recognizable, yet is also part of a more general tendency during his time and place. The word *style* has so many different meanings as to be unwieldy. "She's not my *style*." "I don't care for the new styles in clothing." "His style evolved from folk music." "When this Brother talks, he comes on with style." "The life style of young people during the 1960s was very

8-31 LARRY RIVERS. *Dutch Masters and Cigars III.* 1963. Oil and collage on canvas, 96 × 67⅜". Harry N. Abrams Family Collection, New York

different from that of young people today." At the root of all of these applications of the word *style* is the recognition that objects and individuals and groups of objects and individuals have certain things peculiarly characteristic of them, things which distinguish them from other objects, individuals, or groups. A man with hair to his shoulders, who customarily wears tie-dyed shirts and trousers of blue denim, has a different *style* from someone with a crew cut, a Botany 500 suit, and a "color-coordinated" shirt and tie. The grooming style of the first person identifies him with a completely different group from the one the second belongs to. But someone who shaves all his hair except for a short, four-inch triangle on top, who never wears anything but jump suits and slippers with pointed toes, and who affects a platinum ring through his lower lip could be said to have a unique style. Unless it should catch on, in which case he'd be the founder of a style.

Among the most familiar examples of pure style are the various typefaces used in printing. Figure 8-32 presents the uppercase ("capital") letter S in a number of different styles. The letter's appearance varies according to the kinds of lines and forms that make it up, and it is easy to determine, on a purely formal basis, which lowercase *a* in figure 8-33 goes with which S in figure 8-32.

In art, *style* refers to the customary series of forms, colors, and techniques used by an artist. Sometimes these can be identified as characteristics of whole groups of artists; thus, we can speak of a fifteenth-century Flemish style in painting, of the French Impressionist style, or of the Cubist style. It is easy to see that Robert Campin (fig. 8-34) and Van Eyck (fig. 8-35) have many things in common when compared with Monet (fig. 8-36) and Degas (fig. 8-37). The

8-34 MASTER OF FLÉMALLE (ROBERT CAMPIN?). Mérode Altarpiece of the *Annunciation.* c. 1425–28. Oil on panel, center panel 25″ square, each wing 25 × 10″. The Cloisters, The Metropolitan Museum of Art, New York

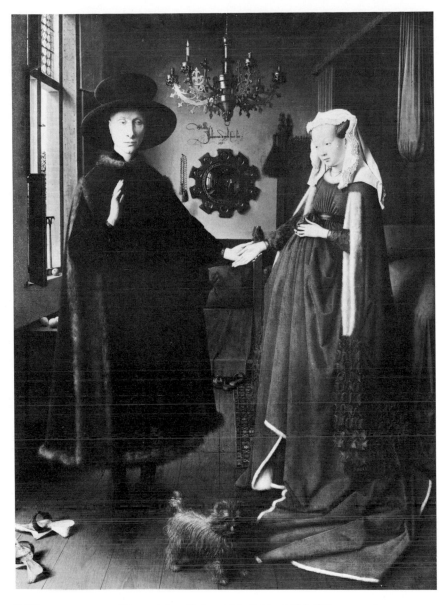

8-35 JAN VAN EYCK. *Giovanni Arnolfini and His Bride.* 1434. Oil on panel, 32¼ × 23½". The National Gallery, London

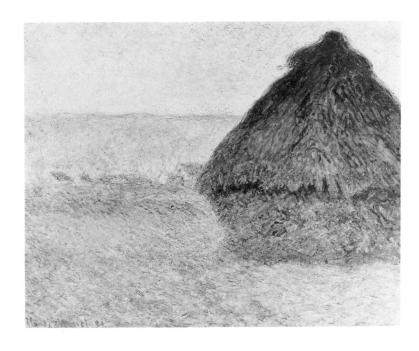

8-36 CLAUDE MONET. *Haystack at Sunset Near Giverny,* 1891. Oil on canvas, 29½ × 37". Museum of Fine Arts, Boston. Juliana Cheney Edwards Collection

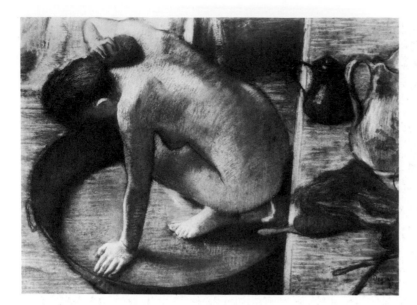

8-37 EDGAR DEGAS. *The Tub.* 1886. Pastel, 23½ × 32⅓″. Musée d'Orsay, Paris

Cubist work of Pablo Picasso (fig. 8-38) and Georges Braque (fig. 8-39) is even more alike than the work of the two Flemish painters or the two Impressionists.

But there is another side to style. There are always specific traits in any artist's work which will differentiate it from that of anyone else. Van Eyck is like Campin, but there are also things about his drawing and painting that are as individual as his fingerprints. That is obviously true of the two Impressionists. Even the Picasso and the Braque have certain distinctive features that will set them apart for the expert eye. If any of these artists had wished to completely submerge his identity in another's style, he would have been unable to do so. No imitation, no forgery, is ever perfect. For in every individual there are parts of the personality that remain invincibly insulated from external influence or conscious will. This truth is one we must not overlook. But no matter how you view it, the style of a period or group is easier to identify than the style of an individual within a period or group. That is, it's a pretty good bet that you wouldn't mistake a Degas for a Monet the way you might the Braque for the Picasso. But there's *no* chance that you'd mistake either the Monet or the Degas for any of the others.

Once in a while we encounter paintings so much alike that a qualitative difference between them seems unlikely. But a little attention to particulars can enlighten us about the way in which individual genius overcomes an imposed style. In the works of Raphael and his teacher Perugino (c. 1450–1523) we have the perfect example. In 1500 Perugino portrayed the marriage of Mary and Joseph (fig. 8-40). In 1504 Raphael painted his *Marriage of the Virgin* (fig. 8-41), following the pattern established by his teacher.

At a glance the two works are almost identical. There is a row of figures in the immediate foreground, a courtyard behind them, and a temple beyond the court. A brief study will show that, while the content is the same and the styles seemingly alike, the individual styles are really quite different.

The Perugino figures form a much more solid row; they are like a wall. We observe them with the same detachment with which we look upon the temple. The principle of horizontality is ruthlessly carried through by Perugino. The figure arrangement, the long panels in the courtyard, the extremely broad temple steps—all stress the horizontal. The temple is a distracting element. It has two porticoes out to the sides. An identical one projects toward us, but we

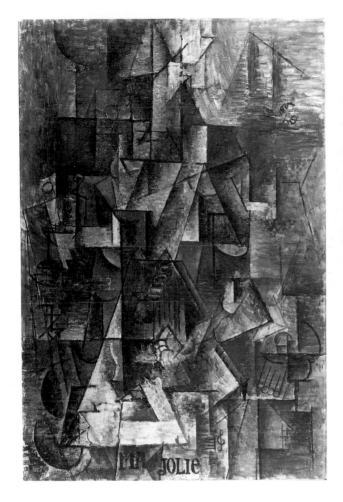

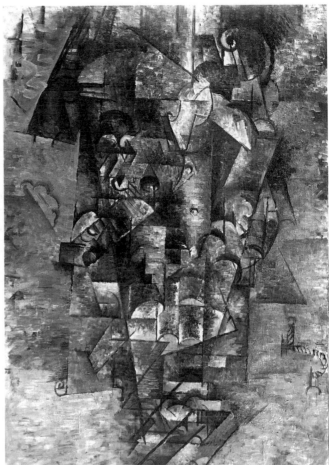

8-38 PABLO PICASSO. *"Ma Jolie."* Paris (winter 1911–12). Oil on canvas, 39⅜ × 25¾". Collection, The Museum of Modern Art, New York. Acquired through the Lillie P. Bliss Bequest

8-39 GEORGES BRAQUE. *Man with a Guitar.* (Begun Céret, summer 1911; completed Paris, early 1912) Oil on canvas, 45¾ × 31⅞". Collection, The Museum of Modern Art, New York. Acquired through the Lillie P. Bliss Bequest

don't realize it's a porch at first. What captures our attention is the doorway in the center of the shaded archway. That door is the most arresting single element in the whole work. The perspective is wrong too. There is one eye level for the temple, another for the figures.

Raphael has overcome most of his teacher's weaknesses. His row of figures is not so absolutely parallel to the picture plane. The young woman on the left stands closer to us than Mary, helping to lead the eye into the picture. Too, the fellow breaking a stick over his knee—symbolic of leaving one family for a new one—matches the girl's diagonal. In the Perugino the same ritual figure is lost among the other members of the foreground group. Raphael's courtyard is calculated to convey depth, and his temple has a coherence Perugino's lacks. Raphael has absorbed the porches into a continuous arcade, and he has decreased the depth of shadow around the door. Moreover, he has given the priest a brocaded belt with a strong vertical accent; it helps connect the temple door to the foreground figures. Too, the doorway is smaller than the one in Perugino. The courtyard panels are shorter, producing a series of brief diagonals that lead from the figures to the temple steps.

Perugino organized his painting in terms of a family of forms that tend to separate things into horizontal bands. It is a unified composition insofar as the visual pattern is concerned. But Perugino's pattern gets in the way of psychological coherence. Raphael's system of forms is as unified as his teacher's; but

8-40 PERUGINO. *The Marriage of the Virgin.* 1500. Oil on panel, 92⅞ × 73¼". Museum of Fine Arts, Caen, France

it contributes to the representation, it doesn't disrupt it. The different emotional tone of the two works is revealed in small by the postures of the individuals portrayed. In Perugino the people to the left and right of the three central figures form self-contained groups. This is one way of keeping our attention on Joseph, the priest, and Mary. Another is by posing the couple in as symmetrical a manner as possible, even using the same curve for the folds of their robes. (This business of repeating poses is a trademark of Perugino's. You can find background figures on the court whose postures reflect those of figures in the foreground. He uses posture as an abstract, formal element.)

Raphael gives his principals much more individuality in dress as well as in pose. And they are related to the others present by their robes: the folds and hems of their gowns are in line with the folds and hems of other gowns. Still, our attention is drawn back to them again and again because of the strategic positioning of the distant figures on the court, the way in which the divisions in the pavement and the central bank of temple steps create two perfect trapezoids, and the linear developments through the group.

The figures in the Raphael, like those in the Perugino, have an eye level separate from the one for the temple. There are also two vanishing points: one in the doorway for the courtyard and temple and one for the figures at the wedding ring Joseph places on Mary's finger. The ring is directly in line with the vanishing point in the door. Technically, the perspective is incorrect. But it emphasizes that the temple and the marriage ceremony are equally important

8-41 RAPHAEL. *The Marriage of the Virgin.* 1504. Oil on panel, 67 × 46½". Brera Gallery, Milan

elements of the scene. The insistence with which both artists try to make this point—the sanctification of love by religious ceremony and the singularity of this particular marriage—is a little obtrusive. The idea is one bound to produce a hint of disunity because our attention is permitted neither to rest on a specific point nor to rove freely over the entire picture. We are torn between the temple and the figures. Nonetheless, of the two treatments Raphael's is by far the more successful. His personal style affords more cohesiveness than Perugino's. His is the more integrated view of the world.

It would be misleading to say that formal composition comes down to nothing more than developing unmonotonous similarities of shape, line, and color. Obviously, there is a good deal more to it than that. Proportions, painting and drawing techniques, spatial illusions, the nature of the content—all have a role in giving any work its unique form. In one way or another we've been dealing with formal composition all along, in discussing the elements of space, line, chiaroscuro, and form. What this chapter has tried to do is summarize some of the relationships critics refer to as "form."

MEDIA AND METHODS

Many of the words used in discussions of art are vague because they were drawn from common language. *Form, style, color,* and *line* are all in very general use and so have meanings other than the special ones we have given them in the vocabulary of art. This was not formerly true of the word *media,* but in recent years it has come to be the case. Nowadays, everyone speaks of "the media." What they refer to are the media of mass communication: radio, television, newspapers, magazines, motion pictures, and so forth. *Media* is the plural form of *medium.* We have the medium of radio, the television medium, and broadcasting media. In the fine arts we are concerned with painting media, sculptural media, printing media, and, within painting, sculpture, and printmaking, the oil medium, the medium of cast bronze, and the medium of the block print.

The medium an artist chooses for a given work has an important bearing on how the work is going to look, and not all media lend themselves to the same expressive ends. Monet's haystack pictures would not be effective cast in bronze, that's obvious. But neither would they be as effective in tempera or watercolor as they are in oil. To understand this is to go a long way toward an appreciation of an artist's work and, therefore, some discussion of media is in order. Again, the size of this book will not permit more than a cursory look at a few of the more prominent two- and three-dimensional media. But one can get a notion of how material considerations affect artistic decisions from examining just a few media and works. Additional information can be obtained from the books listed in the Bibliography on page 403.

Two-Dimensional Media

Painting Media In the discussion of pigments in chapter six I mentioned that paints differ according to the medium or vehicle[1] into which the pigment is mixed. It would be possible to add water to the pigment powders and paint a picture with them. But the pigment would not adhere to the paper or canvas; as soon as the water evaporated, the pigments would dust off. To have a painting it is necessary that the pigments stick to the surface, and this, in its simplest terms, is what a medium causes to happen. A medium binds the pigment particles together and to the picture surface.

Tempera One of the best media for binding pigment is egg yolk. Yes, just plain egg yolk. If you've ever tried to clean breakfast dishes which have been

9-1 SANDRO BOTTICELLI. *The Birth of Venus.* c. 1480. Tempera on canvas, 5'8⅞" × 9'1⅞". Uffizi Gallery, Florence

left sitting for a couple of days, you know how hard dried egg can be. The pigments that Botticelli used to paint *The Birth of Venus* (fig. 9-1) were ground in whole egg, and the name for that medium is *egg tempera*. The term means simply that the pigment has been "tempered" by egg. (What they call "tempera" in grade schools is not real tempera; it's a cheap distemper in which the binder is a glue.) Normally, we speak of egg tempera as "tempera."

Tempera paint has some very desirable characteristics for an art material. The major one is that it is highly permanent; colors ground in it don't change appearance much over a long period of time. But there are also problems connected with its use. It is very viscous—sticky—and it dries instantly. This means that the artist cannot blend tones together smoothly; his picture must be made up of short little strokes, all of which are separate. The Botticelli doesn't look this way in the reproduction because the painting is large and reproductions are small. But if you look at the original from up close, you can observe that it is built of very, very tiny individual brushstrokes.

Another factor tempera painters must take into account is a slight transparency of the medium. It is in the nature of the relation between the pigment and the egg that a completely opaque color cannot be achieved. This means that correction of errors is pretty much out of the question. Consequently, tempera paintings are carefully planned and executed according to a prescribed routine:

1. Tempera paintings are usually done on wooden panels. *The Birth of Venus* was done on linen, but it is an exception. Most of Botticelli's works were done on wood. For a large painting such as his *Madonna of the Pomegranate* (fig. 2-25) several planks of Italian poplar or German limewood were joined together virtually without a seam. The wood used for the panel must be completely dry, and it will have been seasoned for a year or more. It is then sanded to a perfect smoothness.

2. The panel is prepared to receive the picture by covering it with several coats of a mixture of plaster of Paris and glue called *gesso*. The successive layers are sanded alternately rough and smooth so that each layer is bonded to the one before and after it. When sufficient thickness has been applied, the surface is sanded to a degree of smoothness such that the finished product looks like a sheet of ivory.

3. The next step is to make on paper a fine, detailed drawing the exact size the final work is to be. Such a drawing is called a *cartoon* (the source of our term for frivolous drawings) and is made up from various preparatory sketches and diagrams the artist has created in the course of conceiving the

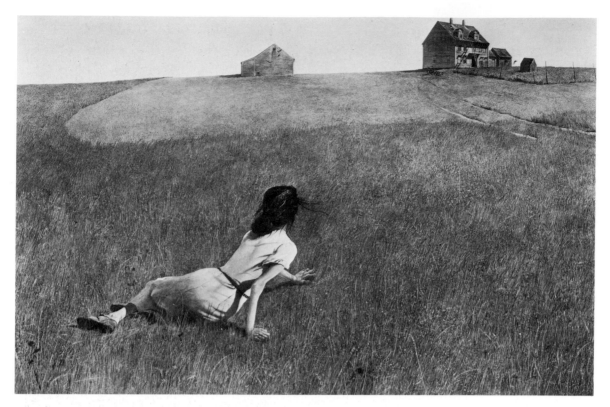

9-2 ANDREW WYETH. *Christina's World.* 1948. Tempera on gessoed panel, 32¼ × 47¾".
Collection, The Museum of Modern Art, New York. Purchase

picture. The cartoon is transferred to the panel in the following manner: Tiny holes are pricked through the outlines of the shapes. Then the cartoon is placed on the panel, and the artist shakes charcoal dust through the holes onto the gesso. The resulting tiny dots can be connected up with a line.

4. The entire work is painted in one color—normally earth green, a dull but highly permanent green made from earth. The shadows will be dark green, the penumbra pale green, and the lights clear white. This *underpainting* is exact but is monochromatic (all of one hue).

5. The artist then builds his picture up in a series of layers. Initially they are very light and transparent, and they grow stronger as the final outside layer is approached. Highlights are most opaque, shadows most transparent. Certain colors are excluded from the palette because eggs contain albumen and albumen contains sulfur, which tends to darken certain pigments.

The effect of the completed tempera painting is one of neatness and delicacy. Because of the semitransparency of the medium and because the gesso base is white, tempera paintings have a certain kind of luminosity and glow denied other media. Still, it is a tedious medium in which to work, and it is rarely used today. Among Americans, though, one of the best known of all modern works is a tempera painting, *Christina's World* (fig. 9-2) by Andrew Wyeth.

At first *Christina's World* resembles a Surrealistic work, but the image is based on fact, not fancy. Christina Olsen was a crippled neighbor of Wyeth's in Cushing, Maine, and she used to crawl about her property in just this way. The poignance of his friend's circumstance touched Wyeth, and in the painting he has turned it into a symbol of each person's solitude. In order to do so, he eliminated a few critical items from the landscape. For instance, there is a grove of trees up to the left of the house, rising against the crest of the hill. Vast emptiness suited the theme of the work, so he left out the trees.

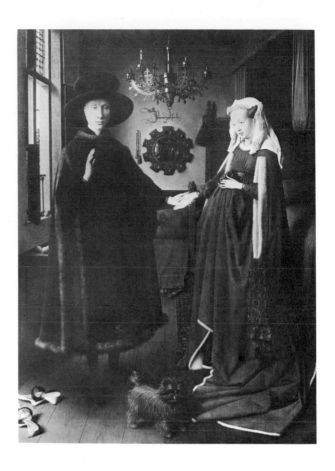

9-3 JAN VAN EYCK. *Giovanni Arnolfini and His Bride.* 1434. Oil on panel, 32¼ × 23½". The National Gallery, London

Oil Paints Robert Campin, painter of the Mérode altarpiece (fig. 8-5), seems to have been the first person to add vegetable oil to his egg yolk and pigment. Since oil dries very slowly, this had the advantage of making the paint somewhat easier to handle. Jan van Eyck and Hubert van Eyck developed Campin's gimmick into an elaborate painting technique which substituted a clear, quick-drying varnish-oil mixture for the egg-oil medium.

Jan van Eyck's *Giovanni Arnolfini and His Bride* (fig. 9-3) was done in almost exactly the way that tempera paintings are. The principal difference was the vehicle for the pigment. But what a difference! Even quick-drying varnishes take many hours to harden, and it is possible to manipulate the layers of transparent pigment (called *glazes*) so that brushstrokes are practically nonexistent. Precise degrees of transparency or opacity can be secured. It is relatively simple to make corrections when painting with oils. The range from dark to light is much greater than with tempera. Since the oil does not affect the color of the pigments, no hues have to be omitted. Moreover, the range of technical effects that can be obtained is far, far greater with oil than with tempera.

Most of the paintings in this book were done in oil. Van Eyck, Titian, Vermeer, Monet, Mondrian, Kandinsky, et al., all worked with oils. Yet how dissimilar were the effects they obtained. Oil paint can be transparent or opaque, can be applied thinly or thickly, can be used to secure precise edges or bold splashes, depending on the preference of the painter. Small wonder that of all painting media oil has been the most popular among artists.

Nothing is without its handicaps, however. Oil color is not quite so permanent as tempera, even though the range of hues and values is far greater. And, while it is relatively easy to correct errors because oil as typically used is opaque and light colors will cover darks, there is at least one factor which limits the painter's freedom. In painting with oils you must always put fat over lean, never lean over fat. This is workshop jargon for indicating that it is not

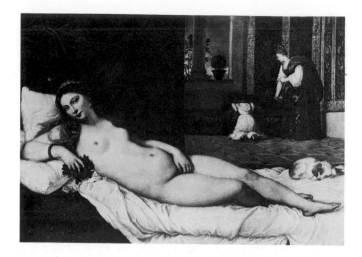

9-4 TITIAN. *Venus of Urbino*. 1538. Oil on canvas, 47 × 65". Uffizi Gallery, Florence

possible to paint a less oily pigment over an oily one. Oh, it's possible to apply it, but the paint will craze and peel off. Oil painters take care to proceed in such a manner that all the paint is of the same oiliness throughout or that successive layers are progressively oilier.

At first, oil paintings were done on wooden panels covered with gesso, just like tempera paintings. But in the early sixteenth century in Italy panels were replaced by canvas stretched over wooden frames. The use of canvas has continued down to the present day. Canvas is lighter than wood, and it is easier to weave large canvases than it is to build immense panels.

Titian's *Venus of Urbino* (fig. 9-4) is a fine example of oil on canvas. The technique Titian followed was essentially as outlined below:

1. Linen canvas is stretched taut over a frame of wood. Then the canvas is rendered impervious to oil (which eventually rots fabrics) by coating it with a hide glue of some sort.

2. Various kinds of grounds other than brittle gesso may be applied. The simplest is white lead with enough oil (10 or 15 percent) to make it plastic. Applied to the canvas with a trowel or thinned with something "lean" (such as spirits of turpentine) so it can be painted on, the white lead forms the base for the picture. Since it is much leaner than any usable oil pigment, it will pose no problems for the artist.

3. The entire surface is stained gray, brown, or dull green with an *imprimatura* of earth color thinned in spirits of turpentine or some other nonoily solvent.

4. Monochromatic underpainting is worked out onto the imprimatura according to the method the artist prefers. It might be as detailed as a tempera cartoon, or it might be sketched onto the canvas rather loosely and then worked up by trial and error. In any case, Titian would have painted the major elements of his *Venus of Urbino* in a monochrome.

5. Hues of varying intensity and value are then glazed over the underpainting. The oil-varnish glazes let the values show through but add the richness of color to the work.

6. Finally, various details and highlights are added to complete the work. Some of the paint is applied opaquely, some of it is *scumbled*. To scumble means to drag the brush lightly across previous brushstrokes or canvas to produce a broken, speckled effect.

The technique described here (but using varying formulas for grounds, underpainting, and glazes) constituted the technical procedure in oil painting from the High Renaissance all the way up to the middle of the nineteenth

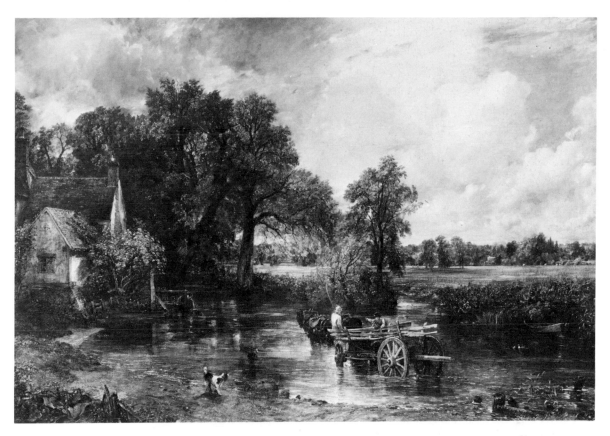

9-5 JOHN CONSTABLE. *The Hay Wain*. 1821. Oil on canvas, 51¼ × 73″. The National Gallery, London

century. Some artists still make use of the same methods today. They provide the painter with well-established and time-tested means of control without rigidity.

Whatever one can say in favor of the Venetian oil technique, it too has strict limitations. Constable's *Hay Wain* (fig. 9-5), Monet's haystacks, or Van Gogh's *The Starry Night* could not have been created using Titian's system. All these paintings are done in what we call *alla prima*. In this technique the final colors and relationships are already present in the first attack on the canvas. This is the way most laymen think most pictures are painted, and it is the way amateurs always try to paint. But it was only after 1800 that many oils were done in this way. The *Hay Wain* had a seminal role in the change from the traditional working up of a painting from monochrome through successive layers of color to the more direct way of painting a picture.

Constable, more than any previous artist, was intrigued by the transitory effects of nature. A close friend of William Wordsworth, he attempted to capture in his paintings all that is spontaneous and naturally poetic in the British landscape. No classical technique could have given us all those flickering reflections on the water or hinted at the flutter of leaves in a summer breeze as successfully as Constable's scumbled color over scumbled pigment. Delacroix recognized the merit of the method when he first saw the *Hay Wain* and incorporated some of its technique into his own work. Realists and Impressionists followed suit. But the Impressionists had the advantage of materials which were not at Constable's disposal.

Today oil paints are sold in tubes. The first year that they were so dispensed was 1841. Prior to that the colors were sold in flat tins or, more commonly, in powders which the artist ground into the medium. Commercially produced oil pigments sold in tubes have some special properties. For one thing, they are far more transportable packed in tubes than in the other forms. This por-

tability made it possible for Monet to go out and paint directly from nature rather than from sketches and memory. The haystack series, among others, is contingent on such direct observation of nature. A second feature of tube colors is that they tend to be thicker than pigments mixed by hand. Tube color is about the consistency of toothpaste; a ribbon of it laid on straight from the tube will stick to the canvas and not run off. Also, brushstrokes can have an extremely high impasto. Van Gogh used his oils in both these ways.

Another factor that had an important bearing on the work of the Impressionists and so-called Postimpressionists was the invention of new chemical pigments. Some of these, like the malachite green that turned Van Gogh's billiard table brown, were disastrous for painting. But many of the new colors were tremendously important for artists like Monet who wished to capture every nuance of nature's hues. Between 1826 and 1861 artificial ultramarine blue, cadmium yellow, mauve, cobalt yellow, and magenta all appeared.

Polymer Paints Contemporary artists are beginning to move away from oil paint and to favor synthetic media, of which the most common is polyvinyl acetate. Polymer pigments look much like oils but have tremendous advantages for many artists. They are similar in many ways to their house-paint brethren, the so-called latex paints. They are water-compatible, that is, they can be thinned with water and the brushes can be cleaned with water. But once they have dried, water will not dissolve them. Neither will anything else except special solvents designed to remove house paint and furniture varnish. You can, therefore, paint layer upon layer of polymer pigments without fear of dissolving the lower layers or worrying about them bleeding through. The paints can be applied as thickly as oil paint, or as thinly, but the painter can ignore any consideration of fatness or leanness. The consequent range of effects is incredible, but the medium lends itself particularly to clean, hard-

9-7 PAUL JENKINS.
Phenomena Graced by Three.
1968. Acrylic, 64 × 48″.
Collection the artist

edge abstractions such as *Yellow Arc* (fig. 9-6) by Michael Smith (born 1936).

Whereas it may take days or weeks for oil paint to dry enough to overpaint, with polymer-tempered pigments it is a matter of minutes or, at most, two hours. Most writers on art consider the quick-drying quality of the polymers to be an advantage, and for most modern styles it is. However, for anyone who works in a style that requires a good deal of blending and carefully articulated modeling, the polymers dry too quickly. The producers of the various brands have marketed agents which slow the drying time of their paints, but I have not yet found one that works really well—at least not as of this writing.

Acrylic Paints Another group of synthetics use acrylic resins as a binder. These paints are oil-compatible and can be thinned with water, linseed oil, or turpentine. The use of oil will slightly slow the drying time. Without the addition of oil these paints behave much like the polymers. Too, the acrylics can be dissolved with turpentine long after they have dried. This means it is possible to "erase" portions of a painting and rework it.

The artist Paul Jenkins (born 1923) has done a number of extraordinary works with acrylic-resin pigments in a way that takes advantage of the relative quickness with which they dry, their clarity, and their range of opacities. In his beautiful *Phenomena Graced by Three* (fig. 9-7) the delicate zones of color

9-8 WINSLOW HOMER. *Hurricane, The Bahamas.* 1898. Watercolor, 14½ × 21″. The Metropolitan Museum of Art, New York

were not painted on but floated and poured on before the canvas was stretched. His ability to control the effects thus achieved is amazing.

Both polymers and acrylics have been tested for durability by exposure to every possible factor except unlimited time. They are far more resistant to climatic conditions, light, and heat than oils or egg tempera. They do not darken as much as oils. And they are generally tougher, more flexible, and less easily damaged.

Watercolor There are several kinds of water-compatible paints—tempera, polymer, acrylic, gouache—but the best-known is transparent watercolor. Transparent watercolor pigment is available to artists either in tubes or in dried cakes which are soluble in water. The binder in this medium is gum arabic, a water-soluble gum which comes from the acacia tree. The painting surface is ordinarily a handmade paper with a prominent texture.

Two of the world's greatest watercolorists, Winslow Homer (1836–1910) and John Marin (1870–1953), happened to have been Americans. Homer's *Hurricane, The Bahamas* (fig. 9-8) exploits every characteristic of the medium. The palm fronds bending in a high wind are captured in a few swift brushstrokes, the buildings noted in a sketchy way that helps convey an impression that the air itself is blurred by the speed of the wind. The sky is overcast and glaring. No white paint has been employed—the latticework behind the red flag was produced by scraping with a knife. Since the major aims of the watercolorist are the attainment of transparency and spontaneity, white paint is almost never used. Traditionalists would consider it cheating.

9-9 JOHN MARIN. *Marin Island, Maine.* Watercolor, 15¾ × 19″. Philadelphia Museum of Art. A.E. Gallatin Collection

Light value is achieved by letting paper show through. This means that Homer always had to start with lights and work toward darks; in working with watercolor this is even more essential than with tempera.

People whose only experience with watercolor was in childhood are always amazed that watercolorists can control the paint. Laymen expect that the paper will lump up and the colors all run together and get muddy. It does require skill to prevent those things, but professional artists' materials help. Good watercolor paper is very heavy and is taped onto a drawing board or tacked to a canvas stretcher while dripping wet. When it shrinks, it stretches as flat and firm as a drumhead. Watercolorists use quite expensive sable brushes which can produce either bold strokes or extremely fine ones, depending on how they're handled. And, of course, professional artists' pigments are much more intense than children's play sets.

John Marin has, by some, been considered the greatest twentieth-century American artist, largely because he used the watercolor medium with unprecedented strength and vigor. *Marin Island, Maine* (fig. 9-9) speaks to the viewer in a kind of shorthand signifying trees, rocks, and rills—a shorthand that does not depart from the realities that inspired the picture. Marin's watercolors are abstract in the ordinary sense that he has left out a lot of nonessentials. They are also abstract in the sense that they are concerned with the play of formal elements in and of themselves. Note the way in which the great sweep in the sky is mirrored in the island and the water. The rough texture of the paper and the transparency of the paint contribute to an extremely effective image of Marin's private island.

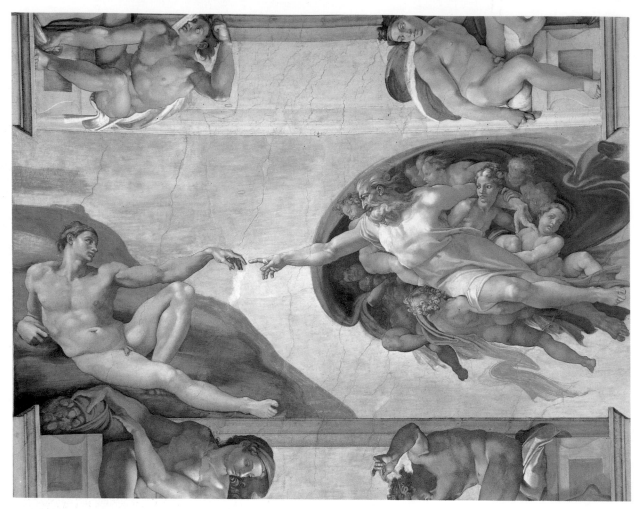

9-10 MICHELANGELO. *The Creation of Adam.* 1508–12. Fresco. Sistine Chapel, Vatican, Rome

Fresco Painting All the paintings we have discussed thus far fall under the general heading of panel pictures. This term applies even though most of them are on canvas and two on paper. The point is that they are not *murals*— paintings done on walls.

Most of the great mural paintings which have been done throughout history are either mosaics, formed of bits of glass and stone, or are frescoes. Because fresco is a bit more difficult to understand without knowing something of the process, I have chosen to deal with it here.

Fresco is an Italian word which means "fresh." There are two kinds of fresco, *fresco secco* (dry fresco) and *buon fresco* (good fresco). The former is done on a dry wall with a medium closely resembling egg tempera.[2] The latter is what normally goes by the name *fresco;* it involves painting into wet lime plaster with pigment mixed into limewater. The layer of calcium carbonate formed by the limewater binds the pigment to the plaster wall, and the mutual wetness of the pigment and the surface causes the color to dye the wall. This makes for a highly permanent decoration, as long-lived as the building itself. Permanence is the main advantage of fresco and is, of course, its own recommendation.

Michelangelo's *Creation of Adam* (fig. 9-10), like all the other works on the ceiling of the Sistine Chapel in the Vatican, is an example of fresco painting. Since plaster cannot be rewet, once it is dry, the fresco artist never applies more plaster to his surface than he knows he can finish in a single day. Consequently, we can find places in this fresco where plaster joints occur.

9-11 Woodgrain and relief prints

9-12 ALBRECHT DÜRER. *Demonstration of Perspective, Draftsman Drawing a Lute.* From the artist's treatise on geometry. 1525. Woodcut. 5¼ × 7⅛". Kupferstichkabinett, West Berlin

9-13 LEONARD BASKIN. *The Anatomist.* 1952. Woodcut, printed in color, block: 18¾ × 11". Collection, The Museum of Modern Art, New York. Gift of the Junior Council

9-14 EMILE NOLDE. *The Prophet.* 1912. Woodcut, 12¾ × 8⅞". National Gallery of Art, Washington, D.C. Rosenwald Collection

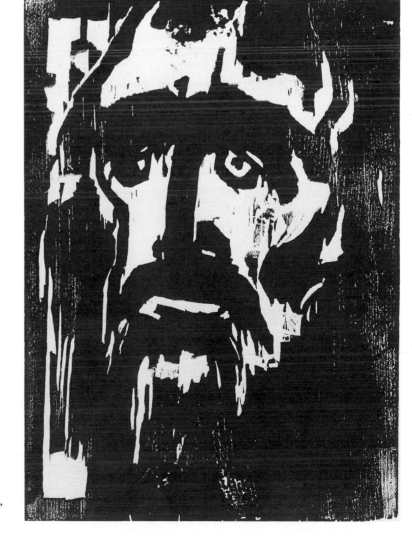

a

b
drawing
cross section of block

c

d

e'

f

9-15 The relief-painting process

red blue yellow

red + yellow = orange

blue + yellow = green

red + blue = violet

9-16 Color printing

There is a seam where Adam's neck fits onto his body and another at the line between the torso and the legs. Adam is about twelve feet long, and it took Michelangelo three sessions to complete him.

Because of the bleaching effect of the plaster, fresco color is never very intense. Some pigments are excluded because of the chemical incompatibility between them and lime. Too, in fresco even more than in tempera, correction is impossible. To have effected a change in Adam's nose, Michelangelo would have had to remove all the plaster containing the head and begin anew. Here, too, elaborate cartoons and precise preparatory studies were necessary before the artist undertook the actual painting.

Frescoes are still done for large buildings, but the method has not changed in hundreds of years except for the introduction of colors that Michelangelo did not possess.

Printmaking Earlier, in chapter three, I spoke of buying artists' prints as an alternative to collecting paintings and distinguished these handmade, multiple originals from the photomechanical reproductions sometimes given the name of "prints." When you compare and contrast the production methods described on pages 56–58 with the processes discussed hereafter, you will be able to appreciate how much more involved is the artist in the creation of a genuine print.

Prints fall into four general categories: relief, intaglio, planographic, and stencil.

Relief Prints The principle of relief printing is easy to grasp because it is so familiar. You have made thousands of them. When you leave a wet footprint on a poolside, you are relief-printing your sole in water onto concrete or tile. Unless you have abnormally flat feet, only the toes, ball, heel, and a tiny part of the outside edge of the foot come into contact with the surface. These are the parts of the sole that are in relief. The arch, the spaces between the toes, and the area between the toes and ball of the foot are recessed; they don't touch the surface, so they don't print. That's all the term *relief printing* means: that the image is printed by carrying ink to the paper from a raised surface. Fingerprinting is another commonplace example. Stamp pads ink the relief surface of the rubber stamp. Typewriter keys strike the ribbon with the relief part of the key and make the mark. Printers' type is another example.

Relief prints can be made from so many substances that it is useless to enumerate them. In grade school halves of potatoes are sometimes used to make relief-print designs. Linoleum is used by children and artists as well. There are many, many possibilities.

Among artists the most common forms of relief printing are *woodcut* and *wood engraving*. The basic difference between the two is that woodcuts are carved into the plank grain of the wood and wood engravings into the end grain (see fig. 9-11). Since it is difficult to secure smooth, unchecked end grain of any size, wood engravings are seldom over a few inches wide. At the same time, because end grain does not pose problems of cutting with, against, or across the grain, it permits much more intricate designs than plank grain. Not that woodcuts are necessarily crude. Dürer's *Demonstration of Perspective* (fig. 9-12) and *The Anatomist* (fig. 9-13) by Leonard Baskin are anything but that. The same thing, however, could be done on a far smaller scale as wood engraving. Of course, not every artist wishes to achieve refinement of detail; in his woodcut *The Prophet* (fig. 9-14) Emile Nolde, the author of the *Last Supper* reproduced as figure 6-4, conveys an image that seems to have been

ripped from the plank by the maddened fingers of a talented lunatic. Such stunningly raw effects are common to the movements identified with Expressionism.

Figure 9-15 is a graphic demonstration of the relief process as it is carried out in woodcut. (*a*) This is the image the artist wishes to print. Notice that the rectangle is to the left of the circle. When the printmaker draws the design onto the plank (*b*), he will reverse the image because all relief prints come out backward. (*c*) He then chisels away all the areas he wants to come out as white when the block is printed. All the relief forms are carved wider at their bases to prevent chipping. (*d*) With a soft rubber or gelatin roller called a *brayer* the artist inks the block with oil-base printers' ink. (*e*) A soft thin rice paper is best for printing. Placed on top of the block, it is rubbed with a wooden spoon or similar implement so that the moist ink is transmitted from the relief surface to the paper. (*f*) An impression is pulled. The block is reinked for the next impression, the rubbing repeated, and so on, until an edition is complete.

Blocks can also be printed mechanically on presses, but hand rubbing is preferred by most artists for a number of reasons. Although tiresome, hand rubbing offers more control, since the printer can see just enough through the rice paper to tell what is properly printed and what is not. Also, in order to be printed on a press properly, a wood block should be absolutely true, which is not necessary with rubbing. Finally, it is possible to print woodcuts of much larger dimensions by rubbing because the size of the block is not limited by the size of the press.

In Dürer's print whatever is white was carved out, and whatever is black was left standing. Similarly, the darker spots in the Baskin are printed from the wooden ridges and plateaus that form the relief surface of the block. The areas that appear to be gray in our reproduction are red in the original print. They could have been blue or green or yellow or any color, since they depend for their hue upon the ink the printer chooses. I do not know whether the anatomist's chart was cut into the same block as the anatomist and inked a different color or cut into a different block and printed separately in red on the same sheet of paper. But most color woodcuts involve separate blocks. By combining several blocks so that their successive impressions overlap on the same piece of paper, it is possible to secure secondary and tertiary hues, as shown in figure 9-16. Such effects can be obtained because the inks can be made transparent by the addition of a clear base. Of course, relationships far more subtle and complex than the diagram suggests can be obtained by a practiced printer. But this is the idea. And it is the procedure followed in the other kinds of printmaking too; normally, a separate color means another block, plate, stone, or screen.

In the beginning and, indeed, for a good many years after the invention of movable-type printing, the only feasible way to integrate pictures into printed text was through the use of woodcuts and wood engravings. As a matter of fact, virtually all of Dürer's woodcuts—including the one in figure 9-12— were intended as illustrations accompanying printed commentary or Biblical verse. There is, therefore, a kind of traditional, nearly hallowed association between the appearance of woodcut imagery and printed words, and one frequently sees articles and stories illustrated with what appear to be woodcut impressions. You should be aware that the qualities of relief prints can be imitated with a graphic-arts material called *scratchboard*, a cardboard covered with a uniform thickness of white clay. The illustrator draws upon this surface with a brush and India ink, then scratches away parts using needles, knives, and special tools. Figure 9-17 is a scratchboard drawing done by the

author as an ensign for a literary magazine. It looks almost exactly like a wood engraving but was certainly a great deal easier to do. But, of course, there is only one drawing. The printed images are all photo-offset reproductions.

One kind of relief printing deserves special mention. Since 1960 *collagraphy*, originated by Glen Alps, has become extremely popular among printmakers. In this technique, pieces of cardboard and of materials such as lace and cloth are glued to a rigid surface (Masonite, hardboard, or metal). The resulting collage (which sometimes includes "found objects") is then inked and printed on an etching or lithography press. Delicate and striking textural effects can be obtained by lacquering the materials; indeed, the design is sometimes created with lacquer brushstrokes alone. Advantages of collagraphy are that it permits the artist to achieve large-scale relationships with relative ease, it produces color fields that are very flat and powerful in their impact, and it lends itself to combination with intaglio and lithographic printing.

Intaglio Prints Intaglio printmaking is exactly the opposite of relief printmaking. Rather than printing from a raised surface, the intaglio method prints from recessions. Line engraving, etching, and drypoint are the most common forms of intaglio. Ordinarily they are done on plates of metal, but it is possible to use other materials, for example Plexiglas or Formica. American currency is printed from steel-plate line engravings by an intaglio process called *gravure*. Most fine-arts prints are done on copper.

A *line engraving* entails incising grooves directly into the metal with sharp steel tools called *burins*. Burins are of various shapes and sizes, but the kind shown in figure 9-18 is typical; it is a lozenge-shaped steel rod bent at an angle of about 30° so that the worker's hand clears the plate. To cut through metal with this instrument requires considerable muscular control, since continuous pressure must be exerted and the burin cannot be tilted or rocked during cutting. Line engraving is a difficult and demanding medium, but the resulting line has a vigor, clarity, and intensity no other kind of mark can match. Dürer's *Adam and Eve* (fig. 9-19) is a superb example, as is Heinrich Goltzius's (1558–1617) *The Farnese Hercules* (fig. 9-20).

The engraved line which results from a sharp groove carved into metal by a V-shaped tool has the capacity to fatten and taper off to a mark so thin as to be invisible to the unaided eye. In *The Farnese Hercules* the artist has followed the forms of an ancient statue which had been discovered in 1540. It is a

9-17 JOHN ADKINS RICHARDSON. Scratchboard illustration for *Sou'wester* magazine. 1979

9-18 Burin

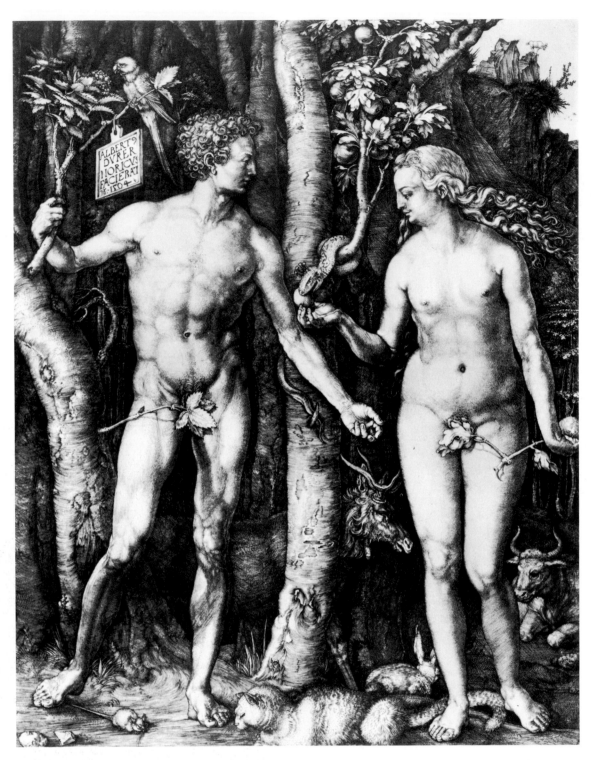

9-19 ALBRECHT DÜRER. *Adam and Eve.* 1504. Engraving, 9⅞ × 7⅝″. Museum of Fine Arts, Boston. Centennial Gift of London Clay

Roman copy of an original done about 350 B.C. by the Greek sculptor Lysippus. It was restored and set up in the courtyard of the Farnese Palace in Rome. When Goltzius's engraving of it is seen as expected, from a slight distance, the skein of lines models the powerful musculature of the mighty hero, Hercules, whom Lysippus had represented exhausted by the eleventh of the twelve labors eventually assigned him. If one steps more closely, to study the skin surface of the first and foremost of the Greek superheroes, one is

9-20 HEINRICH GOLTZIUS.
The Farnese Hercules.
c. 1592–93. Engraving.
Museum of Fine Arts,
Boston

9-21 HEINRICH GOLTZIUS.
Detail of *The Farnese
Hercules*

confronted by a linear maze of dazzling complexity (see fig. 9-21). Figure
9-22 shows the process. (*a*) One begins with a polished copperplate about one-
sixteenth of an inch thick (that is, 16 gauge), completely flat and beveled on all
four edges. (*b*) Sitting facing the direction of the cutting motion, the engraver
pushes the burin through the metal. The burin is never turned; all curved lines
are made by pivoting the plate. Burin grooves are clean, clear, sharp V-shaped
troughs. The deeper they are, the heavier and darker the line they will print.
No mark is too fine to print; the merest scratch will show. One of the

9-23 H. G. ADAM. *Anse de la Torche, No. 12.* Engraving, 18 × 33½".
The Brooklyn Museum, New York

characteristics of an engraved line is that it can be made to fatten and taper. Cross-hatching can suggest powerful volumes by taking advantage of this capacity. Very broad lines in engraving are really the consequence of many smaller cuts made right against one another. This effect can easily be seen in the engraving by H. G. Adam (fig. 9-23). As one cuts, a spiral of metal shaped like a watch spring curls up ahead of the burin. These burrs are razor sharp and must be removed as the engraver proceeds.

As you can see, line engraving is a mode of expression that requires a good deal of practice and tremendous patience. Many artists do not care for the effects it produces, preferring a more spontaneous medium. Others simply have neither the time nor the will to master the peculiar skills required. For these another method of intaglio is available.

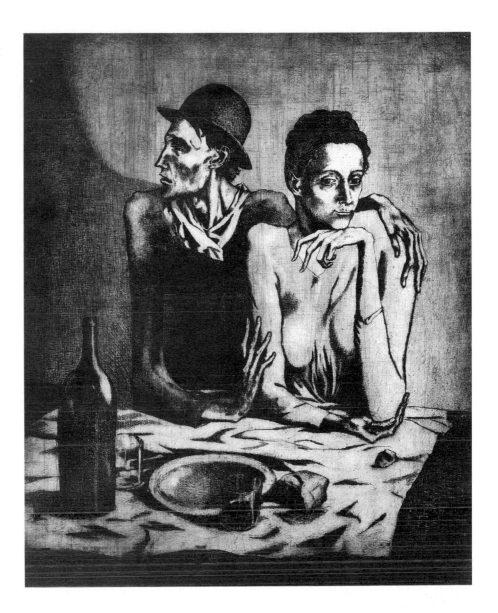

Etchings are far, far easier to produce than engravings. That is why so many painters of the past have chosen this medium instead of some other graphic-arts technique. We have seen a Rembrandt etching, his *The Descent from the Cross: By Torchlight* (fig. 5-40), Picasso's *The Frugal Repast* (fig. 9-24), and Degas's *Self-Portrait* (fig. 5-31), which is also an etching. What these artists have done, in effect, is substitute acid for pressure to create the intaglio recesses in their plates.

Figure 9-25 shows you in part (*a*) the kind of design the artist wishes to produce in an etching. (Notice that both the circles and the lines are partly thin and partly thick and that in one place thick lines cross thinner ones.) As in engraving, the deeper the recess, the darker the line. (*b*) A copperplate identical to the kind used in engraving is covered with a waxy substance called *etching ground* which is impervious to acid. (*c*) The lines are scratched through the wax with a sharp needle so as to lay the metal bare. (*d*) The artist immerses the plate in a solution containing a mordant, for instance, nitric acid. The acid away eats the exposed copper—it "etches" the plate. The longer the plate stays in the solution, the deeper the acid eats. (*e*) To produce the contrast between thin lines and thick ones the etcher removes the plate from the etching solution and paints over the parts he wishes to remain lighter. This is called *stopping out*. Usually one uses an acid-resistant varnish for this

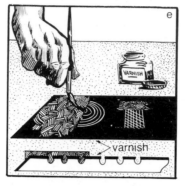
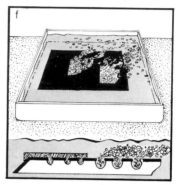

9-25 The etching process

purpose because it is easier to control than ground. (Varnish is no good to use for ground because it is too brittle for the needle to cut cleanly.) (*f*) When the plate is reimmersed in the etching solution, the parts covered by the varnish remain as they were, but the acid continues to eat away at the exposed areas. To achieve the thin lines crossed by heavy ones, the etcher cleans the plate with solvents, regrounds the surface, and draws through the new ground over the old lines. Then the plate is simply re-etched for as long as required to produce the effect. This is easy enough to do because etching ground is applied in a very, very thin layer and the existing troughs are readily visible. Rembrandt was a master of the technique. Some of his shaded areas contain five or six different line weights.

It is also possible to secure black and gray tonal areas in etching by using *aquatint,* a technique that involves dusting the plate with rosin powder, fixing it to the surface by heating the plate, and etching areas of the plate so that the surface becomes sandpapery in texture. There is a method of securing exact duplications of the textures of fingerprints, lace, feathers, and other similarly delicate substances by putting petroleum jelly or tallow into etching ground so that it remains soft. The texture is pressed into this *soft ground.* When it is removed, some of the ground pulls away, leaving an impression. Then the plate is etched as it would be in line etching. There is also a primitive form of engraving called *drypoint.* Here, an etching needle is used to scratch the surface of the metal. The scratching causes furrows of metal to rise up on either side of the groove, and their roughness produces a furry-looking line when printed. All the methods—engraving, etching, aquatint, soft ground, and drypoint—might be used in a single plate.

What puzzles most people about intaglio printmaking is the printing itself. How do you get an image from the recesses? You do it by the process shown in figure 9-26. (*a*) The plate is completely covered with sticky printers' ink. The ink is driven into the grooves with a felt-covered tool called a *dauber.* (*b*) The

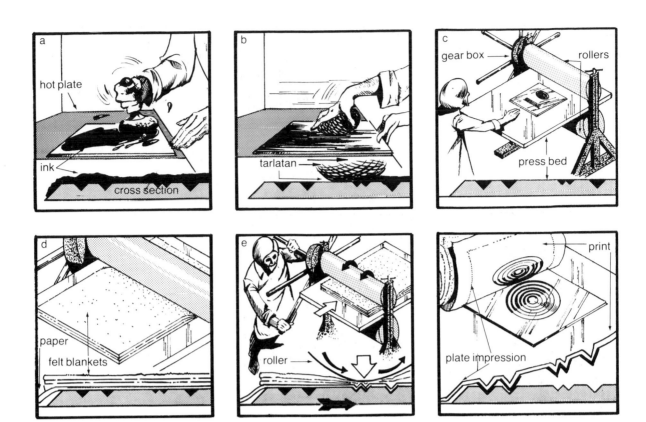

9-26 Intaglio printing

printer wipes the ink from the surface while leaving the ink in the recesses. He begins wiping with coarse, open-weave material such as mosquito netting or tarlatan (starched cheesecloth) and then moves to muslin and/or the edge of his hand. Wiping requires a certain amount of skill, and different people do it in different ways. The idea is to clean the surface and not the lines. (c) The plate, then, rests face up on an etching press, which is essentially a steel bed between gear-driven steel rollers. (d) The artist places on top of the plate a sheet of heavy printing paper, moistened to the point where it is limp, blotted so that no truly wet spots remain. On the paper are placed three soft felt blankets. (e) The press bed rides between the rollers as the artist turns the star-wheel spokes. The top roller squeezes the blankets onto the paper and the paper onto the plate under tremendous pressure. Because the dampened paper is pliable and the felt is soft, the pressure drives the paper down into the grooves. (f) The paper has been *embossed*. If it had been run through the press on top of an uninked plate, it would be white-on-white embossing; since the grooves were filled with black ink, they are now black. Sepia ink produces sepia lines; green, green lines; and so forth. This same printing technique is used in engraving, etching, and all other intaglio processes. Unfortunately for indolent artists, the complete process of inking must be repeated for each impression.

Embossing and intaglio go together. You don't get one without the other. An original intaglio print will also reveal the impression of the plate itself as an indentation in the paper. (The reason we bevel the plate is to prevent the sharp edge from slicing through the paper and also cutting the felt blankets.) Today intaglio prints are framed with a cardboard mat so that a margin of paper shows between the plate impression and the mat. On the bottom margin the artist's signature, the date, the edition number, and the title will appear in pencil. The same procedure is also used when matting other kinds of prints, but with intaglio the relation of the mat to the edge of the impression is much more evident.

9-27 HONORÉ DAUMIER. *Les Témoins (The Witnesses at the Door of the Council of War)*. 19th century. Lithograph, 10 × 8¾". The Metropolitan Museum of Art, New York. Schiff Fund, 1922

Planographic Prints There is only one kind of planographic printing in the fine arts, lithography. Planographic means that the print results from an image that is neither above nor below the surface but on it. The surface involved was originally, and usually still is, the smooth face of a block of Bavarian limestone, hence the name litho (stone)-graphy (drawing or writing). Plates of zinc and aluminum can also be used. Unlike other printmaking media, which depend upon such relatively obvious mechanical differences as raised surfaces that contact paper, troughs that contain ink, or stencils that block out areas so ink can't pass through to them, lithography depends upon the fact that oil and water will not mix.[3]

Lithographs are easily mistaken for ink or crayon drawings because they are drawn with *tusche*, a water-soluble grease that comes in both liquid and crayon form. Honoré Daumier's lithograph *Les Témoins* (fig. 9-27) exemplifies the power of the medium. Compared with relief or intaglio, it is a relatively swift process and far more direct. Neither a woodblock nor an engraved plate looks much like the black-and-white thing printed from them. They are indirect. A woodcut is a carving. When you draw lines to be etched, they appear as bright copper trails against the dark brownish hue of the ground. But in lithography the drawing you make on the stone closely resembles the image it will print, except that it is reversed.

The lithographic process (fig. 9-28) begins with a perfectly flat slab of limestone (*a*) which has been given a slight "tooth" by grinding with carborundum powder. We are going to produce an image like the one at upper

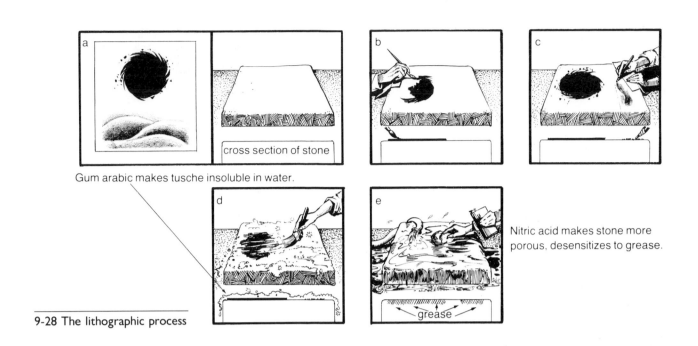

Gum arabic makes tusche insoluble in water.

cross section of stone

Nitric acid makes stone more porous, desensitizes to grease.

grease

9-28 The lithographic process

left. (*b*) For solid areas tusche in liquid form can be painted on or drawn on with a pen. The material is a grease, but it behaves more or less like ink. It can be thinned with water to give watercolor-like effects. (*c*) For gradated areas tusche in the form of a solid crayon is used. There are different grades of crayons, each producing a progressively darker mark. (*d*) Etching the stone is a complicated process involving rosin and whiting (talc) as well as acid, but the basic substance used is the etch itself. This is much milder than anything used in intaglio etching. It is a syrupy mixture of water, gum arabic, and nitric acid. To one and a half ounces of gum arabic solution the artist will add somewhere between fifteen and fifty drops of acid. The exact amount is impossible to say, because stones vary and because temperature, humidity, and the age of the acid all affect the outcome. The lithographer tests his etch on the margin of the stone, and when it foams in a certain way he knows he has what he needs. Delicate crayon work or tusche watercolor variations require a stronger etch than solid spots of tusche. The gum solution is painted onto the stone and left overnight. What happens is complicated, but the upshot of it is this: When the gum arabic comes into contact with the tusche areas, it makes them insoluble in water. The acid bites the limestone just enough to make it slightly more porous than before and, therefore, more capable of absorbing water. (*e*) The next step is apt to terrify the novice, especially if he has spent days and days slaving over an intricate drawing on his stone. With water and turpentine the artist *washes out* the image. It vanishes! (Well, if you look closely, you can see a kind of yellowish stain where the drawing was, but that's all.) At this point the stone is ready to be printed.

The black color of tusche ink and crayons has nothing to do with the darkness of the print; it is nothing but lampblack put into the tusche so artists can see what they're doing. The real difference between a dark lithographic crayon and a light one is that the dark one contains more grease. Similarly, when you add water to tusche ink to make a pale gray, what you actually have done is reduced the amount of grease. Grease is all that counts. And one dares not touch the stone with his hand as he is working because even the cleanest hand exudes a bit of natural oil. This oil, though invisible, will show up as a gray dirty spot when the stone is printed. Any grease that gets onto the stone before it is etched will eventually print.

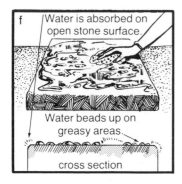

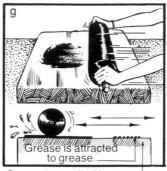

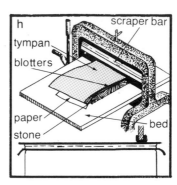

9-29 Lithographic printing

9-30 ROBERT NELSON. "Wagner." 1971. Lithograph and relief printing, 41 × 27½". Collection Southern Illinois University at Edwardsville

Printing the stone (see fig. 9-29) depends upon the antipathy of greasy areas for water and of wet areas for grease. (*f*) The limestone is wet down with water. The open stone areas absorb the water, but it beads up on the areas where tusche had been applied. (*g*) A previously inked roller the size of an extremely large rolling pin but covered with soft leather or rubber is passed over the wet stone. Since the bare stone areas are wet, the ink, which is greasy, will not adhere to them. But in greasy areas the roller pushes the drops of water

out of the way, and the oily ink is attracted to the oily surface. As if by magic, the original drawing reappears on the stone. (*h*) A lithographic press has a movable bed like an etching press but has a *scraper bar* instead of a roller. The stone, which is kept moist all through printing, rests on the bed. As in intaglio printing, the paper is damp. The paper goes onto the stone, a blotter or two on top of that, and a piece of red fiberboard called a *tympan* on top of that. (*i*) The scraper bar, which has been lubricated with mutton tallow, clamps down onto the similarly well-greased tympan, pressing the paper down hard against the stone. (*j*) The printer cranks the press handle, driving the bed along under the scraper bar. The bed, of course, carries the stone along with it, and the pressure of the bar squeezes the image onto the paper. (*k*) Then the stone is rewet, reinked, another sheet of paper applied, and the whole business run back through in the other direction. This is continued until the edition is completed.

Lithographic stones may be used over and over because the tusche and etch affect only the uppermost surface of the stone. When an edition has been run, the stone is ground down with carborundum sufficiently to remove the inked image entirely, and another lithograph can be drawn on the same stone.

Some printmakers, for example Robert Nelson, combine intaglio, relief, and lithographic method in the same design (fig. 9-30).

Stencil Prints (Serigraphs) A stencil is anything that blocks out areas so they will not be touched by something else. The most common kinds are those used to do lettering. *Serigraphy* (literally, silk-writing), or silk-screen, is the most sophisticated of the stencil processes known to the fine arts. It is an extremely flexible medium, capable of hard-edge effects of high impact (fig. 9-31) or of

9-31 MICHAEL SMITH. *Arc I.* 1967. Serigraph, 14⅞ × 14¾". Private collection

9-32 JOHN ADKINS
RICHARDSON. *Road to
Xanadu.* 1963. Serigraph,
11¾ × 14¾". Private
collection

an extremely subtle and delicate imagery rivaling painting (fig. 9-32). For those who do not like to work in reverse, serigraphy is ideal because stencil processes do not require you to reverse your conception.

The technique, as you can see from figure 9-33, is a simple one. (*a*) One begins with a wooden frame over which silk has been very tightly stretched. Silk comes in two weights—standard (x) and heavy (xx)—and is available in coarse (6) to extremely fine (20), that is, from six strands per square inch to twenty per square inch. In my opinion the best silk for average screen-printing use is 14xx. Once the silk is on the frame, any area which contacts wood is taped with brown wrapping tape and waterproofed with shellac. (*b*) All parts of the screen that are not to print are blocked out. There are a number of ways of doing this. Some involve materials that stick to the silk, some entail painting in with glues or lacquers, and some involve "resist" techniques which permit you to put in thin lines or brushstrokes and to use crayon textures. The main point is that because the stencil is being prepared on a silk surface it is possible to block out areas in the center of an open space. (*c*) The printmaker pours into his screen ink containing materials which slow the drying of the pigment and make it flow smoothly. Silk-screen ink comes in a fantastic range of colors (including Day-Glos) and can be oil base, water base, or lacquer. In serigraphy, fast-drying oil inks are customary. (*d*) A *squeegee* (a hard rubber blade inserted in a wooden handle) is used to draw the ink across the screen. As the artist pulls it toward him, he presses it down and squeezes the ink through the mesh of the silk onto the paper beneath the frame. (*e*) The ink goes through the openings in the silk where the stencil is vacant but not where it is solid. When the paper is removed, the texture of the silk will not be visible because the ink is fluid enough to flow around the tiny threads. The printed area is very flat and solid. The printer inserts another sheet of paper, pulls the squeegee in the other direction to produce another print, and so on and on until the run is finished. Once a color has been used up, the screen is cleaned and the stencil removed with solvent, which will either completely dissolve the block-out material or will loosen it but will not affect the silk or the shellacked tape.

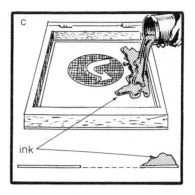

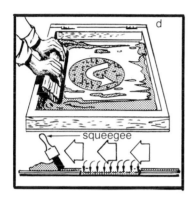
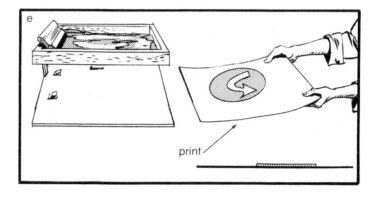

9-33 Serigraph printing

Successive colors are run on the paper by repeating the process described above. By strategic overlapping with the use of transparent bases in the ink, and through controlled printing techniques, it is possible to obtain very elaborate relationships.

Photography By far the most popular printmaking medium is photography. Although technically demanding, even when compared with lithography, it has been made accessible to millions of people through a division of labor that requires great specialization of everyone involved with the exception of one person—the one who aims the camera and snaps the shutter release. Automated cameras with built-in light meters, self-actuated focusing, and instantaneous film development have turned what once was an extremely onerous undertaking into something that's easy to do. Even highly trained professionals who do their own developing use industry-prepared chemical solutions, film, and printing papers.

Things are very different from 1839 when Louis Daguerre (1789–1851) took his famous picture of a Paris boulevard and also, by accident, made the first photograph of a human being, the man having his shoes shined in the lower left (fig. 9-34). In fact, the street was bustling with activity, but *daguerreotypes* required such prolonged exposures that no one except this patient fellow stood still long enough to make an impression. In order to secure an image of the boulevard, Daguerre had first to polish a silver-plated copper sheet and then vaporize iodine onto its surface to create silver iodide, a light-sensitive substance. The plate, kept in utter darkness at all times except when being exposed through the camera lens, was developed by being suspended face down over a container of heated mercury, which deposited a whitish amalgam over the exposed areas. The daguerreotypist dissolved the unexposed silver iodide with salt, then rinsed and dried the plate *very* carefully. All of this work produced a single extremely frangible image that could not be duplicated.

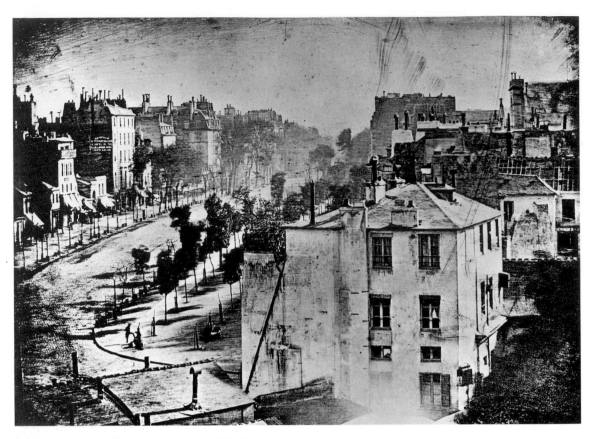

9-34 LOUIS DAGUERRE. *Paris Boulevard.* 1839. Daguerreotype. Bavarian National
Museum, Munich

In the nineteenth century, progress was an obsession, and soon the daguer-
reotype method was replaced by the *collodion process*, which made abso-
lutely gorgeous pictures (fig. 9-35) and also yielded a glass negative from
which any number of prints could be made on sensitized paper. But the
collodion process was difficult to use outdoors because the glass plates had to
be coated with the photo-sensitive collodion solution, exposed and developed
at once, on the spot, *before the solution dried*, in complete darkness. This
latter requirement forced photographers of the era, such as T. H. O'Sullivan
and Civil War chronicler Mathew Brady (1823–1896), to carry a portable
darkroom with them whenever they were working. During the 1870s, how-
ever, it was discovered that a dried-gelatin coating could replace the wet
solution and that, moreover, it was possible to make this dry emulsion a
hundred times more sensitive, so that the recording of rapidly moving objects
became feasible. By 1900 the American inventor George Eastman (1854–
1932) had secured, through legal settlements, patents on a flexible, trans-
parent roll film of cellulose nitrate and paper and a simple box camera, the
Kodak, that used such film. Despite myriad modifications and improvements,
Eastman's process is the one used by photographers today.

Cameras themselves are, contrary to popular belief, quite old, dating back
to at least the tenth century in the form of the *camera obscura*, literally, a
"darkened room." For a fact, until the end of the sixteenth century the camera
was actually a windowless room or large cabinet (Leonardo speaks of one in
the form of a carriage) that had a very tiny hole on one side through which the
rays of the sun cast on the opposite interior wall an inverted image of whatever
was outside. The image was brought into sharper focus and brightened
sometime around 1550, when lenses replaced the hole. By the middle of the

9-35 T. H. O'SULLIVAN. *Cañon de Chelly Cliff Dwellings.* 1873. Collodion print. The Library of Congress, Washington, D.C.

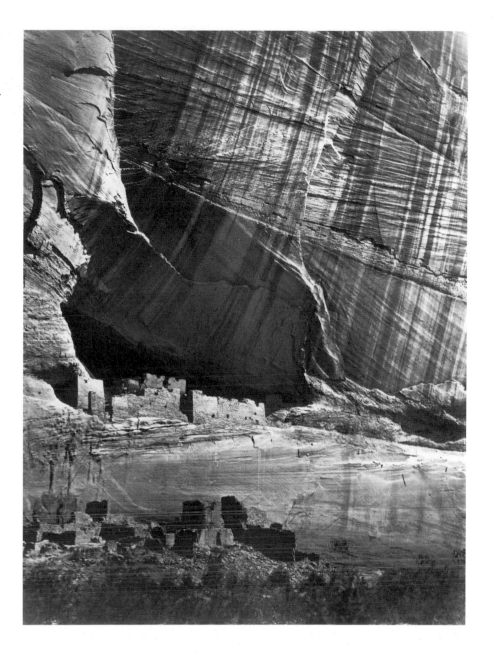

seventeenth century the large cabinet had been reduced to a portable box with a lens and a ground-glass view plate. In this form the camera obscura was used by many artists, including Vermeer and Canaletto, who placed thin sheets of paper over the glass and traced the outlines of nature illumined there. What photography did was combine the painter's tool with eighteenth-century chemistry so that the image on the glass might be preserved. As a matter of fact, the first person to attempt to record images from nature mechanically simply exposed white leather sheets treated with silver nitrate (known since 1725 to darken when struck by light) through his father's camera obscura. The experimenter was Thomas Wedgwood, son of the famous potter Josiah Wedgwood (1730–1795). He was unable to produce a visible picture, but his were the first steps toward the daguerreotype and photography.

Modern cameras come in a great variety of styles, as a quick glance at any camera store showcase will prove. Those in common use by the majority of artist-photographers fall into four principal types (see fig. 9-36): (*a*) The *viewfinder cameras* are those in which the operator frames the subject through a sighting device that in the better models contains a range finder that enables one to focus the lens by bringing a split image into coincidence. This is

9-36 Types of modern cameras: view-finder cameras (a); single-lens reflex cameras (b); twin-lens reflex camera (c); view camera (d)

the typical format for 16 mm. pocket cameras, but there are also excellent 35 mm. viewfinding cameras. They are easy to use, quick, compact, and very reliable. They are, however, no good for close-up work because the viewfinder and lens never frame exactly the same area. In other words, you don't see what the lens sees. At ten or more feet the deviation is immaterial, but it becomes problematical at distances under five feet, leading to such consequences as portrait heads chopped off at the eyes. (*b*) *Single-lens reflex (SLR) cameras* overcome the mismatch of the seen and photographed (known as *parallax error*) by permitting the photographer to focus the very image the lens itself frames. This is done by incorporating into the camera body an elaborate mirror system whose main component reflects what the lens sees up through a focusing prism until the picture is snapped. Then it flips up out of the way momentarily, allowing light to pass through to the film. The mechanism that operates this mirror is highly intricate, so it is not surprising that SLR cameras are far more expensive than viewfinder cameras. They are also heavier and likelier to need repair. Still, they are so convenient and adaptable that they have come to dominate the market in serious 35 mm. photography. Apart from the greater framing accuracy of the SLRs, their major appeal lies in the fact that the viewing system works perfectly with any kind of lens. What you see is what you'll get, no matter whether the lens is conventional, close-up, telephoto, wide-angle, fish-eye, zoom, or what. There are, besides the 35 mm. SLRs, larger-format versions that use 120-size roll film to make negatives that are, in the case of Hasselblad and Rollei, 2¼″ square and, in the case of Mimiya and Pentax, 2¼ × 2¾″. A Hasselblad 500 is the model for our

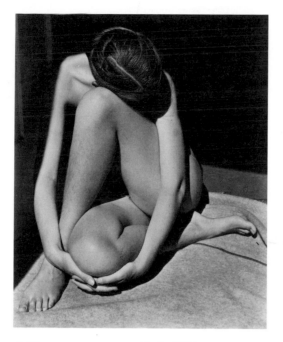

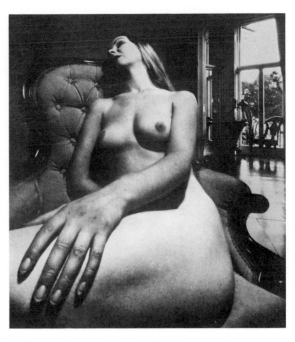

9-37 EDWARD WESTON. *Nude.* 1936.
Photograph

9-38 BILL BRANDT. *Nude.* 1953. Photograph

illustration. (*c*) *Twin-lens reflex (TLR) cameras* have the advantages of the viewfinder cameras in a larger format, producing 2¼″ square negatives, and not so many disadvantages. The parallax error persists but is less apparent because the viewing lens and camera lens are more closely matched. The viewer itself is a ground-glass plate covering most of the top surface of the camera body and, while the image is reversed, it is as large as the negative itself. Moreover, TLRs are mechanically uncomplicated because their viewing mirror does not have to pivot and they are, in consequence, rugged and reliable. Rolleiflex is the prototype and model for the TLRs, and all of the others are patterned after it, though one line (Mimiyaflex) has interchangeable lenses like those of the SLRs. (*d*) *View cameras* were used to make figures 9-37 and 9-38. They are much larger and heavier than the other cameras described here, and they make negatives that are, typically, $8 \times 10″$ on sheet film clamped into a special holder. To operate successfully, cameras such as these require a skilled performer. They have no built-in aids, and they are designed to be used in a circumspect, deliberate way. The accordion-like bellows permits you to increase the depth of field enormously, straighten deviations from the vertical as well as other perspective distortions (or, contrariwise, radically exaggerate deviations), and generally to have as absolute control over the photographic image as it is possible to achieve. These cameras and their interchangeable lenses are startlingly expensive; they are not intended for anyone but serious professionals. Any time large, detailed photographs free of distortion are required, the view camera is the prime choice. They are used in photographing art for reproduction, in architectural photography, product advertising, high-fashion work, and formal portraiture, for example.

The nudes by Edward Weston (1886–1958; fig. 9-37) and Bill Brandt (1906–1983; fig. 9-38) demonstrate the degree to which photography can rival any other printmaking medium in imaginative artistic control. Weston achieved his harmonious relationships largely through very careful posing and lighting of the model. The most striking quality of the Brandt, its exaggerated perspective, derives from the use of a wide-angle lens and an

a

b

9-39 Depth of field: aperture set at f/1.8 (a); aperture set at f/16 (b). Note how much more of the fence is in sharp focus in *b*

extremely minute aperture to produce remarkable *depth of field*. Depth of field is the range of distances in which near and far objects are in focus. Often, amateurs try to produce deliberate photographic distortions with simple cameras. Adolescents seem invariably to snap reclining friends at the same angle from which Mantegna drew his *Dead Christ* (fig. 7-37) so that the feet are enormous compared to the head, but it always turns out that the head is blurry if the feet are in focus or the head is clear but the feet aren't. That is because their equipment is not up to the task they have set themselves.

Generally, the smaller the opening through which light passes through the lens the longer the exposure time and the greater the depth of field (see fig. 9-39). The scale of the opening is determined by what is called the aperture and, in all but the least expensive cameras, the aperture can be changed by closing or opening what is called the *diaphragm* (fig. 9-40), a rosette of movable metal leaves behind the lens. As you shift the *f/stop* ring on the lens housing from lower numbers to higher ones, the opening at the center of the diaphragm decreases in size. The full range of f/stops on modern cameras is

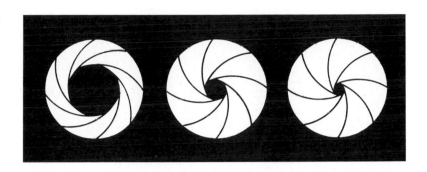

1.8, 2, 2.8, 4, 5.6, 8, 11, 16, 22, 32, 45, and 64, but most 35 mm. cameras begin at 2.8 and run to 22. The symbol *f* stands for focal length, that is, the distance from the lens center to the film plane when the focus is at infinity; *f/*, then, represents a fraction of that distance. The wider the diaphragm is open, the lower the f/stop number and the more light collected in a given amount of time. This means that the aperture is related to the exposure time in a fixed, direct way. If f/8 will give you a correct exposure in $\frac{1}{125}$ of a second, then you can get exactly the same exposure in $\frac{1}{500}$ of a second at f/4. If it takes a full second to take a picture at f/11, you can take it at $\frac{1}{60}$ of a second at f/1.8. It may be necessary to open the aperture quite wide in dim light or even in sunlight if a fast shutter speed is required for the quick exposure of something in motion. (But you must bear in mind that even though the exposures compared above are equivalent, the pictures will have differences; most noticeably, the one-second exposure will have much greater depth of field.)

Exposure time is determined by shutter speed. Commonly, the shutter consists of two opaque sliding panels just ahead of the film; when the control button is depressed the panel that normally covers the film opening moves along a track, permitting the light coming through the lens and diaphragm to reach the film. After an interval, the first panel is followed by the other one, which conceals the film again. The interval, or gap, between the two shutters is the exposure time and it can be set for specified times, ordinarily ranging from one second to $\frac{1}{1000}$ of a second, or for time exposures. In the latter case, the first shutter moves aside when the button is depressed, the second one recovers the film when the button is released. As the film is advanced, the shutter is "cocked" and both panels, their trailing and leading edges now slightly overlapped, return to their starting positions. A mechanical system of this kind—called a *focal plane shutter*—is not suitable for all types of photography, however. Special electronic systems are available for doing such things as depicting bullets in motion.

Finally, one other thing pertaining to aperture settings and exposure times: Film comes in a range of speeds, or degrees of sensitivity. They are designated in terms of *ISO* (International Standards Organization) index numbers (formerly ASA—American Standards Association) with higher numbers indicating greater sensitivity, or speed. Kodak's black-and-white Panatomic X is rated ISO 32, its Plus-X 125, its Tri-X 400, and its Royal-X 1250. Color films generally run from ISO 25 to 1000. It might seem—if you are new to all of this (having come from the dark side of the moon recently) and have been following along—that one could conquer all problems of available light, moving objects, and depth of field simply by using Royal-X or some similarly super-fast film. There is, of course, a "rub." The more sensitive the film the coarser its grain. As always, a gain in one area means some sacrifice in another. Good all-purpose ISO speeds for the average photographer are 400 in black-and-white and 64 in color, explaining the relative popularity of Tri-

9-41 ARTHUR ROTHSTEIN.
Dust Storm (Oklahoma). 1936.
Photograph. Farm Service
Administration

X and Kodachrome 64 or Agfapan 400 and Agfachrome 64. But individual preferences and needs vary widely. The author prefers Plus-X over other 35 mm. films, but people taking pictures of action sports may find Royal-X perfectly suited to their purposes.

Every illustration in this book is really a reproduction of a photograph rather than of a painting, sculpture, building, or print, because they were printed by the photomechanical means described on pages 56–58. Most of these are documentary photographs, intended to record the appearance of an artwork as objectively as possible. Some of them document impressions of movement (figs. 2-15 to 2-18), light and shade effects (figs. 5-4, 5-5), or spatial effects (figs. 7-3, 7-4, 7-11). Some, like figure 6-18, were nothing more than a tourist's souvenir, but even those are a kind of document. Some documentary photographs, however, have a quality that surpasses such archival or private purposes; O'Sullivan's canyon dwellings (fig. 9-35) and the famous *Dust Bowl* image by Arthur Rothstein (born 1915; fig. 9-41) carry moments from the nineteenth century and the Great Depression into our time.

Most of the photographs used in this section of *Art: The Way It Is* result from what might be called the "direct" approach to the medium. Even Bill Brandt's nude study is the result of setting up a camera, selecting an appropriate lens and exposure, and taking a picture of the subject. The exposed film was then developed and printed by the artist, during which processing he could have manipulated value contrasts to produce different kinds of effects or used papers of various kinds to find diversity in prints made from the same negative. Small sections that were too dark could have been "dodged" to lighten them or, conversely, the print could be "burned" in order to darken portions that came out too light. But this kind of control is just a matter of making technical adjustments to whatever was directly photographed. Not all photographers are content to accept the more or less fixed conditions reality imposes upon them.

Artist-photographers who, like Kandinsky, find "no satisfaction in mere

9-42 JERRY N. UELSMANN.
Untitled. 1969. Photograph

9-42 JERRY N. UELSMANN.
Untitled. 1969. Photograph

representation" can apply themselves to the creation of fantastic combinations of images through multiple exposures and montages combining different negatives in one print. Or they can make use of a number of special effects. Among the most startling of these inventors is Jerry N. Uelsmann (born 1934), whose work appears as figure 9-42.

Before leaving the area of photography we should at least mention an art form that is dependent upon film but actually falls within the theatrical or performing arts more than within the visual. I speak, of course, of the cinema, which depends upon strips of photographs taken in sequence at 1/64 of a second per frame. Of course, there are a few films undertaken as purely visual displays of abstract images in sequence and they, at least, deserve to be considered visual art. But the transient, serial nature even of these motion pictures, like that of video imagery, requires a different kind of approach to the composition of pictures than does something static, like painting or still photography. Artwork so decisively marked by temporality and sequential editing is not well matched to the other contents of this book.

Computer Graphics Dealing with every kind of applied-art form is obviously impossible in a book of this scope. But one new mode deserves attention because of the sheer ubiquity of what we call computers. More and more, these mechanical brains are entering into the field of graphic design, or what is more commonly known to the lay public as "commercial art." The influence of the computer has made itself felt also in the fine arts, particularly among the Conceptualists and multimedia artists.

Typically, computer graphics have little to do with art; they are used for graphs and visualizations in business and in science. In fact, the most exotic application just now is being made at Massachusetts Institute of Technology and Princeton's Institute for Advanced Study, where the arcane mechanics of probability generate graphic representations of abstractions called *cellular automata* in a search for the underlying principles of the development of the

multiplicity of forms in nature. But it is difficult to know just how important any present application is going to be. Perhaps we see them from a false angle, just as Daguerre and others saw early photographs. Photographic imagery did not look especially "right" or "truthful" to its pioneers in the way it does to us; instead, they regarded it as being merely objective. It looked stylized to them, possibly because they saw it with unjaded eyes and could more easily perceive the mechanistic aspects of its representations. Perhaps when computers are no longer novel their relation to the visual arts will be vastly different from anything any of us imagines. But already they have made it very easy for nonartists to do certain kinds of drawings.

Computers work with instructions that are very simple in their specific elements—such as A = Yes, AA = No; HOLE IN CARD = 1, NO HOLE IN CARD = 0—but are extremely complicated in their number and interconnections. The pattern of such instructions is called a *program*. What really startles most of us about computers is the incredible speed with which they operate. These machines really do outstrip the human brain in quickness. Why? Because they transmit information and do their calculations electronically. A nerve impulse travels at a few hundred miles per hour. That's quite fast enough for most animal functions to be performed. Electricity moves at tens of thousands a mile per second. There is no comparison, which is not, of course, to say that robots are smarter than people. They *do* think faster though. That's why even a relatively primitive CAD program like the one I used to do the aircraft in figure 7-19 can produce an endless variety of delineations almost instantly. Again, the principles behind such renderings are not hard to grasp. The rules of orthographic projection and, therefore, of perspective are mathematical and the space for a projection can be formulated in terms of analytical geometry as a densely compacted graph of intersecting X (horizontal) and Y (vertical) axes linked by Z axes in depth. Conceive of a multitude of such graphs adjacent to one another and in perfect register, so that they form a cubic volume. Within this matrix it is possible to program all of the information needed to plot the sequential relationship of significant points on a projection that is twisting, turning, rotating, and pivoting. Devising the actual program is, of course, more demanding than merely conceiving of the way intersections in a transparent cube might describe it. But programs for this purpose have become pretty commonplace in certain branches of engineering design. The film industry has turned up glamorously rendered elaborations of the same thing to create and animate amazingly realistic pictures in full color without the use of photography, simply from intricate algorithms.

When I wrote about computer graphics in the third edition of this book, I went into considerable detail about the specifics of the Apple MacIntosh "MacPaint" program that I used to do sample illustrations such as the uppermost rendering in figure 9-43. But, as I said then, one of the troubles with trying to deal with computers in a book is that the field changes with such alarming rapidity that whatever is current at the time of writing will be outdated by the time the volume is on bookstore shelves. I predicted, too, that the "MacPaint" program would soon be simulated by other manufacturers. Not only did these easily foreseeable things come to pass, but the procedures used to draw the pictures have become generally known to practically every subteen. This time I decided merely to present a few other computer images. Pictures don't date as rapidly as the software does. In doing the new ones in figure 9-43 I used an IBM clone with an HPII Laserjet printer. For the initiated reader's information I'll note that the software packages employed were

9-43 Some computer
graphics by the author

DesignCAD 3-D, Coreldraw, Microsoft Paint, and Logitech's Paintshow Plus. Apple makes comparable programs, or is compatible with special versions of those listed, and also uses a microprocessor that gives MacIntosh's graphics users much more speed per dollar than IBM-type systems. With the latter, however, one has a far wider range of choices, support services, and amazingly inexpensive clones.

Three-Dimensional Media I have tended, thus far, to give very short shrift to the sculptural arts because they are three-dimensional and an illustration in a book cannot do them the kind of justice it can a picture. In two dimensions genuine formal analysis of sculpture is impossible; even with a multitude of views of something existing in the round we fail. Motion-picture films which show continuously shifting viewpoints similar to those experienced by the human observer do not capture the full qualities of solid objects. Moreover, tactile values are important to the character of a sculpture. Some works cry out to be touched, caressed, fondled. And people do touch them; they do it so much, in fact, that museums try to discourage the practice. It increases cleaning costs and, in some cases, adds unwanted polish to stone and bronze. Also, pieces can actually be worn away in spots where they're always touched, as in the famous right foot of St. Peter in the Vatican statue.

Sculpture Still, even though pictures can't really do the job, it would be wrong to overlook media that contain some of mankind's noblest conceptions of human form and spatial organization. Basically, there are four kinds of sculpture: (1) those that are carved, (2) those that are built, (3) those which have been cast, and (4) so-called found sculpture.

Carved (Subtractive) Sculpture There is nothing difficult to understand about carved sculpture; it involves nothing more than, as Michelangelo said, "knocking away the waste material." Conceptually the procedure is obvious; doing it is another story. Whittling a small figure from a stick is quite different from hewing some great log down into a statue. And the creation of a thing like Praxiteles' *Hermes and Dionysus* (fig. 4-39) or Michelangelo's *David* (fig. 9-44) out of a monolith is a tremendously impressive feat.

Most of the great carvings of the world are in stone. Some are of igneous rock (granite, basalt, diorite, obsidian), formed from molten minerals that have cooled. Others are of sedimentary rocks (sandstone, gritstone, limestone), formed by deposits of sediment in successive layers. Still others are made from metamorphic rocks (marble, steatite, slate), rocks which have begun as igneous or sedimentary stone and then undergone heat, pressure, and chemical changes that have transformed them. Igneous rocks tend to be very obdurate. Hard to carve but long lasting, they were a favorite of the Egyptians. The sedimentary rocks range from those that are extremely durable to those that are highly impermanent. Of these rocks, limestone is the favorite sculptural material because it is relatively permanent, is easy to work, and can take a very fine polish. But the rock which has unsurpassable properties for sculpture is marble, a metamorphic rock. Marble is greatly varied in color range, from pure cream and white to blazing polychrome, and it is, sculptors say, a pleasure to carve.

Freshly quarried stone is best for carving because exposure to the elements would cause it to form a hard outer skin and make it difficult or impossible to carve. Any block of stone a sculptor is to use must be free of flaws and should be set up according to the structure of the bed from which it came. For a

9-44 MICHELANGELO. *David.* 1501–4. Marble, height of figure, 13′5″. Academy, Florence

standing figure like *David,* a tall block would be used; for a reclining figure, a long low one.

The sculptor in stone who wants to make a very large statue begins his work by making a small version of the statue in clay, wax, or plaster of Paris. This model is called a *maquette* or a *bozzetto.* The proportions of the maquette are carried over to the block mechanically.

The removal of waste material from the block is accomplished by hammering a steel tool into the stone with a mallet of wood or iron. All the differently shaped tools (fig. 9-45) come in various sizes. The "roughing out" of the block is done with a tool called a *point.* The point is just what its name suggests, a sharp-tipped rod. Its purpose is to explode away the stone. Usually the sculptor carves with points to within about half an inch of the final surface. He then switches to the *claw,* so called because of its teeth. Claws used for marble have longer teeth of a harder temper than those used on other kinds of stones. At this stage the sculptor carves his image more precisely into the stone, achieving a kind of three-dimensional cross-hatching. Chisels are used in diminishing sizes to make the final statement. The surface of the work is then refined with rasps, files, and abrasives.

Different kinds of stones dictate special procedures. Granite, for example, is too hard to be modeled with a claw, and so an instrument called a *granite ax* is used. A tool called a *boucharde*—a hammer with teeth not unlike those of a meat mallet—can be used to bruise stone away; it is used on marble and limestone as well as granite. Before the invention of steel, sculptors approached the stone by abrading it with other stones, iron hammers, and chisels. This is the way Praxiteles and other ancient sculptors worked. Indeed, the technique dates back to prehistoric ages when Paleolithic men pounded stone against stone to fashion spearheads and axes. It is a very slow process, pounding the surface of stone to dust, but it has the effect of stroking and smoothing the forms into their final state and lends a sensuousness to the carving that other methods do not attain. Michelangelo gains power and clarity denied Praxiteles but sacrifices some of the Greek's surface appeal.

You perhaps have noticed that David's leg rests against a stump. This sort of leg rest—usually a stump but sometimes an animal, child, kneeling figure, stone, or other object—is found in nearly any stone statue of a standing figure with legs that are not attached to a background. It is not an aesthetic device; it is a structural one. Stone is strong but it is brittle. Marble has so little tensile strength that the thin ankles of the *David* could not possibly carry his massive weight without assistance. The stump was introduced to increase the diameter of the support. In *Hermes and Dionysus* the same function is performed by the falling drapery.

Perhaps the most basic kind of subtractive sculpture is a relatively recent kind that in the past would not have been considered at all artistic. This is *earth sculpture,* which uses the earth and its terrain for a medium. The most essential act the sculptor performs is arranging for the earth to be removed and re-formed, sometimes to exist as an artifact in its own right, sometimes to permit the addition of sustaining walls, ornamental structures, or other elements. Often "earthworks" have the dull and indifferent character of an ordinary excavation. But some are quite striking in their presence. For example, *Four Horizons* (fig. 9-46) by Mary Miss (born 1944) is based on a compass directed to the four quarters and has, in its curious autonomy, the look of some mysteriously puissant emplacement set upon the land by alien forces. At the same time, it summons up thoughts of ritual, ancient rites, and final causes.

claw for marble

point

claw
for stone
other
than marble

chisel

9-45 Stone-carving tools

9-46 MARY MISS. *Four Horizons* (detail). 1976. Steel, concrete, and crushed rock, 140′ across, 8′ deep. Artpark, Lewiston, New York. Courtesy of the artist and Max Protech Gallery

Built (Additive) Sculpture Carving takes away material, building adds it on. The Bakota guardian figure (fig. 2-31) was constructed of elements which had themselves to undergo subtraction in order to fit together but which find their final form only in combination. Tony Smith's (1912–1980) *She Who Must Be Obeyed* (fig. 9-47) was made of wood, joined and painted. Later it was fabricated in steel by welding, another form of building. These are very obvious forms of built sculpture because they involve putting separate components together to form a whole. The most common type of built sculpture, however, is terra-cotta sculpture (the kind shown in figure 9-48). It is of earthenware, a rather soft and porous clay fired at relatively low temperatures (1740–2130° F.) in an oven called a *kiln*.

Clay is the residue of decomposed granite. A sticky substance, it clings to itself because of the peculiar shape of the particles: they are not granular, like particles of sand, but flakelike, which is why they tend to adhere to each other. This makes clay malleable when wet and indurate when dry, an ideal material for the sculptor. Wet clay is usually built, wad by wad, into a piece; it can also be shaped into solid blocks and carved, or thinned into the liquid form called *slip* and cast in plaster molds.

In its raw form clay is highly fragile, but when it is fired it becomes quite hard. In drying and firing, clay shrinks considerably. One way to keep shrinkage to a minimum and decrease the possibility of cracking is to introduce into the clay body a material called *grog* (fired clay which has been ground). Another way is to fire the body very slowly—as is done in making bricks. To prevent uneven shrinkage sculptors usually hollow out the piece

9-48 DAN ANDERSON. *Mad Dog Fern Stand.* 1978. Earthenware and mixed media, height 16". Private collection

9-47 TONY SMITH. *She Who Must Be Obeyed.* 1976. Painted steel. 20 × 30'. Labor Department, Washington, D.C.

9-49 FRANK GALLO. *The Swimmer.* 1964. Polyester resin, 65 × 16 × 41¼". Whitney Museum of American Art, New York. Gift of the Friends of the Whitney and the artist

from the bottom, leaving an equal amount of clay on all sides. Dan Anderson's earthenware piece was built up hollow like a bowl or pitcher. Then it was decorated.

Frank Gallo's (born 1933) girls (fig. 9-49) are a different type of built sculpture. They are made of *epoxy resin* formed in molds of plaster and then pieced into amazingly voluptuous forms. Although the process entails the use of molds, it differs from conventional casting in that the material is not poured into the mold but is itself built up from fiber strips saturated with resin. The same technique produced a less appealing set of figures in Duane Hanson's *Tourists* (fig. 8-19).

Among the most intriguing built sculptures are Louise Nevelson's (1900–1990) wood constructions (fig. 9-50), made up of odds and ends of wood-work, old boxes, and scraps from the carpenter's shop. They are peculiarly evocative, considering the unpretentious materials that have been used in their construction.

Somewhat related, in terms of the unexpected use of materials and methods previously associated with minor endeavors, are works by those artists who weave various kinds of fibers into fabrics. Within the last twenty years fiber artists such as Arturo Sandoval (born 1942) have begun to exploit the ancient practical craft of weaving for distinctly artistic purposes. Sandoval's pieces are extraordinarily inventive and rich, particularly those that have a dis-tinctively sculptural aspect (see fig. 9-51). He incorporates into his work such materials as microfilm, paper, battery cables, and mylar as well as the more conventional natural fibers of old-fashioned fabric design.

9-50 LOUISE NEVELSON. *Sky Cathedral*. 1958. Assemblage: wood construction painted black, 11'3½" × 10'¼" × 1'6". Collection, The Museum of Modern Art, New York. Gift of Mr. and Mrs. Ben Mildwoff

Cast (Replacement) Sculpture Sculpture can be cast from any material that can be transformed from a plastic, molten, or fluid state into a solid state and still hold together. Casting always involves the creation of a mold, that is, a negative form from which a positive cast may be taken. If you fill a bowl with fruit gelatin (Jell-O) in liquid form and let it harden, then tip the bowl over to release the jellied dessert, you have made a casting. The bowl was the negative mold and the molded dessert the positive form, the casting. The same kind of thing can be done with plaster of Paris in place of gelatin or (given a silica bowl) with molten bronze.

A small thing made of solid bronze poses no problems, but a moderately

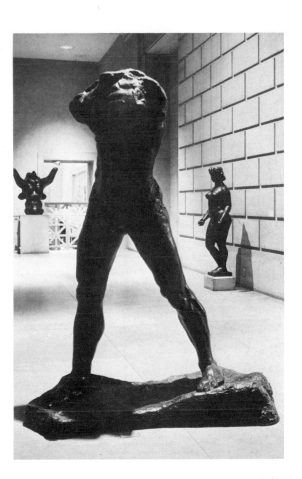

9-52 AUGUSTE RODIN. *The Walking Man.* 1905. Bronze, height 87⅞". Courtesy of Mr. B. Gerald Cantor, New York and Beverly Hills

9-51 ARTURO ALONZO SANDOVAL. *Pond.* 1977. Woven battery cable with patina, 5′ × 9′ × 2″. Private collection

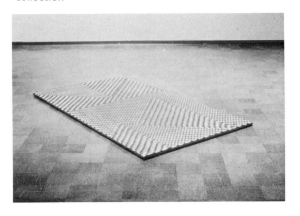

large bronze statue does. For a work larger than you could hold in one hand, it is normal to cast the piece so that its inside is hollow. To do so is more economical, since less metal is used. It also produces a lighter sculpture. And hollow structures are actually stronger than solid ones. Since bronze castings shrink when they cool, solid ones run a greater chance of cracking than hollow ones.

The most flexible method for producing hollow castings of metal is the *cire-perdue,* or *lost-wax,* method. The twelfth-century head by an Ife tribesman in Nigeria was done by this process (fig. 2-33). One of the great masters of lost-wax bronzes was Auguste Rodin (1840–1917), whose *Walking Man* is reproduced here (fig. 9-52).

Close examination of the *Walking Man* would reveal many marks and impressions that suggest direct modeling as if in clay. This is because a bronze casting is made from a sculptural model of wax or clay that is exactly the size and precise character the artist wants the finished work to be.

The lost-wax process is depicted in figure 9-53. The lower diagrams are of the cross section indicated by the dotted line. (*a*) The clay model is (*b*) completely covered with flexible gelatin, which can be cut apart and removed without losing any of the details. It is supported by a plaster jacket. (*c*) The gelatin mold is taken off and then coated on the inside with wax to the normal thickness of a bronze statue—about an eighth of an inch. (*d*) The mold is filled with an investment material made of plaster of Paris and silica. (*e*) Having removed the mold, we are left with a perfect wax casting identical in size and contour to the clay model and filled with a core of investment material. (*f*) Rods of wax are applied to the casting. These rods will carry off melted wax during baking and eventually will provide channels for molten bronze to enter and for air to escape. Iron nails, driven through the wax into the investment

9-53 Lost-wax process

core, protrude from the cast. (*g*) In preparation for baking, the cast is covered with an outer mold of plaster-silica material. It surrounds the rods and nails. (*h*) The whole thing is put into a kiln and heated to 1500° F. This melts and burns out all the wax in the form. What is left is the core, separated from the mold by a space an eighth of an inch wide and held in place by the nails. This is the space formerly filled by the wax, hence the term *lost* wax. (*i*) Molten bronze is poured into the *casting gate,* a large opening at the top of the mold, and fills the cavity. When the bronze has cooled and hardened, the outer mold and inner core are removed, leaving a bronze replica of the wax form complete with the rods and gates. (Accomplishing this in such a way that a number of casts can be made from the same mold and core becomes complicated, but the problems of the foundryman need not concern us here.) The gating structure of rods is cut from the cast with a hacksaw, and then the surface of the work is finished: the holes left by the anchor nails are plugged, the rough edges are reworked, and some areas are accented by the use of files and punches (this last is called *chasing*). If it has been necessary to saw parts of the cast apart in order to remove the core, these parts will be joined together. Today, with modern electronic equipment, it is possible to weld and braze bronze joints. But it is simpler to follow the procedure of antiquity—joining by pounding with a hammer. Bronze is sufficiently malleable to do this without betraying the seam.

After a bronze is finished, the sculptor may wish to enhance it with color. If left alone, the metal will in time acquire the *patina,* or thin layer of corrosion, that gives it its characteristic green or dark brown color, but the natural process of oxidation can be hastened by brazing and the application of organic acids. Obviously, there are many other possibilities. The sculpture can be painted with enamels, materials can be applied to its surface, colored lights can be set to play on it. But sculptors have usually preferred the natural effect over the artificial.

Found Sculpture Sometimes, in a junkyard, attic, or at the beach, one discovers things never intended to be artistic which nonetheless have all the characteristics of a work of art when seen with artistry in mind. For example, figure 9-54 is an iron object I call *Miss America* because of the long legs, absurdly high torso, and tiny head. It might very well be a welded-steel statue by a modern artist with a satirical turn of mind. But it isn't; it's a nineteenth-century tennis-net tightener. An artist I know had it welded onto a metal plate and gave it to me as a tasteful jest. It is an example of *found art.* One of the simplest and most exquisite of these "works" I've ever seen was a chrome-plated camshaft set vertically on an ebony base.

Duchamp's urinal called *Fountain* and Man Ray's *Indestructible Object* (fig. 1-12) are found art with an ideological purpose. Kienholz's tableau (fig. 1-6) is not really found art so much as a *combine,* a combination of common items presented to us as artistically meaningful.

Metalsmithing The art of casting metals will bring to the minds of some the work of gold- and silversmiths, the creation of jewelry. Of course, the very term "jewelry" also summons forth glittering visions of faceted gemstones in costly settings, but our previous text has left us far from anything to do with the lapidary's craft. The forming of precious metals into objects of great worth follows more closely upon the path we have so far taken. After all, goldsmiths are merely sculptors of a very special sort. And, in the hands of a master artisan, even base utilitarian things take on a character so aesthetically

9-54 MARTHA HOLDEN. *Miss America.* 1963. Found object welded to base. Private collection

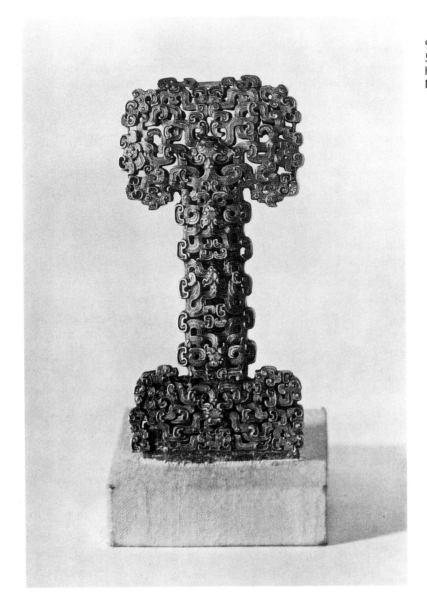

striking in purity that it is difficult to imagine that they have any purpose other than to please the eye. So it is with a dagger's golden hilt (fig. 9-55) that was fashioned in China sometime between the fifth and third centuries B.C., during the Chou Dynasty (c. 1050–249 B.C.). This was a period when rival feudal courts competed with one another in ostentatious displays of wealth and artistic virtuosity, so the extravagant convolutions of the dagger hilt are singularly appropriate to its real purpose.

A contemporary artist/jeweler, E. Austin Goodwin (born 1930), creates fantastical sculpture on a minute scale through a variation of the lost-wax process. His extraordinary chess pieces (fig. 9-56) were formed in wax from which one-piece molds were made. The wax having been melted out, sterling silver was forced into the cavity by *centrifugal casting*—a procedure in which the mold itself is spun at a very high rate of speed while locked onto the end of a steel arm so that molten metal is, quite literally, hurled into the mold space, filling every cranny. Each of these chess pieces is unique since the individual molds were destroyed once casting had been completed.

In the photographs one views each team as an opponent would at the outset of the game; pawns forming the first line, then (left to right) rook, knight, bishop, king and queen, bishop, knight, rook. The positions of queen and king are, of course, transposed in the white-and-black lineups so that, like the other pieces, they face one another across the field of play. Each queen is crowned

9-56 E. AUSTIN GOODWIN. Chess set. 1978. Silver, onyx, limba wood, and jewels, 3¼ × 1¾". Private collection

with a ruby, and both kings wear semiprecious stones in their collars. The pawns, says Goodwin, are hybrids invented by him—the black ones predominantly animal-fish-reptile combinations, the white mostly bird-animal mixtures. The rooks are storybook Bavarian castles, the knights centaurs, the queens sphinxes, the kings dragons, and the bishops "Hindu juggernauts, complete with devout pilgrims being crushed underwheel." Overall, the black team has a more sinister, ominous, and imposing character than the white, which is intended to seem comparatively benign.

Goodwin's work is an example of the conscientious, yet lighthearted way a contemporary craftsperson may approach a timeworn task. Given the solemnity with which European culture surrounds the ritual of chess, these chessmen seem almost frivolous despite the preciosity of their materials. Still, beneath the superficial appearance lurks a profound awareness of the fundamental nature of the game and of the functions of the individual pieces; thus, the queen is the most powerful piece and also the most richly decorated, the knights are tosspot centurions of both four-footed and two-hoofed varieties, and the kings (whose capture is the object of the game) are rather stupid-looking dragons whose evasive maneuvers are limited to clumsy staggers from square to square, one at a time. The nature of the game and the character of those who play it are revealed in subtler ways than may at first seem evident. In a special way, too, the pieces resemble the game itself; they are characterized by an introspectiveness that shouts for attention in a whisper.

Most jewelry today is produced by manufacturing techniques that are, essentially, no different from those of any other industry. Silverware and stainless-steel utensils, engine camshafts and iron stove bolts, all come off impersonal factory lines. Even horseshoes are rarely made by blacksmiths any longer. The few who do still employ old-time skills at the forge and anvil are mostly artists working in an ancient medium. Sometimes, like sculptor Thomas Gipe (born 1938), they devise art objects (fig. 9-57), sometimes they

9-57 THOMAS GIPE.
Finally, An Opportunity To Use My Schmiedehammer. 1985. Cast iron, cast bronze, forged steel, brass, red oak, 53½ × 12 × 12″. Private collection

9-58 THOMAS GIPE.
Fireplace poker. 1984. Hand-forged steel, length 25″. Collection David Grong

9-59 E. AUSTIN GOODWIN. Spoon. 1983. Sterling silver, lapis lazuli, ivory, length 5″. Private collection

9-60 PAULETTE MYERS.
Earth, Sea, and Sky. 1980. Nickel-silver perforation, sterling, hematites, 5 × 8 × 3½″. Private collection

make utilitarian objects (figs. 9-58 and 9-59). Paulette Myers (born 1946), another artist/jeweler, has created a container for jewelry that is itself a precious sculpture (fig. 9-60).

Glasswork When it comes to commonplace utility that seems somehow touched by magic, glassware is unrivaled in appeal. The simplest tumbler will hold rainbows along with water. Although familiar to all civilized peoples, glass remains, nonetheless, a weird sort of stuff, its most striking property being that it is a liquid which has become stiff without becoming solid. It is what physicists call a "supercooled liquid." Common glass "freezes" at temperatures above 300° C. but, unlike most substances, when glass "sets" it doesn't crystallize. Technically, glass that is no longer molten is just a liquid

9-61 CAROLINE BOTTOM ANDERSON. *Splash.* 1983. Hand-formed glass, 7 × 7 × 7". Collection Michael and Ellen Jantzen, Carlyle, Illinois

9-63 DAN ANDERSON. *Water Tower Covered Jar.* 1983. Sand-blasted clay stoneware, 12 × 9 × 9". Collection Dr. and Mrs. William Shieber, St. Louis

9-62 DAVID R. HUCHTHAUSEN. *LS 84 M.* 1984. Glass and Vitrolite, 22 × 14 × 13". Collection Barbara Wagman

that has become so viscous it is rigid. If you think about it for a moment, you can see that glass frequently continues to *look* like a liquid even though it has lost its capacity to flow. Glassblowers often preserve this frozen fluidity as a fundamental element of their designs (see fig. 9-61). And the very fact that a liquid takes the shape of its container permits glassworkers to form their chosen medium into indefinitely various shapes. Glass can be blown just like soap bubbles into delicate globes or can be turned into sheets of plate glass[4] that may be thick, thin, rough, smooth, transparent, translucent, opaque, hard, soft, brittle, flexible, and so forth. Too, it can be colored in many different ways.

David Huchthausen (born 1951) uses the variability of the medium to construct sculptural objects of glass that have curiously philosophic implications. His *LS84M* (fig. 9-62) is typical of the works in the *LS* series in that the

9-64 BRUCE LOWERY. *Left-handed Mustache Cup.* 1980. Stoneware, height 5½". Private collection

9-65 PAUL DRESANG. *Untitled.* 1981. Unglazed porcelain, 9 × 10". Private collection

9-66 PAULETTE MYERS. *Inward Progression.* 1980. Loom-controlled weave, 36 × 96 × 6". Private collection

9-67 RI. Fashion drawings. 1984

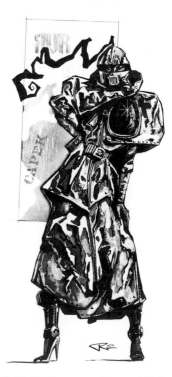

9-68 RI. Costume design. 1984

9-69 ROBERT E. CASS. *Design for a "Derby Flyer Nutzooter."* 1973. Blueprint, 34 × 30". Private collection

9-70 ROBERT E. CASS. *Musical Uoter.* 1973. Steel, rubber, and wood, 156 × 28 × 22½". Collection Southern Illinois University at Edwardsville

shadow the table casts upon the surface below is not what one would at first expect to see. The letter designation of the series stands for *Leitungs Scherben,* meaning "Fragments of Conveyance." This particular piece was formed from cold sheets and rods of colored glass and black-and-white Vitrolite. Vitrolite is a brand name for a special kind of opaque glass once widely used on building exteriors, usually in the form of shiny black tiles. It has expansion/contraction coefficients that make it particularly suitable for use in combination with other kinds of glasses so it lends itself to the kinds of visual paradox Huchthausen likes to compound.

Ceramics There was a time when the kinds of media we are now discussing were universally characterized as being "applied arts" or "minor arts" as opposed to painting, sculpture, and architecture, which were then referred to as the "fine arts." Perhaps there was a justification for such a distinction when painters and sculptors staked their claim to importance on their abilities to make visibly manifest the contents of a noble literature while potters, glassblowers, and metalsmiths turned out useful objects that might or might not be ornamented in imitation of what their artistic "betters" had done in other media. But once the Cubists had turned artistic significance on its head by making the measure of seriousness in art not what it represented but what it was, there was no longer any reason to think that the practitioners of one medium were inherently superior to specialists in another. As we have noted in pages past, master artisans in jewelry, ironwork, and glass have turned their hands as readily and effectively to sculpture as to the creation of utilitarian objects. And, for a fact, an example of fired earthenware (fig. 9-48) has already been used to exemplify one form of additive sculpture.

Ceramic sculpture, however, had usually been distinguished from "pot-

tery" just as sculpture made of iron by the smith's craft had been considered something apart from horseshoes, gates, and the like. Indeed, Dan Anderson (born 1945) made something of a point of this sort of arbitrariness by calling his canine caricature a fern stand and driving a cluster of nails into its back to account for its "madness." But Anderson makes conventional pottery, too (fig. 9-63), by *throwing*, that is, by forming a hollow vessel by hand from wet clay on a potter's wheel. Which is the way Bruce Lowery (born 1952) formed the cylinder of his humorous stein before applying the grotesque "mug" to it (fig. 9-64).

Normally, we think of pottery formed on a wheel as being round and hollow. But, in an original mode more akin to the making of ware than of sculpture, Paul Dresang (born 1948) has disrupted the expected pattern. By the simple yet ingenious ploy of squeezing flat the vessels he has formed from clay in the usual manner, Dresang has created a series of ceramic reliefs (fig. 9-65) that are not only appealing as objects but also make a whimsical comment on the very nature of clay bodies.

Fiber, Fashion, and Other Fabrications Like Dresang's reliefs, Arturo Sandoval's *Pond* (fig. 9-51) remarks on the nature of the medium from which it springs. For here is a positively massive example of exemplary weaving—the warp and woof is hundreds of times heavier than broadcloth—in the form of a Minimalist sculpture. Still, it is a sculpture constructed exactly as one might a piece of shirt cloth upon a primitive loom, except that this fabric is woven from battery cables.

Fiber artists still weave cloth and construct garments, bedclothes, carpets, and wall hangings. But as often as not, they quite literally fabricate sculptural entities (fig. 9-66), using the skills of the weaver, tailor, seamstress, couturier, and fine artist to create relief works or to enwrap space in soft structures unlike any statuary fashioned in the past. As the terminology itself suggests, however, there is a sense in which all traditional fashion designs are sculpture intended to be worn (fig. 9-67), and some artists actually produce clothing that is conceived only for display and has no genuine "wearability" at all (fig. 9-68).

They are not alone in this kind of endeavor. We could cite woodcarvers, furniture makers, and clothing designers who have come to treat the traditional objects of their crafts as inspirations instead of prototypes. There are even industrial designers whose notions are far more intriguing than anything industry is likely to produce. Consider, for instance, the blueprint for Robert E. Cass's (born 1943) attenuated vehicle (fig. 9-69). This is a genuine blueprint, made all the more impressive by reason of its having been drawn in negative, so that whatever is seen here as white was black in the original rendering. More remarkable still, the artist is a skillful builder who has put together sculpture built according to the specifications of the blueprints (fig. 9-70). These handcrafted toys are not only of a meticulously precise finish that rivals the most expensively manufactured luxury machinery, they actually do work; that is, one could actually "zoot" along on this marvelously balanced scooter.

PART FOUR
THE AGES OF ART

TEN

PREHISTORY TO THE FALL OF ROME

The works illustrated in figures 10-1 and 10-2 are of very ancient objects created before the beginnings of history. That is, there are no written records from their times attesting to their existence; spoken language was truly primitive when the earliest of the works was created, and writing waited long after completion of the second one before it made its appearance. We can, however, be sure that the works were done—they exist, after all—and we know they were formed many thousands of years before the birth of Jesus. Perhaps I should be a bit more cautious and assert there is *scientific evidence* that they date from at least as early as the ages given in the captions—15,000 B.C. and 2,000 B.C., respectively.

I hesitate only because of a controversy over what is called "Biblical inerrancy" that has been raging in the United States for some decades. It's the sort of sectarian versus science conflict that does not normally turn up in textbooks on art, but I think it is important to deal with because (1) it bears directly upon the archaeological study of ancient art and (2) I do not believe that it is *altogether* impossible to moderate.

One of the first difficulties most old-fashioned followers of religions—whether Christian, Muslim, Judaic, or whatever—have with the modern world is the tendency of virtually everyone (*except,* ironically, the most sophisticated scientific minds) to equate "scientific" with "truthful." That is, when we hear something affirmed as a "scientific fact," we usually take it as given that it is an absolute truth of nature. A genuine scientist sees it in an entirely different light because scientists really and truly do believe that all scientific verities are subject to continual questioning and eternal doubt. Most of them spend a lot of their professional life trying to *disprove* the hypotheses they've generated. What a number of different kinds of trials cannot invalidate is taken to be provisionally sound. Of course, a given investigator may be quite arrogant about the soundness of his or her theory, but it is often the case that many peers are undertaking experiments to dislodge that theory from its momentarily secure position. That's why Newtonian physics was replaced by

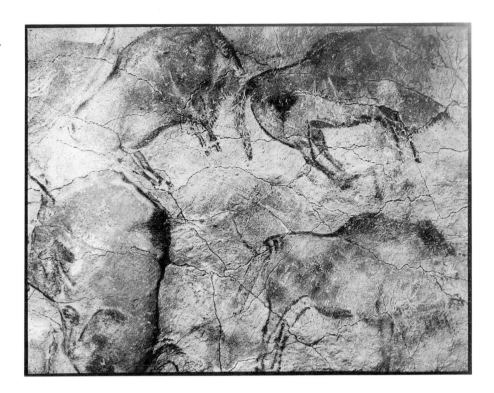

Einstein's relativity, Einstein's field theory overcome by Hawking's string model, and so on. Darwinian evolution was faulty in many respects and it has been undergoing almost continuous revision ever since 1859. What was significant, not to say revolutionary, about it was that Charles Darwin attempted to deal with living plants and animals as material beings subject to cause-and-effect relations like other objects in nature.

Religious faith, in contrast to scientific theory, is not subject to proof or disproof. It may be rational and, so far as that goes, may even be absolutely true and utterly final. But it can *never* be disproved; it is altogether safe from the effects of any test since, by definition, what is supernatural lies beyond physical examination.

The reason this is important to us is that there are people—among whom will be a few members of my reading audience—who believe the universe of stars, planets, and other heavenly bodies came into concrete existence about 7,000 years ago! These are so-called Fundamentalists, pious worshipers who take the word of the Holy Bible as literal, and some would say, *unerring* truth. It's a medieval way of thinking. That doesn't mean it's wrong, but let me show you what it's up against. Afterwards, I will attempt to mitigate the conflict. Please understand beforehand, though, that I am one of those skeptical modernists whom the disciples of inerrancy characterize as "secular humanists." It's a rather apropos description, actually, and I hope to show that I am not quite so blind to the feelings of the other side as are most of my supercilious ilk.

To argue that the universe was a fairly recent creation is tough work because it runs headlong into geological techniques for computing the ages of mineral substances. This is a physical procedure based on the known half-life of isotopes. The term *half-life* is a familiar one. It means, in the simplest possible way of putting it, the rate of decay of radioactivity in a given isotope. For instance, Uranium 235 turns into radium and eventually becomes a stuff we encounter in everyday life as lead. It takes millions of years for a sample of U-235 to be transformed into a chunk of this soft and heavy gray metal. Some isotopes lose their radioactivity in as few as ten seconds. Others take ten years

10-2 Abstract figures from rock engravings at Mont-Bégo, near Tende, France. c. 2000 B.C.

to the sixteenth power! The rate of decay in terms of specific disintegrations of the radioactivity is also calculable, so, if you know that the normal rate for an isotope with a half-life of 100 years is 18 disintegrations per minute and the sample being tested exhibits a rate of 9, you should be able to figure out that it is 50 years old. On the basis of calculations of this sort done with meteorites, earth substances, spectographic and radiographic analyses of stars, etc., the age of the planet earth is estimated at about four and a half billion years, of which time humanity has existed for only 12,000th of one percent. The scientific evidence is nearly impossible to overcome unless one simply discards some of the most fundamental assumptions of physical science, a difficult

thing to do in view of the prominence of its contributions to contemporary civilization. After all, the kind of knowledge that has managed to control nuclear fission and can at least foresee the possibilities of workable fusion really does command some very serious regard.

The principal method for dating works like the prehistoric paintings in figure 10-1 is the *radiocarbon* technique. It depends upon the presence of two varieties of carbon that are present in all living things. Carbon 14 (C^{14}) is produced by cosmic radiation and is absorbed by animal and vegetable matter as carbon dioxide. Carbon 12 (C^{12}) is a similar isotope. The significant difference for us is that when an organism dies, absorption of the C^{14} ceases while the C^{12} is constant in its amount. Knowing the half-life of the two isotopes in a given sample makes it possible to date the death of the plant or creature by calculating the difference between them. The amount of C^{14} in any given piece of bone or hair or tree limb or charcoal is reduced by "exactly" one-half in 5,730 years, give or take 50 years. The normal rate of disintegration is 15.3 per minute, meaning that if your sample reveals a rate of 7.65 that sample is about 11,460 years old. Maybe it's 11,560, perhaps it's 11,360, but the vast probability is that it is somewhere between the two extremes. If the rate of disintegration was 3.82 per minute, we could say the sample is between 23,120 and 22,520 years old. If 1.41 it's about 45,840. Going further back than that is futile since carbon 14 is useful only for dating things of very recent origin—that, is, things of less than 50,000 years. At one time, incidentally, things dated in this way were thought to be a bit younger than they now appear to be. The dates worked out by archaeologists and chronographers after the invention of radiocarbon dating by Willard F. Libby in 1946 were based on a half-life of 5,500 years, plus or minus 30. That figure was derived from a bit of ancient Egyptian woodwork. Wood is good for determinations of this kind because the rings give us a nearly perfect chronology and history of the sample. Newer estimates are based on dead wood from the oldest living things—bristlecone pine trees which grow at very high altitudes in the American Southwest. Some of these are as old as 6,500 years!

Most of us would suppose that when the evidence above has been presented, debate about the approximate age of prehistoric objects would be foreclosed and all disputes ended. In fact, however, all kinds of objections have been raised to certain assumptions connected with scientific chronology[1] and particularly to those having to do with the emergence of the human race. That's largely because evolutionary theory is based on the random selection of various genetic mutations; that is, terrestrial beings and their earthly environment are supposed to have come into existence by purest chance. Most people find it very difficult to believe that the magnificently intricate patterns of the natural world result from millions upon millions of meaninglessly random accidents. Just why *that* seems ridiculous to people for whom the existence of a supreme Creator, capable of fabricating or even managing so many events in serial order, is not only conceivable but taken for granted is itself something of a puzzle to many rationalists. After all, if the one thing is mind-boggling to consider—and it is—then the other should surely seem fantastically far-fetched. But whether fantastic or not, the presence of an omnipotent deity who guides our destinies because we are beloved by it is a need of the human heart against whose yearnings reason falters. And religious skeptics might well take pause when they contemplate the measured tread of the millions upon millions who have marched to worship through all the generations of the past.

Now, then, is it possible to tolerate the story that scientific paleontology tells of things painted on cave walls as long as 20,000 years ago and yet keep

faith with the very words of Genesis? Yes, indeed. In 1857, two years before Darwin published *Origin of Species,* a zoologist by the name of Philip H. Gosse (1810–1888), came up with an ingenious solution that may strike the agnostic as wholly contrived, but it is at least entirely consistent with both the apparent facts and the conditions of belief in Biblical inerrancy. One need only believe that when Jehovah fashioned the first man from clay and formed his mate from a rib of the man[2] the two creatures that resulted resembled those whose images are given to us as Adam or Eve in figures 12-18 and 12-19. Notice that in each case these principals possess navels. Navels! But why should such mementos of umbilical cords be present when neither the first man nor woman came into the world from within a womb? The pictures, of course, don't mean anything, so far as authenticity is concerned. The artists weren't drawing portraits of the originals; they were just using nude human beings as models. But let us assume that Adam *did* have a navel, provided by his Creator to serve as the prototype for all the human beings to come, since those future sons and daughters would need them. God designed the prototype with the physical history of a birth that did not exist. Should that have been the case, then mightn't God also have provided the universe with a temporal history and even with fossils, cave paintings, and the like? Well, this is precisely what Gosse's book *Omphalos* (Greek for "navel") contended. If God could create Niagara Falls, He could simultaneously make the history of the stream bed that would otherwise have led to its creation. To update Gosse's argument, He who can create the suns can also, certainly, make C^{14} in the necessary amounts and half-lives. Those who think the history of prehistoric eons is a marvelous fiction perpetrated by an ingenious God may take it as such. The paintings are still on the rocks, and the dates are as justified as if they were what secular science says is probably the case.

Paleolithic and Mesolithic Art Many of us, upon being shown the bison from Altamira, Spain (fig. 10-1), without a caption, would suppose that they are from a culture more intellectually and socially advanced than the images produced by the people of Mont-Bégo in a remote, nearly inaccessible Alpine region of France (fig. 10-2). The accuracy of the outline of the bison and the subtlety of shading convey what the lay public will, quite naturally, construe to be less "primitive." I myself was very surprised to learn that this depiction of bison came from a culture that is scarcely more exalted than a pack of beasts while the second picture is from a society on the verge of what we would consider "civilized" community. In fact, the two works of art represent the greatest single social and technological change in the entire history of humankind. It is the shift from *Paleolithic* culture, represented by the bison, to *Neolithic* culture. Literally, the terms mean "old stone" and "new stone."

The nomenclature has to do with the character of the tools that are found along with other artifacts of the peoples—the stone spear points, arrowheads, scrapers, hatchets, etc. You will sometimes see these things attributed to the "lower" or "upper" Paleolithic or Neolithic eras. That characterization has reference to the successive strata or layers of earth in which the objects were found. What was earlier was first buried in the silt brought by encroaching waters or other consequences of geological change. What is later is higher in elevation, literally "upper." Paleolithic tools are typically more jagged and irregular than Neolithic ones (see fig. 10-3). The Paleoliths formed theirs by impact-breaking of the rocks—often flint, which snaps along razor-sharp, scallop-shaped edges. The Neolithic artisans have advanced from what anthropologists call "pressure flaking," which wears the flints down in a

10-3 Stone Age tools: Paleolithic (a); Neolithic (b)

a

b

smoother, more controlled fashion, to polishing. The rock painting in figure 10-2 is from a culture that was not yet at quite the technological stage of development usually called Neolithic; it is from the later part of a transitional period that might be thought of as "lower new stone age"—now termed *Mesolithic*. The artwork and culture of Mont-Bégo, however, were more akin to the Neolithic than to the Paleolithic.

Generally, these cultural phases correspond to geologic eras and resulting climatic changes. The Paleolithic period is the earliest and longest in human history, being coextensive with the Pleistocene Era (c. 2,000,000 B.C. to 10,000 B.C.), or "Ice Age." The Mesolithic, or "Middle Stone Age," began about 12,000 years ago when the current geologic era, the Holocene, came into being as the glaciers of the Pleistocene receded. The Neolithic emerged in different parts of the world between about 8,000 B.C. (Asia) and 3,000 B.C. (Europe); it is specifically related to the discovery of means of cultivating cereal grains such as rice, wheat, rye, oats, and barley. The Paleolithic environment created humanity and, in the Neolithic, humanity invented agriculture. From agriculture comes what we know as civilization.

The Paleoliths were cave dwellers who lived as parasites upon the face of a cold and hostile earth, finding shelter in the crevices and hollows of its terrain, slaughtering the beasts of the forest and field for food and clothing, gathering wild cereal grasses and fruit as dietary supplements. Theirs was a truly savage existence, not unlike that of the quadrapeds with which they were in competition. These primitive human beings—*Cro-Magnons*—had at least two great advantages over the other predators, however; they had hands that enabled them to manipulate tools effectively, they stood upright, which increased the flow of blood to the brain, and they were able to communicate information through the medium of speech, a means of signaling that was certainly far more structured and informative than anything found among other animals.

The reason for the prevalance of carved and painted animals on the walls of the great caverns in Spain and France can never be known, really. Here is a case where the experts are *really* guessing, but it does appear that early hunters believed the image did in some way ensure that the tribe would secure the beast. Obviously, the artists who painted these things took their work seriously. They prepared pigment colors from mineral powders and vegetable dyes, mixing them with animal fats and similarly gelatinous substances to make paint. The basic anatomical forms of the animals are frequently suggested by the contours of the cave walls, and sometimes animals will be carved into the surface by emphasizing the humps and hollows that were already there. Paleolithic art is drawn from nature and it is realistic. Probably, it is also magical in intention.

Magic, in the sense I use it here, refers to a belief in the mutual dependency of similar but unrelated events. Such beliefs are tied to a more general conception of nature anthropologists call *animism,* that is, the notion that all objects in existence have consciousness or spirit. If, for primeval man, rocks and trees, streams and clouds, were invested with living spirit, it would have been consistent for him to suppose that carvings and paintings of animals are to some extent the equivalent of the animals. In a sense we do the same. Aren't you more apt to say to a child as you point to a picture of a bison in a book, "See the buffalo?" than to say "See the picture of the buffalo?" Many students of prehistoric culture think that primitive humanity took an image for an insubstantial equivalent of the thing depicted. One can never be sure that such speculations have a basis in prehistoric fact,[3] but they tend to be confirmed by the behavior of peoples more recently in a Paleolithic-like form of development. A famous example appeared in a turn-of-the-century essay by anthropologist Lucien Lévy-Bruhl. He tells of a Sioux warrior accounting for a poor hunting season. The warrior commented that the artist George Catlin had "put many of our buffaloes in his book, for I was with him, and we have had no buffaloes to eat, it is true."[4] The warrior saw no real difference between capturing the image of the buffalo and stealing the animal itself because he saw no opposition between reality and art; for him the two things were continuous.

The "magic" of representation ensnared the essence of the beast. Similar instances have been cited by many other writers, including James George Frazer in his famous *The Golden Bough* of 1911. This is not the kind of magic that we associate with the occult. It isn't supernatural or uncanny; it is a very naive form of materialism. Again, we are familiar with such beliefs even though they may seem alien at first. For instance, people who take astrology seriously do not ordinarily connect it with occult forces—although some spiritualists do employ astrology in their practices. Astrologists usually claim that the influences of the heavenly bodies are physical emanations, natural cosmic forces whose effects are not yet acknowledged by most scientists. That, perhaps, is the way Paleolithic peoples conceived of the magic of the picture. The bison on the wall simulates a future possession of the beast. If you possess the image, you hold the animals' future hostage.

The hunters of the Ice Age sought beasts that were large and dangerous—some of them, like mammoths, larger and more fierce than today's African elephants—using weapons that were terribly crude. No modern hunter would think of setting out after a mammoth, bison, or bear without a weapon capable of killing the brute at some distance; he would choose a high-powered rifle or, at the very least, a heavy hunting bow and steel-tipped arrows. The Paleolithic hunter had no such tools, not even a light, crude bow; he assaulted his monstrous game with traps, a spear, and clubs. Their use required upper body strength of the kind males usually possess rather than the superior endurance of the female. These hunters were men. And, like all professionals in the killer's trade, they were very sensitive to little things, to spoor and hooves and the vulnerable places to strike home with their rough weapons. Moreover, they were more alert than a modern man could ever be because they were fearful to a degree that would, today, be considered neurotic. In their savage circumstances, wariness was an important factor in the capacity to survive; their fear thereby produced not panic but watchfulness and hypersensitivity. And, when a hunter turned to art, his acuity played a powerful role in the creation of images that are authentic-looking in our eyes today. Like most primitive forms of extreme realism, Paleolithic accuracy

derives from the simplicity of silhouettes. The precisely traced outline, combined with ready-made contours in the cave walls, provides a field for the application of color tones that replicate the markings of various kinds of game.

Outlining is the most primitive form of realism simply because it has an isomorphic relationship to the original. That is, the silhouette of my hand is no different, in its essential shape, than the shadow it casts when held up to the sun. Similarly, a photograph of the hand, taken from the same angle, reveals the same contours. Likewise, a meticulous drawing of the hand will present essentially the same image. It is not at all surprising that the very earliest drawings found in the Pleistocene caves are tracings of human hands. This kind of realism is so basic that one doesn't have to learn any artistic conventions to recognize the imagery. The distance from it to the kind of illusionism we associate with Renaissance art or photography is enormous, really, for the latter depends upon an ability to abstract general concepts from specific conventions. It's like the difference between appetite and taste or sex and romantic love. Or savagery and civilization. Figure 10-2, which barely hints at the reality of oxen and their human masters, is unnatural so far as appearances go. It is also a reflection of mental attitudes that form the basis of our own.

Neolithic Art and Tribal Cultures If any change in human history deserves to be called "revolutionary," it is the change from Paleolithic to Neolithic culture, for it constituted the greatest single transformation of the relationship of human beings to their environment that has yet occurred. Our own great-great-grandparents' confidence in their ability to tame the American continent is a direct consequence of the Neolithic revolution; similarly, present anxieties over the effects of that taming on ecological systems grow from Neolithic prototypes.

Paleolithic peoples were one with nature and saw themselves—to the extent that they managed such distinctions—as a part of her. Of course, all humanity is a part of nature, in at least a physical sense, but Neolithic peoples did not view themselves in quite that way. Instead they felt as we do, that they stood somehow apart from everything else in existence, that their capacities distin-

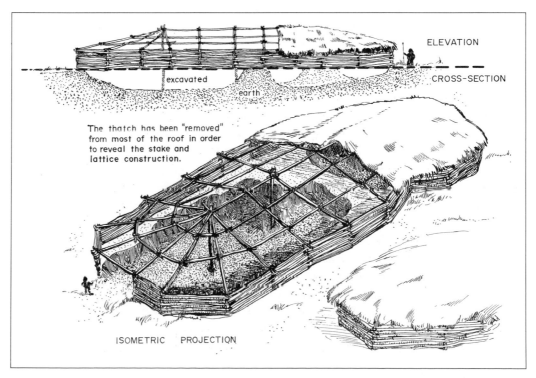

10-4 Reconstruction of a typical European dwelling during the fourth millenium B.C.

guished them from other animal life in a sense that was absolute, even when the family or clan thought of its identity as being connected to a wild animal through totems and the like. And the reason for this conceit is not hard to find. It had to do with the fundamental change distinguishing Neolithic society from Paleolithic times. Primarily, it was a change in the mode of food production. Members of the tribe had ceased being parasitic hunters and had become cooperating farmers, concentrating their energy sources.

The artists who did the engravings scratched into the rocks on Mont-Bégo (fig. 10-2) are known to have been shepherds who, for about three months out of the year, brought their flocks to the high plateaus during the summer. Their lifestyle and approach to art is already marked by what is to become the Neolithic world view. Neolithic times were those of cultivation of plants and domestication of animals. Men and women had begun to farm. They now had crops, they tended herds, and they were more or less able to control their food supply. Thus, the entire rhythm of human existence was transformed; life now revolved around the farm, the field, the pasture. There were settled communities instead of nomadic bands; homes were constructed instead of merely discovered in the raw terrain of the planet. Figure 10-4 is a reconstruction of a typical Central European dwelling during the Neolithic period. You will remark, no doubt, that it is not unlike the fabled "thatched huts" of Africa and Asia.

Prehistoric peoples did not change their way of life voluntarily; they did so in response to a cataclysmic event, the end of the Pleistocene Era and the retreat of the glacier. As this 1,000-foot-thick ice cap melted away, the climate became more temperate. But the consequences were anything but idyllic for the hunters of the Old Stone Age because the big game also moved to the north. Some followed the herds. Others stayed, and the domestication of wild grasses—which was most probably an achievement of womankind, since Mesolithic women were the gatherers of grain for the tribes—provided protein for the tribes in the forms we know as cereal grains. Once a group had accumulated a surplus of grain, it was possible to store fodder for cattle, pigs, sheep, and horses through the winter months. The taming of wild animals had begun far, far earlier in the Mesolithic, with the dog who—if not man's best animal friend, was certainly his earliest.[5] Any of you who have seen a good border collie or other working breed handle a mass of sheep or cattle will know that those who control dogs can control many other beasts of the field.

The mystique of the hunt, which entailed a naturalistic conception of all things, was replaced by a cult of production that involved a differentiation between nature and the forces controlling her. Inevitably, those forces came to be considered superior to nature herself—they were, in a word *supernatural*. Paleolithic people endeavored to defend themselves against pain and want by means of magic, but they didn't connect good or bad fortune with any power behind events. It seems that when human beings started to breed plants and animals, they began to feel that their destinies were directed by invisible beings endowed with powers to control events in the natural world. This idea, that someone or something stands behind human fortune or misfortune, is an abstract conception of existence that must be counted one of the greatest creative leaps of the human intellect. It leads to the notion that demons and gods distribute favors to the farmer just as he or she distributes grain to the herd. This idea of reality, which sees human beings as the livestock of the gods, divided the Neolithic world into two parts, the natural and the supernatural. And concurrent with that dichotomy emerged an art dedicated to something other than the representation of nature. Employed to propitiate

10-5 JOHN ADKINS RICHARDSON, ERNEST SCHUSKY, AND SIDNEY DENNY. Reconstruction of Cahokia Mounds as they would have appeared about 900 A.D.

spirits and demons, designed finally to appeal to something superior to nature in order to stop floods or get rain or overcome a plague, Neolithic art becomes the *antagonist* of nature. Since this art was concerned with the supernatural, it looks *un*natural, and that is an association that continues throughout history. Even when the Greeks of the Iron Age or the Italians of the Renaissance seem to be departing from the rule, they, in fact, remain true to it. What is supernatural is unnatural in appearance. Of course, not every kind of art, even in Neolithic times, was directed at the spirits.

Had we more works from the Neolithic period we would be in a better position to evaluate the purposes of any given piece. Unfortunately, Neolithic artists preferred relatively impermanent materials such as wood, pottery, and fabric to stone, and most of their paintings were not protected through the eons by the dark stillness of caverns. Most of these people lived in thatched huts and few of the dwellings or artifacts they contained have been preserved. All we have left of the villages are isolated sculptures, an occasional rock painting or engraving, some potsherds, and the trace lines of foundations from long-vanished domiciles. Those fragments, along with such monuments as the famous structure at Stonehenge in England,[6] and the great religious sanctuaries in South and Central America and at Cahokia Mounds (fig. 10-5) in Illinois near St. Louis, Missouri, are the main remnants of the Neolithic. Fortunately, there still exist a very few groups of Neolithic peoples, though virtually all of them have been deeply affected by modern civilization and technology. Since, with some obvious exceptions, the appearance and apparent purposes of the art from tribal societies that were still "pure" during the nineteenth century share numerous traits, it is plausible to connect it to the prehistoric art it most resembles. You will understand, though, that this is a caricature and that whatever can be subsumed beneath the general description would be divided by more relevant and apparent distinctions when seen through the eyes of the specialist or the peoples themselves. At the extremes we have already observed are the Bakota guardian figure (fig. 10-6) and the bronze casting from Ife (fig. 10-7). I submit for your study a work from a society that has been given especially thorough study by French anthropologists and to which I, myself, have devoted some critical attention.[7]

Of contemporary ethnic groups in the tribal condition, one of the most

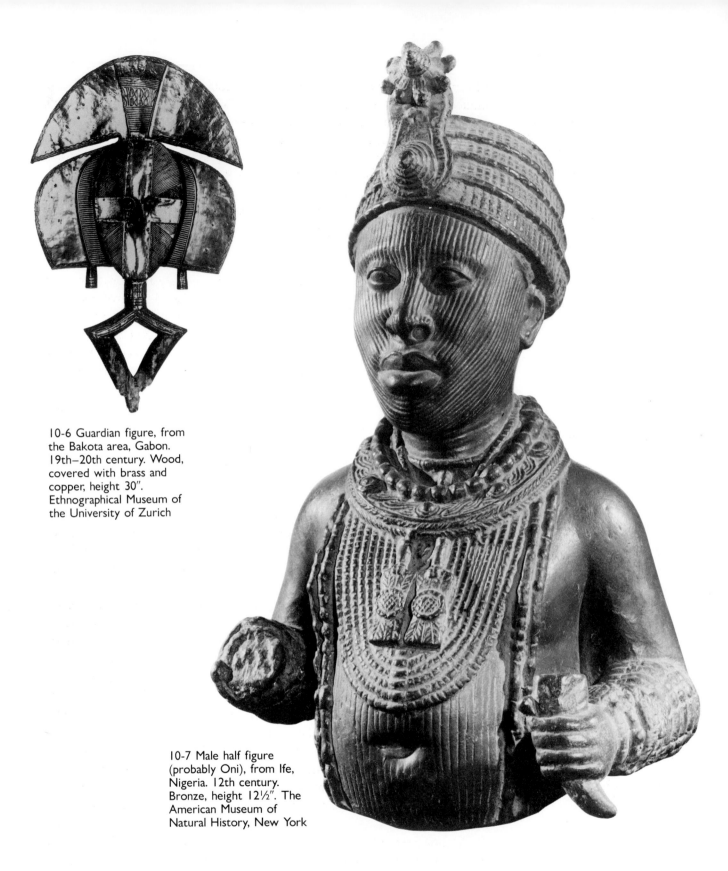

10-6 Guardian figure, from the Bakota area, Gabon. 19th–20th century. Wood, covered with brass and copper, height 30". Ethnographical Museum of the University of Zurich

10-7 Male half figure (probably Oni), from Ife, Nigeria. 12th century. Bronze, height 12½". The American Museum of Natural History, New York

intriguing is that of the Dogon of Mali in Central Africa. The Dogon live to the south of the Niger River in the cliff region that lies within its great bend. An extremely proud people, they have proved unusually resistant to Islamic cultural influences that have had a pronounced effect on all neighboring groups. One reason for their fierce insularity is, perhaps, the complexity of their religion and their sense of having an ordered knowledge of everything in existence. All Dogon activities are underpinned by a precise ritual and accounted for through a cosmogony which sounds vaguely Neo-Platonic. As a matter of fact, it goes beyond most Western philosophies for which it has an

10-8 Female ancestral figure, from Dogon, Mali. 19th century. Wood, height 23". The University Museum, Philadelphia

affinity; Marcel Griaule, an anthropologist from the University of Paris who studied the group for twenty years, says: "[This] conceptual structure, when studied, reveals an internal coherence, a secret wisdom, and an apprehension of ultimate realities equal to that which we Europeans conceive ourselves to have attained."[8] Dogon sculpture (fig. 10-8) asserts an austere, abstract verticality and all of its figures are religious. This particular piece is a female ancestral figure, but one must understand that it is not intended to resemble a deceased relative. Rather, it is a channel of communication with the spirit world that lies beyond visible reality.

The Dogon philosophy of existence is a very intellectual affair and I have chosen this group of Africans partly for that reason. Those of us who have grown up in technological societies are inclined to be very arrogant about our own standing in history's rankings. Indeed, I have heard some of my more benighted and prejudiced students (by no means all of whom are white) characterize African tribesmen as "dumb savages." The reaction is understandable; I'd not like to pretend that I have none of the ordinary biases of my time and place. But here is a cautionary admonition, all the same (see fig. 10-9).

Figure 10-9 has at least once been accused of "reverse racism" but it truly isn't guilty of what's usually meant by that weirdly awkward term. The point it hopes to make should be clear to any unbiased observer. It isn't that the African priest holds a view that is more correct than the one held by the British pilot or Japanese scientist; rather, it's that members of a tribal culture are not necessarily more primitive or naive than members of a technologically advanced society. The members of what we may think of as "traditional" or "Neolithic" societies are not invariably impressed with the superiority of those who alight from a great silver bird. They may be frightened or awed—as we might be of hideous aliens from a UFO—but it doesn't mean they are worshipful. One should always bear in mind that members of a tribe are not inferior, only different in cultural background and technology. Remember, too, that if all of the engineers and technicians died tomorrow, the industrial nations would soon collapse, whereas the tribal groups would continue to go on much as before. Certainly, a people like the Dogon would. Perhaps it will be sufficiently impressive in this respect to learn that the Dogon, unlike virtually everyone else, do not base their calendar on the cyclical movement of our planet around the sun. Theirs is based *on the rotation of a double star system* in the region of Sirius! This is a speck in the heavens that can scarcely be detected with the naked eye. It is a remarkable people who would derive such a system from their conviction that the universe was generated there within a great spiraling vibration and that the ancestors of humanity—male and female twins—originated from the sperm of the primordial god in this region of space.[9]

The Dogon statue at hand is not supposed to resemble the earthly incarnation of someone's ancestor; it is a supernatural being supported, you may notice, by eight smaller figures that form the legs of a stool. These figures represent the gods who were the second generation of humanity; they are identical in appearance even though half are female and half male because they are biological and metaphysical twins. This is an important theological concept for the Dogon. All beings, whether actually genetic twins or not, are living images of the principle of "twinness" (that is, duality) in nature, for each of us possesses two souls, one male and one female. All Dogon sculpture expresses this fundamental principle. Take note of the duality of the sculptural forms: the breasts match the shoulder blades, forming a single quadrangular

mass that rests on the shaft of the torso as a capital does upon a column; the beard is echoed in the headdress; the child resting across the upper forearms is played off against the one carried on the back; the surface ornament sets zigzags in opposition to one another.

The babies are another expression of the paired-opposite theme of duality or twinness that runs throughout this people's thought; they are child-adult images of a type found all over Africa. The meaning of this convention is known. Not only are the newborn entering the world felt to be closest to the ancestors who are departing it, but infantile representations are apt expressions of the desire for procreation. Belief in the inseparability of the past, present, and future contributes to the social cohesion, ethical behavior, and preservation of Dogon society. It is in this light that the sculptures have a constellation of meanings and values that are not concerned with the mundane world of visual sensations but with the supra-sensible world of the spirit and intellect. It is, of course, typical of such objects that they should look unnatural and also that one must have a "key" of special knowledge to decode their meanings. That is especially the case here, and I have not, in this brief treatment, even touched upon the elaborate numerology of the surface markings of the statue, a main point of the cited article on Dogon iconography.

The art of traditional tribal societies is no more marked by crude, superstitious impulse than is that of Western civilization. The Dogon are unusual among cultures for the intellectual refinement of their thought. They are typical of many tribal societies, though, in producing artifacts that symbolize things of the spirit in a complicated, esoteric way. In this they are exactly like the members of what we have come to think of as the great civilizations of preindustrial ages.

In the case of the Ife bust (fig. 10-7) we have an instance of an artifact produced by an African culture that has, by definition, advanced beyond the technological level of the Neolithic. This statue was created by the lost-wax bronze-casting process and proves the society had entered into the next major level of development, the Bronze Age. Although the Ife attained this level after Asians and Europeans had, there is no longer any question that the invention is theirs, independent of its non-African precedents, and was completely indigenous. Archaeologists have established beyond doubt that lost-wax bronze casting was practiced in West Africa long before the first Portuguese explorers penetrated into the region during the sixteenth century. But the Ife civilization began to wither around this time, though the city of Ife is still a center of the political universe of a great number of Yoruba-speaking groups in the region. Among Yoruban subcultures, besides the Ife, are the Oyo, Ketu, Ekiti, and Benin. Sometime during the fourteenth century Ife knowledge of bronze-casting techniques was communicated to the Benin, who developed a unique style combining the naturalism of the Ife with a pronounced stylization more typical of African art.

The most striking thing about Ife sculpture is, surely, its apparent naturalism. Even those longitudinal ridges (common but by no means invariant in Ife busts) are thought to represent a type of scarified tattooing. However, there does seem to be a certain degree of idealization connected with the style — features are somewhat more perfected and symmetrical than we expect of living people — and that, itself, removes the depictions from the category of merely mechanical conformity to nature. The statues may be votive objects having to do with worship of departed ancestral heroes and rulers, but they might also be straightforward royal portraits in which the recognizable image is presented in an appropriately flattering form. We cannot say. Authorities do

10-9 JOHN ADKINS RICHARDSON. *Reason and Faith.* © 1987, John Adkins Richardson

not concur with one another. However, it is safe to assert that the Ife sculptors who lived in West Central Africa during Europe's medieval period have an intellectual and cultural standing with any artists of the age.

The Art of Ancient Egypt The cradle of every great civilization was some Neolithic tribe. But the passage from relatively simple, archaic societies to populous, hierarchical ones does not occur without corresponding transformations in religion and mythology. Custom alone cannot sustain institutions; to subsist, authority must be hallowed and sanctioned by mythic beliefs that set rulers apart from other men or women. Monarchs, unlike mere chieftains, must seem to be made of special clay cast from some higher mold, and the virtues presumed for them must be supposed to be incarnate in their descendents. Usually, the family line has been ordained to rule by some god or other. Thus, the kings of seventeenth-century Europe and the czars of nineteenth-century Russia reigned by "divine right." The earliest chronologies of British kings lead directly back to the god Woton. Even in our own century the emperor of Japan was called the Son of Heaven. It all begins with the ancient lore that attributes to every leader on the threshold of history some supernatural connection. Both Moses and Hammurabi were scribes for their gods. Every pharaoh of Egypt *was* a god.

Ancient Egypt's **royal succession myth** gives the best possible evidence of the continuity and extension of tribal conceptions into awesome principles of human destiny. Moreover, when that myth is examined against what little we have learned of the Dogon, one sees confirmed the relevance of modern archaisms to prehistoric ones. For Egyptian theology must have begun in something bearing a close resemblance to the Dogon myth of creation. Once again there is a primordial god, Ra-Atum-Khepri. He is self-created and, having no mate, creates two other cosmic deities from his own semen. The mating of these twins, Shu (air) and Tefnut (moisture), spawned two more, Geb (the male earth) and Nut (the female sky). Geb and Nut then produced four offspring: two males, Osiris and Set, and two females, Isis and Nephthys. Osiris inherited the Earth of his father but was envied by brother Set, who slew him and usurped the throne. Isis, however, discovered the corpse of Osiris and (in the first recorded story of resurrection) employed her great magic to revive him from the dead. They couple and Isis is impregnated with Horus. Osiris then leaves the Earth to, as ancient Egyptians would have said, "go West" and become lord of the underworld. Horus avenges his father by defeating Set and becoming the rightful king of the Earth.

This primal myth, of which there are many versions, became the basis for the authority of the pharaohs; their royal succession is nothing more than the playing out of the Osiris, Isis, Horus theme in perpetual reenactment. The living king upon the throne was regarded by the people of Egypt as the god Horus, whose totem is the hawk, and was accepted as being immortal, in fact, the son of Isis and heir of Osiris. But to be immortal doesn't mean invulnerable to death in the mundane world; obviously, many pharaohs died during the thousands of years Egypt's civilization prospered. When the pharaoh died he became identified with his father, Osiris, and his own son took his place upon the throne of Egypt as Horus. Becoming Osiris and Horus, however, could be accomplished only by means of ritual magic, and this was the purpose of the involved ceremonials attending the burial of the deceased king and the investiture of his successor. The priests and other mortals who participated in these rites were well motivated to take the whole thing seriously because they believed that the process had, necessarily, to be maintained

10-10 Pyramid of Khufu (Cheops). c. 2570 B.C. Limestone, height 480'. Gizeh, Egypt

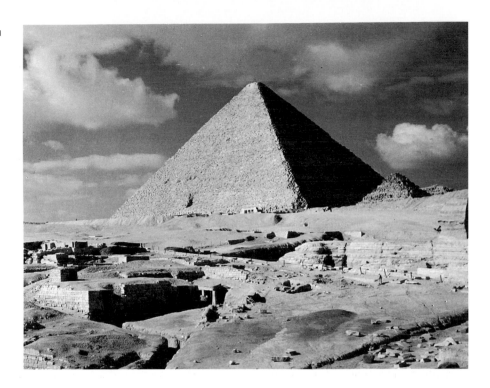

without interruption for the continued existence of the world (nature) and underworld (supernature). Only so long as Osiris and Horus existed would the world exist; without them it would all evaporate.

Woven in and through the royal succession myth were elaborate beliefs about life beyond the grave. Virtually all of the art and architecture that remain from this majestic civilization are reflections of these beliefs. Consider the great pyramids at Gizeh, near the mouth of the Nile. They are solid stone, except for passageways and small crypts, rising as much as 480 feet in the air. The oldest and largest of them, the pyramid of Khufu (fig. 10-10), covers 50,000 square feet and is built of 500,000 blocks of stone weighing two and one-half tons apiece. In a delightful exaggeration, an Arab proverb says: "All the world fears Time, but Time fears the Pyramids." It is true that wind-driven sands of fifty centuries have abraded their surfaces, and the smooth, shining face of white limestone that once sheathed Khufu has now all gone away. Still, the pyramids abide. They are, indeed, models of permanence in architecture, solid rock piles in as stable a form as one can imagine. They are tombs designed with but a single purpose: to protect the mummified cadaver of the dead Osiris and thus insure the spiritual continuity and integrity of Horus's earthly reign.

So far as architectural principles are concerned, the pyramids are not much of an achievement; to build one is simple enough—just lay one bed of stone upon another. Anyone familiar with applied geometry, and the uses of tackle block, level, wheel, and inclined plane, could build a replica of Khufu—if he or she had twenty-odd years, a few million slaves, relentless determination, and *absolute* authority. Many writers—and especially those who like to credit visitors from outer space with the creation of ancient monuments—exaggerate the physical prowess and technical knowledge needed to shift large objects and carve obdurate materials. What can hardly be exaggerated is the degree of will and political power needed to impel men to do the work. The sheer amount of labor required forbade all but the most powerful monarchs from undertaking projects of such vast scale as a pyramid. Still, even the lesser tombs of ordinary rulers are incredible undertakings, given the primitive tools of the builders. Most of them are hewn directly from the living rock of the cliffs along the Nile Valley. In later times the entrances to these were concealed

in order to protect the treasure that was always buried with the deceased. The Egyptians were quite clever about that; the fabulous underground tomb of King Tutankhamen (c. 1355 B.C.) was not discovered until 1922, despite the fact that searchers had for centuries known the approximate location of the site.

Even the ancient Egyptians realized that their embalming arts and indomitable mausoleums would not forestall decay of the flesh forever, and the inevitability of a corpse that had turned to dust posed a problem for them. The attainment of immortality required the preservation of *all* components of the person. To simplify the matter, let me merely note that, while prayer could preserve purely spiritual aspects of what we would call the soul, what the Egyptian religion knew as the *Ka*—a dematerialized replica of the human body—could not be sustained by mere ritual. This ghost, as we would describe it, required a body to inhabit even should the original not be available for use. Too, it required sustenance if some disaster were to annihilate the pious descendents and priests whose duty it was to supply offerings. Fortunately, there was a way to insure against such calamities. The body, the food, and anything else comforting to the Ka in its eternal existence need not ever have lived; for an ethereal ghost, pictures and effigies would do just as well. For that reason we find tombs filled with statuary carved from the most obdurate materials imaginable and walls so burdened with pictures as to suggest a pathological horror of vacant space.

Given that the purpose of the artwork was to serve as a permanent substitute for what it represented, it is not surprising that the preferred form was freestanding statuary of some kind of very hard and durable stone. The statue of Khafra, the pharaoh entombed in the second of the great pyramids, is hewn from diorite, an igneous rock so hard that it is difficult to work even today with tempered chisels of carbon steel. Khafra (fig. 10-11) looks as if he has settled down for prolonged contemplation of the transitory events of the Middle East. He is resolute and unapproachable, his gaze fixed on some higher destiny. We mere mortals in the Cairo museum fall far beneath the dignity of his notice. His is the kind of presentation of the self that is, in art, called *frontal*. That is, he can be conceived of as having a distinct front, sides, and back in a way that is not possible with a figure posed as the *David* of Gianlorenzo Bernini is (fig. 10-12). Khafra's kind of posture, so rigid and austere, corresponds to the ceremonial nature of the entire social scheme at whose center the ruler sits. Khafra is superior to ordinary, asymmetrical, slouchy folks like you and me; even his pose insists upon deference. Perhaps it will not surprise you to learn that an inverse relationship obtains between respect for the subject of a portrait and the realism of the image. There are a few quite realistic portrayals of servants. The scribes wait with their eyes focused on the lips of their master; they have soft bellies and they look like real people might have. The ruler is always a standard red-skinned, twenty-five-year-old athlete in peak condition. Naturally. Think about it. If you were able to choose the age and form you would retain through all eternity, would you select the body that you might actually possess when death's hand found you? Why go through time as a fat and flabby sixty-year-old when you can select a perfect figure in the prime of life? That's what we see in Egyptian statuary.

What we see in Egyptian paintings is not so easily understood. The conventions that dominate the drawing of human figures are not altogether consistent from the beginning of Egyptian history to its end, and there are also variations among works done in different locales, but to the non-specialist Egyptian drawings appear very much alike for hundreds of centuries. And

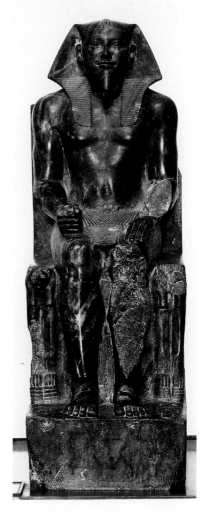

10-11 *Khafra.* c. 2500 B.C. Diorite, height 66″. Egyptian Museum, Cairo

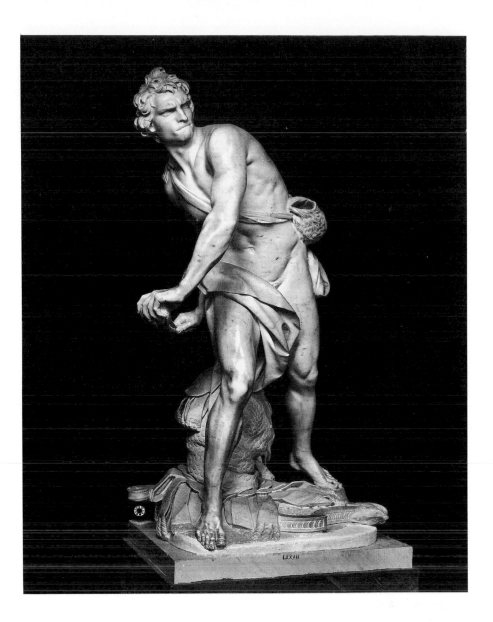

10-12 GIANLORENZO BERNINI. *David.* 1623. Marble, lifesize. Galleria Borghese, Rome

they are strange, not just to the layperson but to specialists as well. Many scholars have speculated on what purposes could have been served by some of the distortions. Why, for instance, are feet always shown as they are in figure 10-13 — from the instep, so that everyone has two left or two right feet? Often the hands are as the ruler's appear here: put on backwards so the fingers are hidden. That seems odd enough. But look at the pharaoh's daughter who shares the boat with him; she has properly oriented digits. Don't expect an answer from me. One of the explanations often expressed, that the Ka would be deformed by realistic devices such as perspective foreshortening, seems very farfetched in view of the malformations it would have to accept were it to accommodate itself to this picture. Some of the other distortions, though, can perhaps be accounted for on the basis of sheer legibility.

The various elements of a human being tend to be presented by the Egyptian artist in their most immediately recognizable aspects. Thus the eye is drawn as if seen from the front even when the head is in profile. And the heads are *always* seen in profile; you never see anyone facing you or look at them from a high or low angle of vision. The chest is frontal except in the case of females, where a breast is often tacked onto the side in its likeliest configuration, that is, in profile. The significance of these modes of presentation become clear when one peruses the contrasts in figure 10-14. On the left, I have copied the head of a serving maid from a banquet scene in an Egyptian tomb, and I

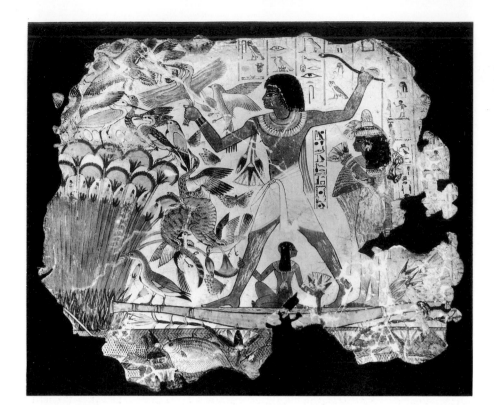

10-13 *Fowling Scene.* Wall painting from the tomb of Nebamun (?), Thebes. c. 1450 B.C. Painting on plaster. British Museum, London

have then isolated the features (eye, nose, lips) and the silhouette of the head. In the same way, on the right, I drew a version of what I imagine the young woman would look like to a contemporary illustrator. Since the profile convention and standard viewpoint are not functions of Western depictions, I show her from a low angle of vision. Here, too, the same elements of the image have been separated out.

I submit that, if you were to hand a card with the Egyptian-style eye printed on it to someone who had no idea of what to expect, asking for an identification of what's represented, it would not be long before the subject would suggest, "Looks like it might be an eye." The same is true for the nose and lips. In point of fact, I know this is likely because I have tried it out in some university classes. The components from the Westernized version were not nearly so recognizable. Several people thought the eye was an exotic bird in flight, or an insect of some kind. Of course, I'll admit the game is sort of "rigged" because the shadows have an effect in isolation that they do not in context. But that only confirms the ambiguity of the Western image; it is not as legible as the Egyptian one. The silhouette of the heads is especially good for making such a contrast. Everyone recognizes the head on the left as that of a human—students usually think it's a female child. What's the best guess as to the identity of the one on the right? "A Martian pig?" (See the pig? The head's on the lower right.) Surely, the point is obvious. The Egyptian approach to portraiture is not visually coherent in terms of naturalism but it is extremely comprehensible intellectually. And, after all, the purpose is to communicate meaningfully with a ghost in the spirit world. Once again, the supernatural evokes the unnatural-looking image. Of course, clarity of purpose does not dictate the inclusion of identical feet and hands drawn in queer relationships, but it might have seemed to justify it in the mind of the Egyptian artist. The preference for arched feet with one big toe, for instance, may be nothing more than the appeal of an economy of means that prevails over detail.

The unrealistic look of the work also does something rather surprising. It conveys a certain respect for the viewer's personal integrity since such figures

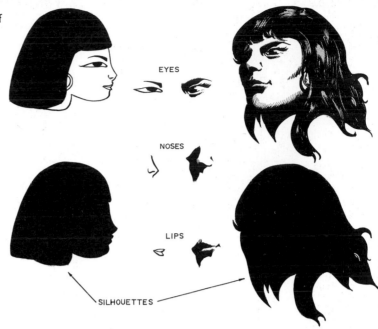

10-14 Head and features of a young woman as they appear in an Egyptian wall painting (left) and as they might be drawn by a contemporary illustrator (right)

EYES

NOSES

LIPS

SILHOUETTES

do not pretend to be what they are not. They make no attempt to delude us with illusionism and, by this frankness, do us a kind of honor. Or so it seems to me. The ancient Egyptians apparently sensed an element of vulgarity in portrayals that are realistic; one has a feeling that they may have felt that there was a sort of violence done to truth when things that were not real were made to appear real. It is a feeling the Greek philosopher Plato shared with them. Too, their extreme conventionality had another, more practical aim. It makes for ease of repetition and high adaptability to every conceivable scale. The artists were producing thousands of images and many of them exhibit identical proportioning, obviously determined by a formula based on a grid pattern. With such a system, even poorly trained artists would know precisely what to do under any given circumstance.

The artist who painted the picture of the pharaoh and the family cat out catching birds was obviously not among the ungifted. For, while the former is drawn in a completely conventional way and his family only slightly less deformed, the animal life surrounding them is delineated with astonishing verisimilitude. Those birds rival the plates of Audubon, and the tabby cat is entirely authentic in its markings and character, particularly since this feline is, both literally and figuratively, in "cat heaven." Most of us tend to imagine that Egyptian cats all resemble the god Bast, whose statues are sometimes seated in the tombs and temples, and that this kitty is like the mutation called Burmese. But all ancient statuary was painted, and many of those temple cats might have originally been striped, like this one. In fact, the breed of cat identified as Egyptian by ailurophiles is spotted, not plain. The realism of the pharaoh's pet, though, is merely a reflection of the rule that beings most highly esteemed—rulers, adults (i.e., humans)—are given less realistic treatment than beings who are relatively less esteemed, namely, the lower ranks, children, the lower animals.

Egypt is a difficult place to deal with in brief, partly because it is the longest lived of any of the great civilizations. It endured from about 3400 B.C. until 30 B.C., when it became a province of Rome and vanished from history. During those millennia a great many changes occurred. In 332 B.C. it was conquered by Alexander the Great, the Greek ruler of virtually the entire Mediterranean area. Upon Alexander's death in 323, rule of Egypt was inherited by his general, Ptolemy, who founded the last great dynasty. The famous Cleopatra

10-15 *Nefertiti.* c. 1365 B.C. Painted limestone, height 19⅝". Staatliche Museen, Berlin

was the daughter of Ptolemy XI and was, like her ancestors, a Macedonian Greek of olive complexion. (There are a number of other Cleopatras, one of whom may have been a black Nubian. She's not the glamorous lady who bore the son of Julius Caesar and became the wife and co-conspirator of Marc Antony.) Sometimes the seat of the Egyptian government was in Memphis (today's Cairo), sometimes Thebes, sometimes elsewhere. Thirty different dynasties passed the scepter from the dead Osiris to the living Horus and at least once (in 1490 B.C.) a woman named Hatshepsut advanced from the position of regent to that of pharaoh, having staked her claim with a prior one of mystical androgeny.

What is intriguing about the vicissitudes of Egyptian history from an art-historical viewpoint is that only once during all this time was there any real disruption of adherence to the traditional principles of rendering. That was during the reign of the first official monotheist, Amenhotep IV, later known as *Akhenaton,* during the 1300s. This fellow was a religious fanatic; he proclaimed that there was no god but Aton, the sun god, and proceeded to anathematize the principal competing cult of Amen, even going so far as to have the name of Amen obliterated, even from inscriptions carrying his father's and his own given name. In fact, his original name meant "Amen is content." whereas his new name means "The Glory of Aton." His rule also saw a shift in art away from strictness of conventional rule toward greater realism. For instance, people have two feet of the normal kind and they are not quite so stiff-looking.

Perhaps to make a clean break with previous administrations, perhaps with a view to removing himself and his family from the fury of the priesthood his edicts had crushed, Akhenaton moved the capital halfway down the Nile between Memphis and Thebes (center of Amen worship). This new city was called Akhet-aton (horizon of the sun) but today it is known after the Arabic name for the place, Tel el Amarna, commonly given as Amarna. When Akhenaton died in 1350, the priests of Amen attempted to expunge from memory all traces of this pharaoh's existence so our knowledge of the period is sketchy. It is obvious, though, that the new religion was accompanied into existence by a relaxation of the old artistic regimen.

Of all the objects that have come down to us from Amarna, the most celebrated is a head of Akhenaton's queen, Nefertiti (fig. 10-15). Her name meant "The Beautiful One is Come," and the sculptor has done the name complete justice. Cool, elegant, of a lofty symmetry, and yet touched with delicate suggestions of sensuousness, this bust is one of the world's great masterpieces of female portraiture. Surprisingly, perhaps, it is not a finished piece; it is a sculptor's working model, having one painted eye and one of rock crystal. The crown is as unusual as the liveliness of the portrait. None like it can be found in other representations of Egyptian queens. It is not just the sculptor Tuthmosis's formal invention, despite the wonderful concord between it and the line of the neck. We know that because it occurs in all other known representations of Nefertiti.

The example of Amarna's art continues to fascinate us because it is the emanation of the interests of a lone man and his wife, the beautiful Nefertiti. It represents an astounding break through the barriers of the most straitlaced of all traditions. Even the questioning Greeks of fifth-century Athens held to their conventions with greater tenacity than did this ancient ruler, his queen, and their artists.

The Art of Ancient Greece In contrast to the art of ancient Egypt and the other ancient urban societies, such as Mesopotamia and Crete that we might deal with had we space, the art of ancient Greece appears entirely liberated from the rigors of convention. In truth, what seems so is not, but Greek habits of mind are nearer our own and, therefore, seem more natural to us. Even the scale of Greek art is less intimidating, more "comfortable." Consider the contrast between two temples of worship, one Egyptian, the other Greek.

The Temple of Horus at Edfu (fig. 10-16) is late and not particularly significant except for its state of repair whereas the Parthenon (fig. 10-17) is one of the most famous buildings of all time. Yet, the former could hold the latter in its courtyard. In photographs the Temple of Horus does not look terribly large unless human beings are shown. But its gateway (or *pylon*) is immense—260 feet across the front and 115 feet tall. It is thirty-two feet wider than the Parthenon is long! The Greeks did, in fact, sometimes build large temples but they are atypical. They did not wish to dwarf humanity with stone. Standing by the pylon at Horus or strolling in the courts of the *really* large temples at Luxor and Karnak, or viewing the great pyramids at Gizeh one is made to feel insignificant by the sheer immensity of the architecture. Not so alongside the Parthenon; it is large but not overwhelming. These differences in scale are significant because they reveal the will to power and domination of the spirit on the part of the Egyptian builders and the contrasting sensitivity to human scale on that of the Greeks. Perhaps that is why the architecture of the ancient Greeks still has real currency today. Their building

10-16 General view, Temple of Horus, Edfu. 3rd–1st century B.C.

styles and elements were revived during the Renaissance, and many of the forms you see in American and European public buildings are imitations of ancient Classical prototypes.

Early in Greek history the three *orders* (fig. 10-18) of Greek architecture emerged. An order is a specific type of base, column, and entablature forming the unit of a style. The diagram describes the principal elements and subelements that constitute the orders. These proportions, however, are not in scale from one to another. For instance, a Doric column is typically much thicker than the other two, which have comparatively slender shafts. (See the glossary for more precise definitions of the elements.)

The Greeks considered the *Doric* order a masculine form and the lighter *Ionic* a feminine style. The *Corinthian* was not popular among Greeks even though it was their invention; a Classical building containing Corinthian columns is almost surely Roman.

The finest example of the Doric order occurs in the Parthenon, constructed about 2,500 years ago on a hill in Athens called the Acropolis. It has been a noble ruin only since 1687. At that time the Turks, who ruled Greece, were warring with the Republic of Venice. A Venetian bomb set off gunpowder stored in the ancient temple, and the resulting explosion destroyed the central portion of the building. Later, between 1801 and 1803, the British ambassador to Turkey, Lord Elgin, arranged to have most of the sculpture removed and taken to England, where it now resides in the British Museum. (At the time, and in some quarters still, Lord Elgin's actions were considered criminal despite the fact that he sold the statues to the British government at a great financial loss to himself. In his day the statues were being ignored and would

10-17 ICTINUS AND CALLICRATES. The Parthenon, Acropolis, Athens. 448–432 B.C.

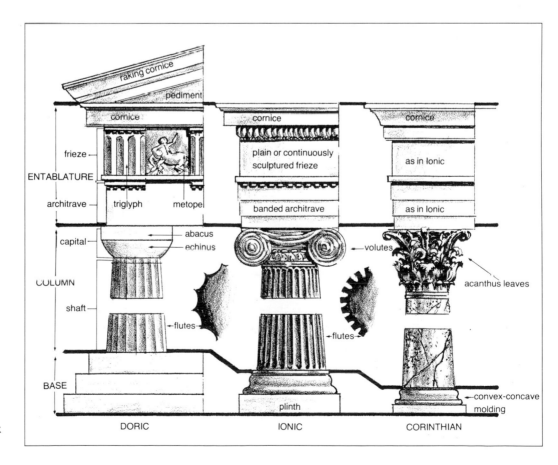

10-18 Orders of Greek architecture

probably have fallen to ruin. He seems to have acted out of highly civilized motives and, in fact, we probably owe their existence to him.) The fragments are now popularly known as the Elgin Marbles. Despite these subtractions, the building remains one of the great edifices of the world.

The Parthenon is an example of *post-and-lintel* construction. That is, posts hold up horizontal beams (lintels), and the roof is laid over and across the support system. The engineering system is a simple one, and it has severe limitations, the most obvious of which is that posts cannot be far apart because stone has so little tensile strength that a long stone beam will break.

What is impressive about the Parthenon is not the engineering but the refinements its architects introduced. Because long horizontal lines in buildings give an impression of drooping, Ictinus and Callicrates contrived to put a faint upward curve in all the steps, cornices, and other prolonged horizontals. Since a completely straight column appears to be concave, the Parthenon's columns were carved with a convex bulge. Such a curve is called *entasis*. Too, a structure which is perpendicular to the ground often looks as though it is leaning forward. This illusion was neutralized in the Parthenon by tilting its front slightly backward. Because a column which is silhouetted against a bright background seems smaller than one which is not, the four corner columns—the ones most often seen against the sky—were made a little larger than the others. Finally, the architects have overcome a problem common to long colonnades, namely, that when all the spaces between columns actually are equal they do not appear equal. That is an effect of perspective distortion. It is negated in the Parthenon by making the spaces widest in the center and progressively smaller toward the ends of the colonnade. The deviations involved in the use of entasis, bowing, tilting, and varied intercolumniation are about two and a half inches at most. This isn't enough to disturb an onlooker, but the prestige of the temple shows that these devices were effective. In the earlier part of the twentieth century the Parthenon was reconstructed as accurately as possible in the city of Nashville, Tennessee (fig. 10-19). The reconstruction gives us a good notion of what the original building looked like.

One of the signal differences between the Parthenon and any Egyptian temple is the way the Greek building welcomes one from all sides. Although the sanctuary within the colonnade could, in fact, be entered only from the ends, the impression the building affords to the person approaching it is of universal accessibility. And, indeed, any city dweller was permitted to come there to do homage to Athena, patron goddess of Athens. Access to Horus was limited to entrance through the pylon's portal, and commoners could not go beyond the open *peristyle* courtyard. The nobility were admitted into the next stage, a columned hall, or *hypostyle*, while only the pharaoh and priests could enter the sanctuaries. In Athens all could stand awed within the sanctuary gazing at the thirty-eight-foot gold-and-ivory statue of Athena Parthenos (Athena the Virgin). And the Virgin of the Parthenon (i.e., "The Virgin's Place"), although gigantic in scale, was formed to look like her worshipers—human.

In looking at Greek sculpture from its beginnings in around 1000 B.C. one must be struck by the progressive efforts of sculptors to model deities after the shapes of living men and women. This tendency on the part of the Greeks is quite extraordinary; no other art of ancient times resembles that of Greece, whether in humanness or in the development away from severe formulas toward an imitation of living beauty. The Greeks were not the first people to celebrate the joys of life on earth but they seem to have been the first to elect it

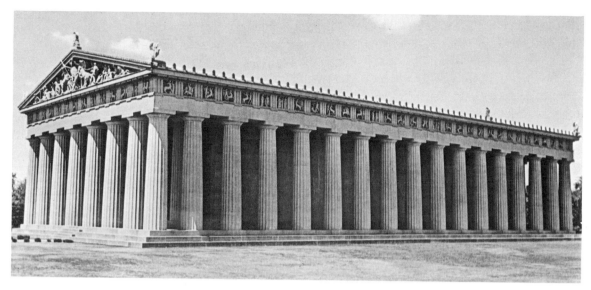

10-19 HART AND HART. The Nashville Parthenon, Nashville, Tennessee (second replica). 1920

their ideal. Homer's hero Achilles says that he would rather be the humblest living slave than the ruler of all afterlife. How different is this from the Egyptian obsession with the world of the dead.

Homer could not have originated such a conception of value but his poetry was the source of its ubiquity. For Homer's *Iliad* and *Odyssey* were known throughout the Greek world and the tales they told reached even the illiterate through the voices of priests and minstrels. They were both history and religion. But what a religion! It was not exclusively Homeric; it was embodied in the disorganized corpus of Hellenic mythology, of which only fragments remain. That's not too important for us since, wherever we begin—whether with Homer before 700 B.C., Hesiod just after, or Apollodorus of Athens in the second century B.C.—our impression will be the same. No one can possibly think of Zeus, Hera, Apollo, Hermes, and the other gods as abstract conceptions. The Olympians aren't even dignified; they are, in fact, more notable for their appetites and excesses than for their virtues. Zeus, the ruler of heaven, is incessantly lecherous and eternally unfaithful to his wife, who is also his twin sister, Hera. Always on the lookout for pretty lovers—usually female but sometimes a youth like Ganymede—Zeus had tremendous advantages over the ordinary philanderer since he could turn himself into clouds, showers of gold, diverse animals, or whatever else he wished in order to disguise himself from his spouse and make his approach to the nymphs more surreptitious and seductive. Hera, a quarrelsome, jealous queen of the gods, responded to her husband's infidelities by changing his lovers into heifers and trees, statues and rivers, insects and reptiles. Except for their supernatural powers these bickering rulers were more like obnoxious neighbors than holy adjudicators. Their companions on Mount Olympus were similarly lustful, brawling, licentious, and vain. The gods are sometimes cowardly and frequently dishonest. The fate of humanity was their sport, and they were worshiped for their power by means of a religion that was hardly more than a sort of supernatural barter system. One gave an offering to a particular god in hopes of gaining his or her favor. Sometimes the offering was a material sacrifice, sometimes only a prayer, sometimes the promise of perpetual adulation. Occasionally one's requests were honored; sometimes they were not.

Once in awhile someone else's pleas cancelled out your own. It was all very much like relationships among people in ordinary society.

The radical anthropomorphism of Greek religion had a pronounced effect upon Greek sculpture.[10] The typically conventionalized, supernatural versions of deities suitable for the Neolithic tribes or ancient Near Eastern artists would not convey the humanistic qualities of the Greek religion. The only direction in which the Greeks could have moved was toward a curious kind of realism in which the forms are human in kind but supernaturally perfect in quality. We have seen already in the contrast between the anatomical architecture of Polyclitus and the torso of a human athlete (see figs. 4-41, 4-42) that Greek sculptural physiques are in point of fact unnatural. Yet, the figures look "natural" in the sense of being somehow unaffected, of seeming to be models for the way human beings *should* look ideally. To achieve this impression is the goal of Greek sculpture. Such an aim is not easily realized, and the earliest manifestations of Greek art are very much like Egyptian forms. But the influence and appeal of humanism were irresistible and, as soon as skills permitted, the Greeks moved away from abstract order toward natural effect. The Greek original that is most like Polyclitus' real works, the *Diskophorus* (fig. 10-20), is already remarkable for its depiction of a lithe, attractive human being with godlike attributes of grace and proportioning. Praxiteles' representation of the god Hermes (fig. 10-21), however, is still more wonderfully exquisite in manner. It is not without reason that the highest compliment the male physique can receive is that of being compared with "a Greek god."

In discussions of this sort we are forced to rely upon male figures because the female nude is unknown to Greek art before the fifth century. Even then an entirely naked woman is extremely rare in Greek art. The reasons for that are due to traditional religious and social restrictions that confined most Greek women to "woman's place," that is, the home. Even famous courtesans like Phryne, the model for Praxiteles' *Aphrodite of Knidos* (fig. 10-22), gained their prestige by dutifulness to male patrons. (In Sparta it was otherwise, but Spartan women scandalized all Greece by their "masculine" immodesty. They participated in athletic contests and exposed themselves with relative indifference. Elsewhere, the female form was as shrouded in drapery as it is today in traditional Arab countries.) You will recall from chapter four that the people of Kos considered it a serious blasphemy for Praxiteles to have revealed Aphrodite's charms.

Human ingenuity being what it is, and the religious emphasis on sexual activity being what it was in the old myths, we should not be surprised to discover that sculptors in Classical times managed to use drapery to reveal almost more than they concealed. The statuary from the Parthenon features goddesses in gowns that cling to every outward curve of breast, thigh, and buttock. By the period of Greek history known as the Hellenistic Age, which follows the death of Alexander the Great in 323 B.C., the sculptors had mastered this technique so completely as to make the presence or absence of clothing irrelevant to modesty. In the famous "Winged Victory" that stands on the main staircase of the Louvre, we see the melding of flesh and fabric folds carried to an extreme that is thrilling to behold. *The Nike of Samothrace* (fig. 10-23) by Pythokritos of Rhodes was carved about 190 B.C. to commemorate a naval victory. Hers is an age of great sophistication and cosmopolitanism in which artists had at their disposal not only the accumulated examples of great art from the vast reaches of Alexander's empire, but also a growing mass of scholarly criticism about such things. The very first art criticism appeared in the early third century, written by the sculptor Xenok-

10-20 POLYCLITUS. *Diskophorus.* Bronze copy. The Louvre, Paris

10-21 PRAXITELES. *Hermes and Dionysus.* C. 330–320 B.C.
Marble, height 85″. Museum, Olympia

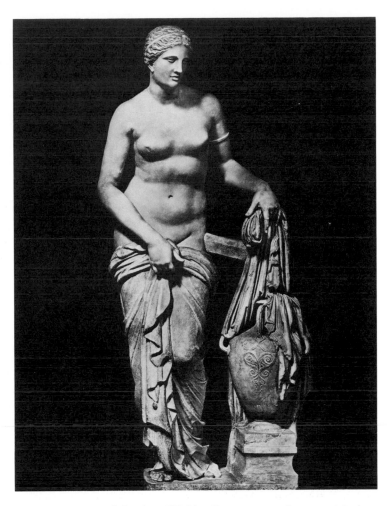

10-22 PRAXITELES. *Aphrodite of Knidos.* Roman copy after an original
of c. 330 B.C. Marble, height 80″. Vatican Museums, Rome

rates of Sicyon. By the end of the century the libraries at Pergamum and
Alexandria were filled with commentaries, anthologies, and technical man-
uals on art as well as copies of famous works of art. Among poets of the age—
Menander, Callimachus, Theocritus—virtuosity was the outstanding capac-
ity. So, too, is it the hallmark of Pythokritos.

Pythokritos stuns the viewer with the powerful impact of Nike's silhouette
and then astonishes us with the lash of curving folds that whip about the
figure. And, as we move to see other aspects of this mighty female presence,
we are struck by constantly new revelations; merely the tracery of garment
folds as they course from the left hip over the groin and across the abdomen is
of an astounding involvement and inventiveness. Abrupt rhythms emphasize
that this is a victory just arrived, standing on the prow of a vessel, a moist sea
breeze pressing the sheer fabric of her dress against her ample, muscular form.
In places the clothing snaps forward as though carried through the moment of
arrest, an impression that is important because it conveys the precise meaning
of the figure. Any hint that victory is fleeting, that she might possibly be taking
off instead of landing, has been suppressed. (Granted, one can find respected
authorities who conceive that she is about to fly away. They are mistaken—
learned, perhaps, but not very astute.) She is composed of countermovements
so that her whole body is twisted on its axis, her face turned to look away from
the raised right arm, the right leg striding out to take the shock of landing as
the left slips from the stormy air.

10-24 *Aphrodite of Cyrene*. 1st century B.C.? Marble, height 60". Terme Museum, Rome

10-23 *Nike of Samothrace*. c. 190 B.C. Marble, height 96". The Louvre, Paris

The *Aphrodite of Cyrene* (fig. 10-24), another Hellenistic figure, is a marvelous example of the erotic ideal of the Greek world. That is a very human ideal, one close to commonplace prettiness and presented to us here in an astonishingly realistic way. The stone is almost distractingly pliant-looking and the proportions of the figure are not unlike those of any number of nubile young women. Of course, her breasts are higher and firmer than most breasts and the cushiony mound of Venus is more exquisitely adapted to the abdomen and thighs than genetic accident allows, but only slight retouching of the photograph (suitably cropped to conceal the fragmentary nature of the piece) would be required to convince most people that figure 10-24 represented a "pleasantly plump" human being and not a marble goddess. In estimating the effect works like this had upon viewers of the past it is necessary always to bear in mind that the ancients painted their statues in lifelike colors.

My emphasis on the humanistic nature of Greek art and thought may seem to exaggerate one characteristic to the detriment of other features of the culture. For instance, it seems reasonable to take into account the political system that brought the Parthenon into being. Athens was, as everyone knows,

a direct democracy in which every citizen was also a voting member of the Athenian legislature. So one might contend that the openness of the Parthenon and its cult to one and all derives from the political ethos more than anything else. Surely, the things are not unrelated. But similar temples were found in all the city-states of ancient Greece, even through Laconia, where dictatorial rule was more common than not. Besides, Athens's democracy was less expressive of the ideal of one vote for every member of the populace than is often supposed. No woman could be a member of the law-making body, nor could any male who was not a citizen of Athens with leisure time for public service. It may interest sentimentalists to know that during the time of the Parthenon's construction, the citizen population was about forty thousand and the number of unenfranchised slaves and resident aliens was three times as great. Moreover, only two or three thousand of the citizens actually had the time and interest to participate in the assembly or serve as magistrates. Finally, the democratic mystique never really took hold of the minds of people. Like many Americans today they had a passion for personal liberty but not enough sense of the common good to sustain the system against the fierce conflicts of factional interests. Practically all of the great philosophers and dramatists are hostile to democracy. Two who did find it congenial were Euripides (c. 480–406 B.C.), whom the Athenians banished, and Socrates (469–399 B.C.), whom they killed. Athenian democracy lasted a very short time, only through part of the fifth century with brief revivals now and again during the fourth.

The appeal for Greeks of the here, the now, the tangible, is what is so striking about their civilization. Already, by the time of Aristotle (384–322 B.C.), the gods were little more than metaphorical expressions of worldly things. Greeks sought mundane explanations for mysterious phenomena and relied on human wisdom rather than divine intervention. The role of reason and order in all of that has been built up from the end of the Middle Ages to the present, making for the kind of overblown reputation that cries out to be deflated, and there are plenty of scholars who dispute the existence of this vaunted Greek rationality. Indeed, there can hardly be any question that the thought of the ancient Athenians was as shabbily inconstant as that of any people. The great philosophers, too, blundered in many ways that are not always easy to excuse, even after our advantages of hindsight have been given due account. But one thing above all seems clear. The oratory that succeeded best in the public squares of ancient Greece was that which made its first appeal to human experience rather than to ineluctable decrees or occult portentions. And what was true of debate was true of art.

The Art of Ancient Rome With the Romans we come to the first people of the ancient world who are easy for most of us to understand fully. They are down-to-earth like the Greeks, but are a much tougher breed. Like us they feel it is not only a right but practically a duty to impose the human will to order upon chaotic nature. When Egyptians or Greeks were confronted by a natural barrier like a mountainside or chasm, they accommodated their ambitions to it. When Roman engineers encounter an obstacle to the transportation of their legions and supplies, they eliminate the mountain and use its stone to construct masonry vaults to span the canyon. Like the Egyptians, they exalt in things of great scale—Roman buildings are the largest built until the invention of steel—but, like the Greeks, they do everything with an eye to human rather than supernatural needs.

Where the Greeks strove for perfection and refinement in their buildings, the Romans preferred majesty. One of the best techniques for achieving scale

in building is a device called the *arch*. Arches are based on the fact that if two things of equal weight lean against each other, both will stand. In a structure like a Roman aqueduct (fig. 10-25) the stones that make any single arch are literally falling toward the center of the arch. The keystone at the center of the top of the curve forms the resting place where all the stones lean together. The stones on the bottom don't pop out because of the equal counterthrust of the arches on either side or (at the ends of the arcade) by the sheer mass of stone. One of the advantages of the system is that no more stone is needed to support an arch at the end of a million arches than is needed to support one arch alone. If you could build an arcade like the Segovia aqueduct clear around the globe so that it met itself, it would be self-supporting. In fact, cylindrical arcades are precisely that.

Roman aqueducts are a perfect example of what the term *imperialism* really means. These structures transported water from distant points into the centers of the cities of the Roman Empire. In a day when water was really precious and was jealously guarded, the peoples conquered by Rome's legions had as much water as they could possibly use. Some of the aqueducts are over thirty miles long. They are artificial streams, carrying water by gravity downgrade from the source to the urban terminus. If you think seriously about this kind of project for a moment, you will see what an impressive feat of engineering, surveying, and masonry construction an aqueduct is. Building an aqueduct is far more difficult than building a pyramid (really just a regularized pile of rock) or a Greek temple. It is not surprising that the

10-26 The Pantheon, Rome. A.D. 118–125

Romans were able to Latinize most of the known world. Not only were they courageous warriors and masterful strategists, they were also superb administrators, great public relations men, and beneficent rulers. Their conquered subjects came to be dependent on them. Rome, of course, had markets for its goods and resources to exploit for its industry.

In the capital city itself the Romans built a palace to all the gods, the Pantheon (fig. 10-26). It involves a different kind of arch, the dome, and a material the Romans used magnificently, concrete. (Many people think concrete is a recent invention, but it is not. What *is* fairly new is steel-reinforced concrete.) The Romans accomplished a good deal with their variety, which used pieces of cut stone for reinforcement. Many of the great buildings of Rome—the Colosseum, the Basilica of Constantine, the Baths of Caracalla—are built of it.

Given the imperious air of the Romans in politics and architecture, one might expect their sculpture to resemble that of the Egyptians, particularly when one learns that the early religion of the Italian peninsula was permeated with ancestor worship. As it happens, nothing could be further from the truth; Roman portrait sculpture (see fig. 10-27) was radically true-to-life. So far as naturalism goes it holds a sovereign position not only in the ancient world but also in the whole history of art at least up to the Italian Renaissance. Every sculpture we have that is known to have been of the second-century emperor Marcus Aurelius—including the famous equestrian bronze on the Capitoline Hill in Rome—resembles the one here on the left. Roman busts are, in effect, photographs in stone. So far as one can tell, they are meant to be just what they seem to be—recordings of the physiognomies and characters of their models. Upon seeing the bust of Lucius Verus (co-ruler with Marcus Aurelius, his adoptive brother, from 161 to 169), I was immediately struck by

how much it resembled an obscure contemporary character actor in films who, in turn, looked like a cowboy I knew when I was growing up in Wyoming. I do not mean to suggest that the similarities had a genetic connection, only to show the specificity that marks this sculpture of someone from a distant time. These Romans look very much like people one might encounter on the street today or see on television news as leaders of today's military forces.

Why such an extreme degree of naturalism? The causes probably lie in the old folk religion and perpetuation of the family through veneration of deceased ancestors. In Roman practice this ultimately resulted not in the creation of devices intended to convey feeling to beings of a supernatural dimension but to the employment of mnemonic icons, like death masks taken as clay molds from the features of cadavers. Such a mask is clearly a primitive version of naturalistic portraiture. Early Romans did not worship the power of generation as a being from the afterworld; they conceived of it as a spirit or animus without any other kind of presence. So far as images of the dead are concerned, their intention seems to have been to honor the memory of the dead as a way of insuring the comfort of the spirit.

None of this has anything much to do with what the state celebrated with its list of gods who match the Greek Olympians. The pantheon of Roman mythological characters, ruled over by Jove and Juno, are cynical derivations of a later age whose religion is patriotism. The original Roman religion was a conglomerate folk cult focused on home and family. The goddess Vesta, for instance, was associated with a hearthfire ever burning in token perpetuation of the family. The spirit Juno was not a goddess, but the power of the wife to bear children. The male capacity for generating them was *genius* and corresponded in some ways with the most powerful agricultural god, Jove (or Jupiter), who produced rain and growth. The two-faced god, Janus, did not at first convey notions of either deceit or of past and future; he was the guardian of the domicile whose masks hung both inside and outside of the doorway to watch all who entered or left. During the fifth and fourth centuries B.C., in order to promote the stability of the state and the patriotic morality of the citizenry, the ruling classes began adapting the popular divinities of the Italian countryside to functionaries of public life and devised solemn, picturesque forms of worship for them. Thus, a hearth was built for Vesta and a college of Vestal Virgins appointed to serve the sacred fire. (Their "purity" was periodically verified by a physical examination failure of which because of defloration would result in public execution. Great motivation to be a "good" girl.) It is from this nationalized religion that we get the Roman equivalents for Greek dieties: Jove or Jupiter for Zeus, Juno instead of Hera, Mercury in place of Hermes, Venus for Aphrodite, Minerva for Athena, Vulcan in place of Hephaestus, Mars for Ares, Pluto instead of Poseidon, and so on.

The revision of belief took a long time and the help of the Latin poets to accomplish but it was from the very outset a state-sponsored religion. Greek cultural influences were profound in cultural areas, especially after 147 B.C., when Greece came under Roman control, but this influence was rather like that of Britain and France upon the United States, largely though not exclusively restricted to the literary and artistic aspects of life. The example of Greek sculpture was constantly before the people in the form of decorative statuary that reproduced, usually in a rather coarse manner, the great works of Greek classicism. Mostly, these were representations of gods. The relatively materialistic world view of the Roman ruling classes gave only a few any

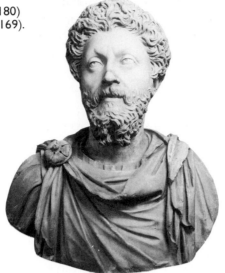 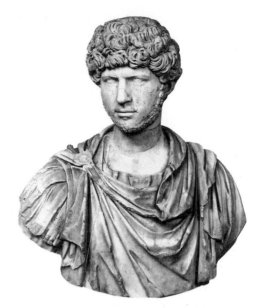

qualms about using superstition and simplistic religious beliefs to suppress dissent and keep the rabble in its place. The Roman masses, however, were correspondingly cynical and didn't take this official religion very seriously until the time of Christ, when Augustus (63 B.C.–14 A.D.), first ruler of the Roman Empire, intensified religious activity with an eye to reinvigorating the patriotic fervor and moral discipline he associated with the past glories of the Roman Republic.

Augustan Rome is the time of the greatest of the Latin poets, Vergil (70–19 B.C.), whose *Aeneid* is a national epic purporting to tell the history of Rome in a grandly Homeric fashion. It is an example of propaganda at a level so exalted as to leave behind any taint of ulterior purpose. Ovid (43 B.C.–18 A.D.) is another Augustan poet. His *Metamorphoses* is a major mythological work. Like Augustus himself, Ovid was an agnostic and a skeptic but his words on religion could stand for the views of most of the senators and caesars of the so-called Republic and for the emperors who followed Julius Caesar's fall, beginning with Augustus: "It is convenient that there should be gods and that we should believe that they exist." Given such an attitude, it is by no means surprising that we find the emperor himself treated as a demigod in his portraiture.

The *Augustus of Prima Porta* (fig. 10-28) is probably a posthumous work, since the ruler is shown barefoot, a Roman convention for funereal images. He is posed in a grandly Polyclitian manner and given a distinctly Hellenic face and figure. His wonderfully ornamented armor contains a relief showing the Parthians returning the standards they had taken from the Romans. Parthia, an Asian nation to the southeast of the Caspian Sea, had defeated Rome in 53 B.C. but was in turn vanquished by her legions in 38 B.C. The relief celebrates Rome's victory and also the liberal magnanimity of Augustus in acknowledging the Parthians' past glory. This kind of thing is very like the use of ancient mythology to transform the hard facts of Roman political life into pseudo-religious balm for the masses. Such maneuvers, along with "bread and circuses," imperial exploitation of other lands, and multifarious political shifts and changes kept Rome going for a long, long while. After all, the Roman Republic existed from the expulsion of the Etruscan king, Tarquin, and proclamation of a republic in 509 B.C., to 27 B.C., when Augustus was proclaimed emperor. The Empire continued on, at first magnificently, then eventually went into a prolonged decline for about as long as it had taken it to

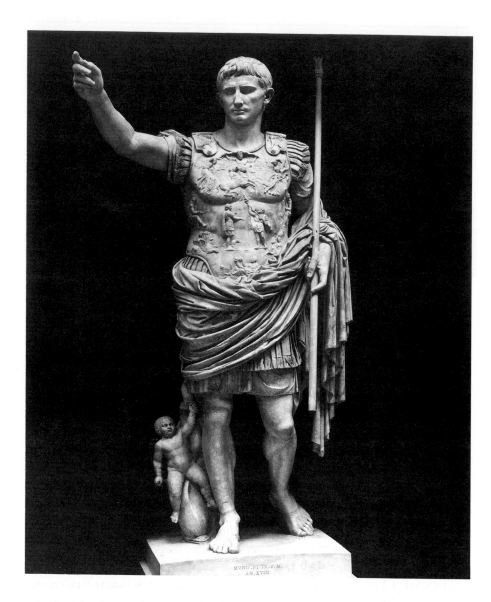

10-28 *Augustus of Prima Porta.*
c. A.D. 15. Marble, height 80″.
Vatican Museums, Rome

rise—until 500 A.D., when the last vestiges of Roman government were swept away by the Ostrogoths, who had occupied Italy since 488. How odd that a world of a thousand years' duration should so often be held up as proof that wine, libertine sex, and violent entertainments are quick death to a civilization. The irony does not lie in the fact that history can bring greatness low; it resides in the fact that the pragmatic, materialistic, and physically powerful Latin civilization was supplanted by the seeming triviality of an impractical, spiritualistic sect known as Christians.

The great English historian Edward Gibbon (1737–1794) used the six volumes of the original edition of his monumental work, *Decline and Fall of the Roman Empire,* to show that Christianity had caused the fall of Rome. Historians today usually see Christianity as a symptom of the fall rather than its cause. Most attribute the collapse to economics and to the excessive dependency of the Roman system upon the conquering of new lands and bringing new people into the orbit of Latin civilization. Others point to a serious medical problem in Rome; namely, the ingestion of a toxic substance, lead, which was used not only in all kinds of cooking vessels and pottery glazes on dining utensils but was also seized upon as rustproof lining for reservoirs containing all the water the aqueducts brought to city neighborhoods from the outlands. Lead poisoning leads to lethargy and general enfeeblement of the victim. Medical archaeologists have, in fact, discovered

unusually high concentrations of lead in the bones of ancient Romans, so the connection with a literal decline of the population is plausible.

Whatever the causes, by the middle of the fourth century Rome was in a terrible predicament and everyone knew it. People felt powerless, insecure, the victims of a fate they never made, and they were anxious about their future, even unto the life beyond the grave. They wanted comfort in a world that was shaken and shaking. As usual in situations of this kind, the people turned to religion. But the state religion could not inspire comfort or loyalty; for the most part the gods of Mount Olympus are too hedonistic to appeal to those who are not themselves self-confident and relatively carefree. What rises in place of the old civic mythology? Oriental cults of personal salvation. In Rome of the decline they are available in great profusion and all of them have certain common features, among which are: (1) the promise of purification of sin and personal guilt; (2) a promise of immortality to devotees whose souls will be "saved" through participation in the sacraments of the cult; and (3) rituals that were colorful and mysterious, full of symbolism that only the initiate could understand. As you can see, this sounds like a description of a standard Christian sect. The most famous of these cults was not much like Christianity, however. Followers of the cult of *Dionysus* sought an ecstatic state of union with the god, and worship featured drunkenness and group sexuality. This is a very doctrinaire cult, but its orgiastic angle made it popular. The others often had features we are familiar with through direct experience. The *Eleusinian* sect entailed confession of one's sins. *Cybele* had a goddess called Nostra Domina and a baptism in which neophytes' sins were washed away in the blood of a bull. The doctrine of resurrection was implied in all of the cults. But a highly popular denomination, the *Mithraic* cult, a variety of the Persian religion, Zoroastrianism, had so many parallels with Christian doctrine that early Christians were shocked by them. They decided the sect had lifted their ideas. Not so. Zoroastrianism antedates Christianity. It is not, however, as old as Judaism.

Of course, Christianity is the cult of individual salvation that turned out to be the winner, and it did so in the face of some real obstacles. Indeed, it seems at first as though its success is the most remarkable thing about it. In the first place, it is a Jewish sect. Not only were Jews held in some disrespect by the Romans, particularly in the provinces,[11] but the Christians were Jews who had been disowned by their own people. Moreover, Christianity's early converts were from the slave and laboring classes, so conversion to its faith had no social prestige. Too, the only exclusively monotheistic religion in the ancient world was Judaism. The Christians not only inherited this conviction; they were a proselytizing group in contrast to the Jews, and they were very arrogant about being obedient to the one, true god. That aroused resentment among pagans for they were very tolerant of other religions, even Judaism.

The elements that made Christianity irresistible were the historical fact of the person called Jesus, who was proclaimed as the saviour of all humanity, not just a limited segment or race. He had lived in recent memory, in contrast to Mithras, and his was a dramatic and awe-inspiring personality whose life story is an example even for atheists. The Christians themselves had peace of mind, hope, and certainty strong enough to carry them through the fires of persecution when, for the rest of the world, there was no peace, hope was dying, and certainty was unattainable. Eventually, even the emperor Constantine (288?–337) proclaims himself a Christian, and the medieval era is begun. People have lost confidence in worldly things; they turn again to the supernatural, with consequences we have learned to expect.

BYZANTINE, ISLAMIC, AND MEDIEVAL ART

To understand the state of mind of the time known as the medieval period or the Middle Ages, which for our purposes lasts from 500 to 1400, one has only to contrast its architecture with that of its past or with the present. Of all the fine arts, architecture is the most complicated, the most comprehensive, and the most expensive. It reveals the values of different periods and places to a far greater degree than any other art because it usually represents the major artistic investment of a society. Consider the contrast between a fourteenth-century European town and contemporary Manhattan.

In the Middle Ages the cathedral was the most prominent building in a town (fig. 11-1). It loomed more than a hundred feet above the marketplace. From almost any point its spires, its buttresses, its walls dominated the scene. It rose up among small buildings like a great island of power, a symbol of the authority of the Church as a worldly institution, an institution to which all men looked for spiritual succor in times of fear and on whose charity they sometimes could rely in times of famine. The cathedral commanded the town in a quite literal way, too. Its spires served as lookout posts in time of war. In peace the music of its bells filled the air throughout the day. (The word *belfry* is derived from the Middle English word *berfray*, a watchtower used in warfare to gain a higher lookout. Since the church towers were used for the same purpose, they were sometimes called *berfrys*. Over the years the pronunciation of the word changed to belfry. The change from *r* to *l* is common, and the association with bells made it all the more likely in this case.) The cathedral made it quite obvious that in the year of our Lord (anno Domini) 1325 the Church was the most powerful institution on earth.

In the vicinity of Rockefeller Center in Manhattan are a couple of cathedrals built in imitation of the Gothic and every bit as large. Poor little things;

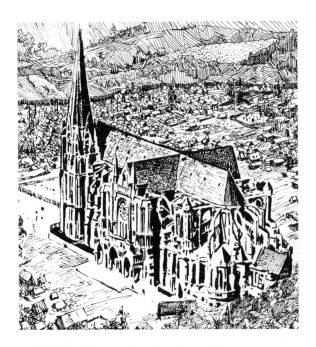

11-1 A Gothic church and its immediate surroundings

11-2 Rockefeller Center and St. Patrick's Cathedral (circled)

they look tiny and forlorn against the backdrop of gigantic towers of commerce and pleasure (fig. 11-2). A two-hundred-foot church spire is a mere trifle compared with one of those skyscrapers. The RCA Building is 850 feet tall. And it is by no means the largest building in New York City. Obviously, the society that builds such architecture is not terribly devout; at any rate, religion does not play anything like the role it did in fourteenth-century Europe. Now the Church looks to the State for protection, and we stake our hopes on economics and technology, not on the will of God. This is clearly evidenced in the scale of the buildings themselves. It is a gross contrast, but a very real one. Of course, there would be no need for places of worship as large as Rockefeller Center, even if everyone in New York City were a devout churchgoer. But, if religion were as important to us as it was to medieval men and women, the church building would be set off in a walled garden of considerable dimensions or would, in some other way, be given such prominence that it could not be overlooked.

The Art of Byzantium The shift of attention away from the natural to the supernatural in the later Roman Empire is very obvious already in monumental works like the great statue of Constantine that stood in his basilica. It now exists only in fragments, but the head alone is eight feet tall. This head (fig. 11-3) is quite unlike previous representations of Roman rulers we have seen. Neither realistic nor an idealized, Hellenic version of Constantine, it is almost a throwback to archaic forms. The eyes are unnaturally large and they are directed at nothing of this world. Like an Egyptian pharaoh, the emperor stares off into the ineffable, his human personality lost in an image of colossal, eternal authority.

Constantine had managed to weld together the partitioned empire created by Diocletian (A.D. 245–313) in 286, and in 330 he established in the eastern portion of the empire a capital that he called the "New Rome," dedicated to the Virgin Mary and named after himself. Constantinople, in Asia Minor at the dividing line of Europe and Asia, the Bosporus, had been the site of an ancient Greek town named *Byzantium*. The name of the town originally there

11-3 *Constantine the Great.* c. A.D. 315. Marble, height 96″. Palazzo dei Conservatori, Rome

has come to be the term used to describe the Eastern Roman Empire, a political unit that survived from 395 to 1453, when Constantinople fell to the Ottoman Turks and was renamed Istanbul. The adjectival form of Byzantium is *Byzantine,* as in "Byzantine Empire." The larger Roman Empire, whether officially divided or not, had always been constituted of a Latin-speaking part on the west and a Grecian portion to the east. Byzantium, of course, was Greek. Even the form of Christianity there came to be quite different from the western Church, a distinction now designated by the terms *Roman* Catholic and *Greek* Orthodox. There are many other contrasts, but what is of importance for art history in general is an economic/political one.

All the while the Western Roman Empire was in decline, the eastern part was prospering. During the sixth century, under the ruler Justinian (483–565), most of the old Empire had been won back from the Ostrogoths and Vandals by the military geniuses Belisarius and Narses. It was Byzantium's "Golden Age." During this time the administrative outpost of Byzantine power in Italy was in a city on the Adriatic Coast, Ravenna. Among the many Byzantine churches built there is San Vitale (fig. 11-4), constructed between 526 and 547. Externally drab, it has interior decorations of an extreme richness (fig. 11-5). Such contrast is typical; it corresponds to the notion of the banality of ordinary mundane existence as contrasted with the richness of internal spiritual life. Thus, while the interior is extravagantly decorated, the purpose is not to delight the viewer's senses so much as to remind him of the beauty of an eternal paradise.

11-4 San Vitale, Ravenna.
A.D. 526–547

In the apse of San Vitale are a number of works in the mosaic medium (see Glossary). One of them (fig. 11-6) is of particular pertinence. It portrays the Byzantine emperor Justinian and his retinue. Justinian is centrally located. Three of the four figures to his left are clerics. The man on his left, rear, and the two on his right are members of the court. An honor guard stands far over to one side. San Vitale owed its existence to imperial support. The gift Justinian holds in his hands, a golden paten, used for holding the communion bread, is symbolic of the munificence of the ruler in providing this house of worship.

The august figures portrayed in the mosaic look rather stiff and a bit choleric. One is apt to attribute much of this to the medium and overlook just how thoroughly conventionalized the work is. If, however, one examines many images from Byzantium, he will soon become aware of the predominance of very strict rules and firm guidelines. For instance, what is depicted here is not a group of people posing for their portraits. What we are supposed to understand is that this is a procession, part of the dedicatory ritual of the church. Now, did processionals in those days progress by side step? No, but there is a convention of representing important figures full face, no matter what the circumstances. This kind of frontality is frequently encountered in highly authoritarian, hierarchical societies; figures are routinely presented as imperious, indomitable, superior to the observer. Judas and Satan, however, are consistently shown in profile in Byzantine art because of the fear of the Evil Eye, a very old superstition pervading many different tribes and civilizations.

Strict convention also determines the arrangement of the personages. The positions of the figures express their precedence and rank. Justinian is at center and overlaps everyone else. That is, if the figures are conceived of as cards, the emperor is on top of the pile. Bishop Maximianus to Justinian's immediate left is labeled. He was of signal importance in the creation of the Byzantine ecclesiastical-civil structure and was also responsible for the completion and consecration of San Vitale. He overlaps the other clergymen. And so it goes. The honor guards are of no individual importance and are sort of crowded and heaped up over on the edge of things. They are overlapped by a shield bearing a monogram devised by Constantine. This device is called the *Chi-Rho* (*X-P*) and represents the first two letters of the word *Christ* in Greek. But it means still more. An *X* is, literally, a cross and must be taken to refer to

11-5 Interior, San Vitale, Ravenna

the Crucifixion. The *P*, especially when given an elongated form, is not unlike a shepherd's crook; it stands for the pastoral mission of the Church and harks back to the parable of the Good Shepherd.

Like many backgrounds in Christian art of the Middle Ages, this one is flat and gold. Golden things in a spiritual context recur constantly in Christian art, and it may seem odd that this should be so. After all, one might think, what could be more closely associated with worldly materialism than gold? Such a reaction is sponsored by innocence of the reasons for man's love of the

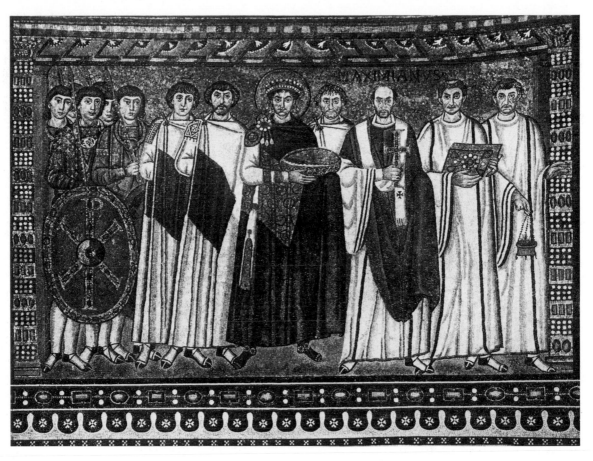

11-6 *Justinian and Attendants.* c. A.D. 547. Mosaic. San Vitale, Ravenna

yellow substance. Gold was and is valued not merely because of its rarity. It is unique among metals in that it does not corrode or oxidize. Even silver tarnishes. But gold remains unblemished. Therefore, ancient people considered it "immortal" and invested it with magical powers and supernatural meaning.

Notice, too, the emperor's halo. There was a tradition in the ancient Roman world of deifying pagan emperors—both Julius Caesar and Augustus were considered demigods—and it was not difficult for early Christians to accept the idea. That would have been particularly true in Byzantium. Byzantium was a "caesaropapacy," that is, a system of rule in which the emperor is not only the secular ruler but also the final ecclesiastical authority, the pope. The laws of the Church and those of the state are one with the law of God, and it is the emperor who administers them.

Ravenna is wealthy in churches, mosaics, frescoes, and other material from the Byzantine culture because it is in Italy instead of the original Eastern Roman Empire. Greece and Turkey fell to Islam in the fifteenth century whereas Italy did not; the Turks were as hostile to things pagan or Christian as Christians had been to things pagan, and they either destroyed the temples of the infidel or transformed them into mosques. One of the churches they used first as a mosque, then a model for other mosques, and finally as a sort of museum was the greatest of all Byzantine churches, the Hagia Sophia (fig. 11-7), or Church of the Holy Wisdom. This wonderful building, which seems to support a hemispherical dome upon a symphonic rise of swelling curves that flow like waves around blocks of masonry, was the inspiration of the emperor himself. Thinking that most men experienced in the design of buildings were too cautious to be original, he selected two who would be willing to try something novel. Anthemius and Isidorus weren't even archi-

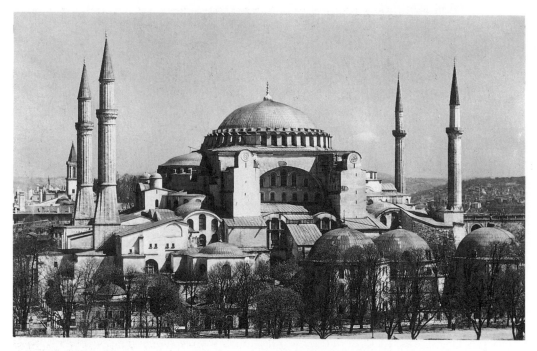

11-7 ANTHEMIUS OF TRALLES AND ISIDORUS OF MILETUS. Hagia Sophia, Istanbul.
C. A.D. 532–37

tects; they were mathematicians. Justinian's bold gamble paid off in one of the most original structures ever erected. It is unique, apart from imitations undertaken by Turkish builders. No wonder Justinian is supposed to have proclaimed: "Solomon, I have vanquished thee!" It is easily the most impressive as well as the most colossal Orthodox church ever built. It owes much of its fame, however, to the singular support system employed for the dome.

Looking up to the inside of the dome (fig. 11-8) one observes below it four immense, curved triangles that look rather like the remainder of a yet larger dome that has had its top and four edges pared away. The actual dome, then, seems to cap the hole on top of the imaginary dome, two bulging excedra and two flat window walls filling the side openings. That is, indeed, the very conception that prepared the way for this unusual building form, which is called a *pendentive* (see fig. 11-9*a*). The problem it is intended to resolve is one that Islamic builders also struggled with: how to cover a rectangular floor plan with a circular dome in a harmonious and structurally sound manner. The Islamic solution was beautiful in its simplicity; it used what are called *squinches*. A squinch is an interior corner support of the kind shown in figure 11-9*b*. Aesthetically, squinches effect the transition from square to circle through mediation of an octagon. Pendentives accomplish the change with a more fluid grandeur, although they have not proved to be as strong except where concrete can be substituted for masonry. That wasn't possible during the years following the fall of Rome because knowledge of concrete construction had been lost and was not rediscovered until the eighteenth century.

Islamic Architecture Today, when one stands in the Asian district of Uskudar in the city of Istanbul and looks across the Bosporus to the peninsula of the old city of Constantinople, one sees a skyline (fig. 11-10) filled with domes and minarets. But two structures loom larger and more in evidence than any of the others. Those are the Hagia Sophia, on the right in the photograph, and the Mosque of Ahmed I, to the left. This beautiful mosque (fig. 11-11) is an imitation of the form of the Christian church that is directly

11-8 ANTHEMIUS OF TRALLES AND ISIDORUS OF MILETUS. Interior, Hagia Sophia

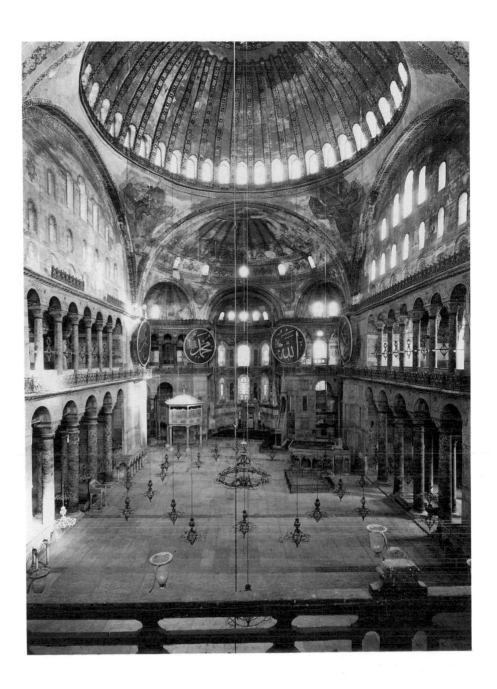

11-9 Pendentive (a); squinch (b)

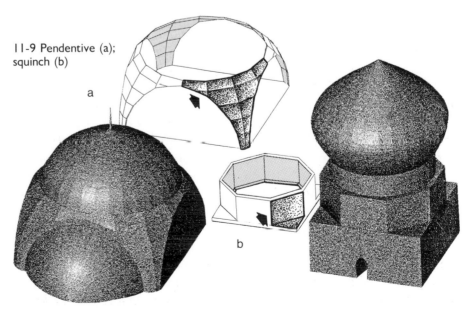

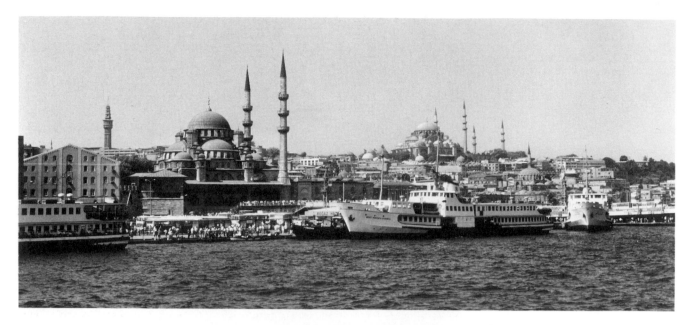

11-10 The "Old City," Istanbul, seen from the Uskudar district

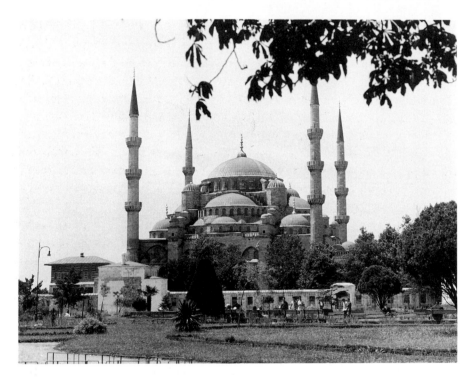

11-11 MEHMET AĞA. The Mosque of Ahmed I, Istanbul. c. A.D. 1609–17

across from it in a vast parklike space. Called the "Blue Mosque" by English tourists because of its exquisitely tiled interior, it is a superb late example of the kind of Ottoman architecture that had flourished under the ruler Suleiman the Magnificent (1494–1566). In fact, the architect has surpassed the Hagia Sophia with his treatment of the exterior masses of the building. The interior is less effective as a space, perhaps, but like many Islamic places of worship it is overlaid with surface ornamentation that is nothing short of spectacular.

A somewhat later structure from another branch of Islam also excels in its ornament. In this case the entire exterior of the building, the four minarets at the corners of a high platform, and the platform itself are of snowy white, unpolished marble that has been decorated with inscriptions from the Koran. These inscriptions are interlaced with floral ornament and all of them inlaid with stone of deepest black as well as semiprecious gemstones of every imaginable hue, the whole done with a meticulousness that rivals any minia-ture painting in the whole history of art. The Taj Mahal (fig. 11-12) is

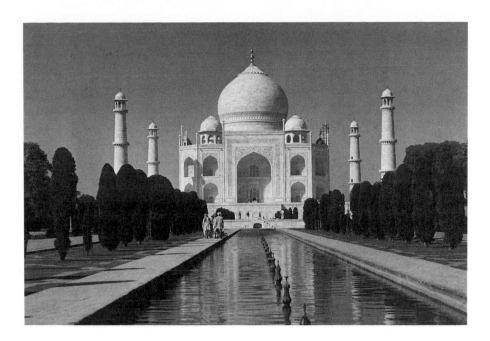

11-12 Taj Mahal, Agra, India. 1623–43

probably the best known of all Islamic buildings and is certainly *the* piece of architecture that nearly anyone would associate with magnificence and conventional beauty. It has also a sentimental legend connected with its history, since it is a mausoleum for the favorite wife of Shah Jahan and himself. The romantics of the Western world have taken this fantastic temple and tomb as the ultimate monument to undying love. Writers of perfume ads have conveyed to innumerable young people the tale of Jahan's adoration of the beautiful Mumtaz Mahal after whose death he was celibate. The fact is that Jahan was a notorious seducer from whom the court diplomats had to protect their wives, both before and after the death of Mumtaz Mahal, which does not make her tomb any less wonderful, of course.

The dome that caps the Taj Mahal is different from any we have seen thus far. It is not a simple semisphere but has a graceful, swelling shape seen in one form or another throughout Islam, topping the towers and temples of many different sects. To characterize this configuration as "onion shaped" detracts from the beauty of the form, but that is the conventional description in English.

Medieval Art and Architecture A dome is a form of *vaulting*, the spanning of space with arched roofs. The simplest form of vault is the *barrel vault* (fig. 11-13), nothing more than one arch set against another until there is a tunnel of arches. When you run two barrel vaults through each other at right angles, you have a *groin vault* (fig. 11-14). Such a vault is stronger than a barrel vault and also permits openings out of all four sides.

Vaulting made it possible for the Western Church to construct the vast cathedrals that dominated the towns of the Middle Ages. These were designed to accommodate large crowds of local worshipers and pilgrims and huge cadres of clerics and monks who performed the rituals and manned the choirs.

There are two large divisions of architectural church style in the Middle Ages. The *Romanesque* style obtains from about 1000 to 1150. The *Gothic* style was prevalent from about 1150 to 1500. The dates are general boundaries, of course, and the individual buildings differ tremendously from place to place. The Romanesque is more varied than the Gothic; it is comparable to the Romance languages—Italian, French, Spanish, and Portuguese—which deviate from the common Latin of their origins. In broad outline, though, the

11-13 Barrel vault

11-14 Groin vault

churches of the medieval period have the same floor plan and functional divisions.

The typical floor plan of a church (fig. 11-15) throughout the Middle Ages is in the form of a Latin cross. The arms of the cross form *transepts,* and the main body is the *nave,* the principal open area of the interior. On either side of the nave is at least one *aisle.* Christian cathedrals are always oriented to the compass points so that the worshipers look to the East (toward Jerusalem). The altar is at the eastern end of the nave, and beyond it is an exedra called the *apse.* West ends vary considerably from one part of Europe to another, but they frequently contain two bell towers, or at least a heavy block of building, to serve as an accent for the entrance.

A cross section (fig. 11-16) of the building usually has the parts shown here. There may be more aisles, and the proportions may differ, but the pattern is pretty much standard. The *clerestory* is a section of the building which rises clear of the roofs of the other parts, and whose walls contain windows which admit light into the nave. The *triforium galleries* run along the top of the aisles and accommodated the overflow traffic on special occasions.

St.-Sernin, a Romanesque church in Toulouse, France (fig. 11-17), was built over a forty-year span on either side of 1100. Looking down on the building from the air, one can observe that it has most of the characteristics of our plan and cross section. A central spire rises from the place where the nave and transepts cross. The contour of the aisle roof and nave is obvious against the block of the west entrance. There are small apses off the main apse; these are chapels. The aerial view shows us a characteristic of most Romanesque churches: they are composed of clear geometric masses—cylinders, cubes, hemispheres, and planes—linked together into a coherent whole. The walls of the building are very heavy so that they can support the masonry structure that rises aloft.

There is no clerestory in St.-Sernin, and its barrel-vaulted nave is not completely satisfactory as a ceiling, so we shall turn elsewhere for a more typical Romanesque interior. St.-Etienne's (fig. 11-18) designers vaulted their roof with a series of domical vaults, each divided into six sections by ribs. For every dome vault in the nave ceiling there are two small ones in the aisle. In St.-Etienne heavy piers hold up the aisle domes and also carry the main weight of the nave. In some Romanesque churches the supporting piers alternate with

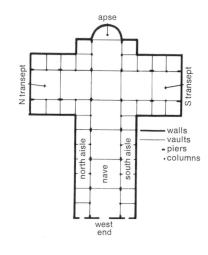

11-15 Floor plan of a medieval church

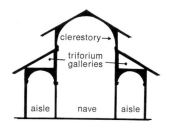

11-16 Transverse section of a medieval church

11-17 St.-Sernin, Toulouse, France. 1080–1120

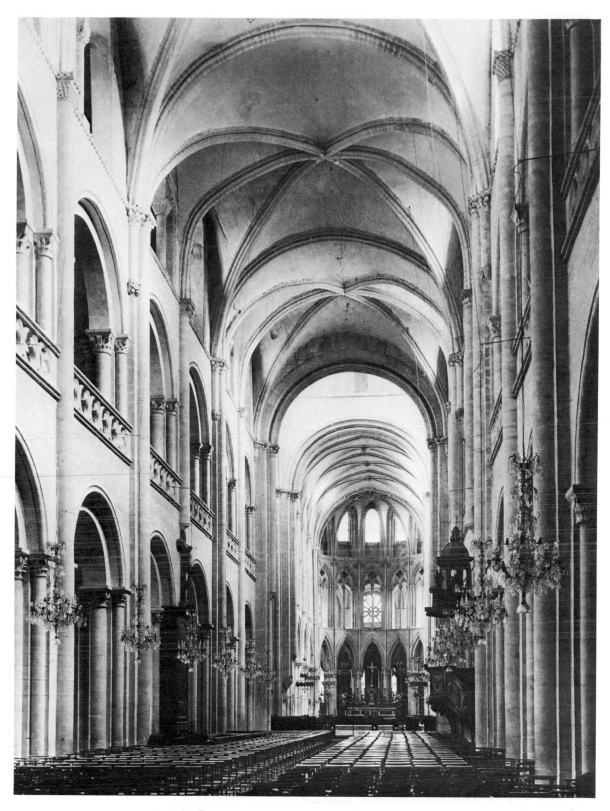

11-18 St.-Etienne, Caen, France. 1068–1120

single columns that support aisle domes and reinforce the transverse ribs of the nave domes. Either of the systems makes it possible for builders to include a gallery above the aisles and also to retain the clerestory. At St.-Etienne domical vaults arch up on all four sides, so the sides along the wall can serve as windows for the nave. The relative lightness of St.-Etienne was the Romanesque inspiration to the Gothic that succeeded it.

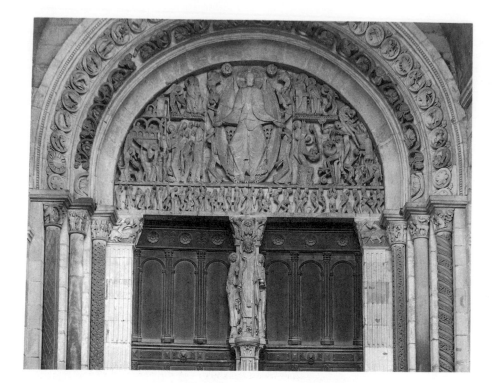

11-19 GISLEBERTUS. West tympanum of St. Lazare, Autun, France. c. 1130

Romanesque sculpture is nearly always an appendage of architecture and it shows some of the same traits as the buildings where it is located, being both massive and complex. Over the entrances to many of the churches are tympana, where sculptural ornaments appear, like the statuary in the pediments of ancient Greek temples. Most of these are anonymous but a few have the artist's name carved in the stone. That is the case with the tympanum from St. Lazare at Autun (fig. 11-19), which was carved by one Giselbertus. He has provided visitors to St. Lazare with a vision of the Last Judgment attended by hideous demons and solemnly dignified angels, some of whom are even more elongated than the ones to be painted by El Greco six centuries later. The Lord stands in the center, surrounded by a full-length halo called a *mandorla,* or "glory," as He renders the divine and final sentence upon naked human beings. The angels save some for paradise, the devils take others up to begin their eternal torture. It is an odd conception of the figure; tremendous agitation is combined with great rigidity of position. The nudes along the lintel have little organic reality for they have been reduced to a vivid shorthand that tells us of their pitiful weakness but little of their flesh. They are the dead souls being raised up from the grave, as was the namesake of the cathedral. And in most cases it is not entirely clear where anyone is going to end up. On the far right the servants of God and Satan are weighing the souls of men. Will the angel take the subject to heaven? Perhaps not. Certainly, the creature in the devil's scale looks villainous, but will purgatory be his limited salvation?

This spiritual uncertainty is typical of the psychological complexity of the Romanesque, a period of fearful faith and terrifying punishments. When ornament is decorative more than didactic it is usually full of complex interlacing, involuted vines or serpents, animals in abnormal conflict, and lettering so complicated as to be almost indecipherable. Giselbertus's carvings are characteristic of the Romanesque world in which the reality of monstrous visions you or I might consider abnormal were taken for granted as commonplaces in daily life. Still, not every bit of art was marked by this fire and brimstone asceticism. There are hymns of promise, hosannas of celebra-

11-20 HILDEGARDE OF BINGEN. *The Celebration of Creation.* Miniature from the *Liber Scivius.* 12th century (original destroyed)

tion of the glory of the Lord and the sweetness of the monastic cell. Indeed, the most popular occupation for the few who could freely choose was the life of the ascetic lived in the cloistered existence of the monastery or convent. And among the greatest geniuses of art to emerge from such a setting was a woman who has only recently been awarded the kind of prominence she deserves, Hildegarde of Bingen (1098–1179).

The prioress of her order on the Rhine, Hildegarde was a scholar and a mystic whose visions are the basis of a series of miniatures illustrating the text of her book, *Liber Scivias* (in effect, "The Book of the Light"). Whether she painted the illuminations herself is uncertain; if not, they were done at her direction and under her guidance. It is usual for art historians to select the most abstract and unusual of the images—one that describes the "Egg of the Universe," because it is so startlingly original—but I have decided to expand the general coverage with her vision of "all creation," as, to use her phrase, "a symphony of joy and jubilation." Here, in nine concentric circles all beings celebrate existence (fig. 11-20). Hildegarde was the author of nine books covering the topics of medicine, science, physiology, and theology as well as numerous poems, one of them a drama set to music "that can rightly be called an opera."[1] As Dominican scholar Michael Fox has said: "If Hildegarde had been a man, she would be well known as one of the greatest artists and intellectuals the world has ever known."

For most of us the word "Gothic" brings to mind cathedrals full of sharp pointed windows and doorways. This is a perfectly plausible response, except for the fact that a *cathedral* is not a type of building but a particular kind of church. It's one containing the cathedra (throne) of the bishop of a see. In other words, the distinction has to do with hierarchy and not with scale. Of course, cathedrals are often the largest and most impressive of the Gothic churches so it is not surprising that the term has come to imply what it does not really mean.

Every true Gothic church has *pointed arches.* These alone don't make it Gothic; some Romanesque buildings also use the pointed arch. But this kind

11-21 Pointed arch

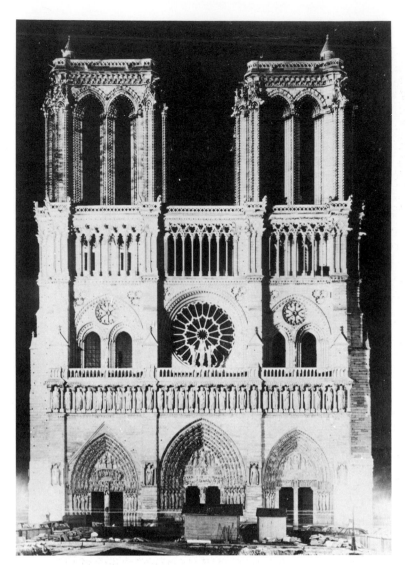

11-22 Notre Dame, Paris. 1163–1200. West facade

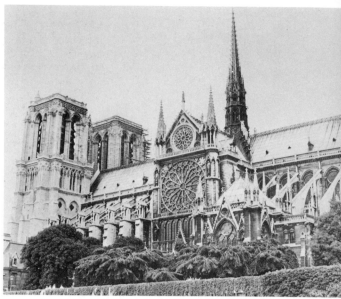

11-23 Notre Dame, Paris. View from the southeast

of arch (fig. 11-21) has attributes which lent it to the aims of the Gothic builders. First, it has less lateral thrust than a round arch. Secondly, the height of a pointed arch is not determined by its width as is that of a round arch. If you want to make a round arch 50 percent higher than another round arch, it must also be made twice as wide. To make a pointed arch higher one has only to change the curve of the sides. Such flexibility is the essence of the Gothic. For Gothic architecture is really a particular kind of engineering system. Its major features are the pointed arch and the *flying buttress.*

Notre Dame in Paris is, I imagine, the most famous of all Gothic cathedrals. Its west facade (fig. 11-22) reveals the divisions within. The central portal corresponds to the nave, and the other two to the aisles. The great *rose window* above the middle portal overlooks the nave. Looking at the building from the southeast (fig. 11-23), one sees how the towers on the west side blocked our view of the gallery roof, the clerestory, the transepts, and the nave roof. They also prevented us from seeing those queer arms sticking out all over the place; they run down both walls and around the apse. They are flying buttresses, and their function is to absorb the thrust of the stone ceiling of the nave. A glance at a transverse section (fig. 11-24) will show how the system operates. The shading represents what is closed in, the interior. The aisle wall is supported by *pier buttresses;* the nave is carried by the flying buttress, really a detached arch which conveys lateral thrust over to the pier.

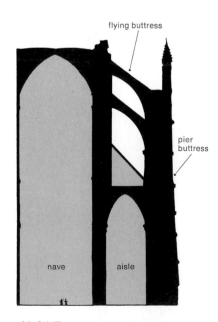

11-24 Transverse section of a Gothic church

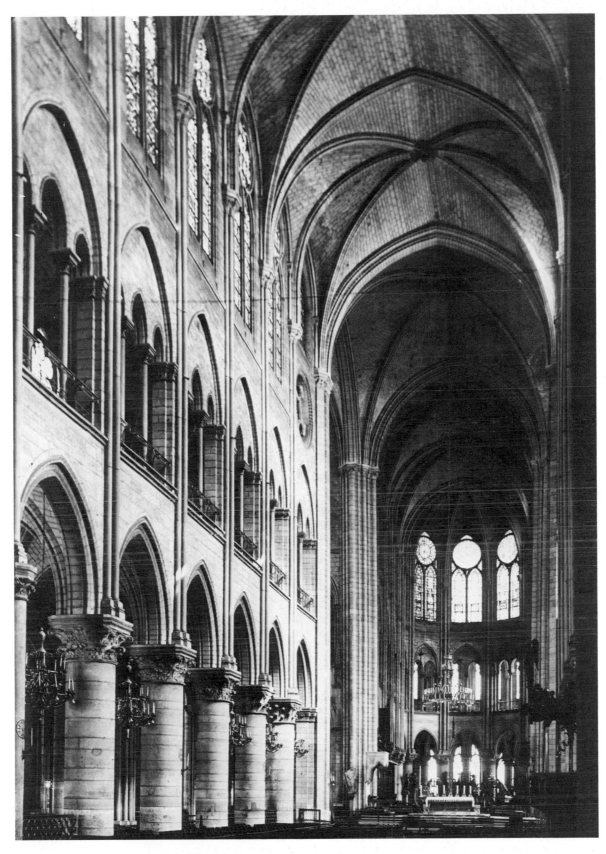

11-25 Notre Dame, Paris. Nave

Notre Dame's interior (fig. 11-25) is loftier and lighter than Romanesque interiors. The vaulting of the nave is similar to the vaulting in St.-Etienne; but the pointed arches that divide the bays permit the crown of the vaults to be level rather than domical, and they free more space for clerestory windows. In fact, the exterior walls of Gothic buildings are practically nothing but win-

dows. Romanesque walls had to be thick to support the weight of the vaults. Notre Dame's buttressing would provide support even if the walls were all pulled away. This fact enabled Gothic masons to incorporate vast amounts of stained glass into their churches. Stained glass has a tendency to absorb light, and the buildings are actually rather dark despite the stupendous amount of window surface. But the windows themselves are like magic jewels, and the shafts of rainbow light that fall onto the stone columns and paint bare floors with radiance transform cold buildings into holy places.

The relatively greater charm and lightness of the Gothic as opposed to the Romanesque corresponds to a somewhat happier view of life as it is lived on earth. Like the architecture, the times are full of oppositions and counterthrusts. The age is not a humanistic one, but neither is it as obsessed with the otherworldly as had been the earlier Middle Ages; hindsight makes it seem a transitional time in the change from the feudalism of the medieval to the primitive marketplace capitalism of the Renaissance. Aside from the economic changes we have touched upon before (see pages 41–49 in chapter two), there were philosophic movements that made for an interest in worldliness as such. To select but one of many, consider the emergence of the Franciscan Order.

St. Francis of Assisi lived from 1182 to 1226 but his view of religion did not have a great impact upon the Church and its public until the later thirteenth and fourteenth centuries. That view involves a drastic innovation in the

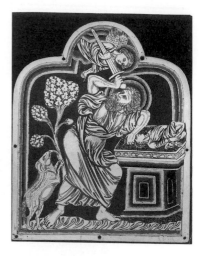

11-26 NICHOLAS OF VERDUN. *Sacrifice of Isaac.* 1181. Gold and enamel plaque, height 5½". Abbey of Klosterneuburg, Austria

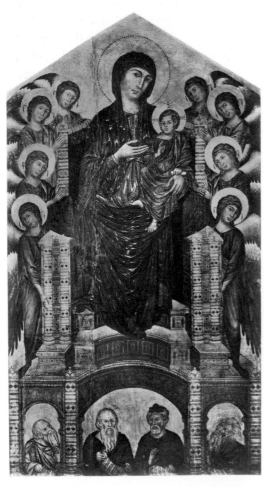

11-27 CIMABUE. *Madonna Enthroned.* c. 1280–90. Tempera on panel, 12'6" × 7'4". Uffizi Gallery, Florence

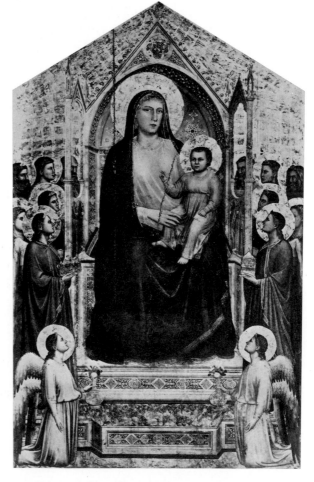

11-28 GIOTTO. *Madonna Enthroned.* c. 1310. Tempera on panel, 10'8" × 6'8". Uffizi Gallery, Florence

11-29 MASTER OF FLÉMALLE (ROBERT CAMPIN?). Mérode Altarpiece of the *Annunciation.* c. 1425–28. Oil on panel, center panel 25″ square, each wing 25 × 10″. The Cloisters, The Metropolitan Museum of Art, New York

religious viewpoint. Francis was what we might think of as an orthodox heretic who replaced dogmatic obedience with personal faith and conceived of the Christian community as a spontaneous relationship between God and humanity that was based on love rather than on a hierarchical chain of divine command. And he delighted in what he believed were tangible evidences of God's love of humankind—such things as birdsong, flowers and fruits, and the physical pleasures of life. He felt such things were gifts from God; in fact, he believed that the entire physical world was a gift. How different is this conception from that of Romanesque authorities, who equated the physical world with things profane and any pleasure growing from it with evil incarnate. Francis turned that notion on its head and, by doing so, laid one of the foundation stones for the humanistic conception of Christianity.

There were many other forces operating to modify the Romanesque world view, some of them—for example, a highly technical philosophical debate on logic called the "Nominalist-Realist Controversy"—more important than Franciscanism, but all had the concerted effect of moving the society away from a rigid supernaturalism toward a more materialistic sort of reality.[2] The results for Gothic art are easy to see in the evolution of religious representations from the plaque by Nicholas of Verdun (fig. 11-26) through Cimabue's *Madonna Enthroned* (fig. 11-27) to the one by Giotto (fig. 11-28). By the middle of the fifteenth century Robert Campin has come to the point of placing Mary, Gabriel, and Joseph in a contemporary Flemish setting that amounts to an inventory of material objects found in households and carpentry shops of his own time (fig. 11-29).

TWELVE

RENAISSANCE, BAROQUE, AND ROCOCO ART

Renaissance Art and Architecture From the late Gothic sprang the Renaissance. Yet when one compares Jan van Eyck's work (fig. 12-1) with that of his probable teacher, Campin (fig. 11-29), it is easy to see just how arbitrary is the distinction between the two. And, after all, the people who were directly involved in the change did not think of themselves as being medieval or Renaissance men or women; *we* think of them that way because we are able to reflect upon the scale of the changes overall instead of being caught up in the multitude of tiny changes that go on from day to day and are for the most part unobserved by people of the time. A person like Jan van Eyck was cognizant of a new interest in the world around him and of fresh observations brought to the depiction of events and was clearly enthusiastic about developing new techniques for retaining these in the paintings that he made, but he may well have thought of himself as the ultimate development of a trend rather than the beginning of a new artistic age. This kind of feeling must have been even more pronounced in the field of architecture.

For centuries the Gothic system of construction remained the loftiest attainment of architectural engineering. No major technical advances beyond it were made until modern times. Still, it would be a mistake to assume that all of the stylistic variations that occurred between the emergence of the Renaissance and the opening of the industrial age were of a purely cosmetic nature. Consider, for instance, the dominant feature of the city of Florence, Italy—the great dome of its cathedral (fig. 12-2). Its construction posed a singularly difficult problem, and the architect solved it with the kind of ingenuity we might expect from the same mind that devised the Renaissance system of scientific perspective.

Filippo Brunelleschi surmounted the limitations of his medieval training when he devised a way to cap a medieval structure with the widest dome built since the Pantheon's and the highest one built up to that time. To accomplish

12-1 JAN VAN EYCK. *Giovanni Arnolfini and His Bride.* 1434. Oil on panel, 32¼ × 23½". The National Gallery, London

this feat he had to invent a special machine to hoist stone, a unique scaffold to support the working masons, and even an unprecedented method of laying brick and masonry. The main difficulty to be overcome, however, was the sheer thrust of the dome at its base. The Pantheon dome had been cast of concrete; like an inverted teacup it bears directly down upon the supporting walls of the temple. But the Florentine dome is of brick and masonry. The tendency of the stones in such a dome is exactly the same as in any kind of arch; falling toward the center, they push outward at the sides. Yet, in Florence the dome, about 150 feet across and 308 feet tall, appears to rest effortlessly, unbuttressed upon its octagonal base. How can that be? What holds in the sides? They are restrained by a girdle. Beneath the superficial covering visible to the eye is hidden a structural system of separate stone arches leashed together by a girdle of heavy, chain-linked, oaken beams. These contain the thrust of the stone in the same way that iron bands strap barrel staves together to make a container that is both strong and self-supporting.

The cathedral dome is thus a clear example of newness set upon the foundations of the past. The building itself dates from the fourteenth century, and the octagonal opening for the dome was finished about 1405. Everything up to that point was strictly medieval in character. Only the *campanile,* or bell tower, might be considered a partial exception; it seems somewhat independent of the building to which it is connected. Designed by Giotto, it has a geometric clarity of parts that at first resembles the Romanesque. But like Brunelleschi's dome, the campanile anticipates the coming age in its logical clarity and self-sufficiency. Its individual parts have a distinctive, autonomous character, much like the parts of a painting from the late fifteenth or early sixteenth century. Masaccio, Botticelli, and Leonardo sought just such clarity in their pictures. They and their patrons shared a taste for natural appearances wedded to abstract design, but they also felt that the harmonies of a simple,

12-2 FILIPPO BRUNELLESCHI. Dome, Florence Cathedral. 1420–36

12-3 FILIPPO BRUNELLESCHI. Pazzi Chapel, Santa Croce, Florence. Begun 1430–33

clear geometry disclosed the pattern of the hidden orderliness of God's universe.

That conviction sprang, most probably, from a passionate interest in ancient Greece that had emerged in Florence during the end of the fourteenth century. As a matter of fact, the term *Renaissance* is ordinarily taken literally to mean a renascence (or rebirth) of the Classical humanism of ancient Greece and Rome. Such an interest in things Classical came to be called *Humanism* largely because of a medieval distinction between Divine Letters (writings on religion) and Humane Letters (writings concerned with worldly affairs). Mainly, Renaissance *Humanism* was a Christian expression of Plato's (427?–347? B.C.) confidence in the essential rationality of existence.

Since Roman ruins stood everywhere in Italy and some ancient buildings and roads were still in use, it is not surprising that the association of Classical design and humanist reason should have found expression in paintings, sculptures, and buildings taking their inspiration from the ancient world.

Brunelleschi's later buildings reveal a progressively greater commitment to Classical models. In his Pazzi Chapel (fig. 12-3), for instance, there are Corinthian columns, an entablature, a central plan similar to that of the Pantheon, and even such Classical refinements as making the height of the supported wall the same as the width of the intercolumniations.

The life history and work of a man like Brunelleschi show just how arbitrary are academic distinctions such as medieval, Renaissance, or modern. Actually, each age is part of a continuous stream of developments, some of which anticipate the future, some of which perpetuate the past. The Renaissance was full of architects designing Gothic buildings, painters emulating Giotto instead of Masaccio, and most people were no more conscious of being part of a rebirth of Classical thought than the reader is aware of being the representative of some massive historical tendency. Yet, there did emerge during the period an influential new culture with a distinctive literature, music, art, and architecture.

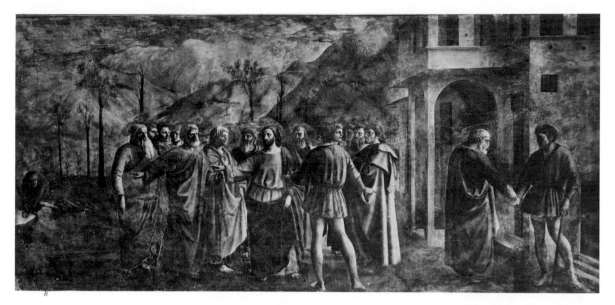

12-4 MASACCIO. *The Tribute Money.* c. 1427. Fresco. Brancacci Chapel, Santa Maria del Carmine, Florence

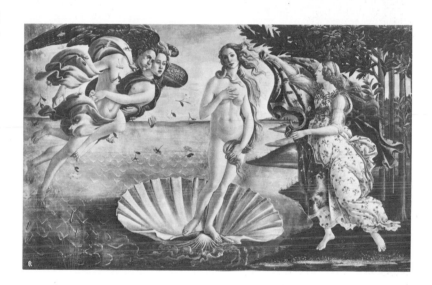

12-5 SANDRO BOTTICELLI. *The Birth of Venus.* c. 1480. Tempera on canvas, 5'8⅞" × 9'1⅞". Uffizi Gallery, Florence

That the culture of the Renaissance is not simply a matter of returning to the Classical past or being enamored of mindless naturalism is evident in the mastery of form exhibited by Masaccio, who combines in his works (fig. 12-4) the new invention of Brunelleschi, perspective, with a rationalized system of light and shade to create a world that may, in fact, resemble what ancient painters like Apelles did, but which is, nonetheless, Masaccio's creation. It embodied a simplicity and harmony against which the natural world may be measured. That is characteristic of Renaissance art over the whole of Europe. Italians seek boldness of theme and scope, Northerners intimacy and precision, but always the artists seem to be gauging the casual realm of ordinary vision against a more permanent truth.

In Botticelli's *Birth of Venus* (fig. 12-5) the form of the nude is derived from Classical sculpture, but the artist is willing to submit this Venus Pudica to sinuous stylizations so radical that her left shoulder is completely deformed. Until the distortion is remarked, however, most viewers are not aware that her arm sprouts from her rib cage in an utterly perverse way. She is also not the willowy beauty we think we see; this is a very chunky young woman. But it is the deviation from the natural in the anatomy of her lines that gives her the grace and floating lightness that have made her so appealing to admirers down

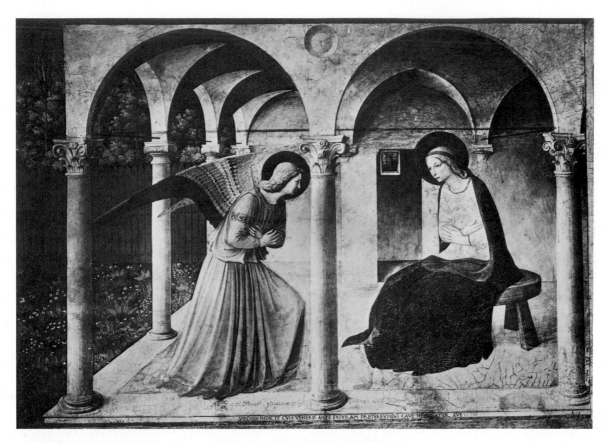

12-6 FRA ANGELICO. *Annunciation.* 1438–45. Fresco. San Marco, Florence

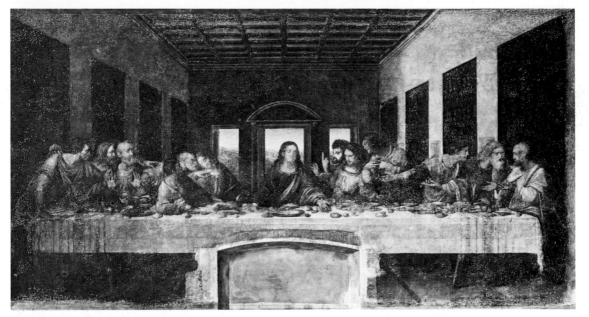

12-7 LEONARDO DA VINCI. *The Last Supper.* 1495–98. Mural. Santa Maria delle Grazie, Milan

through the ages. Exquisiteness of form has overcome ordinary appearances. By contrast, her face *does* have a cool, aristocratic beauty that does seem to have been based in fact. Botticelli uses this face over and over, for various pagan beings, usually Venus, and for the Virgin Mary. It may well be the face of a famous beauty of his day—a woman for whom Giuliano de' Medici, younger brother of Lorenzo the Magnificent, arranged a magnificent pageant in 1475—Simonetta Cattaneo Vespucci, sister-in-law of the explorer Amerigo Vespucci (1454–1512), after whom our continent is named.

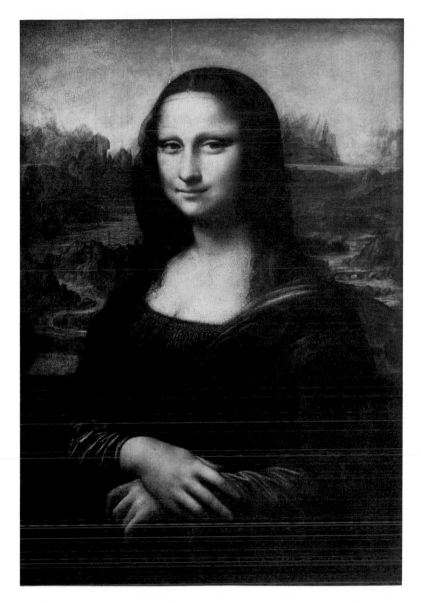

12-8 LEONARDO DA VINCI. *Mona Lisa.* 1503–5. Oil on panel, 30¼ × 21″. The Louvre, Paris

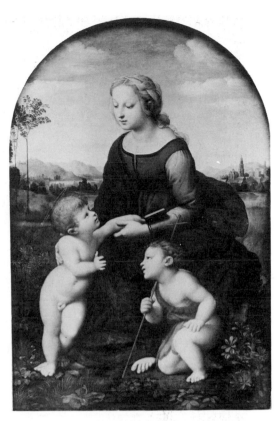

12-9 RAPHAEL. *Madonna of the Beautiful Garden.* 1507. Oil on panel, 48 × 31½″. The Louvre, Paris

Fra Angelico's Dominican world (fig. 12-6) is far removed from the glamour of the Florentine courts and titillating female loveliness of either the realistic or stylized kind. It is the hermetic realm of another ascetic, Thomas à Kempis (1380–1471), from whose *Imitation of Christ* the world is absent. His is like a Romanesque view that *the* evil in the world is our absorption with the world, but it is a gentle solitude full of tenderness and love instead of the terrors of the early Middle Ages. Both of these monastics represent conservative trends in the Renaissance. Angelico uses the new techniques, but employs them in a rather decorative manner, and even a fresco mural like the *Annunciation* conveys an impression of being small in size.

Leonardo da Vinci moves far, far beyond these others. He is the founder of the High Renaissance and the master of whatever truly interests him. His faults are those of the perennial experimentalist who is more interested in solving problems than in completing works. Thus, we are left with only a ghost of *The Last Supper* (fig. 12-7). The *Mona Lisa* (fig. 12-8), an investigation of the psychological ramifications of form, preserves the experiment intact. Here again is seeming realism that outreaches natural shapes. Such a will to order is the ensign of the Renaissance and the basis of the suave sweetness in Raphael's madonnas (fig. 12-9) and Michelangelo's power (fig. 12-10). Wherever we turn during the fifteenth century we find this same marriage of harmony and naturalism. In some cases—that of Dürer comes to

12-10 MICHELANGELO. *The Creation of Adam.* 1508–12. Fresco. Sistine Chapel, Vatican, Rome

12-11 ALBRECHT DÜRER. *Adam and Eve.* 1504. Engraving, 9⅞ × 7⅝". Museum of Fine Arts, Boston. Centennial Gift of London Clay

mind—the emphasis in the work (fig. 12-11) seems more on nature than on composure but the balance is ever delicate and hard to measure rightly.

In architecture the equilibrium is set between beauty of form and practical function. Here the ideal balance, in my opinion, was set by Andrea Palladio (1518–1580), who by 1570 was able to compile his version of Renaissance architecture in a set of four books, the *Quattro Libri,* which conveyed the Palladian vision to the entire Western world. His words and drawings contained within these volumes made Palladio what one critic has called "the

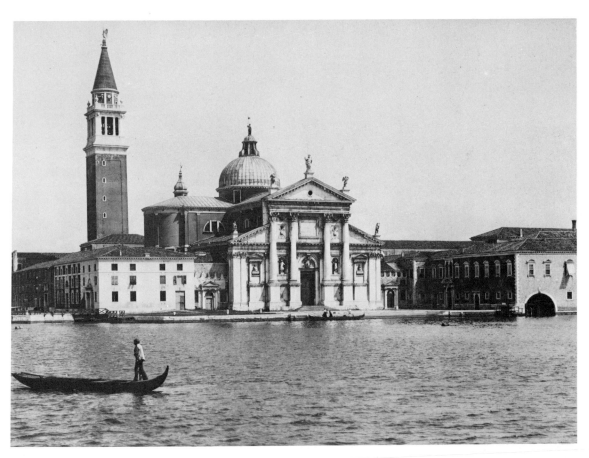

12-12 ANDREA PALLADIO. San Giorgio Maggiore, Venice. Designed 1565. Facade

most influential architect in history."[1] The title is well given. From Palladio's style came Thomas Jefferson's Monticello and the University of Virginia; he was the inspiration for the master of London's skyline, Sir Christopher Wren, designer of St. Paul's; nearly all of the elegant mansions of England and America during the seventeenth and eighteenth centuries have their ancestry in Palladian designs.

His most famous work is a Venetian church, San Giorgio Maggiore (fig. 12-12). This facade would by itself serve to make Palladio's place in history, in at least a small way. You may have noticed that other church architects—for example, the designers of St.-Sernin (fig. 11-17) and Notre Dame (fig. 11-22)—concealed the rather queer shape dictated by the cross section (fig. 11-16) behind the massive walls and towers of the west entrances. In terms of aesthetic unity these disguises were never entirely satisfactory even though they were, as individual things, quite beautiful. Palladio devised a unique and astonishingly plausible solution to this formal problem. Rather than screen out the gap between the central nave and the side aisles, he accepted and intensified it by imposing upon a wideset temple form, ornamented with pilasters, a lofty, slender temple supported by engaged columns. This is an ideal synthesis of Classical Roman elements with the medieval arrangement dictated by function and tradition. It would seem to have been the definitive answer to the problem and yet it is unusual among Palladian inventions in that it has never been repeated and has but rarely served as a point of departure for similar schemes. Perhaps it appeared so late that, unlike earlier treatments, it could not be construed as anything except the work of one man's mind and, thus, made any derivations appear to be mere copies.

The interior of San Giorgio Maggiore (fig. 12-13) has the measured grace one associates with Palladio and those inspired by him. It is rather pristine,

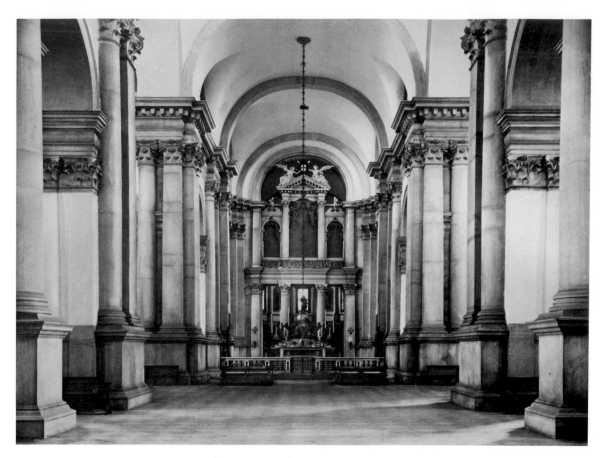

12-13 ANDREA PALLADIO. San Giorgio Maggiore, Venice. Interior

virtually without adornment. The massive pilasters, engaged columns, and gigantic piers comprise a majestic parade of flat, round, and blocked forms. But such measured dignity was already departing Europe even as Palladio's *Quattro Libri* made their appearance.

The contrasts we have already drawn between the Last Suppers by Leonardo (fig. 12-7) and Tintoretto (fig. 12-14) are shared by any number of fifteenth- and sixteenth-century paintings. The cause does not lie in the Protestant Reformation alone. Luther's revolution is but one of many connected disturbances that troubled the beginning of the later century. Italy herself was torn by war. In 1527 Rome was sacked by undisciplined troops under allegiance to Charles V, Hapsburg emperor of Spain, Naples, Sicily, The Netherlands, and Austria who imprisoned the Pope himself. It was a time of intense trial and foreboding, of economic disaster and death from sword and fire, and all of it intermixed with spiteful acts of cruelty and avarice carried out by zealous Catholics from Spain and puritanical Lutherans from the North. This was no time for the cool graciousness of Florentine and Roman and still less welcoming to the luxurious formalities of Venice. Under the Council of Trent (1545–63) the Counter Reformation created the Mannerist style that became the stepping-stone to the grand manner of the Baroque.

Styles of Vision Across Two Centuries Just as there is a branch of art history (iconography) which deals with subject matter, there is a branch concerned with form. Its concern is with historical problems, not with art criticism; it hasn't much to do with quality, it focuses on objective description. It is called *theory of style*. And its principal objective is to explain the evolution of styles throughout history. There are a number of theories of stylistic development, all open to serious question and none without the kinds

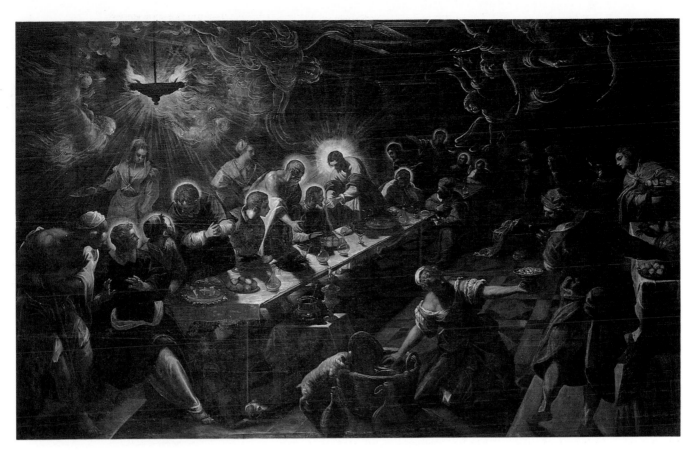

12-14 TINTORETTO. *The Last Supper.*
1592–94. Oil on canvas,
12′ × 18′8″. San Giorgio Maggiore,
Venice

of flaws that would cause any scientific theory to be discarded. One of the most interesting is Heinrich Wölfflin's.

Before we get into this thing, let me make it clear that Wölfflin's theory is applicable only to a specific period, although he himself, writing in the early twentieth century, supposed it applied to most historical epochs. Later he admitted that modern art was not accessible to his theory and also confessed that various factors might influence artistic developments so markedly that they would not appear to correspond to his description. But he was unable to modify the theory to take account of the variables. If I wished to do so, I could give many examples that would dispute Wölfflin's procedures. Anyone seriously interested in art could do the same.[2] I am *not* presenting his theory here with a view to defending it; I use it merely to reveal the ways in which a general view can overcome individual differences among artists.

Wölfflin devised his system in a brilliant analysis of the art of the sixteenth and seventeenth centuries. His contention was that art during this time span tended to move from one set of characteristics to another, specifically from:

1. the linear to the painterly
2. the parallel surface form to the diagonal depth form
3. closed to open compositional form
4. multiplicity to unity
5. the clear to the relatively unclear

He was at pains to point out that he used the terms *sixteenth century* and *seventeenth century* for the sake of simplicity but that the characteristics of the latter had actually appeared before 1600 and lasted on into the eighteenth century. Probably the terms *High Renaissance* and *Baroque* should be substituted for his centuries. In any case, what he was trying to do was map out a

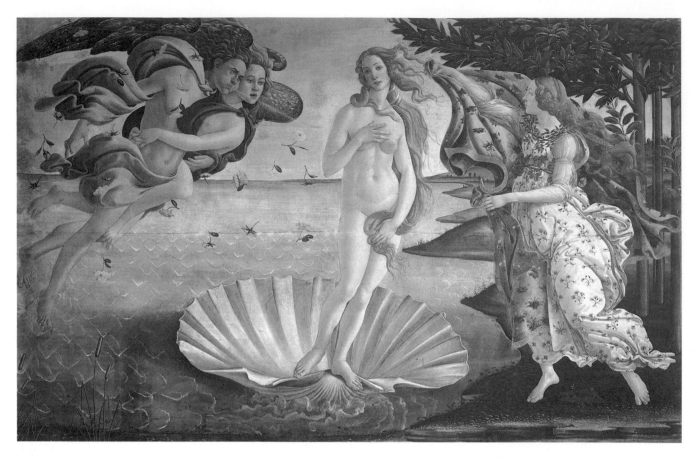

12-15 SANDRO BOTTICELLI. *The Birth of Venus*. c. 1480. Tempera on canvas, 5'8⅞" × 9'1⅞". Uffizi Gallery, Florence

sort of topography of historical developments. He did not argue that all artists in every nation modified their styles in a synchronized fashion. Obviously, some artists are ahead of the times and some behind. His favorite example of High Renaissance painting is Leonardo's *Last Supper,* painted before 1500; and he often uses Tintoretto as an example of seventeenth-century form, although Tintoretto died in 1594. We are dealing here with generalities. But they are generalities with a good deal of substance.

In order to give a very clear picture of what Wölfflin's polarities mean, I shall make an exaggerated comparison between an Early Renaissance masterpiece and one from the full-blown Baroque. Let Botticelli's *The Birth of Venus* (fig. 12-15) of about 1480 represent the first set of terms and Peter Paul Rubens's *The Rape of the Daughters of Leucippus* (fig. 12-16), done about 1616, represent the second.

The linear to the painterly: By "linear" Wölfflin means that outlines are relatively clear and that stress is laid on limits of things. By "painterly" he means depreciating the emphasis on outline and emphasizing the larger zones of dark and light. In the Botticelli the limits of things are clear. It would be wrong to say of the Rubens that edges do not exist; but it is certainly true that they are not nearly so clear as in the Botticelli. Rubens gives more power to the large spots of light and dark. Darks merge into darks and lights flow into lights.

The parallel surface form to the diagonal depth form: Obviously, the spatial arrangement in the Botticelli is of objects parallel to the canvas surface. Of course, there are diagonal elements—such as the lines in the shell—but they are not preeminent. What is most striking about the forms is that they are lined up more or less parallel to the front of the work. Rubens's picture contains elements that are parallel to the canvas, surely; but there are major forms that move back into space on diagonals. Consider, for instance, the recession from the nearest daughter's right hand to the head of the man lifting

12-16 PETER PAUL RUBENS. *The Rape of the Daughters of Leucippus.* c. 1616–17. Oil on canvas, 7'3½" × 6'10¼". Alte Pinakothek, Munich

12-17 Vignettes of Venus (above) and a daughter of Leucippus (below)

her sister. This movement is diagonal across the canvas and also travels progressively deeper into the picture. In more general terms, the effect of the Botticelli is of a very limited space, quite shallow and flat, whereas the space of the Rubens is correspondingly more three-dimensional. This is true despite the fact that the background in the Botticelli portrays things (such as sky) that we know are as far away in fact as any in the Rubens.

Closed to open compositional form: Venus forms a strong vertical axis for the Botticelli. Even though she is posed in a sinuous manner, she has been oriented to the sides of the picture. In fact, everything in the picture has. Verticals and horizontals dominate despite the presence of a few diagonals. This becomes obvious when we contrast *The Birth of Venus* with *The Rape of the Daughters of Leucippus. Open* is, perhaps, not a very good term (*a-tectonic* would be better), but it refers to the fact that in seventeenth-century works the horizontal and vertical elements of the picture edge do not dictate the internal arrangement of forms to the same extent that they do in sixteenth-century works. What is most evident in the Rubens is the diagonal, circular arrangement of things. Briefly put, the Botticelli looks deliberate and studied; the Rubens has a more open, casual look. We might think of the terms *closed* and *open* here as we do in describing personalities as closed or open. By the former we mean constrained, tense, uptight; by the latter we mean free and expansive. Too, closed compositions tend toward symmetrical balance, and open ones are often quite unsymmetrical.

Multiplicity to unity: The Botticelli is constituted of a collection of distinctly separate forms. We can separate out the nude or the two figures representing the Zephyrs and comprehend them as individual items very easily. We might even look at Venus's long hair apart from Venus as a whole.

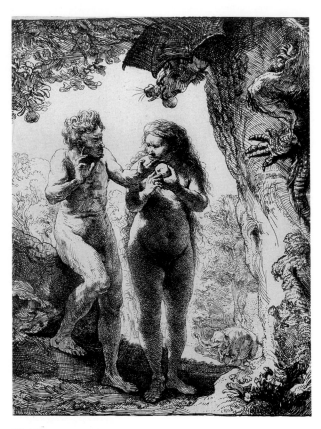

12-18 ALBRECHT DÜRER. *Adam and Eve*. 1504. Engraving, 9⅞ × 7⅝″. Museum of Fine Arts, Boston. Centennial Gift of London Clay

12-19 REMBRANDT VAN RIJN. *Adam and Eve*. 1638. Etching, 6⅜ × 4⅝″. Rijksmuseum, Amsterdam

Venus is a composite of separate pieces; the picture is the result of multiple parts, each worked out as a separate entity. In Rubens it is possible, of course, to speak of a given head or hand or person separately from the others, but no individual figure or part of a figure has the kind of independence one experiences in Botticelli. This can be quickly demonstrated by vignetting Venus and one of the daughters (fig. 12-17). Venus can exist outside her original context; the daughter is dependent on her surroundings. This is what Wölfflin meant by unity in seventeenth-century art—the greater dependence of one part upon the others so that the picture as a whole is a unit.

The clear to the relatively unclear: This development is, like the others, closely connected with the difference between linearity and painterliness. But here Wölfflin was trying to tie together some loose ends. And from his point of view Botticelli wouldn't fit, really: Botticelli would be distinguished from the High Renaissance because he was not striving for the *absolute* clarity of form that later painters such as Leonardo and Raphael sought. Wölfflin's example of absolute clarity is Leonardo's *Last Supper* (fig. 12-7), in which human beings have been reduced to geometric forms, in which the perspective scheme focuses on Christ's head, in which all twenty-six of the people's hands are shown. In Rubens's *The Rape of the Daughters of Leucippus* things are not absolutely clear in this way. Things are loose and swinging, the eye moves freely through the picture, and although five figures appear there are only seven hands.

Let us now compare a sixteenth-century German work with a piece from seventeenth-century Holland. Albrecht Dürer's engraving of Adam and Eve (fig. 12-18) corresponds to all the attributes for High Renaissance work: it is linear, has a parallel surface form, is closed rather than open, multiplicity rules (even the figures are made up of separate muscle groups), and the individual forms are absolutely clear.

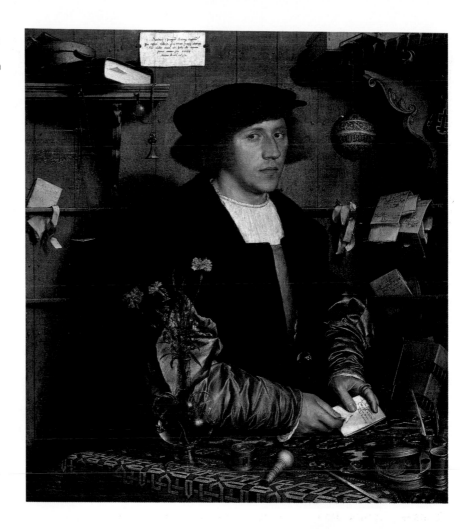

12-20 HANS HOLBEIN THE YOUNGER. *Georg Gisze.* 1532. Oil and tempera on panel, 38 × 33". Staatliche Museen, Berlin-Dahlem

12-21 JAN VERMEER VAN DELFT. *Young Woman with a Water Jug.* c. 1665. Oil on canvas, 18 × 17". The Metropolitan Museum of Art, New York. Gift of Henry G. Marquand, 1889

12-22 PIETER BRUEGEL THE ELDER. *Peasant Wedding.* c. 1565. Oil on panel, 44⅞ × 64". Kunsthistorisches Museum, Vienna

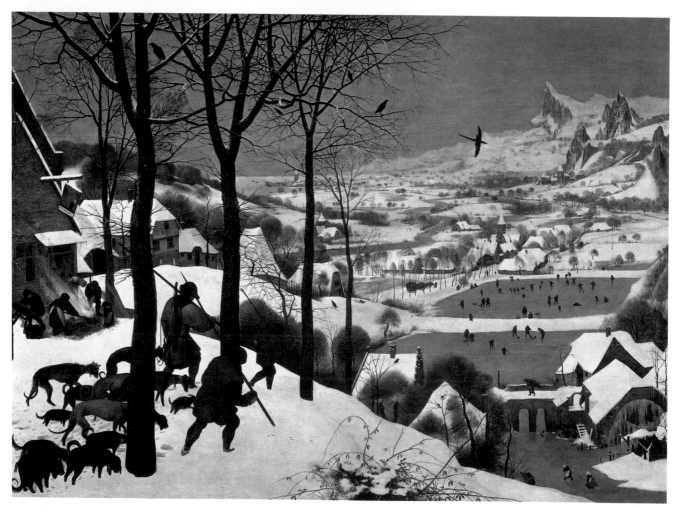

12-23 PIETER BRUEGEL THE ELDER. *The Return of the Hunters.* 1565. Oil on panel, 46 × 63¾". Kunsthistorisches Museum, Vienna

Rembrandt handled the same theme in an etching (fig. 12-19). It is made up of drawn lines, but it is not linear; indeed, there are places where the edges of things are not indicated at all. Notice the lighted side of Eve's right leg or the way shade merges with shadow under the serpent's foot. What strikes one in looking at the etching is not the outline of the forms but the dark and light spots in the work. Also one is much more conscious of diagonal spatial properties in the Rembrandt. The coordination between vertical and horizontal elements within the picture and the edges of the plane is not critical to the

composition. As for clarity, the forms in Rembrandt's work are coherent rather than crisp and clear because of the way he uses light and shadow.

There were also Dutch artists of the seventeenth century who painted very neat, highly detailed pictures. So let us contrast one such picture with a sixteenth-century painting by Holbein. *Georg Gisze* (fig. 12-20) has a more parallel surface form than Vermeer's *Young Woman with a Water Jug* (fig. 12-21). It is more linear. It is pretty symmetrical and not so fluid and open-looking; Gisze is a good deal more fixed in his space than the maid is in hers. He is obviously more a sum of individual parts than she, and so it goes throughout the two pictures. Finally, for all of the sparkling clarity of Vermeer's light effects, the objects are not so definite in their appearance as the sharply detailed things in the Holbein.

Even Wölfflin recognized that not all things fitted neatly into his scheme. To which century could he have assigned figure 12-22? It has a definite linearity, yet the diagonal depth form predominates. There are elements of both the closed and open compositional form. Still, it is made up of individually distinct elements and is clear in the foreground but less so in the distance. It was done in the sixteenth century, as you can see by the caption. Wölfflin called the painter, Pieter Bruegel the Elder, a "transitional painter." He says that Bruegel paved the way for Vermeer but was not yet a Vermeer.

What I am trying to demonstrate is that there are stylistic differences between vast groups of painters that are obvious to anyone who wishes to spend even a little time taking notice of them. In Wölfflin's theory they occur across the centuries regardless of the personal or national differences among the painters. His theory doesn't always work out, but it is true that it describes *most* High Renaissance art in the sixteenth century and *most* Baroque art during the seventeenth. The High Renaissance style of vision is different from the Baroque style of vision. The reason for the emergence of the two modes interests those of us with some concern for the history of ideas, but the point is that you don't have to know anything at all about history to observe the differences in the art; they are revealed in the distinctive forms the pictures take.

Baroque Art and Architecture Bruegel is the perfect artist with whom to initiate a discussion of the Baroque because he is a Northern European genre painter, like so many of the seventeenth-century Dutch artists, and also a Mannerist. It's true that a painting of everyday life like *Peasant Wedding* (fig. 12-22) or *Return of the Hunters* (fig. 12-23) seems at first glance to have very little to do with the exaggerated theatrics of a Tintoretto or an El Greco (fig. 12-24). But Bruegel is rarely as straightforward as he seems; these pictures have a cosmic sweep and, frequently, a strong moralistic element. Many of his admirers think of Pieter Bruegel as "the Peasant Bruegel," a simple fellow without guile or pretension who is in love with rustic life. Nothing could be further off the mark. He is fond of these rude people in a sentimental, somewhat condescending way and he is frequently at pains to point up his subjects' ignorance and their tendency to sin. The wedding feast reveals commoners in acts of drunkenness, gluttony, and sly, small acts of lust. There's a spoiled child in the foreground (identified by the ensign of vanity, a peacock feather). It's a big day for the moon-faced bride, who is enthroned beneath a cloth of honor back against the wall, but not for the painter or the baron of this manor. The latter is over on the right, whiling away the boredom of obligatory routine by chatting with the only other educated man in the room, a monk, while his servant pours wine and the

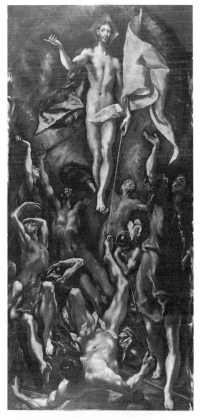

12-24 EL GRECO. *Resurrection.* c. 1597–1604. Oil on canvas, 9'1¼" × 4'2". The Prado, Madrid

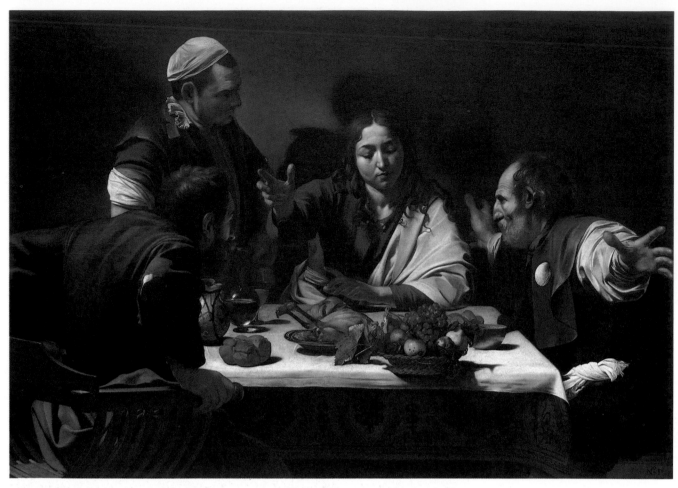

12-25 CARAVAGGIO. *Christ at Emmaus.* c. 1598. Oil on canvas, 55 × 77½". The National Gallery, London

groom helps carry a tray of cheese pies past the greedy diners. Who's the groom? The fellow with the spoon in his hatband; that is a symbol of hospitality and this slight prominence is most likely the last he'll ever have. Bruegel's peasants are always assigned negligible roles.

The hunters in figure 12-23 have returned in early afternoon as part of a panoply of seasonal activities. This picture is one of five known works from this time dealing with the seasons. Probably there were six paintings, originally, one for every two months. The human beings are merely components of the cosmic changes that God imposes upon nature, and they are painted for the amusement of an elite. After all, poor peasants don't purchase oil paintings; the people who bought these works found the rubes depicted exotic and amusing in somewhat the way we look upon "hillbillies." Even the spelling of the artist's name reveals his aspiration for class distinction. When he moved from Utrecht to Brussels in 1557 he changed it from *Brueghel* to *Bruegel*. Dropping the *h* had the same effect as if an American-born *Smith* were to switch over to the British spelling *Smythe*. Bruegel's work is addressed to an elite audience, is very distinctive, and is definitely a representation of an individualistic attitude. In these respects it is like the work of El Greco, the Spanish painter from Crete whose elongated, wraithlike figures, rendered with brushstrokes that flicker like lightning strikes through trails of smoke, appealed to the pious zealotries of Philip II (1527–1598) and his grandees. In much the same way, El Greco's style of vision can be considered a later, more extreme variation on Tintoretto's Mannerism.

The Baroque synthesizes what had gone before. It is an age that gives its painted dreams a good deal more substance than could be supported by Mannerist deliriums, but often presents itself with such spectacular flourishes

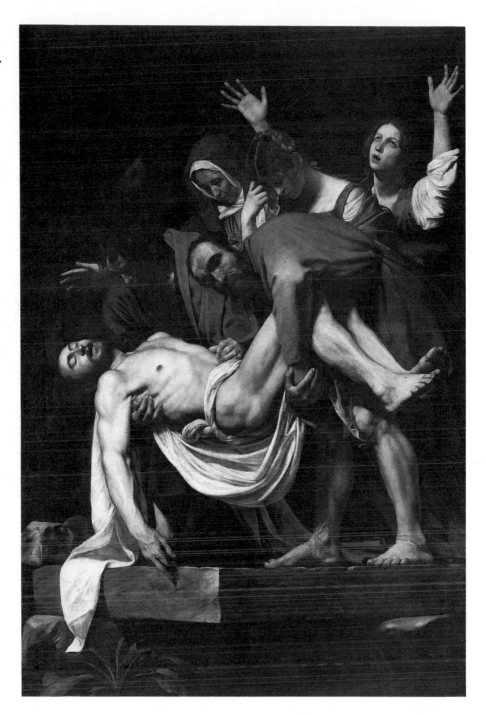

that even the frostiest reserve melts away. Or it gives us a combination of naturalism and design that takes the measure of everything that has gone before. In this latter connection, none can stand with Caravaggio, the one true colossus of painting in seventeenth-century Italy. A homosexual who was in constant conflict with civil authority, he spent the last five years of his brief life as a fugitive from a murder he had committed during a tennis match. His was an unruly and sordid character. And yet, it was he who created some of the greatest, most polished pictures of the age and laid the bases for a whole style called after him which was the principal factor in the development of two of history's loftiest talents, Velázquez and Rembrandt.

Caravaggio's *Christ at Emmaus* (fig. 12-25), which we have already looked at, and the *Entombment of Christ* (fig. 12-26) are both fine examples of his style. It features a brilliantly hard, polished naturalism in which very ordinary-looking people are given roles in the drama of the Passion. Indeed, in the Emmaus picture, Jesus himself is made to look like a rather pudgy youth.

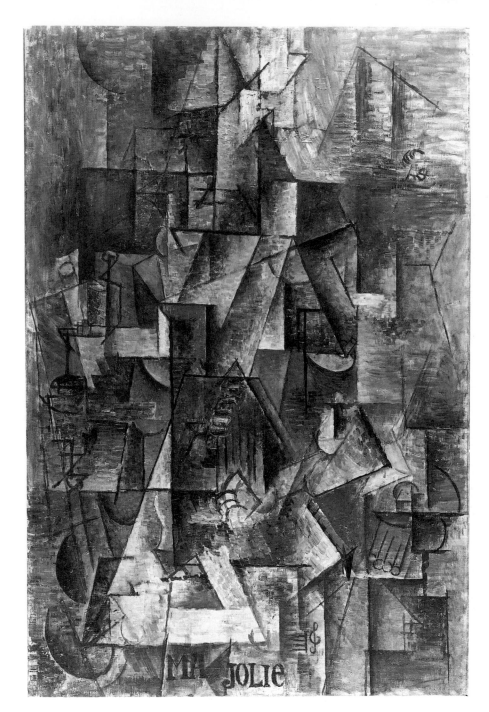

12-27 PABLO PICASSO. *"Ma Jolie."* Paris (winter 1911–12). Oil on canvas, 39⅜ × 25¾". Collection, The Museum of Modern Art, New York. Acquired through the Lillie P. Bliss Bequest

That pertains to the artist's interpretation of the story in the twenty-fourth chapter of Luke, which takes place after the Resurrection in the village of Emmaus just outside of Jerusalem. The risen Jesus has joined two of his disciples, "but their eyes were holden that they should not recognize him." Eventually, however, they enter an inn where "he took bread and blessed it, and broke it, and gave it to them. And their eyes were opened, and they recognized him; and he vanished out of their sight." This is the instant of the dawning. Usually, artists do what Rembrandt did in his depictions of the event and give us the traditional image of a bearded young philosopher; Caravaggio has retained the physical disguise and let the startled gestures of the two companions show that they are aware of His identity.

In Caravaggio's own time many patrons of the Church disliked his persistent portrayal of holy personages as poor commoners—of the sort the Scriptures would lead us to expect—instead of noble patricians like them-

12-28 CARAVAGGIO. *Entombment of Christ,* inverted

selves. They called him vulgar. Predictably, later ages defended the artist for his integrity and emphasized his "honest realism."

In 1921 the traditional view of Caravaggio's style was revised. A major scholar, Lionello Venturi, said that he and others had already clarified the events of the artist's life and work but that the "interpretation of his style came first . . . from a great novelist, Aldous Huxley, who in his earliest novel, *Crome Yellow* (1921), explains from a cubist point of view the simplified, formalized nature represented by Caravaggio."[3]

Probably it is not easy to see much similarity between a Cubist work (fig. 12-27) and the *Entombment of Christ*. Picasso, painter of the Cubist piece, once said that art "has always been art and not nature. And from the point of view of art there are no concrete or abstract forms, but only forms which are more or less convincing lies. . . . Cubism is no different from any other school of painting."[4] The relevance of this statement can be most readily apprehended if we invert the Caravaggio and examine it upside down (fig. 12-28).

One's first impression is of a series of forms looped and knotted together. But the thigh of the dead Jesus appears quite columnar and the lower part of the legs seems to protrude through a rectangular window of shadow. The geometrics of this picture are pronounced once you begin seeking out relationships. Christ's right hand, which appears at the top of the inverted reproduction, is part of a continuous curve that moves through His arm and neck, goes across the shoulders of the mourners who lean over Him, and terminates at the hand of the somewhat theatrical wailer in the background. Her hand, however, initiates another curve which matches the first one. It passes down past the dark rectangle, through Christ's feet to the innermost foot of the apostle supporting His legs. These two "parentheses" bound the figure group. Similar reverberations of forms recur throughout the painting. Almost any apparently realistic painting will exhibit like relationships of forms, but Caravaggio is remarkable for having gone so far without seeming to have stylized his figures. That is, the forms seem to conform to nature even though they have, in fact, been modified by his style, which impresses upon natural things an artistic value and geometry.

The fusion of apparent naturalism with abstract form in the nearly magical way Caravaggio achieves it is, perhaps, another aspect of the "unified unclarity" Wölfflin attributed to the Baroque. Everywhere one looks in the nations of the age, one turns up what seem to be contradictory states of being that have been overcome by artists exercising the exalted sleight of hand that is the stock in trade of the seventeenth-century master. Usually, apparent naturalism forms one side of the contradiction; it is the converse face that challenges expectation. In Caravaggio's case it is the thoroughgoing refinement of the compositions. Something of the sort might be said of Vermeer, who also composed his works like abstract studies (fig. 12-29). If you follow the lower edge of the young woman's raised forearm you will find that the line crosses through the sleeve into the starched white wimple she is wearing and continues up through its hood and then courses down through the inside of the left arm. Also, note the way a sharply defined shape like the one joining her waist and bodice belongs to a family of similar forms throughout the painting. Vermeer reveals a world that is seen as if it were captured in a block of completely clear, transparent jelly that is like nothing so much as air made solid. The effect is strangely naturalistic and, yet, nothing like the world we perceive. What is more, the hues are so controlled that the spatial effects and the impression of light and shade are entirely convincing. Vermeer's countryman, Rembrandt, plumbs other depths and the Spaniard Velázquez plays some of the subtlest tricks of the century.

Velázquez's earlier works, done in his native Seville, are very derivative of Caravaggio's chiaroscuro effects; compositionally, they are not in the same league with the Italian's, but a work like the famous *Water Carrier* is the very epitome of what art history knows as Caravaggesque painting. *The Spinners* (fig. 12-30) was done in his maturity, long after he had become official painter to the Court of Spain. Its apparent fidelity to nature, which includes that illusionistic spinning wheel, causes most of us to take the painting for a documentary description of the royal tapestry workshops, but it has concealed purposes and hidden meanings. The wall hanging in the distant room is an illustration of the legend of Arachne. Arachne, for those of you who have forgotten her story as it occurs in Ovid's *Metamorphoses* and in the *Georgics* of Vergil, was a mortal princess whose skill as a weaver surpassed that of Athena/Minerva herself. The goddess, infuriated by this blasphemous challenge, flew into an uncharacteristically jealous rage and turned her human

12-29 JAN VERMEER VAN DELFT. *Young Woman with a Water Jug.* c. 1665. Oil on canvas, 18 × 17". The Metropolitan Museum of Art, New York. Gift of Henry G. Marquand, 1889

rival into that most proficient of all weavers, a spider. (Thus the name zoologists give that classification of insect life: *arachnae*.) In the painting high-born ladies of fashion, possibly standing in for the muses or arts, virtually merge with the tapestry they are inspecting while the spinners in the foreground gloom work at their daily tasks. The painter's theme is the lofty perfection of the fine arts (that is, painting, sculpture, poetry, drama, and literature) as opposed to the inferior but essential crafts like weaving, pottery-making, or metalsmithing. Not surprisingly, tapestries were designed by painters, not fabric makers. The artist creates; mere artisans are sometimes required to bring his vision into physical existence as a work. In this instance there is a further discrimination resident in that the painter was male, the workers women. This is not so utterly clear in meaning as my offhand commentary suggests, though; Velázquez is an artist who sometimes engaged in manipulations of meaning and form so complicated and puzzling that another of his works, *The Maids of Honor,* was called "a theology of painting" by the Italian artist Luca Giordano (1632–1705).

The technical virtuosity of Diego Velázquez was shared by Rembrandt. Like the Spaniard, he was most valued in his own country as a portraitist who was said to capture the souls of his sitters. But Rembrandt is a master whose genius combines the imaginative power of a great novelist or playwright with unmatched painterly skills. In *Christ at Emmaus* (fig. 1-11) and the etchings of *Descent from the Cross: By Torchlight* (fig. 5-40) and *Adam and Eve* (fig. 12-19) he illustrates the narrative with unique insight and striking originality. This quality comes through with even greater force in the etching *Christ Before Pilate* (fig. 12-31).

The latter's composition, making wonderful use of the curving river of the mob and repetitions of its arc in the canopy and draperies, is not so marvelous as Rembrandt's treatment of the psychology of the principals. His Jesus is no longer the protagonist but is relegated to the background, jostled by hostile

soldiers, while the philosophic Roman procurator of Judaea, Pontius Pilate, attempts to mollify those demanding the death of a troublemaker and self-proclaimed Messiah. Pilate himself is a suave manager of opinion who believes a reasonable bargain may be struck with the priestly rivals of Jesus and hopes to trade a known criminal, Barabbas, for Jesus. One can see that the leaders of the tumult intend to prevail; one among them turns to assure the mob of his confidence in a desirable outcome while the others wheedle, rant, demand. Soon Pilate will turn from this dangerously intractable multitude and pretend to be asserting a principled decision by simply withdrawing from debate. What he actually does is condemn to a horrible death someone he has already declared innocent of any wrongdoing. Taking water, "He washed his hands before the multitude, saying, I am innocent of the blood of this righteous person. See *ye* to it." Rembrandt shows us the man who is good at heart, not a ruthless tyrant, but a weakling and compromiser willing to sacrifice a human victim to put his public at rest and secure a little peace of mind. This is a portrayal worthy of Shakespeare, another seventeenth-century genius who can make us feel sympathy for villains deeply dyed with blood.

The artist Georges de La Tour, who worked his whole life long in Lorraine, France, is another whose paintings combine Caravaggesque lighting effects with unique interests. But he was very much the specialist, obviously the master of his time in reproducing the dramatic results of artificial light (see fig. 5-7).

Another northerner, Peter Paul Rubens, is arguably more important to the course of art history than any of these other men, aside from Caravaggio himself, for it was he who wove together the strands of Mediterranean and Northern European art. He is a master of all subject matter in painting and a courtly professional diplomat as well. Ironically, he is best known to the popular mind for doing paintings of fat nude women, the impression of whose pale flesh is so realistically rendered as to turn the stomachs of many modern viewers. If one studies *The Rape of the Daughters of Leucippus* (fig. 12-16) with attention to the horses, the Gemini, Cupid, and the landscape it is easy to see that this painter is capable of doing whatever he wishes and in a grand style that is unique in its sweep.

The great French painters of this time were not Caravaggesque; they were the Classicists, Nicolas Poussin (1594–1665) and Claude Lorrain, the former a creator of enormously influential figure compositions set in legendary times and bucolic landscapes, the latter a painter of majestic landscapes featuring figures that are supposed to be from ancient literature (see fig. 7-5). Poussin's *Rape of the Sabine Women* (fig. 12-32) sets forth a version of Vergil's account of the way the Romans abducted the women of another tribe to make them their wives. It is a violent scene, full of sound and fury and seeming turbulence—but is, in this artist's hands, very controlled and completely structured. It is comparable to some scene of terrible passion from a grand opera; the events are bloody but the music is beautiful, the gestures statuesque and graceful in manner. Observe, for instance, the way in which a seeming chaos of arms, swords, and bodies forms geometric patterns and chains of shapes that link into a design the throng struggling in the Roman Forum. That kind of ceremonial order and harmony is the trademark of Poussin's style. It sometimes seems to be too rational to contain real life, too posed, too calculating, too polished. But its logic and beauty have been revered by both Classicists and modernists like Paul Cézanne, who profoundly admired him.

Heinrich Wölfflin felt that architecture, no less than painting and sculpture, responded to his descriptive polarities—that the buildings of the Renaissance

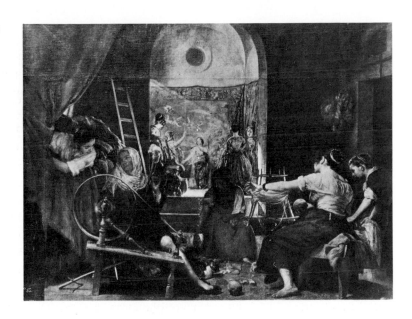

12-30 DIEGO VELÁZQUEZ. *The Spinners.* 1656. Oil on canvas, 7'3⅜" × 9'5¾". The Prado, Madrid

12-31 REMBRANDT VAN RIJN. *Christ Before Pilate.* 1636. Etching, 21⅝ × 17⅝". The Pierpont Morgan Library, New York

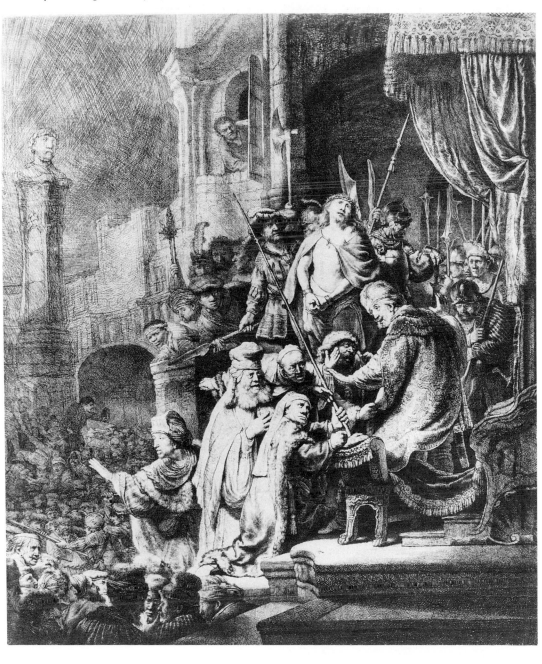

12-32 NICOLAS POUSSIN. *The Rape of the Sabine Women*. c. 1636–37. Oil on canvas, 60⅞ × 82⅝″. The Metropolitan Museum of Art, New York. Harris Brisbane Dick Fund, 1946.

were linear, clear, and multiple while Baroque structures were painterly (that is, dominated by light and movement), unclear, and unified. His system works less well when applied to buildings rather than to pictures, perhaps, but there is quite a good deal to be said in favor of it. Yet, even Wölfflin's categories could not really absorb the varieties of style present during the seventeenth and eighteenth centuries.

The most common way of describing the architecture of the *Baroque* period is to say that it is "ornate." But this is true of the architecture of the period only to the extent that it is accurate to say of Baroque paintings that they are "flamboyant" in the manner of Rubens or Tintoretto. Poussin's work is usually not; neither is that of most of the Dutch. Similarly, there are several kinds of Baroque architectural styles. Some buildings, like the east facade of the Louvre (fig. 12-33), are more restrained than Palladio's; some are heavily laden with ornamental embellishments. Thus, Carlo Rainaldi (1611–1691), in his Sta. Maria in Campitelli (fig. 12-34), piles columns and pilasters atop clusters of columns and pilasters to support segments of entablatures, cornices, raking cornices, and arches. The interior shows a similar profusion of detail. A palace by Guarino Guarini (1624–1683), illustrated in figure 12-35, is less heavily garnished but exhibits its own kind of enrichment of the facade in the undulation of the wall surface itself. Guarini was fascinated by geometric intricacies, and some of his designs are of such ingenuity that they are almost fatiguing to behold. For instance, the supporting elements of a chapel dome in Turin (fig. 12-36) take the form of hexagons inscribed within one another at lateral shifts of 30°.

Elaboration of standard components and exaggeration of the stylistic features of earlier styles were very much in the mood of the Baroque period. The Italians tended toward fanciful extravagance; the French preferred dignity on a majestic scale. But, whether the approach was plain or fancy, the main

12-33 CLAUDE PERRAULT. East Front of the Louvre, Paris. 1667–70

12-34 CARLO RAINALDI. Santa Maria in Campitelli, Rome. 1663–67 Facade

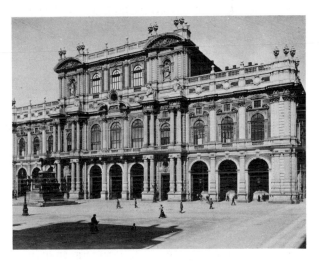

12-35 GUARINO GUARINI. Palazzo Carignano, Turin. Begun 1679

12-36 GUARINO GUARINI. Dome, Chapel of the Holy Shroud, Cathedral, Turin. 1668–94

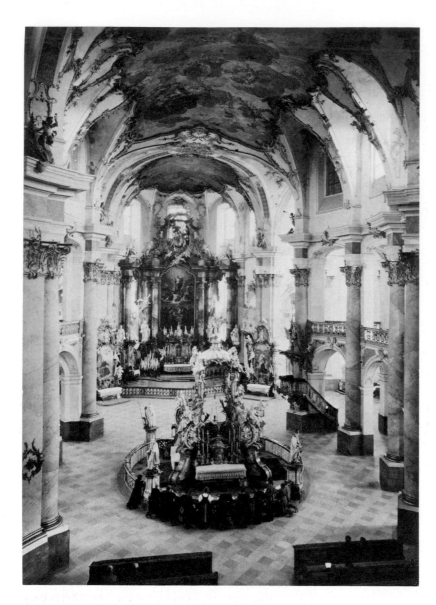

characteristic of the Baroque was grandiosity of conception, and the great buildings of this age often overawe us with effects that are mainly visual rather than structural.

Nowhere is that trait more evident than in the pilgrimage church of Vierzehnheiligen (The Fourteen Saints) near Bamberg, Germany. The exterior gives no real hint of the fanciful complication of the interior (fig. 12-37). Within, every surface is polychrome, all of them seem to float and flow together, and nothing looks altogether solidified. The architect, Balthasar Neumann (1687–1753), turned the realities of a large-scale building into a fairyland of the imagination.

Rococo Art and Architecture Some authorities describe Neumann's work as *Rococo*. No distinction in the entire history of art is less clearly drawn than the one made between Baroque and Rococo. This is not to say that it is a meaningless discrimination. Rococo connotes frivolity and a fragility of effect. Usually, the term can be applied with greatest usefulness to fashionable French interiors of the eighteenth century. One of the finest examples is the Salon de la Princesse in the Hôtel de Soubise (fig. 12-38) in Paris. Here, the grave pomposity of the Baroque gives way to a more lighthearted decor. Classical orders have been supplanted by pictorial diversions. Everything is framed or accented by elaborately delicate plaster moldings. Wood is rarely plain; nearly everywhere it is covered by molded plaster, smooth white paint,

12-38 GERMAIN BOFFRAND. Salon de la Princesse, Hôtel de Soubise, Paris. Begun 1732

or pseudo-Classical representations of antique heroes and heroines acting out their mythological roles. Most often, the buildings containing such rooms were themselves restrained. The houses and their owners were alike; they clothed an exquisite hedonism in garments of conspicuous refinement.

The paintings and sculpture produced to decorate these eighteenth-century homes were well suited to them, being intimate, sensual, gay, and diverting. Grandeur, solemnity, majesty — these suited the marble halls of a royal palace, but how pretentious and unseemly Poussin would appear in the privacy of one's own chambers. What place did grave histories of Rome have above a chaise where facile words and eager hands built afternoons of careless passion? Even in the home of a completely domesticated businessman they would seem ostentatious. Paris turned for its style to a lighthearted manner that would be utterly banal were it not for the obsession with refinement shared by all members of the French upper class. The perfect metaphor for their desire to gloss over unpleasant realities — which is what "refinement" comes down to when all is said and done — is the *bal masque* for which guests masquerade in fancy dress and dominoes. Wealthy aristocrats were capable of indulging in such outrageously cute perversions of reality as staging parties at which the ladies were dressed in costumes modeled after the garments of seventeenth-century shepherdesses but were made instead of silk, satin, and lace. You will be familiar with these outfits as "Little Bo Peep." These women had small flocks of sheep that had been curried and manicured, then dyed in shades of pastel yellow, pink, lavender, mint green, or blue to coordinate with the dresses. In painting and drawing, the best available disguise for the mundane was the facile brushwork of Rubens, so it is appropriate that the premier representative of the Rococo in French painting was born in Valenciennes, a Flemish town that had become French.

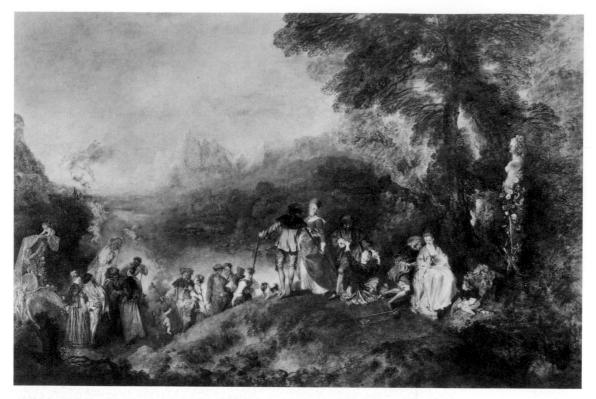

12-39 ANTOINE WATTEAU. *A Pilgrimage to Cythera*. 1717. Oil on canvas, 51 × 76½". The Louvre, Paris

Antoine Watteau (1684–1721) at no time imitated Rubens in a direct fashion but the latter's brushwork and blending of fantasy with naturalism had a strong influence on his own work, the most famous of which is *A Pilgrimage to Cythera* (fig. 12-39), showing couples returning from the mythical island of the Temple of Venus. Clouds of cupids swirl up and away as sexual passion flees and a gentler love descends when the act of love is done. The ephemerality of pleasure and the wistful sentiment that lingers are Watteau's theme and his works are usually permeated with gentle melancholy. The lovers, though, are of an indescribable elegance and even Watteau's trees have an exquisiteness far removed from ordinary bark and leaves. In this painting, as in all of his pictures, the people are hiding from a menace. It is called "reality." His men and women exist in a pastoral fiction where gallantry divests sex of its naturalness and mannered grace has displaced the directness of ordinary social relationships between men and women.

Watteau's is the epitomical expression of his times. While the values it conveys seem not to have been his own so much as those he sensed were congenial to others, his iconography was such as to have determined future taste. In this connection, his focus on costume is itself revealing. The first magazine devoted to women's fashions had appeared in France as early as 1672 and the central lesson of fashion, namely, that the attractions of what is unnatural should supervene, had been well learned by the turn of the century.

The world of fashion may itself be trivial and a symbol of the self-indulgent wastefulness of the more irresponsible members of the privileged classes, but its emergence does disclose a feature of eighteenth-century society that can scarcely be overemphasized as having relevance for our time. That is the rise to prominence of the idea of Woman as something other than sovereign, helpmeet, bawd, or broodmare. Ironically, the increased status of the female came partly from the insinuated eroticism that pervaded upper-class society. For the winning seductress is never ordinary, even when she is plain. The greatest

12-40 ELISABETH VIGÉE-LEBRUN. *Hubert Robert.* 1788. Oil on canvas, 41¼ × 33". The Louvre, Paris

hazard to her success is boredom; she must be always titillating, ever diverting. I do not mean to imply that the advance in the worldly station of women can be wholly credited to the prominence of courtesans like Madame de Pompadour, who is only the most celebrated of her sisterhood of sexual adventuresses. Obviously, there are a thousand other causes, but it is true that Frenchwomen of intellectual ability had far greater acceptance for their wit at the court of Louis XV than elsewhere during the time.

Women in the figurative arts gained considerably. We now begin to see skilled performers who are neither resigned to the dutiful anonymity of the nun nor consigned to the rank of proficient craftswomen. In Paris during 1720–21 there was a great vogue for the pastel portraits of a Venetian artist, Rosalba Carriera (1675–1757), whose rendering of flesh tones was emulated by many successors far more famous today than she. A later woman, Élisabeth Vigée-Lebrun (1755–1842), was celebrated as a painter by such patrons as Marie Antoinette, but this royal connection put her in danger from the Republican revolutionaries when the monarchy fell in 1779. During a thirteen-year exile she became an international celebrity who painted other famous people in Italy, Austria, Germany, and Russia. An unusual example of her work, but one that shows the strength of talent better than the society portraits she earned her living by, is her painting of Hubert Robert (fig. 12-40), the master in depicting ancient ruins.

12-41 JEAN-BAPTISTE-SIMÉON CHARDIN. *Still Life: The Kitchen Table.* 1733. Oil on canvas, 15½ × 18⅝". Museum of Fine Arts, Boston. Gift of Peter Chardin Brooks

Ironically, the painter of the century who is perhaps its outstanding artist was a modest, unassuming fellow whose reputation in his time was very dim indeed. He did not do paintings of well-known personages or of nymphs like those of Boucher and Fragonard. He did homely genre scenes and still lifes, especially the latter. The artist is Jean-Baptiste-Siméon Chardin, whose *Still Life: The Kitchen Table* (fig. 12-41) we have seen before in the pages of this book. Although his subject is without pretension and seems to be rendered in a perfectly naturalistic way, it shares with the works of men like Caravaggio and Vermeer a harmonious solidity that is far beyond the reach of his contemporaries who handled the great commissions for palaces and churches. The artist, in doing his paintings of foodstuffs waiting preparation, must have been exploring the compositional effect of various arrangements as pure artistry without any other justification. This particular work is intriguing for its originality and effectiveness. It's conceived like the form of a crankshaft, with the table's edge serving as an axis for objects that ascend and descend much as the "throws" of the shaft rise and fall with piston rods. Thus, the pestle and mortar on the left are up, the cloth down, the pitcher up, the cloth and chicken's head down, the cooking pot and peppermill up, the ribs down. The ribs themselves contain angular contrasts echoed in the dead chicken's crossed legs, the bail and ladle, and the edges of the muslin towel. Chardin's approach to the vernacular is Rococo in that it treats trivialities as if they were important but it is more akin to the Baroque in its weighted grandeur of conception.

There is a sense in which the works of the Venetians Guardi and Canaletto (figs. 7-40, 12-42) share the purposes of Chardin, at least in straightforward cityscapes like the ones reproduced here, but their hometown is so picturesque that even routine renditions of its streets, buildings, and alleyways are enhanced by the subject's glamour.

The Beginning of an End of Hallowed Ways In the very middle of the century something happened that threw all but the most frivolous spirits into a pensive mood and drew a veil of anxious gloom over much of Europe. A kind of disillusion with spiritual convention came over the world after 9:40

12-42 ANTONIO CANALETTO. *Santa Maria della Salute, Venice.* 18th century. Oil on canvas, 17¾ × 28". Galleria Giorgio Franchetti, Ca' d'Oro, Venice

A.M. on November 1, 1755, when virtually the entire city of Lisbon, Portugal, was leveled by an earthquake in a matter of moments. November 1 is All Saints' Day, when attendance at mass is obligatory for Catholics. As many as 70,000 and no fewer than 30,000 died in the earthquake, most while at worship.[5] This great natural disaster had repercussions far exceeding its immediate horror and devastation, and all sorts of historical transformations have been attributed to it, particularly those attendant upon the diminished importance of conventional religion afterwards. Democratic rebellion against established orders of society and the tremendous prestige of science over religion can be seen as reactions. There was a tendency toward morbidity in many literary and artistic works; the entire Romantic movement has been said to have resulted from it. Goethe said the event had loosed "the Demon of Fear" upon the land. The first horror story, Walpole's *Castle of Otranto*, appeared in print ten years after the Lisbon quake. Even optimistic temperaments react differently to the world than they had before; they make glorious celebrations of awesome nature more often than praises to the wonders of the Lord. If you look at works of art done in the eighteenth century before 1755 and after you can hardly help but be struck by the scarcity of works that are darkly terrifying before the date and the prevalence of such things afterwards.

From this point on there are no historically significant painters of ecclesiastical art—that tradition ended with Giovanni Tiepolo (1696–1770)—and when artists emphasize the spiritual or the supernatural in their works they do so as an expression of a purely personal yearning, as do Van Gogh, Georges Rouault (1871–1958), and Marc Chagall (1887–1985), or as occasional commissions incidental to their main vein of work, as in the case of Delacroix. We find ourselves in a very different world from the one we have examined up to now. It is far less religious, far more materialistic, somewhat more democratic, and not *necessarily* the better for any of this. It is, however, our world and its art is as fitted to it as the art of the past suited that time.

MODERN ART, ITS VARIETY AND UNITIES

If the word *modern* suggests what is up-to-date, then modern art is mis-named. Most authorities date its beginnings with Manet's *Olympia,* and she is now over one hundred years old. *Modern art* is really just a catchall term for the many movements and individual styles that have succeeded Manet's early works. With rare exceptions these styles have been extremely unpopular even when celebrated by umpires of taste—museums, art critics, art collectors, and professors. Modern styles are, by nature, esoteric; that is, understanding of them is limited to a relatively small circle. In one sense all art is esoteric. Were that not so, there would be no need to study it and its meanings. But modern art is more puzzling to laymen than traditional forms have been. After all, you can appreciate Raphael's *Madonna of the Beautiful Garden* (fig. 4-8) or Harnett's *After the Hunt* (fig. 5-48) for what they represent, while remaining ignorant of the artistry that created them. Doubtless there are a few people who fall in love with Mondrian and Kandinsky (see figs. 4-19, 13-1) at first sight, but they are very rare.

One of the things that makes modern painting and sculpture hard to grasp is the sheer variety of its styles. The mortality rate of the movements is the most obvious thing about them. Some "ism" emerges, flourishes for a few years, and then drops out of fashion to be replaced by another mode. Sometimes the history of these "isms" seems like nothing so much as a spectator sport played for a special group of bored sophisticates; the champion of today is old-hat tomorrow. It really isn't that simple, but it sometimes seems to be. All those names: Realism, Impressionism, Postimpressionism, Neoimpressionism, Fauvism, Cubism, Expressionism, Surrealism, Futurism, Neoplasticism, Minimalism, and so on. The mind boggles!

In an earlier book of mine it took almost two hundred pages to cover a rather narrow topic—the relation of certain modern artists and movements to developments in scientific theory—even assuming a slight familiarity with the history of modern art on the part of the reader. Obviously, in one chapter of a book designed to introduce people to all art there is no way in the world to explain much about modern art. At the same time, we have already dealt with

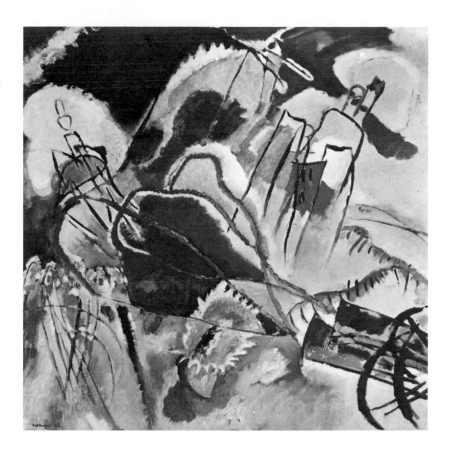

13-1 WASSILY KANDINSKY. *Improvisation Number 30.* 1913. Oil on canvas, 43¼ × 43¾". The Art Institute of Chicago. Arthur Jerome Eddy Memorial Collection

some major modern works in the earlier chapters, so we can make good use of previous analyses in an overview. Bear in mind, though, that this treatment is very superficial and that oversimplification is inevitable in such a survey. All I can hope to do is minimize its effects by warning you beforehand. For those interested in a more complete history of modernity (or, for that matter, of any other period) there are suggested readings at the end of this book.

Neoclassicism To talk of the art of the nineteenth century, one must begin in the eighteenth. For modern art is a middle-class phenomenon, and it was at the end of the eighteenth century that the middle class finally came into political power. This class had had a decisive influence on taste in art from the time it emerged during the late medieval period. But all through the Renaissance political authority had been in aristocratic hands. And when those of middle-class origin became truly powerful—as the Medici did—they soon gained titles and entered into the line of nobles. There were exceptions to this pattern, the most notable being the Dutch Republic, ruled by an elected group of businessmen; but for the most part feudal rule lingered on in politics even as capitalism was driving it from the economic scene.

After the Treaty of Paris (1763), concluding the Seven Years' War,[1] such centers of aristocratic power as the estates, assemblies, and parliaments were under constant pressure from middle-class and popular radicalism. In 1789 the middle-class and radical elements of France combined to overthrow the government in the name of Liberty, Equality, and Fraternity. Out of the French Revolution was born the First Republic of France.

The First Republic turned out to be a thoroughly middle-class affair. One evidence of this is that not once during the famous Reign of Terror did its leader, Robespierre, challenge the right of private property, the thing which gives any middle class its security and its political clout. One might, then, expect the art of the Revolution to resemble that of the Dutch. After all, the

Dutch had the first middle-class republic. Moreover, Dutchlike trends in France (represented by people like Chardin) had persisted throughout the eighteenth century alongside such aristocratic styles as those of Claude Lorrain and Antoine Watteau. It must seem curious that the Revolution chose for its style a "purified" version of old-fashioned Classicism. But it isn't really odd when you consider the alternatives that were available.

Vermeer's scenes of domestic life, Chardin's still lifes, and the hundreds and hundreds of similar works by lesser artists all represented the private interests of the middle-class individual. There was no reason for an *official* style to represent that individual's class until the abolition of all feudal privileges occurred. The moment that occasion arose, with the success of the French Revolution, it became obvious that unheroic attitudes could not convey the patriotism and courage of the revolutionaries. Chardin was no more serious or heroic than Watteau. And the revolutionary situation required themes of tremendous gravity. Of the seventeenth- and eighteenth-century styles then current, only Classicism had seriousness to offer.

Were it necessary for us to make up a style that would be in accord with the mood of the Revolution and the propaganda purposes of the First Republic, we could do so quite easily. Seriousness of theme would be a main requirement. The most suitable subjects would surely be drawn from the histories of ancient Greece and Rome. France was surrounded on all sides by hostile monarchies whose rulers argued that Divinity stood on the side of kings. But France could find in democratic Athens and Republican Rome models of civic virtue even older than the royal houses of Europe. As for form, the circumstances required an art distinguished by dignity and solemnity.

As it happens, we do not have to be content with a description of what the art of the Revolution would have been like. It still exists. And the prescription laid out above is patterned on the canon of Jacques-Louis David (1748–1825), artistic dictator of both the First Republic and the Empire under Napoleon Bonaparte.

In 1785, four years before the Revolution, David had exhibited his *Oath of the Horatii* (fig. 13-2), the first triumph of his special style. Here the content is serious indeed; three brothers swear to win or die for Rome against Alba. But what set off David's *Neoclassicism* from previous Classical styles was the strict economy of means which characterized its form. His technique is abstemious even when compared to that of seventeenth-century Classicists like Nicolas Poussin. Everything is broken down into modalities of three. There are three archways, three figure groups, three brothers, three swords, three spatial levels. And any concession to Watteau-like luxuriance has been ruthlessly suppressed. Even his brushwork is flat, in itself uninteresting. Clarity is the supreme objective of the form, and moral seriousness plus sacrifice the content that it holds. Even before the Revolution the insurgents identified this picture with the goals and ideals of 1789.

Its central theme, drawn from Vergil by way of Corneille's *Horace,* is martial patriotism married to family virtue and sacrifice. The three brothers are committed to trial by combat with three champions from the Curiatii camp of Alba. It is nearly certain that at least one will die, but the situation is complicated by the fact that while one of the Horatii is married to a sister of the enemy, their own sister, Camilla (here dressed in white), is betrothed to another combatant. It is, therefore, foregone that she will lose either a brother or a lover. As it turns out, only one man, a Horatii, survives the fray. When his sister bemoans the loss of her fiancé, he slays her on the spot, crying out: "So shall perish every Roman woman who mourns a foe!" A grim conclusion to

13-2 JACQUES-LOUIS DAVID. *Oath of the Horatii*. 1784. Oil on canvas, 11 × 14′.
The Louvre, Paris

the noble beginning David portrays. Doom portends but patriotic virtue will
be well served by tragedy. David's is the visual anthem for the fraternity of
defiant martyrs who will make a revolution.

David was not the only Neoclassicist. Not by any means. Naturally, there
were a few other great painters among the hundreds trained by official schools
of art. But he is the foremost, and the purest of them all. He was high in the
councils of government, and his ideas virtually dominated the education of
artists all the way into the early twentieth century.

I am not the first person to note that David's was a curiously bloodless and
dispassionate art, considering the kinds of things with which it was associ-
ated. These were the times of the tumbril and the guillotine; public executions
and violent death formed an important item of the citizens' diet. David himself
consigned lifelong friends to the chopping block with no more reluctance than
he'd have thrown away a worn-out brush. And what did he paint all the while?
Pictures that are unemotional, spare, and neat. Impersonal Neoclassicism
was, perhaps, the perfect art to "front" for such mass insanity. Even today the
major polluters of the environment have the cleanest and most antiseptic-
looking homes and offices. But David's times cried out for artistic expressions
of deeper feeling. And creative imaginations were not slow to answer.

One of those imaginations, curiously, belonged to a man who would never
have admitted that his spirit embodied anything other than pristinely aca-
demic Classicism: Jean-Auguste-Dominique Ingres (1780–1867). David's
successor as leader of the Academy, Ingres was the personification of reveren-
tial pedantry and was one of the greatest draftsmen who has ever lived. For a

13-3 JEAN-AUGUSTE-DOMINIQUE INGRES. *The Bather of Valpinçon.* 1808. Oil on canvas, 56⅝ × 38¼". The Louvre, Paris

truly great painter, he was astonishingly obtuse, professing a Neoclassical dogma completely irrelevant to the work that he produced. Practically everyone but Ingres himself recognized that his was an extremely turbulent and original artistic sensibility which could not be suppressed by the theories he relentlessly enforced at the Academy.

Ingres's *Bather of Valpinçon* (fig. 13-3) is Classical in its origins, for the pose is taken from a relief sculpture on a stone sarcophagus from Roman times. But the sensuousness of the nude's pliant flesh is at odds with the Neoclassical doctrine of ruthless intellectuality and moral clarity of feelings. More importantly, though, Ingres's treatment of line and form is wildly removed from the idealized proportioning always identified with Classical designs. Look first to the right shoulder and arm, falling in an uninterrupted arc from the neck to the bed. Only the rhythms of the smoothly delicate chiaroscuro make us believe that the shoulder, elbow, and wrist exist in outline. Too, the right shoulder is abnormally depressed compared with the left; a model posed in this way, seen at this angle, would not look so asymmetrical as this. Consider, too, the incredible distance from her waist to her buttocks. It is nearly as far as it would be to most women's knees. The curve of the left leg orbits the bulge of the bedclothing beneath it in a smooth arc nearly as perfect as that of the right arm—only the knee provides the slightest kind of divergence.

13-4 THÉODORE GÉRICAULT. *The Raft of the "Medusa."* 1818–19. Oil on canvas, 16'1" × 23'6". The Louvre, Paris

These distortions would surely be justified by Ingres on the ground that they are part of the overall harmonics of the composition, that they relate to the whole as the drapery on the left echoes the triangular folds elsewhere, and the convolutions of the turban reflect those of the cloth tucked between the bather's arm and her body and the bunchings of the coverlet on which she sits. But the truth is that Neoclassical formality does not permit the deforming of humanity in ways that depart from the perfecting of nature's mold. Actually, in almost everything but the brushwork, this painting could be taken for an example of the very thing Ingres dedicated much of his life to resisting— Romanticism.

Romanticism *Romanticism* is often defended as a movement that opposed logic and rationality to Pascal's "reasons of the heart," and many people have fallen into the habit of accepting this description as if it were the thing. Just how far most of us have fallen was estimated a number of years ago by Jacques Barzun, who listed eighty separate uses of the term *romantic*.[2] Most of them derive from the idea that Romanticism is irrational. Professor Barzun, however, is of the opinion—an opinion I share—that the Romantics differed from the Classicists mostly in being more comprehensive. Instead of sticking to ancient subject matter of great nobility of purpose, the Romantics took in the whole world, both the tangible and the supernatural. They dealt with the present as well as the past and with exotic places as much as with familiar myths.

The first painting of real importance in the direction of Romanticism was Théodore Géricault's *The Raft of the "Medusa"* (fig. 13-4). What it portrays is not something from the Classical past but a contemporary event. On July 2,

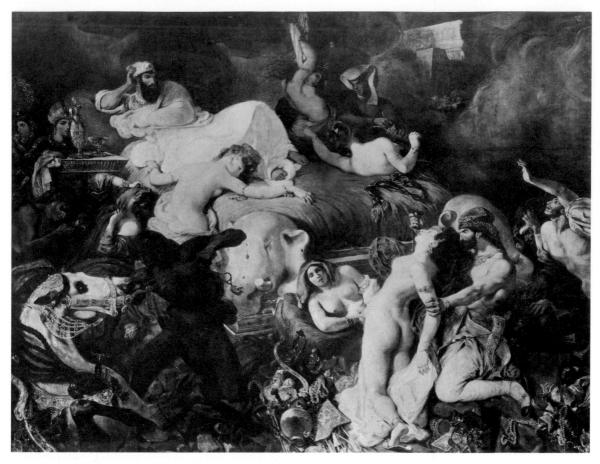

13-5 EUGÈNE DELACROIX. *The Death of Sardanapalus.* 1827. Oil on canvas,
12'11½" × 16'3". The Louvre, Paris

1816, the French ship *Medusa* wrecked off the west coast of Africa. One
hundred and forty-nine passengers and crewmen were cast adrift on a make-
shift raft. By the time they were rescued only fifteen still lived. The tragedy
produced a maritime scandal, and Géricault's picture attracted large numbers
of people both in Paris, where, by taking advantage of a loophole, it was
slipped into the annual exhibition of official art, and in England, where it was
exhibited as a sort of sideshow novelty. The Classicists hated it, but the general
public was introduced to a kind of modern painting that took as its models
Rubens and Michelangelo instead of Poussin.

The picture was filled with innovations. Surrounded by the waves of the sea,
the figures rise in a great wave of humanity at the top of which is a black man.
That Géricault used a black was no accident; one was among the survivors.
That he should be the pinnacle of the group relates to the very origins of
Romanticism in the writings of the philosopher Jean-Jacques Rousseau, who
contrasted the "noble savage" with corrupt Western civilization and who felt
that the European culture of his day thwarted the humanity of man. This
notion—that the civilized and reasoned-out is an assassin of the natural, the
spiritual, and the human—is a recurrent theme that occurs in different guises
throughout recorded history. (We have encountered it more recently in "black
consciousness," in "organic" food, in all back-to-nature movements, and in
the popularity of oriental mysticism.) Romanticism is founded on the as-
sumption that the object of life and art is to grasp *all* directly, spontaneously,
and freely.

Romanticism abandoned nothing; it simply incorporated far, far more. It
wasn't just a style; it was a genuine intellectual movement, comprising all
sorts of styles and many different art forms. The most famous Romantics are

13-6 GUSTAVE COURBET. *The Stone Breakers.* 1849. Oil on canvas, 5'3" × 8'6".
State Picture Gallery, Dresden

the writers Lord Byron, Sir Walter Scott, and Johann Wolfgang von Goethe. *The Death of Sardanapalus* (fig. 13-5) by the greatest of all Romantic painters, Eugène Delacroix (1798–1863), was based on one of Byron's poems. It concerns an Assyrian potentate who is determined that conquering invaders already at the palace gates shall not enjoy anything he himself prizes. As he is about to immolate himself, he has all his treasures—including his concubines—heaped upon the luxurious funeral pyre. He and all he values are to go up in flames together. Nothing could be less Neoclassical than this subject. It is violent, it is exotic, it is based on contemporary literature rather than the writings of antiquity, and it is painted in a manner altogether different from David's.

Where David sought precision, Delacroix sought power. David's edges are definite and predictable; Delacroix's are more obscure than the Baroque. Where color, for the Neoclassicist, was just added to the drawing as decoration, in Delacroix's painting the color is rich. David's brushwork is as dry and flat as that of the house painter; Delacroix's is lush and textured—it has what painters call a "juicy" look.

The Romantics rediscovered the Middle Ages and the Renaissance. Frequently their subjects were remote in space as well as time. Delacroix visited the Near East to paint Morocco's blazing shores and clamorous marketplaces. Others came to the New World, and still others traveled to Asia, that most ancient world of all. The Romantics tried to capture in paint and poetry the whole of man's experience. Part of that experience is, of course, not dramatic or bizarre in any way at all but simply ordinary day-to-day living.

Realism and Impressionism Of all the many offshoots of Romanticism, the one that produced the most revulsion was a movement which has come to be known as *Realism.* Its principal exponent was Gustave Courbet (1819–1877), whose *Stone Breakers* (fig. 13-6) gives you some sense of the style. Courbet was sympathetic to these rough working men in their rude

13-7 HONORÉ DAUMIER. *The Laundress.* c. 1861. Oil on panel, 19¼ × 13″. The Louvre, Paris

13-8 EDOUARD MANET. *Olympia.* 1863. Oil on canvas, 51¼ × 74¾″. Musée d'Orsay, Paris

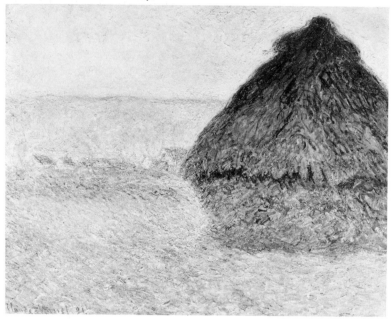

13-9 CLAUDE MONET. *Haystack at Sunset Near Giverny.* 1891. Oil on canvas, 29½ × 37″. Museum of Fine Arts, Boston. Juliana Cheney Edwards Collection

clothing, but, compared to the prettified characters of Neoclassicism or Delacroix's people with their grand passions, Courbet's peasants are vulgar. It was obvious to the middle-class viewers of the day that the painter of such ignoble men must be a socialist. Now political philosophy and compassion for the downtrodden don't have to be connected. But Courbet himself confirmed the opinion, saying that he was "not only a socialist, but also a democrat and a republican, in short a partisan of the entire revolution, and above all a realist, that is, a sincere friend of the real truth." Need I add that the socialists soon began defending Realism as the true art of the age?

Left-wing cartoonist Honoré Daumier shows us, in his serious pictures (fig. 13-7), the side of Realism that is dependent more on subject matter than on technique. He frequently portrays people of the city who are cut off from the benefits of middle-class urban existence. He is realistic in his willingness to face unpleasant social facts of inequality rather than in his manner of portrayal. Daumier, Courbet, and Naturalist writers like Emile Zola stood on the side of the radicals. From the very outset Realism and the movements it sponsored set themselves in opposition to the official representations of middle-class taste.

Manet's *Olympia* (fig. 13-8) was as shocking as any Courbet peasant because of the artist's characterization of Titian's Venus as a Parisian whore.

Of course, Manet went beyond Courbet's Realism when he diminished chiaroscuro and intensified the role of hue. His painting opened the way for the truly radical realism of the French *Impressionists,* who, typified by their leader, Claude Monet (fig. 13-9), turned the matter-of-fact technique of the Realists into a registering of exquisite color sensations. Too, Impressionist subjects reveal a quite different sort of taste; they are usually attractive things: landscapes, boulevards, café scenes, ballets, pretty women, picnics, horse races, boating parties, dances, and so on. The colors are pretty and the things portrayed pleasurable or pleasant. Such subjects seem far removed from the vision of Courbet or Daumier. Yet the Impressionists felt that they were rejecting the values of the middle classes. They weren't, really. What they were doing, without knowing it, was opposing the values of the philistine middle class with the more sophisticated tastes of the cultivated elements of that class. In other words, they rejected the kind of ordinary pictures and ideas that respectable bourgeois society equated with responsible behavior and the good family life. Instead they created pictures that tied in with the more liberal tastes of the fashionable ladies and gentlemen of nineteenth-century Paris.

At the outset Impressionism was extremely unpopular with all classes of people, but before the end of the century its practitioners were famous and successful. This is not surprising; their viewpoint was the same as that of the cultivated man-about-town. Except that they weren't all men.

French Impressionism produced two outstanding women painters in Manet's sister-in-law, Berthe Morisot (1841–1895), and the American Mary Cassatt (1845–1926). The former patterned her style after that of Manet's later work (see fig. 13-10). Cassatt began with a style modeled on that of Degas. She went on to produce a distinctively feminine version of Impressionism—feminine at least in terms of subject matter: nearly always women and little girls (see fig. 13-11).

Most of its practitioners were not really dedicated to a thing called "Impressionism." Degas (fig. 13-12) did not consider himself an Impressionist. He looked upon his own work as a kind of modern Classicism despite the tendency of the color in his pastels to resemble more and more that of Monet and Monet's followers. One genuine Impressionist, Renoir (fig. 13-13), grew impatient with the casual easiness of the style and combined Neo-Renaissance drawing with contemporary color (fig. 7-46). He is not usually grouped with the Impressionists; usually he is called a Postimpressionist. So is Cézanne.

The term *Postimpressionism* is a clumsy one. It wasn't invented until 1911, when it was first used as the title for an exhibition of modernist paintings being shown in London. All its inventor, the English critic Roger Fry, meant to accomplish with it was to indicate that the paintings so designated came after Impressionism and owed something to it. The term confuses people because it contains artists as diverse as Van Gogh, Cézanne, and Odilon Redon (1840–1916). The sole value of the label lies in indicating that these men shared the same voyage from nineteenth-century Impressionism to the more extreme movements of the twentieth century.

A more useful way of looking at the history of modern art is to conceive of it as a set of related but contrasting elements, like complementary colors or odd and even numbers. This conception sees everywhere an antecedent contest between Classical precision and Romantic power. There are paired opposites all along the way: David versus Delacroix, Seurat versus Van Gogh, Mondrian versus Kandinsky, Anuszkiewicz versus Pollock. Alongside a tendency toward pure formalism there flows a strong current tending to absolute subjectivity. If one thinks of these tendencies as streams analogous to actual rivers, one must

13-10 BERTHE MORISOT. *Woman at Her Toilet.* c. 1875. Oil on canvas, 23¾ × 31¾". The Art Institute of Chicago. Stickney Fund

13-11 MARY CASSATT. *La Toilette.* c. 1891. Oil on canvas, 39 × 26". The Art Institute of Chicago. Robert Alexander Waller Memorial Collection

13-12 EDGAR DEGAS. *The Tub.* 1886. Pastel, 23½ × 32⅓". Musée d'Orsay, Paris

13-13 PIERRE-AUGUSTE RENOIR. *Le Moulin de la Galette.* 1876. Oil on canvas, 51½ × 69". Musée d'Orsay, Paris

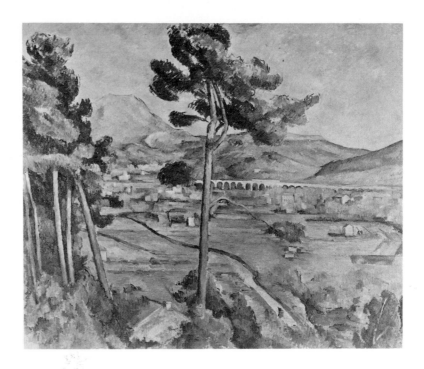

13-14 PAUL CÉZANNE. *Mont Sainte-Victoire,* 1885–87. Oil on canvas, 25⅝ × 31⅞". The Metropolitan Museum of Art, New York. The H.O. Havemeyer Collection. Bequest of Mrs. H.O. Havemeyer, 1929

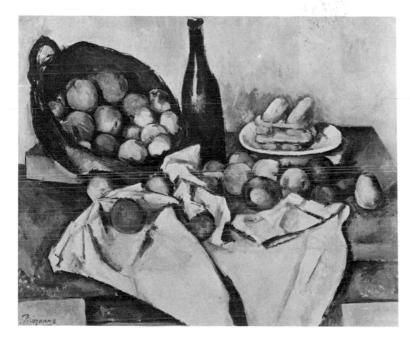

13-15 PAUL CÉZANNE. *The Basket of Apples.* 1890–94. Oil on canvas, 25¾ × 32". The Art Institute of Chicago. Helen Birch Bartlett Memorial Collection

think of them as meandering alongside each other in a common voyage from Impressionism to the present. Sometimes they are parallel. Sometimes they link and pool. Sometimes they are so far apart as to seem entirely unrelated.

The Rationalist–Formalist Current Of all the followers of the Impressionist method, Paul Cézanne is the most prominent. Although he shared the Impressionists' sentiments about the value of modernity and freedom, he soon became disenchanted with the relative formlessness of their art. His transformation of that art into a personal style which included works as intricate and majestic as *Mont Sainte-Victoire* (fig. 13-14) and *The Basket of Apples* (fig. 13-15) is one of the most astonishing occurrences in the history of art. His emphasis on formal structure set him apart from all the others.

Georges Seurat, too, sought to rationalize Impressionism. And his work (fig. 13-16) is even more concerned with the constructive aspects of art than

13-16 GEORGES SEURAT. *A Sunday Afternoon on the Island of La Grande Jatte.* 1884–86. Oil on canvas, 6'9½" × 10'1¼". The Art Institute of Chicago. Helen Birch Bartlett Memorial Collection

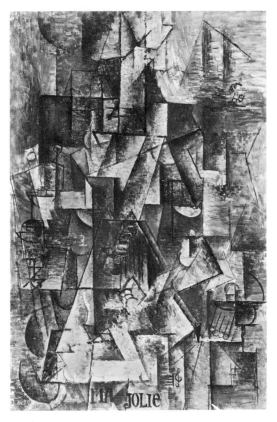

13-17 PABLO PICASSO. *"Ma Jolie."* Paris (winter 1911–12). Oil on canvas, 39⅜ × 25¾". Collection, The Museum of Modern Art, New York. Acquired through the Lillie P. Bliss Bequest

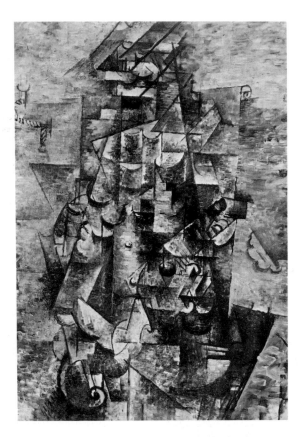

13-18 GEORGES BRAQUE. *Man with a Guitar.* (Begun Céret, summer 1911; completed Paris, early 1912). Oil on canvas, 45¾ × 31⅞". Collection, The Museum of Modern Art, New York. Acquired through the Lillie P. Bliss Bequest

Cézanne's. But its peculiarity is such that its influence has been somewhat limited, whereas Cézanne's has been widespread.

The most obvious consequence of Cézanne's example is *Cubism.* Many stages intervened between *Mont Sainte-Victoire* and *"Ma Jolie"* (fig. 13-17), but Picasso's picture is a direct descendent of the Cézanne. So is Braque's (fig. 13-18). The obsession with structure for its own sake, the concern with overlapping planes, the spatial ambiguity—all these things were derived from Cézanne. Of course, Cézanne was not the only influence on Cubism; African art was another.

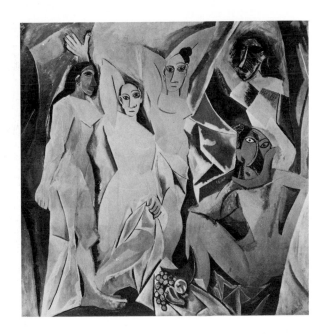

13-19 PABLO PICASSO. *Les Demoiselles d'Avignon.* Paris (begun May, reworked July 1907). Oil on canvas, 96 × 92". Collection, The Museum of Modern Art, New York. Acquired through the Lillie P. Bliss Bequest

In 1907 Picasso painted the most important of the works from his so-called Negro Period, *Les Demoiselles d'Avignon* (fig. 13-19). The derivation of the masklike forms on the right is obvious. But notice, too, that those forms are repeated throughout the composition.

Before World War I, African art was extremely popular among the intelligentsia in Europe, particularly in France. There was, however, no interest to speak of in the cultural sources of the works. What interested Frenchmen was the extraordinary perfection of formal composition exhibited by "uncivilized" tribesmen from Africa. From Picasso's point of view the Bakota sculptor of the guardian figure (fig. 13-20) was already a modern artist. Some of this sentiment is Romantic identification of the so-called primitive with all that is basic to human life. British novelist D. H. Lawrence, writing of an African statue in *Women in Love,* expresses this strongly:

> Her body was long and elegant, her face was crushed tiny like a beetle's, she had rows of round heavy collars, like a column of quoits, on her neck . . . She knew what he himself did not know. She had thousands of years of purely sensual, purely unspiritual knowledge behind her . . . Thousands of years ago, that which was imminent in himself must have taken place in these Africans: the goodness, the holiness, the desire for creation and productive happiness must have lapsed, leaving the single impulse for knowledge of one sort, mindless progressive knowledge through the senses.

More important is Picasso's recognition of the genius of black artists whose work he saw in Paris. There is neither time nor space in this little book to go into the continuous influence of African forms on the development of early Cubism. Suffice it to say that the importance of black culture is, in this instance at least, universally recognized and generally accepted.

"*Ma Jolie*" is the consequence of many different things. Yet the movement that produced it, Cubism, is the most unique and revolutionary of all modern styles. Nothing before or after it can approach its radicalism. To say so probably sounds odd, even narrowminded. It isn't, actually.

The Cubist position was that a painting is only a painting just as a building is a building, and that a picture ought to look no more like a house, tree, or person than a house ought to resemble a baker's roll. Once Cubism had come

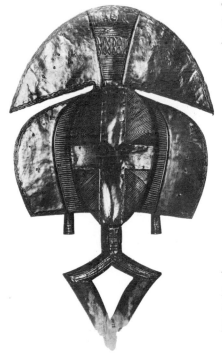

13-20 Guardian figure, from the Bakota area, Gabon. 19th–20th century. Wood, covered with brass and copper, height 30". Ethnographical Museum of the University of Zurich

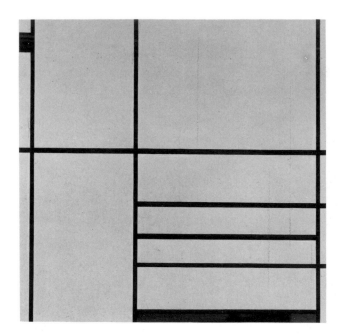

13-21 PIET MONDRIAN. *Composition in White, Black, and Red.* 1936. Oil on canvas, 40¼ × 41". Collection, The Museum of Modern Art, New York, Gift of the Advisory Committee

13-22 KASIMIR MALEVICH. *Suprematist Composition: White on White.* 1918. Oil on canvas, 31¼ × 31¼". Collection, The Museum of Modern Art, New York

to that, once it had broken with the manufacture of illusions, it freed the painter from what had seemed self-evident boundaries. After that it didn't much matter what a painter did. If the work didn't have to look *like* anything else, the barriers were down, and anything went so far as technique and general approach were concerned. This is one reason for Picasso's incredible variety of styles. *"Ma Jolie"* was painted in 1911–12, his *Girl Before the Mirror* (fig. 6-5) in 1932. They are very different at first sight, but the emphasis on pure form is common to both.

Piet Mondrian went further still in the hope of attaining what he called "concrete universal expression." His *Neoplasticism* (see fig. 13-21) eliminated from painting everything that was not absolutely fundamental: con-

trast, opposition of directions, variations of scale. The Russian *Suprematist* Kasimir Malevich (1878–1935) went beyond even Mondrian. His notorious *White on White* (fig. 13-22) reduces painting to the ultimate simplicity of a white square in a white square at an angle. Malevich recognized that the next logical steps would be a blank canvas and then pure space. At various times since 1918 isolated avant-garde artists *have* exhibited plain white canvases,

13-23 NAUM GABO. *Linear Construction, Variation.* 1942–43. Plastic and nylon thread, 24½ × 24½". The Phillips Collection, Washington, D.C.

13-24 TONY SMITH. *She Who Must Be Obeyed.* 1976. Painted steel. 20 × 30'. Labor Department, Washington, D.C.

and exhibitions of empty rooms have been offered to a dismayed public. But, since unpainted pictures and vacant space are not very marketable as art, the trend has never become an important one.

In the field of sculpture the mood of the Neoplasticists and Suprematists was matched by *Constructivism*. The works of Naum Gabo (1890–1977) are of a precision appropriate to mathematical models and entail the use of then newly invented materials such as nylon and plastic (fig. 13-23). Like the paintings of Mondrian, they appeal to our sense of exactitude and clarity. Resembling nothing in the natural world, they seem to represent its underlying laws.

Today also there are artists who find this realm of form and logic congenial to their expressive aims. The *Op Art* movement illustrated by figure 6-21 is one example. And there is a form of sculpture that has come to be called *Minimal* or *Primary*, which is clearly related to the example of Malevich. The works tend, like *She Who Must Be Obeyed* (fig. 13-24) by Tony Smith, to be massive in scale and unadorned. Frequently, they are slightly disconcerting—seeming to defy the dictates of gravitation or optical law.

Minimalism and Op Art find a sort of marriage in what has been termed "systemic painting," which combines very strict reductiveness with exciting visual effects. Of the artists associated with this trend, Frank Stella (born 1936) is perhaps the best known. His *Sinjerli Variation I* (fig. 13-25) is a beautifully precise synthesis of hard geometry and vivid color. Stella's work has become progressively more sculptural in the succeeding decade. In the same way, Minimalist sculpture has tended to become more colorful, and it is frequently impossible to determine whether the pieces are meant to be paintings or sculptures, which, of course, merely demonstrates the futility of categories in the present age. Challenging conventional aesthetic categories is instinctive to the kind of Minimalism practiced by artists such as Carl Andre. They have reduced the pristine to the absurdly simplistic so far as form and media are concerned (fig. 13-26), then attributed lofty significance to seeming commonplaces in somewhat the same way the Structuralists in anthropology discover the profoundest social meanings in the most ordinary kinds of behavior.

The Subjective–Expressionist Current It is possible to demonstrate that the apparent objectivity of Renoir, Cézanne, and Seurat disguises, in every case, a deeply troubled spirit. But their work expresses torment in a very indirect fashion. The work of Vincent van Gogh, the genius of the other side of modern art, conveys feeling in a far more direct way. He reveals some of his feelings in every part of *The Starry Night* (fig. 13-27), for each brushmark is the track of an impulse directed by emotion. His conviction that truth is a marriage of objectivity with one's subjective reactions is implicit in *The Night Café* (fig. 13-28) in the identification of the colors of the room with emotional forces. For Van Gogh, things are what they seem, and what they seem is as much the product of one's feelings about the objects as it is of their material reality.

Van Gogh's position is not a sovereign one. There were other late-nineteenth-century artists who held similar views; among the more notable were Paul Gauguin (1848–1903), James Ensor (1860–1949), Henri de Toulouse-Lautrec (1864–1901), and Edvard Munch (1863–1944). All of them were unstable and frequently distraught. They staked everything on art. They were outcasts from respectable society who lived on the fringes of the underworld, among prostitutes, thieves, drug addicts, and derelicts. They turned Impressionism into an art of vehement self-expression; it sometimes

13-25 FRANK STELLA. *Sinjerli Variation I*. 1968. Fluorescent acrylic on canvas, diameter 10′. Harry N. Abrams Family Collection, New York

13-26 CARL ANDRE. *Equivalents*. 1966. Bricks in units of 120, $3 \times 20'$, $4 \times 15'$, $5 \times 12'$, $6 \times 10'$. Installation by Tibor de Nagy. The Tate Gallery, London

13-27 VINCENT VAN GOGH. *The Starry Night.* 1889. Oil on canvas, 29 × 36¼". Collection, The Museum of Modern Art, New York. Acquired through the Lillie P. Bliss Bequest

13-28 VINCENT VAN GOGH. *The Night Café.* 1888. Oil on canvas, 28½ × 36¼". Yale University Art Gallery, New Haven. Bequest of Stephen Carlton Clark, B. A. 1903

13-29 HENRI MATISSE. *Green Stripe (Madame Matisse)*. 1905. Oil and tempera on canvas, 15⅞ × 12⅞". Royal Museum of Fine Arts, Copenhagen. Rump Collection

seems as though their art was the only thing in the world that made life bearable for them.

Just after the turn of the century, a movement came into existence that translated the despair of the 1880s and the 1890s into positive terms. Henri Matisse (1869–1954), the leader of the *Fauves,* believed that the sources of joy lie within each person. The goal is to release them. Matisse held an abundant, optimistic view of life and expressed it in a robust painting style (fig. 13-29). He and his colleagues—André Derain (1880–1954), Georges Rouault (1871–1958), Maurice Vlaminck (1876–1958), Raoul Dufy

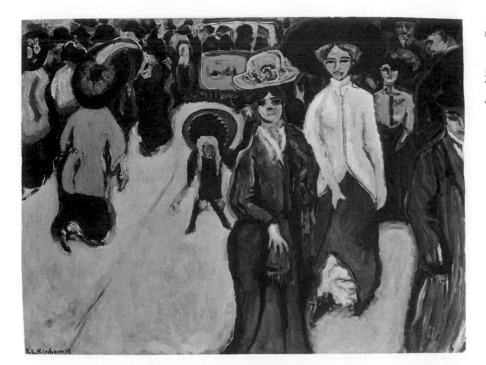

13-31 *Approaching Storm at Halfmoon Bay.* Oil on canvas

(1887–1953), and others—were called "*fauves*" (wild beasts) by a hostile critic, and the name stuck. The paintings looked wild to people of the time, but the ferocity is more that of playful puppies than of dangerous animals. For it is with Fauvism that the radicalism of youth entered into the fine arts for the first time. The conflict between the Establishment and youth was already an old story in European politics, but young artists had never been sufficiently self-assured to create a painting style distinctly their own. (Even the prodigy Picasso derived his early styles from older French and Spanish masters.) Of all the Fauves, only Matisse was much over thirty, and he remained perpetually young in spirit. What Fauvism expressed was joyous, pagan self-affirmation. It was the shout of the young.

It was in Germany, during those years just prior to World War I, that the first movement called *Expressionism* arose. It had two branches, *Die Brücke* (The Bridge) and *Der Blaue Reiter* (The Blue Rider). The first was founded in

Dresden in 1905 by Ernst Ludwig Kirchner (1880–1938). His work (fig. 13-30) and that of followers such as Emil Nolde (see fig. 6-4) had a decidedly representational character and showed the influence of the bright color areas of Van Gogh and Gauguin. The work of these artists is similar to Fauvism in general appearance and character, although it projects a far more pessimistic view of mankind.

Der Blaue Reiter is a more interesting movement. Less derivative of the past, it tended to be abstract, symbolic, and generally more advanced. Moreover, its artists were more varied in style and philosophy. Der Blaue Reiter's locale was Munich, a more sophisticated and cosmopolitan city than Dresden, and its artists seem to have had more native talent than those of *Die Brücke*. The leader and principal artist was Wassily Kandinsky, a Russian émigré. In his mature work he seeks to accomplish with paint all that music can express. Specifically, he wished to use paint to evoke emotion the way music can. Kandinsky once wrote that "the observer must learn to look at the picture as a graphic representation of a mood and not as a representation of objects." Now, the notion that art can be used to convey mood is nothing new; what's different is the idea that it can do so in the way music does—without representing objects.

Perhaps I may be excused for relying upon my own experience in this connection. I can, after all, vouchsafe for my own *intentions,* if not for my achievements. Several decades ago, as a young man, I spent an afternoon at a beach near San Francisco with my current beloved. It was a stormy autumn day that marched the sea to shore in ranks of heavy breakers, and it was just the sort of moment I wished to preserve and recapture. So I painted a picture of it. For me, at least, the painting (fig. 13-31) conveys the mood of a time that has long gone by. It retains the sky, the shore, the sea, and the young woman. Since these things hold for me the memory of the event, seeing them again brings back old feelings. But, what if I had been a composer and not a painter? Then I would have had to rely upon other means to preserve the feeling of the day in my art. I could perhaps have written what Franz Liszt (1811–1886) called *programme music,* that is, instrumental music that suggests particular themes and mental pictures. It is the purpose of *symphonic poems* (also called "tone poems") to do this in a one-movement work and, in a very real sense, Kandinsky—who was himself a talented musician—was attempting to effect in paint this same kind of thing. That is, he wished to evoke moods without relying upon representationalism of an obvious kind. Whether he accomplished his ends is, of course, a matter of opinion. But that he undertook the task in earnest is not really open to debate.

Improvisation Number 30 (fig. 13-32) is fascinating in that it is a genuine improvisation, undertaken without foreknowledge of precisely what would happen. Each part of the canvas has its own peculiar character, and yet all the parts go together. Kandinsky managed to harmonize what would otherwise be chaotic through color, variations in pigment, and lines that trail through color zones, interlace, and cross out one another. If you invert the page, you can discover all sorts of families of forms which have emerged spontaneously. Kandinsky's work is very lyrical and highly personal. It is not accessible to everyone, certainly. But, then, neither is Brahms, Beethoven, or Bowie.

Another member of Der Blaue Reiter who is of great importance to the history of art was the Swiss painter Paul Klee. His works are very mystical, and often the mysticism is combined with satire. For example, his *Twittering Machine* (fig. 13-33) is a symbolic comment on the arrogance of applied science. He is saying that, yes, it is possible to create a machine for duplicating

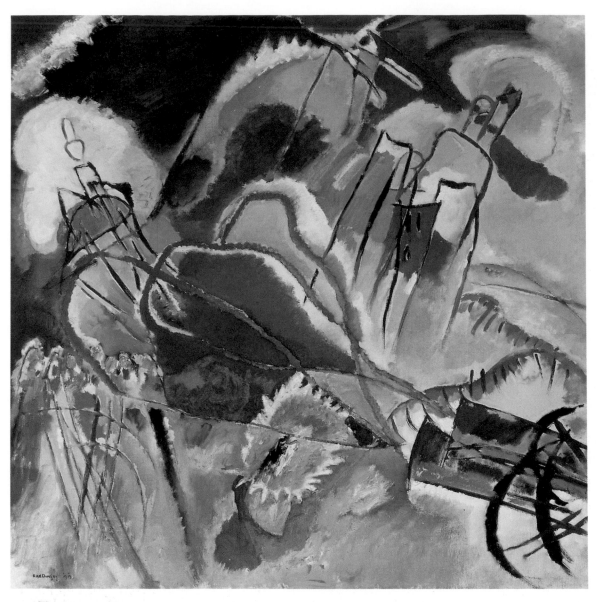

13-32 WASSILY KANDINSKY.
Improvisation Number 30. 1913. Oil
on canvas, 43¼ × 43¾". The Art
Institute of Chicago. Arthur Jerome
Eddy Memorial Collection

birdsong—here you crank the handle, a sine curve rotates, and the birds jerk up and down, chirping—but see how silly and grotesque the machine would be. Klee employs in works of this kind a drawing method calculated to translate his images from the real into the fantastic. They do not resemble things of this world. For instance, it is impossible to tell whether we are looking at the base of the machine from above or below, or even whether it's a tablelike pedestal or an excavation similar to an open grave.

The third important member of Der Blaue Reiter was Franz Marc (1880–1916), who died in World War I and never reached the limits of his potential. As *Deer in a Forest, II* (fig. 13-34) shows, this artist was influenced by the faceted forms of Cubist art; he used them, however, to very different ends than the Cubists. His was an attempt to, as he said, "animalize" art, to give painting the vitality of nature's throb. His work indicates the degree to which the various kinds of modernisms overlap and coalesce. Here Fauvist color plus Cubist forms equals Marc's Expressionism.

Sometimes the merging of existing forms into another style is less a matter of artistic form than of attitude. *Dadaism,* founded in Zurich, Switzerland, in

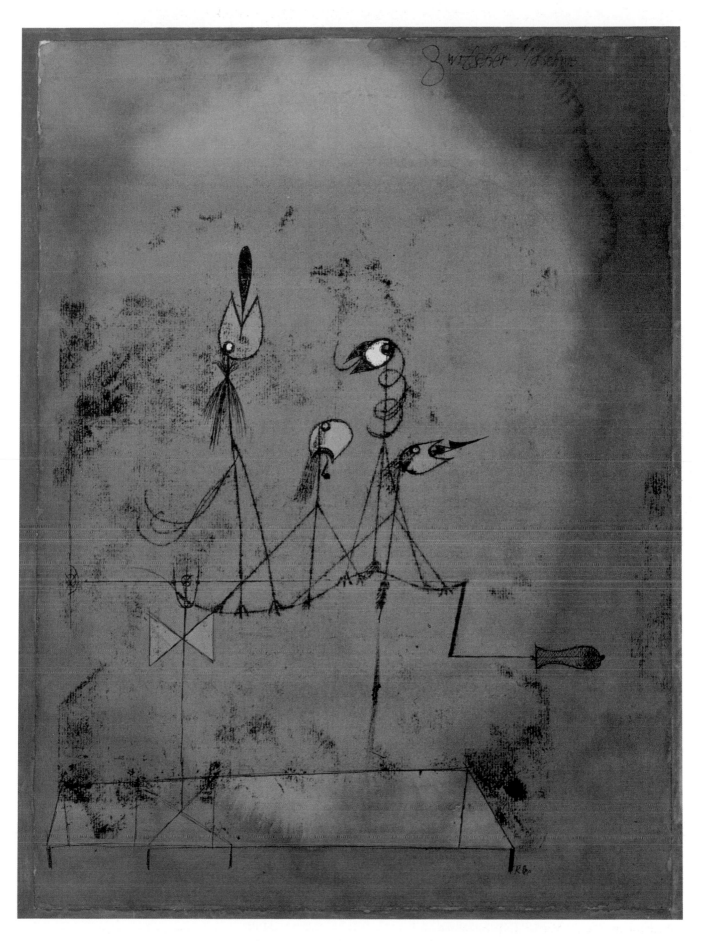

13-33 PAUL KLEE. *Twittering Machine.* 1922. Watercolor and pen and ink on oil transfer drawing on paper, mounted on cardboard, 25¼ × 19″. Collection, The Museum of Modern Art, New York. Purchase

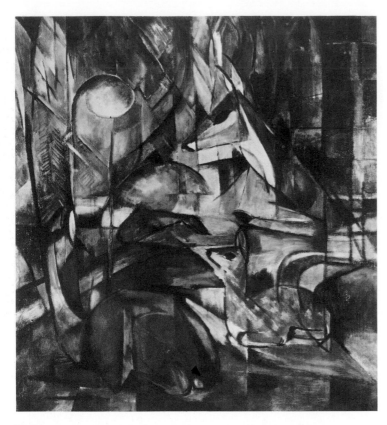

13-34 FRANZ MARC. *Deer in a Forest, II.* 1913–14. Oil on canvas, 43½ × 39½". Staatliche Kunsthalle, Karlsruhe, West Germany

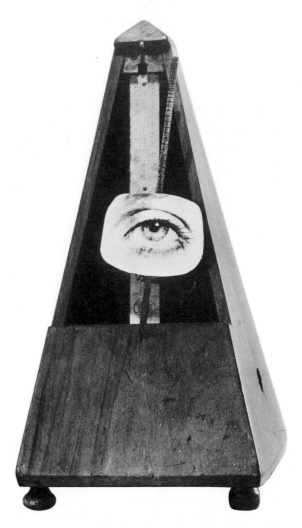

13-35 MAN RAY. *Indestructible Object (or Object to be destroyed).* 1964. Replica of 1923 original. Metronome with cutout photograph of eye on pendulum, 8⅞ × 4⅜ × 4⅝". Collection, The Museum of Modern Art, New York. James Thrall Soby Fund

1916, was such a movement. It was nihilistic, that is, it held that *all* traditional values and beliefs were unfounded, and life was without sense or purpose. The poets and artists who participated in the movement were reacting to World War I. They resemble some of the more extreme factions of the counter-culture of the 1960s except that they went far beyond any of these underground groups in ridiculing the hallowed values of Western civilization. Louis Aragon's poem "Suicide" is nothing but the alphabet in its normal order. Other Dadaists created "poems" by cutting words from newspapers, putting them into a hat, and glueing the words to paper as they were drawn at random from the hat. The poetry was, naturally, nonsensical.[3]

Man Ray's *Indestructible Object* (fig. 13-35) is an example of a Dadaist "ready-made," ordinary objects put in incongruous combinations or circumstances and treated as art. More famous is the urinal that Marcel Duchamp (1887–1968) signed "R. Mutt" and exhibited as *Fountain*. Such things were, of course, the wittier ancestors of Carl Andre's firebrick sculpture. When Duchamp's *The Bride Stripped Bare by Her Bachelors, Even* (fig. 13-36) was being shipped to an art show in 1923, the glass on which it was painted cracked in transit. Duchamp was pleased! He said that the cracks "completed" the painting. His behavior was perfectly consistent with the idea that all rational activity is absurd.

13-37 SALVADOR DALI. *Apparition of a Face and Fruit Dish on a Beach.* 1938. Oil on canvas, 43½ × 57″. Wadsworth Atheneum, Hartford, Connecticut. The Ella Gallup Sumner and Mary Catlin Sumner Collection

13-36 MARCEL DUCHAMP. *The Bride Stripped Bare by Her Bachelors, Even (The Large Glass).* 1915–23. Oil and lead wire on glass, 9′1¼″ × 5′9⅛″. Philadelphia Museum of Art. Bequest of Katherine S. Dreier

Dadaism couldn't last. In the first place, the Dadaists were so clever and talented a group that quality and wit distinguished their work even when they were aiming at the ridiculous. Secondly, when anyone decides to contemplate the futility of it all, he's bound to see that it's useless. In 1924, to generate a new kind of order out of the chaos Dada had created, a Dada poet named André Breton (1896–1966) founded *Surrealism.* This movement drew upon Sigmund Freud's psychoanalytic theories, which attribute the greater part of human activity to the motives of the unconscious mind.

Salvador Dali is not the best example of a Surrealist, but he is *the* Surrealist in the public's mind. His *Apparition of a Face and Fruit Dish on a Beach* (fig. 13-37) can tell us a good deal about Surrealism. The first thing to understand is that the picture does not have a specific, concrete meaning. Like a dream it is subject to a variety of interpretations. (In fact, Dali claims that he is reproducing his dreams and hallucinations with photographic clarity.) For Freud the dreams of men throw open windows on their souls. So do our responses to ambiguous stimuli. You may not be able to say exactly what this picture means to you, but it means *something,* because, in Freudian terms, you "project" your unconscious feelings onto it just as Dali has projected his into it. Dali's art has had much more popular appeal than that of any other modern painter because of the slick rendering it entails. Those techniques of his aren't particularly impressive to art historians and critics because they have all been cribbed from Baroque artists like Caravaggio and Vermeer. What is most remarkable about Dali is his subject matter. It is truly inventive. Who else would come up with a limp watch, the perfect symbol for subjective time, which sometimes crawls and other times races by too fast?

13-38 MAX ERNST. *Europe After the Rain*. 1940–42. Oil on canvas, 21½ × 58½".
Wadsworth Atheneum, Hartford, Connecticut. The Ella Gallup Sumner and Mary
Catlin Sumner Collection

Dali represents a branch of Surrealism that might be called "literalist" because it attempts to mimic dreams and the like in a literal way. Yves Tanguy (1900–1955), René Magritte (1898–1967), and Max Ernst (1891–1976) are others in this group.

Max Ernst is really *the* Surrealist painter. He invented most of the mannerisms commonly identified with a Surrealist style in sculpture and in painting. Ernst's *Europe After the Rain* (fig. 13-38) employs a technique he perfected after it was first used by a Spanish Surrealist, Oscar Dominguez (1905–1957), to produce entirely accidental effects. It is *decalcomania,* which sounds like a mental aberration but is the same word that Americans have shortened to *decal.*[4] It means "transfer," and is, in painting, the result of pressing a sheet of glass or other flat surface that has been coated with a thin layer of paint against the surface the artist is using as a painting ground, transferring the wet pigments with sometimes surprising results. Ernst's ability to control the textural effects so produced was nothing short of uncanny. His molten earths, feathery plumage, and terribly decaying ruins had the awe-inspiring authenticity of color photographs of genuinely material things alien to human experience. And this use of decalcomania was only one of many techniques he contributed to the Surrealist movement.

Still greater than Ernst's was the influence of the paintings done between 1910 and 1915 by the Italian Giorgio de Chirico (1888–1978), who described his work as "metaphysical." These descriptions of piazzas of imaginary places (fig. 13-39) had an electrifying effect upon Tanguy, Magritte, and Dali when they first encountered them, and because eerie vistas of De Chirico's art were carried over into theirs, they claimed him for one of their own movement. But his was, in fact, a less pessimistic Romanticism which established, he once said, "a new astronomy of objects attached to the planet by the fatal law of gravity." Still, the mood that invested his pre–World War I pictures—full of silences held between parentheses of distant thunder and shadows as heavy as iron lying across courtyards drawn in queer perspective—pervades much of what we might call "literalist" Surrealism, that is, the kind that depicts dreamlike incongruities.

There is another major type of Surrealist art which, for lack of a better term, we can call "abstract Surrealism." Paul Klee has sometimes been associated with it, but the best example is the Spaniard Joan Miró (1893–1983).

Miró's *Person Throwing a Stone at a Bird* (fig. 13-40) is not an accurate

13-39 GIORGIO DE CHIRICO. *The Soothsayer's Recompense.* 1913. Oil on canvas, 53⅜ × 71″. Philadelphia Museum of Art. Louise and Walter Arensberg Collection

13-40 JOAN MIRÓ. *Person Throwing a Stone at a Bird.* 1926. Oil on canvas, 29 × 36¼″. Collection, The Museum of Modern Art, New York. Purchase

reproduction of a mental image, surely. Rather, it is a memory recalled in ideographic form, that is, by way of symbols that stand for ideas and experiences. It has been suggested that what we see here is a record of the occasion described in the title, with only the most impressive elements retained. The stone and its trajectory and the fulcrum of the thrower's arm are extremely evident. The eye, aiming at the bird's bright plume, and the foot to which the thrower has shifted all his weight are stressed. What is not essential has been eliminated. This interpretation may err in its simplicity. Whatever the case, Miró does insist that his work is not formal in intention. It looks as though it might be, true enough. The shapes have certainly been adjusted with an eye to their compatibility. Miró would say that the arrangement of shapes is just a means to an end and that the picture really has to do with explicit life experiences. The only "abstract Surrealist" whose work resembles Miró's very closely was Hans Arp (1887–1966). Others in this branch include André

13-41 JACKSON POLLOCK. *Autumn Rhythm*. 1950. Oil on canvas, 8'9" × 17'3". The Metropolitan Museum of Art, New York. George A. Hearn Fund, 1957

Masson (1896–1987), Arshile Gorky (1904–1948), and Matta Echaurren (born 1912).

The 1950s, particularly in the United States, saw a synthesis of Expressionist and Surrealist trends in a kind of art called *Abstract Expressionism*. Willem De Kooning is one representative. Jackson Pollock (1912–1956) is another. In one sense everything that Pollock did was already contained in the works of Kandinsky. His immense painting *Autumn Rhythm* (fig. 13-41) is on a far grander scale than anything Kandinsky ever did; but the impulsiveness, the complete nonrepresentationalism, the evocation of mood through color harmonies, all that is similar. The technique is what's different.

Pollock created his pictures by pouring paint from cans onto a horizontal canvas. To paint a picture in this way strikes many people as completely ridiculous. After all, anyone can pour paint from a can. True. But anyone can make marks with an artist's brush too. It's what you do with the marks that counts. And poured liquids can be controlled, as anyone who has ever poured chocolate syrup over ice cream should know. If you move the stream of syrup slowly, you get a fatter line than if you move it fast. If you move it very fast, you get dotted lines from the broken drips. Move it too fast, and it spatters chocolate all over the table.

Neatness is not a factor in Pollock's art, but control was an important aspect of its creation. His method was not nearly so haphazard and arbitrary as it must seem at first sight. He followed a very deliberate procedure that can be discerned in the final work. He usually began by laying in a background color or colors. Then, on top of this background, he poured paint in a trail that established large, dominant movements that more or less decided the composition of the picture. Next, with another color, a series of subordinate movements were created, usually more intricate ones. From this point on it was a matter of embellishing and articulating the maze of lines and forms growing on the surface.

Autumn Rhythm is not simply a flat picture. Its vortex of thready lines and enmeshed strands of pigment gives one the sense of looking at a tremendously complicated structure existing on a vast, unbounded scale somewhere outside nature. If you think of the works as they originally appeared, lying flat, so that you are looking down into them, they assume new power and force. The space

13-42 GEORGE GROSZ. *Fit for Active Service*. 1916–17. Pen, brush, and India ink, 20 × 14⅜". Collection, The Museum of Modern Art, New York. A. Conger Goodyear Fund

13-43 FERNAND LÉGER. *The Card Players*. 1917. Oil on canvas, 50⅜ × 76". Kröller-Müller Museum, Otterlo, The Netherlands

they contain approaches the conditions of an aerial view shot with vapor trails. The maze is more fascinating than anyone might at first imagine.

Some Synthetic Styles There are a great many modern styles that do not fall into either of the two mainstreams mapped out so sketchily above. Some of them are the result of a pooling of the two currents. In Germany, following World War I, a movement called *Die Neue Sachlichkeit* (The New Objectivity) combined Expressionist distortion and Realist attitudes into a style that expressed some of the most horrifying visions art has yet seen. George Grosz (1893–1959) indicted the military-industrial bloc in a series of works of which *Fit for Active Service* (fig. 13-42) is a good example. Such intensely bitter images typify the movement, whose main artists were Grosz, Otto Dix (1891–1969), and Max Beckmann (1884–1950).

French artist Fernand Léger, discharged from the service after he was injured in a gas attack at Verdun, took a curiously positive attitude toward the then-new machinery of war. In *The Card Players* (fig. 13-43) he has reduced a famous Cézanne into mechanical parts assembled in turn into the forms of soldiers taking their leisure in the trenches. Everything is metallic-looking; even the smoke from the pipe of the player on the right has been turned into a row of shiny plates. Léger said of his war experience: "I was dazzled by the breech of a 75 millimeter gun . . . the magic of light on white metal. This was enough to make me forget the abstract art of 1912–13."

Similar in attitude to Léger were the Italian *Futurists*, whose devotion to the beauty of pistons, power, and motion let them proclaim, as Filippo Marinetti (1876–1944) did, that "a roaring motorcar, which looks as though running on shrapnel, is more beautiful than the *Victory of Samothrace*." Or, in Umberto Boccioni's words: "The opening and closing of a valve creates a rhythm just as beautiful but infinitely newer than the blinking of an animal eyelid." Boccioni (1882–1916) said that modern sculpture must "give life to objects by making their extension in space palpable, systematic, and plastic." His *Unique Forms of Continuity in Space* (fig. 13-44) attempts to fix in a frozen pattern all the positions of the various elements of a human form in motion. It has a kind of terrifying power, this heavy, striding monster. It is probably the greatest of all Futurist works, a truly violent contrast to the quiet piazzas where time has stopped in the paintings Giorgio de Chirico was doing in the same country at the same time. Metaphysical painting and Futurism

13-44 UMBERTO BOCCIONI. *Unique Forms of Continuity in Space*. 1913. Bronze (cast 1931), 43⅞ × 34⅞ × 15¾". Collection, The Museum of Modern Art, New York. Acquired through the Lillie P. Bliss Bequest

were hopelessly adjacent antagonists, the former a nostalgic reverie for what had never been, the latter a movement dedicated to what its first manifesto declared was the freeing of Italy from her "numberless museums that cover her with countless cemeteries."

There are also, of course, myriad individual painters and sculptors whose mannerisms and preferences do not really fit well into any single movement or composite of movements. Ivan le Lorraine Albright's pictures (fig. 5-25) resemble Realism in some ways, Surrealism in others, and The New Objectivity in still others. Pop artists like Roy Lichtenstein (fig. 8-30) and their associated workers—for instance, Larry Rivers (fig. 8-31), Jasper Johns (fig. 6-8), and Edward Kienholz (fig. 1-6)—have derived a great deal from both the rationalistic and Expressionistic currents. Richard Lindner (fig. 4-36) stands somewhere between the Pop artists and the Surrealists. Mark Rothko (fig. 6-3) incorporated into his style both Abstract Expressionism and the superrational directions signalized by Mondrian and Malevich.

Lest this brief survey give you the impression that only the names here listed are of importance, I should mention that I have not even scratched the surface. In the realm of fantasy the painter Marc Chagall is at least as important as Klee or Miró. Rouault is as outstanding as Matisse. A list of important modern artists not mentioned elsewhere in this book would include the painters Bonnard, Modigliani, Kokoschka, Soutine, Schwitters, Tchelitchew, Gris, and Feininger. It would contain such sculptors as Brancusi, Giacometti, Nicholson, Moore, Calder, Pevsner, Duchamp-Villon, David Smith, and many, many others. (Even as I type these lists, I think of artists I have omitted who are more important than some included: for example, the painters Dubuffet and Bacon and sculptors Lipchitz and Paolozzi. And—oh well.) All I have tried to do in this chapter is give you a chronological, historical outline in which to place the artists we have already discussed. It is, however, also a good place to include a group of artists whose work has been ignored elsewhere in these pages.

Conceptual Art Possibly the so-called conceptual artists do not belong in any book so concerned with material objects as this one is. For these people do not create paintings or sculptures, prints or pottery; instead, they attempt to evoke from viewers new conceptions of the world in which we live. And those conceptions are what they hold to be art. To the extent that Andre's sculpture (fig. 13-26) or Robin Winters's "bad art" (fig. 13-45) does this it is allied with conceptualism. But, then, so too would be Masaccio and Duchamp. Many works falling into the category of *Conceptual Art* have much more in common with theater and dance than with painting or sculpture. Indeed, some of the "pieces" are made up exclusively of words in the form of lists, strict descriptions, quotations, and enigmatic (often shallow) aphorisms. That the art produced thereby is itself purely ideational—having no more material attributes than a mathematical proof—is seen as the most important thing about it.

Frequently, conceptual artworks have expressed a very distinct ideology. Since ordinary artists produce things that can be purchased, their art easily fits into the value scheme of ordinary commercial activity. By eliminating the possibility of anyone actually possessing their art, some conceptualists hoped to overcome the prevailing commercialism of the art world. They failed, of course.[5] Still, the activity of those who disavow art objects has been salutary in opening up new possibilities for creative expression within the arts, especially by way of cooperative ventures by avant-garde workers in such distinctive disciplines as music, theater, dance, cinema, and electronics. As it

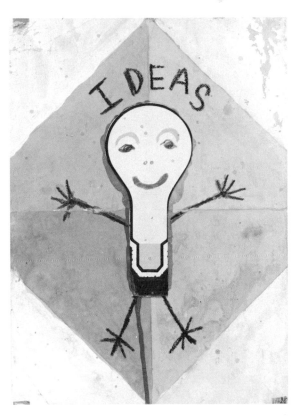

13-45 ROBIN WINTERS. *Ideas.* 1977. Mixed media on paper, 11½ × 8″. From the series Travel Notes, 1975–80. Collection the artist. Courtesy of Michael Klein Gallery, New York

13-46 CHRISTO. *Wrapped Coast, Little Bay, Australia.* 1969. Surface area of project, 1,000,000 square feet. © Christo 1969

happens, however, most of what these people do is without visual interest. The exceptions, though, are of considerable importance.

Christo (born Christo Javacheff, 1935) is, at least marginally, a conceptual artist. But his creations are not only visible, they make truly remarkable additions to the landscape. Christo's largest undertaking was the wrapping of a mile of the Australian coast in one million square feet of polyethylene plastic. The result (see fig. 13-46) actually modifies the appearance of the cliffs, lending to them a precipitousness of line and a consistency of color which hints at drawing almost as much as it does at sculpture or architecture. Thus, in concealing the landscape, Christo reveals new aspects of a shoreline to any moderately interested observer. The sheer logistics of such an enterprise are themselves impressive. The scope of the planning, the marshaling of financial support, the enlistment and direction of literally hundreds of voluntary participants is inevitably dramatic and inspiring. But the results are singular. Whether Christo's vast packagings of whole buildings and landmarks, canyon-spanning curtains, and colorfully "aimless" fences are sufficiently artistic to justify the cost paid out for their extremely brief existences is, of course, arguable. But his creations do constitute a foundation for extensions of creative possibilities in the visual arts.

Architecture in the Age of Science The central fact of the nineteenth century is the Industrial Revolution. Factory-produced bricks, iron posts, and steel beams could be carried anywhere by trains and steamships. Inevitably, the availability of such structural materials in the profusion that mass production made possible was going to make for portentous changes in the nature of buildings and in the ways they were concentrated together. But, for the first part of the century, this would not have seemed the case. Architects—by then professionally trained in schools dedicated to the purpose—had the whole

history of styles at their disposal and new materials with which to achieve constructions unfeasible in the ages when those styles first emerged. Nineteenth-century designers did not hesitate to conceal ironwork behind Gothic pinnacles, Ionic columns, or Renaissance facades, and a great many anomalous designs date from this time. But there were also some glorious achievements.

Paris is surely among the most beautiful and picturesque of all cities. Its stately thoroughfares and mighty monuments date, for the most part, from the reign of Napoleon III, whose principal engineer, Baron Georges-Eugène Haussmann (1809–1891), rebuilt Paris with one eye on beauty and imperialist showmanship while the other was firmly fixed on the military usefulness of wide, well-lit boulevards and open squares. Baron Haussmann's Paris lent itself to dominance by artillery and massed troops with a clear field of fire, unlike the narrow streets of earlier times where a group of ten good revolutionaries could resist a hundred of the ruler's mercenaries simply by restricting the opening to the width of an alleyway.

The focus of the Paris that Haussmann created was to be the Opéra (fig. 13-47), designed by Charles Garnier (1825–1898). Although this structure is of wrought iron, its visible surfaces are multicolored marbles, onyx, bronze, and other traditional materials. The facade is an opulent overlay of motifs culled from French and Italian palaces of the Renaissance. The very splendor of their profusion has been described as "barely tolerable" by a noted Renaissance specialist. He goes on to say of the Grand Staircase, possibly the most famous of all staircases, that its richness "becomes offensive to modern eyes."[6] His is a discriminating vision and the sensibility is a polished one. For us more ordinary people, however, the Opéra is the most illustrious of all theaters, a veritable measuring stick for what we mean by "magnificent." Of course, she's a bit of an old fraud, what with all of those columns and beams and neo-Baroque arches supporting nothing at all while they themselves are

13-48 GUSTAVE EIFFEL. Eiffel Tower, Paris. 1889

held up by a skeleton of iron. But what of it? The final effect is very grand and not at all incoherent. Still, one can understand Empress Eugénie's dismay over the sheer ostentation of the place. Certainly it appeals to some moderns largely because it gratifies our fantasies as to what grandeur really is. Appropriately, perhaps, it is a theatrical spectacle writ large. It is also a marvelously functional opera house; the architectural historian Nikolaus Pevsner has called it "glorious."[7] But no one could call the surface treatment straightforward or honest.

On the other hand, the structure that *has* become the focal point of modern Paris is altogether candid. The Eiffel Tower (fig. 13-48) is nothing more than a spire of exposed ironwork. Built for the Paris Exposition of 1889, the tower was designed by Gustave Eiffel (1832–1923), already celebrated as a designer of railway stations, bridges, and viaducts. Inspired by the pylons he had created for daring bridges over deep gorges and vast rivers in Europe, Africa, and Indochina, his tower is 300 meters (984 feet) high and, when built, was the tallest structure in the world.

That the tower should be as uncompromising as it is in expressing the purely engineering side of building is rather surprising. Eiffel himself was not advanced or radical in his artistic tastes; his home was filled with routinely uninspired, conservative art objects. His main purpose for the tower was to show that the French tricolor at its peak flew higher than the flag of any other nation. He would have liked to disguise his structural steel with a veneer of tradition, but as it turned out, the only concession made to decorative effect was in the purely ornamental arches that link the four great piers. For there were some overwhelmingly practical reasons for revealing the construction itself, the principal one being the propaganda purpose of the great exhibition.

The French, having lost the Franco-Prussian War of 1870–71 and having suffered the economic consequences thereof, were attempting to regain their share of the world's business. Both the Eiffel Tower and the great Hall of Machines by the architect Dutert and the engineer Contamin were radically advanced, employing prefabricated steel components assembled on the site to create a situation in which the tallest structure in the world looked down upon a building whose span of 380 feet was unprecedented. These two huge structures dominated the fair and advertised to the world that France was in the technological forefront of the Industrial Revolution despite the damages she had suffered in the war.

At first the tower was very unpopular. To the representatives of good taste it was considered a disgrace, an affront to the beautiful city of Baron Haussmann. But by 1910 it had become a beloved symbol of the uniqueness of the ancient town and modern metropolis whose very name suggested everything that was up-to-date and progressive.

Paris got the entrances to its subway stations (fig. 13-49) a little more than a decade after the tower. These take a very different approach to the use of metal. Here, functional components of wrought iron have been treated in a fanciful, decorative way to suggest that the Métro gives access to some exotic, magical underworld. The designer, Hector Guimard (1867–1942), was the leading exponent in France of a trend or movement called *Art Nouveau*. The term includes all sorts of different stylistic approaches. Tiffany glass is considered exemplary of the style, but so are the book illustrations of Aubrey Beardsley (1872–1898) and the bold geometry of buildings by the Scotsman Charles Mackintosh (1868–1928). What ties them all together is a common repulse of strictly traditional forms. Normally, this took an approach similar to that of Guimard; sinuously wrought metals and interlaced lines of a feverish movement entwine around flat, unbroken areas or encircle an open space. Where one might have expected plain wrought iron, lilies and budding plants burst forth. In just the opposite way, Art Nouveau illustrator Beardsley took a figure like Salomé (fig. 13-50), who is usually treated in a highly organic and sexually provocative manner, and reduced nature to an exquisitely refined family of black-and-white partitions.

Beardsley's deliberately "weird" approach to his subject was motivated by the cult of "decadence" subscribed to by Beardsley and the author of *Salomé*, Oscar Wilde. Whatever in life the ordinary person might consider perverse or

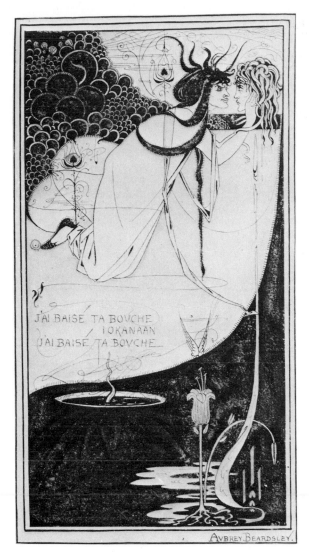

13-50 AUBREY BEARDSLEY.
Salomé. 1893. India ink and
watercolor, 10⅞ × 5¾".
Princeton University
Library, Princeton, N.J.

13-51 CHARLES MACKINTOSH. Glasgow School of Art.
1896–1910

unnatural seemed inherently artistic to this segment of Art Nouveau. Mackintosh, quite contrary to this, was conventional in his personal life. Indeed, his buildings—though they sometimes appear extraordinarily modern—were often inspired by the traditional forms of baronial manor houses in his native Scotland. His Glasgow School of Art (fig. 13-51) took its lead from the baronial style but was given a unique, untraditional character by virtue of the elegantly elongated bay windows. Mackintosh also designed as much of the interiors of his buildings as possible; in this one, shelving, cabinetry, tables, and even the chairs were his creations. They tend to have the same economy of line and form as the exterior of the building, repeating throughout the attenuated proportions of the soaring window lines.

In one way or another, the Opéra, the Eiffel Tower, and Art Nouveau signify the forces setting the direction for modern architecture. That may seem an odd thing to say about the Opéra, but the mere fact that its ornate facade is draped upon a substructure of iron ties it to such advanced buildings as the Wainwright Building (fig. 13-52) in St. Louis, Missouri, designed by the American Louis Sullivan.

If modern skyscrapers have a father, he is Louis Sullivan (1856–1924), and he owes his paternity to the existence of steel. Without steel beams the construction of a skyscraper would be unthinkable. Forged steel has higher compressive strength than stone and vastly more tensile strength than wood or iron. The Wainwright Building may seem quite conventional to modern eyes. It isn't even very tall. Its ten stories hardly compare with the soaring Eiffel

13-52 LOUIS SULLIVAN. Wainwright Building, St. Louis, Missouri. 1890–91

13-53 LOUIS SULLIVAN. Ornamental panel from the Schiller Building. 1892. Plaster, 26½ × 26½″. Collection Southern Illinois University at Edwardsville

Tower. But it represents a milestone in the development of high-rise architecture. The building itself is a cage of steel which reveals its gridlike cells in the verticals and horizontals of the window units. These are clad in vertical strips of brick and horizontal panels of terra-cotta embellished with one of the many Art Nouveau designs of Sullivan's own creation (fig. 13-53). Into this one building, then, are compressed all of the advanced trends in nineteenth-century building design: a steel skeleton revealed externally and neatly clad with the clean stylizations of Art Nouveau. The clarity of this late-nineteenth-century structure was further purified by twentieth-century architects working in what came to be called the *International Style,* an architectural movement that emphasized the properties of steel and strove to make buildings reveal them. Mies van der Rohe (1886–1969) was the outstanding spokesman for the International Style. His Seagram Building (fig. 13-54) is essentially a steel cage supporting floors and partitions to make rooms and corridors. The exterior is a light skin of bronze and amber-colored glass.

Skyscrapers worthy of the name did not appear first in New York City but were built initially in Chicago during the enormous building boom that followed the fire of 1871. One of the great architects of modern times, Frank Lloyd Wright (1869–1959), was a product of that boom. In 1936 he built a private home, the Kaufmann House (fig. 13-55), called *Falling Water* because it straddles a waterfall. One of the great home designs of all time, it is of interest here because it involves the use of steel-reinforced concrete and a structural system called *cantilever.* A cantilever is a horizontal beam extending out from a supporting post and carrying a load. Here the terraces are cantilevered. A central block of building houses utilities and chimneys and acts to anchor the horizontal extensions. Many skyscrapers and apartment houses utilize this system, which was first employed in steel bridges, cranes, and railway terminals.

Another towering figure of modern architecture was inspired by a European exhibition of Wright plans. This creator, a Swiss named Charles-

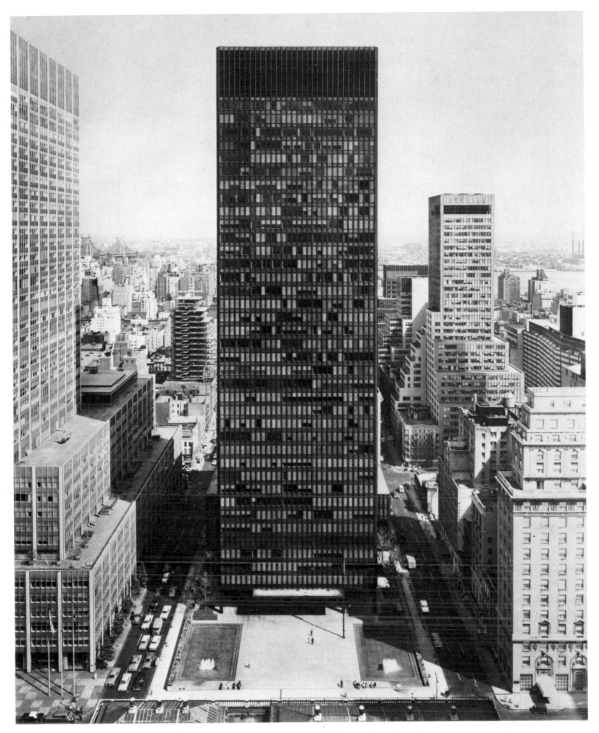

13-54 MIES VAN DER ROHE AND PHILIP JOHNSON. Seagram Building, New York. Designed 1958

Edouard Jeanneret (1887–1965), adopted the pseudonym Le Corbusier (the name of his maternal grandmother). Le Corbusier built his first masterpiece of domestic architecture in France several years before Wright built Falling Water. The Villa Savoye (fig. 13-56) is as urbanely detached from Nature as Wright's house is integrated with her. Le Corbusier conceived of the home as a shelter from which nature could be viewed and taken advantage of. The interior of the dwelling is far more complicated than it appears. The upper level is a box containing the living area. But part of it is open to the sky. Rooms lead onto a terrace that is sheltered by walls. These walls are penetrated by openings that extend the window lines. What you see in the photograph is the box that surrounds the irregular and beautifully articulated interior, an interior of several levels tied together and attached to the terraces by a series of

ramps. The cylinders rising above the box form a tower housing the staircase and act as a windbreak for the roof garden. Set well back beneath the overhang are the garage and the service areas.

Both Wright and Le Corbusier have designed major projects known to all the world—to cite only two, Wright's Guggenheim Museum in New York City and Le Corbusier's plan for the new capital of the Punjab at Chandigarh, India. In Chandigarh Le Corbusier got a chance to undertake an entire architectural environment—something both he and Wright had always wanted to do. Both had distinctive theories of how the vast populations of the world should be housed. Their differences in attitude are interesting to consider.

Wright, a son of the wide-open Midwest at the turn of the century, had the point of view of an American Romantic; he disliked cities and believed in the dispersal of the population through an open landscape of farms and unblemished nature. It is an appealing dream, one that the suburbanites seek and never find. Wright felt that by clever use of land and strategic placement of service centers and commercial complexes modern man could have the best of the rural and the industrial. This antagonism to population density is just what one would expect from the naturist who designed Falling Water.

Le Corbusier was a sophisticated European intellectual. His ideal was to house people in tremendous buildings separated by parks and boulevards, canals and thoroughfares. He once proposed a solution to the traffic-population density problem which involved highways that would run on top of continuous apartment buildings of typically Le Corbusieran scale.

Whether cities are going to disappear or whether they will survive in some new form is still controversial. One thing is clear; the present form of the city is incapable of supporting life in a humane fashion. Even the wealthiest apartment dwellers are assailed by poisoned air, horrendous noise, and unsafe

13-55 FRANK LLOYD WRIGHT. Falling Water, Bear Run, Pennsylvania. 1936

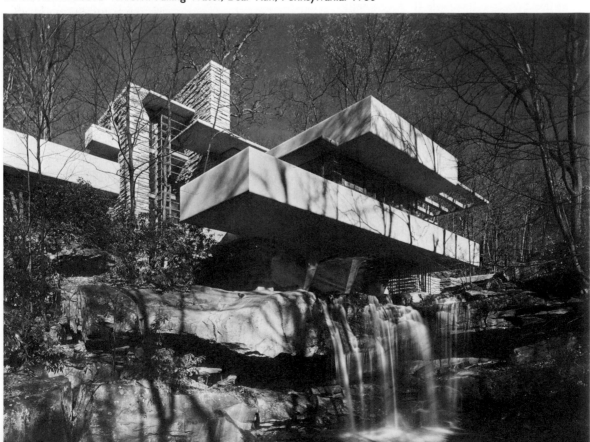

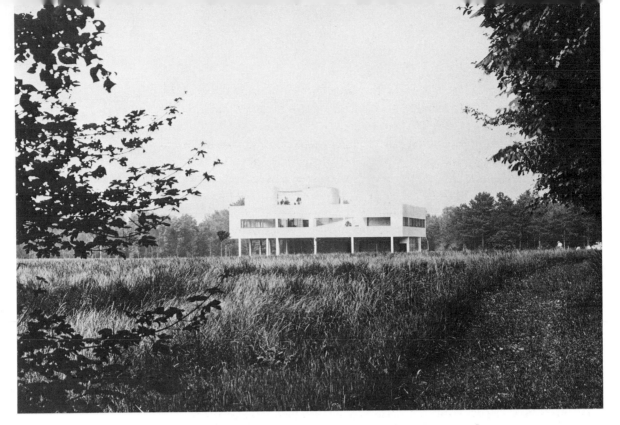

13-56 LE CORBUSIER (CHARLES-EDOUARD JEANNERET). Villa Savoye, Poissy-sur-Seine, France. 1928–30. Photograph courtesy, The Museum of Modern Art, New York

streets. Most thinkers today tend to incline in the direction Le Corbusier indicated—dense concentrations of people and unspoiled intervals between them.

One thinker and designer who devoted considerable attention to the problems of survival on the planet Earth was R. Buckminster Fuller (1895–1983). Fuller felt that all architecture of the past is obsolete; he would have said that every building we have so far discussed is inappropriate for humanity's future existence on the Spaceship Earth. He was trained not as an architect but as an engineer, and his ideal structures from the past were not buildings, but plant stalks, crystals, tension bridges, sailing ships, and airplanes. Strength, efficiency, and lightness dominate his designs, the most famous of which is the *geodesic dome*. A geodesic is the shortest distance between two points on a mathematically derived surface such as a plane (where the geodesic is a straight line) or sphere (where the geodesic is the arc of a great circle, that is, a circle that is the intersection of the surface of a sphere with a plane passing through the center of the sphere). One of the largest Fuller domes is the one used in the United States Pavilion at Montreal's EXPO 67 (fig. 13-57). The dome is constructed of steel pipe and transparent acrylic panels. It is 200 feet tall and 250 feet across. All together, the metal pipes weigh 720 tons. Yet, in terms of total space contained, this averages out to four ounces per cubic foot, an absolutely astonishing figure. No other man-made shelter comes close to the efficiency of the geodesic dome. These domes, built of triangular sections, can be constructed of anything from cardboard to steel and are being appropriated by all kinds of counter-culturists in both communes and private hideaways. They are tremendously strong—the tetrahedron, a pyramid composed of equilateral triangles, is the strongest structure known—and there seems no limit to the size that can be attained. Considering their advantages and spaciousness, the domes are dirt cheap. Fuller proposed a two-mile-wide dome for New York City and designed a floating, two-hundred-story, tetrahedron-shaped city near Tokyo.

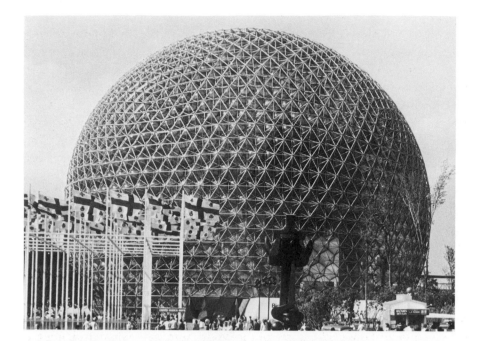

13-57 BUCKMINSTER FULLER. United States Pavilion, EXPO 67, Montreal. 1967

13-58 SAFDIE, DAVID, BAROTT, AND BOULVA. Habitat, EXPO 67, Montreal. 1967

Habitat (fig. 13-58), the massive experimental housing project built for EXPO 67, looks weird, but its inhabitants like living there today, in the 1990s, even more than they did when it was new and glamorous.[8] This pileup of one- and two-story apartments consists of precast modular boxes which were fitted together by an assembly-line technique. What is particularly intriguing about Habitat is that this machine-made stack of blocks makes buildings with hand-laid brick seem mechanistic. For Habitat is more like a Mediterranean seacoast village than an apartment house. The ingenious Israeli architect Moshe Safdie (born 1938) designed the cubicles so that they can be coupled together in a number of ways, then opened up and partitioned off to make individual interiors more distinctive than is customary in ordinary apartments. Moreover, each apartment is sealed off from the others, having its own entrance from "sidewalks" that form a network of streets through the cluster. And each apartment has its own private terrace.

As an experiment in low-cost, high-density housing, Habitat was expensive—even more so than anticipated, because the special crane designed to position the cubicles turned out to be inadequate, and a second had to be built. The complex cost fifteen million dollars to construct. But now that the crane exists and the other bugs are out, it could be duplicated for about five million dollars. In fact, the duplicate would be of higher quality; interior finish in the original was skimped in the interest of keeping down ever-rising costs. Too, the more units such a complex contains, the less cost there is per unit.

The idea of using prefabricated apartment units that can be "plugged" into larger matrices had occurred to Le Corbusier too. He had, in point of fact, experimented with them, inserting identical apartments into a concrete grid. Buckminster Fuller's Tokyo project also conceived of the living units as segmental—indeed, he envisioned each unit and any stable collection of them as portable.

Which of these ideas will dominate the city of the future is impossible to say. Quite likely all of them will be synthesized and used by lesser men. Their hope will be to house the masses of the world humanely while avoiding the desecration of land produced by the suburban sprawl with its commuter highways and dreary shopping plazas. To do so is within technological reach; what is needed is the will.

Even the most concerned among us is discouraged to be told that it is imperative for us to reconstruct human society and—as a preliminary—pull down all that time and experience have built up. Moreover, we *should* be upset by such assertions because the very newest order it is possible to achieve, no matter how bold its experiments, must be as continuous with the past and the present as the new generations of human beings are continuous with those that went before. The American novelist, William Faulkner, once said: "The past is never dead. In fact, it isn't even past." If that is true, it is equally true that the greatest promise in city planning lies in the direction of preservation and re-adaptation of existing structures. Unfortunately, success in doing that is rare; isolated examples of rebirth are heavily outnumbered by failed attempts to revitalize some area or other. Various private interests and outmoded regulations combine to make a monstrous opponent to rehabilitation. Only infrequently does government authority or citizens' outrage overcome commercial interests. In most of our metropolises, however, the problems are terrifyingly large, real, and worsening, and it will take more than neglect to cure what threaten to become terminal afflictions.

In general, most of us can easily agree that rehabilitation is preferable to destruction. Deciding what is to be saved, how, where, and when is not so easy to do; getting whole groups of people to concur with a given recommendation is nearly impossible. Usually, the situation is muddled and the solution controversial. Again, we can turn to Paris for an example. I am thinking of a remarkable building, the Pompidou Center (fig. 13-59) located in the so-called Plateau Beaubourg just north of the Seine River.

Georges Pompidou (1911–1974), President of France from 1969 to 1974, was one of those leaders who was more enamored of progress than tradition. Like the French of 1889, he wished to restore his nation to her earlier level of economic distinction. But he became a veritable assassin of the obsolete and a nearsighted, if not blind, champion of modernity. Thus, distressed by the horrendous traffic jams of Paris, he set out to replace the picturesque quais of the Seine with automobile expressways. That aim was accomplished on the Right Bank, which now resembles any of a dozen anonymous riverside drives

13-59 RENZO PIANO AND RICHARD ROGERS. Pompidou Center, Paris. 1976

along streams coursing through the industrial cities of the United States. The Left Bank seems secure in its picturesque dignity; transformation of it was blocked by Valéry Giscard d'Estaing, Pompidou's successor.

In light of Pompidou's zealous promotion of newness, it is hardly surprising that his name should be associated with an extremely radical piece of museum architecture. He had expressed a passionate interest in establishing in Paris a "cultural center that is both a museum and a center of creation, where the plastic arts would be side by side with music, cinema, books, and audiovisual research." This idea struck fire. It was heavily promoted in the press and supported by various groups interested in returning Paris to the cultural prominence she had enjoyed before World War II. After several false starts, the project was undertaken. A site had been available for about forty years in the form of five acres of land that had been cleared for an urban-renewal project in 1930. That project had been aborted; the Plateau Beaubourg sat empty. It has now been filled with the most aggressively modern of all cultural centers. Designed by Renzo Piano (born 1937), an Italian, and the English architect, Richard Rogers (born 1933), the Pompidou is a vast affair (166 meters long, 60 wide, and 42 tall) that has been compared in appearance to an oil refinery, a distillery, and a hundred other things, none of them associated in the public mind with beauty or good taste. Even in this, perhaps, the Center is heir to all that Eiffel had begun.

In structure the building is exoskeletal. That is, the supporting trusses are on the exterior of the walls rather than hidden behind them. So, too, are the ducts and pipes that, in most buildings, would be concealed by partitions, walls, and ceilings. The eastern face of the Pompidou Center exposes them in polychromed distinction. Air-conditioning ducts are blue, waterpipes green,

13-60 RICARDO BOFILL AND TALLER DE ARQUITECTURA. *Les Arcades du Lac,* Le Viaduc, St. Quentin-en-Yvelines, France. 1972–83. Photo: Charles Jencks. Courtesy Academy Editions, London

elevators red, and so on. The effect is startling. But keeping the structure and functional entrails of the Center on the perimeter provided a tremendous amount of unimpeded space within the 17,000 square meters the windows enclose. Contained therein are the following: 1) The National Museum of Modern Art, formerly housed on Chaillot Hill at the Avenue du Président Wilson; 2) Paris's first genuinely *public* library (The world-famous Bibliothèque Nationale is a library for serious scholars, and other well-known collections are for use by students.); 3) The Center for Industrial Design, providing displays of everything from architecture and furniture to posters and commercial pottery; 4) IRCAM (Institute for Research and Coordination in Acoustics and Music), a subterranean complex of studios and laboratories directed by internationally renowned composer-conductor Pierre Boulez; 5) Multi-purpose halls for theater, musical performances, cinema, and public lectures; 6) A poetry gallery; 7) A children's studio for introduction to art; 8) A permanent exhibit featuring the reconstructed studio of pioneer modern sculptor Constantin Brancusi (1876–1957); 9) A sculptural maze by contemporary French sculptor Jean Tinguely (born 1925); 10) A bar and restaurant.

These things, along with a miscellany of offices and so on, comprise the Center. They are embraced by a scaffold-like cage containing such notable innovations as roll-down metal shutters that drop automatically when the interior temperature rises from solar gain or from a fire. In case a fire does occur, the shutters serve to protect the external structure and also the adjacent buildings. Many visitors who care not at all for the appearance of the glass-enclosed escalators running up the side of the building are favorably impressed with the way these function, for they permit one to enter the building at whatever level he wishes. In terms of convenience and efficiency the Pompidou Center is a splendid exploit.

As for the style of the architecture, opinions will vary. And if this book has done even a part of its work, you should be well aware of just how arbitrary and changeable such likes and dislikes can be. Certainly, the Pompidou Center is presently in the same situation the Eiffel Tower once was; it is anathema to conservative taste. But it has turned out to be unexpectedly

popular to visit and shows every likelihood of eventually becoming an object of civic pride. Indeed, the structure has already inspired a more-or-less spontaneous renewal of the area around it. Decaying buildings have been refurbished, restored, and redecorated. There are now pedestrian walks, and new shops abound. The street sellers of the city are drawn to the zone. And tens of thousands of people have been attracted to an area that was what Americans call "blighted." Today the atmosphere is festive and the Beaubourg neighborhoods are becoming increasingly prosperous.

Predictably, some critics of the Pompidou Center would prefer a building designed with a facade to match the architecture of the Opéra or Louvre or other public buildings in the traditional styles that predominate along the boulevards of Paris. Of course, they are likely to be disappointed by modern architects who feel that adopting Baroque or nineteenth-century mannerisms would be like playing chamber music at a rock concert. But all is not lost for those who detest the impersonal pragmatics of the modernist approach, for recent decades have given birth to a miscellany of rebellious tastes that take the whimsical, the chimerical, the pretentious, and the purely ornamental very seriously indeed. The set of attitudes—and a very mixed set it is—have come to be called, collectively, *Postmodernism.*[9] A good example for our purposes is an apartment complex located just outside of Paris, near Versailles. It is as different from the Seagram Building or the Pompidou Center as one can imagine, except that it is also contemporary, being technologically advanced in its construction and memorable for its external appearance. It is Ricardo Bofill's (born 1939) *Les Arcades du Lac* (fig. 13-60).

The apartments are based on gigantic bays of precast concrete and faced with building elements that are, like those of Garnier's Opéra, purely surface fixtures. The immense impersonality of the place tends to put off the idle stroller in the pedestrian piazzas—spaces as vast in their emptiness as the Turin of De Chirico's paintings. And yet, the majesty of something like the viaduct, whose arcades punctuate the rhythm of its march out into the lake, is truly thrilling. The whole place is like Corbusier overlaid with Palladio and Guarini. All that Bofill's design lacks, as critic Charles Jencks has said, is "the urban fabric, the old buildings, historical and functional diversity—all the background which would give his foreground more meaning."[10] This is, however, the kind of complaint the architect would brush aside; he proclaims himself a new Michelangelo and is fond of what amounts to an architectural *contrapposto* that is indifferent to petty feelings about being caught in a game that plays individualism off against mass-produced design components. Le Corbusier and Wright had the same kind of olympian self-assurance about the human subjects of their experiments.

Ultimately, architects will have to be primarily concerned with human survival and not just creature comforts for architects and their patrons. The real issue of architecture is going to come down to a matter of providing shelter in a world of limited resources. Presently, there is more hysteria on the part of "professional" doomsayers of the environmental movement, and mindless complacency on the part of nearly all the rest of us, than there is reason being brought to bear upon the problem posed by a burgeoning world population and decreasing resources. None of the architecture we have studied here, except Buckminster Fuller's, has much bearing upon the essential problem that must be solved. But the kind of ingenuity all of the architects have exhibited in being creative artists should give us a little hope. Whether they can take much confidence from us is more to the point because it seems that we must change a good deal more than we might wish simply to survive.

When I began this quite cursory survey of art history I noted that the Neolithic farmers set the pattern for our lifestyles and our destiny. Perhaps they have also prepared our way to doom. Anthropologist Ernest L. Schusky has coined a term, *Neocaloric,* to describe the direction in which agriculture has been moving since the Neolithic period when farmers got back about ten or twenty calories from the land for every calorie they expended.[11] Of course, their traditional society used at least ninety percent of its human energy just to provide food for itself. Today in developed countries the human energy allotted to food production and processing has declined to less than fifteen percent. Most of us have been taught to think of this advance in productivity as progressive; in fact, its positive values are overwhelmed by a deficit called entropy. The contemporary farmer, using machinery, fertilizers, pesticides, and so forth, expends about eight calories for every one produced and, by the time the foodstuff reaches the dining table, twenty to thirty calories have been burned up to produce every calorie consumed. That's thirty to one! No wonder the earth's in trouble; we are literally "eating it up."

Attempts to construct energy-efficient homes for the radically different society humanity must build if it is to survive have been rare. It may be that we will have to return to a farming economy supported by light industry, as in the days before the turn of the last century, even if population growth can be sharply decelerated. But your farmhouse will have to be a lot more efficient than the glorified hut of a century ago.

Figure 13-61 shows the exterior of a home designed by Michael Jantzen (born 1948) as a prototype for a mass-produced, ecologically responsible dwelling. Made from interlocking steel silo components and other prefabricated mechanical units, the structure is very heavily insulated and is indefinitely expansible. Somewhat "unfriendly-looking" from the outside — probably because it is an unfamiliar concept for a home — the dome house interior (fig. 13-62) has a soft and dreamy look because the walls are curved and the sense of being embraced by an articulate space is so palpable. Even conservative viewers tend to be won over by the practicality of this lived-in ecology laboratory, though. It is warmed by body heat and incidental waste energy from major appliances and cooled primarily by the effect of the concrete slab on which it rests. On a 102° day it never gets above 78° within,

even when no blowers or heat exchangers are in operation. The house is as free of dependency on energy grids and fossil fuels as it is possible for it to be and still be a reasonably up-to-date, comfortable, middle-class domicile. Jantzen has devoted himself to dealing with a major architectural problem and some of his other designs are more revolutionary than the house built of silo domes. In another book I and a pair of co-authors discussed these things at some length.[12]

Homes of the type Jantzen specializes in have received far more attention abroad than in the United States because it is in places like Japan and Italy that housing needs are critical, energy costs astronomical, and the people well-educated and technologically sophisticated. It will be for the immediate benefits in the area of mass housing that these nations will adopt such "extreme" designs as Jantzen's or Fuller's. But it is a direction like theirs that seems to hold out the best chance for housing humankind and humanity's livestock, too, in an age of straitened resources and rationed energy.

On this perhaps too pessimistic note, we close. The end to which this book was designed to lead—feeling able to enjoy art at its best, whether it is truly classic in aspect or avant-garde in attitude—is a rather modest objective. For to be unintimidated by art and the pomposities sometimes set up alongside it is only a beginning. I hope that what I have done toward achieving that start can never become a hindrance to further growth. Still, no matter how helpful you have found the book, to put too much value on these particular words, examples, and values would be unfair to yourself, embarrassing to me, and unjust to the field of art. There are other ways, perhaps better ways, of looking at art. And there are vast ranges of expression untouched by *Art: The Way It Is.* One of the ways art "is" is being too rich for description in any one volume. For that reason a bibliography is included and also a glossary of terms general in the field of art. By making use of these, one may develop a far more discriminating, yet elastic sense for art. My responsibility is at an end; from here on where you go and how you proceed is up to you and those you choose to lead you. Good luck.

NOTES TO THE TEXT

NOTES TO CHAPTER ONE

1. Erwin Panofsky, *Meaning in the Visual Arts* (Garden City, N.Y.: Anchor Books, 1955), p. 19.

2. René Huyghe, *Ideas and Images in World Art,* trans. Norbert Guterman (New York: Abrams, 1959), p. 9.

3. Somewhere Vladimir Nabokov, a celebrated lepidopterist and the author of significant novels in three languages, mentions that he has never been able to master the art of refolding a road map.

4. It is not trashy in the sense of being obscene, however, although this charge has been brought against it. The figures in the rear seat are as incomplete as the automobile body; if we did not associate motor vehicles with instruments of illicit pleasure, the tableau would not be suggestive.

5. There are, of course, collections consisting of the works of a single artist and public galleries concerned with special periods or themes. But these are oddities and their interest is usually not artistic so much as historical. For instance, the Amon Carter Museum of Western Art in Fort Worth, Texas, is full of pictures and sculptures detailing the brief glory of the Old West. Some of these works are of genuinely high aesthetic quality but it was their content that brought them to the attention of the curators in the first place. Thus, an equestrian work by one of the great horse painters of all time, Ernest Meissonier (1815–1891), a French painter of genre subjects, would not find its way into this collection unless it had been owned by a cattle baron or a Western painter.

6. For those who haven't read this tale, it concerns a pompous ruler who is "conned" by two characters who claim that they weave a beauteous fabric which is invisible to anyone who is incompetent to hold his or her position. In fact, they weave nothing, but only pretend to—the sovereign's garment is purely imaginary. But since no one—least of all an emperor—wishes to be thought undeserving of his job, all his subjects pretend that they can see the new clothes. Indeed, they vie with each other in praising the quality of the material. The entire adult population is unstinting in its admiration of the emperor's new clothes. It is only when an innocent and unpretentious child cries out that the emperor has no clothes on that the hoax is revealed.

7. The numbers are arranged alphabetically by their names, the last number being called zero. As for the mysterious OTTFFSSENT, these are the initials of the names of the cardinal numbers from one to ten.

8. Wassily Kandinsky, *Concerning the Spiritual in Art,* trans. Francis Golffing, Michael Harrison, and Ferdinand Ostertag (New York: Wittenborn, Schultz, 1947), p. 40. The earlier remarks on *Improvisation Number 30* appeared in a letter to Arthur Jerome Eddy that is quoted in his book *Cubists and Post-Impressionists* (1914).

NOTES TO CHAPTER TWO

1. The impression that the reflection is larger than it measures is due to the belief that one's image is on the plane of the mirror. Actually, it is twice that distance. As Dr. Henry Knoll, senior scientist at Bausch & Lomb's Soflens Division, diagrams it:

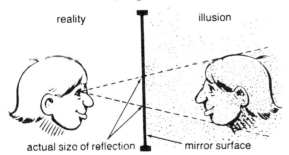

2. In this connection it might be remarked that a wage is not the same as a profit. You profit only if you invest less than you get back.

3. That is to say, American "Indians."

NOTES TO CHAPTER THREE

1. This was in February 1890 in Brussels. A painter, Anna Bock, paid 400 francs for *The Red Vineyard,* a picture showing a group of women from Arles picking grapes alongside a canal. This was a reasonably good middle-range price for a painting by an unknown artist.

2. Those original oil paintings sold in furniture stores and traveling sales are indeed "original" in the sense that they are handmade. But buyers should beware of what they are getting. The people who turn out this stuff paint the same pictures over and over, sending similar ones to different outlets in different locations. Every once in awhile something of quality sneaks in, but that is rare.

3. Maurice Raynal, "The Lessons of Cézanne and Seurat," in *History of Modern Painting from Picasso to Surrealism* (Geneva: Skira, 1950), p. 12.

4. *Paul Cézanne, Letters,* ed. John Rewald, trans. Marguerite Kay (London: Bruno Cassirer, 1941), p. 234.

5. *Ibid.,* p. 268.

6. John Berger, *Ways of Seeing* (London: Penguin Books, 1972), p. 63.

7. David Freedberg, *The Power of Images* (Chicago: University of Chicago Press, 1989), p. 17.

NOTES TO CHAPTER FOUR

1. These marks are sometimes referred to as draftsman's lines. Unfortunately, this terminology confuses most people because to them a "draftsman" is someone who prepares plans and diagrams using mechanical drawing instruments. This use of the term *draftsman,* however, is a very special one. It is comparable to the use of the term *driver* at a racetrack. If you were at Indianapolis or Sebring for the races and a track official asked you if you were a driver, you would say "no" because you would realize that he wanted to know whether or not you were entered as the driver of a racing car. But if I were to see you on the street and ask whether you were a driver, you'd probably say "yes." To artists a draftsman is anyone who draws well, and someone like Degas or Picasso is characterized as a fine draftsman. Thus, a draftsman's line is the kind of mark produced by a drawing implement such as a pen or pencil.

2. Catholic scholars use the term "Catholic Reform" instead of "Counter Reformation," because the reforms associated with the period had, in fact, begun before the rise of Protestantism.

3. There has been controversy over the authorship of this statue since it was discovered at Olympia in 1877. The director of the excavations, Gustave Hirschfeld, decided that it was probably a copy by a late Greek artist of the Praxiteles work mentioned in an ancient travel book by the Greek geographer Pausanias (c. A.D. 154–200). The beauty of the piece overwhelmed scholarly quibbles and for a century most writers attributed it to Praxiteles. Presently, specialists usually deny that it is an original. This is a controversy not likely to be resolved. For what little it is worth, my own opinion is that it is by Praxiteles but was "restored" sometime during the second century B.C.

4. Kenneth Clark, *The Nude* (Garden City, N.Y.: Anchor Books, 1959), pp. 172–73.

5. I am not making reference here to the absence of pubic hair, something about which people often wonder but rarely ask. The deletion is a tradition stemming from cosmetic practices of the courtesans of ancient Greece, who removed all body hair for hygienic purposes by painting themselves with hot wax and then stripping it away once it had dried, a technique still employed by some women in Middle Eastern countries today. In any event, the sculptors imitated the effect in ancient times and later artists imitated them. By the nineteenth century, however, timidity about the carnal nature of people caused the same procedure to be applied to paintings and statues of males, something the ancients had not done.

6. Clark, *op. cit.,* p. 61.

NOTES TO CHAPTER FIVE

1. It is true, of course, that white people have made use of the identification of black with evil and white with purity. In fact, describing the skin of the lighter races as "white" is itself this sort of thing; no human skin is genuinely white, not even an albino's. Still, blackness does not always have negative connotations. There are, after all, raven-haired beauties as well as tall, dark, handsome men. Most formal evening wear is black. For many years most automobiles were black. And every businessman wants to be "in the black."

NOTES TO CHAPTER SIX

1. See, however, note 3 to this chapter.

2. It is typical to say (as I did in the first edition of this book) that red "absorbs all the white light except red." But, in fact, a spectrophotometer reveals that a red absorbs only a fraction of non-red light at the same time it reflects back nearly all of the red. I am indebted to Charles C. Fuller for bringing this to my attention.

3. Most authorities would view this as a weakening of the intensity of the red, but I prefer not to think of it in this way because we so often refer to "bright pinks" or to a "dull rose." A bright, intense red will make a bright, intense pink; a dull red will make a dull pink.

4. I was once seated behind two middle-aged ladies at the movies. Suddenly during a travelogue feature one turned to the other and said, "Ain't it too bad life's not in Technicolor?" I thought this very sad, since it indicated something about the way most people see. Technicolor or Kodachrome intensifies certain hue levels and dark-light contrasts. Everything looks lush. But it eliminates far more than it captures. Still, most of the population is conditioned to see in the coarsest possible way.

5. Hermann von Helmholtz, *Treatise on Physiological Optics*, ed. James P. C. Southall (New York: The Optical Society of America, 1925), III, 6–7.

6. Quoted by John Rewald in *Post-Impressionism from Van Gogh to Gauguin* (New York: Museum of Modern Art, 1956), p. 83.

7. See Larry T. Reynolds, "A Note on the Perpetuation of a 'Scientific' Fiction," *Sociometry,* XXIX (March, 1966), 85–88.

NOTES TO CHAPTER SEVEN

1. The first record of perspective theory appears in a little book published after Masaccio's death. It is Leonbattista Alberti's *Della pittura,* the most influential of all early Renaissance treatises on art. It first appeared in Latin in 1435 under the title *De pictura* and in the following year was rewritten in Italian by the author, who dedicated it to Brunelleschi.

2. Obviously, the actual procedure for drawing a CAD image cannot be set out in a footnote. The following description is merely to give the reader a very general notion of what the monitor image looks like and what kinds of things you have to consider. The diagram below represents the Design CAD 3-D screen. Notice, first, that there are four "views" of the vase—three elevations in small rectangles along the left side and an axonometric image in the larger box. There are "menus" of over 100 special commands, that allow the operator to perform quickly and easily feats of rendering that would otherwise require far more time, ability, and energy. For instance, one can rotate shapes around an axis while they are being precisely duplicated with a specified frequency. Thus, the vase is nothing more than

a line spun around a vertical axis with its form copied over and over, thirty times. (The ellipses tie the points of variation together. When a curve is "swept" this way, the result is a far more densely packed set of rings.) Another command will enable one to duplicate the vase itself any number of times and rotate *it* about an axis. You can stretch objects, deform them, reform them, shade them, merge them, etc. The absolutely essential trick to master, no matter what kinds of manipulations you are undertaking, is the simultaneous positioning of the cursor in the same position in every one of the four views. In my example below, the large starburst form is the default (automatically selected) cursor. It is correctly positioned to place a point on the lip of the container. The plus sign version of the cursor also appears to be on the lip in the large view but a glance at views 3 and 4 shows that, although it is in line with the lip, it is too near to the picture plane (i.e., the screen surface) to coincide with it. The dot form of the cursor is near enough, but it is also at the wrong height and too far beyond the vase to make contact. It is a simple matter, intellectually, to see what must be done to place a mark where it is needed but it requires practice to manage it, particularly since instruction manuals in the computer business are invariably written by people so familiar with the programs that they take something like this for granted and never bother to mention it.

3. Helmholtz, *op. cit.,* pp. 8–9.

4. The term *frontality* is a somewhat vague one in art circles. When applied to modern works, it means what is suggested here. But it is also used to describe figurative statuary that has a definite front and back, and distinct left and right sides. Egyptian statuary is frontal, Bernini's is not. In a related way we describe such static figurative painting styles as the Egyptian and Byzantine as frontal. Consciousness of surfaces to the front of the work is the distinctive feature of all these usages.

5. It is not my intention to argue such difficult matters in a book intended for neophytes. Those with a special interest in philosophy, the history of science, or the history of art are directed to chapter five of my book *Modern Art and Scientific Thought* (Urbana: University of Illinois Press, 1971), where I dealt at length with this subject. That book, however, is no longer in print. Fortunately, a far more definitive study has been published and I recommend it highly. See Linda Dalrymple Henderson, *The Fourth Dimension and Non-Euclidean Geometry in Modern Art* (Princeton: Princeton University Press, 1983).

NOTES TO CHAPTER EIGHT

1. A very thorough discussion of scholarly agreements and disagreements on the meanings of this painting can be found in Linda Seidel, "Jan van Eyck's Arnolfini Portrait: Business as Usual?," *Critical Inquiry* (Autumn, 1989), 54–86. Dr. Seidel believes that the scene is a record of an "irregular" financial transaction involving the bride's dowry and that the painting was commissioned by her father. The painting is masquerading as a religious picture but what it is really about is a fiscal arrangement, with the woman a commodity. Even her dress is the green of the cloth Florentine bankers did business úpon.

2. The letters in the Greek word for fish, ΙΧΘΥΣ, are also the initial letters of the words in the statement Ιηθους Χριστος Θεου Υιος Σωτερ, which means "Jesus Christ, Son of the Redeeming God."

3. Two comments on the handguns: (1) The "Luger" is so called after its designer, Georg Luger, but that is just a nickname. The proper trade name is *Parabellum,* the telegraphic address of the manufacturer, Deutsche Waffen & Munitionsfabrik of Berlin. (2) The phobic reactions of some readers to the mere sight of guns should not lead them to the unwarranted conclusion that the author favors households armed with unregistered firearms. He has deliberately chosen what seems inappropriate in order to make a point.

4. Meyer Schapiro, *Cézanne* (New York: Abrams, 1952), p. 90.

5. Normally, it is said that the painter severed "his ear." In the previous editions of this book I wrote that he had "cut off the lobe" of the ear. Why the disagreement? Dr. Rey, an intern who treated Van Gogh after he was admitted, unconscious, to the hospital at Arles, France, on Christmas Eve, 1888, said he had lopped off the whole ear with a razor. The policeman on duty in the district that night agreed. On the other hand, Dr. Gachet—who treated the artist in 1890 in

```
ROOTMENU

ARC/CIRC
BLOCKS1
BLOCKS2
DISPLAY
EDIT
FILES
HIDE
INFO
LINES
NOTES
PARAMETER
POINTS
SOLIDS
SHADE
SURFACES

END
```

Auvers for mental illness—and Van Gogh's sister-in-law both said that he had removed only the lobe. I imagine that the problem is that the mutilation involved more than a mere lobe but not the entire external ear. Which ear? The right.

6. *Mona* is a contraction of the Italian word *madonna* and means "my lady." Lisa, of course, is short for Elizabeth.

7. Albert Boime, "Roy Lichtenstein and the Comic Strip," *Art Journal*, XXVIII (Winter, 1968–69), 158.

NOTES TO CHAPTER NINE

1. Some writers differentiate between the *medium* and the *vehicle*, with the vehicle in oil paint being the binder (oil) and the medium being whatever is used to thin it (turpentine). Such a distinction is useful in technical discussions with studio craftsmen but would serve only to complicate a text intended for laymen.

2. Leonardo's *The Last Supper* was done in a version of *fresco secco*. The *buon fresco* method was too restrictive for his restless, inquisitive temperament. Always an experimenter, he decided to try out a mixture of tempera and varnish on a dry plaster wall sealed with a varnish. The paint began to flake away as soon as the work was completed. Before World War II, the method of repair had been a piecemeal one, with restorers replacing the missing pigments fleck by fleck. After the war, deterioration was arrested by fixing the pigment to the wall with synthetic resins. Recently, another total restoration has been undertaken.

3. For those who have used the previous editions of this book, I should note that in those versions I rather carelessly described the difference between lithography and other printmaking techniques as being "chemical" vs. mechanical. A ceramist and sometime colleague, Lawrence Buxbaum, brought to my notice that this is, in fact, erroneous; that oil and water don't mix is due to their physical character. The antipathy isn't really "mechanical" but neither is it chemical.

4. At one time *sheet glass* was flat glass produced by blowing discs and trimming them. Now the term usually refers to sheets of glass made by a process called *drawing,* which consists of forcing molten glass through a slot into a long, narrow container. *Plate glass* has a smoother surface; it is produced by rolling sheets of hot glass between water-cooled cylinders. A third form of flat glass is *float glass.* It is made by allowing molten glass to flow over and lie suspended upon a bed of molten metal, and it has a "true" surface, like plate glass.

NOTES TO CHAPTER TEN

1. Among these is the fact that cosmic radiation has, in fact, *not* kept carbon 14 a constant fraction of all atmospheric carbon, an assumption that seems fundamental to the principle of radiocarbon dating. The Industrial Revolution is known to have lowered the ratio, and atmospheric testing of atomic devices has raised it. Mightn't other events in the past have affected the ratio? The testing of bristlecone pines and cross-dating of them has produced wood samples dating back almost 9,000 years. Measuring the C^{14} present in these very old samples has allowed precise calibration of radiocarbon dating at least *that far back.*

2. To dismiss a perplexingly common misapprehension, males do not have fewer ribs than females. An acquaintance who is highly knowledgeable about Biblical matters from a literary viewpoint notes that the Hebrew word for "rib" is similar to the word for "fall," a suggestive parallel in light of the frequent use of these things in the Old Testament. For instance, the name Adam in Hebrew means "man," the name Eve "life."

3. Everything that can be said about the motivation for the cave paintings is at least partly wrong. The interpretation I am employing here first appeared in Salomon Reinach's "L'Art et la Magie" in *L'Anthropologie,* no. 14 (1903) and has become more or less standard. It is very plausible-sounding but is also subject to a number of critical embarrassments, for which see Peter Ucko and Andrée Rosenfeld, "Critical Analysis of Interpretations and Conclusions and Problems from Paleolithic Cave Art," in *Anthropology and Art,* ed. Charlotte M. Otten (Garden City, N.Y.: The Natural History Press, 1971), pp. 247–81. Ucko and Rosenfeld suspect that Paleolithic representations were made for reasons that "totally escape the modern observer." After all, consider the consequences if future archaeologists knew nothing of our own era except what they could conclude from irradiated remnants of Disneyworld.

4. Lucien Lévy-Bruhl, *How Natives Think,* trans. Lilian A. Clare (New York: Alfred A. Knopf, 1926). This is the authorized translation of *Les Fonctions mentales dans les sociétés inférieures,* 1910. The quoted line is from George Catlin's *The North American Indians* (Edinburgh: J. Grant, 1903), I, pp. 122–23.

5. Dogs are found in association with human beings already during the Paleolithic Age; their skeletons turn up around the garbage heaps of the cave dwellers. For the old hunters a dog would have been an ideal companion because of its sense of smell. If all of the nerve tissue in a man or woman devoted to the olfactory sense were spread out in a skein it would cover about one-sixth of the body; that of a canine would blanket the entire animal. Moreover, dogs run in packs, a sort of tribal community, and they are very trainable. Felines, the only obvious alternative to the dog as aides to the hunter, are individualists and don't have sharper noses than humans. Cats have fantastic vision and hearing, it's true. But the only species of cat that has been successfully trained to serve humankind is the cheetah, a curiously doglike feline.

6. Stonehenge is a *cromlech,* or circle of stones, made up of monoliths weighing several tons and called *menhirs.* Computer studies have shown that, whatever else were its uses, Stonehenge was a remarkably accurate calendar—in effect, a gigantic sundial and astral observatory. At the Cahokia site, thousands of miles and an ocean away, a similar structure of vertical poles served comparable purposes, predicting the solstices, equinoxes, and intervals between.

7. John Adkins Richardson, "Speculations on Dogon Iconography," *African Arts,* XI, No. 1 (October, 1977), 52–74.

8. Marcel Griaule and Germaine Dieterlen, "The Dogon," in *African Worlds,* ed. Daryll Forde (Oxford: Oxford University Press, 1954), p. 83.

9. The fact that the ancient Egyptians also based their calendar on the motion of the star Sirius is only one of numerous parallels between the two cultures, and it is conceivable that Dogon cosmogony is the most complete surviving version of the first creation myth. Needless to say, the elevated intellection of the technologically "primitive" Dogon has also been attributed to the influence of the same extraterrestrial visitors who are supposed to have engineered the pyramids and great temples along the Nile.

10. This is only a probability in the case of painting since not a single painting has survived from ancient Greece. References in ancient literature to pictures, however, indicate that imitation of nature was the rule, and certain types of pottery decoration—particularly socalled "Attic white" funeral vessels—tend to substantiate literary intimations.

11. Antisemitism, as a form of ethnic hatred separate from tribal warfare, is a very old phenomenon, dating from Alexander's conquest of Palestine, four centuries before the crucifixion of Jesus. When the Greeks attempted to impose their paganism on Jewish youngsters, the Jewish community defended their own religious convictions with severe determination, leading the conquerers—rather irrationally—to think of the Jews as an arrogant and seditious minority. The Jews, somewhat more logically, saw the arrogance all on the side of the Greeks. In any event, we have the remnants of this contest of wills still with us today.

NOTES TO CHAPTER ELEVEN

1. Michael Fox, "Commentary" on Hildegarde of Bingen in *Illuminations of Hildegarde of Bingen,* trans. Gabrielle Uhlein (Santa Fe, N.M.: Bear & Co., 1985), p. 6.

2. The Nominalist-Realist Controversy is the major philosophic issue of the twelfth century. It involves the kinds of questions laypeople usually become very impatient with in a matter of moments, but that are basic to much of what the same people believe. It's rather like theory of numbers; only specialists understand it, but simple computations depend upon it. In this case, the issue is whether concepts are real or are just names for things. That is, do we have a concept of whiteness that is applied to various instances that we then recognize as being white or, conversely, is "whiteness" just a word used to describe a lot of things we have encountered that share a certain

visual character? To say the concept is a real thing identifies one with the Realists and to believe it is just a name is to be a Nominalist. Most people today are "naive empiricists" who take a Nominalist position. But then it turns out that most of them hold other ideas inconsistent with this attitude (in the same way that a "naive materialist" may interpret reality as being something that can be directly sensed as physical phenomena while at the same time praying to a supernatural being). The issue itself was of very great importance to the Church because belief in the Holy Trinity was justified by St. Augustine with Realist logic and to take a Nominalist view seemed to support the Muslim contention that Christians pretended to worship one god but really worshiped three: God the Father, God the Son, God the Holy Ghost. It is a worrisome question for conservative theologians and is, in fact, a genuinely problematical issue in the foundations of scientific thought. For art history it is of importance as a matter that caused thinkers like St. Thomas Aquinas (1225–1274) and William of Occam (1300?–1349) to focus upon the works of Aristotle (384–322 B.C.) and thereby emphasize humanistic literary sources.

NOTES TO CHAPTER TWELVE

1. Ada Louise Huxtable, "The Most Influential Architect in History," *New York Times Magazine,* July 17, 1977, p. 22.

2. In 1938 Paul Frankl published an immense work, *Das System der Kunstwissenschaft (A System of Aesthetic Theory),* which attempted to retain what seemed valid in Wölfflin's theory while overcoming its difficulties. Frankl's theory depends on the assumption that art, at its extremes, represents things as either in a state of Being—having a firmly fixed existence (Raphael)—or in a state of Becoming (Rembrandt). Within each of these categories are three stages: preclassic, classic, and postclassic. The preclassic and postclassic have within them alternative directions. It is a far more complicated and subtle theory than Wölfflin's. Like all of these systems, it is, at last, merely a complicated construction that pieces together myriad subjective opinions of an erudite scholar.

3. Lionello Venturi, *Four Steps Toward Modern Art* (New York: Columbia University Press, 1956), p. 24.

4. Pablo Picasso, in an interview with Marius de Zayas, "Picasso Speaks," *The Arts* (May, 1923), 316.

5. The ironic religious angle made the event particularly disturbing to complacencies of the faith. Voltaire used it in *Candide* to attack Leibnitz's optimism about this existence being "the best of all possible worlds." (People tend to overlook the word *possible* in this phrase; Leibnitz could have laughed at Woody Allen's line about God not being cruel, just an underachiever.) Whatever the theological implications, it was a great loss of life. To get some notion of the relative dimensions of the tragedy, we may contrast it with the San Francisco quake of 1906. That resulted in "only" 700 deaths. By far the most devastating earthquake of modern times—at least up to this writing—was in China in July, 1976, when 750,000 were said to have died. Three years later, the government reduced this estimate to 250,000, but many observers are suspicious of the lower figure since whole sections of the locales where the worst tremors occurred have been sealed off from all but officials of the central government.

NOTES TO CHAPTER THIRTEEN

1. The Seven Years' War (1756–63) was a conflict between France, Austria, Russia, Saxony, Sweden, and Spain on the one side and Prussia, England, and Hanover on the other. There were two issues: (1) French-English colonial rivalry in America and India and (2) the struggle between Austria and Prussia for supremacy in Germany. The war proved Prussia's rank as a leading power and made England the world's chief colonial power at France's expense.

2. See Jacques Barzun, *Classic, Romantic, and Modern* (Boston: Atlantic Monthly Press, 1961), pp. 155–68.

3. No one agrees on who appropriated the word *dada* as a trademark for the group, but it is supposed to have been discovered by accident in a German-French dictionary. Hugo Ball wrote: "In Rumanian, *dada* means yes, yes, in French a rocking horse or hobby horse. To Germans it is an indication of idiot naivety and of a preoccupation with procreation and the baby-carriage." Quoted in Hans Richter, *Dada: Art and Anti-Art* (New York: Abrams, 1970), p. 32.

4. The term *decalcomania* combines the French word *décalquer* (meaning "to counterdraw") and the Greek word for madness, *mania*. Evidently, the ending was applied during the 1860s when there was an avocational vogue of unusual intensity for transferring designs from specially prepared paper onto glass, pottery, and so forth.

5. The example of music might well have warned the zealots of the reality of their situation. After all, it is the perfect example of an art form one cannot own. That is, one cannot possess Arnold Schoenberg's Second String Quartet, Opus 10, in the same, exclusive sense that one can own a portrait by Rembrandt. That is because the quartet exists as a musical piece only when it is performed; the score is not the art work and a recording is only of a given performance. This ephemeral property of music has not prevented business interests throughout the world from making use of masterworks for commercial ends. The principal difference between symphony orchestras and groups of conceptual artists is that the musicians exert vastly wider influence and enjoy the support of serious-minded people from all parts of the political spectrum.

6. Frederick Hartt, *Art: A History of Painting, Sculpture, and Architecture* (Englewood Cliffs, N.J.: Prentice-Hall, 1976; New York: Abrams, 1976), II, p. 331.

7. Nikolaus Pevsner, *A History of Building Types* (Princeton, N.J.: Princeton University Press, 1976), p. 84.

8. See Witold Rybczynski, "With Wear and Tear, Habitat Has Become a Home," *The New York Times* (Sunday, August 5, 1990), p. H-27.

9. The term *postmodernism* has a multitude of connotations, some of them having a distinctly political character, the political complexion of which I have discussed in an article, "Assault of the Petulant: Postmodernism and Other Fancies," in the Spring, 1984, volume of *The Journal of Aesthetic Education*. Postmodernist artwork is never really antimodernist in its stance since it makes no attempt to hold up tradition as the objective standard of a style. Yet, it is distinctly different from standard modernism in being willing to use appearances for mere effect. The volume cited in note 10 below provides a wonderful survey of the variety of styles comprised by the postmodernist movement in painting, sculpture, and architecture.

10. Charles Jencks, *Post-Modernism: The New Classicism in Art and Architecture* (New York: Rizzoli, 1987), p. 261.

11. See Ernest L. Schusky, *Culture and Agriculture: An Ecological Introduction to Traditional and Modern Farming Systems* (New York: Greenwood Press, 1989), passim.

12. See John Adkins Richardson, Floyd W. Coleman, and Michael J. Smith, *Basic Design: Systems, Elements, Applications* (Englewood Cliffs, N.J.: Prentice-Hall, 1984), pp. 230–35.

BIBLIOGRAPHY

The following books have been selected because they are (1) of general interest and intelligible to the layman; (2) generally available in college, university, and public libraries; and (3) usually contain bibliographies directing readers to more specialized works.

ARNASON, H. H. *History of Modern Art: Painting, Sculpture, Architecture.* 3rd ed. Englewood Cliffs, N.J.: Prentice-Hall, 1986. New York: Abrams, 1986.

ARNHEIM, RUDOLPH. *Art and Visual Perception.* Berkeley and Los Angeles: University of California Press, 1954. A classic among writings on the psychology of art.

CLARK, SIR KENNETH. *The Nude: A Study in Ideal Form.* New York: Pantheon, 1956. One of the world's foremost art historians explores the tradition of the nude in sculpture and painting from ancient to modern times. Beautifully written and comprehensible to the layman.

GARDNER, HELEN. *Art Throughout the Ages.* 9th ed., revised by Horst de la Croix and Richard G. Tansey. New York: Harcourt, Brace and Jovanovich, 1990. A superb revision of the most famous of all American art history texts (first published in 1926), far more scholarly than earlier editions of the work.

GOMBRICH, ERNST H. *Art and Illusion.* New York: Pantheon, 1960. A masterful work on the psychology of representation in the visual arts. Erudite and entertaining.

GOMBRICH, ERNST H. *The Story of Art.* 12th ed., rev. and enl. London: Phaidon, 1972. Written for English high school students, this is an incredibly good brief introduction to the history of art.

HARTT, FREDERICK. *Art: A History of Painting, Sculpture, and Architecture.* 3rd ed. Englewood Cliffs, N.J.: Prentice-Hall, 1989. New York: Abrams, 1989.

HAUSER, ARNOLD. *The Social History of Art.* Translated in collaboration with the author by Stanley Godman. 2 vols. New York: Knopf, 1951. A synoptic history of art and literature from a sociological slant. Of amazing breadth, the work is rather heavy going for the unsophisticated, and one must be wary of the author's Marxist biases. But it is full of stimulating ideas.

JANSON, H. W. *The History of Art: A Survey of the Major Visual Arts from the Dawn of History to the Present Day.* 4th rev. and expanded ed. by Anthony F. Janson. Englewood Cliffs, N.J.: Prentice-Hall, 1991. New York: Abrams, 1991. An excellent survey of the history of Western art. Highly informed, easy to read, and beautifully illustrated.

LAZZARI, MARGARET R., AND LEE, CLAYTON. *Art and Design Fundamentals.* New York: Van Nostrand Reinhold, 1990. A clever introduction to the foundations of art by two designer-intellectuals with unusually clear perceptions of the differences between what is merely fashionable and what is truly fundamental.

MALRAUX, ANDRÉ. *The Voices of Silence.* New York: Doubleday, 1953. A famous and highly effective work by the French novelist, scholar, and political thinker.

PANOFSKY, ERWIN. *Meaning in the Visual Arts.* Garden City, N.Y.: Anchor Books, 1955. A collection of essays by a great iconographer, written over a period of more than thirty years and covering a wide variety of subjects.

RICHARDSON, JOHN ADKINS; COLEMAN, FLOYD W.; AND SMITH, MICHAEL J. *Basic Design: Systems, Elements, Applications.* Englewood Cliffs, N.J.: Prentice-Hall, 1984. A general introduction to design that contains historical, critical, and technical information on fine art, illustration, two- and three-dimensional design.

GLOSSARY

The following list contains many terms not used elsewhere in this book. Although one may expect to encounter these terms in connection with art, I have not always had occasion or space to touch upon them. Cross references are indicated by words in small capitals.

ABACUS. In architecture, a flat block used as the uppermost part of the capital of a COLUMN.

ABSTRACT ART. Art dependent on the idea that artistic values reside in forms and colors independent of subject matter. An abstract work may resemble something else (apples, nude women, etc.), but the stress will be on form and color. Any work of art can be looked upon as an abstraction, but some styles (CUBISM, ABSTRACT EXPRESSIONISM, NEOPLASTICISM) intentionally emphasize the formal over any symbolic value.

ABSTRACT EXPRESSIONISM. A style of painting in which the artist expresses his feelings spontaneously and without reference to any representation of physical reality. Normally the term signifies a movement that originated in America during the late 1940s, but Wassily Kandinsky had pioneered the essentials of the manner before World War I.

ABSTRACTION. A work that is deliberately "abstract art," as in: "This painting by Picasso is an abstraction."

ACTION PAINTING. A type of ABSTRACT EXPRESSIONISM incorporating impulsive gestures.

AESTHETIC. Having to do with art and beauty. Often used synonymously with a theory of art or to refer to the characteristics of a given style, as, for example, "the IMPRESSIONIST AESTHETIC." (Sometimes spelled ESTHETIC.)

AMPHORA. A jar with two handles used by the ancient Greeks and Romans for storing grain, oil, condiments, etc.

APSE. The exedra, normally semicircular, at the end of a Christian church. It occurs also in the Roman public buildings known as BASILICAS.

AQUEDUCT. A watercourse, often supported in places by an ARCADE.

ARCADE. A series of ARCHES carried by pillars.

ARCH. An engineering device used to span an open area. Arches are

curved and made of wedge-shaped blocks called voussoirs. The central voussoir is known as the keystone. In arch construction no mortar is required; gravity operates to pull the blocks together in such a way that they lean on one another.

ARCHAEOLOGY. The scientific investigation of ancient cultures and civilizations by means of their artifacts.

ARCHAIC ART. A term having various meanings depending on its context. (1) In reference to the field of art, generally, it suggests the very beginnings of art and is applied to all prehistoric art and, by extension, (2) to the artifacts of tribal cultures of later eras. (3) When applied to the art of ancient Greece, it refers specifically to objects created prior to 600 B.C.

ARCHITRAVE. see ENTABLATURE.

ARMORY SHOW. The first large, public exhibition of modern art in the United States. Organized by THE EIGHT and some sympathizers, it was held in the 69th Regiment Armory building in New York City in 1913. The show outraged the average viewer and the press, but it was the most influential ever presented in America, for the European works in it opened a vast range of possibilities to domestic artists.

ART NOUVEAU. A decorative style of the 1890s which attempted to break with past traditions. It is characterized by interlacing plant forms and similar organic elements along with relatively flat color treatments.

ASH CAN SCHOOL. see THE EIGHT.

ATMOSPHERIC PERSPECTIVE. The illusion of depth in painting created by reduction of contrast between lights and darks, cooling of colors, and blurring of outlines as things represented recede from the picture plane.

AVANT-GARDE. French word for vanguard. Artists who are unorthodox in their approach. The connotation is that such people are "ahead of their time," but it sometimes happens that they are merely eccentric. Still, REALISM, EXPRESSIONISM, DADAISM, CUBISM, and the others are all examples of avant-garde movements.

BAROQUE. Generally, the seventeenth century. The term connotes grandiose elaboration in architecture and decoration, since that is typical of the period. Dutch art of the period, however, is quite different and is distinguished by the name Protestant Baroque.

BARREL VAULT. see VAULT.

BASILICA. In ancient Rome, a public building used for various assemblies, particularly tribunals. It is rectangular in plan and is entered on the longer side. See also CHRISTIAN BASILICA.

BATIK. A process of dyeing cloth by painting designs on in wax so that only exposed areas are impregnated with the dye. The wax is removed after dyeing.

BAUHAUS. A school of industrial design founded in Weimar, Germany, in 1919 by architect Walter Gropius. Known for its attempts to integrate art and technology.

BENDAY PATTERN. In commercial printing, the technique invented by Benjamin Day (1838–1916) which adds tints to the linecuts by means of dots, lines, and other regular patterns.

DER BLAUE REITER. "The Blue Rider." A branch of German EXPRESSIONISM centered in Munich. Tends to be far more abstract than DIE BRÜCKE.

BROKEN COLOR. The technique of applying paint in brief, rather heavy strokes on top of a background color. Typical of IMPRESSIONISM.

DIE BRÜCKE. "The Bridge." A branch of German EXPRESSIONISM centered in Dresden. Very similar in appearance to FAUVISM but more pessimistic about things in general.

BUON FRESCO. see FRESCO.

BUTTRESS. In masonry, a support to take up the THRUST of an ARCH or VAULT. A pier buttress is a solid mass of stone that rises above the outer wall of a Gothic or Romanesque church. A flying buttress is an arch or series of arches carrying the thrust of the nave vaults across open space to a pier buttress.

BYZANTINE. Pertaining to the BYZANTINE EMPIRE. Byzantine painting is characterized by a religious ICONOGRAPHY, rich use of color, highly formal design, and frontal, stylized presentation of figures. Byzantine architecture is characterized by domes, spires and minarets, and the widespread use of MOSAICS.

BYZANTINE EMPIRE. The Eastern Roman Empire. It lasted from A.D. 395 to 1453. Its capital was Constantinople, built on the site of the ancient Greek city of Byzantium by Constantine the Great.

CAMPANILE. A bell tower.

CANTILEVER. An engineering form which projects into space at one end and is firmly anchored at the other.

CAPITAL. see COLUMN.

CARTOON. A full-size preliminary DRAWING for a painting. Also, a frivolous or satirical drawing. (The former is the original meaning but is retained today only within art circles.)

CENTRIFUGAL CASTING. A process of metal casting commonplace in jewelry-making and other fields in which smallness of scale and precision of form are usual. Molten metal is forced into a mold by spinning the latter at extremely high speed on the end of a steel arm.

CERAMICS. Pottery making. More specifically, objects made of clay and fired at high temperatures to render them stronger and/or waterproof.

CHARCOAL. A drawing medium produced by charring organic substances (wood or bone) until they are reduced to carbon. A drawing made with charcoal.

CHASE. To ornament metal by indenting it with a hammer and tools that do not cut it. See also REPOUSSÉ.

CHIAROSCURO. Light-dark relationships in a work of art.

CHOIR. The space in a Christian church reserved for singers and clergy.

CHRISTIAN BASILICA. An early church form resembling a Roman BASILICA in plan, but entered from one end and having an APSE at the other.

CIRE-PERDUE PROCESS (or lost-wax process). A process of metal casting that consists of building up a refractory mold around a wax model, baking it until the wax melts and drains off through small holes in the mold, and then pouring metal into the empty space.

CLASSICAL. Narrowly, the term refers to the art of the ancient Greeks during the "Golden Age" of the fifth century B.C. By extension it is applied to all the works of antiquity from 600 B.C. through the fall of Rome. By still further extension Classical is used to describe any form thought to be derived from Greek and Roman examples; thus, the art of the Italian Renaissance is sometimes called Classical. It is, however, rather more common to refer to styles derived from the Antique as representing CLASSICISM. To be Classical implies perfection of form, emphasis on harmony and proportion, and restraint of emotion. Normally, the term is applied only to art that is idealistic and representational.

CLASSICISM. see CLASSICAL and NEOCLASSICISM.

CLERESTORY (or clearstory). In architecture, a part of a building raised above an adjoining roof and containing windows in its walls.

CLOISONNÉ. From the French word cloison (partition). A metalsmithing process in which strips of metal are soldered to a base, thus forming cells to contain enamel or other decorative materials.

CLOISTER. A covered walk on the side of a court. Common in MEDIEVAL monasteries in western Europe.

COLLAGE. A picture made up in whole or in part by gluing various materials (newspaper, wallpaper, cloth, photographs, bits of wood, etc.) to a piece of canvas or other GROUND.

COLLAGRAPHY. A relief-printing method which uses as the printing surface cardboard shapes and pieces of materials glued onto a base. It is often used in conjunction with INTAGLIO or LITHOGRAPHIC techniques.

COLLOTYPE. A photoreproduction method for making prints from photosensitive gelatin spread on sheets of glass or metal.

COLOR-FIELD PAINTING. A kind of painting emphasizing large, usually unbroken, zones of color. Normally the term is applied only to paintings done by artists active after 1950.

COLUMN. A vertical, cylindrical architectural member used to bear weight. Columns consist of a base at the bottom, a SHAFT, and a capital. Sometimes, as in DORIC columns, the base is nothing more than whatever the shaft rests on. The capital is the upper member of the column, and serves as a transitional unit from the vertical SHAFT to the horizontal LINTEL.

COMPLEMENTARY COLORS. Colors which are opposite each other on

a color wheel. When mixed together in proper proportions, they form a neutral gray.

CONCEPTUAL ART. A form of art whose "product" is not a physical object but a mental conception of some sort. The work may entail the use of pictures, documents, recordings, and other data, but the work itself is a mental synthesis of the material. Similar to and related to HAPPENINGS.

CONNOISSEUR. Technically, an expert on art whose profession is identifying the specific artist who created a specific work. Generally, a person of highly developed artistic sensibilities.

CONSTRUCTIVISM. A twentieth-century movement in sculpture which emphasizes precision, technology, and NONREPRESENTATIONAL form.

CONVENTION. A practice established by custom and performance and widely recognized and understood.

COOL COLORS. Blue and such hues as approach blue.

CORBELED ARCH. A primitive sort of ARCH which spans an opening by means of masonry walls built progressively farther inward until they meet.

CORINTHIAN ORDER. The least consistent of the three principal ORDERS of Classical architecture. Frequently it resembles the IONIC except for the capital (*the* distinguishing feature of Corinthian), which is treated as a vase of acanthus leaves. Invented by the Greeks, it was never popular among them but found favor with the Romans, who admired its grandiose character.

CORNICE. see ENTABLATURE.

COUNTER REFORMATION. The reform of the Catholic Church during the sixteenth century. (The term is objected to by Catholics because, in fact, the reforms had begun before the rise of Protestantism.) The founding of the Society of Jesus (the Jesuit order), the convening of the Council of Trent, and the establishment of the papal Inquisition are among the notable consequences of Catholic reform.

CROSS-HATCHING. The production of relative VALUE relationships in drawing by placing sets of more or less parallel lines on top of one another at varying angles.

CROSSING. The space in a cruciform church where the NAVE and TRANSEPT cross.

DADAISM. A MOVEMENT begun in Zurich during World War I. It reacted to the war by expressing the absurdity of all CONVENTIONS and the futility of all acts. It soon became international in scope.

DIPTYCH. A two-panel altarpiece or devotional picture, normally hinged so that it can be closed like a book.

DISTEMPER. Any of a number of water-base paints using a simple glue or casein as the binder. Calcimine, showcard, and poster colors are examples. (The "TEMPERA" of the primary grades is a distemper.) The term is more common in Great Britain than in the United States.

DORIC ORDER. The most consistent of the three major ORDERS of Classical architecture. It is characterized by a COLUMN resting directly on the floor and a shaft with continuous fluting. The capital has a round, bulging element called an ECHINUS and is topped by an ABACUS. The ENTABLATURE has a plain architrave and a FRIEZE made up of alternating TRIGLYPHS and METOPES.

DRAWING. The projection of an image on a surface by some instrument capable of making a mark. Drawings may be done with pencils, pens, brushes, PASTELS, crayons, CHARCOAL, ETCHING tools, and numerous other implements. Most often, drawings serve as studies or sketches for a work in some other medium, but they are frequently done as completed works in themselves.

DRYPOINT. The simplest form of metal ENGRAVING. Done by scratching a soft metal such as copper with a sharp steel needle.

EARTHWORKS. In art, a form of sculpture in which the artist designs a pattern that is carved, dug, or built into the landscape itself.

ECHINUS. In the DORIC ORDER, the bulging cushion-like member between the ABACUS and the NECKING.

THE EIGHT. A group of painters active in New York City at the beginning of the twentieth century. For the most part, they were REALISTS with strong social convictions, and they took as their subjects the streets and back alleys, the tenements and their immigrant inhabitants. They are better known today as the Ash Can School, an appellation that most of us suppose was tacked onto them by critics offended by the raw candor of their work but that actually was first applied openly in 1937 by Helen Appleton Read in her introduction to the catalogue for the exhibition, *New York Realists, 1900–1914* at the Whitney Museum of American Art. The term seems to have been invented by cartoonist Art Young, a doctrinaire socialist, who told the leader of The Eight, John Sloan, that the only "revolutionary content" in their works were the ash cans. (See William Innes Homer, *Robert Henri and His Circle*. Ithaca: Cornell University Press, 1969, pp. 130 and 230, n. 18.)

EMBOSS. To raise up from a surface.

ENCAUSTIC. A painting MEDIUM using hot colored waxes. It is extremely permanent.

ENGAGED COLUMN. A COLUMN forming part of a wall and more or less projecting from it.

ENGRAVING. The process of cutting a design into a substance, usually metal, with a sharp tool. Also refers to a print made from an engraved plate.

ENTABLATURE. The horizontal portion of a building between the capitals of the COLUMNS and the roof or upper story. In Classical architecture the entablature consists of a horizontal beam called an architrave (which may be plain or banded), a FRIEZE (in the DORIC ORDER made up of TRIGLYPHS and METOPES and in the IONIC and CORINTHIAN either unadorned or covered with a continuous relief decoration), and a cornice. The latter is a projecting molding that runs along the top of the entablature.

ENTASIS. A slight, almost imperceptible curve in architectural elements, particularly in the shafts of Classical COLUMNS.

ESTHETIC. see AESTHETIC.

ETCHING. The process of producing a design on a metal plate by use of acid or similar mordants. Also refers to a print made from an etched metal plate.

EXPRESSIONISM. Strictly, German Expressionism. A MOVEMENT in the arts that originated in Germany just prior to World War I, emphasizing the subjective aspects of the artist and his subjects. By extension, any art of this type.

FAUVISM. A turn-of-the-century MOVEMENT in France characterized by bright, flat zones of color. Similar to German EXPRESSIONISM of the more representational sort (e.g., DIE BRÜCKE), except that it took a far more optimistic view of humanity and our circumstances.

FENESTRATION. The arrangement of windows in a building. Sometimes the term is applied to the arrangement of all the openings—windows, doors, and so on.

FERROCONCRETE. Steel-reinforced concrete. That is, concrete reinforced by embedding steel mesh, nets, rods, or bars in the cement while it is wet.

FLORENTINE RENAISSANCE. The period from the fourteenth to the sixteenth century in the city of Florence, the cradle and the jewel of the Italian RENAISSANCE.

FLYING BUTTRESS. see BUTTRESS.

FOLK ART. Art and craft objects produced by untrained people as an expression of community life. Usually the craftsmen are anonymous and the objects relatively utilitarian.

FRESCO. The term *fresco*, used alone, refers to what is known, strictly, as *buon fresco*—a painting made on wet plaster so that the pigments become incorporated into the plaster. *Fresco secco* is painting done on dry plaster so that the wall surface serves as a GROUND.

FRIEZE. The band between the cornice and the architrave in an ENTABLATURE. By extension, any richly ornamented band and, further, any arrangement suggesting such a frieze.

FRONTALITY. In sculpture and figurative painting the term refers to deemphasis of the lateral aspects of things. In painting, generally, it refers to the arrangement of planes parallel to the canvas surface. With respect to modern art it has a less precise meaning, but suggests that the tangible, two-dimensional surface of the picture is emphasized.

FUTURISM. An Italian MOVEMENT originating prior to World War I which hoped to glorify the dynamism of the machine age.

GENRE. Normally the word is used to refer to pictures in which the subject matter is drawn from everyday life. It is also used in a more general sense to describe whole categories of subject matter. Thus,

one may speak of "the landscape genre," "the still-life genre," "the genre of figure painting," and so on. Sometimes it is applied to mediums: genre of painting, sculpture, etc.

GEODESIC DOME. A building form, constructed of small, triangular MODULES, devised by Buckminster Fuller.

GERMAN EXPRESSIONISM. see EXPRESSIONISM.

GESSO. A mixture of plaster of Paris and glue used as a GROUND for painting.

GLAZE. In painting, a PIGMENT (usually oil) applied in transparent layers. In CERAMICS, a vitreous coating applied before firing to seal the surface or used as decoration.

GOLDEN AGE. Any age of high culture in a civilization. Most commonly, the term is applied to Athens under Pericles (495–429 B.C.) and to the BYZANTINE EMPIRE under Justinian (A.D. 527–565).

GOLDEN SECTION or GOLDEN MEAN. A ratio between the two dimensions of a plane figure or the two divisions of a line such that the shorter element is to the longer as the longer is to the whole.

GOUACHE. Opaque rather than transparent WATERCOLOR. The medium is essentially the same as in transparent watercolor, except that the proportion of binder to PIGMENT is greater and an inert pigment such as precipitated chalk has been added to increase the opacity of the paint.

GRAPHIC. Literally, written, drawn, or engraved. In the arts the term refers, in a narrow sense, to drawing and printmaking. But it is also used in the more commonplace sense to describe something that is striking in its clarity.

GROIN VAULT. see VAULT.

GROUND. Usually, the surface to which paints are applied. In ETCHING the term refers to the waxy coating used to cover the plate and prevent mordants from acting upon it.

HAPPENING. A satiric act which takes place in a specially constructed or devised environment. Has both sculptural and theatrical aspects, but no permanent form is established. The "put-on" side of such an event is considered a vital part of its seriousness.

HARD-EDGE PAINTING. Any painting style employing very clean, sharp edges and flat areas of color. Normally restricted in application to work done by artists active after 1950.

HUE. The name of a color, such as red, blue, yellow (primaries); orange, green, violet (secondaries); and the intermediate (tertiary) colors.

ICON. Literally, an image. Specifically, an image of a sacred person regarded as an object of veneration in the Eastern Church.

ICONOCLAST. Image breaker. Originally the term was applied to the BYZANTINE ruler Leo III (680–740), who opposed the religious use of images. It has been extended to apply to anyone who actively questions generally accepted intellectual, ethical, or moral attitudes.

ICONOGRAPHY. The study of images primarily in terms of their symbolic intentions. (The study of the deeper significance of content and its general importance is sometimes referred to as iconology.)

ILLUMINATED MANUSCRIPT. A manuscript whose pages (and especially the initial letters) are decorated with silver, gold, and bright colors. Sometimes such manuscripts contain MINIATURES.

ILLUSTRATION. Imagery that relates explicitly to something else— that serves to clarify or adorn an anecdote, literary work, description, event, etc.

IMPASTO. The texture of paint applied in a thick, pasty form.

IMPRESSIONISM. Specifically, French Impressionism. A MOVEMENT in painting that originated during the last third of the nineteenth century. It attempted to attain a sort of ultimate NATURALISM by extending REALISM beyond value relationships to an exact analysis of color. A typical Impressionist work is painted with short, brightly colored dabs of paint. The subject matter tends to be unproblematical and undramatic.

INTAGLIO. A design sunk into a surface so that the impression it makes is in RELIEF. Signet rings are common examples, as are engraved plates.

INTENSITY. The dullness or brightness of a color. (Not to be confused with VALUE, meaning the color's darkness or lightness.) Often referred to as chroma.

INTERCOLUMNIATION. The space between COLUMNS in a row of them.

IONIC ORDER. The second major ORDER of Classical architecture. It is lighter than the DORIC and is distinguished by the scroll-like volute decoration of the capital. The shaft has separated flutes and a concave-convex molding at its base. With the exception of those in Athenian buildings, Ionic COLUMNS usually rest on PLINTHS. The ENTABLATURE contains a banded architrave and a FRIEZE that is either plain or ornamented with a continuous RELIEF decoration.

JUGENDSTIL. A German decorative style that parallels ART NOUVEAU.

KEYSTONE. see ARCH.

KINETIC ART. Works of art that are designed to move, either in response to human presence (because of touch, electric-eye beams, etc.) or because they are mechanized.

LINTEL. A horizontal beam spanning an opening.

LITHOGRAPHY. A printing technique in which the image to be printed is drawn on a flat surface, as on Bavarian limestone or a sheet of zinc or aluminum. The process takes advantage of the antipathy of oil for water.

LOCAL COLOR. The natural color of an object as seen under normal daylight.

MAGIC REALISM. A style of painting that often overlaps with SURREALISM but is distinctive in that it involves a sharp, precisely detailed rendering of real things. There are actually two types: (1) that which brings prosaic things into unusual and disturbing juxtaposition, (2) a variety that depicts ordinary things with such abnormal clarity as to lend them extraordinary overtones.

MANDORLA. An almond-shaped aureole or nimbus (sometimes called a glory) surrounding the figure of God, Christ, the Virgin Mary, or sometimes a saint.

MANNERISM. A style in Italian art that developed between about 1520 and 1600.

MEDIEVAL PERIOD. see MIDDLE AGES.

MEDIUM. The vehicle or liquid with which PIGMENT is mixed. In a more general sense, the material through which an artist expresses himself (e.g., paint, metal, wood, printmaking). In technical usage the term refers to the substance used to thin or otherwise modify the PIGMENT and its vehicle.

METAPHYSICAL PAINTING. An Italian MOVEMENT in painting during the earlier part of the twentieth century. The strangely evocative paintings by Giorgio de Chirico formed the basis of the movement and also had a profound influence on SURREALIST imagery.

METOPE. One of the panels between the TRIGLYPHS in a DORIC FRIEZE. Often these are decorated with RELIEF sculpture.

MIDDLE AGES. The period in Western history between, generally, A.D. 400 and 1300.

MIMESIS. Literally, to imitate. Thus, the representation by illusion of the properties of the external world.

MINIATURE. Any small image, but particularly a little picture illustrating an ILLUMINATED MANUSCRIPT.

MINIMAL ART. Painting and sculpture that stress the simplest color relationships and/or most clearly geometric forms.

MODELING. The forming of three-dimensional surfaces. Thus, the creation of the illusion of such surfaces within the two-dimensional confines of painting or drawing.

MODULE. A given magnitude or unit in the measurements of a work of art or building. Thus, if one used a sixteen-inch module in designing a house, all dimensions would be some multiple of sixteen inches.

MONOCHROMATIC. Consisting of variations of a single HUE.

MOSAIC. The decoration of a surface by setting small pieces of stone or glass (called tesserae) into cement.

MOVEMENT. A general cultural tendency, sometimes carried out by people known to one another but frequently a more diverse response to given stimuli. Thus, one can speak of "the IMPRESSIONIST movement," of a "Black Nationalist movement," or of a "youth movement."

MULLION. A vertical bar used to section off the panes of a window.

NABIS. A group of French painters active between 1889 and 1899. The most outstanding members were Pierre Bonnard and Edouard Vuillard.

NAIVE ART. Works of art created by those without professional training in which a lack of sophistication is preserved as a positive value.

NARTHEX. A porch adjacent to the front of a church and forming a vestibule. Usually it is colonnaded or ARCADED.

NATURALISM. In literature the term corresponds to French REALISM in painting. In art, however, it usually signifies accuracy of transcription of nature. Harnett, Courbet, Manet, and Norman Rockwell are all naturalistic to some degree.

NAVE. The major, central part of a church. It leads from the main entrance to the altar and is separated from the side aisles (if any) by piers and COLUMNS.

NECKING. An indentation between the ECHINUS and shaft of a COLUMN.

NEOCLASSICISM. The attempt in the eighteenth and nineteenth centuries to revive the ideals of the Greeks and Romans in French painting. By extension, any style based on the principles of Neoclassicism. The style attempts to attain perfection and harmony through prescribed limits.

NEOIMPRESSIONISM. The style of painting devised by French painter Georges Seurat at the end of the nineteenth century. It involved a quasi-scientific method of applying color and a highly controlled system of drawing and composition. Called Divisionism by its inventor. Other prominent Neoimpressionists were Charles Angrand, Henri Edmond Cross, and Paul Signac.

NEOPLASTICISM. A type of NONOBJECTIVE painting that reduced form to horizontal and vertical movements and used only black, white, and the primary colors. Its principal practitioner was Piet Mondrian.

NEOROMANTICISM. A painting style associated with and resembling the representational form of SURREALISM, but distinguished by its evocation of lyrical and nostalgic sentiment. The main artists are the brothers Eugene Berman and Leonid Berman (who signs his work "Leonid"), Christian Bérard, and Pavel Tchelitchew.

NEUE SACHLICHKEIT. "The New Objectivity." A reaction against EXPRESSIONISM which occurred in Germany during the post–World War I period. It is "objective" only in that it took a more realistic view of the physical world. Marked by a concern with social problems.

NEW OBJECTIVITY. see NEUE SACHLICHKEIT.

NONOBJECTIVE ART. see NONREPRESENTATIONAL ART.

NONREPRESENTATIONAL ART. Works of art that make no attempt to produce illusions of reality.

OGEE. A double or S-shaped curve. Also refers to the bulging form produced by two ogee curves that mirror one another and meet in a point (i.e., ogee arch).

OP ART. "Optical art"—that is, works of art which depend for their interest on optical illusion, fugitive sensations, and other subjective visual phenomena.

OPTICAL COLOR. The apparent color of an object as opposed to its LOCAL COLOR.

ORDER. Any of the characteristic styles of Classical architecture determined by the particular kinds of ENTABLATURES and COLUMNS used. The three major orders are DORIC, IONIC, and CORINTHIAN. There are also, however, other types and also blends of elements referred to as Composite orders. Applied in broad usage to any systematic treatment of architectural form employing standard components.

PALETTE. The surface on which a painter mixes his paints. More generally the habitual set of colors used by a given artist or group.

PASTEL. PIGMENTS mixed with gum and compressed into stick form for use as crayons. A work of art done with such pigments.

PATINA. A greenish film that forms on copper or bronze through natural or artificial oxidation. Effects similar to this on other substances.

PEDIMENT. In Classical architecture, the triangular space formed by the end of a building with a pitched roof.

PERISTYLE. A continuous colonnade surrounding a building or a court.

PERSPECTIVE. The common name for central projection, a scheme for representing three-dimensional objects on a two-dimensional surface in terms of relative magnitude.

PIER BUTTRESS. see BUTTRESS.

PIGMENT. A substance that has been ground into a fine powder and is used to color paints or dyes.

PILASTER. A flat, rectangular projection which resembles an ENGAGED COLUMN.

PLINTH. A block serving as a pedestal for a column or statue.

POINTILLISM. The application of pigment in small dots rather than by means of the usual brushstroke. Employed by the NEOIMPRESSIONISTS but also used by other artists.

POLYPTYCH. A many-paneled altarpiece or devotional picture, sometimes hinged so that it can be folded up.

POP ART. Serious painting using elements from commercial illustration, cartoons, signs, and ordinary mass-produced objects as subject matter.

POSTIMPRESSIONISM. A catchall term for the styles employed by painters influenced by IMPRESSIONISM who modified it into more personal modes of expression. The painters most frequently cited as examples of Postimpressionists are Cézanne, Renoir, Van Gogh, and Gauguin.

POSTMODERNISM. A name given to a variety of contemporary styles that employ many technical means associated with modern art but deviate from it in being less formal and more eclectic.

POTTERY. Objects of clay that have been hardened by firing.

PRECISIONISM. A MOVEMENT in American art that began in the 1920s, typified by the work of Charles Sheeler and Georgia O'Keeffe. It combines realistic subject matter with extreme formal control.

PRIMITIVE ART. A term becoming less common because of overuse and pejorative connotations. It has the following meanings, more or less in this order: (1) art produced by tribal cultures; (2) art created by amateur artists in which unsophisticated vision and lack of technical skill have, for one reason or another, come to be counted as virtues; (3) art produced by Netherlandish and Italian painters active before 1500.

PRINT. A work of art produced in multiple copies by hand methods and printed by the artist himself or under his direct supervision.

RAKING CORNICE. The molding edge on the slanting sides of a PEDIMENT.

REALISM. A nineteenth-century MOVEMENT in painting which stressed matter-of-fact descriptions of actual things. Frequently, as in Courbet (who coined the name of the style), Realism focused on the squalid and depressing. But Manet's work shows that ignoble themes are not fundamental to the manner. It is really a nonsentimental, rather broad version of NATURALISM.

REFORMATION. A religious revolution in western Europe during the sixteenth century. It began as a reform movement within the Roman Catholic Church but evolved into the doctrines of Protestantism. Its outstanding representatives are Martin Luther and John Calvin.

REFRACTION. The bending of a light ray or wave of energy as it passes through a substance.

REGIONALISM. The name given to the work of certain American painters prominent in the 1930s. Their works tended to represent specific regions and to portray common people in everyday activities. Notable among these are Thomas Hart Benton, Grant Wood, Edward Hopper, and John Steuart Curry.

RELIEF. In sculpture, the projection of a form from a background to which it is attached. In high relief the figures stand far out from the base. In bas-relief (or low relief) they are shallow.

RENAISSANCE. Usually signifies the rebirth of art and humane letters (as opposed to divine letters) during the fourteenth and fifteenth centuries, particularly in Italy. Early Renaissance covers the period from about 1420 to 1500 and High Renaissance from about 1500 to 1527 (the date of the sack of Rome by the Holy Roman Emperor Charles V). These dates are for painting and architecture in Italy; for literature, the date is often given as Petrarch's birth, 1304. Some authorities define the High Renaissance as lasting until 1580. With respect to England, the dates are quite different. William Shakespeare is considered a Renaissance playwright, though he was born in 1564 and died in 1616.

REPOUSSÉ. The forming of a design in metal by working it from the back and leaving the impression on the face. See also CHASE.

REPRODUCTION. The production of multiple images of a work of art by photomechanical processes. (Compare PRINT.)

ROCOCO. Primarily a style of interior decoration in vogue in France from the death of Louis XIV (1715) to around 1745. It had some influence in Germany, Austria, Italy, and Spain, particularly in the northern countries. Tending toward prettiness and frivolity, its effects can be seen in paintings by Watteau, Boucher, Fragonard, and Tiepolo, but it reached its loftiest form in Catholic Germany and Austria, where it produced extraordinarily beautiful church interiors.

ROMANTICISM. A MOVEMENT in painting that first appeared in France during the early nineteenth century. It attempted to express the entirety of human experience, both real and imagined. By extension, applied to any work of art expressing interests thought similar to or characteristic of Romanticism.

ROSE WINDOWS. The large circular windows of stained glass found in Gothic cathedrals.

SARCOPHAGUS. A stone coffin.

SCHOOL. A word with a great variety of meanings, all of them based on the assumption of identifiable similarities among the works of various artists who (1) studied with the same master, (2) imitate the same master, (3) work together as a group, (4) express the same interests in their works, (5) lived in the same place and time, (6) have the same country of origin. Thus: the School of Raphael (1 and 2); the French Impressionist School (3); the Pop Art School (4); the School of Florence (5); the Italian School, as contrasted with the French School (6).

SCULPTURE IN THE ROUND. Freestanding statues, such as Michelangelo's *David*, as opposed to RELIEF sculpture.

SFUMATO. Gradations in tone and color, used to produce a hazy effect and blur the edges of a form.

SGRAFFITO. A design produced by scratching through one layer of material into another of a contrasting color. Frequently used in pottery decoration, but also employed by painters and sculptors.

SHAFT. The long part of a COLUMN between the base and capital.

SLIP. Clay which has been thinned to the consistency of cream. It can be poured into molds of plaster and thereby cast into pots or can be used as a paint to ornament CERAMIC pieces.

SOCIAL REALISM. A general term used to describe various styles in art (Courbet's, Daumier's, Grosz's, e.g.) which emphasize the contemporary scene, usually from a left-wing point of view and always with a strong thematic emphasis on the pressures of society on human beings.

SPANDREL. The triangular space between the curves of two adjacent ARCHES.

STEEL-REINFORCED CONCRETE. see FERROCONCRETE.

STEREOTYPE. In common usage, a standardized mental picture that represents things in a false and oversimplified manner. (For example, the stereotype of women as poor drivers or of Negroes as lazy and superstitious.) In art the term refers to a form that is repeated mechanically, without real thought. In printing it refers to identical relief printing surfaces produced by taking a mold from a master surface and then casting copies. These copies are called stereotypes.

DE STIJL. A Dutch magazine of the early twentieth century devoted to NEOPLASTICISM. (In Dutch, the title means the Style.) The term is used to refer to the ideas advocated by the magazine; they had a marked influence on the BAUHAUS and on commercial design generally.

STUCCO. A finish for the exterior walls of a structure, usually composed of cement, sand, and lime.

SUPREMATISM. A NONREPRESENTATIONAL style devised by Kasimir Malevich in the early twentieth century. It amounts to a kind of Russian NEOPLASTICISM.

SURREALISM. The post–World War I MOVEMENT which drew inspiration from Freudian psychology and extended the arbitrary irrationality of DADAISM into a doctrinaire exploration of the unconscious.

TAPESTRY. A heavy, handmade textile in which the threads (usually the weft or horizontal threads) are woven to create a picture or abstract pattern.

TEMPERA. Paint using egg as the binder for the pigment. Technically called egg tempera.

TERRA-COTTA. A brownish-orange earthenware used for sculpture and pottery or as a building material. Sometimes it is GLAZED, sometimes not.

TEXTURE. The tangible quality of a surface—that is, its smoothness, roughness, slickness, softness. The simulation of such qualities by illusion in drawing and painting.

THRUST. The outward force exerted by the weight of an ARCH or VAULT.

TRACERY. Stone forms that decorate Gothic windows and hold the glass in place.

TRANSEPT. Either of the arms of a cruciform church that extend at right angles to the NAVE.

TRIFORIUM GALLERY. In a cathedral, the area above the aisle and between the NAVE ARCHES and the CLERESTORY.

TRIGLYPH. In the DORIC ORDER, a panel of three projecting members separating the METOPES in the FRIEZE.

TRIPTYCH. A three-panel altarpiece or devotional picture, usually so designed that the central panel is twice as wide as the other two, with the latter hinged so that they can be folded over to cover the central one.

TYMPANUM. The recessed face of a PEDIMENT or, in medieval cathedrals and other buildings, the space above a LINTEL and within an ARCH often containing RELIEF sculpture.

VALUE. The relative lightness or darkness of a color.

VAULT. Any roof constructed on the ARCH principle. A barrel vault is a continuous row of arches joined to one another. A groin vault consists of two barrel vaults intersecting each other at right angles. A dome is a hemispherical vault—an arch turned on a central upright axis. Vaults may be of masonry, brick, or concrete.

VOUSSOIR. see ARCH.

WARM COLOR. Red and the hues that approach red, orange, and yellow. Sometimes yellow-green is considered a warm color.

WATERCOLOR. Strictly, any pigment mixed with water, but usually signifying transparent watercolor in which the binder is gum arabic.

WOODCUT. A relief printing surface carved from the plank grain of a piece of wood. The image printed from such a surface.

WOOD ENGRAVING. A relief printing surface carved from the end grain of a piece of wood. The image printed from such a surface.

GUIDE TO THE PRONUNCIATION OF ARTISTS' NAMES

Correct pronunciation of foreign names has very little to do with artistic understanding per se, but knowing the sound of a name is often helpful in communication. Therefore, I have included the following guide, which contains names of all artists whose work is reproduced in this text with the exception of those pronounced in the customary American way.

The guide entails a simplified approach, aiming at *acceptable* pronunciations rather than absolutely perfect ones. The subtleties of variation among tongues make it impossible to illustrate precise discriminations without the use of language records and specialized alphabets and markings. In using the guide, keep in mind the following:

Italicized syllables are to be stressed.

An *x* indicates a guttural. (*H* pronounced while clearing the throat approximates this sound.)

The sounds *ö* and *ü* have no equivalent in English; to say them, shape your lips to say *e* as in "evil" and sound the *o* or *u*.

The French nasal sounds (*an, in, on, un*) can only be conveyed orally, but the general idea is to sound the letters through your nose.

Words appearing in parentheses repeat the sound just given.

Vowel sounds are indicated as follows:

a is as in *man*	*eye* is as in *mine*
ay is as in *lane*	*oe* is as in *oar*
ah is as in *dart*	*oo* is as in *boor*
e is as in *Ben*	*o* is as in *box*
ee and *ea* are as in *keen*	*uh* is as in *mud*
or *lean*	*u* is as in *use*
i is as in *in*	

ANGELICO, FRA Ahn-*djay*-li-coe, Frah

ANUSZKIEWICZ, RICHARD Ann-uh-*skay*-vitch (*Not* An*noose*-kuh-vitz)

BOCCIONI, UMBERTO Baht (bought)-tshee-oe-nee, Oom-*bar* (beat)-toe

BOFILL, RICARDO Boe-fil, Ree-cahr-doe

BOTTICELLI, SANDRO Baht (bought)-tea-*tshel*-ee, *Sand*-roe

BOUGUEREAU, WILLIAM Boo-guh-roe, Vill-yam

BRAQUE, GEORGES Brack, Zhor-zh (Often, by error, *brock*.)

BRONZINO, ANGELO (AGNOLO) Bron-*dzee*-no, *Ahn*-djay-loe

BRUEGEL, PIETER Broo-gl, Pea-tr (*Never Brü-gl* despite many dictionary entries and the like. Dutch has no umlaut sound.) Often spelled *Brueghel*, as the artist did until 1559, when he dropped the *h*.

CAMPIN, ROBERT Can (French nasal)-pin (French nasal), Rahb-air

CANALETTO, ANTONIO Ca-nal-*et*-toe, Ahn-*toe*-nee-oh

CARAVAGGIO Cahr-a-*vadj*-gee-oe

CASSATT, MARY Cass-*satt*, *Ma*-ree

CÉZANNE, PAUL Say-zann, Pol (doll)

CHARDIN, JEAN-BAPTISTE Shar-din (French nasal), Zhahn Bat-tea-st

CHIRICO, GIORGIO DE *Key*-ray-coe, Dj-*or*-djioh day

CIMABUE Tshee-ma-*boo*-ay

CORBUSIER, LE Cor-boos-ee-ay, Le (Real name: Charles-Edouard Jeanneret)

COROT, JEAN-BAPTISTE CAMILLE Cah-roe, Zhahn Bat-tea-st Ca-mee-y

COURBET, GUSTAVE Coor bay, *Güss* tav

DAGUERRE, LOUIS Dah-*gar*, Loo-ee

DALI, SALVADOR *Dah*-lee, Sal-vah-*dor* (more)

DAUMIER, HONORÉ Doe-mee-ay, Oe-nah-ray

DAVID, JACQUES-LOUIS Da-vid, Zhahk Loo-ee

DEGAS, EDGAR Duhg-gah, Ed-gar

DELACROIX, EUGÈNE Duh-la-crwa, Oe-zhen

DUCHAMP, MARCEL Dü-chan (French nasal), Mar-sel

DÜRER, ALBRECHT *Dü*-rur, *Al*-brext

EYCK, JAN VAN *Ay*-ick, Yan van

GABO, NAUM *Ga*-boe, *Na*-oom

GARNIER, CHARLES Gahr-*yay*, Sharhl

GÉRICAULT, THÉODORE Zhay-ree-coe, Tay-oe-dor (more)

GIORGIONE Djior-dji-*oe*-nay

GIOTTO Djiot-toe

GOGH, VINCENT VAN Xoh*x*, *Vinn*-cent van (But in English, usually van *goe*)

GOLTZIUS, HEINRICH *Xoll*-tsee-uhs, *Heyen*-rick

GOYA, FRANCISCO *Go* (gosh)-ya, Fran-*this*-coe

GRECO, EL *Grek*-coe, Ell

GROSZ, GEORGE Groes (grow), Zhorzh

GRÜNEWALD, MATTHIAS *Grü*-nay-valt, *Mat*-tea-as

GUARDI, FRANCESCO Goo-*ahr* (are)-dee, Fran-*chess*-coe

HOLBEIN, HANS *Hoel* (hole)-beyen (mine), Hans

INGRES, JEAN-AUGUSTE-DOMINIQUE In-gr, Zhahn Oe-gust Do-men-*eek*

KANDINSKY, WASSILY Kan-*din*-skee, Vass-*see*-lee

KIENHOLZ, EDWARD *Keyen* (mine)-hoelts (bolts)

KIRCHNER, ERNST LUDWIG *Kir-x*nr, *Air*-nst *Lood*-vig

KLEE, PAUL Klay, Pol (doll)

LA TOUR, GEORGES DE La-toor, Zhorzh duh

LÉGER, FERNAND Lay-zhay, Fair-nan (French nasal)

LEONARDO DA VINCI Lay-oe-*nar*-doe da *Vinn*-tshee

LICHTENSTEIN, ROY *Licked*-en-steyen (wine)

LORRAIN, CLAUDE Loe-rin (French nasal), K-load (Real name: Claude Gellée)

MALEVICH, KASIMIR Mal-*ay*-vitch, *Kah*-si-mir

MANET, EDOUARD Ma-*ne* (like *net* without the *t*), *Ay*-dwar

MANTEGNA, ANDREA Man-*ten*-ya, Ahn-*dray*-ah

MARC, FRANZ Mahrk, Frahnts

MASACCIO Ma-*zatsh* (watch)-shee-oe

MATISSE, HENRI Mah-tea-ss, An (French nasal)-ree

MICHELANGELO Me-kell-*an*-djay-loe

MIES VAN DER ROHE, LUDWIG Mees (lease) van duhr *Roe*-heh, *Lood*-vig

MIRÓ, JOAN Mi (mist)-*roe*, *Xo*-ahn

MONET, CLAUDE Mo (motto)-ne (like *net* without the *t*), K-load

MORISOT, BERTHE Mo (motto)-ree-zo, Ber (berry)-t

NOLDE, EMILE *Noel*-day, *Ay*-meal

PALLADIO, ANDREA Pah-*lah*-deeoh, Ahn-*dray*-ah

PICASSO, PABLO Pea-*cahs*-so, *Pah*-bloe

POLYCLITUS Poli-*klee*-tuhs or Poli-*kleye*-tuhs

POUSSIN, NICOLAS Poohs-sin (French nasal), Nee-coel (coal)-ah

PRAXITELES Prak-*sit*-uhl-eez

PRUD'HON, PIERRE-PAUL Prü-don (French nasal), Pea-air Pol (doll)

RAPHAEL *Rah*-fa-ell (Not *Ray*-fay-ell)

REMBRANDT VAN RIJN *Rem*-brant van Rheyen (Rhine)

RENOIR, PIERRE-AUGUSTE Ren-*wahr* (very soft *r*), Pea-air Oe (oh)-güst

RODIN, AUGUSTE Rod (not *road*)-in (French nasal), Oe (oh)-güst

ROUSSEAU, HENRI Rooss-*ssoe* (so), *Ahn*-ree

RUBENS, PETER PAUL *Roo*-bns, Pay-tr Pah-ool

SEURAT, GEORGES Ssö-rah, Zhorzh

TINTORETTO Tin toe *ret* toe

TITIAN *Ti*-shn

VELÁZQUEZ, DIEGO Vayl (veil)-*ath*-keth, Dee-*ay*-goe

VERMEER, JAN Ver (very)-*may*-r, Yan

VIGÉE-LEBRUN, ÉLISABETH Vee-zhaye Lub-run, Ale-ee-za-bet (*Not* th)

WATTEAU, ANTOINE Vat-toe, An (French nasal)-twahn (But usually Anglicized to Waht-toe in the United States.)

INDEX

Page numbers are in Roman type. Numbers in *italic* type indicate pages on which illustrations appear. Titles of works of art are in *italics*.

religion, and artistic convention, 41–49
Rembrandt van Rijn, 49, 118, 172, 232, 340, 341; *Adam and Eve*, 270, 334–35, 341; *332; Christ at Emmaus*, 21, 49, 338, 341; *22, 48; Christ Before Pilate*, 341–43; *343; Descent from the Cross: By Torchlight*, 114, 231; *115; Syndics*, 204
Renaissance, 45–46, 318, 325, 353, 359; High, 216, 325, 329, 330, 332, 335
Renaissance art, 25, 320–28; architecture and, 320–22, 326–28, 342, 344, 384; Italian, 13, 44–45, 46, 76–77, 323–28; nudes in, 85, 86, 87, 323; perspective in, 148, 152, 165–66, 187, 320, 330–31; realism in, 44–45, 47–49, 50, 273; Wölfflin's theory of, 329–35, 342
Renoir, Pierre-Auguste, 54, 85, 174, 361, 368; *Bathers*, 174, 361; *175; Moulin de la Galette*, 19, 54, 55; *20, 54, 362*
replicas, 61–62
reproductions: photomechanical, 56, 58, 59, 61, 225; *60;* prints and, distinguished, 56–61, 225
Resurrection, see Greco, El
Return of the Hunters, see Bruegel
Richardson, John Adkins: *Approaching Storm at Halfmoon Bay*, 27–28, 373; *28, 372;* Cahokia mounds, reconstruction drawing, 275; *275; Golf Course at Lake of the Ozarks*, 27–28, 29; *28; Maxor*, 73–74, 75; *73; Maxor of Cirod*, 172; *171;* model of fishing schooner, *19; Portrait of Glenda in an Eighteenth-Century Mode*, 27–28, 29; *28; Reason and Faith*, 277; *279; Road to Xanadu*, 237–38; *238;* science-fantasy illustration, *17;* scratchboard illustration, 226–27; *227; Still Life with Striped Cloth*, 27; *27; Ted, Red, and Willie & "The Spinster Who Liked Cats,"* 74; *74*
"rightness," formal, 188–97; *189, 190*
Rivers, Larry, 204, 382; *Dutch Masters and Cigars III*, 204; *205*
Road to Xanadu, see Richardson
Robespierre, Maximilien de, 353
Rockefeller Center, New York, 302–3; *303*
Rockne, Knute, 146–47
rock paintings, Mont-Bégo, France, 266, 270, 271, 273, 274; *268*
Rockwell, Norman, 138; *Saying Grace*, 138–39; *139*
Rococo art and architecture, 346–50
Rodin, Auguste, 255; *Walking Man*, 255; *255*
Rogers, Richard, 394; Pompidou Center, Paris, 393, 394–96; *394*
Roman: art, 295–301; architecture, 295–97, 327; sculpture, 82, 84, 91, 93, 228, 297–99, 303; *see also* Classicism
Roman Empire, 296–97, 299–301, 303, 304, 307
Romanesque: art, 314, 319, 325; architecture, 311–15, 317, 318, 321
Roman mythology, 298, 299, 301
Romanticism, 351, 357–59, 361
Rome, Italy, 297, 303, 344
Rood, Ogden, 145
Rothko, Mark, 73, 88, 382; *Orange and Yellow*, 70, 73, 129; *71, 131*
Rothstein, Arthur, *Dust Storm (Oklahoma)*, 246; *246*
Rouault, Georges, 351, 371, 382
Rousseau, Henri, *Dream*, 105; *105*
Rousseau, Jean-Jacques, 358
Rubens, Peter Paul, 85, 94, 342, 344, 347–

48, 358; *Rape of the Daughters of Leucippus*, 94, 330–32, 342; *94, 331*
Russell, Charles, 75, 76, 77; *Loops and Swift Horses Are Surer than Lead*, 75; *16, 76*

Sacrifice of Isaac, see Nicholas of Verdun
Safdie, Moshe, 392; Habitat, EXPO 67, Montreal, 392–93; *392*
St.-Etienne, Caen, France, 312–13, 317; *313*
St. Lazare, *see* Gislebertus
St. Louis, Missouri, 387–88
St. Patrick's Cathedral, New York, 302–3; *303*
St.-Sernin, Toulouse, France, 312, 327; *312*
Saito, Ryoei, 55
Salomé, see Beardsley
Sandoval, Arturo, 253; *Pond*, 253, 264; *255*
San Giorgio Maggiore, *see* Palladio
Santa Croce, Pazzi Chapel, *see* Brunelleschi
Santa Maria della Salute, Venice, see Canaletto; Guardi
Santa Maria in Campitelli, *see* Rainaldi
San Vitale, Ravenna, Italy, 304–5; *305–7*
Saying Grace, see Rockwell
Schapiro, Meyer, 187
Schiller Building panel, *see* Sullivan
Schulz, Charles, 37; *Peanuts*, 37; *37*
Schusky, Ernest, 395; Cahokia Mounds, reconstruction drawing, 275; *275*
Schwitters, Kurt, 382
science-fantasy illustration, *see* Richardson
scientific perspective, 47, 152–54, 158–68, 171–73, 188; *159–65*
Scott, Sir Walter, 185, 359
scratchboard, 226–27; *227*
sculpture, 250–57; built, 252–53; carved, 250–51; *251;* cast, 254–57, 258, 278; *256;* found, 257
Sea Goddess, see Goltzius
Seagram Building, New York, *see* Johnson; Mies van der Rohe
Seated Boy with Straw Hat, see Seurat
Segovia, Spain, Roman aqueduct, 296; *296*
Self-Portrait, see Degas; Tupai Kupa
Self-Portrait with Palette, see Cézanne
serigraphy, 237–39; *239*
Seurat, Georges, 97, 144–46, 361, 363–64, 368; *Seated Boy with Straw Hat*, 111, 113; *110; Sunday Afternoon on the Island of La Grande Jatte*, 97, 144–45, 363; *97, 145, 364*
shade, 38, 40; chiaroscuro and, 103–14; *103, 106, 113;* color value and, 132, 136; form as revealed by, 97, 107, 118, 143; *106, 143;* in lettering, 103; *103;* light and, 47, 98–122, 323; *100, 112, 113, 119, 120;* modeling in, 103–14, 141; in photography, 101, 107, 118; *100; see also* darkness
Shakespeare, William, 185, 342
She Who Must Be Obeyed, see Smith, Tony
silk-screen process, 237–39; *239*
simultaneous contrast, 136, 142, 143, 145; *136*
Sinjerli Variation I, see Stella
Sistine Chapel, Rome, 93
Sky Cathedral, see Nevelson
skyscrapers, 387–88
Sleeping Venus, see Giorgione
Smith, David, 382
Smith, Michael, 219; *Arc I*, 237; *237; Yellow Arc*, 219; *15, 218*
Smith, Tony, 252; *She Who Must Be Obeyed*, 252, 368; *253, 367*

social forces, and artistic convention, 49–51
Socrates, 295
Soothsayer's Recompense, see Chirico
Soutine, Chaim, 382
Sparta, Greece, 292
spatial order, 148–78; Cubist treatment of, 177–78, 193; *177;* depth illusion, 148–52, 171, 176; focus, 148, 154, 158, 244; *150, 244;* Impressionist treatment of, 172–74; in photography, 152–54; *see also* perspective
Spinners, see Velázquez
Splash, see Anderson, Caroline
squinches, 308; *309*
Starry Night, see Gogh, Vincent van
Starstruck, see Kaluta; Lee
Stella, Frank, 368; *Sinjerli Variation I*, 368; *369*
stencil printing, 237–39
Still Life: Kitchen Table, see Chardin
Still Life with Striped Cloth, see Richardson
stipple drawing, 108; *36, 103*
Stone Age, *see* Mesolithic; Neolithic; Paleolithic
Stone Breakers, see Courbet
stone carving, 250–51; *251*
Stonehenge, England, 275
Story of the Champions of the Round Table, see Pyle
Street, Dresden, see Kirchner
Structuralism, 368
Stuart, Gilbert, 61; *"Athenaeum" Portrait of George Washington*, 61–62; *61*
Study for La Source, see Prud'hon
style, 204–11; *206;* incompetence as explanation of, 29–35; Wölfflin's theory of, 329–35, 340, 342, 344
Suleiman the Magnificent, 310
Sullivan, Louis, 387; Schiller Building ornamental panel, 388; *388;* Wainwright Building, St. Louis, 387–88; *388*
Sunday Afternoon on the Island of La Grande Jatte, see Seurat
Sunday (Old Russia), see Kandinsky
Suprematism, 367–68
Suprematist Composition: White on White, see Malevich
Surrealism, 214, 352, 377–80, 382
Suze, see Picasso
Swimmer, see Gallo
Sylvester, John, *Tupai Kupa*, 50; *50*
Syndics, see Rembrandt
synthetic media, 218–20

Taj Mahal, Agra, India, 310–11; *311*
Tanguy, Ives, 378
Tarquin, Etruscan king, 299
Tate Gallery, London, 26, 27
Tchelitchew, Pavel, 382
Ted, Red, and Willie & "The Spinster Who Liked Cats," see Richardson
Témoins (Witnesses at the Door of the Council of War), see Daumier
tempera painting, 137–38, 212–16, 219, 222, 225
Temple of Horus, Edfu, Egypt, 287; *288*
texture, 122–27; *123, 126*
Thebes, Egypt, 283, 286, 287
Theocritus, 293
Third of May, 1808, see Goya
three-point perspective, 159; *161*
Three Women, see Léger
Tiepolo, Giovanni, 351
Tiffany glass, 386
Tinguely, Jean, 395
Tintoretto, 49, 118, 330, 335, 336, 344;

PHOTOGRAPHIC CREDITS

The author and publisher wish to thank the libraries, museums, galleries, and private collectors named in the picture captions for permitting the reproduction of works of art in their collections, and for supplying the necessary photographs. Photographs from other sources are gratefully acknowledged as follows: Alinari, Florence: 1-3e, 2-12, 2-22–2-25, 2-27, 3-11, 4-21, 4-23, 4-26, 4-31, 4-34, 4-44, 4-45, 5-24, 5-35, 5-51, 5-54, 7-2, 7-9, 7-10, 7-12, 7-35–7-37, 8-6, 8-7, 8-8a, 8-8b, 8-9a, 8-9b, 8-18, 8-20, 8-21, 9-4, 9-44, 10-12, 10-17, 10-22, 10-26, 11-4–11-6, 11-27, 11-28, 12-2, 12-4, 12-6, 12-7, 12-10, 12-12, 12-13, 12-35; Anders, Jorg P.: 12-20; Anderson, Rome: 4-29, 9-1, 12-5, 12-34; Andrews, Wayne, Detroit: 11-19, 12-38; Annan, T. & R., Glasgow: 13-51; Archives Photographiques, Paris: 1-11, 2-28; Artothek, Munich: 12-16; Bildarchiv Preussischer Kulterbesitz, Berlin: 3-8; Blomstrann, E. Irving, New Britain, Conn.: 5-26; Brogi, Florence: 10-28, 12-3; Bundesdenkmalamt, Vienna: 2-21, 11-26; Canali, Rome: 12-14, 12-26, 12-28; Clements, Geoffrey, New York: 1-14, 1-30, 8-28, 8-31; Cox, Charles H.: 9-61, 9-63; Deutsche Fototek, Dresden: 13-6; Dingjan, A., The Hague: 5-20; French Government Tourist Office, New York: 11-17, 11-22, 11-23, 11-25, 13-47–13-49; Hedrich-Blessing, Chicago: 4-20, 13-52; Hirmer Photoarchiv, Munich: 10-10, 10-11, 10-16, 10-23, 11-3, 11-8; Hürriyat, Turkish Publishing and Marketing, Inc., New York: 11-10; Kidder-Smith, G.E., New York, 11-7, 12-36; Klein, Michael R., New York: 1-20; Marburg Foto Archiv, Marburg/Lahn: 12-33; Photo Mas, Barcelona: 2-19, 2-20, 5-41, 8-8d, 8-9d, 10-25, 12-30; Montreal, city of: 13-57; Nippon Television Network Corporation: 9-10; O.K. Harris Gallery, New York: 8-19; Peterson, Ad, Amsterdam: 1-6; Piaget, St. Louis: 5-57; Pollitzer, Eric, New York: 1-8, 8-30; Quattrone, Mario, Florence: 12-15; Renner, Edward, Frankfurt: 12-37; Richardson, John Adkins, Edwardsville, Ill.: 1-1, 1-2, 1-4b, 1-4c, 1-7, 1-21–1-24, 1-33–1-36, 2-1–2-3, 2-5–2-8, 2-13–2-18, 3-5, 3-6, 4-2–4-7, 4-10–4-14, 4-16, 4-17, 4-25, 4-38, 4-41, 4-42, 4-49, 5-3–5-6, 5-34, 5-37, 5-38, 5-50, 5-53, 5-56, 5-60, 5-61, 6-1, 6-6, 6-7, 6-9, 6-17, 6-18, 7-3, 7-4, 7-11, 7-14–7-31, 7-33, 7-34, 7-43, 7-50, 7-51, 8-2, 8-10, 8-11, 8-13, 8-14, 8-17, 8-32, 8-33, 9-16, 9-17, 9-22, 9-25, 9-26, 9-28, 9-32, 9-33, 9-36, 9-39, 9-40, 9-43, 9-45, 9-53, 9-67, 9-68, 10-2–10-5, 10-9, 10-14, 11-9, 11-20, 13-31, 13-61, 13-62; Roubier, Jean, Paris: 11-18; Service Photographiques des Musées Nationaux, Paris: 1-9, 2-26, 3-2, 4-8, 4-15, 4-33, 4-35, 5-7, 5-33, 5-43, 5-44, 5-55, 6-15, 8-23, 8-37, 12-9, 12-39, 12-40, 13-2–13-5, 13-7, 13-8, 13-12, 13-13; Shunk-Kender, New York: 13-46; Soprintendenza alla Antichità, Rome: 1-16, 4-28, 4-40, 10-24; Staatsbibliothek, Berlin: 10-15; Steinkopf, Walter, Berlin: 1-15, 5-59, 8-4, 8-8c, 8-22; Sutherland, Eric, Minneapolis: 4-36; Tiers, Monkmeyer Press Photo Service, New York: 11-12; Vertut, Jean: 10-1; Weston, Cole, Carmel, Cal.: 4-24, 9-37; Wyatt, A.J., Philadelphia: 9-9, 13-36.